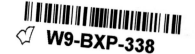

The Museum of Fine Arts, Houston
A Guide to the Collection

Henri-Emile-Benôit Matisse; French; Le Cateau 1869–Nice 1954. *Portrait of Olga Merson*, 1910.
Oil on canvas; 39¼ × 31¾ (99.7 × 80.7). Signed lower right corner: Henri Matisse. Museum purchase with funds provided by the Agnes Cullen Arnold Endowment Fund, 78.125. See no. 213.

The Museum of Fine Arts, Houston
A Guide to the Collection

Introduction by William C. Agee

THE MUSEUM OF FINE ARTS, HOUSTON: 1981

This project is supported by a grant from the National Endowment for the Arts
in Washington, D.C., a Federal agency.
Works accessioned as of June 30, 1980, are included, as are
life-time interest gifts and promised gifts.

Published by The Museum of Fine Arts, Houston
Printed in the United States of America by The Press of A. Colish, Inc.,
Mount Vernon, New York
PHOTOGRAPHY CREDITS: Figure 1, Hedrich-Blessing; Figure 5, Maurice Miller;
Figure 6, Rob Muir; Figure 9 and Plate 32, Allen Mewbourne;
Figure 10, Frontispiece, and Plates 1, 4–31, 33–36, Malcolm Varon.

Library of Congress Cataloging in Publication Data

Houston, Tex. Museum of Fine Arts.
 The Museum of Fine Arts, Houston.
 Includes index.
 1. Art—Texas—Houston—Catalogs. 2. Houston,
Tex. Museum of Fine Arts—Catalogs. I. Title.
N576.H7A6 708.164′1411 80-81646
ISBN 0-89090-001-9
ISBN 0-89090-002-7 (pbk.)

Contents

LIST OF PLATES *vii*

PREFACE AND ACKNOWLEDGMENTS *ix*

INTRODUCTION: A Brief History of The Museum of
 Fine Arts, Houston *xiii*

Notes to the Guide *2*

Asian *3*

Ancient *8*

Early Christian and Medieval *16*

Renaissance *22*

Seventeenth Century *47*

Eighteenth Century *64*

Nineteenth Century *89*

Twentieth Century *121*

Post-1945 *155*

Pre-Columbian and Tribal Arts
 Pre-Columbian *184*
 North American Indian *193*
 African *209*
 Pacific *214*

INDEX OF ENTRIES *219*

List of Plates

FRONTISPIECE. Henri-Emile-Benôit Matisse, *Portrait of Olga Merson*

1. Wang Li, *Two Mynahs*
2. Magna Graecian, *Relief with a Symposium Scene*
3. Roman, *Portrait of a Ruler*
4. German, *Canon Page from a Sacramentary, with the Crucifixion*
5. French, *Virgin and Child*
6. German, *Reliquary Monstrance from the Guelph Treasure*
7. Master of the Straus Madonna, *Madonna and Child of the Goldfinch*
8. Fra Angelico, *The Temptation of St. Anthony the Abbot*
9. Rogier van der Weyden, *Virgin and Child*
10. Hans Memling, *Portrait of an Old Woman*
11. Ferrarese School, *Meeting of Solomon and the Queen of Sheba*
12. Bartolommeo Veneto, *Portrait of a Man*
13. Veronese, *The Dead Christ with Angel and a Monk*
14. Bernardo Strozzi, *The Guardian Angel*
15. Laurent de La Hyre, *The Rape of Europa*
16. Philippe de Champaigne, *The Penitent Magdalen*
17. Frans Hals, *Portrait of a Woman*
18. Mattia Preti, *The Decollation of St. Paul*
19. Nicolas Bertin, *Prophets and Kings of the Old Testament Adoring the Name of Jehovah and Awaiting the Messiah*
20. Bernardo Bellotto, *The Marketplace at Pirna*
21. Pompeo Batoni, *Portrait of a Man*
22. American, *Easy Chair*
23. Théodore Chassériau, *Woman and Little Girl of Constantine Playing with a Gazelle*
24. Charles-François Daubigny, *Sluice in the Optevoz Valley*

25. Herter Brothers, *Lady's Writing Desk*
26. Pierre-Auguste Renoir, *Still Life with Bouquet*
27. Vincent van Gogh, *The Rocks*
28. Paul Signac, *A Pine on the Road to Saint-Tropez*
29. André Derain, *The Turning Road*
30. Georges Braque, *Fishing Boats*
31. Pierre Bonnard, *Dressing Table and Mirror*
32. Georgia O'Keeffe, *Grey Line with Black, Blue and Yellow*
33. Jackson Pollock, *Number 6*
34. Kenneth Noland, *Half*
35. Maya, *Cylindrical Vessel*
36. Zuni Pueblo, *Jar*

THE guide to The Museum of Fine Arts, Houston, was begun ten years ago by Philippe de Montebello, director, and Jack Schrader, then chief curator, and was nearing completion in 1974 when I came to the Museum. However, I soon realized that the collection was growing so rapidly that the guide would be outdated before it was published. The responsibilities of settling into the new Brown Pavilion and of launching the appropriate programs for a greatly expanded Museum were additional factors that necessitated postponement of the project.

Indeed, the expansion of the collection has been so extensive that the guide is now vastly different in format and purpose. For example, only in 1969 did the Museum firmly establish a policy of comprehensive collecting. Therefore, it was necessary in an earlier day to include numerous objects from all areas, regardless of their importance, to demonstrate that the still-young Museum was a general art museum. With the passage of time and thanks in large part to Mr. de Montebello, the Museum's scope has been well established, and the original purpose has since been replaced by other priorities. The guide now contains far fewer entries than first planned and instead concentrates more on the truly major works and real strengths of the collection. To be sure, a balance has been maintained by including works from all cultures and media represented in the Museum's collection, but the guide now reflects more accurately the true nature of the Museum's collections at this point in its rapidly evolving history. That holdings in the Renaissance or Twentieth Century are far stronger than those in East Asian or Ancient is clearly demonstrated by the present composition of the guide. In choosing objects for inclusion, an absolute standard of quality and importance was used throughout; the lengths of the sections have not been arbitrarily balanced. Nevertheless, in attempting to give a sense of the overall range of the collection, worthy objects were omitted from every section. This volume is an introductory guide to the collection, not a full catalog.

In every way the guide is the result of a collaborative effort that extends over a long period. Great credit is due first to Philippe de Montebello, who launched the project, and to members of his staff, who began the first serious research on the collection and wrote many of the original

entries. The dictates of space in the revised format necessitated omitting many of these entries, but their efforts still stand behind the entire project. Jack Schrader, chief curator from 1970 to 1973, played a fundamental role in planning, writing, and editing, and his work on what are now the Ancient, Early Christian and Medieval, and Renaissance sections remains highly important. Much work in collating and editing entries, as well as in writing the Renaissance and Seventeenth Century sections, was done by Kent Sobotik, chief curator from 1973 to 1978. Research and writing on works from the eighteenth and nineteenth centuries was originated by Thomas P. Lee, a member of the curatorial staff from 1970 to 1977; E. A. Carmean, curator of twentieth-century art from 1970 to 1974, did original research in his field, although many modernist works included in the guide have entered the collection since 1974. Alvia Wardlaw Short and Patricia Gilbert Baca of the Museum staff began research and writing on the Tribal Arts collection. In the early stages of preparation, the expertise of various scholars was sought. The late Professor Mino Badner of Rice University, Dr. Gordon Eckholm of the Museum of Natural History in New York, and Dennis Harrington, then of the University of Houston, made valuable suggestions for the Pre-Columbian and Tribal Arts section. Dr. Henry C. Fischer of the Metropolitan Museum of Art, New York, provided needed information on Egyptian objects, and Professor Ralph F. Glenn of Oakland University, Rochester, Michigan, wrote the original entries for the Asian section. I am grateful for their assistance.

The large number of important acquisitions made in the last six years has necessitated many new entries, and old entries have been considerably revised in the light of recent information. An essentially new format also required extensive and new collating, coordination, and editing. For superbly carrying out these demanding, seemingly unending, tasks and for bringing the guide to completion, the Museum owes an enormous debt of gratitude to the entire present curatorial and support staff.

Judith Rooney, associate curator, deserves special praise for her unstinting work in overseeing the myriad responsibilities involved with the entire project; in addition, she has written the painting and sculpture entries for the Twentieth Century and Post-1945 sections. David B. Warren, associate director of the Museum and curator of the Bayou Bend Collection, has been responsible for the entries on American art and decorative arts since the inception of the book. He has been ably assisted in this area first by Dean F. Failey and more recently by Katherine S. Howe, associate curator. J. Patrice Marandel, curator, not only wrote and helped revise numerous entries on older art, but also made invaluable suggestions regarding the format and contents. John Minor Wisdom, Jr., curator, was largely responsible for the nineteenth-century entries as well as for all entries on prints and drawings. The Museum began collecting photography on a broad scale in 1975, and Anne Tucker,

curator of photography since that time, wrote the entries pertaining to this medium. Celeste Adams, who in addition to her duties as chairman of the Department of Art History and Education is curator of Asian art, has written the Asian entries.

In the area of Tribal Arts, I am deeply indebted to Leon Siroto, New York, for the entries on African art, to Julie Jones of the Metropolitan Museum of Art, New York, for the entries on pre-Columbian art, to Douglas Newton of the Metropolitan Museum of Art, New York, for the entries on Pacific art, and to Evan Maurer of the Art Institute of Chicago for the research and writing of the North American Indian entries. Kate Leader edited and coordinated all material with great skill, for which I owe her my deep thanks. Karen Bremer, assistant curator, and Carolyn Vaughan, curatorial assistant, have provided important assistance at every step, and Linda Nelson, librarian, has unfailingly provided needed bibliographical and research assistance.

This book would never have been possible without Edward B. Mayo, registrar, and his staff. Over a period of twenty years, Mr. Mayo has maintained impeccable accession files that contain the basic information underlying every entry. As ad hoc Museum archivist, he has also added invaluable information to all sections of the guide. Further, he has been responsible for the infinitely delicate task of measuring and remeasuring every object. We all owe him and his assistants an untold measure of gratitude.

The design, layout, and production of the guide was placed in the enormously capable hands of Bert Clarke, of the Press of A. Colish, Mount Vernon, New York. I am most grateful for his assistance and advice. Malcolm Varon has done the color photography, and the black and white photography was carried out by Allen Mewbourn.

Finally, on behalf of the entire Museum, I would like to extend my deepest appreciation to the Charles E. Merrill Trust, the Brown Foundation, the McAshan Educational and Charitable Trust, and the National Endowment for the Arts for generous grants that have made this publication possible.

WILLIAM C. AGEE
Director

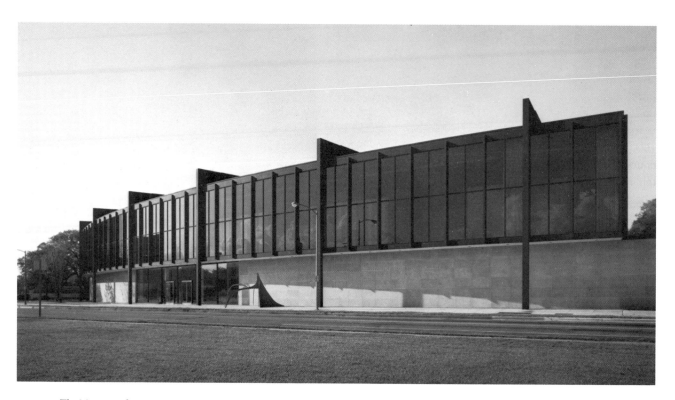

FIGURE 1. The Museum of Fine Arts, Houston, North Entrance.

Introduction: A Brief History of The Museum of Fine Arts, Houston

by William C. Agee

THE Museum of Fine Arts, Houston, is a privately supported, general art museum devoted to collecting and exhibiting in all areas of art history. It is a young institution, younger even than a purely chronological history would indicate. Its roots can be traced to 1900, but the Museum only opened in 1924 in a small building, and it was not until the mid-1940's that the collections had taken on any real substance. In many ways, the Museum did not truly begin to mature until the early 1960's under the direction of James Johnson Sweeney. The present course, which accounts for the Museum's recent growth, was only established firmly in 1969 when the Museum adopted a policy of broad, systematic collecting in the history of art and for the first time took steps to assure a strong financial base both for operations and acquisitions as well as for an appropriate physical plant.

The Architecture

Today the physical plant consists of three separate buildings (the Museum proper, Bayou Bend, and the Alfred C. Glassell, Jr., School of Art) as well as the Lillie and Hugh Roy Cullen Sculpture Garden; together they constitute the entity now known as The Museum of Fine Arts, Houston. These four units were built and merged in a period extending over three quarters of a century, in what can be identified as eight distinct phases.

The Museum is the outgrowth of the Houston Public School Art League, founded by five women on April 13, 1900, for the stated purpose of "the encouragement of art and culture in the public school system," to be achieved by circulating in the schools "good graphics," which included reproductions of famous paintings and monuments. In 1913 the group was chartered as the Houston Art League to serve the city as a whole. By this time, a small art collection had been formed and was housed in the offices of the mayor and City Council as well as in homes of League members. Plans for a museum building were begun, and in 1917 a permanent site at South Main and Montrose was acquired with a gift of $3,300 from Joseph S. Cullinan. A deed was prepared stipulating that a

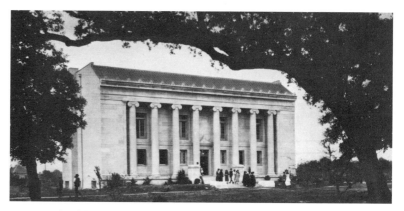

FIGURE 2.
View of The Museum of Fine Arts, Houston, 1924.

museum building, costing not less than $20,000, be erected within ten years, and on April 12, 1917, the site was dedicated. However, the United States declared war against Germany the next day, and construction was postponed.

The League pursued plans for the building in 1919 after George M. Dickson had given his collection of paintings and sculptures. William Ward Watkin (1886–1952), formerly of the firm Cram, Goodhue and Ferguson, was commissioned to design the building. Freely mixing classical and Spanish elements, he planned a large classical structure, surrounding an open courtyard.*

However, the necessary funding was not available, and the League could only build the central block. On April 16, 1922, ground was broken, and the Museum opened to the public on April 12, 1924, under the direction of James Chillman, Jr. At this time, the League changed its name to The Museum of Fine Arts of Houston (later shortened to The Museum of Fine Arts, Houston), a change made official on May 7, 1929, when the Museum began to operate under a state charter, supported by private donations and annual appropriations from the city.

When the building opened in 1924, plans for two additional wings had been announced, but adequate funding was not yet possible. By 1926 the west wing, facing Montrose with a columnar facade and including five galleries, and the smaller east wing, housing the Museum School, were opened, creating a distinctly asymmetrical design. After completing the second phase of construction, Watkin prepared drawings for a master plan to extend the building to the north edge of the site and surround a formal courtyard. However, no further construction was undertaken for some twenty-five years, when the third building phase was carried out in 1953 with the completion of the Robert Lee Blaffer Memorial Wing, designed by Kenneth Franzheim (1890–1959). The

*An excellent and detailed discussion of the architectural evolution of the Museum, including elevation drawings and floor plans, is given in Donnelley Erdman with Peter C. Papademetriou, *The Museums of Fine Arts, Houston—fifty years of growth, 1922–1972,* Architecture at Rice #28, Houston, 1972. Most of the summary discussion here is based on that publication.

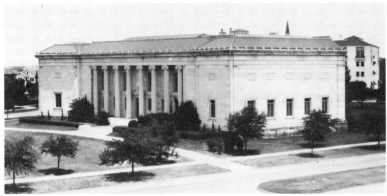

FIGURE 3.
View of The Museum of Fine Arts, Houston, 1926.

new wing was essentially a square, two-story addition that re-established the axial balance of Watkin's original design.

Only a year later the Museum was able to take a far-reaching step forward, one that marked a new era. In 1954 Miss Nina J. Cullinan, long a distinguished patron of the arts, whose father had made possible the acquisition of a permanent site for the Museum, announced a gift in memory of her parents, Joseph Stephen and Lucie Halm Cullinan, for the construction of a new exhibition hall. She made only one stipulation—that a special building committee select "an architect of international reputation." Ludwig Mies van der Rohe (1886–1969) was the unanimous choice, and he was retained to prepare a master plan to meet the future needs of the Museum. In the spring of 1954, Mies began his design of Cullinan Hall. He developed a symmetrical, axial plan, with splayed wings that responded to the irregular outlines of the site and created a large, clear-span space by suspending the roof from the underside of four exposed, steel-plate girders carried in exterior steel columns.

FIGURE 4.
Cullinan Hall, constructed 1958.

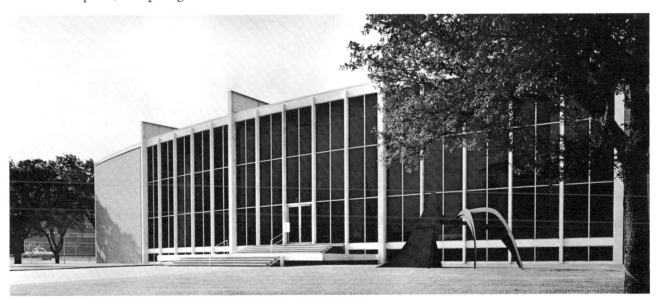

FIGURE 5.
Interior view, showing detailing of juncture
between 1926 and 1958 additions, seen from
Brown Pavilion.

FIGURE 6.
Bayou Bend, Garden Facade.

Mies honored Watkin's original plan to organize the wings around a formal court to some extent. However, he had first visited the site on a hot day and said, "but in this climate you cannot want a patio." Thus Cullinan Hall became a two-story, enclosed space "set" into what was to have been the courtyard; the north front was formed by a glass curtain-wall. More importantly, Mies maintained the spirit of the original architecture by his precise detailing in joining the old and new buildings and in the rhythmic, harmonious delineation of Cullinan Hall and the entire master plan. He thus created a modern restatement of a classical vocabulary. Construction took two years, during which time the old building was remodeled, and Cullinan Hall opened on October 9, 1958.

The Museum was significantly expanded both in its physical plant and in the scope of its collection with the magnificent gift from Miss Ima Hogg in 1957 of her house, Bayou Bend, and her collection of American painting and decorative arts. Located on Buffalo Bayou five miles from the Museum, the twenty-eight-room house was designed by John F. Staub in 1927. Now known as the Bayou Bend Collection of The Museum of Fine Arts, Houston, it underwent the necessary modifications and was opened to the public on March 5, 1966. Miss Hogg (1882–1975) was a truly great philanthropist, and her gift of Bayou Bend stands out as one of the most important in the Museum's history.

In 1970 the Museum was able to undertake completion of Mies's master plan through an extraordinary gift from the Brown Foundation, the largest single gift bestowed upon the Museum in its history to that time.

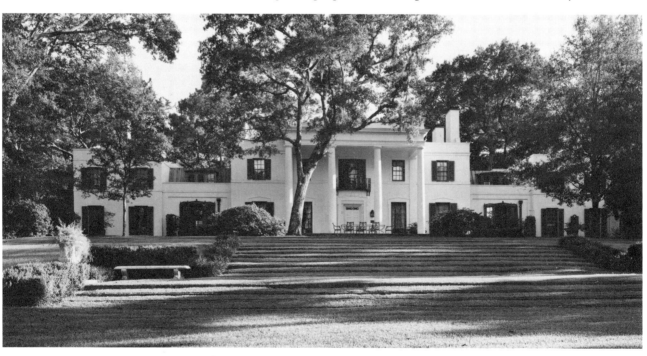

The generosity of the Brown Foundation also made possible the first substantial endowment, not only to maintain the new pavilion, but also to establish adequate operating funds for the entire Museum. The Brown Pavilion extended north to Bissonnet Street and more than doubled the Museum's gallery space from 26,033 square feet to 75,331 square feet, with total footage, including office, storage, and service areas, reaching 135,522 square feet.

Only a few changes in the original design of 1954 were made in the actual construction of the Brown Pavilion: the garden courts on the east and west sides were enclosed, the entrance canopy was eliminated, and internal changes were made for storage and service areas. During construction, the older rooms were remodeled, and several areas were converted into new galleries. Construction was completed in late 1973, and the Brown Pavilion opened on January 14, 1974. The Pavilion consists of three floors, the most important being the dramatic Upper Brown Gallery, a sweeping exhibition space over eighty feet wide and some three hundred feet long that provides an openness and flexibility unmatched by virtually any exhibition hall in the country.

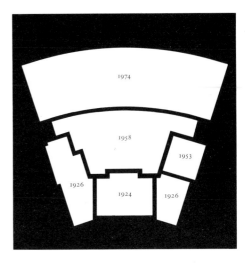

FIGURE 7.
Outline of The Museum of Fine Arts, Houston, showing its growth, 1924–1974.

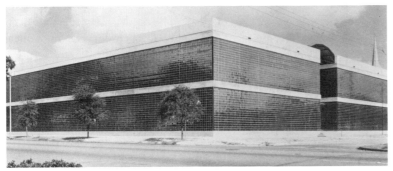

The Museum School had grown considerably since its establishment in 1927 and by 1972 could no longer be quartered in the Museum building. In that year the School had moved to a rented facility two miles from the Museum, and after the opening of the Brown Pavilion an adequate facility close to the Museum became a first order of business. Land immediately across Bissonnet Street north of the Museum had been acquired for the Museum in 1970 and then sold to the city with the stipulation that the Museum build and maintain a public park. In 1977 additional land adjoining this site on the north was acquired, and plans for a new school building were pursued, made possible by the generosity of Alfred C. Glassell, Jr. The two-story building was designed by Eugene Aubrey of S. I. Morris Associates and is constructed of glass block and concrete. It comprises two large work areas on either side of an atrium covered by a translucent canopy. Ground was broken on October 23, 1977, and the Alfred C. Glassell, Jr., School of Art opened on January 12, 1979. Its 41,000 square feet provide the space and facilities commensurate with past growth and future needs.

FIGURE 8.
The Alfred C. Glassell, Jr., School of Art, Southwest Exterior.

During the construction of the School, it became evident that the land between the School and the Museum required a more formal design than previously envisaged in order to connect properly the two buildings and to provide the appropriate setting for a collection of nineteenth- and twentieth-century sculpture. Several noted landscape architects were asked to present possible solutions, and Isamu Noguchi was commissioned in 1978 to design a formal sculpture garden. The garden has been made possible by a major gift from the Cullen Foundation and is named the Lillie and Hugh Roy Cullen Sculpture Garden. Noguchi's design provides a tranquil, landscaped area for the quiet contemplation of works of art while visually and physically connecting the School and Museum buildings. With a public opening scheduled for 1982, the final stage of the physical plant as currently conceived will be completed. At the same time, however, given the Museum's recent and projected growth, the Museum is already planning for the needs of coming decades.

The Collection

The Museum opened in 1924 with a modest collection, consisting primarily of the George M. Dickson Bequest, which had been given to the Houston Art League in 1919. The Bequest comprised twenty-five paintings, an engraving, five bronzes, a few ivories, and fragments of stained glass; the most important works were paintings by Anton Mauve, J. Léon Gérôme, and William Merritt Chase. The collection received little further assistance until the 1930's when Annette Finnigan made a series of gifts of fine lace and antiquities from Egypt, Greece, and Rome, the most important of which is an Attic grave stela. In its early years, and indeed until the late 1960's, the Museum's collection suffered from the absence of any purchase funds, and it was not until 1939 that the Museum received its first substantial gift. In that year, Miss Ima Hogg —who played a crucial role in the Museum's development—donated over one hundred important works on paper by artists such as John Singer Sargent, Paul Cézanne, Pablo Picasso, Emil Nolde, Lyonel Feininger, Paul Klee, and others, many of which rank among the Museum's most important holdings of art on paper. The Museum was again the beneficiary of Miss Hogg's generosity and of her wide range of interest and superb taste in 1944 when she donated a large collection of North American Indian artifacts. Her gift forms the backbone of the Museum's collection in this area. In compliance with the wishes of her brothers, Mike and Will, Miss Hogg gave a large group of paintings and one sculpture by Frederic Remington in 1943.

The most important gift in the Museum's history to that time came in 1944 with the acquisition of the Edith A. and Percy S. Straus Collection, a gift that has shaped the collection to this day. The collection, which numbers eighty-three works, was formed in New York with the guid-

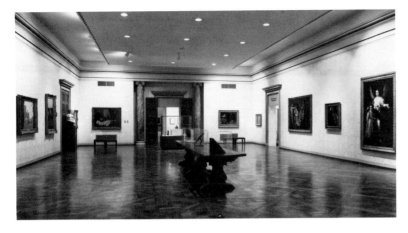

ance of the noted scholar Richard Offner, and its overall quality and importance are exceptional. It consists primarily of Italian bronzes (for example, Andrea Riccio, L'Antico, Antonio Susini), Trecento and Quattrocento paintings (for example, Fra Angelico, Giovanni di Paolo, the Master of the Straus Madonna), Northern Renaissance paintings (for example, Rogier Van der Weyden, Hans Memling, Corneille de Lyon), and eighteenth-century works (for example, Clodion, Jean-Antoine Houdon, Louise Elizabeth Vigée-Lebrun).

Shortly thereafter, beginning in 1947 and continuing in the 1950's, the Robert Lee Blaffer family gave a series of important paintings that substantially extended the Museum's collection of European art. The Blaffer gifts ranged from two early works by Giovanni di Paolo and a Frans Hals portrait to paintings by Paul Cézanne, Edgar Degas, Auguste Renoir, and Edouard Vuillard. In 1961 the Samuel H. Kress Foundation presented a gift, which included major paintings such as Bernardo Belloto's *The Marketplace at Pirna* and the superb still life by the Spanish seventeenth-century master Juan van der Hamen and added significantly to the collection's strength in older European art.

Under the directorship of James Johnson Sweeney, the Museum made significant gains in its holdings of non-European art. In 1965 Mrs. Harry C. Hanszen, who over a long period made many important gifts, donated some 150 pre-Columbian objects that form the core of the Museum's collection in this area. At the same time, many superb pieces of African and Oceanic art entered the collection through the generosity of Mr. and Mrs. John de Menil, whose all-encompassing interests and continuing assistance enriched the collection with key works ranging from the great Roman bronze *Portrait of a Ruler* to Jackson Pollock's *Number 6*, 1949.

Although still without a permanent accession fund, the Museum had now established momentum made possible by the generosity of such donors, and in the 1960's the number of good friends increased. The Esther Florence Whinery Goodrich Foundation and family gave several

major gifts, including the large *Still Life* by Willem Claesz. Heda, the sanguine *Study after the Rose Nude* by Henri Matisse and the *Woman with Phlox* by Albert Gleizes. Mr. and Mrs. Theodore N. Law made the first of their many vital gifts, which range from *The Rape of Europa* by Laurent de La Hyre to the superb 1927 *Two Women before the Window* by Pablo Picasso and the *Back I* of 1909 by Henri Matisse.

In 1966 the public became the beneficiary of one of the most important gifts in the Museum's history when Bayou Bend, the home of Miss Ima Hogg, was opened as the Bayou Bend Collection of The Museum of Fine Arts, Houston. The house, which had been donated in 1957, and its furnishings, given in the following years, comprise one of the finest collections of American art and decorative arts from the early seventeenth to the mid-nineteenth century in the country. Miss Hogg continued to supplement the collection until her death in 1975, and since that time further additions have been made through Museum acquisition funds and the generosity of many donors. By any standard, the richness of the Bayou Bend Collection makes it one of the Museum's strongest assets.†

The Museum received its first acquisition fund in 1968 with a bequest from the Estate of Laurence H. Favrot. These funds, expended between 1969 and 1972 under the directorship of Philippe de Montebello, enabled the acquisition of several major works of Medieval art, including the superb reliquary monstrance from the Guelph Treasure; in addition, other first-rank works such as the Mattia Preti and the fifth-century B.C. Greek relief with a symposium scene entered the collection.

A landmark in the Museum's history was set in 1969 when the magnificent generosity of the Cullen Foundation—a crucial factor in the Museum's growth—established the Agnes Cullen Arnold Endowment Fund for the purchase of works of art, the first and most important such fund ever to come to the Museum. The fund has been used for major acquisitions, often for works that have been the first of their kind to enter the collection. Through it outstanding works by Philippe de Champaigne, Claude Lorrain, Luca Giordano, Théodore Rousseau, Théodore Chassériau, Henri Matisse, and Georgia O'Keeffe, as well as a tenth-century A.D. Indian Vishnu stela and a ninth-century B.C. Assyrian relief have considerably expanded and strengthened the collection.

When the Brown Pavilion and remodeled galleries opened in early 1974, the Museum was fortunate to exhibit on long-term loan the superb collection of Impressionist, Post-Impressionist, and early modernist paintings that had been gathered over a fifteen-year period by John A. and Audrey Jones Beck. In the fall of that year Mrs. Beck announced the extraordinary gift of nine of the paintings—works by Honoré Daumier, Vincent van Gogh, Mary Cassatt, Paul Signac, André Derain, Georges

† For a full catalog see David B. Warren, *Bayou Bend: American Furniture, Paintings, and Silver from the Bayou Bend Collection* (Houston: The Museum of Fine Arts, Houston, 1975).

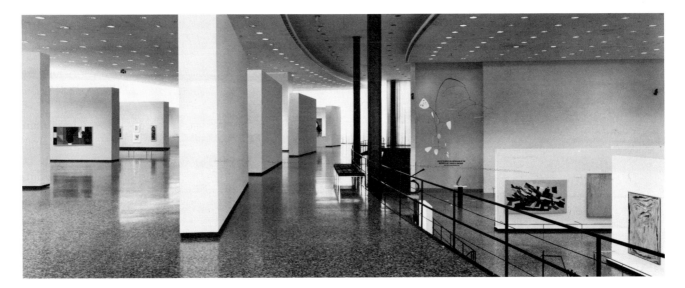

FIGURE 10.
Interior view of Upper Brown (left) and Cullinan Hall (right).

Braque, Wassily Kandinsky, Pierre Bonnard, and Henri Matisse. While all are outstanding works, special note should be made of Derain's 1905 *The Turning Road*, the artist's masterpiece and a key work of Fauvism, and the 1909 Braque, *Fishing Boats*, a high point of early Cubism. At the same time Mrs. Beck established a fund that has enabled the Museum to acquire paintings by Claude Monet, Alfred Sisley, Frédéric Bazille, Paul Gauguin, Roger de La Fresnaye, and others. Sadly, John Beck did not live to see the collection installed at the Museum. As a tribute to him, an annual memorial lecture in his name was established in 1975, and noted scholars are invited to speak on topics within the area covered by the Beck Collection.

The fundamental role held by the Brown Foundation in the development of the Museum has been noted. In April 1976 the Foundation announced the most significant gift in the Museum's history, a ten-year challenge grant for operations and acquisitions that represents a substantial increase in endowment funds for the purchase of works of art. Also included in the gift was a direct grant for purchases; by the two means the Museum has acquired major modernist paintings by artists such as Clyfford Still and Morris Louis. In addition the Brown Foundation has made other direct grants that have enabled the purchase of *Back IV* (ca. 1931) by Henri Matisse and a rare painting by the American Cubist Patrick Henry Bruce. Through these gifts, as well as through the personal gifts of Mr. and Mrs. George R. Brown, the collection has grown dramatically.

In the last five years the increased number of donors who have significantly assisted the Museum has been gratifying; the dictates of space preclude listing them all, but full credit is given in the entries. Their generosity has allowed the Museum to build on existing strengths and has enabled the extension of the collection to new areas. In 1975, for exam-

ple, Target Stores, Inc., a division of Dayton-Hudson Corporation, made an initial gift with annual supplements that have provided the means to collect seriously in photography. The Target Collection of American Photography and holdings in European photography give the Museum a collection that previously did not exist. Over the years, many generous donations from Mr. and Mrs. Harris Masterson, especially in the decorative arts, have greatly benefited the collection. Since 1976 Dr. and Mrs. Evan Horning annually have given important prints by artists ranging from Albrecht Dürer to Henri Matisse, strengthening the graphic holdings. Dr. and Mrs. Mavis P. Kelsey have donated and continue to add to what now constitutes almost the entirety of Winslow Homer's woodcuts. Other Homer works on paper are also included in their collection. In addition, generous gifts in recent years from Mr. and Mrs. Isaac Arnold, Jr., Mr. and Mrs. George S. Heyer, Jr., Mr. and Mrs. Meredith Long, Mr. and Mrs. Robert Straus, and Mrs. Mary Alice Wilson have added major works of both Western and Asian art to the collection. It is through the generosity of these donors that the Museum can look optimistically to the future.

Plates

PLATE 1. Wang Li; Chinese; Chia-hsing, Chekiang Province, active late 16th–early 17th centuries. *Two Mynahs*, dated 1620. Two of artist's seals follow inscription; three collector's seals at lower corners. Paper, ink, slight color; 52½ × 17¾ (133.4 × 45.1). Gift of Mr. and Mrs. George Lenert Kroll, 75.343. See no. 5.

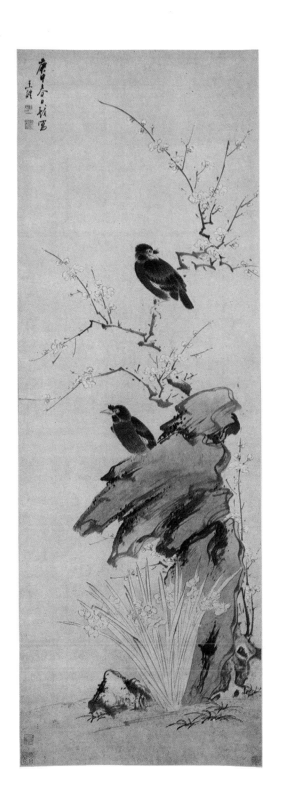

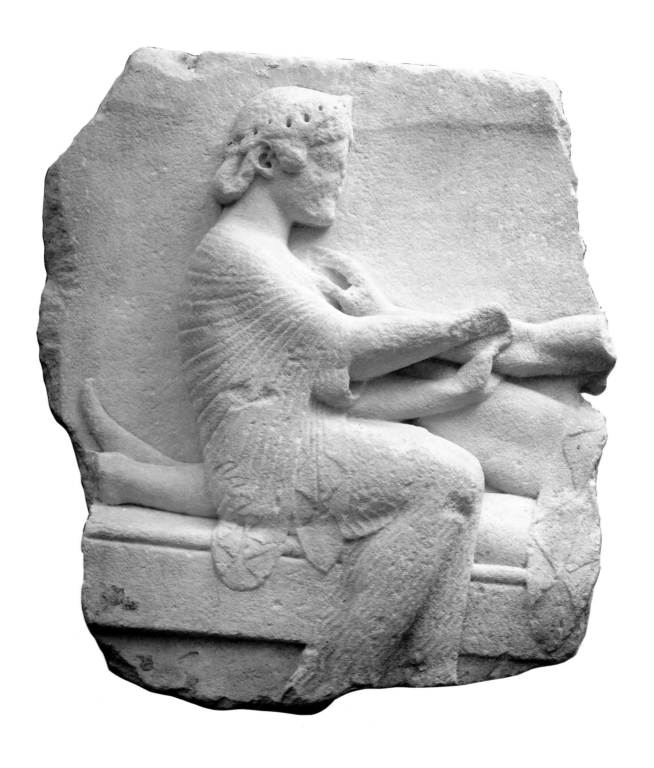

PLATE 2. Magna Graecian, Late Archaic period. *Relief with a Symposium Scene*, ca. 480 B.C.
Marble; 24 × 21⅞ (61.0 × 54.5). Museum purchase with funds provided by the Laurence
H. Favrot Bequest Fund, 72.25. See no. 14.

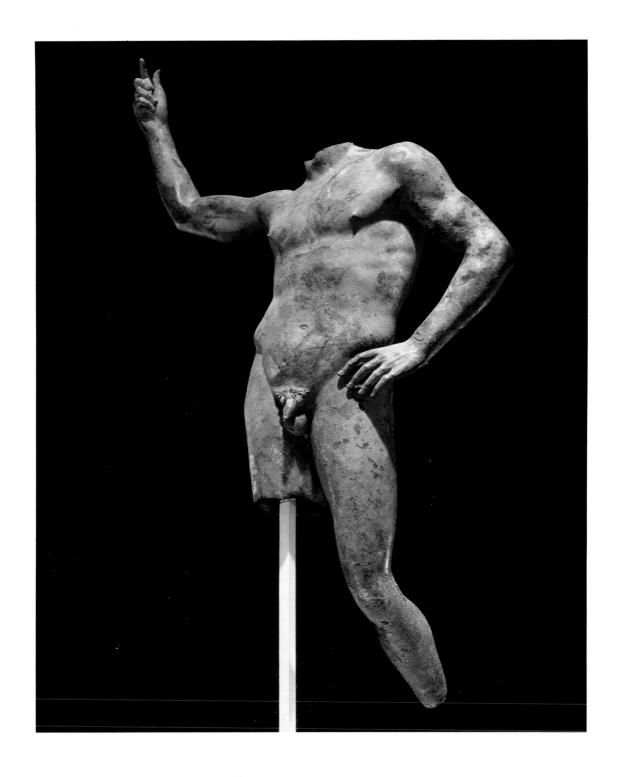

PLATE 3. Roman, Severan Period. *Portrait of a Ruler*, first quarter of the 3rd century A.D. Bronze; maximum preserved h. 82 (208.3). Gift of D. and J. de Menil in memory of Conrad Schlumberger, 62.19. See no. 22.

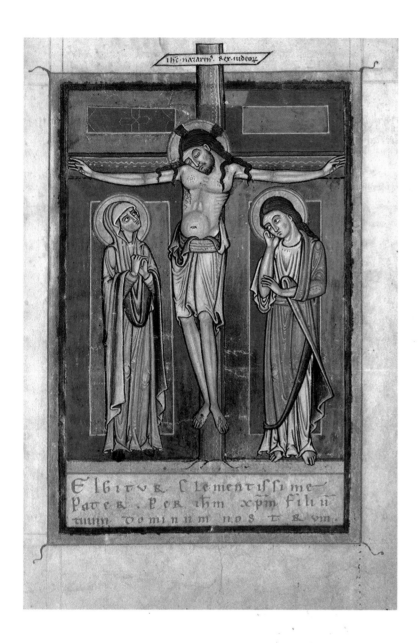

PLATE 4. German, Lower Saxony, perhaps Hildesheim. *Canon Page from a Sacramentary, with the Crucifixion*, ca. 1150–1160. Tempera and gold leaf on parchment; 11⅞ × 7⅞ (30.2 × 20.0); image 9⅜ × 6¼ (23.8 × 15.9). Museum purchase with funds provided by the Laurence H. Favrot Bequest Fund, 71.8. See no. 28.

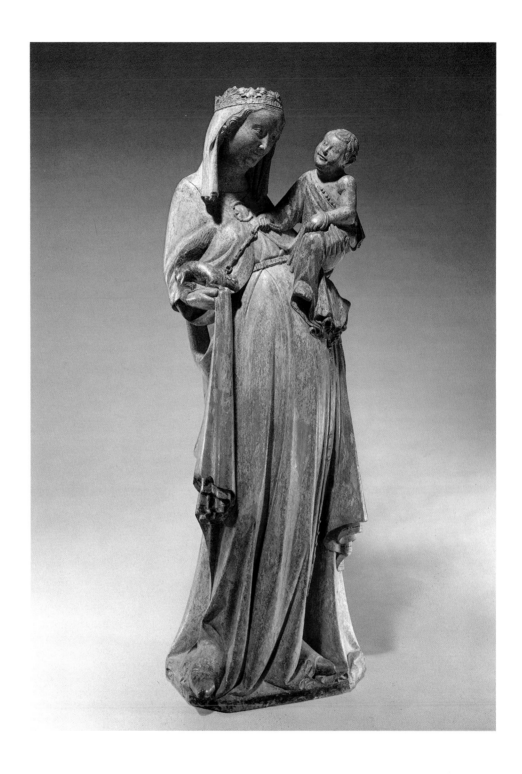

PLATE 5. French, Normandy. *Virgin and Child*, early 14th century. Limestone with remains of original polychromy; h. 40⅜ (102.5). Museum purchase with funds provided by the Laurence H. Favrot Bequest Fund, 71.15. See no. 32.

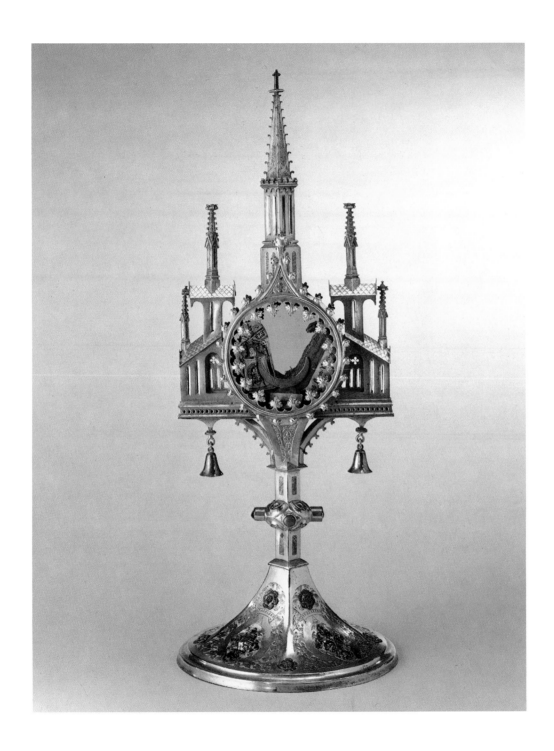

PLATE 6. German, Lower Saxony (Hildesheim). *Reliquary Monstrance from the Guelph Treasure*, early 15th century. Engraved copper-gilt, silver, translucent enamel; h. 21⅛ (53.6). Museum purchase with funds provided by the Laurence H. Favrot Bequest Fund, 70.16. See no. 35.

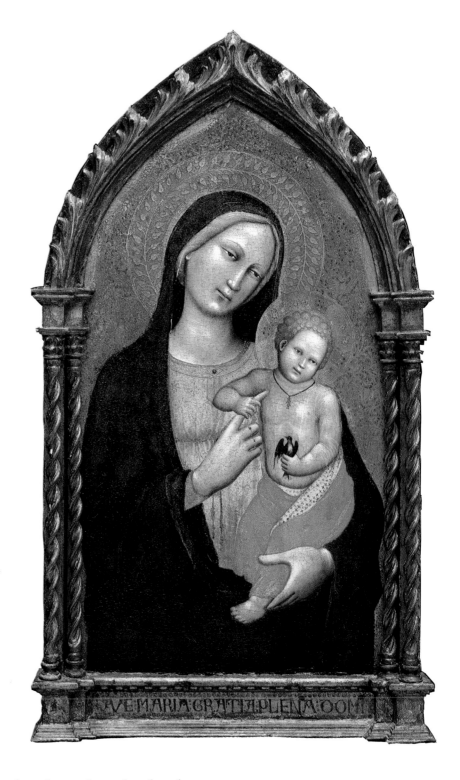

PLATE 7. Master of the Straus Madonna; Italian; Florence, late 14th–early 15th century.
Madonna and Child of the Goldfinch, before 1405. Tempera and gold leaf on panel; 35⅝ × 20¾
(90.5 × 52.7). Edith A. and Percy S. Straus Collection, 44.565. See no. 41.

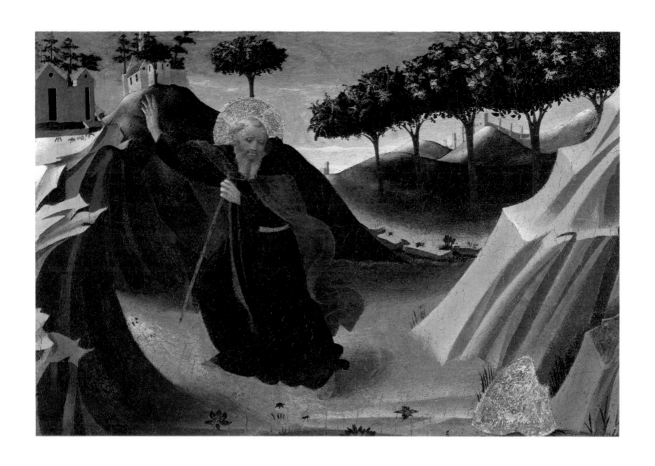

PLATE 8. Fra Angelico; Italian; Siena 1395/1399–1482/1483. *The Temptation of St. Anthony the Abbot*, ca. 1430. Tempera on panel; 7¾ × 11⅛ (19.7 × 28.0). Edith A. and Percy S. Straus Collection, 44.550. See no. 43.

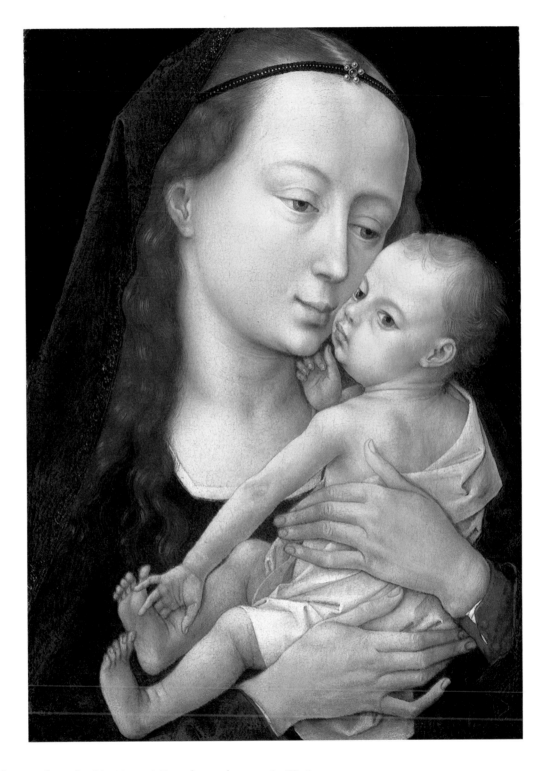

PLATE 9. Rogier van der Weyden; Flemish; Tournai-Brussels 1399/1400–1464. *Virgin and Child*, after 1454. Oil on panel, 12⅜ × 9 (31.9 × 22.9). Edith A. and Percy S. Straus Collection, 44.535. See no. 48.

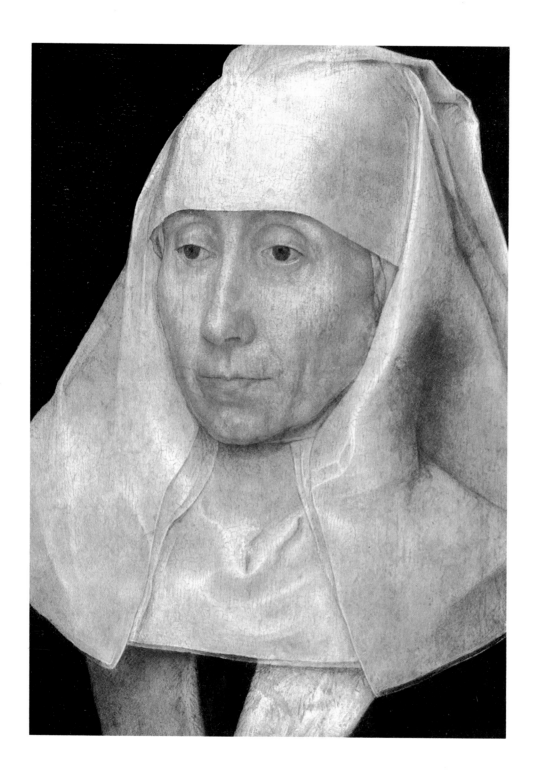

PLATE 10. Hans Memling; Flemish; Bruges ca. 1433–1494. *Portrait of an Old Woman*, ca. 1468–1470. Oil on panel; 10⅛ × 7 (25.7 × 17.7). Edith A. and Percy S. Straus Collection, 44.530. See no. 49.

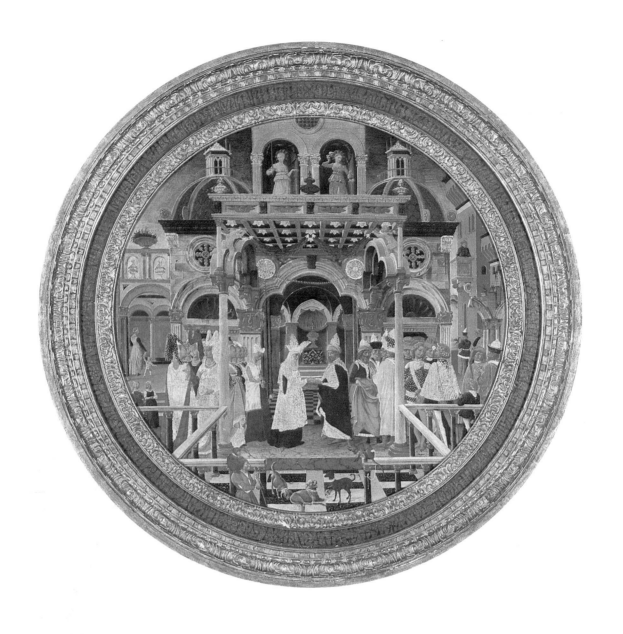

PLATE 11. Ferrarese School, Italian. *Meeting of Solomon and the Queen of Sheba*, ca. 1470.
Tempera on panel; diam. 36⅜ (92.3). Edith A. and Percy S. Straus Collection, 44.574.
See no. 51.

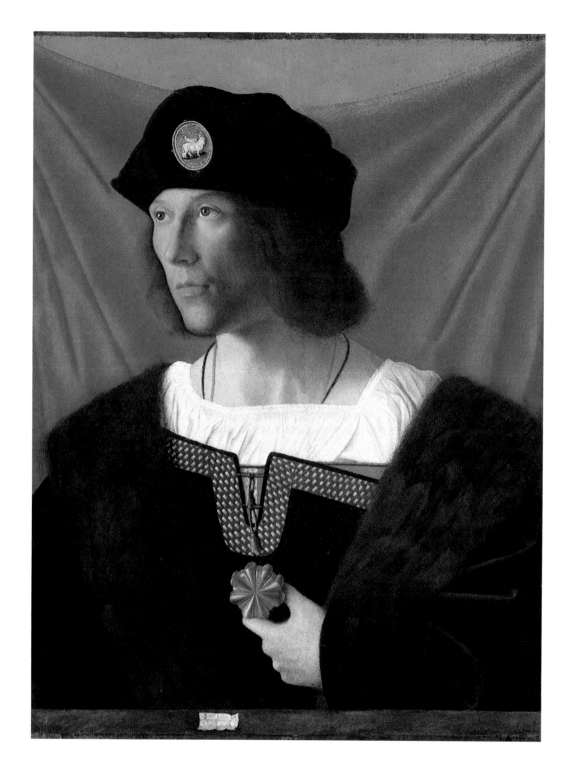

PLATE 12. Bartolommeo Veneto; Italian; Venice (?) 1502–1546. *Portrait of a Man*, 1512 (?).
Oil on panel; 27⅞ × 21½ (70.8 × 54.6). Edith A. and Percy S. Straus Collection, 44.573.
See no. 71.

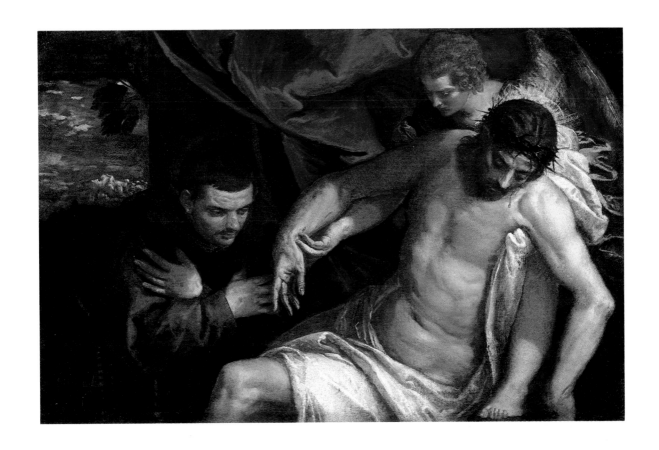

PLATE 13. Paolo Caliari, called Veronese; Italian; Verona 1528–Venice 1588. *The Dead Christ with Angel and a Monk*, ca. 1585. Oil on canvas; 33⅞ × 49⅞ (85.9 × 126.6). Gift of Mr. and Mrs. Isaac Arnold, Jr., in memory of Hugh Roy and Lillie Cullen, 79.254. See no. 85.

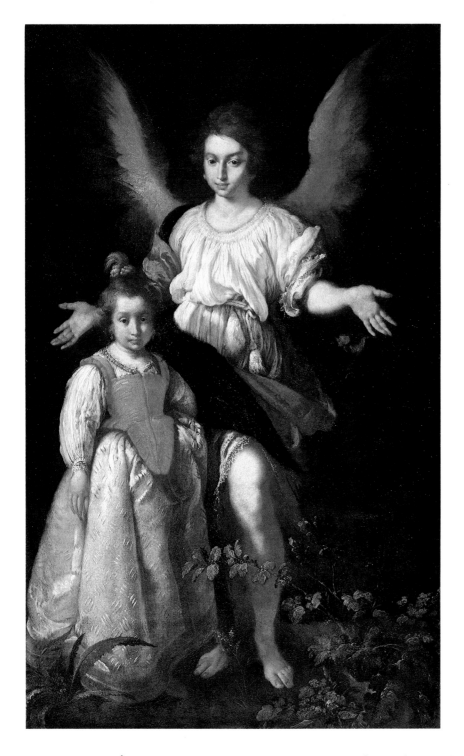

PLATE 14. Bernardo Strozzi; Genoese; Genoa 1581–Venice 1644. *The Guardian Angel*,
ca. 1630. Oil on canvas; 83⅞ × 50¾ (213.0 × 129.0). Anonymous gift in honor of Mrs.
William Stamps Farish (née Libbie Randon Rice), Benefactress and Lifetime Trustee of
The Museum of Fine Arts, Houston, 76.256. See no. 92.

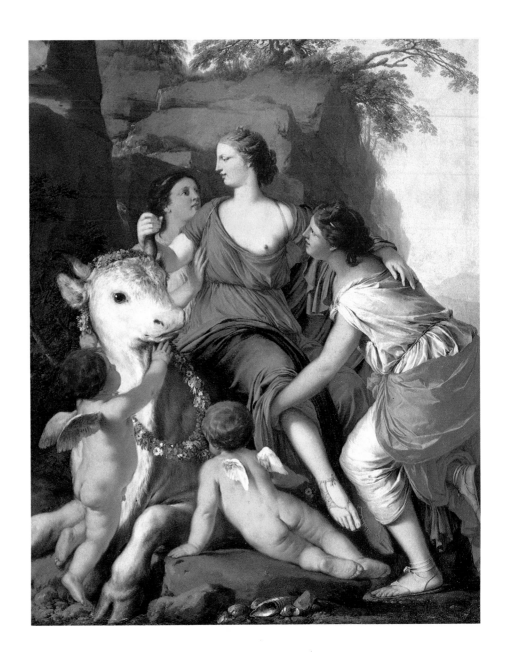

PLATE 15. Laurent de La Hyre; French; Paris 1606–1656. *The Rape of Europa*, 1644. Oil on canvas; 46 15/16 × 59 7/16 (119.0 × 150.9). Signed and dated front lower center: L. de La Hyre in.+F. 1644. Gift of Mr. and Mrs. Theodore N. Law, 70.12. See no. 99.

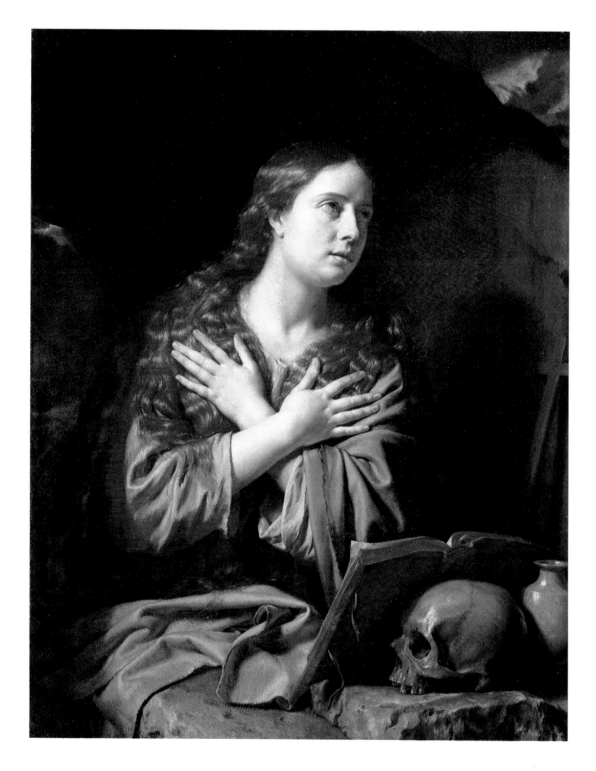

PLATE 16. Philippe de Champaigne; French; Brussels, Belgium 1602–Paris, France 1674.
The Penitent Magdalen, 1648. Oil on canvas; 45⁹⁄₁₆ × 35 (115.9 × 88.9). Museum purchase
with funds provided by the Agnes Cullen Arnold Endowment Fund, 70.26. See no. 100.

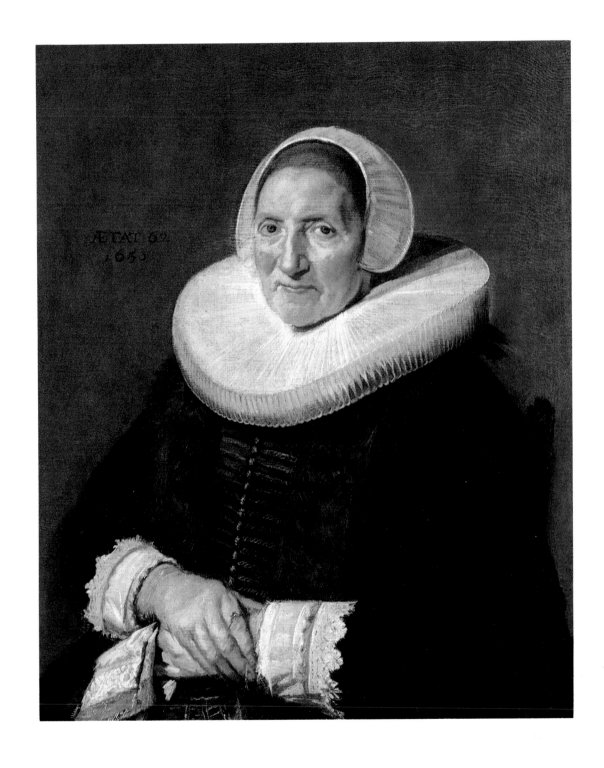

PLATE 17. Frans Hals; Dutch; Antwerp ca. 1580–Haarlem 1666. *Portrait of a Woman*,
1650. Oil on canvas; 33⅝ × 27¾ (84.6 × 69.2). Inscribed upper left: AETAT 62/1650.
Robert Lee Blaffer Memorial Collection; Gift of Sarah Campbell Blaffer, 51.3. See no. 102.

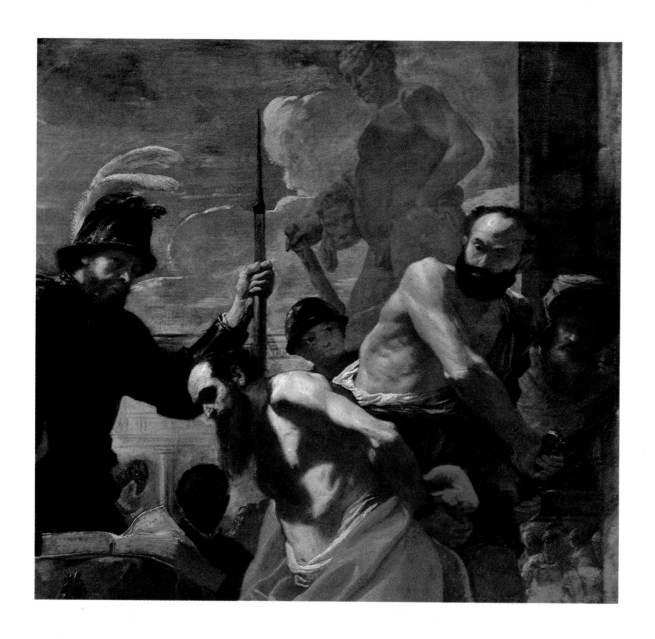

PLATE 18. Mattia Preti; Neapolitan School; Taverna 1613–Malta 1699. *The Decollation of St. Paul*, ca. 1656–1659. Oil on canvas; 70 11/16 × 73¾ (179.6 × 187.3). Museum purchase with funds provided by the Laurence H. Favrot Bequest Fund, 69.17. See no. 103.

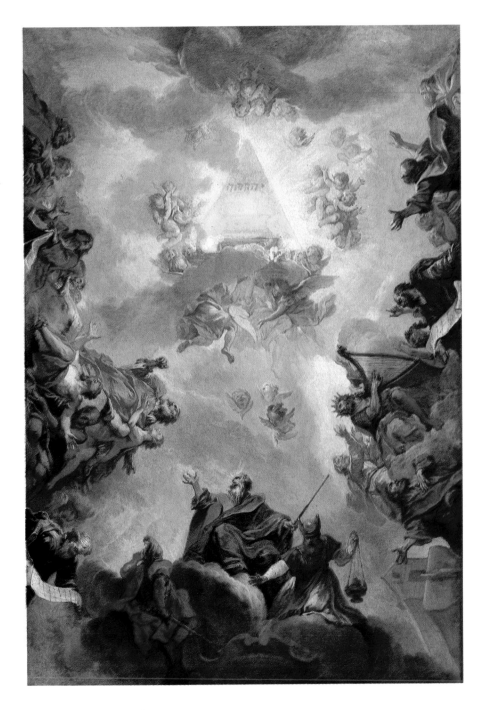

PLATE 19. Nicolas Bertin; French; Paris 1668–1736. *Prophets and Kings of the Old Testament Adoring the Name of Jehovah and Awaiting the Messiah*, 1718. Oil on canvas; 51¼ × 37⅜ (130.0 × 94.8). Inscribed on the cartouche: Virtutem operum suorum annuntiabit populo suo/videt sic illis hereditatem gentium (He has proclaimed the power of His works to His people/He has given them the inheritance of the nation); signed: Nicolas Bertin. invenit/ Pinxit. Museum purchase with funds provided by the Laurence H. Favrot Bequest Fund, 69.5. See no. 117.

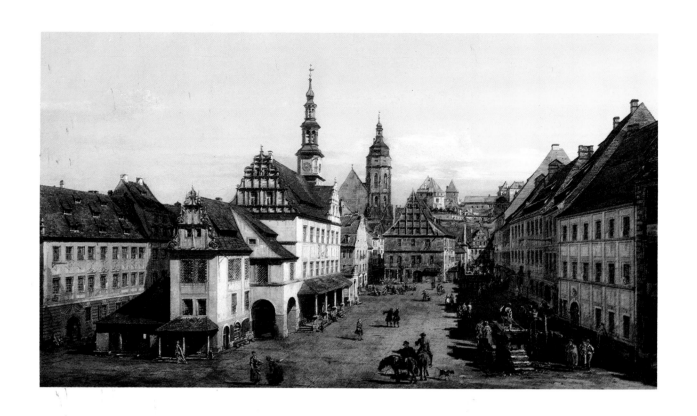

PLATE 20. Bernardo Bellotto; Italian; Venice 1720–Warsaw 1780. *The Marketplace at Pirna*, ca. 1750. Oil on canvas; 19 × 31⁹⁄₁₆ (48.4 × 79.6). Samuel H. Kress Collection, 61.71. See no. 131.

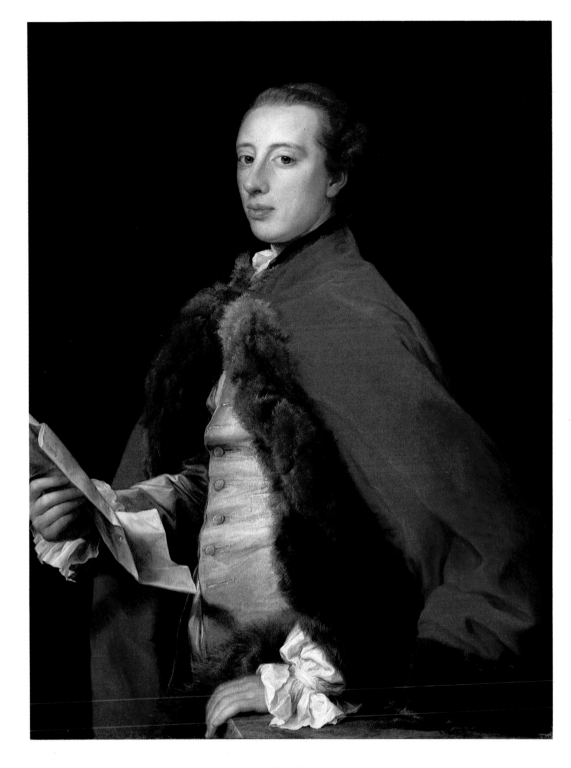

PLATE 21. Pompeo Batoni; Italian; Lucca 1708–Rome 1787. *Portrait of a Man*, 1758.
Oil on canvas; 39⅛ × 28 ¹⁵⁄₁₆ (99.4 × 73.5). Signed and dated on back: POMPEO BAT-
TONI FECIT 1758. Samuel H. Kress Collection, 61.76. See no. 132.

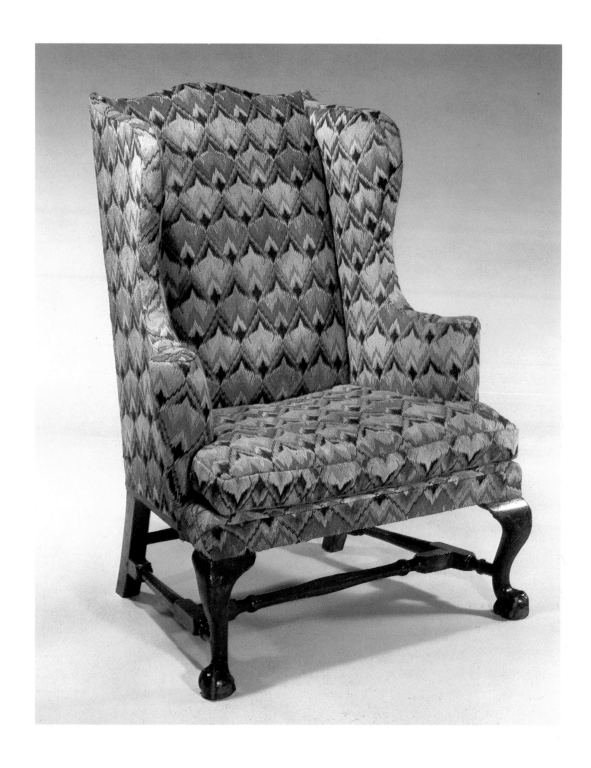

PLATE 22. American, Massachusetts. *Easy Chair*, 1750–1770. Mahogany, maple; h. 45½
(110.5), w. 32⅜ (82.2), d. 32⅝ (82.8). Bayou Bend Collection; Gift of Miss Ima Hogg,
B.60.89. See no. 133.

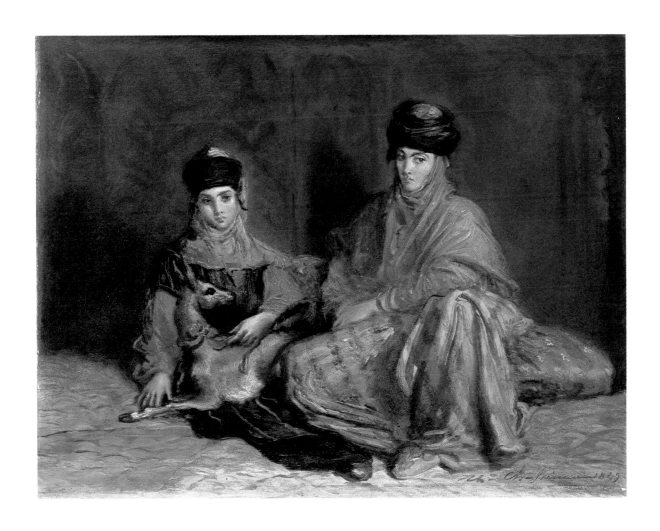

PLATE 23. Théodore Chassériau; French; Samaná, Hispaniola 1819–Paris, France 1856.
Woman and Little Girl of Constantine Playing with a Gazelle, 1849. Oil on panel; 11⁹⁄₁₆ × 14⁵⁄₈
(29.4 × 37.1). Signed and dated lower right: Thᵣₑ Chassériau 1849. Museum purchase
with funds provided by the Agnes Cullen Arnold Endowment Fund, 74.265. See no. 168.

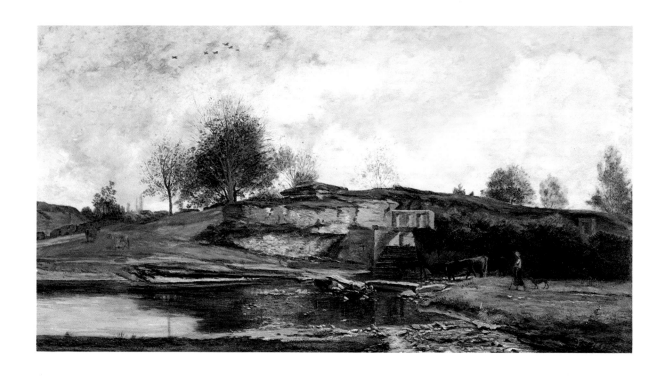

PLATE 24. Charles-François Daubigny; French; Paris 1817–1878. *Sluice in the Optevoz Valley*, 1854. Oil on canvas; 35½ × 63¼ (90.2 × 60.7). Museum purchase with funds provided by Anaruth and Aron S. Gordon, 79.122. See no. 170.

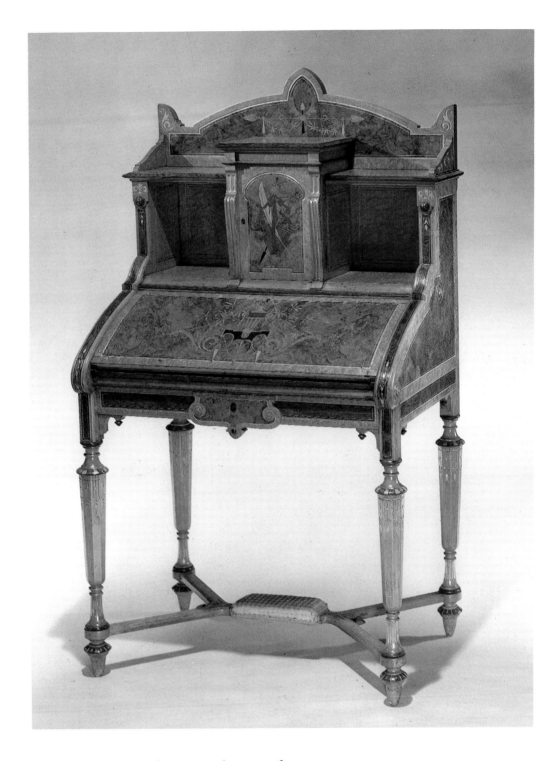

PLATE 25. Herter Brothers; American; New York, New York, active after 1865–
ca. 1900. *Lady's Writing Desk*, ca. 1870–1875. Maple, walnut, walnut veneer, rosewood;
h. 54⅝ (138.7), w. 31¼ (79.4), d. 20⅛ (51.1). Branded in wood on underside: HERTER
BRO'S. Museum purchase, 77.373. See no. 181.

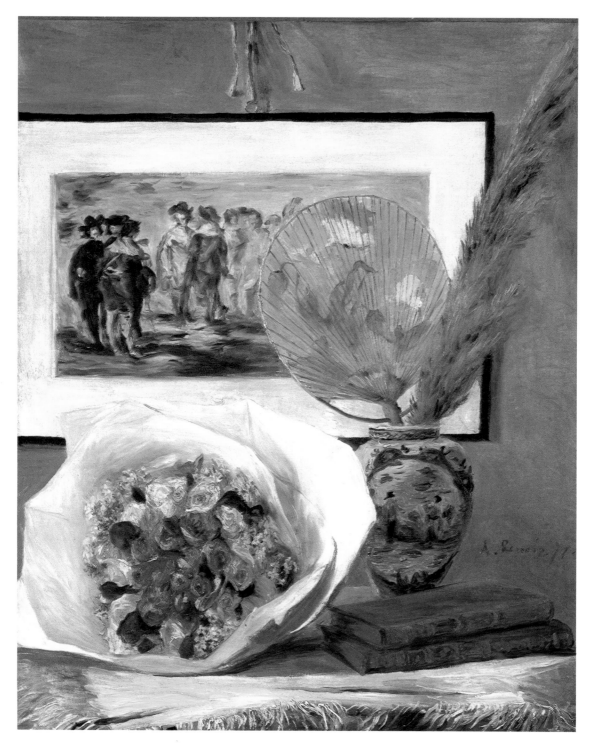

PLATE 26. Pierre-Auguste Renoir; French; Limoges 1841–Cagnes 1919. *Still Life with Bouquet*, 1871. Oil on canvas; 28 13/16 × 23 3/16 (73.3 × 58.9). Signed and dated lower right: A. Renoir. 71. Robert Lee Blaffer Memorial Collection; Gift of Sarah Campbell Blaffer, 51.7. See no. 185.

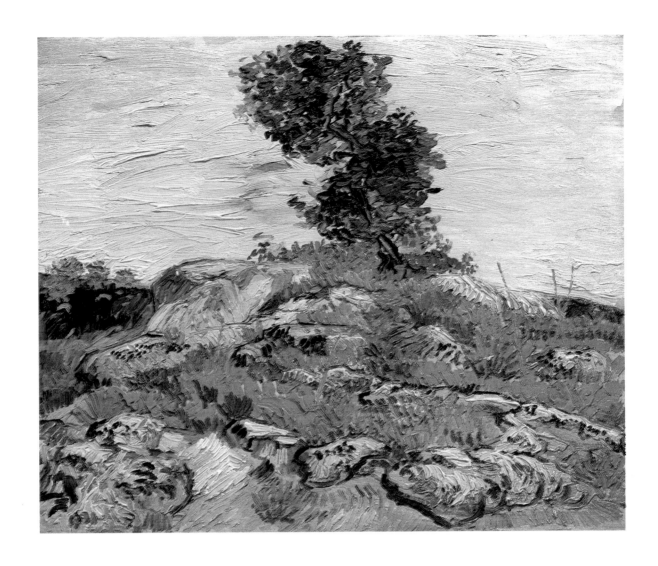

PLATE 27. Vincent van Gogh; Dutch; Groot Zundert, Holland 1853–Auvers, France 1890. *The Rocks*, 1888. Oil on canvas; 21⅝ × 25⅞ (54.9 × 65.7). John A. and Audrey Jones Beck Collection, 74.139. See no. 196.

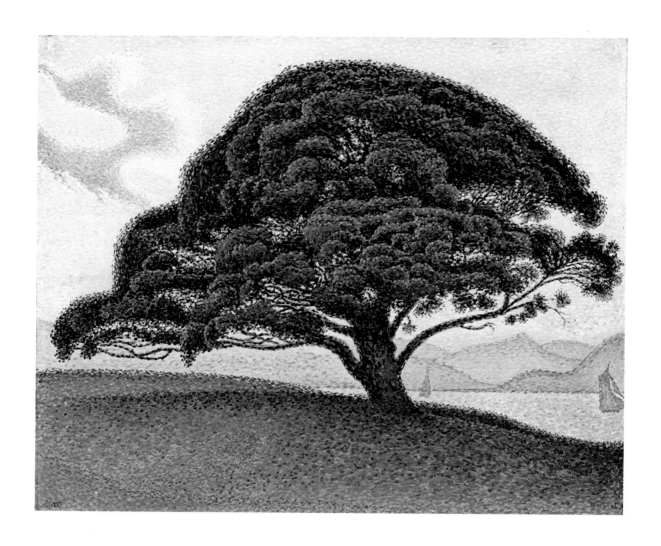

PLATE 28. Paul Signac; French; Paris 1863–1935. *A Pine on the Road to Saint-Tropez*,
1893. Oil on canvas; 25⅞ × 31⅞ (65.7 × 81.0). Inscribed lower left: Op 239. Signed lower
right: P. Signac 93. John A. and Audrey Jones Beck Collection, 74.142. See no. 203.

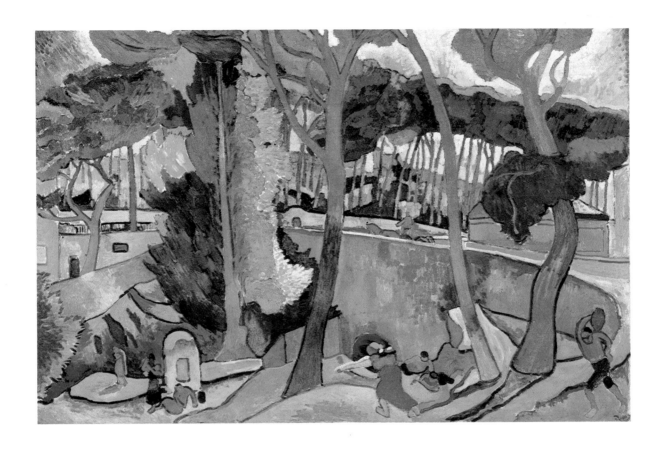

PLATE 29. André Derain; French; Chatou 1880–Garches 1954. *The Turning Road*, 1906.
Oil on canvas; 50½ × 76⅝ (128.2 × 194.6). Signed lower right corner: Derain. John A.
and Audrey Jones Beck Collection, 74.138. See no. 209.

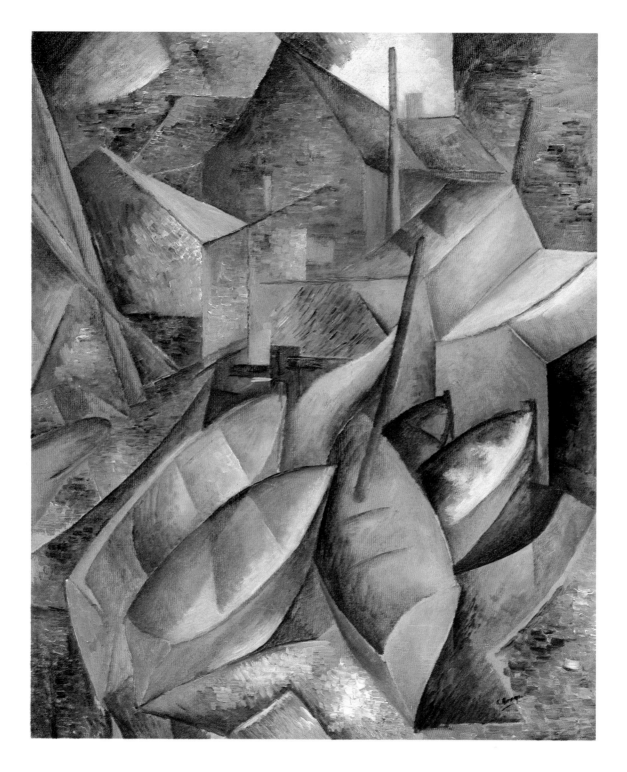

PLATE 30. Georges Braque; French; Argenteuil-sur-Seine 1882–Paris 1963. *Fishing Boats*, 1909. Oil on canvas; 36¼ × 28⅞ (92.1 × 73.3). Signed lower right: G Braque. John A. and Audrey Jones Beck Collection, 74.135. See no. 212.

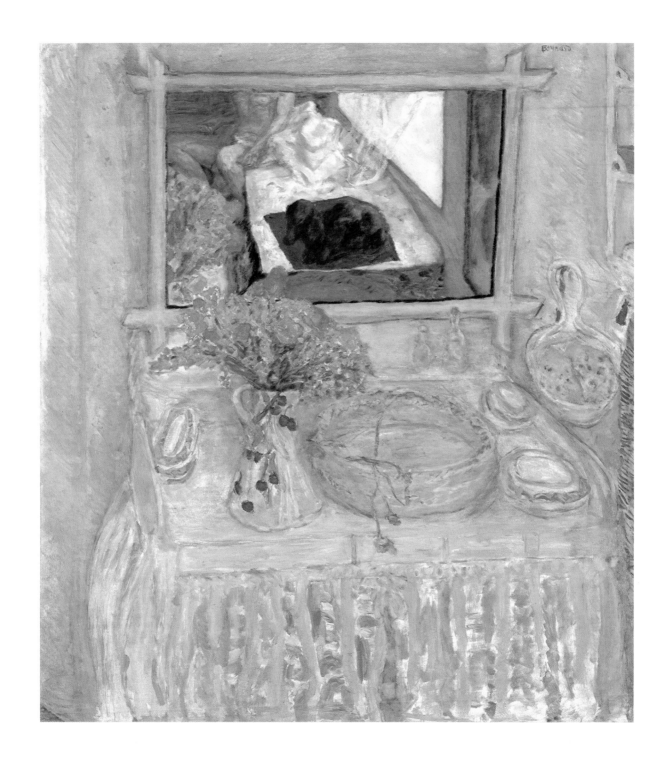

PLATE 31. Pierre Bonnard; French; Fontenay-aux-Roses 1867–Le Cannet 1947. *Dressing
Table and Mirror*, ca. 1920. Oil on canvas; 49 × 43⅛ (124.5 × 109.3). Signed upper right:
Bonnard. John A. and Audrey Jones Beck Collection, 74.134. See no. 231.

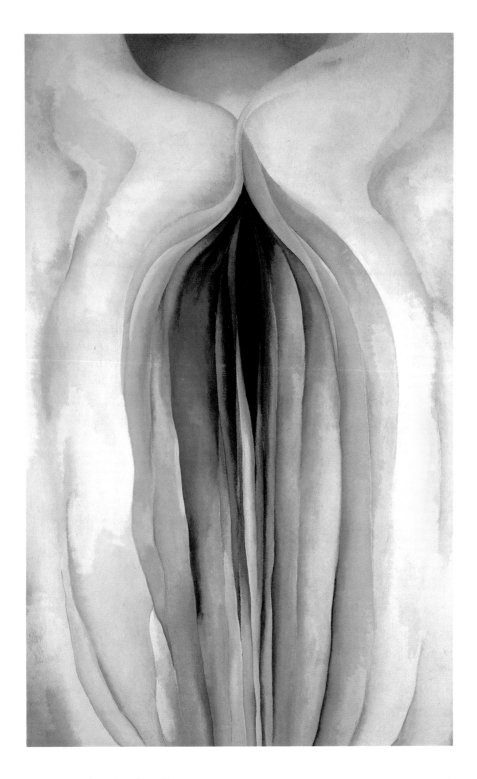

PLATE 32. Georgia O'Keeffe; American; Sun Prairie, Wisconsin 1887. *Grey Line with Black, Blue and Yellow*, ca. 1923. Oil on canvas; 48 × 30 (121.9 × 76.2). Museum purchase with funds provided by the Agnes Cullen Arnold Endowment Fund, 77.331. See no. 236.

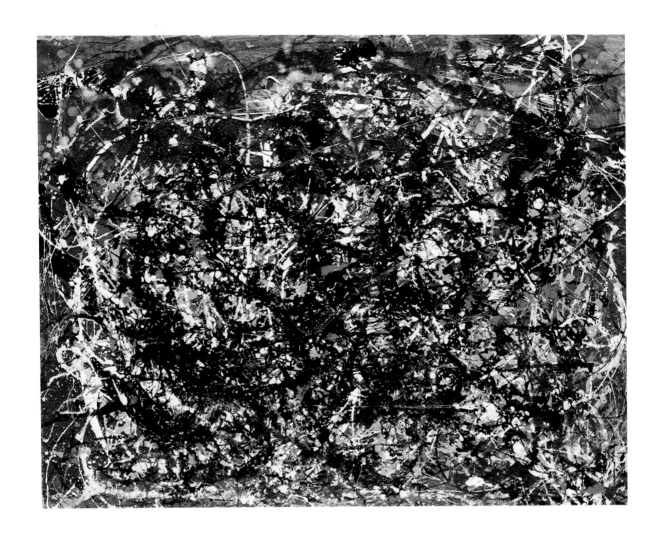

PLATE 33. Jackson Pollock; American; Jackson, Wyoming 1912–Southampton, New
York 1956. *Number 6*, 1949. Duco and aluminum paint on canvas; 44³⁄₁₆ × 54 (112.0 × 137.3).
Gift of D. and J. de Menil, 64.36. See no. 260.

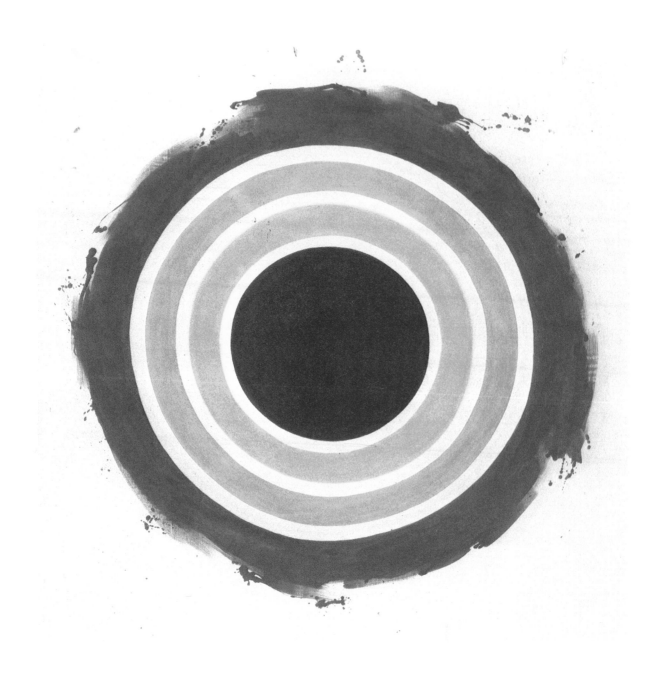

PLATE 34. Kenneth Noland; American; Asheville, North Carolina 1924. *Half*, 1959.
Acrylic on canvas; 68⅝ × 68⅝ (174.3 × 174.3). Museum purchase, 74.260. See no. 272.

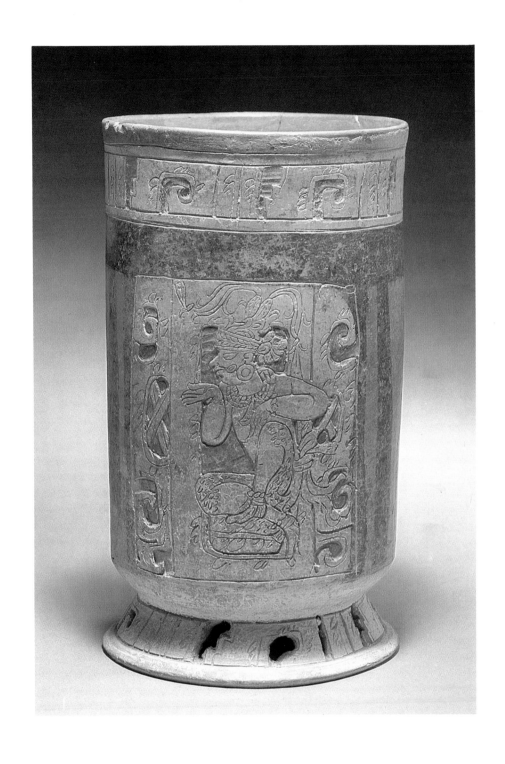

PLATE 35. Maya, Mexico. *Cylindrical Vessel,* 9th–10th centuries A.D. Ceramic; h. 8¾ (22.2), diam. 5⅟₁₆ (12.9). Museum purchase, 67.11. See no. 310.

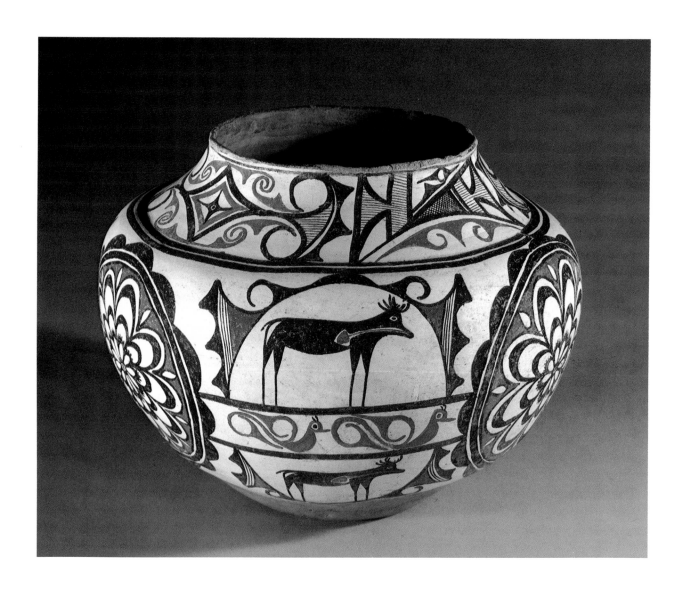

PLATE 36. Zuni Pueblo. *Jar*, ca. 1880. Ceramic; h. 9⁹⁄₁₆ (23.6), diam. 13 (33.0). Gift of Miss Ima Hogg, 44.96. See no. 323.

A Guide to the Collection

Works accessioned as of June 30, 1980, are included, as are life-time interest gifts and promised gifts.

Works are arranged in approximate chronological order. They are divided into ten broad, historical sections that cover wide chronological and geographic areas.

The entries are intended to give some biographical information, to place the work within its historic context and within the artist's oeuvre, and to describe briefly the important and unique qualities of the individual object. In the Pre-Columbian and Tribal Arts section, the social and cultural context of the work and the specific characteristics of the object are described. North American Indian art is arranged by pueblo or geographic area, and most entries describe several objects.

If known, the nationality of the artist precedes the place of birth and death. If these locations are the same, the location is mentioned only once. If the places of birth and death are different, each location is given. If the countries of birth and death are different, each country is listed for clarification.

Dimensions, exclusive of frame, list inches before centimeters, which are placed within parentheses; height precedes width. Documented dates follow the name of the object. When dates are not documented a general period is designated, or an approximate period is indicated by "ca."

The first two digits of the accession number represent the year of acquisition. A "B" preceding the accession number indicates the Bayou Bend Collection of The Museum of Fine Arts, Houston. A "TR" preceding the accession number indicates a promised gift.

Color plates follow the order of the entries as they are arranged in the guide. All objects reproduced in the color-plate section are also reproduced in black and white within the text.

No attempt has been made to unify the individual styles of the contributors. Initials at the end of each entry, right margin, identify the author or authors of the entry.

Contributors:

CA	Celeste Adams	JMR	Judith McCandless Rooney
DFF	Dean F. Failey	JS	Jack Schrader
KSH	Katherine Susman Howe	LS	Leon Siroto
JJ	Julie Jones	KS	Kent Sobotik
JPM	J. Patrice Marandel	AT	Anne Tucker
EM	Evan Maurer	DBW	David B. Warren
DN	Douglas Newton	JMW	John Minor Wisdom, Jr.

I CHINESE
Early Western Han Dynasty, 206 B.C.–9 A.D.

Stamped Tomb Brick, 206 B.C.–9 A.D.
Terra cotta, red and white polychrome; 24¾ × 47½ (62.9 × 120.7)
Gift of Carol and Robert Straus 69.25

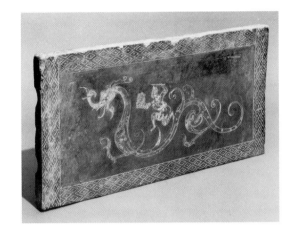

When the victorious General Liu Pang seized the Wei Valley and declared him-
self emperor, he chose Han as his dynastic name and established the first ruling
house of native Chinese origin. Han dynasty China parallels the Roman Empire
of the West in historical time, military prowess, and cultural significance. The
four centuries of Han, interrupted by Wang Meng's usurpation 9–23 A.D., are
distinguished chronologically as Former and Later Han, or as Western and
Eastern Han. The latter designation refers to the moving of the capital from
Ch'ang-an in the west to Lo-yang in the east.

 Although the Houston brick is associated with the Lo-yang region, the tombs
near the village of Chin Ts'un predate the move of the Han capital. This area
along the foothills of the Mang Mountains had been a favorite burial place for
Chinese rulers and officials since the preceding Chou dynasty. Chambered and
single tombs with walls of baked clay bricks begin to bear decorative and pic-
torial motifs early in the third century B.C.

 The linear flourish of the Han *lung* dragon and warrior is a distinct departure
from the earlier, squat *kuei* dragon of Chou dynasty bronzes. Associated from
antiquity with the emperor and the direction east, the dragon is also a symbol of
the life force. Its appearance on surviving Han bricks is rare. The crisp heraldic
quality of the image is accountable to a stamping technique used on the border
as well as on the dragon and rider. Multiple wooden stamps impressed separate
sections of the image into the wet clay. An occasional misregister is common
and notable here along the border and tail volute of the dragon. CA

2 CHINESE
Early T'ang Dynasty, 7th–8th centuries A.D.

Pair of Grooms, 7th–8th centuries A.D.
Terra cotta, traces of polychrome; 1: h. 15 (38.1); 2: h. 14⅞ (37.8)
Gift of Carol and Robert Straus 73.67. 1,2

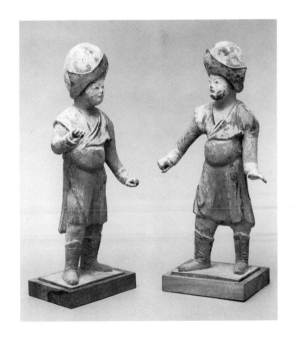

The worldly and opulent character of T'ang art reflects the cultural diversity and
political confidence of a nation that had become a model of high culture. By the
early seventh century, T'ang rulers had established military outposts along the
trade routes to central Asia and the Mediterranean. The T'ang capital of Ch'ang-

an became an affluent cosmopolitan center. Through its streets passed a multitude of foreign visitors, traders, and entertainers.

Tomb figures of the T'ang dynasty record in vivid detail the people of every social class. These *ming ch'i*, or spirit objects, were placed in tombs to serve as replicas of men and animals who would accompany the deceased into the next world. Because of their exotic features and costumes, foreign visitors and prisoners of war held particular interest and were recorded with assiduous accuracy.

Houston's pair of grooms possesses the full-bodied presence of mature T'ang style. The sturdy figures exhibit a naturalistic paunch echoed in their bulbous hats with upturned, three-cornered brims. Portrayed holding imaginary lead ropes, the grooms are probably Sogdian racial types. The Sogdians, native to the area north of Bactria in the modern region of Samark and Bukhara, were known throughout Asia as accomplished horsemen. The figures are dressed in Iranian-style, single-lapeled tunics and high boots. They are enhanced by the application of unfired pigments of cinnabar, white, and ocher. CA

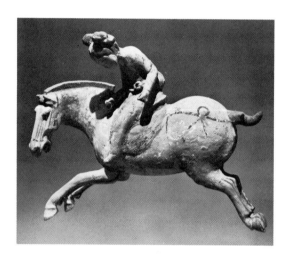

3 CHINESE
Early T'ang Dynasty, 7th–8th centuries A.D.

Equestrian Figure, 7th century
Painted pottery, gilt; l. 13¾ (34.9)
Gift of Carol and Robert Straus 73.68

The emperors of T'ang China acquired a passion for horse breeding. Importing magnificent horses from Bactria in Asia Minor, the imperial stables established rankings according to beauty and ability. In the prosperous capital at Ch'ang-an and in other urban centers, horses with elaborately trimmed manes and docked tails were displayed in parades and games of entertainment. Persians introduced the sport of polo to the Chinese. It arrived by way of central Asia and appeared as a subject in tomb sculpture during the late sixth and early seventh centuries.

The Houston figure of a lady playing polo is an example of painted red buff pottery. The court lady wears a fitted gown bearing traces of cinnabar and gilding; the decoration on the horse is painted with unfired black and brown pigments. The horse's "flying gallop," an unnatural position with four legs extended, disappears during the eighth century with T'ang's increasing emphasis on realism. Here, the energetic posture of the horse and the pressing effort of the rider capture the essence of equestrian sport. CA

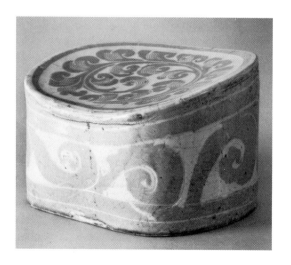

4 CHINESE
Sung Dynasty, 960–1279

Pillow with tiger design, 12th century
Seal of Chang family impressed before firing on bottom
Tz'u Chou ware; h. 3¹⁵⁄₁₆ (10.1), w. 8¹⁵⁄₁₆ (22.6), d. 7¹⁄₁₆ (18.0)
Gift of Mr. and Mrs. Arthur B. Rothwell 75.351

As early as the Sui dynasty (581–618 A.D.), pottery kilns at Tz'u Chou in Honan province had begun to produce ceramic wares from the *tz'u* stone of the area. A northern ware closely related to Ting types, Tz'u Chou ceramics are typically a porcelaneous stoneware of grey buff body covered with a white clay slip. Often painted with a robust decoration in brown or black washes, the best examples of the wares have a transparent overglaze of creamy tonality. Although the enormous production at Tz'u Chou and surrounding kiln sites extended into the

modern era, Tz'u Chou wares of the Sung dynasty are generally regarded as the apogee of the type.

The Houston pillow was stamped before firing with the seal of the Chang family, famed for its production of Tz'u Chou ceramic pillows. Painted in brown slip with vigor and fluidity, a tiger crouches in the foreground of a landscape succinctly defined within an ogee medallion. A single calligraphic brushstroke traces the tiger's pliant form, suggesting a beast of obliging complaisance. Such a whimsically humorous image, more often encountered in Japanese art, supports a theory that some Tz'u Chou wares may have been a source for Kenzan's seventeenth-century ceramics. CA

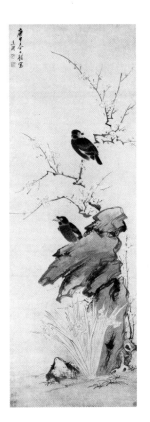

5 WANG LI

Chinese; Chia-hsing, Chekiang Province, active late 16th–early 17th centuries

Two Mynahs, dated 1620

Two of artist's seals follow inscription; three collectors' seals at lower corners
Paper, ink, slight color; 52½ × 17¾ (133.4 × 45.1)
Gift of Mr. and Mrs. George Lenert Kroll 75.343

Wang Li was a native of Chia-hsing, a city near Hang-chou in Chekiang province. He was a follower of Chou Chih-mien of Su-chou. Chou Chih-mien, a student of Shen Chou, was a professional painter known for his descriptions of plum blossoms. During Southern Sung (1127–1279), the plum blossom assumed prominence as an appropriate subject for literati painters. It was regarded as one of the "four gentlemen," subjects associated with the character of the gentleman scholar. In Sung literature, the plum blossom is a symbol of aesthetic refinement. Since it blooms in winter, it also suggests unworldliness and late maturing.

Distinctions between professional and literati painters were not clearly delineated. Professionals often developed specialties in painting subjects associated with scholar amateurs. During late Ming, works by famous specialty and landscape painters were collected and reproduced in woodcut editions. The *Shih-chu-chai shu-hua-p'u* or *Collection of Writing and Painting from the Ten Bamboo Studios* included copies of bamboo, stones, flowers, and blossoming plum. Its eight volumes appeared between 1624 and 1627. Chou Chih-mien's style is represented.

Two Mynahs, signed and dated 1620, coincides with the appearance of pattern books on Chinese painting. Wang renders individual components—birds, rocks, narcissus, plum blossom—with attention to distinct character. The pepper-dot technique of the rocks recalls Shen Chou, as the plum blossom evokes the art of Chou Chih-mien. The masterful precision of brush in the treatment of the mynah birds is belied by an inscription of typically amateur informality: "Playfully painted in the spring of *keng-shen.*" CA

6 JAPANESE

Heian Period, 794–1185
Bosatsu, mid-12th century

Cypress wood; h. 39⅜ (100.0)
Museum purchase 68.50

The final phase of the Heian period witnessed a climax of Buddhist religious fervor that expressed itself in arts of ethereal refinement. Temple architecture

and sculpture conformed to ideal canons of proportion; standards for beauty assumed a mathematical purity. Jōchō, the leading Buddhist sculptor of the age, created the archetype for this aesthetic in the Amida Buddha of 1053 set in the Phoenix Hall of the Byodo-in at Uji. Succeeding generations of sculptors restated the style of Jōchō and his highly productive workshop, utilizing the *yosegi* technique he had developed. *Yosegi*, a process of assembling sculpture from pieces of wood glued or pegged together, produces hollow, lightweight sculptures that do not acquire the deep cracks of solid wood figures.

Bosatsu, Japanese for Bodhisattva, belongs to a class of Mahayana Buddhist deities that possess the power to achieve nirvana but refrain from entering eternal bliss in order to assist mankind to salvation. Wealthy patrons in the Heian capital and in Nara commissioned sculptures of the Bosatsu embellished with lacquer, paint, and gilt. Placed for veneration in local temples, these sculptures composed brilliant pantheons of Buddhist deities.

The Houston Bosatsu exhibits a delicacy of surface carving characteristic of late Heian and of the light and versatile *yosegi* technique. The figure's equipoise and serene expression repeat the classic symmetry of the Jōchō manner. A softly schematic drapery sweetens the late phase of a style that drew initially upon imposing T'ang prototypes. Traces of pigment and gold remain in the figure's headdress.

CA

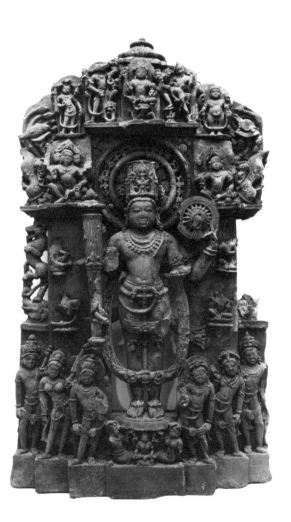

7 INDIAN
Medieval Period

Vishnu and his Avatars, ca. 10th century
Red sandstone; h. 54½ (138.4)
Museum purchase with funds provided by the
Agnes Cullen Arnold Endowment Fund 71.1

In the Mathura region of India's central heartland, an indigenous style of sculpture, abundant and life-affirming, established a presence that continues throughout the course of Indian sculptural tradition. Carved from the red sandstone of the area, confidant and weighty male and female fertility gods evolved into Hindu and Buddhist deities. Vishnu, the Hindu god who preserves the world, traces his origin to one of the Vedic sun gods. Broad-shouldered and swelling with life-breath, Indian *prana*, the figure is a summation of Mathura style. Despite evolution, this national style remains difficult to date accurately within the Medieval period because of its consistency and endurance.

Houston's sandstone relief is most probably from the state of Madhya Pradesh, famed for its stupa and railings at Bharhut and the temple complex at Khajuraho. The central standing figure of Vishnu forms a trimurti (trinity) with the gods Shiva and Brahma described at the top of the relief on the extreme left and right. Vishnu's avatars are the embodiments of his principles and the forms he assumed in his heroic mission as preserver. Two groups of three figures frame Vishnu's feet. Four are personifications of Vishnu's principal attributes, and two are guardian figures. The Hindu preference for profuse figural imagery often served as religious metaphor and guided worshipers to abstract truth through tactile reality.

CA

8 INDIAN

Medieval Period

Shiva Nataraja, 13th century
Bronze; h. 29½ (74.3)
Gift of Carol and Robert Straus 73.77

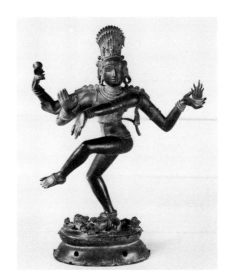

Bronze sculptures of south India almost exclusively describe the Hindu pantheon.
A plethora of dynamic Hindu deities had eclipsed the quietly contained icons of
Buddhism by the year 1000. Shiva, the god of dance and cosmic movement, is
the most dramatic and most popular deity. Multiple arms gesture protection to
the worshiper and express the dual Shiva nature in the fire of destruction and
drum of creative vibration. The right leg is bent at the knee as it presses underfoot
the prostrate infant shape of the Apasmars Purusa, an embodiment of forgetful-
ness or ignorance.

Houston's bronze icon originally included a flaming arc encircling the dancing
god. It is cast in the lost-wax method and in complexity and attention to detail
is an outstanding example of Indian casting technique. Carried in procession on
poles laced through its base, the god was ornamented with jewelry and dressed
in resplendent costumes. Because these sacred images were produced in the con-
text of a hierarchical religion, artists adhered to religious canons that set the size
and proportions of the figure according to the importance of the deity.

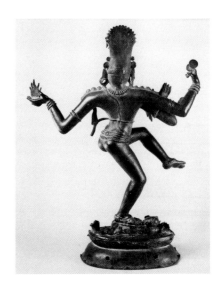

Bronze, a material favored by European mannerists for its dynamic and elegant
potential, defines the aesthetic of south India. Poised in an exquisite moment of
eternal motion, dionysian yet aristocratic, the god Shiva resolves the opposites
of his nature in a single image. Intricate jewelry and body ornaments emphasize
the smoothness of Shiva's leonine form; twining serpents on his headdress and
arms connote life and fertility. The third member of the Hindu trinity, which
includes Brahma and Vishnu, Shiva dances a cosmic dance in which the universe
is the light reflected by his limbs as he moves in the orb of the sun. CA

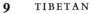

9 TIBETAN

Mahakala Heruka, 17th century
Gilt bronze; h. 3⅞ (9.8)
Gift of Dr. and Mrs. Samuel C. Woolvin 71.68

Tibetan Lamaism is based upon Indian Tantric Buddhism, which was uniquely
adapted to the political and cultural context of Tibet during the 7th century A.D.
Heruka refers to the wrathful manifestation of the chief Tantric deity, Samvara.
The Mahakala is a Tibetan form of the Indian god Shiva and is described as a
Tantric duality—black Mahakala and white Mahakala.

Houston's tiny, gilt bronze, votive figure represents the black Mahakala. One
of the Dharmapalas, he defends the faith of Tibetan Buddhism. His expression
is ferocious; his attributes, demonic. Flourishing a ring of skulls, the Heruka
wears a belt and headdress adorned with these symbols of Tantra. His multiple
hands hold a knife and cranial cutting as well as the drum associated with Shiva.
He assumes a militant posture common to wrathful deities. The flamelike hair,
bearing traces of red pigment, extols his demonic aspect. The bronze is cast by
the lost-wax method, gilded, and chased. Conceived for a domestic or portable
shrine, the miniature work conveys a compelling fury and vigor. CA

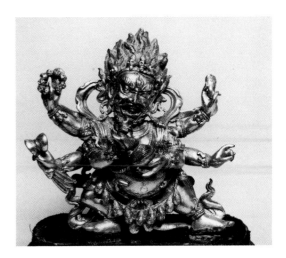

Ancient

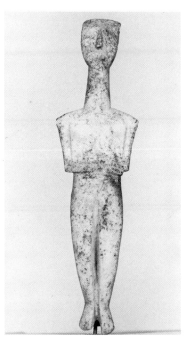

10 CYCLADIC
Early Cycladic Period

Female Idol, 2500–2000 B.C.
Marble; h. 9⅝ (24.4)
Annette Finnigan Collection; Gift of Miss Annette Finnigan 37.26

Marble statuettes are now considered the finest product of the Early Bronze Age civilization that dominated the Cyclades (Aegean Islands not including Crete) from about 2800 to 1550 B.C. However, their appeal to today's audience had to await recognition of the genius of such abstracting sculptors as Constantin Brancusi (1876–1957; no. 226), to some of whose works they show a marked similarity. Regularly found in grave sites and in both male and female forms, the statuettes are believed to have been made for religious use, the particular nature of which remains unknown. The columnar form of the female nude with its arms crossed occurs most frequently on the islands of Amorgos, Syros, and Naxos; characteristically the female organs are summarily indicated or partly omitted. Technical difficulties in shaping a slab of marble without causing it to split may have contributed to the abstract style, but the decisive trend away from the plasticity of Neolithic (Stone Age) idols toward greater schematization of the body found in these Bronze Age works may also evidence increasingly abstract thought on the part of a higher civilization. KS/JMW

11 EGYPTIAN
Hermopolis, Egypt

Fragment of a Relief, probably representing *Akhenaten Visiting the Temple*, ca. 1363 B.C.
Limestone; 8⅞ × 21 (22.5 × 53.3)
Gift of D. and J. de Menil 62.13

Long recognized as one of the earliest centers of civilization, Pharaonic Egypt arose about 2850 B.C. and lasted, with occasional foreign domination, until the country fell to Alexander the Great in 332 B.C. The basic canons of Egyptian art developed early in the third millennium B.C. and underwent remarkably little change in succeeding centuries. Their nature was broken in the fourteenth century B.C. when Amenhotep IV became Pharaoh (ca. 1370–ca. 1353 B.C.) and created a new form of worship, substituting Aten, the sun disk, for Amon, the previously dominant god. He also changed his own royal name to Akhenaten

and created a new capital city, Akhetaten, now Tell el Amarna. Under Akhenaten art became more naturalistic, particularly in the modeling of anatomical details, as, for example, hands and feet. Such naturalism was, however, subject to overall curvilinear rhythms, and it could be said that the essence of Amarna period art was not so much naturalism per se as the substitution of a new, rhythmic convention for an older, more static one. The new art form was short-lived. With the advent of Tutankhamen to the throne, the priests of Amon returned to power. The Great Temple to Aten was destroyed, and the older artistic conventions were reinstated.

Houston's relief fragment, another adjoining one containing a cartouche of Nefertiti, and further elements of a doorjamb survive from what must have been a masterpiece of relief sculpture from Tell el Amarna, reused along with other Amarna blocks at Hermopolis nearby. Parallel scenes from another find of the Amarna period, the tomb of Huya, suggest that the delicately carved hand and thighs belonged to a full-length figure of King Akhenaten, possibly represented visiting the Great Temple as a member of the party of his mother, Queen Tiy. Soft, curving forms enrich the design, and movement, suggested in the lithe hand, is made explicit in the drapery. To the left, the architectural detail documents a type of inlaid stonework much favored in the Amarna Age. KS/JMW

12 ASSYRIAN

Eagle-Headed Winged Deity, 883–859 B.C.
Gypsum; irreg. 42⅛ × 26 (107.0 × 66.1)
Museum purchase with funds provided by the
Agnes Cullen Arnold Endowment Fund 80.53

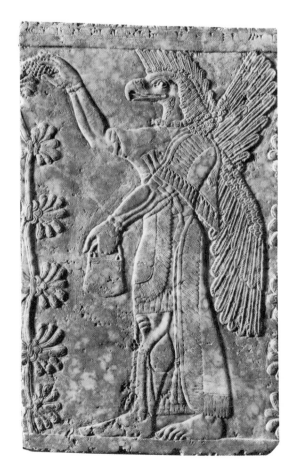

The Assyrians won control of Mesopotamia (the area between the Tigris and Euphrates river valleys, modern Iraq) in the thirteenth century B.C. In the eleventh century they began to expand, eventually conquering the ancient city of Babylon, holding what is now Syria, Lebanon, and Israel, and even entering Egypt in 663 B.C. Fifty years later the empire disappeared, falling to a resurgent Babylonian dynasty.

Assyrian art is generally carved in relief though there are occasional statues in the round. Most sculpture involves the monarch, either by invoking protective deities or by recording his successes in the hunt or his victories in war. Though scenes of hunting and warfare are often portrayed with astonishing naturalism and movement, the standard Assyrian depiction of the gods involves a powerful, static convention of representation. As in Egyptian art, shoulders are often presented frontally though the head and legs are shown in profile.

The Museum's relief, originally acquired by Lord Sandon, eldest son of the Earl of Harrowby, when he visited Nimrud in 1853, comes from one of the great sources of Assyrian art, the North-West Palace of King Ashurnasirpal II (883–859 B.C.) at Nimrud, near Mosul, modern Iraq. The Palace was discovered by Sir Henry Layard in the 1840's and excavated by him over succeeding years. Most of its works of art are in the British Museum, which has reliefs similar to the Houston relief, but others are in museums around the world. The subject of the Houston relief has been identified as involving either a rite of purification or the fructifying of the palm tree. The cuneiform inscription at the top of the relief offers no clue, for it is merely part of a standard, often repeated, phrase telling of the glory of the king. Despite the savage mien, appropriate to a people as ferocious as the Assyrians, the eagle-headed deity was a beneficent force, whether as protector of the ruler or of the crops. JMW

9

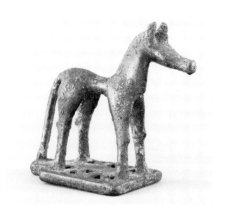

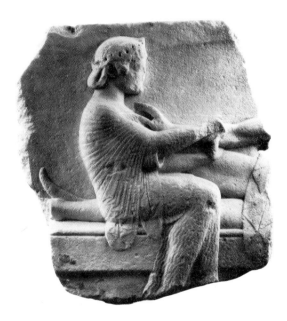

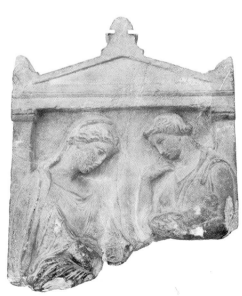

13 GREEK
Late Geometric Period

Statuette of a Horse, ca. 750–700 B.C.
Bronze; h. 2¹³⁄₁₆ (7.1)
Annette Finnigan Collection; Gift of Miss Annette Finnigan 37.22

Though the development of Greece in the two centuries following the downfall of Bronze Age Mycenae (about 1100 B.C.) is obscure, it is clear that a new civilization using iron had arisen by about 900 B.C. This civilization, based on independent city-states, of which Athens was by far the most important culturally, lasted until its domination by Philip of Macedon in 337 B.C. and by his son Alexander the Great (336–323 B.C.)

Small statuettes of animals form an important body of Geometric-period bronzes. These miniatures served as votive offerings for pilgrims visiting the panhellenic sanctuaries like Olympia, where large caches have been found. The Houston statuette of a horse, with its tubular midriff and snout, shows a clear stylistic affinity with horses on contemporaneous painted pottery. In both cases the animals are reduced to an abstract form that has given the name "Geometric" to the style constituting the earliest period of Greek art. JS/JMW

14 MAGNA GRAECIAN
Late Archaic Period

Relief with a Symposium Scene, ca. 480 B.C.
Marble; 24 × 21⁷⁄₁₆ (61.0 × 54.5)
Museum purchase with funds provided by the Laurence H. Favrot Bequest Fund 72.25

As a result of the overpopulation of mainland Greece and occasional defeat in war many Greek cities were founded in Southern Italy (ancient Magna Graecia). They flourished in the sixth and early fifth centuries B.C. but began to decline in the second half of the fifth as native Italic tribes expanded. City by city, Magna Graecia eventually fell to Rome. The Museum's relief is said to have come from Metapontum, one of the major cities, first excavated in 1825–1826.

The relief is carved in the late Archaic style: movement and three-dimensionality, particularly the foreshortening of the woman's torso, are convincingly portrayed. Drapery patterns are presented with an abstract rhythm unlike the more convincing naturalism associated with the Classical style that would follow the Archaic. The scene depicts a banquet or symposium in which a young woman proffers a reclining man something, perhaps fruit or a cup of wine. JS/JMW

15 GREEK
Attic

Grave Stela of a Woman, mid-4th century B.C.
Marble; 20 × 17⅛ (50.8 × 43.5)
Annette Finnigan Collection; Gift of Miss Annette Finnigan 37.25

The Classical style developed in Greece, particularly in Athens, its leading city, between 480 and 450 B.C. It dominated Greek art at least until 330 B.C., when increased realism broke the balance between naturalism and idealism that gave Classical art the quality of serenity characteristic of its essential nature.

The mature style of the Classical Period in Greece, as perpetuated by a number of Attic grave monuments from the end of the fifth century B.C. and the beginning of the fourth, is visible in Houston's fragment of a grave stela from the middle of the fourth century. Convincing naturalism is shown in the clinging drapery. The architectural framing device repeats a form favored for similar monuments from the end of the fifth century. A slightly newer idea enhances the feeling of intimacy: the female figures are placed in closely adjacent positions with their heads bending towards one another so that the principal lines of drapery and of arm position lead to a point off-center. The seated woman at the left is evidently the deceased. The presence of a child held by the servant woman suggests she probably died in childbirth. The infant wrapped in swaddling is a rare motif in Greek funerary stelae. The relief is believed to be from Athens, a tradition borne out by the fact it is rendered in the Pentelic marble favored by Athenian sculptors. Although the figure of the servant, particularly her raised arm and neck, is somewhat restored and recut, the head of the deceased woman is a beautiful example of Classical serenity. JS/JMW

16 APULIAN

Epichysis with Eros and Two Women, ca. 320 B.C.
Terra cotta; h. 8⅜ (21.3)
Museum purchase with funds provided by Mr. and Mrs. John J. Moran
76.199

By the fourth century B.C. many of the native South Italian tribes had become partly Hellenized as a result of influence from cities such as Tarentum, which had been settled by Greeks migrating from overpopulated Hellas. Even the Etruscans had been influenced by Greek art, not only from Magna Graecia (Greek-settled Southern Italy), but also from trade with Athens, including a substantial trade in Greek vases. Though this exchange waned before the period under discussion, it fostered an important local industry in vase painting, particularly in Apulia (the "heel" of the Italian "boot" with Tarentum as its major city), where works loosely based on Athenian models were produced. In general the figures on Apulian vases lack the sophisticated linear design of Attic examples but, despite their provinciality, compensate by vigorous movement.

The Museum's Apulian *epichysis* (wine pitcher) is a well-preserved example of a form particularly associated with Apulian vases but not found in Greece itself; the form is believed to have been derived from earlier examples in metal. Its subject, *Eros and Two Women,* shows the god as a sepulchral divinity whose function was to deliver cult objects to the tomb. Thus the vase can be considered funerary art rather than art produced for ordinary use. JMW

17 GREEK
Hellenistic

Necklace with Ethiopian Head Clasps, 3rd–2nd centuries B.C.
Gold, carnelian; l. 16¹⁵⁄₁₆ (43.0)
Annette Finnigan Collection; Gift of Miss Annette Finnigan 37.41

The victory of Alexander the Great over the Persian empire in 333 B.C. made Greek civilization enormously more wealthy in the Hellenistic age than it had

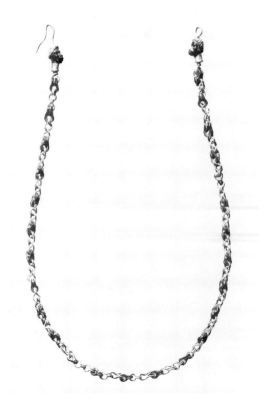

been in the Classical era, and contacts with the East, in particular with Persia, prompted the appearance of polychromed effects in Greek jewelry during the age of Alexander. The use of carnelian for chain links to alternate with gold in necklaces and bandoliers originated about the third century B.C.; in the Houston necklace the carnelian alternates with two loop-in-loop segments of gold chain. The two heads of Ethiopians, also carved of carnelian and coiffured in gold, are similar to a pair of earrings in the Louvre in Paris. JS/JMW

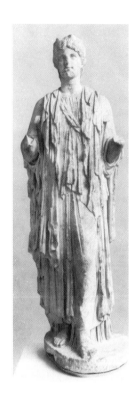

18 ROMAN
Republican

Standing Figure of a Goddess, 1st century B.C.
Marble; h. 74¼ (188.6)
Museum purchase with funds provided by Mr. and Mrs. John J. Moran
74.253

With the exception of portraiture, Roman free-standing sculpture is to a great extent an art of reproduction. Roman patrons, when they were not ordering exact replicas of much-admired Greek originals, seem to have preferred a style in conscious imitation of Greek art. Houston's majestic marble goddess exemplifies Roman interest in reviving Greek styles, sometimes in pure form, but occasionally mixed as here. Her voluminous drapery recalls the Classical Period of the second half of the fifth century B.C.; however, her noble but slightly stiff carriage suggests the period about two generations earlier when the Classical style was being formed. Her missing arms would have held the attributes that would have made the goddess's identification possible JS/JMW

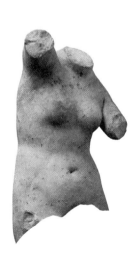

19 ROMAN

Torso of Aphrodite Anadyomene, 1st century A.D.
Marble; h. 46 (116.8)
Gift of D. and J. de Menil in memory of Claire Schlumberger 61.8

Although numerous small bronze and terra-cotta replicas of famous Hellenistic sculptures exist, large marble versions are relatively rare. The Houston sculpture is a Roman copy or adaptation of the first century A.D. of the Hellenistic Greek original from the third or second centuries B.C. It was once a full-length figure, but the sensitively carved torso (the neck trimmed for another head, removed by a former owner) shows something of the sensuous quality of the lost original. The epithet Anadyomene ("emerging from the sea") is applied to representations of Venus that actually portray the goddess finishing her hairdress. JS/JMW

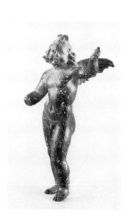

20 GRAECO-ROMAN

Statuette of Eros, 1st century B.C.–1st century A.D.
Bronze; h. 2¹⁵⁄₁₆ (7.5)
Edith A. and Percy S. Straus Collection 44.603

From the fourth century B.C., ancient bronze statuettes lost their significance as votive offerings and became simple, but luxurious, objects of art attesting to the

culture of their owners. A number of them represent the god Eros, wings spread, striding forward with the left leg and raising the left arm. Houston's Graeco-Roman example is of particularly fine quality; even the locks of hair are finely chiseled. Roman bronze statuettes, rediscovered in the Renaissance, inspired such sculptors as Antico and Riccio (see nos. 57, 68, 69) to produce similar works in a classical style. It is interesting to note that the Straus collection, rich in Renaissance bronze statuettes, contained this one superb ancient piece. JS/JMW

21 GRAECO-EGYPTIAN
Alexandrian

A Youth Clasping a Bird and a Bunch of Grapes, 2nd century A.D.
Marble (Rhodian?); h. 27⅞ (70.8)
Gift of Mrs. Anne Schlumberger Doll 57.50

The conquest of Egypt by Alexander the Great led to the merging of Greek and Egyptian civilizations, a process that continued when Egypt fell to Rome in the first century B.C. Though reminiscent of copies of the *Eros* by the Greek sculptor Lysippos (ca. 360–ca. 320 B.C.), Houston's nude youth may represent Harpocrates (the son of Isis and Osiris), whose attributes are a bunch of grapes and a dove. Just as the Museum's sculpture illustrates the Alexandrian mythological merging of Harpocrates with Eros, so, too, it exemplifies the alteration of Hellenistic naturalism into the softer, more idealized style of the Alexandrian School.
JS/JMW

22 ROMAN
Severan Period

Portrait of a Ruler, first quarter of the 3rd century A.D.
Bronze; maximum preserved h. 82 (208.3)
Gift of D. and J. de Menil in memory of Conrad Schlumberger 62.19

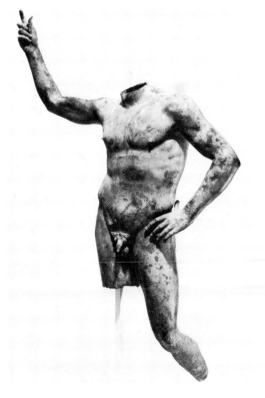

In the Hellenistic and Roman periods many rulers followed the precedent set by Alexander the Great of having himself portrayed as a divine, heroic being; Houston's monumental bronze suggests the stance of copies of Lysippos's (ca. 360–ca. 320 B.C.) lost *Alexander with the Lance*. The Museum's statue is said to come from the region of ancient Pisidia (in what is now Turkey) where a number of Roman imperial portraits have been found. It is generally agreed the work represents an idealized ruler—the fact that the head is missing precludes precise identification—but the statue might conceivably represent another subject. (See Philip Oliver-Smith, "The Houston Bronze Spearbearer," *Antike Plastik*, 1976, pp. 93–108, accepting the general view but raising the possibility that the statue could be a Roman copy of a Greek work representing a god, hero, or athlete.)

Though the convincing but generalized anatomy of the Houston bronze would be stylistically compatible with an earlier date, other objects believed to be from the same location—portraits of members of the Antonine and Severan imperial families—have provided a consensus among scholars that the bronze dates from the first quarter of the third century A.D. As such, the majestic work constitutes a swan song of the ideal Classical art that was to be abandoned in the centuries to come. JS/JMW

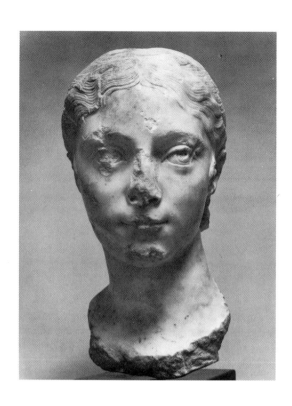

23 ROMAN
Severan Period

Portrait Head of a Young Woman, ca. 200–220 A.D.
Marble; h. 14⁷⁄₁₆ (36.7)
Museum purchase with funds provided by the
Laurence H. Favrot Bequest Fund 70.39

Perhaps reflecting the importance of the family in Roman society, the art of portraiture was Rome's most important contribution to sculpture. Although the flow of Roman portraiture is unbroken from the first century B.C. to the third century A.D., it is in the period of the Museum's sculpture, the third century A.D., that some of the greatest Roman portraits were sculpted—at the point when the concept of an ideal Classical serenity began to fail. In these works incised and drilled eyes replace blank ones, giving the figures a new sense of naturalism and animation.

The smooth, glossy surface of the Museum's head, difficult to achieve under ancient polishing techniques, suggests that the sitter was a member of the imperial family. Two identifications have been made: Fulvia Plautilla, wife of the Emperor Caracalla, and Julia Paulia, wife of the Emperor Elagabalus. Both empresses reigned for only a short time. Fulvia Plautilla was married to Caracalla in 202 A.D., banned a little more than a year later, and beheaded in 212. Julia Paulia was married to Elagabalus in 219 A.D. and enjoyed imperial privileges through 220 (Elagabalus was murdered in 222). Thus a date of circa 200–220 A.D. seems certain for Houston's statue even if the identity of the sitter is not clear. The lack of finish at the base of the neck indicates that the head was probably meant to be inserted into a bust and shoulder, perhaps even into a full-length figure. JS/JMW

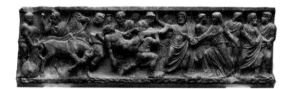

24 ROMAN
Late Severan Period

Sarcophagus Front: The Return of the Body of Meleager to Kalydon, ca. 220–230 A.D.
Marble; h. 24¾ (62.9), w. 83¼ (211.5), d. 13 (33.0)
Museum purchase with funds provided by the
Agnes Cullen Arnold Endowment Fund 76.228

About 100 A.D. inhumation, as opposed to cremation, became the standard burial custom in the Roman Empire. As a result, the marble sarcophagus, though it had existed for centuries, became a characteristic Roman art form. In general sarcophagi from Rome and the western empire were carved on three sides, the fourth being placed against the tomb, whereas in the east all four sides were carved. The summary carving on the ends of the Museum's piece indicates that it had no carving around the back and is, therefore, of the "Roman" type.

As Rome was much influenced by Greek culture, sources derived from Greek mythology were common subjects on sarcophagi. The Museum's sarcophagus is no exception. It depicts the return of the body of Meleager to Kalydon, his native city. According to the legend, the Fates decreed that Meleager would live so long as a log in the fire at his birth was unconsumed. Years later his mother, Althaea, who had snatched the log from the fire, was so furious when Meleager

slew his brothers after an argument over a boar hunt that she threw the log back in the fire. Thereupon, to her horror, her son died. The composition was transformed into Christian subject matter in the Renaissance, most notably in Raphael's *Entombment*, a similarly composed painting with the body of Christ substituted for Meleager. A number of Meleager sarcophagi exist, however, and there is no reason to believe that any Renaissance artist ever saw the particular example belonging to the Museum.

The Houston sarcophagus dates from the third century A.D., specifically from the reign of Lucius Septimus Severus. Severus's reign witnessed the beginning of the breakdown of the artistic goal of the classically ideal body (see nos. 15, 22) in favor of the representation of emotion, which in turn led to medieval emphasis on the spiritual. Thus the pathos suggested in Althaea's outstretched arms prefigures Early Christian Art. JMW

Early Christian and Medieval

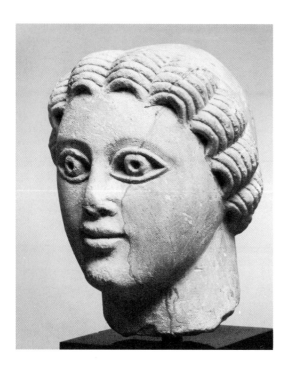

25 COPTIC

Male Head, ca. 400
White limestone; h. 6⁹⁄₁₆ (16.7)
Gift of Heinz Herzer 72.14

The Copts, descendants of the ancient Egyptians, constituted an important Early Christian community of distinct character with its own liturgy and produced a popular post-Hellenistic art whose forms were rooted in classical antiquity. Houston's small limestone head shows a severe abstraction of forms in its striking simplicity, its beautiful arrangement of crescent-shaped hair, and its monumental feeling achieved by the huge, staring eyes. Yet the lips and the squarish chin indicate that classical Roman sculpture served as the point of departure for its style.

Since the head is dated from the period before Christian motifs became common in Coptic art, the figure of which this head is a fragment probably was a pagan mythological subject. It is remotely possible that the figure was freestanding; more probably it formed a deeply undercut portion of a sizeable bas-relief in which classically inspired figures, stylized foliate ornament, and, possibly, Christian symbols served in the decorative scheme of a Coptic religious building.

JS

26 EARLY CHRISTIAN OR MEDIEVAL

Shallow Footed Bowl, 3rd–7th or 11th–12th century A.D.
Red opaque glass; h. 1¹³⁄₁₆ (4.6), diam. 6¼ (15.8)
Museum purchase 70.95

Houston's bowl of beautiful, purplish-red, opaque glass mixed with flakes of white is fashioned in the late Roman technique but is probably Early Christian or Medieval in origin. The predominant tone is reminiscent of the color chosen and worn by the Byzantine emperors, whose favored porphyry marble material may be simulated here through the variegated pattern. The fact that this and similar glass bowls reportedly were excavated in South Russia, where a large amount of Byzantine silver has been found, further points to Constantinople or some other center in the Byzantine realm as the place of origin. A similar bowl is preserved in the treasury of the Cathedral of Bamberg, and others are in the Toledo Museum of Art, Toledo, Ohio, and the Corning Museum of Glass, Corning, New York. Mrs. Gladys Weinberg, who published the report of similar plates excavated at Corinth, Greece, is of the opinion that they are Medieval rather than Roman or Early Christian, a view shared by the authorities at the Toledo Museum (letter of Kurt T. Luckner, dated January 29, 1975). JS/JMW

27 BYZANTINE

Constantinople

Plaque with the Koimesis, 10th century

Ivory; 4⁹⁄₁₆ × 3⁷⁄₁₆ (10.5 × 8.7)
Museum purchase with funds provided by the
Laurence H. Favrot Bequest Fund 71.6

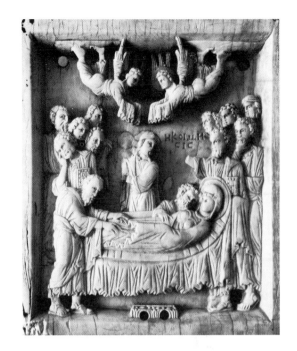

Ivory carving played a principal role in the art of the Middle Ages, and often-times carved ivories possess the highest quality of workmanship found in any medium at a given moment of medieval history. From the ninth to the twelfth century in both the East and the West, the best workshops of ivory carvers were imperially maintained, attesting to the importance of the medium. Skilled sculptors of ivory primarily produced objects and ensembles for ecclesiastical decoration and use.

Houston's relief plaque, representing the Koimesis or Dormition of the Virgin, shows the sophistication of ivory carving during the middle period of imperial Byzantium. Its disciplined style results from an adherence to dominant court workshop traditions in tenth-century Constantinople. The plaque shows the Byzantine tendency to enhance the spiritual value of a religious representation through abstracting the forms and establishing a hierarchy among the figures without detracting from the strong classical element with which the Byzantine style is infused, and the virtues of which Byzantine artists discovered anew in the late ninth century. The plaque is from a portable diptych, or possibly a triptych, representing the Twelve Great Feasts of the Orthodox Church. JS

28 GERMAN

Lower Saxony, perhaps Hildesheim

Canon Page from a Sacramentary, with the Crucifixion,
ca. 1150–1160

Tempera and gold leaf on parchment; 11⁷⁄₈ × 7⁷⁄₈ (30.2 × 20.0); image
9⅜ × 6¼ (23.8 × 15.9)
Museum purchase with funds provided by the
Laurence H. Favrot Bequest Fund 71.8

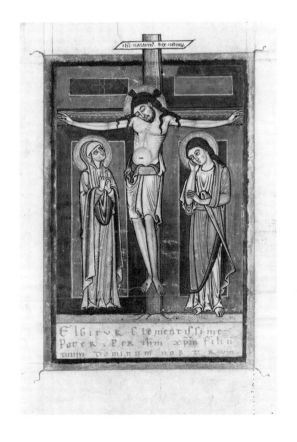

The finest talents in painting during the Middle Ages were usually illuminators of liturgical manuscripts, whose focal importance as the primary implements of formalized church worship as well as the principal carriers of picture types cannot be underestimated. At the height of monastic power, during the eleventh and twelfth centuries, a gradual transition from the Gregorian and other earlier re-formed Sacramentaries, or principal texts for celebration of the Mass, took place in favor of the more modern Missal, which newly made available to the Mass celebrant the formulae for low Mass in addition to those for high or solemn Mass.

Houston's Canon Page, with a magnificent representation of the Crucifixion on the recto, comes from such a transitional Sacramentary. Its place of origin is very possibly the important center of Hildesheim in Lower Saxony, a region that repeatedly fell under the influence of Cologne throughout the history of medieval art. The local Hildesheim tradition of manuscript illumination is noted for its superrefinement, its economy of means, and its singular impression of monumentality, characteristics that evolved as almost definitive of the Romanesque style. The crucified Christ in the Houston miniature is executed with a desire for

strict delineation of angularity, and monumentality is achieved by placing emphasis on verticality and bold decorativeness rather than by giving the composition breadth and the figures corpulence. Byzantine influence, here held over from eleventh-century German art in which it appears more strongly, is but mildly and naturally assimilated. JS

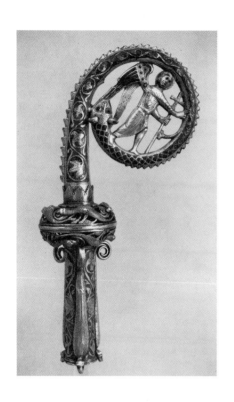

29 FRENCH
Limoges

Crozier Head with St. Michael Trampling the Serpent,
second quarter of the 13th century
Copper-gilt, champlevé enamel; h. 10¾ (27.3)
Museum purchase with funds provided by the
Laurence H. Favrot Bequest Fund 70.38

Late twelfth- and early thirteenth-century Limoges metalworkers who specialized in an enamel technique known as champlevé formed workshops that flourished as what might be called large order houses for persons requiring superior liturgical objects of various descriptions. The continued popularity of Limoges crozier heads for bishops' staves is demonstrated by the large number of examples found buried with their bishop owners, often beneath tomb slabs in the cathedral pavements carved with the bishops' effigies. The subject of St. Michael, especially suitable for a bishop whose duty was to be constantly vigilant against evil before his flock, is here represented in a manner more advanced than two other known, but more common, Limoges models of the subject. The figure tumbling forward with the curved movement of the volute conforms to the vigorous style of the High Gothic and recalls advances in design made in the stained glass of Chartres Cathedral around 1210–1220. JS

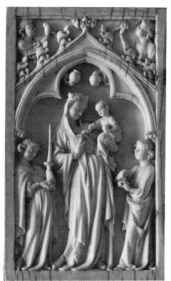

30 WORKSHOP OF THE MASTER OF THE BERLIN TRIPTYCH
French

Virgin and Child in Glory, second quarter of the 14th century
Ivory; 5½ × 3¼ (14.0 × 8.3)
Museum purchase with funds provided by the
Laurence H. Favrot Bequest Fund 71.7

Carved ivories are among the finest products of French artists of the late thirteenth through the end of the fourteenth century. Many of them are in the form of relief triptychs or diptychs suitable for private devotional purposes because of their portable size. The Museum's plaque with the Virgin and Child originally formed the left wing of a small diptych, in the right wing of which the Crucifixion must have been represented. Faces constructed of smooth ovoids, drapery folds that emphasize diagonal lines, and fingers that barely escape being excessively elongated are the hallmarks of the plaque's style. These traits and the rare iconography of two angels swinging censers down behind the architectural gable point to the immediate circle of a master carver responsible for a triptych now in Berlin. JS

31 NORTH ITALIAN (?)

Enthroned Virgin and Child, third quarter of the 14th century
Ivory with traces of polychromy; h. 8%₁₆ (21.7)
Edith A. and Percy S. Straus Collection 44.602

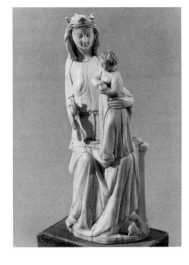

Although most fourteenth-century, carved, ivory devotional images of this type
have been assigned to French, especially Parisian, ateliers, the Museum's *Enthroned
Virgin and Child* shares features such as the slanted, almond-shaped eyes and cer-
tain peculiarities of the drapery with some other ivory figures that may have
been carved in North Italy after French models. Houston's ivory may come from
the central part of a polyptych, in which it would have been flanked by the
standing figures of candle-bearing angels. The monster in the form of a wyvern
of friendly appearance, trodden by the Virgin's left foot, carries with it the impli-
cation of the *Sedes Sapientiae*, or Throne of Wisdom. JS

32 FRENCH
Normandy

Virgin and Child, early 14th century
Limestone with remains of original polychromy; h. 40⅜ (102.5)
Museum purchase with funds provided by the
Laurence H. Favrot Bequest Fund 71.15

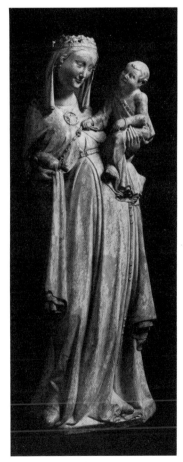

Normandy was an important locale for stone carving in fourteenth-century
France, though its sculpture is less well known than works from the Ile-de-France
and Burgundy, perhaps because much of the Norman material is still in situ.
French fourteenth-century sculpture, Norman included, is noted for decorative-
ness, for a preference for intimacy over monumentality, for a synthesis of natu-
ralism and stylization, and for a tendency toward sentimentality. The Houston
Virgin and Child epitomizes these characteristics because of the decorative folds
of drapery, the rhythmic, unnatural stance, and the lively interplay of its figures,
who nonetheless have stock facial expressions. The medium size of the piece is
also characteristic, though the polychromy (paint) is unusual and suggests that
the artist was influenced by painted ivory statuettes.

It is probable that the Houston *Virgin and Child* was originally a cult figure in
a parish church, for a strong Norman tradition emphasized the role of such
churches. The sculpture is said to come from the village of Golleville, a likely
but undocumented provenance. As the *Virgin and Child* is related to an important
Benedictine figure of mercy known as *Nôtre Dame de Montront* from Belarbre,
presently in the parish church of St.-Jacques-de-Néhou (Manche), it may have
been sent to Golleville by the Benedictine order.

Squirrels were popular ladies' pets in the period, and secular depictions of a
fashionable lady with a pet squirrel are not uncommon. However, the repre-
sentation of the *Virgin and Child* with a squirrel, as in the Houston sculpture, may
be unique and is at least most unusual. Though research has not revealed the pre-
cise symbolism of the leashed animal, it is almost inconceivable that no religious
meaning was intended. JS/JMW

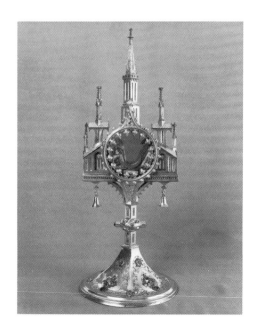

33 FRENCH

Mosan

Funerary Processional Figure Reading a Prayer Book,
third quarter of the 14th century

White marble; h. 17⅛ (43.5)
Edith A. and Percy S. Straus Collection 44.580

A type of tomb decoration incorporating pleurant monks and other funerary processional figures in shallow niches along the four sides of a raised, free-standing tomb emanated from France in the late thirteenth century and was widely imitated throughout Western Europe during the fourteenth and early fifteenth centuries. The Houston figure, which belongs to a small surviving group of marble tomb figures from the Mosan and Lower Rhine regions, comes from such a decoration. In material and execution closer to Mosan than to Rhenish examples, it also represents the less usual secular processional figure. JS

34 FRANCO-NETHERLANDISH

God the Father, early 15th century
Ivory; h. 9¹³⁄₁₆ (24.9)
Edith A. and Percy S. Straus Collection 44.581

The revolution wrought upon the art of sculpture in France by a number of Netherlandish sculptors, headed by Claus Sluter (active 1379/1380–1405/1406) and his assistant Claus de Werve (active 1380–1439) close to the turn of the fourteenth century, can be appreciated in the Museum's exceptionally rare ivory figure of *God the Father.* The abundant, spilling drapery folds that intensify the feeling of volume and weight in the figure, as well as the momentary quality bespoken by the figure's stance and hand gesture and the realism expressed in the face, suggest a direct connection with the art of Claus Sluter. Formerly it was thought the figure represented Christ Preaching, but Philippe Verdier (Article 1975) and Colin Eisler (Lecture 1980) now believe the figure was once part of a group depicting the Trinity.

Altogether the figure reflects the elegance and sophistication of the International Style, the style adopted around 1400 and characterized by a love for calligraphic outline and curvilinear patterns of Gothic drapery and by a marked tendency toward realistic detail. Originating in the wake of social change that enabled not only princes and dukes but also the lesser nobility to become patrons of the arts, the International Style was as uniform throughout Western Europe as the aristocratic taste to which it catered. JS/JMW

35 GERMAN

Lower Saxony (Hildesheim)

Reliquary Monstrance from the Guelph Treasure,
early 15th century

Engraved copper-gilt, silver, translucent enamel; h. 21⅛ (53.7)
Museum purchase with funds provided by the
Laurence H. Favrot Bequest Fund 70.16

Since 1264, when Pope Alexander IV established the Feast of Corpus Christi, a liturgical object known as an ostensory or monstrance (both terms derive from Latin verbs meaning "to show") has been a common sight in the solemn pro-

cessions held in conjunction with that feast, celebrated in June on the Thursday after Trinity Sunday. Houston's monstrance, an important example of the work of late Medieval German goldsmiths, combines the original function of displaying the consecrated Holy Wafer with that of exhibiting wrapped relics of saints. It comes from the Cathedral of St. Blaise in Braunschweig (Brunswick), Lower Saxony, where it formed part of the celebrated collection of the ducal house of Braunschweig-Lüneburg known as the Guelph Treasure. Its upper structure, which simulates the tower and crossing of a late Gothic church, derives from Lower Saxon architectural prototypes. Its decoration, including roof imbrication and crowned pomegranate designs on the four fields of the foot, is based very closely on contemporaneous work of Cologne goldsmiths. In addition to the stationary, crescent-shaped metal holder for the Holy Wafer and the loosely arranged relics, the elaborately framed, double-windowed capsule contains a later inserted, hand-colored, miniature woodcut on parchment, the pilgrim's souvenir of a Jubilee Year visit to Rome (1475?). JS

36 NORTH GERMAN

Double Mazer Cup, late 15th century
Wood, copper-gilt, champlevé enamel; 8³⁄₁₆ × 6¹⁵⁄₁₆ (20.8 × 17.6)
Museum purchase with funds provided by the
Laurence H. Favrot Bequest Fund 71.11

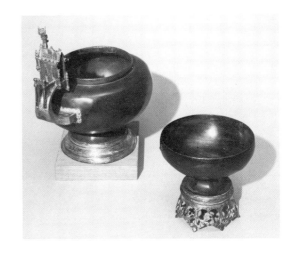

Seeming like an object from a fairy tale, Houston's fanciful cup combines the elegant work of a goldsmith with skilled turning and faceting by a lathe worker. Its handle ornament, consisting of a trumpeting angel on top of a tiny chapel approached by a drawbridge, is of unique inspiration. Its champlevé enamel coat of arms inside the crown points to the counts of Eutin in Schleswig-Holstein (North Germany) as the original owners. The top becomes a cup for drinking when inverted; and the bottom, being exactly four times the measure of the cup, serves as a reserve vessel for wine. The type of wood used indicates that the Museum's double beaker was kept for tasting and enjoying new wines. JS

37 ENGLISH
Nottingham

Virgin and Child Enthroned, late 15th century
Alabaster with traces of polychromy; h. 30⅝ (77.8)
Gift of D. and J. de Menil in memory of Arthur Jago 62.3

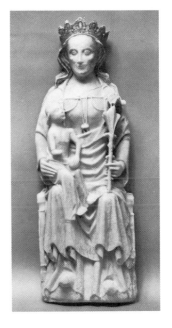

Carving in alabaster was practiced both on the Continent and in England during the fifteenth century; but owing to the availability of a large quantity of the material in southern England, by far the greater amount of alabaster sculpture was produced there. Nottingham, though the best known, is not the only English center involved in the mass production of large, alabaster altarpieces composed of somewhat flattened, schematically defined figures such as the Houston Virgin and Child, so the precise origin of most of these pieces is uncertain. The altarpieces, or retables, were often made for export and have been found all over Western Europe and Scandinavia. As part of a retable, a Virgin and Child of this size probably would have formed the central subject. In her left hand the Virgin holds a lily, a symbol of her purity, while the Child clutches an apple or some other fruit in His left hand. Originally the group would have been painted in bright colors. JS

Renaissance

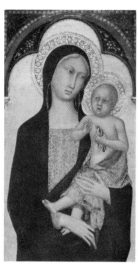

38 CIRCLE OF THE SO-CALLED BARNA DA SIENA
Italian; Siena, active second third of the 14th century

Madonna and Child, second third of the 14th century
Tempera and gold leaf on panel; 32⅛ × 17½ (81.5 × 44.5)
Edith A. and Percy S. Straus Collection 44.564

Formerly attributed to the famous Sienese painter, Simone Martini (1284–1344) and to his brother Donato, the Museum's *Madonna and Child* is a work dependent on the styles of Simone Martini and Duccio di Buonisegna (known from 1278–1318) and shows a close relationship with works by the so-called Barna da Siena, one of the most important mid-fourteenth-century Sienese painters and a proponent of a humanizing tendency that goes beyond the elegant and aristocratic forms associated with his predecessors. The Houston panel has been linked with another at Yale as having originally formed part of the same polyptych. JS

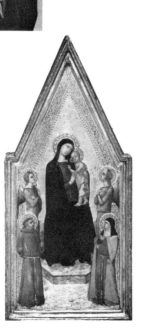

39 CIRCLE OF THE SO-CALLED BARNA DA SIENA
Italian; Siena, active second third of the 14th century

Madonna and Child with Saints and Angels, second third of the 14th century
Tempera and gold leaf on panel; 16 × 6¾ (40.6 × 17.1)
Edith A. and Percy S. Straus Collection 44.566

Houston's elegant panel—in a format that usually is characteristic for the center of a portable triptych—appears more jewel-like than the *Madonna and Child* formerly attributed to Simone Martini (see no. 38). Yet it is possible to see the two works as by the same hand. The flat, elongated body of the Madonna, the decorative lines of the drapery, and the bright colors are typical Sienese Gothic characteristics. The tender intimacy of the Madonna and Child, who are observed by Saints Francis and Clare, reflects the Franciscan Order's emphasis on the simplicity and humanity of the Holy Family. JS

40 CIRCLE OF ALLEGRETTO NUZI
Italian; Florence, active third quarter of the 14th century

Saints and Angels, ca. 1370
Tempera and gold leaf on panel; 44.568: 42½ × 20⅟₁₆ (107.9 × 50.9);
44.569: 42⅜ × 20⅟₁₆ (107.6 × 50.9)
Edith A. and Percy S. Straus Collection 44.568, 44.569

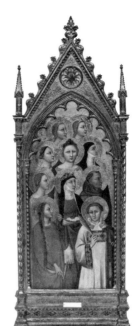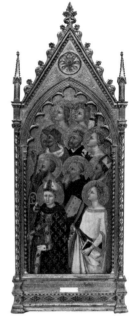

The Houston panels were once components of a large altarpiece of the Coronation of the Virgin, the three central panels of which are preserved in Southampton, England. Martyrs, saints, and angels here form part of the heavenly court that usually accompanies the crowning of the Virgin as Queen of Heaven, a popular subject in Gothic art. The style is proximate to the work of Allegretto Nuzi, a painter from the Marches who was probably trained by Nardo (active ca. 1350–1360) and Jacopo (active 1365–1398) di Cione, and who was much influenced by Tuscan art. Francescuccio Ghissi (active 1359–1395), one of Nuzi's collaborators, has been identified as the author of the Coronation altarpiece; but Nuzi himself may have designed it. JS

41 MASTER OF THE STRAUS MADONNA
Italian; Florence, late 14th–early 15th century

Madonna and Child of the Goldfinch, before 1405
Tempera and gold leaf on panel; 35⅝ × 20¾ (90.5 × 52.7)
Edith A. and Percy S. Straus Collection 44.565

About two dozen pictures have been attributed to the anonymous late fourteenth-century Master of the Straus Madonna, who was still active in 1405. In the Museum's picture, which gives him his name, archaizing reminiscences of the style of Agnolo Gaddi (1350–1396), a follower of Giotto (1266/1267–1337), mix with ornamental features of the International Style (see no. 34). The Master of the Straus Madonna is also distinguished for a personal taste in the traditional patterning of the gold ground and for striking combinations of rich colors. The Christ Child is shown holding a goldfinch, a common Christian symbol of the Soul; and He wears a coral pendant, a talisman that served in ancient Greece to protect against evil. JS

42 LANGA MASTER
Spanish; Aragon, active ca. 1400–1430

Virgin and Child with Angels, ca. 1400–1430
Tempera and gold leaf on panel; 77½ × 40⅛ (197.3 × 101.9)
Museum purchase 58.6

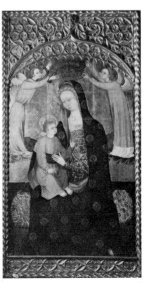

A Spanish exponent of the International Style of Europe around 1400 (see no. 34), the Langa Master combines the iconography of the Coronation of the Virgin with the Virgin and Child Enthroned in the Houston painting and betrays wider Burgundian influence. In spite of a flattening of the Virgin's dark blue mantle, an effect heightened by the regular overall gold pattern, sculptural tendencies are revealed in the Child's body and the Virgin's face. The anonymous Aragonese artist is named for his retable at Langa del Castillo in northern Spain. JS

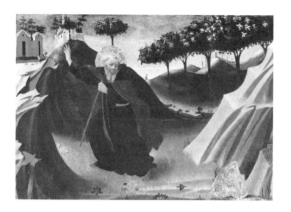

43 FRA ANGELICO
Italian; Siena 1395/1399–1482/1483

The Temptation of St. Anthony the Abbot, ca. 1430
Tempera on panel; 7¾ × 11⅛ (19.7 × 28.0)
Edith A. and Percy S. Straus Collection 44.550

Houston's small panel, attributed by Bernard Berenson, Lionello Venturi, and John Pope-Hennessy to Fra Angelico himself rather than to a follower (an opinion advanced by R. Offner), is probably a fragment of a larger work. Yet it has been so far impossible to link it precisely with a known work, although Pope-Hennessy has stressed its similarities to the *Penitence of St. Julian* in Cherbourg and has suggested that both pieces may have originated as parts of the same predella.

Guido di Pietro, better known as Fra Angelico, entered the Dominican order around 1423. His first activity as a painter is recorded in 1418. His position as a monk did not force him to lead a secluded life. On the contrary Fra Angelico became one of the leading painters of his generation. His fame is attested to in a letter written in 1438 by Domenico Veneziano (1405–1461), who mentions him as one of the most important painters in Florence.

Influenced by Masaccio's (1401–1428) innovative ideas and particularly by his frescoes in the Brancacci Chapel at S. Maria del Carmine, Florence, Fra Angelico adopted this painter's new conception of volumes and space but converted them to the spiritual aims that confer upon his own works their ethereal quality and mystical significance. The pivoting motion of St. Anthony as he turns away from the temptation of a heap of gold placed in his path by the Devil and the aerial perspective of the luminous horizon are advanced Renaissance aspects of the painting, while the schematic rocks and out-of-scale buildings are deliberate archaisms. JPM

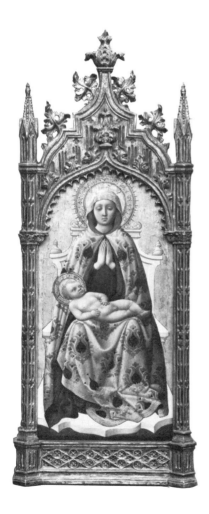

44 ANTONIO VIVARINI
Italian; Murano ca. 1420—Venice (?) after 1470

Madonna and Child, ca. 1445
Tempera on panel; 34⅝ × 17¼ (88.0 × 43.8)
Edith A. and Percy S. Straus Collection 44.575

Around the middle of the fifteenth century, Venetian artists like Antonio Vivarini and Jacopo Bellini (first mentioned in 1423–1470/1471), two major figures of the International Style, introduced in their works innovations that were foreign to the Gothic tradition still prevalent in Venice.

Antonio Vivarini was born in Murano and worked in and around Venice all his life. Alone or in collaboration with his brother-in-law, Giovanni d'Alemagna (active before 1450), Vivarini created large polyptychs (Basilica Eufrasiana, Parenzo, 1440; S. Zaccaria, Venice, 1443–1444; Praglia polyptych, ca. 1450) that are the landmarks of his career. Vivarini also worked on the decoration of the Oretani Chapel in Padua, but his modest contribution there is overshadowed by the main representations entrusted to Andrea Mantegna (1431–1506).

An early work by Vivarini, Houston's *Madonna and Child* has been linked stylistically to other Vivarini altarpieces of the mid-1440's. In the soft, yielding quality of the paint, Vivarini's personal style is here already fully developed. The Madonna's hieratic expression, the gold ground, the ornamental, linear

style, and the realistically observed details are features inherited from the Venetian Byzantine-Gothic icon traditions Vivarini's later pictures also preserve. However, the foreshortening of the Child and throne and the organic solidity of the figures themselves reveal Vivarini's exposure to Tuscan artists working in Venice and to the formal logic of their Renaissance style. JPM

45 GIOVANNI DI PAOLO
Italian; Siena 1395/1399–1482/1483

St. John the Baptist and Catherine, ca. 1440
Tempera on panel; 53.2: 41 × 18⅞₁₆ (104.3 × 46.8); 53.3: 41³⁄₁₆ × 17½
(104.6 × 44.4)
Robert Lee Blaffer Memorial Collection; Gift of Sarah Campbell Blaffer
53.2, 53.3

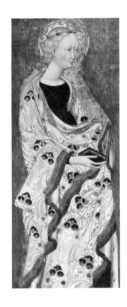

According to John Pope-Hennessy, the two Houston panels, originally full-length figures joined together as a single panel, are fragments of a large polyptych executed in 1436 by Giovanni di Paolo for S. Francesco in Siena. The polyptych included figures of St. Matthew and St. Francis now at the Metropolitan Museum of Art, New York.

The conservatism and purity of Sienese painting is clearly exemplified in the Houston works. Although executed after Masaccio's (1401–1428) death, these panels display a poetic refinement of linear rhythms and subtle color patterns that contrast with the dramatic solidity of form Masaccio had already introduced into the Florentine school. The ascetic figure of the Baptist, with his deeply moving expression, is enhanced by the almost geometric configuration of the folds of his red cloak. St. Catherine, on the contrary, is a gracious and enticing figure, draped in a sumptuous robe of pearl gray with white brocade, rich embroideries, and an ermine lining. The soft inclination of her graceful neck and face is carefully balanced and echoed in the sinuous movement of the drapery and the pale radiance of her dress. The delicate harmony of these figures is not new in Sienese painting but reaches here its highest point of intensity. JPM

46 SANO DI PIETRO (ANSANO DI PIETRO DI MENCIO)
Italian; Siena 1406–1481

Madonna and Child with St. Jerome, St. Bernardino, and Six Angels, after 1450
Tempera on panel; 23½ × 16 (59.7 × 40.6)
Edith A. and Percy S. Straus Collection 44.572

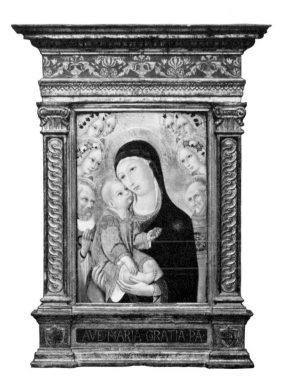

A pupil of Sassetta (1392–1450/1451), Sano di Pietro worked in Siena all his life. His activity is recorded there for the first time in 1428. During his long career, Sano was a prolific artist who created an easily recognizable picture type of which the Houston panel is a particularly fine example. In spite of the progressiveness of nearby Florence, Sano di Pietro remained faithful to the Sienese tradition. Well into the Quattrocento, his works attest to the vitality of the Sienese taste for graphic refinement and pure compositions prevalent since the thirteenth century.

The Houston panel typically presents the central image of the Madonna and

Child surrounded by angels and two saints, St. Jerome and St. Bernardino da Siena. St. Bernardino, often represented by Sano, was a Sienese preacher and reformer, who was canonized in 1450. A *terminus post quem* can thus be established for the picture, which must have been completed shortly after St. Bernardino's canonization. JPM

47 GIOVANNI DI PAOLO
Italian; Siena 1395/1399–1482/1483

St. Clare Saving a Child Mauled by a Wolf, mid-1450's
Tempera on panel; 8⅛ × 11½ (20.6 × 29.2)
Edith A. and Percy S. Straus Collection 44.571

Giovanni di Paolo can be considered an archaic painter. First influenced by Taddeo di Bartolo (ca. 1362–1422) and Gregorio di Cecco (active 1389–1423), he also encountered the works of the more advanced Sassetta (1392–1450/1451) or Gentile da Fabriano (ca. 1370–1427), but the impact of these artists upon Giovanni di Paolo was limited and did not affect the dramatic power of his compositions. Oblivious to the expressive potential of Renaissance discoveries, Giovanni di Paolo continued to work in a style based upon late medieval formulas. His paintings reveal a world of Gothic piety and asceticism close to the mystical world of Lorenzo Monaco (1370/1371–1422/1424).

 Like most of Giovanni di Paolo's known works, the Museum's small panel is a dismembered part of a larger ensemble of which only four elements of the predella survive. They illustrate the life of St. Clare, the first woman to become a disciple of St. Francis. In Houston's panel, St. Clare is about to answer the intercessions of a mother by restoring the limb torn from her child by a wolf. The scene is treated with an almost naive concentration on dramatic religious narrative and continues in this respect traditional Sienese Gothic art. Yet the orthogonal lines give order and scale to the landscape setting and show the artist's awareness of the innovative perspective system developed by Florentine masters of the early Renaissance. JPM

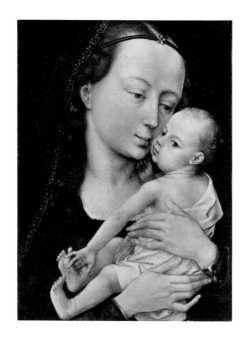

48 ROGIER VAN DER WEYDEN
Flemish; Tournai-Brussels 1399/1400–1464

Virgin and Child, after 1454
Oil on panel; 12⁹⁄₁₆ × 9 (31.9 × 22.9)
Edith A. and Percy S. Straus Collection 44.535

Following the great period of symbolic expressiveness and innovative composition in Flemish panel painting between 1425 and 1460, new currents appeared in Flemish art. Included among these was an iconocizing trend that manifested itself in a return to small devotional images in panel painting, particularly to bust-length representations of Christ or of the Virgin and Child. Indicative of his genius as well as of his innately introspective personality is the work of Rogier van der Weyden, one of the prime innovators among the older generation of artists. Rogier led in this new trend; not only did he anticipate his own imitators in the paraphrasing of his earlier works, but also he turned to Italo-Byzantine icons for new thematic material. Houston's representation of the *Virgin and Child*,

one of Rogier's late works, and probably his last half-length Virgin and Child, is evidence of Rogier's familiarity with the *Notre-Dame de Grâces* of Cambrai and is the means by which Rogier transmitted this famous icon form to Dieric Bouts (1420–1475) and Hans Memling (ca. 1433–1494). It promotes the theme of the Christ Child toying with a strand of His mother's hair.　　　JS

49　HANS MEMLING

Flemish; Bruges ca. 1433–1494

Portrait of an Old Woman, ca. 1468–1470

Oil on panel; 10⅛ × 7 (25.7 × 17.5)
Edith A. and Percy S. Straus Collection　　　　44.530

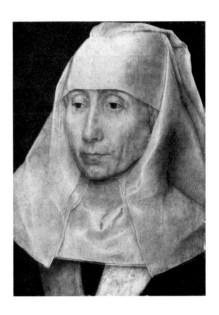

Hans Memling, a painter of German birth who presumably received training from Rogier van der Weyden (1399/1400–1464) in Brussels, made his most original and impressive contribution to Flemish art in the realm of portraiture. A wealthy, middle-class Bruges citizen is portrayed in the Museum's picture, which, with the matching portrait of the husband (Metropolitan Museum of Art, New York), is apparently the earliest of Memling's known portraits. Despite certain similarities to Rogier van der Weyden's style of portraiture, *Portrait of an Old Woman* shows the influence of Jan van Eyck (ca. 1390–1441) on Memling's work. Curiously, after the woman's husband died, her veil was repainted to take the form of a widow's veil. A pair of hands in the corner has also been painted out.　　　JS

50　ATTRIBUTED TO THE MASTER OF GEORG MUEHLICH'S MEISTERLIN CHRONICLE

German (Augsburg); active last third of the 15th century

The Crucifixion, ca. 1465–1470

Tempera and oil on panel; 28¾ × 19⁷⁄₁₆ (73.0 × 49.5)
Anonymous gift in honor of James Chillman, Jr.　　　72.32

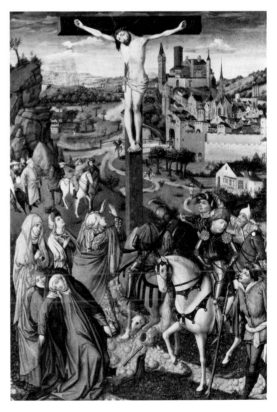

The Crucifixion was probably originally a component of an altarpiece, either one scene among many in the wings of a large polyptych of the Passion of Christ or the central panel of a triptych. Christ on the cross towers over the assembly of onlookers in the foreground and over the city of Jerusalem, represented as a typical thriving and sophisticated large German town of the late fifteenth century.

The anonymous painter of *The Crucifixion* shows an amazing grasp of the realistic landscape style born among Franco-Flemish manuscript miniaturists in the early years of the fifteenth century. Through his use of tiny figures in the background—horses riding down winding paths, crossing bridges—he exhibits his awareness of paintings in the Flemish tradition of Jan van Eyck (ca. 1390–1441), Robert Campin (1378/1379–1444), and Rogier van der Weyden (1399/1400–1464).

An attribution to the Master of Georg Muehlich's Meisterlin Chronicle is suggested not merely by the similar mechanics of landscape representation but also by the unique spirit with which landscape and figures are executed. The text of the chronicle compiled by Sigmund Meisterlin was set down in script by Georg Muehlich of Augsburg in 1457. Sometime later, probably after 1460, illustrations

were added to the manuscript in a style that points forward to Houston's panel painting. The maturity of the background landscapes in both the panel and the chronicle, if both works are by the same hand, shows not only that the artist had received Netherlandish or Lower Rhenish training, but also that he was the most progressive interpreter of landscape in Germany during his day.　JPM

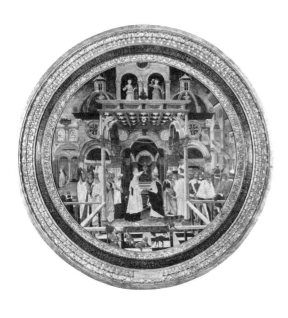

51　FERRARESE SCHOOL
Italian

Meeting of Solomon and the Queen of Sheba, ca. 1470
Tempera on panel; diam. 36⅜ (92.3)
Edith A. and Percy S. Straus Collection

44.574

The meeting of Solomon and the Queen of Sheba was a subject widely used among Renaissance artists to commemorate weddings. The theme also appears in a marriage salver in the Boston Museum of Fine Arts. Both the Houston and the Boston paintings are related stylistically to another salver representing the Judgment of Solomon now in Richmond, Virginia. The three paintings, of which the Houston tondo is the finest, must have been executed in Ferrara about 1470. Although the artist remains unknown, he was probably close to the court painters of Ferrara, Cosimo Tura (ca. 1430–1495) or Francesco del Cossa (ca. 1436–ca. 1478), for his style is similar to the style of the frescoes at the Schifanoia Palace in Ferrara.

Solomon's aristocratic company—defined by strict outlines, gilded and punched surfaces, bright colors, and naturalistic details—is representative both artistically and socially of the court taste of the Este family, who ruled fifteenth-century Ferrara. The rationalized architectural space of Solomon's temple, with its central vanishing point located in the altar chalice, is evidence of the permanent mark left on Ferrarese painting by the Tuscan artists Leon Battista Alberti (1404–1472) and Piero della Francesca (ca. 1416–ca. 1492), who were invited to the Este court during the 1440's.　JPM

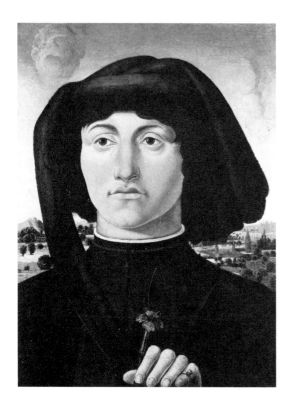

52　COSIMO ROSSELLI
Italian; Florence 1439–1507

Portrait of a Young Man with a Pink, ca. 1460–1507
Tempera on panel; 14⅞ × 12⅛ (37.7 × 30.8)
Robert Lee Blaffer Memorial Collection; Gift of Sarah Campbell Blaffer

55.88

The prolific Cosimo Rosselli studied with Neri de' Bicci (1419–1491) but broadened the limited experience provided by this traditionalist Florentine painter through his contact with Benozzo Gozzoli (1422–1497). Rosselli was an important fresco painter, working for Pope Sixtus IV on the decoration of the Sistine Chapel (1481–1482); his masterpiece is considered to be his work in Florence at S. Ambrogio. Among Rosselli's most illustrious pupils are Piero di Cosimo (1461/1462–1521?) and Fra Bartolommeo (1475–1517).

The Houston portrait of a man was formerly attributed to Piero di Cosimo; yet the formal, rather stiff, attitude of the sitter is typical of Rosselli, a representative of tradition against the innovations that characterize Florentine painting in

the fifteenth century. Rosselli's frescoes, notably those at the Sistine Chapel, do not compare with frescoes executed by the more illustrious artists who worked on the project, but they are often enlivened by personal elements, among them portraits that compare easily with and relate stylistically to the Museum's panel. If Rosselli was oblivious of his contemporaries' achievements, he may have responded more positively to a type of portrait brought to perfection in Northern Europe. The attitude of this sitter and his relationship to the landscape recall portraits by Jan van Eyck (ca. 1390–1441) or Hans Memling (ca. 1433–1494). Rosselli may have known works by these artists, and in his *Portrait of a Young Man* he gives his personal interpretation of their style. JPM

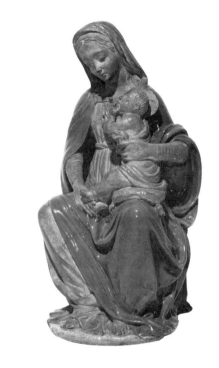

53 BENEDETTO DI LEONARDO, CALLED BENEDETTO DA MAIANO
Italian; Florence 1442–1497

Madonna and Child, ca. 1475–1497
Glazed terra cotta; h. 17³⁄₁₆ (43.7)
Edith A. and Percy S. Straus Collection 44.589

In the mid-fifteenth century, the Florentine sculptor Luca della Robbia (1399/1400–1482) achieved fame not only for his marble and bronze sculptures but also for his large glazed terra-cotta pieces. His technique became a family tradition and assured the reputations both of his nephew and pupil, Andrea della Robbia (1435–1525), and of Andrea's son Giovanni della Robbia (1469–1529).

According to some scholars, Wilhelm von Bode in particular, the partial glazing of the Houston terra cotta is the work of Giovanni della Robbia, while the modeling of the statue itself is the work of Benedetto da Maiano. The partial glazing is explained by the fact that some colors could not be properly obtained and were thus painted, in particular the flesh tones.

Benedetto da Maiano is known as a sculptor and architect who worked in Florence and for Naples (without leaving his hometown). His works include the door of the Palazzo Vecchio, the tomb of Filippo Strozzi at S. Maria Novella, and the pulpit of Santa Croce, his masterpiece. Small terra cottas like the Museum's example were probably models for larger pieces. It has been advanced that Houston's piece could also be the work of one of the lesser Florentine terra-cotta sculptors, Benedetto Buglioni (1461–1521) or Francesco Buglioni (1460–1520). JPM

54 ANTONIAZZO ROMANO
Italian; active between 1460 and 1510

Madonna and Child with Donor, ca. 1475–1480
Tempera on gold ground panel (in tabernacle frame with angel);
39 × 28¾ (99.1 × 75.5)
Edith A. and Percy S. Straus Collection 44.551

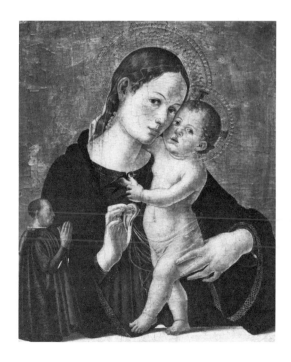

Little is known of the life of Antoniazzo, but his activity is recorded in Rome between 1460 and 1510. He worked there on several decorative projects including the *Camera di S. Caterina* in the church of S. Maria sopra Minerva.

Antoniazzo's works demonstrate the influence of Melozzo da Forli (1438–

1494) and, through this artist, of Piero della Francesca (1416–1492). Working in Rome, Antoniazzo could not ignore the achievements either of Perugino (1448–1523) at the Sistine Chapel (1480–1482) or of Ghirlandajo (1449–1494) at the Vatican Library (1474), which are also echoed in the Museum's picture. The Houston panel is, according to Gregory Hedberg (unpublished thesis), the best version of this composition, which is repeated (without the donor) in a panel in Assisi and in a now homeless panel. Related panels are in Detroit, Fermo, Florence, and Rome. JPM

55 BERNARDINO FUNGAI
 Italian; Fungaia 1460–Siena 1516

 The Rescue of Hippo, late 15th–early 16th century
 Tempera on panel; 20⅜ × 79½ (51.7 × 201.9)
 Edith A. and Percy S. Straus Collection 44.560

Themes of chastity and other Christian virtues were often depicted on marriage chests or *cassone*. The subject of Houston's *cassone* panel has been identified as the legend of Hippo, a Graeco-Roman myth that has also been the subject of stories by Boccaccio and Petrarch. Captured by enemy sailors, the Greek woman Hippo was supposed to have thrown herself into the sea to escape her captors. Here, however, the artist, or the iconographer who devised the subject of the painting, has altered the ancient story and has given it a happy ending. Because of the destination of the painting as a marriage-chest panel, the ancient moral has been changed: honor is to be valued above life itself, and Hippo is rescued from the sea by an Apollo-like Poseidon and brought safely to shore as a reward for her chastity.

Bernardino Fungai was the pupil and collaborator of Benvenuto di Giovanni (1436–ca. 1518). The influence of Umbrian painters can be perceived in the rounded, limp, elongated features, cool atmosphere, and spacious landscape. Indeed, Fungai, who was a rather eclectic artist, was influenced by Pinturrichio (ca. 1454–1513), Signorelli (1445–1523), and Perugino (ca. 1448–1523). JPM

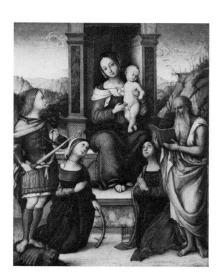

56 BERNARDINO ZAGANELLI
 Italian; Cotignola, second half of the 15th century—1510

 The Virgin and Child Enthroned with Sts. Michael, Catherine, Cecilia, and Jerome, late 15th–early 16th century
 Oil on panel; 9⅞ × 8 (25.1 × 20.3)
 Museum purchase with funds provided by Alice N. Hanszen 78.1

Modern scholarship has not yet been able to distinguish fully Bernardino Zaganelli's hand from the hand of his brother Francesco (died in Ravenna in 1532). If the traditional attribution of the small Houston panel to Bernardino is correct, it would bring an important addition to the corpus of this artist, whose only authenticated work is a Saint Sebastian (1506, National Gallery, London). The two brothers collaborated on many occasions, and it was only after Bernardino's death in 1510 that Francesco's paintings showed a more personal style.

Cotignola is in the province of Umbria, and the works of the Zaganelli reflect the multiple influences that prevailed there. The brilliant colors of the picture

link it to the miniatures used to illustrate manuscripts in Northern Italy. The North Italian influence is also suggested by the presentation of the Virgin and Child enthroned in front of a landscape. The figures themselves, however, reflect Florentine influences, Piero di Cosimo's (1461/1462–1521) in particular, as well as those of the more local Umbrian Pietro Perugino (1448–1523) and Perugino's greatest pupil, Raphael (1483–1520). The painting hints at the High Renaissance goal of depicting a synthesis of realism and idealism in which nature and humanity are presented in ideal form but with the convincing suggestion that they represent the appearance of what life would be like if only it were perfect. Houston's small work, which carries all the power of a large *pala d'altare*, was probably a private devotional commission. JPM

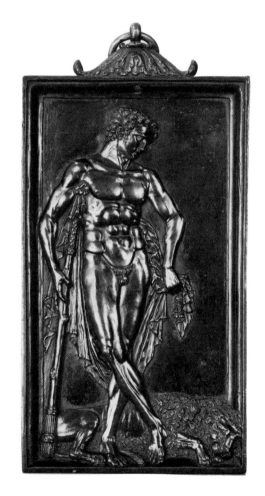

57 PIER JACOPO ALARI-BONACOLSI, CALLED L'ANTICO
Italian; Mantua ca. 1460—Bozzolo 1528

Hercules Resting after Slaying the Nemean Lion, ca. 1500
Bronze, inlaid silver; 11 × 5 13/16 (27.9 × 14.8)
Edith A. and Percy S. Straus Collection 44.582

At the end of the fifteenth century, Mantua ranked among the most sophisticated courts of Europe; poets, humanists, painters, and sculptors, under the patronage of Isabella d'Este, contributed to its flourishing and helped to make it one of the most active centers of the Renaissance. With the Mantuan rulers, the artists shared a deep interest in the rediscovery and preservation of antique monuments; recently excavated pieces were avidly collected and restored, and works in the antique style were commissioned. The court painter Andrea Mantegna (1431–1506), for example, used antique motifs that were archaeologically correct in his compositions.

Like Mantegna, the sculptor Pier Jacopo Alari-Bonacolsi was attached to the court of Mantua. He owed his nickname, L'Antico, to his astonishing ability to create small bronzes evocative of antiquity, not only because of their subject matter but also because of their perfection. Employed by the Gonzaga family to restore antiques, execute medals, and work as a jeweler for them, his greatest accomplishments reside in his small bronzes, based on antique themes but considerably reworked according to contemporary style. His work can best be seen today in Vienna, where most of it is kept, with individual and rare pieces in only a few other museums.

L'Antico is one of the finest bronze sculptors of the Renaissance. The smooth surfaces of his bronzes are unique. He affects an extremely classicizing style, in contrast to the naturalism of the contemporary Florentine or Paduan bronze sculptors, and often uses gilding for parts of his statuettes.

The Houston plaque has been attributed to L'Antico by Leo Planiscig on the basis of similarities with a series of large roundels depicting the *Labors of Hercules* (Kunsthistorisches Museum, Vienna; Bargello, Florence; Victoria and Albert Museum, London), traditionally attributed to this artist. In the roundels as in the plaque, Hercules is represented with exaggerated, muscular features and curly hair. In the Houston plaque, the movement of the hero's cloak introduces a naturalistic note which contradicts the classicism of the representation but which is a characteristic of the artist. Furthermore, the small piece of inlaid silver in the eye recalls the partial gilding L'Antico used in other pieces as well as a technique found in antique bronzes. JPM

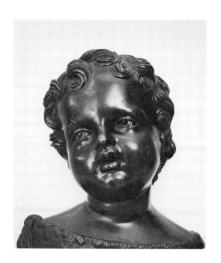

58 CIRCLE OF ANTONIO LOMBARDO
Italian

St. John the Baptist, ca. 1500–1510
Bronze; h. 5½ (14.0)
Edith A. and Percy S. Straus Collection 44.588

In spite of its quality and fame, the Houston bronze, of which other variants exist in New York and Oxford, remains the work of an anonymous sculptor. It has been formerly attributed to Vittorio Ghiberti (1416–1496) on the basis of its relationship to the heads in the borders of the Baptistry doors in Florence. More recently scholars have agreed that the style of the Museum's head is more likely Venetian and close to the works of Antonio Lombardo (ca. 1458–1516). Lombardo worked for the churches of San Marco and San Zeno as well as for the Palazzo Ducale in Venice.

The rediscovery in 1506 of the Laocöon group, a late second-century B.C. monumental sculpture, generated a tremendous interest in Hellenistic sculpture. Regardless of their original subject matter, Renaissance artists adapted these Greek prototypes to their own purposes. The adaptation of a pagan motif to a religious use can be seen in the boyish face of the Houston bronze: the childish features of the young Saint John derive from a Hellenistic composition almost as well known as the Laocöon, the *Boy with a Goose*. JPM

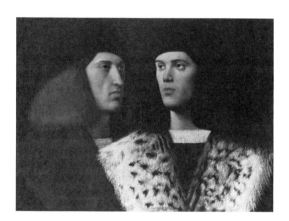

59 VITTORE BELLINIANO (DI MATTEO)
Italian; Venice, active 1507–1529

Two Young Venetian Men, ca. 1500–1525
Oil on canvas; 18 × 24⅞ (45.7 × 63.2)
Edith A. and Percy S. Straus Collection 44.553

Little is known of Vittore di Matteo, known as Belliniano because of his close relationship to Giovanni Bellini (ca. 1430–1516), with whom he collaborated on several occasions. His work reveals a personality much attuned to the best art of his time. In this early example of a double portrait, the quiet, introspective mood of the sitters seems to relate to the poetic classicism of Giorgione (1477/1478–1510). The restricted palette of earth tones and the vigorous play of light over textures seen in the impressionistic handling of the fur collar and the subtle way in which the heads emerge from the background can be traced to the work of the young Titian (1488/1489–1576).

The same sitters appear in reversed positions against a landscape background in a painting in the Louvre, variously attributed to Belliniano or to Giovanni Busi, called Cariani of Bergamo (1480/1485–ca. 1547). JPM

60 MASTER OF THE DRAPERY STUDIES
German; Strasbourg, active ca. 1500

Ecce Homo, ca. 1500
Pen, brown ink; 6⅝ × 10¹⁵⁄₁₆ (16.7 × 27.7)
Museum purchase 72.44

The Master of the Drapery Studies, also known as the Master of the Coburg Roundels, is an artistic personality originally named by the German art historian

Friedrich Winkler in an article published in the Yearbook of the Wallraf-Richartz Museum in 1930. Winkler assembled a number of anonymous drawings in various collections, especially in Coburg, and concluded that they were all by the same artist, who was active in the Rhineland around 1500. Subsequent art historians have generally agreed that the drawings are by the same hand, but no one has been able to discover the name of the artist nor any finished pictures by him. Whatever his name, the Master of the Drapery Studies produced a Medieval pattern book instead of following the Renaissance ideal that drawing embody the draftsman's power of invention: substantially all his drawings appear to be copies after the works of other northern artists, presumably made to record compositions the draftsman could then use himself.

Houston's drawing, which has not been identified as a copy after a known work, has been placed in the group by John Rowlands of the British Museum, who found it especially close to a drawing in Rotterdam depicting *The Raising of Lazarus*. Typical of the artist's reliance on Medieval artistic concepts are the zigzag drapery folds that fall as abstract arrangements rather than reveal the anatomy underneath. Such pattern-book designs must have been in universal use in Medieval times, but few have survived, and these few offer precious evidence of the difference between Medieval and later views of art. JMW

61 ALBRECHT DÜRER
German; Nuremberg 1471–1528

St. Eustace, ca. 1500–1501
Engraving; trimmed just within the platemark
13¹⁵⁄₁₆ × 10⅜ (35.4 × 26.4)
Signed bottom center in plate with monogram
Edith A. and Percy S. Straus Collection 44.548

Albrecht Dürer learned to use the engraver's tool, the burin, in the studio of his goldsmith father even before he was apprenticed at age thirteen to Michael Wolgemut, a painter and designer of woodcuts. After absorbing the Northern tradition—German art was heavily indebted to the Flemish fifteenth-century paintings of Jan van Eyck (ca. 1390–1440) and Rogier van der Weyden (1399/1400–1464)—Dürer visited Venice, first in 1494–1495, later in 1505–1507. His Venetian trips gave him first-hand knowledge of the art of the Italian Renaissance, and much of the rest of Dürer's life was devoted to absorbing such Renaissance concepts as the creation of monumental, naturalistically convincing figures set within a measurable geometric space.

St. Eustace, produced early in Dürer's career, is his largest engraving and owes much to the landscape backgrounds of Flemish paintings. It depicts a Roman general who converted to Christianity after seeing a stag with an image of the crucified Christ between its antlers. In technical terms, the print explores the range of tones possible within the medium of engraving and creates atmospheric perspective by contrasting dark, rich, foreground lines with lighter, more delicate, distant ones. In addition, Dürer displayed a concern with ideal proportions that lasted throughout his career. Here the proportions of animals are examined, but in other works he extended his interest to the study of humanity as well.
JMW

62 ALBRECHT DÜRER
German; Nuremberg 1471–1528

Virgin and Child Seated by the Wall, 1514
Engraving; 5⅞ × 3¹⁵⁄₁₆ (14.9 × 10.1)
Initialed and dated in the plate at center right edge on wall: 1514
Gift of Marjorie G. and Evan C. Horning 77.364

The extent to which Albrecht Dürer mastered the Italian Renaissance concept of an ideal but naturalistically convincing figural art can be seen in *Virgin and Child Seated by the Wall.* The Virgin sits regally, the position of her knees clearly indicated beneath the drapery. Equally apparent are concepts of monumentality and simplicity as the Virgin and Child constitute a three-dimensional pyramid set against an unornamented receding wall. In this engraving, as in others made in the latter part of Dürer's career, he abandoned the strong contrast of light and dark visible in *St. Eustace* (ca. 1500–1501, see no. 61) in favor of less deeply gouged lines, which produced more silvery tones than the darker tones of his earlier works. JMW

63 FOLLOWER OF JOACHIM PATINIR
Flemish

St. Jerome Praying in a Landscape, ca. 1500–1524
Oil on panel; 16 × 23 (40.6 × 58.4)
Gift of Mr. and Mrs. Harris Masterson 56.18

Joachim Patinir was the first Fleming to make landscape the prime subject of his paintings. He rendered his native, rugged Valley of the Meuse in cool, blue atmospheric perspective and a mixture of fantasy and naturalistic detail, generally overwhelming the ostensible religious subject of his pictures with the immensity of the natural world. Many Netherlandish landscape painters in the generations following Patinir were deeply influenced by him, particularly Adriaen Isenbrandt of Bruges (d. 1551), to whose style the Houston panel also bears a strong resemblance. JS

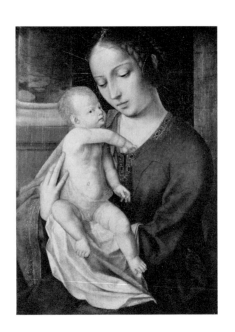

64 MASTER OF THE HOLY BLOOD
Flemish; Antwerp–Bruges, first quarter of the 16th century

Virgin and Child, ca. 1500–1525
Oil on panel; 19¾ × 14¼ (50.2 × 36.2)
Edith A. and Percy S. Straus Collection 44.531

The Master of the Holy Blood, so named after a triptych still located in the Chapel of the Brotherhood of the Holy Blood in Bruges, was an artist who seems to have led an active workshop that specialized in devotional paintings and altarpieces in the triptych form. His style is so clearly influenced by the great early sixteenth-century Antwerp painter, Quentin Massys (1466–1530), that

there can be little doubt he received his training in Massys's studio before settling in Bruges.

Houston's *Virgin and Child*, a painting of unusually high quality, unlike the generally mediocre material that emanated from the Master's workshop, may have been modeled directly on a design by Massys. The momentary theme of the Child reaching into His mother's bodice in preparation for His feeding and the torsion in the Child's body are especially worthy of Massys. JS

65 FOLLOWER OF BAREND VAN ORLEY
Flemish

Saint Matthew and *Saint Hugo*, early 16th century
Oil on panels; 58.19a: 9¹⁵/₁₆ × 3 (25.2 × 7.6); 58.19b: 9⅞ × 2¹⁵/₁₆ (25.1 × 7.4)
Gift of Mrs. Raymond H. Goodrich 58.19 a, b

Formerly attributed to Barend van Orley (ca. 1488–1541), the two Houston panels have recently been identified by John David Farmer (written communication) as the work of a totally unknown artist who imitated van Orley's mannered style. Called by Farmer the "Brussels Master of 1520," on the basis of his only dated work, a polyptych in the Musée de l'Assistance Publique, Brussels, his identity is a mystery but his work fairly easily recognizable. Farmer stresses the characteristics of his figures: "men with curly, fluffy hair, pouchy eyes and dimpled chins." Farmer suggests that the two small panels in Houston could belong to a *Lamentation* in the Bonnefantenmuseum, Maastricht. JPM

66 STYLE OR WORKSHOP OF SIMON BENING
Flemish; Bruges 1483/1484–1561

Triptych with the Virgin and Child and Saints Catherine and Barbara, ca. 1500–1550
Tempera on vellum; center, 9⅞ × 7¼ (25.1 × 18.4);
left wing, 9¾ × 2¾ (24.8 × 7.0); right wing, 9¹³/₁₆ × 2¾ (24.2 × 7.0)
Edith A. and Percy S. Straus Collection 44.529

Relations between Bruges and the nearby city of Ghent and an eclectic workshop practice distinguish a school of manuscript miniaturists that flourished in Bruges at the end of the fifteenth and early sixteenth centuries. Gerard Horenbout (ca. 1465–ca. 1540) and Simon Bening (1483/1484–1561) were among those who built great reputations by adapting famous compositions of leading panel painters—Hugo van der Goes (ca. 1440–1482) and Gerard David (ca. 1460–1523) included—to the format of book illustration. Houston's small triptych, composed of painted sheets of parchment of which the central "panel" is based on a painting by Gerard David, has been attributed to Cornelia Cnoop (active ca. 1500), David's wife, who was inscribed in the Bruges guild of illuminators. However, none of Cornelia's works has been identified, and the style of the triptych, which resembles another triptych of miniatures in Madrid, points to Simon Bening's workshop. In the backgrounds of each wing, the martyrdoms of the respective female saints are represented. JS

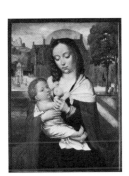

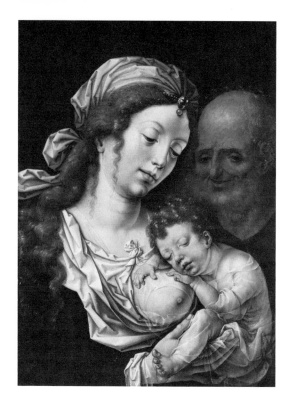

67 JAN GOSSAERT, CALLED MABUSE
Flemish; Maubeuge ca. 1478–Middleburg 1533

The Holy Family, early 16th century
Oil on panel; 20¼ × 14⅜ (51.4 × 36.5)
Robert Lee Blaffer Memorial Collection; Gift of Sarah Campbell Blaffer
59.27

Jan Gossaert spent most of his adult life in Middleburg after a youthful career in Antwerp. In the Houston picture, the Christ Child sleeping on His mother's breast after suckling is but a variation on one of Gossaert's favorite themes—the Virgin and Child in half-length. The addition of Joseph, caricatured as an old man after the taste of Antwerp Mannerism, makes the panel a *Holy Family*. The large size of the figures in relation to the picture's height and width and the suggestions of shallow space created by the dark background are typical of the artist, who nevertheless achieves the illusion of depth and three-dimensionality through the lighting of the voluptuous, full-blown figures. In this late work, the artist's debt to the works of such compatriots as Hugo van der Goes (ca. 1440–1482) and Gerard David (ca. 1460–1523) is less apparent than his knowledge of the prints of Albrecht Dürer (1471–1528). JS

68 ATTRIBUTED TO ANDREA BRIOSCO, CALLED RICCIO
Italian; Padua ca. 1470–1532

Chained Satyr, ca. 1510
Bronze; h. 5⁹⁄₁₆ (78.6)
Edith A. and Percy S. Straus Collection 44.594

The large Paschal candelabrum executed in 1507 by Riccio for the Santo in Padua can be considered the source for many later works by Riccio and his followers. A work of extreme complexity and a technical tour de force, it provided a repertoire of figures and ornaments for these artists and set the high level of quality for Paduan bronzes. In typical Renaissance fashion, this bronze designed for the Catholic cult incorporated many elements borrowed from the pagan world. Its corner figures, for instance, are sphinxes rather than religious symbols or saints.

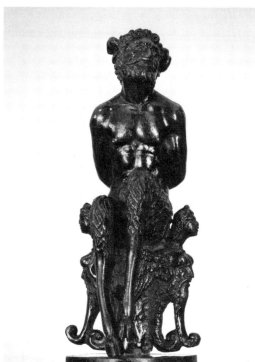

Riccio elaborated upon these sphinxes in many smaller bronzes; these imaginary figures reappear in his work as inkwells, or, as in Houston's *Chained Satyr*, as supports for the main figure. Furthermore the expression of pain on the satyr's face, both grotesque and poignant, as the monster is trying to free himself from his ties, echoes the resigned and frozen attitude of the sphinx bound to the pedestal in the Paschal candelabrum.

The Houston bronze is a version of a prototype of which several other casts exist. It relates precisely to a larger group that includes not only the bound faun but also a satyress and Eros (Ashmolean Museum, Oxford, and, without Eros, Louvre, Paris). Riccio and his pupils often isolated figures from their elaborate groups and cast them as single objects.

Modern scholarship does not agree on the authorship of the Houston bronze. While John Pope-Hennessy verbally expressed the opinion that it might be autograph, Andrew Ciechanowiecki and Ursula Schlegel thought that it might rather be the work of one of Riccio's most gifted followers, Desiderio da Firenze (active 1532–1545). They based their conclusion on the similarity between the Houston bronze and the satyr attributed to Desiderio in the Victoria and Albert Museum, London. JPM

69 ANDREA BRIOSCO, CALLED RICCIO

Italian; Padua ca. 1470–1532

Vulcan Forging the Arrows of Cupid, early 16th century

Bronze; diam. 3³⁄₁₆ (8.0)
Inscribed on back: R^OI
Edith A. and Percy S. Straus Collection 44.596

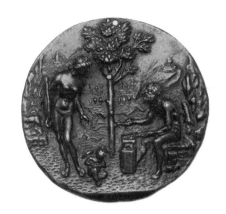

Due to the presence of Donatello (1386–1466) in Padua, where he worked at the
Santo, this city became an important center for bronze sculpture in the late
fifteenth and early sixteenth centuries. Artists from Florence and Padua and
technicians from Venice contributed to the emergence of one of the most attrac-
tive genres in Renaissance sculpture: the small bronze. One of the most brilliant
exponents of this genre was Andrea Briosco, called Riccio, a native Paduan who
worked on a large scale at the sanctuary of the Santo (he contributed a cande-
labrum and bas-reliefs) but who is mostly known for his smaller bronzes, reliefs,
or plaquettes. These works encountered such success that they were repeated in
somewhat altered form by Riccio and endlessly copied by his imitators.

Riccio's style is based on the study of classical works, but he never ignored a
popular, extremely realistic—and sometimes coarse—tradition for grotesque
subjects. Satyrs, grimacing figures, and animals are part of his repertoire as well
as the calmer world of the Olympian gods illustrated in the Houston plaquette.
At the right Vulcan is forging arrows; to the left, Venus, carrying a bow, seems
to address him while Cupid is crouching on the ground. The scene takes place
in an idyllic landscape with a town in the background. Leo Planiscig sees the
influence of the Venetian painter Giorgione (1477/1478–1510) in this type of
work. Riccio's representation shares with Giorgione's the same bucolic and
undefined character; both Riccio and the painter of the *Tempesta* (Accademia,
Venice) or of the *Concert champêtre* (Louvre, Paris) belong clearly to the same
intellectual milieu.

Although more works are attributed to Riccio than he ever executed himself,
the Museum's very fine plaquette, superior in quality to one of the same subject
in Berlin, which is likewise signed on the back, bears the kind of finish that only
Riccio himself was able to confer on his works. JPM

70 NORTH ITALIAN

Hercules and the Nemean Lion, early 16th century

Gilt bronze; h. 7⁹⁄₁₆ (19.2)
Edith A. and Percy S. Straus Collection 44.591

The Museum's inkstand has as its subject one of the twelve labors of Hercules.
Originally attributed to the Florentine painter and sculptor Antonio Pollaiuolo
(1431?–1498), who painted a series of the labors of Hercules in 1460, the Houston
bronze in its vigorous action and attention to anatomical details does reflect his
style but cannot be attributed to Pollaiuolo himself. It does, however, show the
more spontaneous approach to antiquity of the early Renaissance as opposed to
the rather cold, archaeological classicism of the High Renaissance. Variants of
the composition in London, Oxford, and New York have borne attributions
to such diverse artists as the Florentine sculptors Bertoldo di Giovanni (active
second half of fifteenth century) and Giovanni-Francesco Rustici (1474–1554),
or to the Paduan Bartolommeo Bellano (ca. 1434–ca. 1496), and the Venetian
Tiziano Aspetti (1565–1607). JPM

71 BARTOLOMMEO VENETO
Italian; Venice (?) 1502–1546

Portrait of a Man, 1512 (?)
Oil on panel; 27⅞ × 21½ (70.8 × 54.6)
Edith A. and Percy S. Straus Collection 44.573

During the Renaissance, Venice was perhaps the Italian city most open to foreign trends. Besides the Byzantine influence that had been part of the city's heritage since the Middle Ages, Venice was also, because of its location, a main point of contact with septentrional artists. Albrecht Dürer (1471–1528) visited Venice on two occasions. On his second trip in 1505–1507, he was a much respected artist. Although he was received with envy by the Venetian painters, they could not avoid his influence.

 Bartolommeo Veneto had been a pupil of Giovanni Bellini (ca. 1430–1516); like his master, Veneto executed Madonnas, but he achieved greater fame with his portraits of fashionable young men. Bartolommeo developed a grand manner that focused on the opulent costumes and rich adornments of his patrician patrons but that often showed a dependence upon Dürer's models. The Houston portrait is a typical and superb example of this dual influence. The thoughtful and sensitive young man is psychologically characterized in the straightforward, unpretentious fashion of North Italian and German portraitists, in spite of rich features such as the opulent costume, dramatic lighting, and formal backdrop. The portrait once bore a date probably to be read as 1512 or 1520. JPM

72 VICENZO CATENA
Italian; Venice ca. 1480–1531

Sacra Conversazione, ca. 1520
Oil on canvas; 30⅝ × 41 (76.8 × 104.0)
Samuel H. Kress Collection 61.61

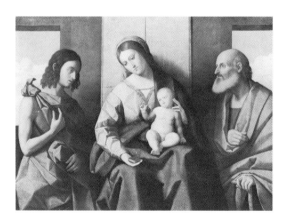

Informal groupings of saints around the central figure of the Virgin Mary holding the Child are traditional features of Venetian Renaissance art. These representations, which bear no relation to a specific story from the gospels or to the particular legends of the represented saints, are called *sacre conversazione*. Their invention is usually credited to Venetian painters of the late fifteenth or early sixteenth century, such as Giovanni Bellini (ca. 1430–1516), who often favored an unorthodox, or at least innovative, iconography. One of the trademarks of these representations is their informality. In the Houston example, however, Catena has represented the Virgin against a rich brocade background, which confers on her figure a hieratic dimension. This detail might have been derived from Flemish models, for Flemish painters created a type of religious representation comparable to the Venetian *sacre conversazione* but in which the Virgin Mary is always enthroned under a majestic dais.

 Vicenzo Catena is famous for this type of painting, which he created in great numbers. His style is close to Bellini's, but particularly remarkable in Houston's picture is the extensive use of geometric shapes to set off the figures of the saints. If his symmetrical composition is somewhat conservative, and even perhaps archaic, the painting is not devoid of "modern" elements. The gestures of the saints and the glances they exchange create a poetic mood enhanced by the

artist's soft handling of the brush; the resulting dreamlike quality was favored by Venetians and is best expressed in Giorgione's (1477/1478–1510) paintings. It was, however, only after Giorgione's death in 1510 that Catena softened his style in imitation of this painter. The Houston painting can be dated about 1520.

JPM

73 LORENZO LOTTO
Italian; Venice (?) 1480–Loreto 1556

Holy Family with St. Catherine, 1520's
Oil on canvas; 27¹⁵⁄₁₆ × 37¼ (70.9 × 94.6)
Samuel H. Kress Collection 30.5

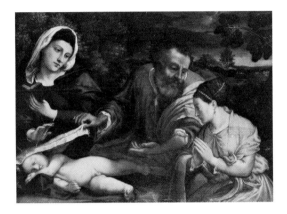

Although probably born in Venice and exposed to the art of Giovanni Bellini (ca. 1430–1516), Lorenzo Lotto's career took place outside that city. He worked mostly for provincial centers, in the Marches and in Bergamo. He also worked in Rome, where he participated in the decoration of the *Stanze* at the Vatican. Lotto's style profited from multiple influences: quick to understand the expressive power of Raphael's (1483–1520) manner as well as the effects of light favored by the German painters, Lotto could graft such eclectic elements to his withdrawn, introverted, and pietistic manner in a combination that gives his work its incomparable—if somewhat awkward—flavor.

The Houston painting was executed in the 1520's, at a time when, according to Vasari, Lotto was following "partly Bellini and partly Giorgione." The idea of the composition, a poetic derivation from the Venetian *sacra conversazione*, recalls these masters, but the intimist and sweet atmosphere is typically Lotto's, as is the almost naive execution. Lotto is evidently more concerned with the message of the picture—the communication of devout feelings—than with its aesthetic achievement.

After the refined production of Giovanni Bellini or the astonishing inventions of Giorgione (1477/1478–1510), Lotto's accomplishments may seem pedestrian, but, seen in a different perspective, they also appear to be the expression of a great modernity. The Houston painting, in spite of its roughness and provincial elements, can indeed be looked at as a link between Giorgione and Correggio (1489–1534), or Bellini and Caravaggio (1570–1610), whose directness it prefigures.

JPM

74 SEBASTIANO DEL PIOMBO
Italian; Venice (?) ca. 1485–Rome 1547

Portrait of Anton Francesco degli Albizzi, ca. 1525
Oil on canvas, transferred from panel; 53 × 38⅞ (134.6 × 98.7)
Samuel H. Kress Collection 61.79

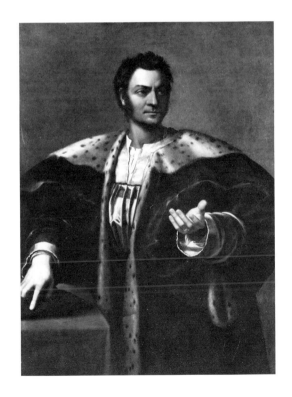

Little is known of Sebastiano del Piombo's early career or training. He was probably born in Venice and, according to Vasari, was apprenticed to Giovanni Bellini (ca. 1430–1516) and Giorgione (1477/1478–1510). Sebastiano worked mostly in Rome, after he arrived there in 1511. A year later Michelangelo (1475–1564) completed the ceiling of the Sistine Chapel, and Sebastiano became one of his closest friends and proteges. Sebastiano had already established him-

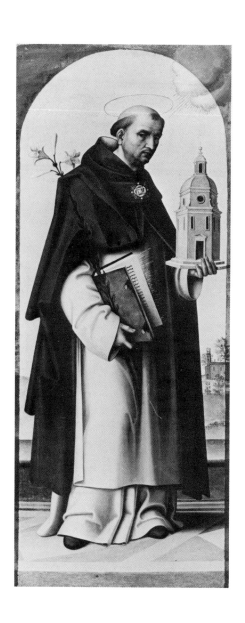

self as a first-rank portraitist, comparable to Raphael (1483–1520). Michelangelo, who recognized in Sebastiano an extremely talented artist, encouraged him and even helped him to carry out some of his most ambitious projects (*Pietà*, Viterbo Museum; *Borgherini Chapel* at S. Pietro in Montorio, Rome; *Resurrection of Lazarus*, National Gallery, London). Raphael died in 1520. When Sebastiano did not leave Rome after the city's sack by Imperial armies in 1527, he was without rival. He then created some of his most powerful portraits, including the Houston painting and his masterpiece in this genre, the *Portrait of Clement VII* (Museo di Capodimonte, Naples).

Sebastiano's aesthetic preferences led him toward a lavish manner that not only reflects Michelangelo's powerful style but also prefigures the deliberate excesses of the Mannerist school. The features of his sitters are often exaggerated to enhance their psychological qualities or to amplify their physical presence. The imposing, richly dressed gentleman of the Houston portrait has been identified as the Florentine diplomat Anton Francesco degli Albizzi, who commissioned his portrait from Sebastiano while on a visit to Rome. The portrait can be dated about 1525, when it is described as finished by Sebastiano in a letter of April 29 to Michelangelo in Florence. Vasari singled out the Albizzi portrait, commenting that all Florence marveled at the execution of the head and hands, velvets, linings, and silks of Albizzi's costume. Similarities of style between this and other works of 1525–1526 and the richness of the sitter's costume favor the hypothesis that the Houston painting is indeed the famous Albizzi portrait. The opulent materials and vibrant quality of light within a dense atmosphere recall Sebastiano's early Venetian heritage, while the scale, breadth, and monumentality of the figure are personal characteristics of style that were reinforced by the Roman example of Michelangelo. JPM

75 GIOVANNI BATTISTA BERTUCCI
Italian; Faenza, active 1503–1516

St. Thomas Aquinas, ca. 1512–1516
Tempera on panel; 54½ × 21⅜ (138.3 × 54.4)
Robert Lee Blaffer Memorial Collection; Gift of Sarah Campbell Blaffer
64.34

In 1512 the Umbrian painter Giovanni Battista Bertucci, received the commission for an altarpiece for the chapel of St. Thomas Aquinas in the church of S. Andrea at Faenza. When completed in 1516, the altarpiece contained a central panel, the *Virgin and Child in Glory* (National Gallery, London) and at least two side panels, one representing *St. Thomas Aquinas* at the Museum and the other depicting *St. John the Evangelist* in the Blaffer Foundation, Houston. In their symmetry and linear clarity, the Houston panels reflect Bertucci's indebtedness to the High Renaissance style of his fellow Umbrians Perugino (ca. 1448–1523) and Pinturicchio (ca. 1454–1513). Even the High Renaissance architectural ideal of the central ground plan is reflected in the model of the church St. Thomas Aquinas presents to the Virgin. KS

76 BERNARDINO LUINI
Italian; Luino (?) 1480/1485—Milan (?) 1532

Pietà, ca. 1515
Oil on panel; 34⅜ × 23¹¹⁄₁₆ (87.2 × 60.2)
Samuel H. Kress Collection 61.68

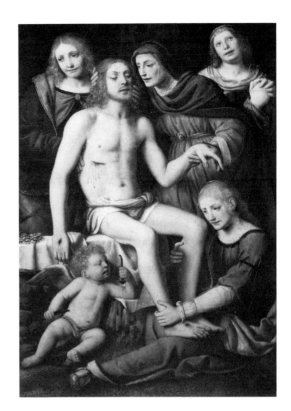

Bernardino Luini is commonly referred to as a Lombard follower of Leonardo
(1452–1519), an appellation that describes adequately his superficial qualities but
tends at the same time to confer upon him a prestigious lineage he does not
entirely deserve. If his compositions are clearly derivative of Leonardesque
formulas—adopted almost exclusively for decorative effect—the roots of his art
lie in the more conservative tradition of late Quattrocento Lombard art. This
tradition is exemplified in the influence of Vincenzo Foppa (1427/1430–1515/
1516) and Borgognone (active 1481–1522) upon Luini's fresco at Chiaravalle
(1512), the first work that can be ascribed to him without doubt.

His artistic education is uncertain; he may have taken an early trip to Rome
and Florence. Luini is known above all for his frescoes in the churches and
palaces of Milan. His masterpiece is the series of frescoes done for the Besozzi
Chapel at S. Maurizio, Milan, at which he worked until 1530. Luini also painted
many smaller works, madonnas, and pietàs that reflect the art of Leonardo.

The Houston *Pietà*, usually dated around 1515 (except by Roberto Longhi,
who dated it around 1530), is typical of Luini's work; it gives a rather lifeless and
cold interpretation of Leonardesque motifs, arranged together without much
sense of composition, or rather juxtaposed like the elements of a collage. Luini
shares this Leonardesque veneer with other Northern followers of Leonardo
who understood the importance of Leonardo's formal innovations but not the
principles of his art. JPM

77 RAFFAELINO DE'CARLI OR DE'CAPPONI, CALLED
RAFFAELINO DEL GARBO
Italian; Florence ca. 1470–1525

Portrait of a Young Woman, early 16th century
Tempera on wood; sight 15¼ × 9¾ (38.7 × 24.8)
Edith A. and Percy S. Straus Collection 44.554

Formerly in the collection of the Kaiser-Friedrich Museum in Berlin, the Houston
panel was attributed to a follower of Sandro Botticelli (1455–1510). In 1932
Bernard Berenson recognized in it a work by Raffaelino del Garbo, an attribu-
tion that has not been questioned since.

Raffaelino del Garbo was first influenced by Filippino Lippi (1457?–1504) and
later by the Umbrian painters, Perugino (ca. 1448–1523) in particular. His work
can be divided in two parts, according to these influences. The Houston portrait
belongs to his early career and shows strong Florentine characteristics. Its insist-
ence upon clear drawing, the strict profile presentation of the model, and the
sparse use of colors are elements that perhaps look backwards when compared
to contemporary Florentine creations; but in the soft movement of the hair and
the delicate expression of the lips, Raffaelino finds accents that bring him close
to Botticelli. JPM

78 HANS HOLBEIN THE YOUNGER
German; 1497/1498–1543

Portrait of Sir Henry Guildford, ca. 1527–1532
Oil on panel; diam. 5¹³⁄₁₆ (14.8)
Edith A. and Percy S. Straus Collection 44.549

As portraitist to Henry VIII from 1532 until his death, Hans Holbein the Younger, a German artist trained in the workshop of his father in Augsburg, painted many members of the English court. However, Houston's miniature portrait of Sir Henry Guildford, comptroller of the king's household, is a reminiscence of Holbein's earlier trip to England in 1526–1528, during which time Sir Henry was awarded the Order of the Garter, as evidenced by the collar worn in the portrait. The large, rectangular likeness of Sir Henry (at Windsor Castle) and its pendant, Lady Mary Guildford (now in St. Louis), were executed by Holbein in 1527 to commemorate Guildford's advancement to the Order. The Houston portrait, which repeats the design of the former in a circular format, originated either at the same time or after 1532, the year of Sir Henry's death, as a memorial medallion—perhaps to decorate the bottom of one of the round boxes that were in vogue at the time. In the latter case, a companion portrait of Lady Guildford would have decorated the top; indeed, both the Houston example and a circular version of the 1527 portrait of Lady Guildford were engraved by Wenzel Hollar in 1647, when they were in the collection of the Earl of Arundel. A stiff, conventionalized repetition of the Houston portrait, minus the baton and the original inscription on the frame, is in Detroit. JS

79 NICCOLÒ TRIBOLO
Italian; Florence 1500–1550

Day, ca. 1535
Terra cotta; h. 8⅜ (21.3), w. 11¹³⁄₁₆ (30.0), d. 4⅜ (11.1)
Edith A. and Percy S. Straus Collection 44.584

Few works of art have exerted as much influence upon generations of artists as the figures of Night, Day, Dawn, and Evening created by Michelangelo (1475–1564) for the tombs of Giuliano and Lorenzo de Medici (1521–1534). Vincenzo Danti (1530–1576), Daniele da Volterra (1509–1566), and Pietro Tacca (1577–1640) are only a few among the many artists who executed small clay copies after, or inspired by, the powerful figures of the Medici Chapel at San Lorenzo in Florence. Among the assistants who helped Michelangelo in this project was Niccolò Tribolo who, according to Vasari, modeled clay sculptures after Michelangelo's as early as 1535. Vasari himself owned a clay figure of Night by Tribolo.

Niccolò Tribolo was a Florentine artist who had worked with Jacopo Sansovino (1486–1570) on the facade of San Petronio in Bologna. He collaborated with Michelangelo for only one year, the last year of the installation of the Medici monuments, and remained famous above all for his designs for Florentine gardens, such as the Boboli Gardens or those at the Villa Petraia.

The Houston figure of Day is a small and powerful work that captures the impressive strength of the original sculpture by Michelangelo. Its illustrious provenance (it belonged in the sixteenth century to the famous von Praun col-

lection in Bologna) has led some scholars to believe that it was an original work by Michelangelo. However, recent scholarship has convincingly attributed it to Tribolo on the basis of a similar terra cotta in the Bargello in Florence.

Such small terra cottas were sought by artists who wished to study at leisure these famous compositions and also served as models for bronze castings. Tribolo, like other artists who copied it, completed the back of the figure, which had been left unfinished in the original. A drawing by Jacopo Tintoretto (1518–1594) after such a model—possibly by Tribolo—is in the collection of the Metropolitan Museum of Art, New York. JPM

80 MICHELE TOSINI (MICHELE DI RIDOLFO)
German; Florence 1503–1577

St. Mary Magdalene, ca. 1550
Oil on panel; 34¼ × 25¹³⁄₁₆ (87.0 × 65.7)
Samuel H. Kress Collection 61.67

A minor Florentine painter, Michele Tosini began his career in a very conservative manner inherited from his master Ridolfo Ghirlandajo (1483–1561). After resisting the innovations brought into the Florentine tradition by the Mannerist painters, he ultimately yielded to these transformations around 1540 and superficially adopted some of their characteristics. Mannerist artists like Rosso (1494–1540) or Pontormo (1494–1556), impressed by the late achievements of Michelangelo (1475–1564), had for many years replaced the calm order of High Renaissance art with a search for powerful effects. Their figures are often distorted or elongated, their colors used in an unorthodox fashion that gives their compositions an atmosphere of unreality and makes them easily recognizable.

The exaggerated modeling of the saint and the tormented and theatrical expression on her face, which contrasts with the delicate colors of her dress, help form an image that is both poignant and decorative, artificial and expressive. In that respect, the style of the Houston picture recalls the work of Giorgio Vasari (1511–1574) more than the paintings of Pontormo or Rosso, which are strongly structured despite their complicated compositions. Tosini collaborated with Vasari on the decoration of the Palazzo Vecchio in Florence. JPM

81 LUCAS CRANACH THE YOUNGER
German; Wittenberg 1515–Weimar 1586

The Fall of Man, 1549
Oil on panel; 8⁹⁄₁₆ × 6¾ (21.7 × 17.1)
Edith A. and Percy S. Straus Collection 44.546

Although signed with the Cranach family monogram, the winged serpent, *The Fall of Man* is a work by Lucas the Elder's son, as it is dated 1549, by which time the elder Cranach (1472–1553) no longer painted. The Houston painting has the same enamel-like surface and attention to detail that is characteristic of the father's work. It also reflects a certain eclecticism because it makes what could be called a Reformation icon of the father's most often repeated Biblical subject.

JS

82 JONAS SILBER

German; active ca. 1572–1589

Coriolanus Meeting the Roman Women, ca. 1575
Bronze; diam. 6¹⁄₁₆ (15.4)
Museum purchase 71.56

Livy tells the story of Coriolanus, the hero of the Volscian town of Corioli who was charged with tyrannical conduct in Rome. Having left the city, he led an army against it but was convinced by the supplications of his mother and of his wife to turn back. This episode of Roman history was the subject of one of the woodcuts done by the Swiss artist Jost Amman (1539–1591) to illustrate his *Neuwe Livische Figuren*, a book published in Frankfurt in 1573.

Shortly after the publication of Amman's book Jonas Silber used his plate as the model for Houston's bronze medal. Little is known of Jonas Silber beside the fact that he worked in Heidelberg, Danzig, and Nuremberg, the leading center for goldsmithing and bronze casting in South Germany. His work is rare and has been confused for a long time with that of Hans Petzoldt (1551–1633), the foremost goldsmith in Nuremberg after Wenzel Jamnitzer (1508–1585). In 1926 Otto von Falke was able to isolate Silber's creations from those of these other goldsmiths.

The fact that South German medals and plaquettes were made by goldsmiths explains their characteristic ornamental details and fine chiseling. Unlike Italian medals, which relate to large contemporary sculptures, German medals and plaquettes, as demonstrated in this case, bear a close relation to graphic art of the time, a particularity that accounts for the pictorial quality of these works.

The Museum of Fine Arts, Houston, owns another medal by Silber, *Dido at Carthage*. Both medals are found together in the Historisches Museum in Basel and the Hermitage in Leningrad and were probably conceived as a pair. JPM

83 JOST AMMAN

Swiss; Zurich 1539–Nuremberg 1591

Ensign Carrying a Flag, ca. 1575–1591
Pen, black ink; 6¹⁵⁄₁₆ × 4⁷⁄₁₆ (17.5 × 11.2)
Museum purchase with funds provided by the Laurence H. Favrot
Bequest Fund 70.37

Little is known of the artistic origins of Jost Amman save that he left his native Zurich for Nuremberg where he was established by 1562. His master has never been established with certainty though it has been suggested that he worked under Virgil Solis (1514–1562). In any event Amman was one of a group of artists, mostly printmakers, known as the "Little Masters," who reflect the enormous influence of Albrecht Dürer (see nos. 61 and 62). It is often difficult to attribute drawings to a particular Little Master, but similarities in handling between the Museum's drawing and others such as an *Ensign Carrying a Flag* in the Berlin Museum (a work very like ours), an *Allegorical Figure of Astrology* at Windsor Castle, and a *Reclining Stag* in the National Gallery of Art, Washington, D.C., provide confirming evidence for the attribution of the Museum's drawing to Amman. The elegant, regular penwork in the soldier's costume indicates that the drawing was a study for a print in which variations in light, shade, and tex-

ture would be rendered by a similar pattern of outline and "crosshatching" (as the network of strokes crossing one another at right angles is called).

The drawing is undated, but it would appear possible that it is connected with Amman's designs for 365 woodcuts and etchings in Leonard Fronsperger's *Kriegsbuch* (*War Book*) first published in 1573. As J. L. Schrader pointed out in an article in The Museum of Fine Arts, Houston, *Bulletin* (September 1972), the Museum's drawing is close to a woodcut in Jost Amman's *Kunstbuchlin* (*Art Book*; 1599 edition). However, the drawing could have been made many years earlier than the woodcut, for the cuts used in the book are believed to have been based on earlier work. JMW

84 DOMENICO TINTORETTO
 Italian; Venice 1560–1635

Tancred Baptizing Clorinda, late 1580's
Oil on canvas; 66⅜ × 45³⁄₁₆ (168.4 × 114.7)
Samuel H. Kress Collection 61.77

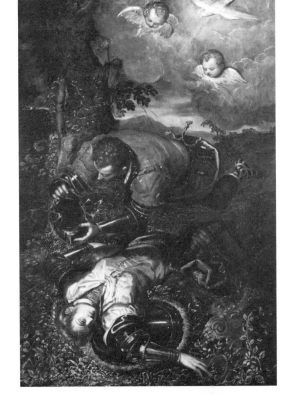

The subject of *Tancred Baptizing Clorinda* is taken from an episode in Torquato Tasso's *Jerusalem Delivered*, an epic poem that reflects the preoccupation of sixteenth-century Venetians with the Turkish political and religious menace. In the poem, the Christian knight Tancred has dueled with and mortally wounded his heathen love, Clorinda, whom he had failed to recognize in battle dress. Clorinda's dying wish to be baptized as a Christian is fulfilled by Tancred in this scene, raising Clorinda's tragic death to the level of a martyr's sacrifice for Christian redemption. The painting postdates the publication of Tasso's poem in 1581 and corresponds to other works from the Tintoretto workshop of the late 1580's. The relative roundness and solidity of the figures and the freezing of movement into static symbol recall paintings executed by Domenico's father, Jacopo Tintoretto (1518–1594), for the Palazzo Ducale, Venice; however, the hard surfaces, the naturalistic details, and the sharp contours that mark Houston's painting are characteristics of Domenico's personal style. KS

85 PAOLO CALIARI, CALLED VERONESE
 Italian; Verona 1528–Venice 1588

The Dead Christ with Angel and a Monk, ca. 1585
Oil on canvas; 33⅞ × 49⅞ (85.9 × 126.6)
Gift of Mr. and Mrs. Isaac Arnold, Jr., in memory of
Hugh Roy and Lillie Cullen 79.254

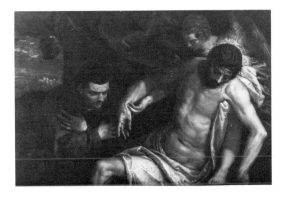

Paolo Caliari, better known as Veronese, is, with Titian (1488/1489–1576) and Tintoretto (1518–1594), one of the most important representatives of the sixteenth-century Venetian school. Veronese was the son of a stonemason. The eclectic cultural background of his hometown, Verona, provided the young Veronese with an abundance of examples from which he rapidly created his own style. Although he first adopted the refinements of drawing and composition of the Mannerist school, he did so with great freedom and a highly personal and bold sense of color. These qualities became more evident in the Venetian works of the late 1550's. Veronese had settled in Venice around 1555, and his brightly

colored compositions were admired by all, including Titian. Veronese's accomplishments culminated in the decorations of the Villa Barbaro a Maser (1562), a major monument of sixteenth-century Venetian painting.

After 1575 Veronese's work changed considerably. More intense, personal, or dramatic elements replaced the brilliance of the youthful works. The Houston painting, rediscovered recently and published by both Rodolfo Palluchini and Terisio Pignatti, adds significantly to the body of autograph late works by Veronese. It relates stylistically to other representations of the Dead Christ, notably those in Berlin and Leningrad.

The subject of these pictures, not *Depositions* but visions of the body of the Dead Christ supported by angels, is relatively familiar in Venetian iconography. Yet it is brought to a new dimension in the Houston painting. Veronese insists on the physicality of the dead body, and the introduction of a donor disguised as St. Francis indicates the artist's intention to blend the earthly world and the supernatural into a single image: Christ is represented as a dead man whose arm —the center of attention and of the composition—hangs lifelessly while the human and living donor is shown as a saint, complete with stigmata. The confusion of these two realms as well as the reference to another type of composition favored by Venetian painters, the *sacra conversazione*, are indicative of the intellectual complexity of Veronese's late works. Furthermore, the heavy, dark colors—only enhanced by the delicately painted, transparent garb of the angel— help to establish a deeply emotional atmosphere. JPM

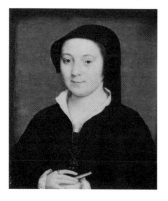

86 CORNEILLE DE LYON
French; The Hague 1500/1510–Lyon 1574

Portraits of René, Isabelle, and Marie de Batarnay, mid-16th century

Oil on panels; 44.538: 7 × 5¹¹⁄₁₆ (17.8 × 14.4); 44.539: 6⁹⁄₁₆ × 5⁷⁄₁₆ (16.7 × 13.8); 44.540: 6⁹⁄₁₆ × 5⅜ (16.7 × 13.7)
Edith A. and Percy S. Straus Collection 44.538, 44.539, 44.540

Although the French Renaissance was influenced above all by the presence or the example of Italian artists in France, the Northern element was not negligible either. A Dutch artist, Corneille de Lyon, established a type of portrait that has remained associated with French art of the sixteenth century as much as have the portraits of his exact contemporary, François Clouet (1500/1510–1572). Corneille de Lyon was born in The Hague, and his early training, if one can judge from his style, must have taken place in Flanders. He spent most of his time in Lyon, became a French citizen, and was made court painter to Henri II in 1551.

A popular artist who was widely copied, Corneille de Lyon created portraits that rarely vary. His works are small and refined, and his sitters are represented either frontally or from a slight angle against a blue or green background. His subjects are the aristocratic members of the French court. The three sitters of the Houston portraits are related: René de Batarnay, his wife Isabelle, née Savoie, and their daughter, Marie, who later became the Comtesse de Joyeuse. Corneille's portraits always avoid superfluous details and concentrate on the qualities of the sitters. Costumes and jewels are mere indications of rank or wealth. Attention is given above all to the expression and to the fine, miniature-like rendition of the various textures. JPM

Seventeenth Century

87 ANTONIO SUSINI
Italian; Florence, active 1580–1624

Madonna and Child, ca. 1600
Bronze; h. 15¾₁₆ (38.6)
Edith A. and Percy S. Straus Collection 44.586

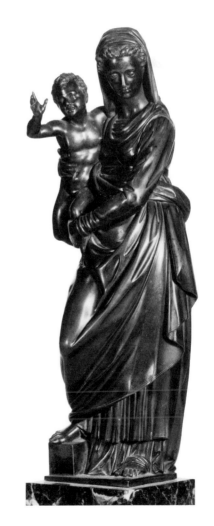

Born in Flanders in 1529, settled in Florence in 1561, protected by the Medici, Giovanni Bologna (also known as Giambologna) was perhaps the most inventive sculptor of his time. A truly international artist, he welcomed in his studio young sculptors from all European countries, and they eventually brought his style to the various courts for which they worked. His own bronze statuettes were also distributed widely throughout Europe, being the Medici's standard diplomatic presents.

Toward the end of his life, Giovanni Bologna devoted all his energy to the growth and prosperity of his studio, and he continued to receive full credit for the sculptures for which he had created the models, even though the actual casting and chasing had been entirely carried out by assistants. This procedure accounts for the confusion that has surrounded his work for many years, or at least for the generous attribution to him of works of modest quality. Only recently has scholarship tried to distinguish between his own works and those of his assistants.

The Houston bronze was originally attributed to Giovanni Bologna but has been convincingly reattributed to Antonio Susini by Charles Avery in 1978. Susini was one of Giovanni Bologna's most gifted assistants: he worked both on highly finished bronzes after models done by his master and on his own compositions. Around 1600 he set up his own studio in Florence and was held in high esteem by Giovanni Bologna himself.

The reattribution of the Museum's bronze to Antonio Susini is based on archival as well as on stylistic evidence. Giovanni Bologna is not credited with the invention of a Virgin and Child, whereas Susini is mentioned in the inventory after the death of Lorenzo di Jacopo Salviati (1609) as the author of a Virgin and Child *sua inventione* whose description fits the Houston bronze. Furthermore, F. Kriegbaum has pointed out the stylistic similarities between the Houston bronze and the two groups of the *Punishment of Dirce* (Galleria Borghese, Rome; Hermitage, Leningrad), which are signed and dated. JPM

47

88 ORAZIO GENTILESCHI
Italian; Pisa, Italy 1563–London, England 1639

A Sibyl, ca. 1620
Oil on canvas; 32⅛ × 28¾ (82.5 × 73.0)
Samuel H. Kress Collection 61.74

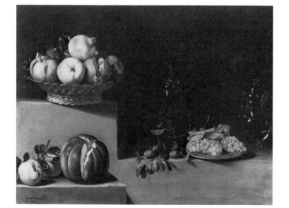

Although born in Pisa, Orazio Gentileschi was trained in Florence before settling in Rome around 1578. The main influence upon his own work was the art of Caravaggio (1573–1610), an artist ten years his junior, whom he had befriended. Leaving Rome definitively in 1621, Gentileschi became one of the leading figures in the spread of Caravaggesque formulas throughout Europe; he successively settled in Genoa, Turin, Paris, and London, where he died. The Museum's *Sibyl*, so called because of the slab with hieroglyphics, is a typical work of the artist in that it combines a natural elegance with Caravaggio's use of chiaroscuro. The attention given to the rendition of the brocade might be an echo of Florentine taste for rich detailing and is one of Gentileschi's trademarks. The adoption of Caravaggesque elements, such as the half-length figure, the play of light on the face and neck of the model, a popular type, and the contrasting of the image against the dark background, is altered by a baroque exuberance and an obvious delight in brilliant details.

Gentileschi's mild Caravaggism made this kind of picture more acceptable to a larger public than the works of Caravaggio himself. The achievements of the painters of the Utrecht school (see nos. 90 and 91), for instance, attest to Gentileschi's popularity as much as they acknowledge their debt to Caravaggio.

JPM

89 JUAN VAN DER HAMEN Y LEON
Spanish; Madrid 1596–1631

Still Life, 1626
Oil on canvas; 33 × 44⅝ (83.8 × 113.4)
Signed and dated lower left corner: Ju van der Hamen fa. 1626
Samuel H. Kress Collection 61.78

Because of the supremacy of Spain over Flanders, political and cultural exchanges were numerous between the two countries. Juan van der Hamen was born in Madrid, the son of an aristocrat from Brussels, Jan van der Hamen, who was an *arquero* or member of the Burgundian Guard at the court. In spite of his origin, van der Hamen's training was entirely Spanish, and his works belong to that school. His early apprenticeship is not documented, although he was probably influenced by the painter Juan Sánchez-Cotán (1561–1627). Like Sánchez-Cotán, van der Hamen is best known for his still lifes, although he also executed religious and historical pictures such as the decoration of the Convent of the Encarnación (1626) in Madrid.

Van der Hamen strives for formal clarity and a precision of design that allow him to display a stupendous technical ability. The artificial composition of the Houston picture, with its elements raised on platforms, forfeits conventional symmetry in order to give each object its full weight. Melons and pomegranates, dense and heavy, contrast with the translucid clarity of the Venetian-style glass vessels. Unlike many artists of the Baroque period, van der Hamen does not confer symbolic overtones to his still life. Its quiet and austere atmosphere, which

makes each object's presence felt, actually adds to the illusionistic quality of the picture. This immediacy is a Spanish characteristic van der Hamen shares with the two greatest Spanish painters of the seventeenth century, Diego Velázquez (1599–1660) and Francisco de Zurbarán (1598–1664). JPM

90 GERRIT VAN HONTHORST
Dutch; Utrecht 1590–1656

Venus Chastising Cupid, 1628
Oil on canvas; 50¼ × 57½ (127.5 × 146.0)
Signed and dated lower right on the stone: G. Honthorst 1628
Museum purchase with funds provided by Alice N. Hanszen 75.41

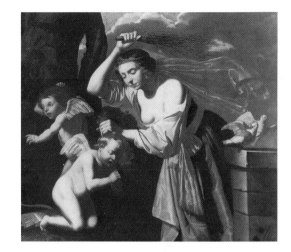

One of the North European centers where the ideas of Caravaggio (1573–1610) were especially well received was the Dutch city of Utrecht. Artists connected with that school, whether they were native-born or had trained or settled there after years of study in Rome, adopted Caravaggio's use of chiaroscuro and gave it a particularly dramatic dimension. One of the leading painters of the Utrecht school was Gerrit van Honthorst, often referred to as "Gherardo delle Notti" because of his remarkable ability to paint night scenes. He studied with Abraham Bloemaert (see no. 91) and spent about ten years in Italy between 1610 and 1620. After his return to Holland, he became famous enough to receive a visit from Peter Paul Rubens (1577–1640) in 1627.

Venus Chastising Cupid was painted in 1628, perhaps in England, where the artist was the guest of Charles I. Although Honthorst relinquished the dark tones and the rendition of the artificial source of light usually associated with Northern Caravaggism, he did keep several aspects of Caravaggio's art. The Museum's Venus is as buxom and popular as Caravaggio's own *Madonne*; the subject of the painting, Venus chastising "blind" Love while "seeing" Love runs away, is a restatement of the theme of Eros and Anteros and had been treated by other Caravaggesque painters such as Bartolommeo Manfredi (ca. 1587–1620/1621). The naturalism of the scene is a Caravaggesque characteristic and is remarkably, if perhaps too decoratively, translated in Honthorst's scrupulous attention to details and rendering of textures. JPM

91 ABRAHAM BLOEMAERT
Dutch; Dordrecht 1564– Utrecht 1651

The Gateway to a Town, ca. 1630
Pen and brown ink heightened with watercolor; 8¹¹⁄₁₆ × 12⅛ (22.4 × 30.8)
Signed: A. Bloem f
Museum purchase 74.254

The long career of Abraham Bloemaert began when Mannerism dominated Northern art and ended only after the Baroque had been thoroughly established. Not surprisingly Bloemaert's early drawings and paintings show the sinuous, elegantly contorted forms characteristic of his Mannerist origins. However, Bloemaert was not immune to the more naturalistic elements of Baroque art as it came into being in the Netherlands, and his later works reveal this influence. Houston's drawing, delicately heightened with watercolor, depicts humble

buildings. Such studies were made in the latter part of Bloemaert's career for background elements, especially in landscape paintings with Old or New Testament figures. Houston's drawing is signed by the artist himself, an unusual occurrence. Most names of artists written on old master drawings are no more than old collectors' inscriptions, more often than not overambitious in terms of the name inscribed. The drawing is not dated but is close to a drawing in Amsterdam depicting a *Dilapidated Farmhouse*, which is in turn a study for the background in *Tobias and the Angel*, a painting in Hamburg, signed and dated 1629. The architecture in the Houston drawing is also similar to an arch in another finished painting in Amsterdam, *Rest on the Flight*, signed and dated 1632. Thus a date of circa 1630 seems probable. JMW

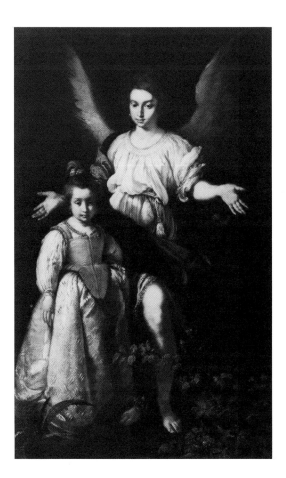

92 BERNARDO STROZZI
Genoese; Genoa 1581–Venice 1644

The Guardian Angel, ca. 1630
Oil on canvas; 83⅞ × 50¾ (213.0 × 129.0)
Anonymous gift in honor of Mrs. William Stamps Farish (née Libbie Randon Rice), Benefactress and Lifetime Trustee of The Museum of Fine Arts, Houston 76.256

During Bernardo Strozzi's lifetime, his hometown of Genoa occupied for many years a privileged position among the major artistic centers of the Italian peninsula. Because of its location, the city served not only as a first-rank port but also as a vital link between the southern part of Italy and the northern states, as well as with the Northern European countries. The city was open to foreign artistic influences, Northern in particular. Artists returning to their native countries from Rome often sojourned there and left important marks of their passage through Genoa. Peter Paul Rubens (1577–1640), Pierre Puget (1620–1694), or Anthony van Dyck (1599–1641), are only some of the many artists who worked in that city. In Van Dyck's case, his influence over local artists became extraordinary, and he helped to create a tradition of portrait painting upon which the Genoese artists elaborated their own style.

Genoese artists themselves were prone to traveling. Luca Cambiaso (1527–1585), the most important Late Renaissance artist in Genoa died in Spain, leaving a void that remained unfilled until the emergence of Bernardo Strozzi, a Capuchin monk who worked in his hometown until 1630, before settling in Venice.

Strozzi's early works are marked by the eclecticism characteristic of Genoa: Tuscan Mannerist influences are combined with Northern, Sienese, or Bolognese elements, taken notably from Francesco Vanni (1563?–1610) or Federico Barocci (1535?–1612). These artists had been invited to Genoa and had left important pictures in Genoese churches. Strozzi's own style matured between 1610 (the date at which he was allowed to leave his convent to work as a painter) and 1630 (the date of his departure for Venice).

The Guardian Angel was executed shortly before Strozzi's departure from Genoa and represents one of the highest achievements of his career. The subject, in spite of its apparent simplicity, is hard to define. The child is probably a daughter of one of the aristocratic Genoese families, Spinola or Doria (the painting was once in a Palazzo Doria in Genoa). Whether the child is represented departing this world or as a living child, cured after an illness and protected by her Guardian Angel, is difficult to ascertain. In either case, the painting, intended

as an altarpiece for a private chapel, conveys a deep and solemn mystery and has a moving character that is impossible to escape.

By the time he painted *The Guardian Angel*, Strozzi had relinquished the Mannerist refinements of his early works. Under the influence of Paolo Veronese (1528–1588) whom he admired, his art attained a frankness of expression that remained unsurpassed. The simple composition of the painting, culminating in the widespread red wings of the angel, which balance the gesture of his out-stretched arms, as well as the rich texture of the girl's dress, the lively detail of the plants in the foreground, and the bold brush stroke contribute to the powerful realism of the representation. The highly spiritual atmosphere of the painting establishes its emotional strength. JPM

93 CLAUDE GELLÉE, CALLED LE LORRAIN
French; Champagne, France 1600–Rome, Italy 1682

Pastoral Landscape with a Rock Arch and a River, ca. 1630
Oil on canvas; 37⅝ × 52⅞ (95.5 × 135.3)
Museum purchase with funds provided by the Agnes Cullen Arnold
Endowment Fund 73.172

The two most important French painters of the seventeenth century, Nicolas Poussin (1594–1665) and Claude Gellée lived and worked almost exclusively in Rome. Perhaps because of this unusual situation, or perhaps simply because they represent French painting at its highest level, their names are usually mentioned in relation to one another. Both artists painted extensive landscapes, an innovation in the French tradition, but these landscapes are more revealing of the artists' different backgrounds than of a common culture. Whereas Poussin affirms himself as the heir to the noble tradition of landscape painting established by the Bolognese school and before it by the Venetian painters of the Late Renaissance, Claude appears to have been more aware of an equally lively aspect of landscape painting in Italy, best represented by his master, Agostino Tassi (1565–1644). Tassi and the Flemish artist Paul Brill (1554–1626), also active in Rome, led the way to a more naturalistic approach to landscape painting despite the conventionalism of their works. It was from their example, as well as from the direct observation of nature in the Roman *campagna*, that Claude developed his style.

Claude Gellée was born near Nancy in Lorraine, a province from which such diverse artists as Jacques Callot (1592–1635) or Georges de La Tour (1593–1652) were native. At an early age, he arrived in Rome and worked as a pastry cook in the home of Agostino Tassi. He graduated promptly from the kitchen to the studio and became Tassi's pupil. Through him, and probably through Goffredo Wals, with whom he subsequently studied in Naples, Claude came in contact with the late Mannerist Flemish tradition of landscape painting: Tassi himself had been Paul Brill's pupil. Claude returned to his native country only once in 1626–1627. By 1640 he had achieved considerable reputation in Rome as a painter of landscapes. He died there, highly respected by all, in 1682.

The Houston landscape, recently rediscovered, is an important work that belongs to Claude's early style. The composition is still conventional, and the organization of the landscape recalls the paintings of Paul Brill or Tassi: *repoussoir* trees framing the composition, cattle in the foreground, clear definition of successive planes. But in its details as in its general atmosphere, the painting already prefigures the achievements of the artist's maturity. A gentle mood is conveyed

by the most delicate nuancing of colors. The arch, a Mannerist, almost theatrical, invention, opens up the composition and gives it a depth typical of his later paintings. Finally, direct observation of nature is evidenced in the depiction of the ruin on top of the cliff, reminiscent of the Temple of the Sibyl at Tivoli, and in the bucolic evocation of country life—not unlike a rural scene by a Northern master—but above all close to Virgil's poetry, Claude's constant source of inspiration. JPM

94 SÉBASTIEN BOURDON

French; Montpellier 1616–Paris 1671

Laban Searching the Belongings of Jacob, ca. 1634–1637

Oil on canvas; 19¼ × 26¼ (49.0 × 66.8)
Gift of the Armand Hammer Foundation and the Occidental Petroleum Company and Museum purchase 80.16

Of all the French painters who lived in Rome in the early seventeenth century, Sébastien Bourdon perhaps responded most to the leading examples of contemporary Italian art and to the entire cultural life of the city. Northern artists, French and Spanish, painters from other Italian cities were part of this extraordinarily active center. Bourdon, who arrived there in 1634, became famous by imitating the genre scenes of the Bamboccianti, Northern painters of tavern scenes like Pieter van Laer (1599–1642). He broadened his horizon by following the works of artists like Andrea Sacchi (1599–1661) and Giovanni Benedetto Castiglione (1611?–1663/1665) as well.

The Museum's recently rediscovered painting, *Laban Searching the Belongings of Jacob*, is not a direct imitation of Castiglione but borrows at least its subject from the Genoese master. Castiglione, famous for his paintings of caravans, which allowed him to depict animals, exotic trees, and brilliant still lifes, had treated the theme several times. In the Houston painting, which must have been executed in Rome between 1634 and 1637, Bourdon departs considerably from his model by adopting a more intimate scale, by introducing genre details—such as the woman nursing her infant—and above all by selecting a range of pale colors where light blues and pearly grays, Bourdon's typical hues, dominate.

Laban Searching the Belongings of Jacob bears the distinction of having belonged to the French painter Louis-Michel van Loo (1707–1771). Sold after his death in 1772, it was drawn in his sale catalog by Gabriel de Saint-Aubin (1724–1780), who had executed a painting of the same subject in 1753 (Louvre, Paris; sketch in the Cleveland Museum of Art). JPM

95 NICOLAS CHAPRON

French; Châteaudun, France ca. 1606–Rome, Italy ca. 1656

The Presentation of the Virgin in the Temple, 1639

Oil on canvas; 23¼ × 17⁵⁄₁₆ (59.1 × 44.1), maximum h. 28 (71.0)
Museum purchase with funds provided by the Laurence H. Favrot Bequest Fund 70.19

The return of Simon Vouet (1590–1649) from Rome to Paris in 1628 can rightly be considered the major artistic event in France during the seventeenth century.

His arrival introduced the type of composition and the chiaroscuro made popular by Caravaggio (1573–1610) to a whole generation of French painters who had not yet had direct exposure to these ideas. Many minor but talented painters, among them the little-known Nicolas Chapron, enthusiastically adopted Vouet's style without altering it. Chapron studied with Vouet in Paris, where he met Nicolas Poussin (1594–1665) during Poussin's visit to France in 1641–1642. Chapron returned with Poussin to Rome, where he executed copies after the *Stanze* of Raphael (1483–1520) at the Vatican. Recent research has led to the reattribution of a handful of paintings to Chapron, making the Houston work an object of great rarity and a landmark in understanding this artist.

The Presentation of the Virgin is a finished *modello* for one of the few known compositions by Chapron, a painting of this subject in the chapel of Saint-Nicolas at Compiègne, fully signed and dated 1639. At that time, Chapron had not yet encountered Poussin and was working exclusively in the manner of Simon Vouet. The eighteenth-century critic and collector Mariette said of Chapron that he was "not one of Vouet's least important pupils." This euphemism proves that enlightened connoisseurs remembered a century later the importance of a painter who had been able to adopt the grand style of Simon Vouet, including his harmonious color sense. JPM

96 MATHIAS STOMER
Dutch; Amersfoort ca. 1600–Sicily after 1650

The Judgment of Solomon, ca. 1640
Oil on canvas; 60⅛ × 80¹¹/₁₆ (152.5 × 204.9)
Museum purchase with funds provided by the Laurence H. Favrot
Bequest Fund 70.15

The details of Mathias Stomer's life and career are not well known. He was born in the Netherlands and probably trained in Utrecht, where he could have been exposed for the first time to the works of Gerrit van Honthorst (see no. 90). He saw this artist's works again in Rome, where his presence is recorded in 1630. In 1631 his presence in Naples is attested, and it is known that in the early 1640's he settled in Sicily, where he may have remained until his death.

Stomer's work reflects the art and artists with which he came in contact. In the wake of Caravaggism that swept through Italy in the early part of the seventeenth century, he selected the work of his countryman Gerrit van Honthorst as his model. Their productions are indeed difficult to tell apart, but in his later, Sicilian works, Stomer seems to have achieved a freedom of style quite removed from Honthorst's work.

The Houston painting had for a pendant "Mucius Scaevola" (now in the Art Gallery of New South Wales in Sydney, Australia). These two scenes, one from Roman history, the other from the Bible, bear the same moral meaning and illustrate the triumph of Truth over Treachery. Both works were probably executed during the early part of Stomer's career in Sicily. They reveal a direct debt to Honthorst, notably in the use of hidden candlelight to illuminate the scene and cast dramatic shadows. Further influences are apparent in the figure of the executioner holding the child, which is a direct quote from the little-known Caravaggesque painter from Verone, Pasquale Ottino (1580–1630). The French sculptor active in Rome, François Duquesnoy (1593–1643), provided the model for the dead child with one of his most famous sculptures. JPM

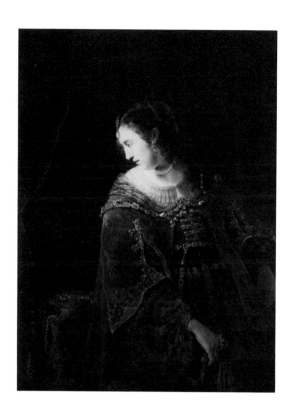

97 FERDINAND BOL

Dutch; Dordrecht 1616–Amsterdam 1680

Portrait of Saskia (Vanitas), ca. 1640
Oil on canvas; 50⁹⁄₁₆ × 36⅛ (128.4 × 91.7)
Gift of Mrs. Harry C. Hanszen 69.4

Ferdinand Bol was born in Dordrecht in 1616 and came at an early age to Amsterdam, where he became the pupil, closest associate, and friend of Rembrandt van Rijn (1606–1669). Bol worked in Rembrandt's studio between 1633 and 1640, and all his works reflect closely the style of his master. At his best, Bol is a brilliant painter who captures, notably in the portraits, all the technical effects of Rembrandt, but who fails to achieve the psychological intensity characteristic of his master.

Houston's painting, traditionally referred to as a portrait of Saskia van Ulenbroch, Rembrandt's wife, counts among Bol's most successful achievements. According to a tradition well established during the Baroque period, the portrait is at the same time a costume piece and an allegory. The sitter is represented looking at a mirror, set on a table on which jewels are lying. Both mirror and jewels are standard features of *Vanitas* pictures, or pictures with a moralistic content intended to remind the viewer of the transitory nature of earthly life. At the same time, Bol takes obvious delight in the rendering of precious stones and rich fabrics, which give the portrait an exuberant feeling.

To enhance the impact of the portrait, Bol has adopted Rembrandt's somber manner, devoting special attention, however, to the beautiful face bathed in light. Against the dark background of the picture, the face and glistening details of the brocade and jewels shine and give the composition its dramatic power.

JPM

98 BERNARDO CAVALLINO

Neapolitan; Naples 1616–ca. 1656

The Sacrifice of Noah, ca. 1640–1650
Oil on canvas; 40¼ × 30¾ (102.2 × 78.1)
Samuel H. Kress Collection 61.63

In the context of seventeenth-century Neapolitan painting, the art of Bernardo Cavallino strikes a personal and isolated note. Although he studied with Andrea Vaccaro (ca. 1598–1670) and Massimo Stanzione (1585–1656), he can be described at best as an artist whose paintings offer a contrast to the official art of his time. To the large ensembles favored by his contemporaries, Cavallino prefers compositions that are moderate in size but executed with extreme care.

His artistic education must have been vast and cosmopolitan. Cavallino's paintings are somewhat reminiscent of Northern Mannerist compositions, but they also acknowledge a debt to Caravaggio's (1573–1610) naturalism, filtered through the works of the Neapolitan painter Giovanni Battista Caracciolo (d. 1637). Following the example of these artists, Cavallino painted popular types disguised as the protagonists of Biblical subjects. This naturalism enabled him to introduce subtle psychological nuances in his limited religious repertoire. Cavallino's use of colors is unorthodox; he often juxtaposes strong and unrealistic colors, which contribute to the unusual atmosphere of his work. The miniature-like execution of his paintings in which figures are small and uncropped, an almost feminine grace, and his delicate brush stroke are qualities that prefigure the eighteenth century.

JPM

99 LAURENT DE LA HYRE
French; Paris 1606–1656

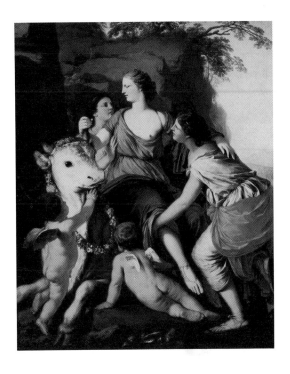

The Rape of Europa, 1644
Oil on canvas; 46¹⁵⁄₁₆ × 59⁷⁄₁₆ (119.0 × 150.9)
Signed and dated front lower center: L. de La Hyre in. + F. 1644
Gift of Mr. and Mrs. Theodore N. Law 70.12

Unlike many of his contemporaries, Laurent de La Hyre never studied in Italy. Born in Paris, he was first the pupil of his father, Etienne de La Hyre (ca. 1583–1643), and then of the painter Georges Lallemand (ca. 1575–1635), who introduced him to the Mannerist style of the Second School of Fontainebleau. His first works reflect this influence, but La Hyre rapidly became one of the leading exponents of the classical doctrine in France. Four years after he executed the Museum's painting, a work of his mature period, La Hyre became one of the twelve original members of the French Academy of Painting founded by Louis XIV.

Some historians maintain that his strictly French, even Parisian, upbringing, devoid of foreign or provincial traditions, is responsible for the clarity of La Hyre's style, remarkable for its pure, almost dry, sense of drawing and a frank juxtaposition of colors. Others contend that around 1625–1630, after painters such as Simon Vouet (1590–1649) and Jacques Blanchard (1600–1638) returned from Italy, La Hyre experienced through their works an indirect contact with Caravaggio (1573–1610) and the achievements of the Bolognese painters, Annibale Carracci (ca. 1560–1609) and Guido Reni (1575–1642).

The majestic proportions of *The Rape of Europa,* its sense of theatricality, and the powerful use of volumes seem to indicate a knowledge of the Bolognese school, while the naturalistic details of the landscape are French qualities that La Hyre brought to perfection.

In the seventeenth century, a tapestry was woven at the Gobelins after this painting, attesting to the fame of the composition. JPM

100 PHILIPPE DE CHAMPAIGNE
French; Brussels, Belgium 1602–Paris, France 1674

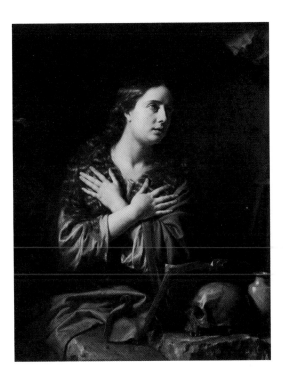

The Penitent Magdalen, 1648
Oil on canvas; 45⁹⁄₁₆ × 35 (115.9 × 88.9)
Museum purchase with funds provided by the Agnes Cullen Arnold
Endowment Fund 70.26

It would be unfair to study French religious painting of the seventeenth century without considering the philosophical or mystical movements and the political situations that prompted these works. Instead of the loud statements offered by official pictures of the Counter Reformation, Philippe de Champaigne brought into his religious paintings a world of private piety and devotion. An extremely devout person as well as an artist of fierce integrity, Champaigne was born in Brussels in a family of French descent. He studied with the landscape artist, Jacques Fouquières (1580–1659) and, as early as 1621, was employed by the Court. He settled in Paris definitely in 1628 without ever going to Italy. Champaigne enjoyed the patronage of Cardinal Richelieu, of Louis XIII, and of Queen Anne of Austria, as well as of Louis XIV. Private patrons were also numerous, and around 1643 Champaigne came in contact with Port-Royal. His own

daughter became a nun there, and the austere rules of the convent—a center of Jansenist thinking—as well as its moral rectitude are often reflected in Champaigne's devotional pictures as well as in his stern portraits full of inner spirituality.

The Penitent Magdalen was executed for the Parisian convent of the Dames du Saint-Sacrement in 1648, the year Champaigne became, like Laurent de La Hyre (1606–1656), one of the twelve original members of the French Academy of Painting. Champaigne's representation of the Magdalen is indebted to a famous composition by Titian (1477–1576), known to him through engravings or through derivations done by artists such as Anthony van Dyck (1599–1641), but Champaigne's restatement of the theme had neither the sensuality of Titian's painting nor the vibrant energy of van Dyck's. Its crisp drawing, icy colors, and porcelain-like surface are personal characteristics that perhaps betray a Northern influence or the artist's early Flemish training. Above all, they help create a dignified and poignant image that expresses his personal faith with directness and sincerity. JPM

101 WILLEM CLAESZ. HEDA
Dutch; Haarlem 1593/1594–1680/1682

Still Life, 1656
Oil on canvas; 44 × 60 (111.7 × 152.3)
Signed and dated on tablecloth: Heda 1656
Gift of Mr. and Mrs. Raymond H. Goodrich 57.56

Willem Claesz. Heda accomplished for still-life painting what his contemporaries Josefsz van Goyen (1596–1665) and Pieter Saenredam (1597–1665) did respectively for landscape painting and painting of church interiors. Like them, he created a genre, which he brought to perfection by repeating his compositions, changing only slightly from one to another the arrangement of objects he had once chosen to depict. All three painters also share a predilection for paintings executed in an almost entirely monochromatic scale.

Heda began as a figure painter but rapidly became the leading representative of the Dutch school of still life. His arrangements of objects were known as *monochrome ontbijt* (or monochromatic breakfast pieces). In spite of their repetitiveness, a certain evolution can be detected in his work, which became richer and more decorative in the 1650's.

Typically, in the Houston still life Heda juxtaposes glasses (such as a German *Roemer* or a tall glass *Façon de Venise*), silver vessels, and oyster shells set on a white tablecloth. The monochromatism of these objects is subtly enhanced by the pink ham, the light blue decoration of the Delft plate, and the acid yellow of the half-peeled lemon. It is characteristic of Heda not to organize the components of his still life but to paint them instead as if a real breakfast had been abruptly abandoned: a beaker is upset, plates are negligently piled up, glasses are half emptied, and the lid of the silver pitcher is left open. A symbolic overtone can be perceived here: the enjoyments of life are interrupted, perhaps by death, or abandoned for higher ideals.

The still life is set against a conventional gray-greenish background that matches the general tonality of the arrangement. Heda's world is self-contained and expresses simultaneously an appetite for worldly goods, so lusciously depicted, and a desire for intellectual rigor, conveyed through the economy of colors. Little reference is made to an actual space or to the exterior world, made present only through the reflection of otherwise invisible windows on the surface of the *Roemer*. JPM

102 FRANS HALS
Dutch; Antwerp ca. 1580–Haarlem 1666

Portrait of a Woman, 1650
Oil on canvas; 33⅜₆ × 27⅜₆ (84.6 × 69.2)
Inscribed upper left: AETAT 62/1650
Robert Lee Blaffer Memorial Collection; Gift of Sarah Campbell Blaffer
51.3

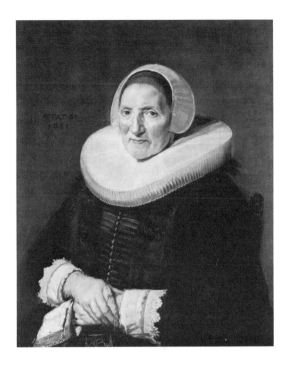

Although the circumstances of Frans Hals's birth are not known, it is known that his family was in Haarlem by 1591. About 1603 he studied under Karel van Mander (1548–1604), a painter of allegorical pictures in the Mannerist style, but Hals's painting owes little to his teacher. Even his specialization in portraiture and genre paintings of such low-life subjects as drinkers contrasts with the more "elevated" subjects recommended by van Mander. In fact the thick paint and spontaneous, free brush strokes that typify Hals's handling of paint have no precedent anywhere. As early as 1620, Hals received commissions for group portraits, the most prestigious kind of portrait commission in seventeenth-century Holland, and seems often to have been well paid for his work. However, he suffered constant financial difficulties, perhaps more for personal reasons than as a result of his contemporaries' failure to appreciate the originality of his style. Hals's reputation declined after his death and only revived in the nineteenth century when the free brushwork of such painters as Gustave Courbet (1819–1877) and Edouard Manet (1832–1883) was understood.

Houston's picture has been identified as the portrait of Elizabeth van Meeren, wife of the Seigneur of Kessel, on the basis of what appears to have been an eighteenth-century inscription. The inscription disappeared in the course of a 1930's restoration when the canvas was removed from a wood panel back, and there seems no reason to regard it as conclusive. Thus, little more is known about the sitter than what is learned from Hals's own inscription on the front of the painting: the sitter was age sixty-two in 1650 when the picture was painted. Seymour Slive of Harvard University has suggested that the Museum's painting and a *Portrait of a Man* in the Howard Collection, Penrith, Cumberland, are companion pictures. As such they can only depict a husband and wife, albeit of unknown identity. *Portrait of a Woman* is somewhat abraded in the head and ruff (as is the Howard picture), but the brilliance of Hals's genius can be seen in her hands and cuffs, which, as is characteristic of Hals's style, are more freely painted than is the sitter's face. JMW

103 MATTIA PRETI
Neapolitan; Taverna 1613–Malta 1699

The Decollation of St. Paul, ca. 1656–1659
Oil on canvas; 70¹¹⁄₁₆ × 73¾ (179.6 × 187.3)
Museum purchase with funds provided by the Laurence H. Favrot
Bequest Fund 69.17

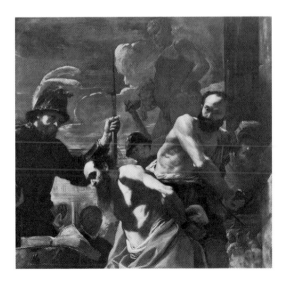

The political changes that affected Naples during the seventeenth century and its strategic position in the Mediterranean world contributed to the attraction the city held for many artists from various parts of Italy and Europe; Spanish, German, and Flemish artists were as much a part of Naples' artistic life as the native painters. The Calabrian Mattia Preti first studied and worked in Rome,

where he attained enough fame to be entrusted in 1650 with the decoration of the church of S. Andrea della Valle. His motivation to settle in Naples remains uncertain but may be linked to the fact that the city had been decimated in 1656 by the plague and that its artistic community had been greatly reduced. His first large commission there dealt with plague-related subjects.

In spite of his origin, Preti is rightly considered one of the founders of the Neapolitan Baroque. His style is easily recognizable; Preti affects broad compositions, strongly organized along geometric lines. He borrows from Caravaggio (1573–1610) the violent effects provided by the use of chiaroscuro and paints thinly on coarse canvases. Perhaps the Spaniard José Ribera (1588–1656), then active in Naples, influenced Preti in his choice of violent subjects. Houston's *Beheading of St. Paul* is one of a set of three paintings commissioned from Preti by a Flemish merchant settled in Naples, Ferdinand van den Einden. The other two paintings, the *Crucifixion of St. Peter* and the *Martyrdom of St. Bartholomew*, are respectively in the Barber Institute, Birmingham, England, and the Currier Gallery of Manchester, New Hampshire.

The somber and tragic mood of these paintings, befitting a post-plague period, dominates all Preti's works as well as most Neapolitan paintings of the time until Luca Giordano (1632–1705), Preti's pupil, introduces a richer palette, brilliant execution, and less dramatic subjects. By the time these changes had occurred, Preti was no longer active in Naples but was working in Malta, where he died.

JPM

104 CIRCLE OF BERNINI
Roman School

Portrait of Clemente IX, 1667–1669
Gilt bronze; diam. 12 (30.5)
Inscribed along rim of plaque: CLEMENS. IX. P.O.M.
Museum purchase 75.27

Under the short pontificate of Clemente IX (1667–1669), Gian-Lorenzo Bernini (1598–1680) was entrusted with many commissions for the Church: the restoration of the Ponte Sant'Angelo; the enlargement of the apse of Santa Maria Maggiore and of the rooms at the Quirinale, one of the Pope's residences; and the construction of the chapel of San Domenico at Santa Sabine. Giulio Rospigliosi, who became Pope Clemente IX, had begun his association with Bernini long before his pontificate, and the two men had been friends for over thirty years. Between 1667 and 1669, Bernini also received private commissions from the Pope: he undertook the construction of Clemente's villa at Lamporino and made plans for the embellishment of his hometown, Pistoia.

Given this friendship and the commissions lavished upon the artist, it is surprising that only one portrait of the Pope by Bernini is recorded (a marble bust, formerly in the Rospigliosi collection, now lost). The fact is even more startling because Bernini executed portraits of all the other popes who ruled during his lifetime, from Paolo V (1618) to Urbano VIII (1633), Alessandro VII (1655), and Clemente X (1670 and 1677). Attributed to the circle of Bernini, the Houston medallion lacks the broad generosity of Bernini's own style. Two portraits of Clemente IX by the little known Girolamo Lucenti (ca. 1627–1698) have survived, and Lucenti is said to have used models by Bernini for his own bronze castings (a bronze bust in the Detroit Institute of Arts, and a medallion in the Fogg Art Museum, Cambridge, Massachusetts). It would be tempting to relate

the Houston medallion more directly to Lucenti's works; in any case the medallion's exact relation to the Bernini prototype could only be ascertained by the possible rediscovery of the lost bust. JPM

105 WORKSHOP OF BERNINI
Roman School

Portrait of a Man, ca. 1675–1685
White marble; h. 34½ (87.6)
Museum purchase with funds provided by General and
Mrs. Maurice Hirsch 73.80

The exuberance and vitality of Gian-Lorenzo Bernini's (1598–1680) best portraits can be felt in this impressive bust, the work of one of his most gifted pupils. The broad movement of the drapery and the intensity of the subject's expression, both realistic and highly spiritual, are typical of Roman Baroque funerary sculpture. The Houston bust was probably intended as a tomb effigy, set in a wall, with its subject looking toward the altar of the chapel. It relates in this respect to Bernini's *Bust of Gabriele Fonseca* (S. Lorenzo in Lucina, Rome) without attaining the highly emotional intensity of Bernini's composition.

The more tempered character of the sculpture has led several scholars to advance names of artists working in the orbit of Bernini. Yet firm identifications of the sculptor and of the sitter have not been made. The bust was once thought to represent the sculptor Alessandro Algardi (1595 or 1602–1656), whose tomb by Domenico Guidi (1625–1701) had been dismantled in the nineteenth century. Advanced by David Bershad, this theory has been refuted on several grounds by Olga Raggio, who first remarked that Algardi's features are well known and do not correspond to those of this man; furthermore Miss Raggio notes that Algardi was proud of the *Croce di Cavaliere* he had received from the Pope in 1650 and would not have agreed to be represented without it. Miss Raggio also refutes the attribution to Guidi, on the basis of comparisons with known busts by this artist, which all show stiffness and rigidity lacking in this extraordinarily lively work. Olga Raggio suggested at the same time a convincing attribution to the little known Michele Maglia, or Michel Maille (active 1678–1700), a French sculptor established in Rome, whose tomb effigies of Ercole and Alvise Bolognetti (1681) in the church of Gesù e Maria bear close similarities to the Houston bust. Another attribution, put forward by James David Draper, gives Giacomo Antonio Lavaggi (active late seventeenth century) as the author of this work. Yet the few known works by Lavaggi show a dryness foreign to the present bust. JPM

106 LUCA GIORDANO
Neapolitan; Naples 1634–1705

Allegory of Prudence, 1682
Oil on canvas; 36%₁₆ × 36%₁₆ (92.9 × 92.9)
Museum purchase with funds provided by the Agnes Cullen Arnold
Endowment Fund 75.33

Luca Giordano studied under Giuseppe Ribera (1588–1656) in his native Naples, but his style matured through his contacts with the works of Pietro da Cortona

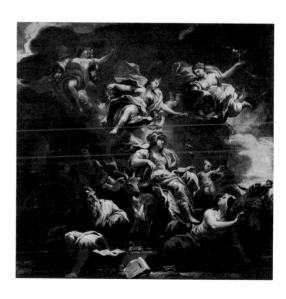

(1596–1669) and of the Venetian painters, Veronese (1528–1588) in particular. Cosmopolitan in his education, Giordano also led an international career; he worked in Naples, Venice, Florence, and Spain at the invitation of Carlos II. Besides executing numerous pictures of relatively modest scale, Giordano's major achievements reside in his large decorative programs for which he attained unequaled fame. His swiftness of execution was proverbial, and he was nicknamed *Fa presto* because of it. Unlike Cortona, his prime example, Giordano shunned conventional ways of working. He seldom drew, for instance, and preferred to paint directly, almost without any preparation. It was, however, his habit, shared with many artists of the Baroque, to paint smaller studies, or *modelli*, for works he intended to carry out on a larger scale.

In 1682 Marchese Francesco Riccardi decided to have the gallery and the library of his palace in Florence decorated with frescoes, according to a growing fashion. He entrusted the illustrious Giordano with this commission. The project was not completed until 1685, but *modelli* such as the *Allegory of Prudence* were probably executed in 1682 and submitted to Marchese Riccardi for his approval. The iconographical program illustrated in the gallery represents *Mankind's Progress by Means of Wisdom*: Science, personified by Minerva, assisted by the Virtues, enables Man to rise above the material world. This painting represents Prudence, one of the Virtues, holding her attributes, a mirror and a serpent twisted around an arrow. Around Prudence, other allegorical figures, Fraud, Obstinancy, Grace, Abundance, Health, Order, and Experience complete the elaborate *tableau*. JPM

107 FRENCH

Venus Marina, 1650–1700
Bronze; h. 9¼ (23.5), w. 22½ (57.2), d. 10⅛ (25.7)
Museum purchase with funds provided by the Laurence H. Favrot
Bequest Fund 69.3

Since the Renaissance it had been customary for many sculptors to translate on a smaller scale and in bronze newly discovered antique statues. This habit was perpetuated at least until the early years of the nineteenth century and gave the more talented artists a chance to elaborate on these compositions and to make them their own. At the end of the Renaissance, a sculptor like Giovanni Bologna (1529–1608) ran a successful studio where his original compositions were cast next to reductions after the antique. For many years even the most inventive sculptors often worked on sculptures whose type had been established long before their own time.

Houston's *Venus Marina*—so called because of the shell against which her pillows are propped—recalls not only a famous bronze of a *Sleeping Nymph* by Giovanni Bologna, but also the *Sleeping Ariadne*, a celebrated Graeco-Roman sculpture excavated and previously executed in bronze during the Renaissance.

If the type of this sculpture can easily be established, its provenance and authorship are more difficult to ascertain. It was once believed to be the work of the famous seventeenth-century French sculptor, Pierre Puget (1620–1694), but it has been tentatively reattributed by Klaus Herding to Gilles-Marie Oppenord (1672–1742) on the basis of a drawing kept at the Musée Condé in Chantilly. Oppenord is known above all as an *ornemaniste* whose work helped establish the Rocaille style in France. He is not known as a bronze sculptor but may have

provided the drawing for this sculpture, which would have then been cast by an artist such as Charles Cressent (1685–1768). On the other hand, the Houston Venus is a unique cast, and the Chantilly drawing, which represents the sculpture resting on an elaborate rococo pedestal, may also indicate that Oppenord only designed a sumptuous pedestal for an earlier bronze of extreme rarity.

The classicizing features of the Venus and the solid geometry of her body exclude an Italian origin for the piece and indicate instead a French provenance as well as a date close to Puget's own, between 1650 and 1700. JPM

108 NICOLAS LAUDIN, I
French; Limoges 1628–1698

Cup and Saucer, ca. 1660–1690
Painted enamel on copper; cup: h. 3⅛₆ (7.8); saucer; diam. 4¾ (12.1)
Marked in gold under rim on saucer: NL audin; in gold on bottom of cup:
NL audin emailleur/pres les iusuistes/ à Limoges
Museum purchase with funds provided by Mrs. George R. Brown
in memory of Ruth T. Shartle 74.261.1, 2

Enamel is a vitreous form of glass mixed with metallic oxides for color and applied to a metal base. The process originated in antiquity and flourished at Byzantium in the early medieval era. Later, Limoges and Cologne became great centers of champlevé and cloisonné enamel work in the thirteenth and fourteenth centuries. In the sixteenth century, Limoges emerged as a major producer of painted enamel and remained preeminent into the early eighteenth century.

The Laudin family produced five successive generations of master enamelers spanning the sixteenth, seventeenth, and eighteenth centuries. With the Limosins they were the most skilled masters of their trade. Nicolas Laudin, I, and his brother Jacques Laudin, I, sons of the patriarch Noel, were members of the second generation.

The Houston cup and saucer, dark blue on the outside, pale blue inside, and each highlighted with delicate, scrolled, gilt ornament, are painted with polychrome mythological scenes set within white roundels. Small, grisaille profile portraits of Roman Emperors set within ovals with raised, white, scrolled ornament above and below separate the scenes on the side of the cup. The portraits are identified below with gilt Roman numerals "VIIII" and "X" and probably depict the ninth emperor Vitellius (69 A.D.) and his successor Vespasian (69–79 A.D.). The presence of these numbered portraits suggests that the cup was part of a larger set of at least six, each of which included two portraits of the first twelve Caesars from Augustus through Trajan. A pair of candlesticks in the Walters Art Gallery, Baltimore, painted by Nicolas Laudin's brother, Jacques Laudin, I, has this arrangement. The Caesar portraits, which may have been derived from a print source, are very similar in design and execution to those on the Walters candlesticks.

The mythological scenes, "Europa and the Bull" and "Narcissus at the Fountain" on the cup and "Venus and Adonis" on the saucer, may also have been based on print sources. All depict impending tragedy—for Europa abduction and rape, for Adonis violent death, and for Narcissus rejected love and spellbinding starvation. The cup and saucer represent the finest enameling and indicate the degree to which classical antiquity pervaded French taste. DBW

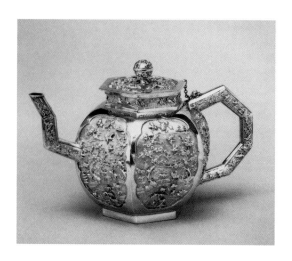

109 ENGLISH

London

Tea Pot, 1682–1683

Silver; h. 4¾ (12.0), w. across spout and handle 8½ (21.6), d. 5 (12.7)

Anonymous promised gift TR134-79

Tea was introduced to England from China in the middle of the seventeenth century. Lacking traditional pottery or metal forms for serving this newly fashionable drink, the English used the Chinese hot water vessel as a model. The Museum's teapot, the earliest known English silver example of the form, clearly reflects its Chinese prototypes, both in its octagonal shape and in the chinoiserie ornament of birds and foliage set within ovoid reserves. The jointed spout and handle further enhance its oriental appearance. While Houston's teapot is apparently unique, oriental ornament was not uncommon in London silver of the 1680's. The pot is extremely heavy, having been cast rather than hammered, and the surface ornament has been carved out of the solid. DBW

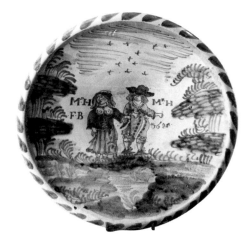

110 ENGLISH

Lambeth

Charger, 1685

Earthenware, polychrome tin-enamel; diam. 13¾ (34.9)

On front: MS H/ F.B , MR H and date 1685

Bayou Bend Collection; Gift of Miss Ima Hogg B.57.60

Tin-enameled earthenware, which originated in Mesopotamia in the ninth century B.C., spread to Italy and Spain from the Arab world in the late Middle Ages and thence to northern Europe. The earliest recorded English manufacture is 1567. In the seventeenth century and first half of the eighteenth century these "delft" wares, as they were generally called, were tremendously popular both in England and in the American colonies.

The Bayou Bend example is one of a group of decorative chargers or large plates designed to be hung on the wall. Designated "blue dash" for the painted ornament around the rim, these chargers usually depict royalty, heroes, or Adam and Eve when geometric or floral designs are not used. Often they are dated. The Houston plate portraying a Mr. and Mrs. H., presumably a marriage commemoration, is seemingly unique. Mrs. H.'s plunging neckline recalls the ribald character of Restoration England, when the plate was made. The trees, grass, and piles of hay are rendered in polychrome metallic overglazes. DBW

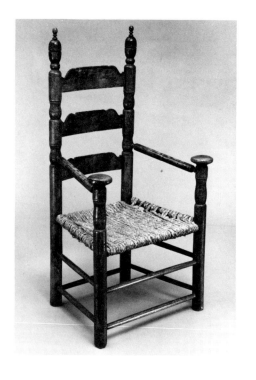

III AMERICAN

East Haven/Branford, Connecticut

Great Chair, 1660–1700

Ash; h. 49 (124.4), w. 26 (66.0), d. 19½ (49.5)

Bayou Bend Collection; Gift of Miss Ima Hogg B.69.354

Seventeenth-century chairs such as the Bayou Bend example were produced by turners working on lathes. The major decorative impact is developed through

the variety of shapes and dimensions of the turned members. Although originally far less common than stools, a relatively large number of these great chairs survive today. Repetition of ogee shapes in the arm supports, stiles, and back spindles is a feature of this chair seen in other examples produced in the vicinity of New Haven, Connecticut. Houston's chair has a family history of ownership in Branford, just outside New Haven, further confirming its place of origin.

DBW

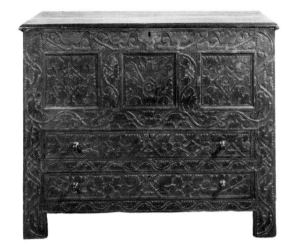

112 AMERICAN

Massachusetts

Two-Drawer Chest, 1670–1710

Oak, pine; h. 38¹¹⁄₁₆ (98.3), w. 48⅛ (122.2), d. 17¹³⁄₁₆ (45.2)
Later spurious inscription on back of bottom drawer: Mary Allyns Chist Cutte and joyned by Nich: Disbrowe
Bayou Bend Collection; Gift of Miss Ima Hogg B.69.356

Seventeenth-century American case pieces, made by craftsmen called joiners, are characterized by simple framed construction with mortise and tenon joints and inset panels. Proportions are heavy, and the center of gravity is low. Ornament tends toward an overall pattern as seen in the shallow-carved, meandering vine, leaf, and tulip motifs that cover the front of the Bayou Bend example. Originally the surface was painted with bright colors, now lost. Details of the carving, especially the lozenges and initials within the panels and the undulating vines and flowers, place the chest stylistically in a group made along the Connecticut River in the Hatfield, Massachusetts, area. It was once thought that the joiner of the piece wrote the inscription, but research has revealed that he was unable to write and the ink is modern. DBW

113 AMERICAN

Northeastern Massachusetts

Toilet Table, 1690–1710

Oak, pine; h. 31⅞ (81.0), w. 27⅝ (70.2), d. 19 (48.2)
Bayou Bend Collection; Gift of the Houston Chapter of Kappa Alpha Theta B.70.24

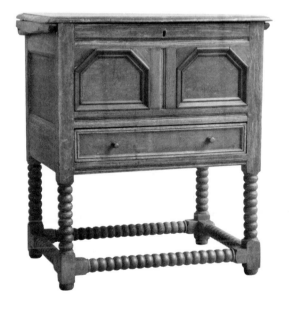

The Bayou Bend toilet table is one of a related group produced in northeastern Massachusetts. Although they may have been made as late as 1710 they utilize typical seventeenth-century mortise and tenon, frame and inset-panel construction. The use of paint in imitation of richer, more expensive materials was not uncommon in American seventeenth- and early eighteenth-century furniture, and traces on the table indicate that originally the legs and grooved moldings were black to suggest ebony, while the panels and drawer front were red to suggest cedar. Asymmetrical painted trees, which looked like inlay, ornamented the panels. While the original use of this form is not certain, it probably served as an early dressing or toilet table. DBW

Eighteenth Century

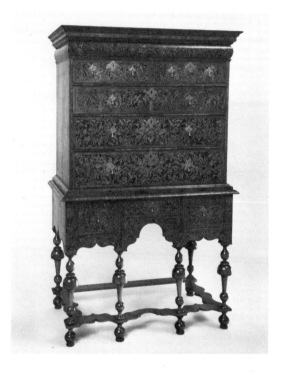

114 AMERICAN

Boston, Massachusetts

High Chest of Drawers, 1690–1715

Walnut, burl walnut veneer; h. 68¼ (173.3), w. 40⅜ (102.5), d. 23¾ (60.3)
Bayou Bend Collection; Gift of Miss Ima Hogg B.69.43

Few early pieces of American furniture have the visual excitement of a group of high chests made in Boston during the first quarter of the eighteenth century. Craftsmen, newly arrived from England, introduced the skills of cabinetmaking, distinguished from the joiner's art by its use of dovetail construction and thin wood veneers. In the Bayou Bend example the burled walnut veneer is brilliantly applied both to the front and sides of the piece. The combined influences of the Renaissance and Baroque styles, which reached England almost simultaneously, gave case pieces of furniture a decidedly architectural appearance, with carefully articulated base and cornice moldings enhancing the finest examples. This type of chest, raised up on high legs, was an important new furniture form and remained fashionable until after the American Revolution. DFF

115 JOHN CONEY

American; Boston, Massachusetts 1655/1656–1727

Tankard, ca. 1700

Silver; h. 7⅛ (18.1), w. across handle 7⅝ (19.3), diam. 5 (12.7)
Mark on upper band and on lid: IC over a fleur de lis within a heart
Bayou Bend Collection; Gift of Miss Ima Hogg B.74.19

The tankard, a drinking vessel with handle and lid, was primarily used for beer or ale. The form, which appeared in English silver in the sixteenth century, came to America in the seventeenth century and remained fashionable there until about 1800. John Coney's tankard at Bayou Bend is a particularly handsome example of the finest silver tankards made in Boston at the turn of the eighteenth century. Typical features include the mask and dolphin thumbpiece, rat-tail drop at the upper juncture of the handle with the body, grooved handle with scroll, and cut-card work at the lower juncture of the handle and body. The stepped, fluted lid with its central finial is quite unusual on a tankard but does relate in design to the lids of covered, two-handled cups of the same period. Coney's skill as an engraver is indicated by the elegant baroque-style coat of arms of the Foster family, which ornaments the front of the barrel. The names of seven

generations of owners are engraved on the bottom and attest to the regard with which this piece was held by the family in which it descended.

John Coney, a member of the first generation of native-born Boston silversmiths, was the most versatile and productive silversmith of his period. The combination of decorative elements, proportion, and overall design result in an object of great beauty and sophistication. DBW

116 CORNELIUS KIERSTEDE

American; Albany, New York 1674–New York, New York 1757

Silver Bowl, ca. 1710
Silver; h. 2³⁄₁₆ (5.6), w. across handles 6⁵⁄₁₆ (16.1), diam. 4³⁄₈ (11.1)
Bayou Bend Collection; Gift of Miss Ima Hogg B.63.3

Dutch-inspired, the rare, two-handled, paneled bowl is a distinctive seventeenth- and early eighteenth-century New York-Albany silver form. Thought to have been used originally for serving raisins in brandy, the bowls are characterized by their six panels or lobes, often ornamented with a raised or repoussé and chased floral motif. While the larger examples have cast, S-scroll caryatid handles, the smaller bowls, such as the Bayou Bend example, employ twisted silver wire or cut sheet. An interesting feature of the bowl, which is also found on the lids of many New York tankards, is the French coin, dated 1693 and bearing the head of Louis XIV, inserted in the bottom. The engraved initials M and G probably refer to Maria Pruyn Gerritsen (d. 1731) of Albany. The bowl descended directly in this family until acquired by Bayou Bend. DFF

117 NICOLAS BERTIN

French; Paris 1668–1736

Prophets and Kings of the Old Testament Adoring the Name of Jehovah and Awaiting the Messiah, 1718
Oil on canvas; 51¼ × 37⅜ (130.0 × 94.8)
Inscribed on cartouche: Virtutem operum suorum annuntiabit populo suo/videt sic illis hereditatem gentium (He has proclaimed the power of His works to His people/ He has given them the inheritance of the nation)
Signed: Nicolas Bertin. invenit/Pinxit
Museum purchase with funds provided by the Laurence H. Favrot Bequest Fund 69.5

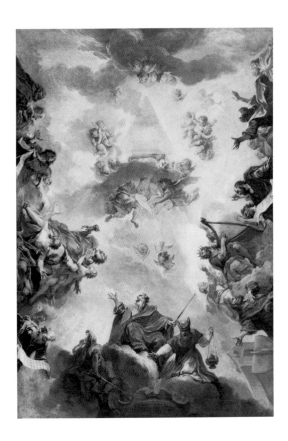

Nicolas Bertin, a painter rescued from total oblivion by recent scholarship, was in his own day a well-known artist. He was a pupil of Guy Louis Vernansal (1648–1729), Jean Jouvenet (1644–1717), and Bon Boullongne (1649–1717) and led the typical career of an *académicien*. He won the Grand Prix, which enabled him to spend four years in Rome, where he arrived in 1685. Named to the French Academy of Painting in 1703, he became a professor there in 1716 for twelve years. Employed by Louis XIV to decorate the Trianon at Versailles, Bertin was also sought by other European rulers. He worked for the courts of Munich and Mainz but declined these princes' offers to become their court

painter, as he had declined the position of director of the Académie de France in Rome.

Bertin is a delicate painter, working best in small scale. His refined and chiseled works display a striking sense of color. Juxtapositions of strong hues are arresting but eschew vulgarity. His paintings witness his efforts to break away from the classicizing tradition established by Charles Le Brun (1619–1690) and to find personal solutions to the treatment of religious or mythological themes. Bertin's work, nourished by the Italian tradition he had been able to study during his sojourn in Rome, bears evidence of his admiration for Veronese (1528–1588) and Pietro da Cortona (1596–1669).

The ceiling for which the Museum's painting is a sketch counts among Bertin's most famous compositions and was described by Dézallier d'Argenville in his account of Bertin's life (1745). It was executed in 1718 for the château of Plessis-Saint-Pierre in Normandy and represents the name of God, written on a pyramidal slab, held in glory by angels. On three sides, groups of prophets and other figures from the Old Testament frame the central image. Dézallier d'Argenville praised the painter for creating so many individual figures and yet preserving the unity of composition. The originality of Bertin's design comes perhaps from the influence upon his work of Cortona's famous ceiling for the *Salone* of the Palazzo Barberini in Rome (1633–1639) and of Andrea Pozzo's (1642–1709) amazing tour de force ceiling at S. Ignazio, Rome. Pozzo's composition was executed in 1685, the year Bertin arrived in Rome, and must have exerted a lasting impression on the young artist's mind. JPM

118 JEAN–BAPTISTE PATER
French; Valenciennes 1695–Paris 1736

Pastoral Concert, early 18th century
Oil on panel; 11¹¹⁄₁₆ × 8⁷⁄₁₆ (29.6 × 21.4)
Edith A. and Percy S. Straus Collection 44.544

Jean-Baptiste Pater, like Jean Antoine Watteau (1684–1721), was born in Valenciennes. In 1713 he went to Paris to study with Watteau, but Watteau's impatience with his pupil discouraged the young Pater, who soon returned to Valenciennes. Eight years later, however, just before Watteau's death, Pater worked again in his studio, with more success that time. Despite the favor in which he was held during his lifetime (Emperor Frederick II of Prussia owned almost fifty paintings by him), Pater was not officially accepted by the art establishment until late in his short career. In 1728 he was received at the French Academy of Painting, but in the special category of painter of modern subjects.

Pater has epitomized for generations the grace of French eighteenth-century art. His repertoire is limited, and his compositions usually derive from prototypes established by Watteau. He painted reunions in parks, dances, cavalry scenes, and some illustrations of literary subjects in a style owing much to his teacher. Pater is not an innovator, but he is the best representative of a genre that is particular to the first years of the reign of Louis XV.

Although not mentioned in the most comprehensive publication on Pater (F. Ingersol-Smousse, *Pater*, 1928), Houston's small panel can be attributed without hesitation to him. The composition, with its three figures engaged in merry-making in a garden under a bacchic herm that sets the idyllic mood of the picture, is representative of Pater and can be encountered, slightly altered, in many other

works. Unlike Watteau's figures, which seem to live in a twilight between reality and pure fantasy, Pater's are more real, perhaps slightly pedestrian, and help transform the representation into a pleasant costume piece. JPM

119 ALESSANDRO MAGNASCO
Italian; Genoa 1667–1749

Landscape with Washerwoman, early 18th century
Landscape with Figures, early 18th century
Oil on canvas; 61.72: 28⅜ × 22¾ (73.2 × 57.8); 61.73: 28⅜ × 22¹¹⁄₁₆
(73.2 × 57.7)
Samuel H. Kress Collection 61.72, 61.73

The son of the painter Stefano Magnasco (1635–1681), Alessandro was sent to Milan in 1677 to study under Filippo Abbiati (1640–1715). His own style developed after he became acquainted with the paintings of the Lombard artist Morazzone (1573–1625) and the engravings of Jacques Callot (1592–1635) and Salvator Rosa (1615–1673). These artists communicated to Magnasco a taste for the fantastic and the grotesque, which became recurrent motifs throughout his work. He spent most of his life in Milan, with the exception of a brief time at the court of Grand Duke Giovanni Gastone de Medici in Florence, but returned to Genoa to spend his last years there. Magnasco was particularly influential on the Venetian painters Marco and Sebastiano Ricci (1676–1729; 1659–1734). Remembered above all for his landscapes and genre scenes of interiors with monks, nuns, or gypsies, Magnasco was also a religious painter of first rank.

In the two Houston landscapes, Magnasco combines his enjoyment of nature with his depiction of everyday scenes or bucolic evocations. The landscapes are painted with bravura, and the figures display Magnasco's nervous and effective drawing style. Magnasco helped establish landscape painting as a major, independent genre, and his decorative effects, sinuous drawing, and speedy technique paved the way for the full development of the rococo style. JPM

120 ANTONIO CANAL, CALLED CANALETTO
Italian; Venice 1697–1768

Grand Canal, Entrance Looking West, 1720
Grand Canal, Looking Southeast from near Rialto Bridge, ca. 1730
Oil on canvas; 56.2: 19½ × 29 (49.6 × 73.6); 55.103: 19⁹⁄₁₆ × 28¾
(49.7 × 73.0)
Robert Lee Blaffer Memorial Collection; Gifts of Sarah Campbell Blaffer
56.2, 55.103

The Venetian tradition for large-scale compositions and decorations was still lively in the eighteenth century and was given its apotheosis in the works of the Tiepolos. Concurrently, however, a new genre flourished, which assured the fame of Venice for many years. Painters like Carlevaris (1665–1730/1731), the Guardis, Canaletto and Bellotto (1720 or 1724–1780), who were related, developed a type of cityscape that was innovative and immediately successful abroad, notably in England. The cityscape painter most in favor in England during the period was Canaletto. In the field of landscape he was considered the fashionable

artist whose works had to be acquired by any cultivated gentleman who had accomplished the Grand Tour and wanted to keep in his collection the finest mementos of his experience.

Canaletto was the son of Bernardo Canal, a painter of theater sets, with whom he worked and from whom he supposedly learned the rules of perspective, which were so important for his own compositions. In 1719 he went to Rome and may have become familiar there with the paintings of Giovanni Panini, an artist who was painting Roman cityscapes as well as creating original and imaginary views of cities using Roman landmarks as motifs (see no. 125). A year later, Canaletto was back in Venice and began his association with English clientele. This association led him to leave for England, where he sojourned almost without interruption from 1746 until 1755. Canaletto's works can be classified in two major categories: topographic views that depict with extreme precision particular aspects of Venice, and imaginary views or *capricci* in which Venetian monuments have been displaced and rearranged according to the painter's fancy.

The two Venetian landscapes in the Museum's collection belong to the first category. One shows the entrance to the Grand Canal, with the Church of Santa Maria della Salute on the left; the other shows a view of the Grand Canal, looking from near the Rialto Bridge toward the Palazzo Foscari. These views were popular among travelers in the eighteenth century (as they still are today, being the subject of countless color postcards), and it is of no surprise that they were intended for a British client who purchased them from Joseph Smith, an English merchant who settled in Venice at the beginning of the century and worked all his life as an agent for Canaletto. (Smith himself assembled a large collection of *vedute* by Canaletto, which subsequently were bought by George III and are still in the British Royal collections.)

Despite the repetitiousness of his subject matter, Canaletto is an extraordinarily brilliant artist who delicately enhances his subject by a careful selection process. Details are omitted in order to focus on an essential image. His fine colors are a subtle combination of all hues associated with the real Venice as much as with the idea, or the memory, of the city. Executed in his studio after "life studies," his paintings are, therefore, more than "photographic" records; they are intellectual recreations and, at their best, attain a pure and almost abstract quality, which makes them appealing to modern sensibility. JPM

121 FRANCESCO MONTI
Italian; Bologna 1685–Bergamo 1767

Jael and Sisera, ca. 1730
Oil on paper, laid on canvas; 16⅛ × 11⅝ (41.0 × 29.5)
Museum purchase 72.20

Early in the seventeenth century, the Bolognese school of Agostino and Annibale Carracci (1557–1602; 1560–1609), Guido Reni (1575–1542), Guercino (1591–1666), and Domenichino (1581–1641) enjoyed a privileged moment of its history. Not only did these painters contribute magnificently to the cultural prestige of the city, but also their works became a source of reflection for generations of artists. Roman painters of the seventeenth and eighteenth centuries were nourished by their examples, and their fame reached foreign artists, who came to Bologna to study their works. In contrast, the Bolognese school of the late seventeenth and eighteenth centuries has often been considered minor, and only recently has it been reassessed.

The second generation of seventeenth-century Bolognese painters is dominated by two very different artists, Donato Creti (1671–1717) and Giuseppe Maria Crespi (1665–1747). While Creti continued the classical manner of Guido Reni, Crespi introduced a more exuberant style that reflects the eclecticism of his formation.

Francesco Monti, whose work reflects the impact of Crespi's painting upon a younger artist, was born in 1685, studied with Giovanni Giuseppe dal Sole (1659–1719), and was already well known by 1720. Shortly after that date McSwinny asked him to collaborate on one of the paintings of *Allegorical Tombs* executed by several artists working in collaboration for the Duke of Richmond. In 1736 Monti moved to Brescia and spent the rest of his life in Lombardy.

Houston's small monochromatic painting represents the story of Jael and Sisera, taken from the book of Judges (4:5). Although Crespi did not have direct disciples, many painters, such as Monti, tried to emulate his vivacious manner, fresh execution (traditional drawing is replaced by a direct and nervous application of paint), and sense of chiaroscuro, well rendered in this *grisaille. Jael and Sisera* must be dated about 1730, shortly before Monti's departure for Lombardy.

JPM

122 FRANCESCO FONTEBASSO
Italian; Venice 1709–1769

The Adoration of the Shepherds, mid-18th century
Oil on canvas; 17¹¹⁄₁₆ × 23³⁄₁₆ (44.9 × 58.9)
Illegible inscription on the lower left: (. . . basso?)
Museum purchase with funds provided by Mary Alice Wilson 73.1

Born in Venice, Francesco Fontebasso is said to have studied in Rome and Bologna before returning to his hometown. A pupil of Sebastiano Ricci (1659–1734), whose works his own acknowledge, he also engraved many compositions by Ricci. Fontebasso represents a clear link between the works of two eighteenth-century giants of Venetian painting, Ricci and Giovanni Batista Tiepolo (1696–1770), whose style greatly influenced Fontebasso's later career. For that reason, Fontebasso has often been considered a minor or derivative artist, but his paintings have occasionally been confused with Ricci's. Modern critics have reevaluated his importance in the Venetian school of the eighteenth century and ranked him along with Giambattista Pittoni (1686–1767) or even with Gian Antonio Pellegrini (1675–1741).

Fontebasso was a prolific artist. In 1736 he went to Trento and decorated the Church of the Annunziata. Called in 1761 by Catherine the Great, he traveled to St. Petersburg and left many decorations (some of which were destroyed in the nineteenth century) in the Imperial Palace and the Winter Palace. He returned to Venice by way of Mittau where he worked for the Duke von Brühn.

Houston's *Adoration of the Shepherds*, perhaps a study for a larger picture or decoration, can be compared stylistically to the *Adoration of the Kings* (Accademia, Venice), a piece that belongs to the period when Fontebasso worked under Ricci's influence. Fontebasso, who painted religious subjects, portraits, and genre pictures, seems more comfortable treating realistic details than organizing large compositions. Typical of this predilection are the girl holding a basket of birds, the woman and child who open the door to come in and look at the scene, and, above all, the beautiful figure of the kneeling shepherd in the foreground. JPM

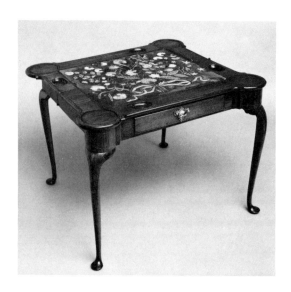

123 AMERICAN
Probably Boston, Massachusetts

Card Table, 1730–1745
Mahogany; h. 26¹¹⁄₁₆ (67.7), w. 36⅞ (93.6), d. 31⅜ (82.2)
Bayou Bend Collection; Gift of Miss Ima Hogg B.69.406

Typical of its New England origin are the slender legs and shallow frame top of the Bayou Bend gaming table, one of the few known American tables of this type with an accordion-action, extendable top. Closely related examples are in the Museum of Fine Arts, Boston, and Pilgrim Hall, Plymouth, Massachusetts. Thin bands of checkered inlay around the drawer front, the skirt, and the top repeat the delicate proportions of the whole. The original crewelwork top, a floral montage, is believed to have been done by a member of Peter Fanueil's family, from whom the table has descended. DFF

124 PAUL DE LAMERIE
English; Hertogenbach, Holland 1688–London, England 1751

Ewer, ca. 1735
Silver; h. 14¹⁵⁄₁₆ (38.0), w. 13 (33.1)
Anonymous promised gift TR 682-74

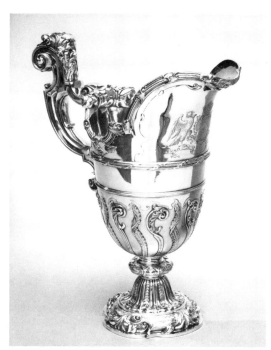

The Edict of Nantes, which permitted Protestant worship in France, was revoked by Louis XIV in 1685. As a result many French Protestants, or Huguenots, fled France for Holland and England during the 1680's and 1690's. Among them were the family of Paul de Lamerie and the silversmith Pierre Platel, to whom de Lamerie was later apprenticed. The influx of French Huguenot silversmiths into England led to the introduction of highly ornamented silver that contrasted sharply with the plain silver surfaces historically favored by English taste.

Paul de Lamerie, representing the second generation of English Huguenot craftsmen, became one of the most prominent London silversmiths. Apprenticed to Platel from 1703 to 1710, de Lamerie registered his mark in 1712 and four short years later in 1716 was appointed "Goldsmith to the King." In the 1730's de Lamerie introduced the asymmetrical scrolls, shells, and leafage of French rococo taste into English silver. Houston's ewer is an early example that incorporates rococo motifs, specifically the scrolls and leaves on the base of the foot and the wavy leaves and scrolls in the lower section of the body.

Silver ewers and basins had long been used at the English dining table for washing hands, but with the introduction of forks at the end of the seventeenth century the form became largely ornamental. At about the same time the Huguenot craftsmen introduced the helmet shape with baluster foot and open, harp-shaped handle. Used as decoration on the sideboard, the ewer and basin grew in both size and impressiveness until the 1750's, when the forms lost popularity. The Museum's example bears the arms of Loftus, the family name of the Earls of Ely, and is known as the "Ely Ewer." It bears the standard lion passant and crowned leopard's head of the London guildhall as well as de Lamerie's mark but, curiously, is lacking the usual date letter. DBW

125 GIOVANNI PAOLO PANINI

Italian; Piacenza 1691–Rome 1765

Imaginary Landscape with Monuments of Ancient Rome, 1737

Oil on canvas; 38 15/16 × 54 1/8 (98.9 × 137.4)
Signed and dated on stone to right: G.P. PANINI ROMAE 1737
Samuel H. Kress Collection 61.62

Giovanni Panini was the most celebrated and influential landscape painter of the eighteenth century. He was born in Piacenza but moved in 1711 to Rome, where he rapidly achieved fame. At the time he was elected a member of the Accademia di San Luca (1717), he was already a well-known artist whose works sold to an international clientele. Famous for his landscapes and views of elaborate interiors, Panini was also an architect and a fresco decorator, working among other places in Rome at the Quirinale (1722) and the Palazzo Albani (1720).

In Houston's imaginary landscape, Panini juxtaposes arbitrarily some of the most famous monuments of Rome: the Pantheon and the Column of Trajan, both realistically depicted with their Latin inscriptions; and the porphyry sarcophagus, which became in 1740 the tomb of Pope Clement XII in the Corsini Chapel in the Basilica of S. Giovanni Laterano. It had been customary for artists since the Renaissance to include representations of antique buildings in the backgrounds of their pictures, but Panini invented this type of composition, with its accumulation of actual ruins grouped according to the artist's fancy. His compositions were an important influence on the development of the Neoclassical style in England and France. Paintings by Panini were *de rigueur* in Adam's interiors, where their subjects fitted the classical elements revived by this architect and decorator. In France Panini enjoyed special favor. Married to a French woman, the sister of Nicolas Vleughels (1668–1737), the director of the Académie de France in Rome, Panini influenced all French landscape painters of the late eighteenth century, from Joseph Vernet (1714–1789) and Joseph Lacroix de Marseille (ca. 1700–1782) to Hubert Robert (1733–1808), whose imaginary views could not be conceived without Panini's antecedent.

The Houston picture and its pendant, a *View of the Colosseum with Antique Ruins* (formerly at the Cranbrook Academy, and more recently on the English art market) were already in a French collection in the eighteenth century and, according to tradition, might have been painted for Cardinal Polignac. JPM

126 GIOVANNI BATTISTA PIRANESI

Italian; Mestre 1720–Rome 1778

Imaginary Prisons (Plate XIII, first state of two), 1744–1745

Etching; 15 3/4 × 21 1/4 (40.0 × 54.0)
Signed recto lower right corner in plate: Piranesi f.
Museum purchase with funds provided by Alice C. Simkins 78.146

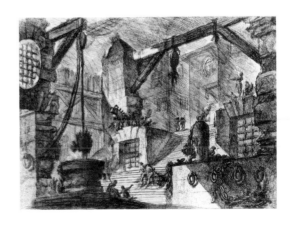

Giovanni Battista Piranesi was born in a small town near Venice, the son of a stonemason. Piranesi is believed to have studied under his engineer-architect uncle, Matteo Lucchesi, and under another architect named Scalfurotto. He also is thought to have studied printmaking under Carlo Zucchi and stage design with the Bibiena and Valeriani families. In 1740 Piranesi went to Rome but was back in Venice in 1744. In 1745 he returned to Rome where he spent the rest of

his life. Though Piranesi considered himself an architect, his activities in that area were largely confined to the remodeling of one church and abortive plans for another. In Piranesi's day as in ours, his fame rested on his etchings; his views of Rome were particularly well-known, but his *Imaginary Prisons* are now considered his masterpieces.

The *Imaginary Prisons* consist of a set of fourteen large etchings of which this is Plate XIII. They are not dated but are believed to have been made in Venice in 1744 or 1745. In the *Imaginary Prisons*, all elements of Piranesi's training came together, for they represent a combination of architecture and stage design within the medium of etching. Their origins lie in baroque opera sets, and Venice excelled in the art of stage design, particularly after the city's fallen economic circumstances made it too expensive to erect real palaces. In the *Imaginary Prisons* gigantic chains and torture devices abound, for as their title states the views represent the artist's romantic caprice rather than real life. About fifteen years after the plates were first etched, Piranesi reetched them. In this, the original version (first state), one sees a delicacy of detail and feeling for light and atmosphere that are missing from the reissued plates, in which Piranesi added architectural elements with greater emphasis on solidity than fancy. JMW

127 JOHANN WOLFGANG VAN DER AUWERA
German; Würzburg 1708–1756

Kneeling Angels in Adoration, ca. 1745–1750
Limewood; 74.59.1: h. 14¹¹⁄₁₆ (37.3), w. 11 (27.9), d. 8¹⁵⁄₁₆ (22.7); 74.59.2: h. 14¹⁵⁄₁₆ (38.0), w. 10¾ (27.3), d. 10⁵⁄₁₆ (26.2)
Museum purchase 74.59.1, 2

The pair of kneeling angels in the Houston Museum has been attributed to Johann Wolfgang van der Auwera on the strength of comparisons with known works by this artist: drawings in the Martin von Wagner Museum, Würzburg, and altars in the Heusenstamm, Offenbach-am-Main, and in Brühl (1740, destroyed in World War II). Both altars were the result of a collaboration between Auwera and Johann Balthasar Neumann (1687–1753).

Johann Wolfgang van der Auwera was the son of Jakob, a sculptor from Malines who had moved to Würzburg in 1706. Johann studied in Vienna (1730–1736) and returned to Würzburg to be employed by the Prince-Bishop at the decoration of the Residenz. In 1738 he was made court sculptor and in 1740 traveled with Neumann through the Rhine valley and the Netherlands.

The prototype for these two models, or *bozzetti*, can be traced back to the angels of Gian-Lorenzo Bernini (1598–1680) at S. Agostino, Rome (1626–1628), but the crisp quality of the carving and the somewhat angular features of the angels point not only to Auwera's personal style but also to the general characteristics of Central European rococo sculpture. The finished sculptures would have been part of a large decorative ensemble including columns, other sculptures, perhaps a painted altarpiece, and a richly decorated altar. This ensemble, or *Gesamtkunstwerk*, would then have been painted in bright polychromy or partially gilded. JPM

128 AMERICAN

New York

Side Chair, ca. 1745

Mahogany; h. 41½ (105.4), w. 21⅝ (54.9), d. 22³⁄₁₆ (56.3)
Bayou Bend Collection; Gift of Miss Ima Hogg B.69.33

The intricate double cipher of the letters RML in the splat of the Bayou Bend chair is understood by family history to refer either to Margaret Beekman and Robert Livingston or to Mary Stevens and Robert Livingston, Jr. Marked III on the inside of the back seat rail, it is one of a set that originally contained at least eight chairs. While the carved cipher is unique in the known corpus of American chairs, the generous proportions, heavy seat rail, and shaped terminals of the rear legs are commonly found in Queen Anne–style chairs from New York.

 DFF

129 ENGLISH

Staffordshire

Agateware Coffee or Chocolate Pot, ca. 1745–1750

Lead-glazed earthenware; h. without lid 6¾ (17.1), h. with lid 9 (22.9),
w. across handle 6⅛ (15.6), diam. 4⅞ (12.4)
Bayou Bend Collection; Gift of Miss Ima Hogg B.56.107

In ancient Rome, during China's T'ang Dynasty (618–908), and again in England in the mid-eighteenth century, potters produced agateware; they combined different colors of clay to produce a marbleized ceramic body covered with a clear, lead glaze. The result is a handsome, complexly patterned piece with the pattern permeating the vessel, rather than riding on its surface as colored glazes would do.

The agateware coffee or chocolate pot at Bayou Bend is made of a cream-colored earthenware veined in blue and brown, colors that were probably achieved by the addition of cobalt and iron to the pale clay. Simply mixing the three clays together would have reduced the marbling to a dull blur; shaping the pot on a potter's wheel would have had the same blurring effect. Therefore, this clay was colored in three separate batches and then beaten, rolled, and stacked in flat layers. The clay was then cut in cross section and the process repeated. After the clay was suitably blended, it was molded, not turned, into its final, octagonal, baluster-shaped form.

Both coffee and hot chocolate were mid-seventeenth–century additions to English diets, and their serving pots are frequently the same form. In both silver and ceramics there are examples of spouts at right angles to handles, as is the spout in the Bayou Bend example. The spout is equipped with a strainer, a device that seems more appropriate for coffee than for chocolate.

The pot is just one of many agateware examples in the Bayou Bend Collection, and is very similar to a companion in the Burnap Collection of English Pottery at the William Rockhill Nelson Gallery in Kansas City, Missouri. KSH

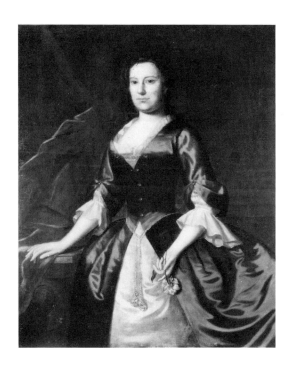

130 ROBERT FEKE
American; Oyster Bay, New York ca. 1707–(?) ca. 1752

Anne McCall, ca. 1746
Oil on canvas; 49 × 39 (124.4 × 99.1)
Bayou Bend Collection; Gift of Miss Ima Hogg B.71.81

Robert Feke, active in the 1740's, was the most important native-born American artist in the first half of the eighteenth century. Many aspects of Feke's life and career are still shrouded in mystery. He first appears in Newport, Rhode Island, in the late 1730's, and his last works were Boston commissions in 1749. While the bulk of his clients were painted in New England, Feke did travel twice to Philadelphia, in 1746 and in 1749.

The portrait of Anne McCall, which dates from his first visit to Philadelphia, is typical of the composition used by Feke: he incorporates rich drapery and monumental architecture to the left of the figure, who is given a grand, aristocratic pose, all Baroque details introduced to English portraiture by Sir Godfrey Kneller (1646–1723) in the seventeenth century. This portrait style was conveyed to the colonies in part through prints, and a circa 1737 mezzotint by John Faber (1684–1756) after a portrait of Queen Caroline by Joseph Highmore (1692–1780) has been identified as the source for *Anne McCall*. In adopting the prototype, Feke simplified the architectural setting, changed the position of the subject's arms, and omitted the royal crown and scepter. The resultant triangular arrangement of the head and upper torso and arms is echoed by the panel of the skirt below. The broad areas of color—blue dress, pink panel, and dark red drapery—make a bold Baroque statement.

The painting of Anne McCall, one of three made by Feke for the McCall family in 1746, is closely related to his other Philadelphia works of the period, particularly to the portrait of Mrs. Charles Willing, which is signed "R. Feke" and dated "1746" and further helps in dating the Houston picture. Anne McCall wears the same dress as her sister and mother in their Feke portraits; each daughter holds one flower, while the mother holds two, suggesting that Feke conceived the portraits as an ensemble. DBW

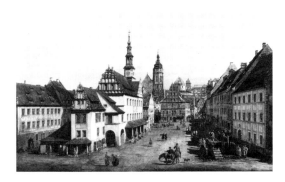

131 BERNARDO BELLOTTO
Italian; Venice 1720–Warsaw 1780

The Marketplace at Pirna, ca. 1750
Oil on canvas; 19 × 31 5/16 (48.4 × 79.6)
Samuel H. Kress Collection 61.71

Bernardo Bellotto was the nephew of Antonio Canaletto (1697–1768), under whom he was trained and whose name he adopted. Although clearly related—the two painters are *vedutisti*, or painters of city views, and Bellotto's early Venetian scenes are remarkably close to his uncle's—Bellotto and Canaletto are very different artists. In 1738 Bellotto's style was mature enough to enable him to enter the Venetian painters' guild. He traveled to Rome, Tuscany, and North Italy in the 1740's. In 1747 he left Italy for Eastern Europe. He died in Poland after having visited or sojourned in Dresden, Vienna, and Munich.

Between 1752 and 1755 Bellotto painted ten large views of Pirna, a small town a few miles from Dresden. These large views are today in the Dresden Gemälde-

galerie, but Bellotto repeated some of them on a smaller scale. Although some of the small replicas were executed by other artists, the best examples, like the Houston painting or the view of Pirna's citadel at the Art Institute of Chicago, can certainly be considered autograph.

Bellotto does not seek the theatrical effects of his uncle. His views are based on direct and careful observation and are neither artificial in composition nor repetitive. Bellotto affects a personal palette where dark tones predominate. He excelled at rendering the somewhat cold light of Eastern Europe and its particular transparence. His views of Eastern European cities are also extraordinary historical documents, because the houses and architectural details are represented with acute precision. Thanks to these documents a city like Warsaw, which Bellotto painted extensively, was reconstructed after its destruction during World War II according to its original layout and spirit. JPM

132 POMPEO BATONI
Italian; Lucca 1708–Rome 1787

Portrait of a Man, 1758
Oil on canvas; 39⅛ × 28¹⁵⁄₁₆ (99.4 × 73.5)
Signed and dated on back: POMPEO BATTONI FECIT 1758
Samuel H. Kress Collection 61.76

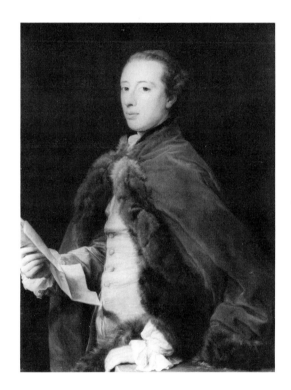

Born in Lucca, Pompeo Batoni went to Rome in 1727. He studied briefly with Sebastiano Conca (1680–1764) and Agostino Masucci (1691–1748). Francesco Imperiali (active ca. 1730's), with whom he established a friendly relationship, helped him define his own style. Throughout his life, Batoni painted religious and mythological compositions, scenes from classical history, and a great many portraits. Besides kings, empresses, and popes, Batoni painted almost every English baronet on his Grand Tour as well as many Polish and Russian counts and dukes. His reputation as the most famous painter in Rome rose in the late 1730's and early 1740's, and in 1746 he received the commission of a large altarpiece to be executed in mosaics for St. Peter's.

The subject of the Houston portrait is unknown. It is traditionally referred to as a portrait of a young Englishman, but it has been advanced that the sitter might be Count Potocki, the subject of one of Jacques-Louis David's (1748–1825) most brilliant equestrian portraits. The painting presents all the characteristics of Batoni's portrait style. The features of the sitter are realistically represented. Batoni does not flatter his models but always gives them dignity and a certain hauteur befitting their aristocratic natures. The fur-lined cloak indicates that the sitter is traveling. His attitude, a three-quarter view, and the few props used belong to Batoni's established repertoire and reappear in many other portraits. (Batoni charged his clients according to the size of the portraits and the amount of landscape and number of objects represented.) Most remarkable are the meticulous execution, which enhances the fine drawing, and the rendering of textures done in a smooth and somewhat icy manner.

Batoni's portraits, like his other compositions, show the transition between the buoyancy and prettiness of the Rococo period and the rigid and somewhat artificial qualities of Neoclassicism. His portraits are severe, but their austerity is tempered by the vigorous execution and brilliant colors that set them apart from contemporary production. JPM

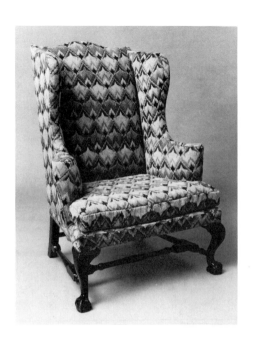

133 AMERICAN
Massachusetts

Easy Chair, 1750–1770
Mahogany, maple; h. 45½ (110.5), w. 32⅜ (82.2), d. 32⅝ (82.8)
Bayou Bend Collection; Gift of Miss Ima Hogg B.60.89

Original flamestitch-patterned needlepoint upholstery covers the front surfaces of the easy chair; original red wool harrateen covers the chair back and edges the seat cushion. The same watered, rolled, and stamped harrateen in a butterfly-leaf design is known on a small sample at the Essex Institute, Salem, Massachusetts. Worked in shades of yellow, blue, red, and green, the remarkably well-preserved embroidery is typical of a popular, although time-consuming, method of eighteenth-century decoration. Inventory studies indicate that easy chairs were placed mainly in bedrooms and used by the rich or elderly. DFF

134 CHELSEA PORCELAIN WORKS
English; Chelsea ca. 1745–1769

Dish, ca. 1756–1769
Soft paste porcelain; l. 8¾ (22.2), w. 7¼ (18.4)
Gold anchor painted on underside
Gift of Mr. and Mrs. Harris Masterson in honor of John C. Masterson
74.170

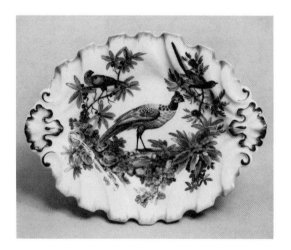

The chronicle of the development of European porcelain is a long and fascinating one. Europeans admired Chinese hard-paste porcelain composed of kaolin and petunse for its white translucence, chip resistance, ability to be finely potted, and handsome ground for glaze. Not until 1715 did a European porcelain works, the Meissen factory in Saxony, produce a product comparable to the Chinese discoveries made centuries earlier. In 1743 the English produced their first artificial porcelain. It was "softer" than its prototype and was fired at a lower temperature, but it, too, was translucent. In 1745 the Chelsea Porcelain Works was founded. The chemical content of Chelsea's initial products closely resembled glass; however, by 1755 potters at the Chelsea works began to introduce as much as 40 percent bone ash (hence the term "bone china") into their ceramics, and with this chemical change came the need to adjust the glazes.

As is typical of Chelsea porcelain in the post-1755 "Gold Anchor" era, the dish is covered with a thick, clear glaze that tended to run upon heating. Since the dish was propped on three kiln stilts during firing, thick glaze settled around its foot ring and collected in droplets on its base. Consequently the bottom of its foot ring has been ground flat. The unique character of this glaze and the three surviving pockmarks made by the kiln stilts are common to Chelsea porcelains of this period.

Houston's plate is inspired by contemporary silver shapes implying a shell. Chelsea decorated similarly molded plates in several different motifs including Turkish warriors (Metropolitan Museum of Art, New York), botanical illustrations (Colonial Williamsburg, Virginia), and flower sprigs and insects (Christie's, April 21, 1980, lot 84). The pheasant, here painted in overglaze blue, yellow, brown, plum, and sienna and surrounded by a turquoise rim and plum shells flanked by gilt scrolls, is frequently seen in mid-eighteenth–century English porcelain decoration. KSH

135 AMERICAN

New Hampshire

High Chest, 1760–1790

Maple; h. 88¼ (224.1), w. 41⅞ (106.3), d. 19⅝ (49.8)
Bayou Bend Collection; Gift of Miss Ima Hogg B.69.231

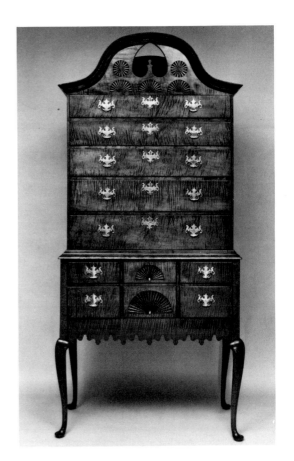

Fashionable furniture of the urban areas was frequently imitated by country craftsmen, often with interesting results. Probably made in New Hampshire about 1760–1790, the maple high chest at Bayou Bend displays an unusual combination of decorative elements that might best be termed artisan or craftsman mannerisms. These distinctively individual features include the cluster of fan and pinwheel motifs within the closed bonnet top and the large, deep drawer of the lower section, whose front is given the appearance of six smaller drawers. DFF

136 AMERICAN

Philadelphia, Pennsylvania

Pier Table, 1760–1790

Mahogany, oak, poplar, pine, marble; h. 29½ (74.9), w. 49¹³⁄₁₆ (126.5), d. 22½ (57.1)
Bayou Bend Collection; Gift of Miss Ima Hogg B.59.82

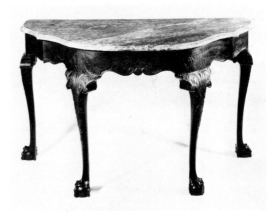

The rococo style, which originated in France in the 1720's, came to America via England in the 1760's. One of the important sources for American furniture in that style was a design book published in 1754 by Thomas Chippendale (1718–1779), and the American rococo bears his name. The citizens of Philadelphia, a city that was a prime exponent of the Chippendale style, favored the marble-top pier table as a form to be placed against the wall (or pier) between the windows of their parlors and dining rooms. The half-round example at Bayou Bend has a serpentine skirt and is unusual in its boldness of design. While imported marbles were often used, the original conforming top is gray Pennsylvania marble from King of Prussia. Asymmetrical rococo ornament of acanthus leaves and ruffles is carved on the legs and skirt. The claw and ball feet are a common detail of the American Chippendale. Houston's table was originally one of a pair; its mate, now in the collection of the Rhode Island School of Design, has mirror asymmetry. DBW

137 FREDERICK BASSETT

American; New York, New York 1740–1800

Tankard, 1761–1800

Pewter; h. 7⅛ (18.1), w. across handle 7⅜ (18.7), diam. 5 (12.7)
Mark in center inside bottom: FB
Bayou Bend Collection; Gift of Miss Ima Hogg B.60.55

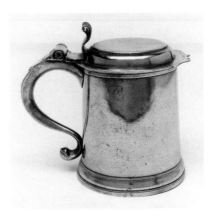

Pewter, an alloy of tin, lead, and antimony, is worked primarily in molds rather than being hammered like silver. Because of the expense invested in their brass molds, American pewterers were reluctant to introduce stylistic changes in their products, and pewter forms lagged behind developments in silver. Bayou Bend's

handsome tankard from the third quarter of the eighteenth century has a straight-sided barrel, a flattened top, and a crenate, overhanging lip and is virtually identical in form to American and English silver tankards of the second half of the seventeenth century. Marked, American, eighteenth-century tankards, although originally numerous, are today fairly rare, and most of those that remain seem to have been made in New York. The flat-topped variety is especially rare.

Frederick Bassett belonged to the second generation of a prominent New York family of pewterers who were active in that city for most of the eighteenth century. Their work is of the highest quality both in terms of aesthetics and craftsmanship. DBW

138 HUBERT ROBERT
French; Paris 1733–1808

The Large Staircase, 1761–1765
Pen and black ink, brush with gray wash and watercolor over black chalk, on off-white, laid paper; 12¹¹⁄₁₆ × 17¹¹⁄₁₆ (32.2 × 44.9)
Signed and dated lower right: Robert f. 17??
Edith A. and Percy S. Straus Collection 44.545

After early study under the sculptor Michel-Ange Slodtz (1705–1764), Hubert Robert went to Rome where he was admitted to the Académie de France in 1754. He returned to Paris in 1765 and became a successful painter specializing in depictions of classical ruins, both real and imaginary, but also painting contemporary views. In later years Robert was involved with plans to create a national museum that came to fruition with the founding of the Louvre.

The Museum's drawing is based on the Gardens of the Palazzo Farnese at Caprarola, Italy. However, it was characteristic of Robert to depart from topographical accuracy in order to allow his imagination free play, and the statue of Roma seated in the niche was taken from a fountain in front of the Palazzo Senatorio in Rome. Robert must have been fond of the composition, for a number of other versions, both paintings and drawings, exist and were published by Victor Carlson in 1968 and 1978. Although the last two digits of Robert's date are unclear, Carlson believes that the technique of the drawing is similar to other works produced in the latter part of Robert's Italian period. JMW

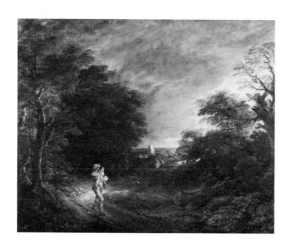

139 THOMAS GAINSBOROUGH
English; Sudbury 1727–London 1788

Landscape with a Woodcutter, ca. 1763
Oil on canvas; 39½ × 49⅞ (100.3 × 126.7)
Gift of Mrs. Elizabeth Wymond Clark in memory of Harry C. Wiess
61.9

Thomas Gainsborough was known primarily as a portraitist, but so strong was his interest in landscape that his first and last paintings belong to this genre. Born in Suffolk, Gainsborough went to London for the first time in 1740. He visited artists in their studios and may have received some lessons from Hubert François Gravelot (1699–1773). His first landscapes reflect the influence of Jacob Ruisdael (1628/1629–1682) and Jan Wynants (1620/1625–1684). After 1759 Gainsborough

moved to Bath, and his style changed. Works by Claude Lorrain (1600–1682) and Peter Paul Rubens (1577–1640) influenced his development, and direct observation of nature took a preponderant role. He often executed his landscapes after drawings done outdoors and brought back to his studio twigs, moss, rocks, and leaves to use as models. While he continued his activity as a portrait painter, showing only sporadically at the Royal Academy, with which he was in constant disagreement, Gainsborough never ceased to experiment with new kinds of landscapes and in 1783 painted landscapes on glass, which were meant to be artificially lighted from behind. During the last years of his life he painted seascapes.

Landscape with a Woodcutter was painted around 1763 and represents the transition between the landscapes Gainsborough executed in Suffolk and the brilliantly colored and luminous works of his Bath period. With surprising effectiveness, Gainsborough combines naturalistic details, such as the figure of the peasant or the rocky road, with a composition that recalls the grand style of Claude Lorrain. The trees are neatly grouped to frame the center of the composition; the light is dramatically distributed and accents the foliage as well as the central figure of the boy. Gainsborough had seen by then some of Rubens's most impressive landscapes such as the *Watering Place* (ca. 1620/1625, The National Gallery, London) and had learned from this master how to render the shimmering of light to enhance the liveliness of his composition and its dramatic power.

Gainsborough's clientele shunned his landscapes. He rarely sold them but rather gave them to friends. The Houston picture was presented to Dr. Rice Charlton, a physician who had saved the painter's life during a long illness. The painter Thomas Barker (1769–1847) saw it while in this doctor's collection and executed two copies of it. JPM

140 ATTRIBUTED TO TOWNSEND-GODDARD SCHOOL
American; Newport, Rhode Island

Dressing Table, ca. 1765
Mahogany, poplar, pine; h. 34¹¹⁄₁₆ (88.1), w. 39³⁄₁₆ (99.5), d. 21 (53.3)
Bayou Bend Collection; Gift of Miss Ima Hogg B.69.91

The origin of America's block-front furniture with its alternate convex and concave sections is not entirely clear, but evidence suggests that the style originated in Boston. There is no doubt that the combination of blocking and bold, lobed shells reached its highest expression in the furniture produced in Newport, Rhode Island, by the Quaker cabinetmaking clan of Townsends and Goddards. In the Bayou Bend example the shell motifs have been applied to a dressing table with inset kneehole, made of brilliant, amber-colored mahogany. Typical of Newport design are the continuation of the convex blocking through the bracket feet and its termination in small scrolls. While a dozen or more similar examples exist, the Houston kneehole dressing table is most closely related by design and construction to a dressing table in the Garvan Collection at Yale University.
 DBW

79

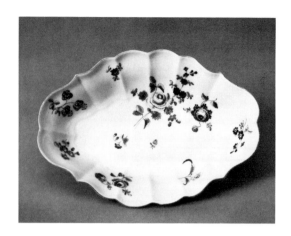

141 WORCESTER PORCELAIN FACTORY

English; Worcester 1751 to present

Pair of Serving Bowls, ca. 1770–1780

Soft-paste porcelain; h. 2 (5.1), w. 10⅜ (26.4), d. 7½ (19.1)

Gift of Mr. and Mrs. Harris Masterson in honor of Mr. and Mrs. T. N. Law 78.263.1, 2

England's respected Chelsea factory began porcelain production in 1745, and six years later Dr. John Wall and three other men established the Worcester Porcelain Factory, which also specialized in soft-paste porcelain products. For the next seventeen years Worcester and Chelsea remained the leaders in English ceramic decoration, particularly in the use of solid ground colors upon which enamel decoration was applied. Although blue was the most common ground color, as early as 1760 Worcester also marketed crimson, pink, brick-red, and yellow grounds, frequently painted in a fish-scale pattern. In 1768, when the Chelsea factory closed and many Chelsea decorators joined Worcester's staff, Worcester's products grew even more accomplished. In all probability, the Museum's handsome dishes date from this new era.

The two molded bowls, although unmarked, share the same triangular (in cross section) foot as so many other contemporaneous Worcester products. On their undersides, their glazes have a faint aqua cast and tiny black specks and recede slightly from the foot rims. All are Worcester characteristics. Each bowl is rimmed in honey gilt (so named because Worcester used honey as a support for its gilding applications) and is painted in a fragile, rare translucent yellow. The blossoms, some carefully placed to conceal flaws in the bodies, are in green, pale blue, rose, purple, brick-red, and dark yellow enamels.

These bowls and the Chelsea plate (see no. 134) are just two examples of an extensive collection of continental and English (particularly Worcester) porcelain in the Museum's collections. KSH

142 JOHN SINGLETON COPLEY

American; Boston, Massachusetts 1738–London, England 1815

Mrs. Paul Richard, 1771

Oil on canvas; 50 × 39½ (127.0 × 100.3)

Bayou Bend Collection; Gift of Miss Ima Hogg B.54.18

John Singleton Copley was the most accomplished painter working in America prior to the Revolution. Born in Boston, Copley was raised as the stepson of Peter Pelham, an immigrant English mezzotint artist who came to Boston in 1726. Exposed to a world of prints and pictures, it is not surprising that Copley turned to painting at the young age of fifteen. Although his early works were heavily dependent stylistically on earlier Boston painters, John Smibert (1688–1751), Robert Feke (1707–1752?), and Joseph Blackburn (active 1754–1762), Copley rapidly developed his own style of linear, closely observed, penetrating, and realistic characterization. While his work of the 1760's incorporated rococo details and often landscape backgrounds, toward the end of that decade Copley began to evolve a more subdued style of dramatically lighted subjects against a dark background.

The portrait of Mrs. Paul Richard, a seventy-one-year-old widow painted in

that mature style during the artist's 1771 visit to New York, is one of Copley's superb studies of older women. Recent cleaning has revealed that the chair in which she sits is covered in a brilliant blue damask, providing a pleasurable visual contrast to the warm brown silk of Mrs. Richard's dress. However, the eye is immediately drawn to the powerful face, relentlessly but lovingly rendered in every detail. Copley's portrait of Mrs. Richard stands among his finest American works painted before his departure for England in 1775. DBW

I43 GIOVANNI DOMENICO TIEPOLO
Italian; Venice 1727–1804

Study for an Altar with St. Francis of Paola, St. Anthony of Padua, and an Angel, ca. 1770

Ink and wash on paper; 8⅞ × 5¹³⁄₁₆ (22.5 × 15.0)
Gift of Alice C. Simkins 79.121

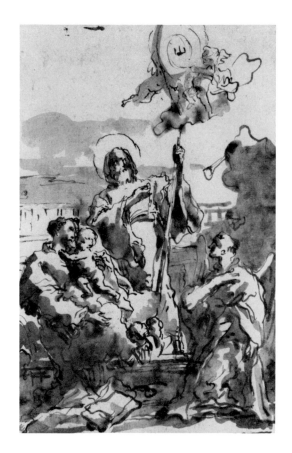

Giovanni Domenico Tiepolo was the son of the more famous painter Giovanni Battista Tiepolo (1696–1770). Taught by his father, Giandomenico, as he is sometimes called, assisted Giambattista in the family workshop, essentially in Venice, but also at Würzburg, Germany, and Madrid, Spain.

 Although Giandomenico was heavily dependent on his father's style in painting, his own artistic personality is more apparent in his drawings. His draftsmanship retains Giambattista's flickering use of wash and creation of highlights based on the reserve color of the paper, but Giandomenico's line is more vigorous and more accented than is that of his father. Most of Giandomenico's drawings, especially a group depicting the life of Commedia dell'Arte character Puncinello, were made as finished works. The Houston drawing, however, is a study for an altarpiece, though the picture appears never to have been painted. When it was in the Janos Scholz collection, the drawing was exhibited at the Cini Foundation in Venice, and the cataloger, Michelangelo Muraro, suggested a date of about 1770 based on a comparison with a drawing in the Museo Civico di Bassano, Italy. JMW

I44 JEAN-SIMON BERTHÉLEMY
French; Laon 1743–Paris 1811

The Pest of Milan, late 1770's

Oil on canvas; diam. 26⅛ (66.3)
Museum purchase with funds provided by the Laurence H. Favrot
Bequest Fund 70.20

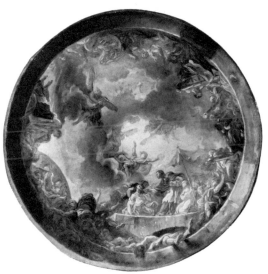

The career of Jean-Simon Berthélemy reflects the troubled times in which he lived; born during the reign of Louis XV, Berthélemy worked for Louis XV, Louis XVI, and Napoleon. Berthélemy led an important academic career. After studying with Noël Hallé (1711–1781), he won the Grand Prix in 1767. In 1771 he went to Rome and stayed at the Académie de France until 1774. He became a member of the Académie Royale de Peinture in 1781. Patronized by Marie-Antoinette, he painted decorations for the queen's apartments at Fontainebleau. From 1791 until 1807, Berthélemy held the position of costume designer at the

Opéra, an activity interrupted between 1796 and 1798 by his nomination to the commission designated to transfer works of art to France from occupied territories in Italy. Upon his return, he became an advisory director of the Musée Central des Arts (the predecessor of the Musée du Louvre). Berthélemy exhibited regularly at the Salon between 1781 and 1808.

Stylistically, Berthélemy's works vary between the rococo manner that characterizes his early production and revived classical motifs and compositions that make him one of the early exponents of Neoclassicism.

The Pest of Milan is a study for a ceiling painting. A relatively early work, it reveals Berthélemy's debt to Italian models. The subject, the plague-stricken Milanese comforted by S. Carlo Borromeo, is an Italian theme rarely treated by French artists; the execution of the tondo, with its swirling movement, recalls many ceilings in Roman churches, such as the cupola executed by Giovanni Lanfranco (1582–1647) at Sant' Andrea della Valle (1625–1628). Contemporary critics often scorned Berthélemy for his backward-looking manner into which he occasionally lapsed even after his adoption of a Neoclassical idiom. The Houston study does not appear to have been carried out on a larger scale for a known church. JPM

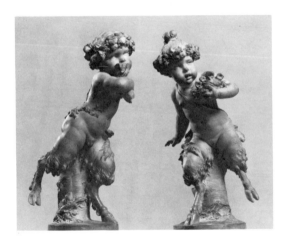

145 CLAUDE MICHEL, CALLED CLODION

French; Nancy 1738–Paris 1814

The Bird Nest Thieves, third quarter of 18th century

Terra cotta; h. each including base 16 (40.6), h. each excluding base 12¼ (31.1)
Signed on tree trunk: Clodion
Edith A. and Percy S. Straus Collection 44.576, 44.577

Claude Michel, better known as Clodion, was born in 1738 in Nancy in a family of sculptors. His uncle and first professor was Lambert-Sigisbert Adam (1700–1759), but Clodion also studied with Jean-Baptiste Pigalle (1714–1785). He won the Prix de Rome in 1759 and remained for ten years in Italy, where he was well known. This stay in Italy was particularly important for Clodion, who forged there a repertoire of subjects he repeated throughout his life. He usually represented small mythological figures, putti, satyrs, nymphs, often grouped with semierotic overtones. Clodion embellished his mythological subjects copied from antique vases, cameos, or reliefs with effects borrowed from Peter Paul Rubens (1577–1640) and from the creations of contemporary French painters. For generations after the Revolution, and notably for the Goncourt brothers, Clodion epitomized the spirit of the eighteenth century in France.

Houston's two figures of bird catchers are typical of his production. Several versions are recorded, whether in terra cotta, marble, or bronze. Clodion's works were so popular that they were often translated into decorative bronzes and used even as candelabras. The Houston pair comes from the famous Demidoff Collection. Another terra-cotta version of the satyr holding an owl was featured in the sale of the Prince de Conti in 1777, where it was paired with a young girl holding a pigeon and a cage by another sculptor, La Rue (1720 or 1731–1765). JPM

146 ANGELICA KAUFFMAN

Swiss; Coire, Switzerland 1741–Rome, Italy 1807

Ariadne Abandoned by Theseus on Naxos, 1774
Oil on canvas; 25⅛ × 35¹³⁄₁₆ (63.8 × 91.0)
Signed and dated lower left: Angelica Kauffman Pinx. 1774
Gift of Mr. and Mrs. Harris Masterson III in memory of Neill Turner
Masterson, Jr. 69.23

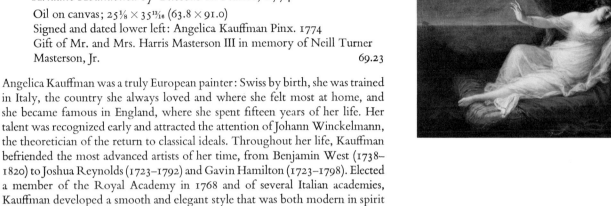

Angelica Kauffman was a truly European painter: Swiss by birth, she was trained
in Italy, the country she always loved and where she felt most at home, and
she became famous in England, where she spent fifteen years of her life. Her
talent was recognized early and attracted the attention of Johann Winckelmann,
the theoretician of the return to classical ideals. Throughout her life, Kauffman
befriended the most advanced artists of her time, from Benjamin West (1738–
1820) to Joshua Reynolds (1723–1792) and Gavin Hamilton (1723–1798). Elected
a member of the Royal Academy in 1768 and of several Italian academies,
Kauffman developed a smooth and elegant style that was both modern in spirit
and acceptable to art collectors, making her one of the foremost exponents of
international Neoclassicism. Like Elisabeth Vigée-Lebrun (1755–1842) or Pom-
peo Batoni (1708–1787), Kauffman executed portraits of the most eminent
aristocrats and enlightened spirits of her time, including Goethe. Protected by
the courts of England and Naples, she also painted such sovereigns as Paul I of
Russia, Joseph II of Austria, Ludwig of Bavaria, and Christian VII of Denmark.

Ariadne Abandoned by Theseus on Naxos was executed in 1774 and shown the
same year at the Royal Academy. Its first owner was George Bowles, one of
Kauffman's most important patrons. The scene represents Ariadne, the daughter
of Minos and Pasiphae, abandoned on Naxos by her Athenian lover, Theseus.
Ariadne laments her fate, hardly consoled by the casket of jewels she is left with.
The picture recalls Pompeiian frescoes Kauffman may have known through
her association with the Neapolitan court. The frescoes, made known to the
public through engravings, were avidly studied by artists of the period and were
fundamental to Winckelmann's theories of Neoclassicism. Kauffman's version
of the story is not imitative. The spirit of the picture is Pompeiian, but its exe-
cution bears a grace and shows a refinement that are hers alone. JPM

147 FRANCESCO GUARDI

Italian; Venice 1712–1793

View of Venice: Santa Maria della Salute and the Dogana,
ca. 1783
Oil on canvas; 19⅝ × 35⅜ (49.9 × 89.8)
Edith A. and Percy S. Straus Collection 44.562

The exact chronology of Francesco Guardi's career is not well established. He
was trained in the studio of his brother Gian Antonio (1699–1760). Because the
two artists collaborated on several occasions their individual responsibilities are
sometimes difficult to differentiate. Francesco's individuality affirms itself only
after his brother's death in 1760; yet it is likely that he started working in the
genre for which he became famous at an earlier date, perhaps as soon as 1740.
His oeuvre includes figure paintings, large landscapes (usually commissioned to
record some major Venetian festivities), many views of Venice, real or imagi-
nary, and *capricci* (caprices).

After the departures of Antonio Canaletto (1697–1768) and Bernardo Bellotto (1721–1780) from Venice in search of more lucrative markets, Guardi became the most prominent *vedutista* (painter of city views). His paintings are, however, extremely different from the works of these two artists: reserving precision and accuracy to official commissions, Guardi favored smaller landscapes, painted in a quick and free manner that confers upon even his real views of the city a fantastic quality. Although considered by nineteenth-century critics to be an isolated artist in his own time, or even to be a precursor of Impressionism (an opinion still commonly held), Guardi must be understood in the context of Venetian painting. This school always favored, and particularly so in the eighteenth century, a more direct transcription of perceived sensations. In painting views of Venice, Guardi found the perfect subject to carry on this style. The quality of the light and the transparency of the water, which confer to the buildings a diaphanous appearance, could not be more suited to his painterly approach.

Like Canaletto, Guardi was patronized by English clients. The Houston painting was executed for Mr. Ingram, an English dilettante established in Venice.

JPM

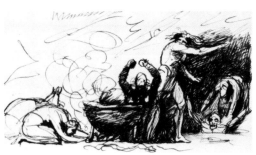

Detail

148 GEORGE ROMNEY

English; Dalton-in-Furness 1734–Kendal 1802

Sketchbook, September 1783

Pen and sepia ink, brush and sepia wash, black chalk; each page
4⁷⁄₁₆ × 7½ (11.3 × 19.1)
Annotated in artist's hand: Septr 83
Gift of Mr. and Mrs. Harris Masterson in honor of Mr. and Mrs. George R. Brown 78.187

George Romney came from Lancashire, England. At first apprenticed to a traveling portrait painter named Christopher Steele, Romney was able to come to London in 1763 and to travel extensively in France and Italy. The 1780's were Romney's most successful period. After some years of ill health, he left London in 1798 for the region of his birth, where he died after a brief period of insanity.

Though Romney is best known for his portraits, he also worked on a number of pictures for John Boydell's Shakespeare Gallery, an ambitious scheme for an admission-charging gallery of depictions from the works of the great dramatist. The Museum's sketchbook contains six drawings for *The Infant Shakespeare Attended by Nature and the Passions* and, probably, one drawing for *The Infant Shakespeare between Comedy and Tragedy*, two allegories Romney made for Boydell. Further drawings, closely similar in composition to the *Infant Shakespeare*, depict the *Young Jupiter* (with attendants and the nanny goat from which he was fed). It would appear that Romney's *Infant Shakespeare* compositions developed out of the drawings for the *Young Jupiter*, which perhaps explains why the latter picture was never completed. Other sketches represent classical scenes, and the artist's notation on the flyleaf, "Polynices Subjects," suggests that some of these could relate to the Greek legend of Antigone, who buried her rebel brother Polynices against royal command. At least one drawing is a study for a cartoon, *The Ghost of Darius Appearing to Atossa* (Royal Institute, Liverpool). Others could represent entirely different tales, including, as Gert Schiff has suggested, a scene from Horace in which witches brew a love potion by killing a male child.

The sketchbook, formerly in the collection of J. P. Heseltine, contains fifty-eight pages plus covers. The endpapers contain miscellaneous notations, mostly of sitters, plus the engraved bookplate of a former owner, Lord Nathan of Churt, and the annotation that the sketchbook was in Miss Romney's sale of 1894.

<div align="right">JMW</div>

149 JEAN-HONORÉ FRAGONARD
French; Grasse 1732–Paris 1806

Rodomonte and Mandricardo State Their Case before Agramante,
1780's

Pen, brown and gray wash over black chalk; 15½ × 10¼ (39.4 × 26.0)
Museum purchase with funds provided by General and Mrs. Maurice
Hirsch 78.64

Apprenticed to the rococo master François Boucher (1703–1770) when he was about fifteen, Jean-Honoré Fragonard was sent shortly thereafter to study under the still-life and genre painter Jean-Baptiste-Siméon Chardin (1699–1779) before returning to Boucher for further instruction. In 1752 Fragonard won the Prix de Rome, which entitled him to a scholarship at the Académie de France in Rome. However, he continued to study in Paris until 1755 when he left for Italy, where he remained until 1761. In addition to Italian art and the French art of his immediate predecessors, Fragonard was much affected by Flemish and Dutch baroque painters, particularly by Peter Paul Rubens (1577–1640). Indeed, Rubens's influence may be related to Fragonard's broadening of the traditional rococo style by the addition of a more vigorous touch. Admitted to the Académie de France in 1765, Fragonard became a highly successful painter of *fêtes galantes* (pictures depicting the pleasures of the well-to-do), landscapes, and portraits, but the oncoming taste for Neoclassical severity and the French Revolution of 1789 reduced his popularity.

Rodomonte and Mandricardo State Their Case before Agramante is one of a series of about 150 drawings illustrating *Orlando Furioso* (Roland Mad), a tale of knights and sorcerers by the sixteenth-century Italian poet Ariosto. Although the date of the drawings has been debated, their style suggests that they were executed in the 1780's, a period when Fragonard had little public following and no pressing demand for paintings. The drawings were clearly designed as book illustrations, but no volume was ever produced. In Fragonard's free, gestural use of chalk and wash, the *Orlando Furioso* drawings subsume the art of Peter Paul Rubens, to whose vigorous brushwork Fragonard was much indebted, and foretell Honoré Daumier (see no. 176).

<div align="right">JMW</div>

150 JEAN-ANTOINE HOUDON
French; Versailles 1741–Paris 1828

Portrait of Anne-Ange Houdon, 1790

Painted plaster; h. with base 15⅝ (39.7), h. without base 12 (30.2)
Signed on right shoulder: Houdon
Edith A. and Percy S. Straus Collection 44.578

Jean-Antoine Houdon is the major French sculptor of the eighteenth century and one of the greatest portraitists of all times. His work can be divided in two

<div align="center">85</div>

parts, the official portraits, for which he affects a severe style, and the informal portraits of friends or relatives, which are freer in execution.

Houdon was educated at the Ecole Royale des Elèves Protégés at Versailles. His teacher was Michel-Ange Slodtz (1705–1764), but he was influenced by the work of Jean-Baptiste Lemoyne (1704–1778) and Jean-Baptiste Pigalle (1714–1785). Houdon received the Prix de Rome in 1764. Although he exhibited at the Salon for the first time in 1769, he was only made an *académicien* in 1777, after having received commissions from such important patrons as the Duke and Duchess of Saxe-Gotha and Catherine II. Close to Benjamin Franklin and Thomas Jefferson, he received the commission to do a statue of George Washington and visited the United States in 1785 to model his sitter from life. He last exhibited at the Salon in 1814.

The sitter for this small plaster is Houdon's second daughter, Anne-Ange, at the age of about two. Besides following the normal trend for an artist of his generation to move from a light rococo style to more austere Neoclassical formulas, Houdon also always adapted his work to the personality of his model. In this relatively late work, the soft features of the child are captured with beguiling informality, and the quick upward turn of the head gives the sculpture its vitality. JPM

151 WEDGWOOD

English; Staffordshire 1759 to present

Vases in the Etruscan Style, ca. 1785–1795
Basalt (black stoneware); B.69.523.1: h. 11⅝ (28.7),
w. across handles 7½ (19.0), diam. 6¹⁄₁₆ (15.4);
B.69.523.2: h. 11⅜ (28.9), w. across handles 7⁷⁄₁₆ (18.9), diam. 6⅛ (15.5)
Impressed on each base: WEDGWOOD
Bayou Bend Collection; Gift of George Valian B.69.523.1, 2

In the last decades of the eighteenth century the rediscoveries of the ancient cities of Pompeii (1748) and Herculaneum (1738–1780) combined with Napoleon's Mediterranean campaigns to awaken a new interest in archaeological classicism in Western European cultures. Josiah Wedgwood (1730–1795), who recognized his English clients were growing tired of traditional cream-colored tablewares, was sensitive to this trend and thought there might be a new market for products directly inspired by ancient red-figured Greek vases.

To reach this market Wedgwood and his partner, Thomas Bentley (d. 1780), set up a ceramic works at Etruria, Staffordshire (1766), where they developed their famous basalt clay. Basalt is a fine stoneware that appears black because of its high manganese content; it is left in its biscuit state. Wedgwood and Bentley produced their first basalt wares in 1769. Like the Bayou Bend examples, their first products were decorated in encaustic (meaning "burnt-in") red, white, and other colors. Basalt products were sometimes called "Egyptian wares," despite the fact that the four examples were based on designs taken from Sir William Hamilton's Etruscan vase collection that had recently been acquired by the British Museum, London.

The Wedgwood vases are modeled on the ancient volute-krater form, so named for the scroll handles that are so closely related to the scrolls on ionic column capitals. Like many of the ancient prototypes, their handle bases are framed by graceful swans' heads. One vase (B.69.523.1) possibly illustrates the

mythological twins Apollo and Artemis (or Diana, as she was sometimes called), and the other (B.69.523.2) depicts two unidentified classical figures. In spite of Wedgwood's historical approach to his Etruscan wares, they are unmistakably products of the late eighteenth century. Their spare ornamentation and frozen imagery vary greatly from their ancient prototypes and exhibit the elegant, conservative control of a copyist rather than the surety of a creative spirit. KSH

152 CHARLES WILLSON PEALE

 American; Queen Anne's County, Maryland 1741–Philadelphia, Pennsylvania 1824

 Self-Portrait with Rachel and Angelica Peale, ca. 1790
 Oil on canvas; 36 × 27⅟₁₆ (91.4 × 68.7)
 Bayou Bend Collection; Gift of Miss Ima Hogg B.60.49

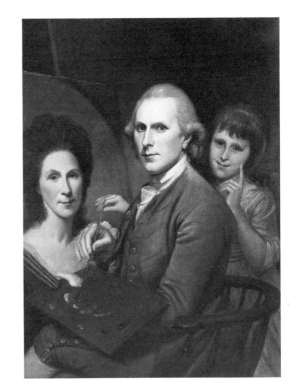

Charles Willson Peale, although apprenticed to a saddler, soon turned to painting and through the patronage of the Annapolis planter, John Beale Bordley, was sent in 1767 to London to study under Benjamin West (1738–1820). While the young Peale spent two years in West's studio, he did not absorb the grand Neoclassical style that his master was espousing. Rather he seems to have become thoroughly grounded in English rococo portraiture and the rococo conversation piece before his return to America in 1769. Peale, working in the middle colonies, lived in Annapolis until 1776, when he moved to Philadelphia. There, while continuing to paint, Peale became involved in numerous scientific and museological pursuits.

 Throughout his life Peale's ties with his large family were tremendously important, as several rococo conversation pieces of family members attest. He also created a series of penetrating self-portraits. Both themes are combined in *Self-Portrait with Rachel and Angelica Peale*. The artist is shown engaging in his everyday business, painting, in a rococo *portrait d'apparat*; his daughter, Angelica Kauffman Peale, stands behind him, his wife Rachel's likeness appears on the canvas to the left. While the concept is decidedly rococo, Peale has painted the picture with the more neoclassic, clear, crisp style that he adopted during the 1780's. Although Peale's visage is dominant, the placement of the hands and faces in an upward sweeping arc links all the figures, while the curves of the chair back and pigment on the palette direct the eye back once more to the hand-face passage. DBW

153 JAMES PEALE

 American; Chestertown, Maryland 1749–Philadelphia, Pennsylvania 1831

 Pleasure Party by a Mill, ca. 1790
 Oil on canvas; 26⅟₁₆ × 40 (66.5 × 101.6)
 Bayou Bend Collection; Gift of Miss Ima Hogg B.62.16

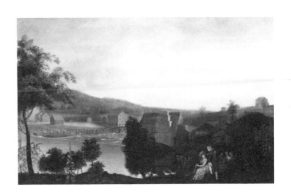

James Peale has long been overshadowed by his prolific older brother, Charles Willson Peale. James became Charles's assistant upon the elder Peale's return from England in 1769 and two years later was given instruction by his brother in watercolor and oil painting. Following the Revolution James settled in Philadelphia and developed a successful career as a painter of miniature portraits;

later in the 1820's he turned almost exclusively to the still life and is known today for his work in those two areas.

As early as the 1780's James Peale was interested in landscape painting, anticipating by a generation the romantic landscape tradition that emerged in America in the early nineteenth century. In *Pleasure Party by a Mill*, Peale combines the rococo conversation piece—the picnickers—with the topographical study of an actual site. Drawings in Peale's surviving sketchbook, now at the Philosophical Society in Philadelphia, include Peale's study of the mill, dam, and hillside at Bloomsbury in northwestern New Jersey, where the Peale family summered. Also included in the sketchbook are detailed, almost scientific studies of plant material; the same plants, rendered with realistic accuracy, appear in the foreground of the painting. The broad expanse of sky is filled with fluffy clouds tinged with sunset pink presaging romantic developments. Peale's *Pleasure Party by a Mill* not only is one of the earliest American landscapes but also, with elements of both rococo and romantic painting, stands as an important link between the eighteenth and nineteenth centuries. It further suggests that James Peale's importance as a painter has been underrated. DBW

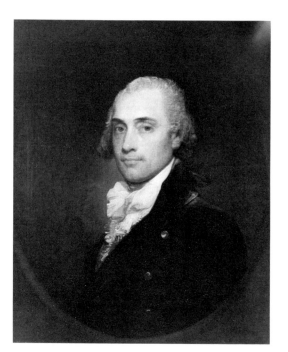

154 GILBERT STUART
American; Kingston, Rhode Island 1755–Boston, Massachusetts 1828

John Vaughan, ca. 1795
Oil on Canvas; 30⅛ × 25 (76.4 × 63.5)
Bayou Bend Collection; Gift of Miss Ima Hogg B.61.55

Gilbert Stuart studied in Newport and in Edinburgh with the Scottish painter Cosmo Alexander (d. 1772) before eventually going to London in 1777, where he lived and worked with Benjamin West (1738–1820) for five years. In 1782 he opened his own studio and achieved tremendous success. However, Stuart's spendthrift lifestyle caused him such financial difficulties that in 1787 he was forced to flee to Dublin, where he worked for six years before a hasty departure to America to escape further debts. After a year in New York, Stuart moved to Philadelphia, which in 1794 was the nation's capital. Later he worked in Washington, D.C., before finally settling in Boston.

While Stuart was in Philadelphia John Vaughan, the subject of the Bayou Bend portrait, commissioned him to paint a portrait of George Washington from life. The resultant work (known as the Vaughan-type pose and the first of Stuart's three studies of Washington) is perhaps the best-known image in American painting. John Vaughan's own portrait was executed in the same year, and in it Stuart incorporated a similar composition—a bust-length figure, timeless and motionless against a sunset glow. Stuart was particularly interested in capturing the luminous glow of life in his high-color flesh passages, a quality superbly rendered in the Bayou Bend portrait. His sure, spontaneous brushwork is particularly evident in the sketchy treatment of Vaughan's stock and lace, while the harmonies of warm flesh, green coat, white stock, and gray hair against the sunset red background clearly underline Stuart's skill as a colorist. DBW

155 AMERICAN
Ornamentation: Samuel McIntire
Salem, Massachusetts 1757–1811

Side Chair, 1790–1800
Mahogany, ebony, ash, maple; h. 38 (96.5), w. 32 (81.3), d. 20 (50.8)
Bayou Bend Collection; Gift of Miss Ima Hogg B.61.92

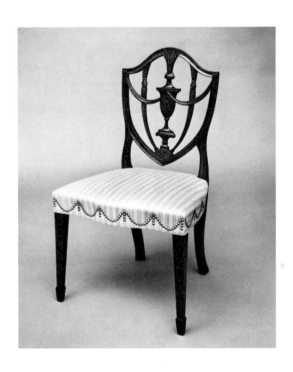

The Neoclassical style of the English architect, Robert Adam, became fashionable in America after the Revolution. It was disseminated to American cabinetmakers in part through design books. Plate 2 of George Hepplewhite's *Cabinet-Maker and Upholsterer's Guide* (1788) provided the basic model for the Salem-made example at Bayou Bend. The shield-shaped back, central urn, and swag of drapery echoed in the arrangement of the tacks on the seat rail are elements of classical design reinterpreted and recombined in the Neoclassical taste of the Federal period. The Houston chair, one of a pair, is part of a large set made for Elias Hasket Derby. Samuel McIntire, the famed Salem craftsman, carved the grape-leaf ornament on the chairs and on other furniture made for the Derby family. DBW

156 JOHN AND THOMAS SEYMOUR
American; Devon, England ca. 1738–Boston, Massachusetts 1818
Devon, England ca. 1771–Boston, Massachusetts 1848

Lady's Desk, 1794–1804
Mahogany, pine, light wood inlay; h. 41³/₁₆ (104.6), w. 37½ (95.2), d. 19½ (49.5)
Bayou Bend Collection; Gift of Miss Ima Hogg B.65.12

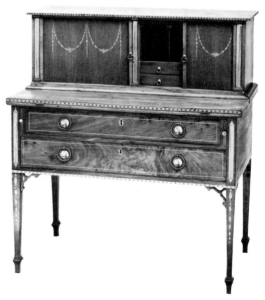

The lady's desk, a highly sophisticated, specialized form, appears for the first time in America at the end of the eighteenth century. The type represented at Bayou Bend, made in the Boston and Salem, Massachusetts, area, has no direct English antecedent. The drawer section below the writing surface and the cabinet with tambour doors above are characteristic of early Federal period desks. The tambour doors are made of narrow strips of wood applied to a canvas backing and slide horizontally from the center to reveal letter holes and drawers.

The Bayou Bend example, attributed to John and Thomas Seymour, represents the most expensive and elaborate early Federal period furniture made in Boston. Elegant features include the drawer pulls of English enamel and the

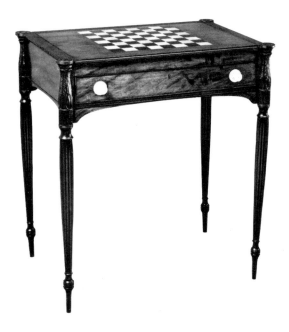

delicate, contrasting, light-wood inlays of Neoclassical swags on the tambour, of pendant husks on the legs, and of horizontal, patterned stringing. The extraordinary quality and combination of stylistic details suggest that this lady's desk was made by one of Boston's most talented cabinetmakers. That it is nearly identical to a desk at the Winterthur Museum in Delaware, which bears the label of the eminent Boston firm of John and Thomas Seymour, is the basis for ascribing this example to them. Script initials JS in pencil serve to confirm the attribution. DBW

157 AMERICAN
Salem, Massachusetts

Gaming Table, 1805–1810
Mahogany, rosewood, maple, pine, ivory, paint; h. 30½ (77.5), w. 28¼ (71.7), d. 19¹⁄₁₆ (48.4)
Bayou Bend Collection; Gift of Miss Ima Hogg B.69.377

American furniture of the Federal period was often both innovative and specialized. The reversible top of the Bayou Bend gaming table, inlaid on one side as a checkerboard, can be removed to reveal a space painted for backgammon. This area and the drawer interior are painted the distinctive light blue seen in much Boston and Salem furniture of the period. Finely executed leaf carving on the corners relates to the documented work of the Salem cabinetmaker William Hook (1777–1867), but the profile of the turned legs is quite different from his known style. The ivory or bone drawer handles are also seen on case pieces from that city. Following the American Revolution, Salem emerged as a major furniture center, its wealth based on new maritime trade. Houston's sophisticated gaming table represents the finest Salem craftsmanship. DBW

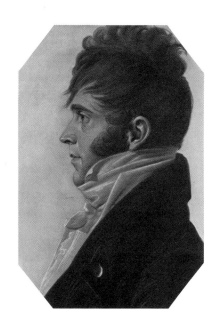

158 CHARLES-BALTHAZAR-JULIEN-FÉVRET DE SAINT-MEMIN
French; Dijon 1770–1852

Unknown Man, ca. 1804–1809
Black chalk heightened with white on pink paper; 21½ × 15½ (54.6 × 39.4)
Bayou Bend Collection; Gift of Miss Ima Hogg B.59.52

Originally from Dijon, Burgundy, the family of Charles-Balthazar-Julien-Févret de Saint-Memin fled France after the Revolution. The Saint-Memins arrived in New York as a step toward settling in Santo Domingo, where Madame Saint-Memin had large land holdings, but revolutions there forced them to remain in America. The young Saint-Memin turned to art about 1796 as a means of helping support his family. Largely self-taught, though he would have received some instruction in drawing at the Ecole Militaire in France, he specialized in portraits that he drew with the aid of a "physiognotrace," an invention that allowed an artist to reproduce the profile of a sitter with mechanical exactness. Saint-Memin then added freehand details to his drawings to remove the stereotyped quality that might have resulted had he relied exclusively on the machine.

He engraved many, if not most, of his drawings, presumably so the sitters could bestow them on friends, but the care with which he chose colored paper, generally pink as in the Bayou Bend example, suggests that the drawings were also regarded as works of art. Such a view is bolstered by the fact that the original black and gold eglomisé (painted glass) matting of many of Saint-Memin's works, including the Houston example, indicates that the drawing was destined to be framed and hung on the wall.

From 1804 to 1809 Saint-Memin was active in Annapolis, Baltimore, Washington, D.C., Richmond, and Charleston. In 1810 he returned to France, where he spent the remainder of his life, except for a trip to New York from 1812 to 1814. At one time thought to represent Richard M. Johnson, vice-president under Martin Van Buren, the subject of the Houston drawing was later identified with an engraving by Saint-Memin entitled *Alexander Smith* (apparently of Baltimore), to which it is indeed very close. The sitter's costume is consistent with fashionable dress of the period when Saint-Memin was active in Baltimore. The drawing is, however, equally close to a watercolor in the Maryland Historical Society believed by family tradition to represent a member of the Philpot family, possibly the Baltimore merchant David Conyngham Stewart (1775– ca. 1820). As the Stewart identification is uncertain and as there is no record of an Alexander Smith in the Baltimore city directories of 1804–1809, it seems safer to conclude that the true identity of the sitter in the Houston drawing remains unknown. JMW

159 ROBERT-JACQUES-FRANÇOIS-LEFÈVRE, CALLED ROBERT-LEFÈVRE
French; 1755–1830

Portrait of a Woman Leaning on a Green Velvet Cushion, 1807
Oil on canvas; 37⅜ × 28¾ (95.0 × 73.0)
Signed lower left: Robert-Lefevre fec.t 1807
Museum purchase with funds provided by Mary Alice Wilson 79.120

Robert-Lefèvre, a lawyer before he entered the studio of Baron Regnault to study painting, became as a result of his portrayals of Napoleon one of the most successful portraitists of the Empire and Restoration periods. Houston's picture, signed and dated 1807, was exhibited in the official Salon in 1808 as *Portrait of a Woman Leaning on a Green Velvet Cushion*. It is supposed by tradition to represent the wife of the Spanish ambassador to Paris whose presumed wish for anonymity is reflected in the painting's title.

The picture is characteristic of Neoclassical portraiture. It is equally finished throughout and so highly finished that it is difficult to see individual brush strokes. The artist has used local color: each object is given one hue that is darker in shadow and lighter in highlit areas. Little use is made of color reflections or of the law of optics (firmly established about twenty years after the picture was painted), which states that the shadowed areas of an object contain some of the complementary colors of the object's highlit areas. Color reflections and laws of optics were to become important to the Romantic painters, who reacted against Neoclassicism in favor of a more freely brushed style. JMW

160 THOMAS FLETCHER AND SIDNEY GARDINER
American; Alstead, New Hampshire–Philadelphia, Pennsylvania 1866
Unknown 1787–Vera Cruz, Mexico 1822

Pitcher, 1815
Silver; h. 13⁷⁄₁₆ (34.1), w. across spout 10⅛ (25.7), d. 6⅝⁄₁₆ (16.0)
On front of body: LADY HOUSTOUN PRESENTS THIS PITCHER TO /
COLONEL JOHNSTON WITH HER GRATEFUL THANKS / FOR HIS
ATTENTION IN SETTLING THE ESTATES OF / SIR PATRICK AND
SIR GEORGE HOUSTOUN.
Marks: "F&G" and "Philadᵃ." within rectangles
Bayou Bend Collection; Gift of Mrs. James P. Houstoun, in memory
of James Patrick Houstoun, Jr. B.77.16

Presentation silver, usually bowls or two-handled cups made to commemorate historical events or special occasions, had existed to a small degree in America since the eighteenth century. In the early years of the Republic and particularly following the War of 1812, presentation pieces from the citizenry to heroes and leaders became more common. Nowhere were more sophisticated examples made than in the shop of Thomas Fletcher and Sidney Gardiner of Philadelphia, whose presentation pieces were commissioned by grateful citizens from the north to the deep south.

The national reputation of Fletcher and Gardiner and the strong patterns of trade between Savannah and Philadelphia explain why Lady Houstoun of Savannah turned to that firm to supply her presentation piece. The original bill of sale, dated November 15, 1815, from Fletcher and Gardiner to Lady Houstoun survives in a private collection. Sir Patrick, the 5th Baronet Houstoun, had come to Georgia with Oglethorpe. He died in 1762. Sir George, the sixth and last Baronet, died in 1795, but it took a number of years to settle his vast estate. James Johnston, Jr., a cousin, was one of the executors, and Lady Houstoun, the presenter, was Sir George's widow.

The Houstoun pitcher represents the highest Empire style and, in overall design, reflects the strong influence of French taste in Philadelphia at that time. Typical are the classical urn shape and classical ornament: paw feet, crossed olive branches on the square plinth, acanthus leaves on the base of the body and top of the lid, eagle-headed handle, and dolphin finial. A closely related pitcher is in the Winterthur Museum in Delaware. The Houstoun pitcher remained in the Johnston family, descendants of the Houstouns, until it was acquired by the donor, who presented it to the Bayou Bend Collection. DBW

161 AMERICAN
New York, New York

Sofa Table, 1815–1825
Mahogany, pine, ash, brass, gilt; h. 28½ (71.4), w. 55¼ (140.3),
d. 27⅞ (70.8)
Bayou Bend Collection; Gift of Miss Ima Hogg B.71.106

Many of the new, specialized forms of furniture of the early nineteenth century were for the use of ladies in the pursuit of needlework, writing, and reading.

The sofa table was, as the name suggests, intended for placement in front of a sofa and was often, as in the Bayou Bend example, equipped with a drawer fitted out with an adjustable, felt-covered writing surface and compartments for the storage of writing materials. Perhaps the most distinctive decorative feature of Houston's example is the pair of gilt-winged caryatid figures, ultimately derived from Roman prototypes through French Empire designs and seen in the most sophisticated New York Empire furniture. DBW

162 AMERICAN
New York, New York

Sofa, ca. 1820–1825
Mahogany, pine, gilt; h. 34¹¹⁄₁₆ (88.1), l. 95½ (242.6), d. 27⅞ (70.8)
Bayou Bend Collection; Gift of Houston Chapter of Kappa Alpha
Theta B.78.79

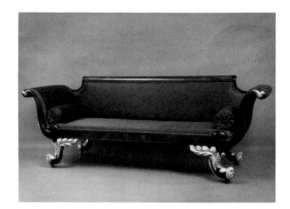

In the enthusiasm for the classical past of Ancient Greece and Rome that dominated European and American fashion in the opening years of the nineteenth century, furniture designers attempted to create pieces that reflected as closely as possible antique prototypes. Thus, the scrolled line of ancient chairs and couches was adapted to the wooden frames of their modern counterparts. At the same time, classical decorative motifs were also incorporated into the designs. The dolphin, one of those motifs, found particular favor in England and subsequently in America following the naval victories of Lord Nelson.

Nowhere have the scrolled line and classical dolphin been combined with more assurance than in a small group of extraordinary Empire-style sofas probably made in New York about 1820–1825. The sinuous dolphin of the Bayou Bend example thrusts his scaly body upward into the arms; trailing, gilded sea leafage forms the transitional bracket between leg and horizontal seat frame. The resultant sculptural form is one of the most successful of any period in American furniture design. The round, tubular cushions also draw on ancient prototypes.
 DBW

163 ATTRIBUTED TO JOSEPH MEEKS AND SON
American; New York, New York, active 1797–1868

Sideboard, 1825–1835
Mahogany, pine; h. 65 (165.1), w. 68 (172.7), d. 26 (66.1)
Bayou Bend Collection; Gift of Mrs. Harry C. Hanszen B.67.6

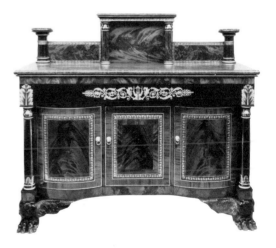

The use of painted furniture was a tradition in America dating back to the seventeenth century. In the Empire period of the early nineteenth century, gold stenciling in imitation of ormolu mounts on black background was a decorative technique used widely both in Baltimore and in New York. When combined with highly figured mahogany veneers as on the Bayou Bend pedestal-end sideboard the effect was both spectacular and luxurious. The columns, paw feet, eagle brackets, and lion-head pulls are motifs derived from ancient Roman furniture prototypes and reflect the influence of the ancient world on Empire furniture. In overall design and painted ornament the sideboard relates to known examples produced by the eminent New York cabinetmaking firm of Joseph Meeks and Son and is therefore attributed to it. DFF

164 TUCKER PORCELAIN FACTORY
American; Philadelphia, Pennsylvania 1825–1838

Pitchers (Pair), ca. 1828
Porcelain, polychrome, gilt; B.71.53: h. 9⅜ (23.8), w. 5¾ (14.6), maximum w. 7¹¹⁄₁₆ (19.5); B.80.1: h. 9⁷⁄₁₆ (23.9), w. 5¾ (14.6), maximum w. 7⅝ (19.4)
Bayou Bend Collection; Gift of 1970 Class of Bayou Bend Docents
B.71.53
Bayou Bend Collection; Gift of Mr. and Mrs. Garrett R. Tucker, Jr.
B.80.1

The firm of William Ellis Tucker, operating in Philadelphia between 1825 and 1838, is credited with producing the first commercially successful porcelain in the United States. Of all the surviving Tucker porcelain, pitchers are by far the most prevalent. Usually Tucker sought by imitation to compete with imported wares. However, the design for the vase-shaped pitchers with fluted base appears in a Tucker pattern book now in the Philadelphia Museum and is considered unique to Tucker. The Bayou Bend examples are painted with naturalistic, polychrome flowers and gold-band accents. On the front of each pitcher are the initials RS, for the original owner, and the date, 1828. DBW

165 AMERICAN
Baltimore, Maryland

Quilt, ca. 1846–1852
Cotton; 117 × 109½ (297.0 × 277.0)
Gift of Mrs. John D. Rockefeller, Jr. 45.4

Warm, economical, handcrafted quilts made of colorful cotton cutouts applied to white grounds and intricately quilted to hold cotton batting in place have been staples in American homes since our founding. As with furniture and other decorative arts, over the years certain regional characteristics have developed in quilts. Baltimore of the 1840's and early 1850's is known for very distinctive appliqué quilts usually made of individual squares framed by bright borders, frequently of calico or chintz. Designs often include cornucopias, bouquets in vases, fruit in compotes, wreaths, and patriotic trophies with eagles. Distinctive blue and brown, roller-printed fabrics are also hallmarks of the type, as are remarkable squares associated with such important topics as railroads, the Temperance Movement, Baltimore's Independent Order of Odd Fellows, and, in the case of Houston's quilt, Texas independence. The Texas legislature adopted the lone star for its seal in December 1836, and the state was admitted to the Union in 1845.

In spite of several different autographs on the quilt's squares, the Museum's quilt and others like it were not necessarily made by those whose names appear inscribed. Consistent design, uniform quality, and repeated fabrics all point to a thriving cottage industry, which recent scholarship (Dena Katzenberg, *Baltimore Album Quilts*, Baltimore Museum of Art, forthcoming 1980) proves was centered around a Methodist ladies' quilting group and the expert hand of one needleworker, Mary Evans.

The quilt is one of approximately fifty American quilts and coverlets in the collections of Bayou Bend and the Museum. KSH

166 EDWARD HICKS

American; Newtown, Pennsylvania 1780–1849

Penn's Treaty with the Indians, ca. 1830–1840
Oil on canvas; 17½ × 23½ (44.4 × 59.7)
Bayou Bend Collection; Gift of Alice C. Simkins in memory of
Alice N. Hanszen B.77.46

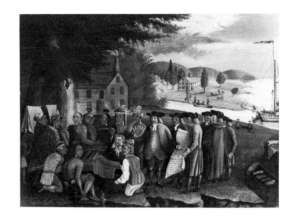

Edward Hicks, although employed as a sign and coach painter during most of
his adult life, regarded himself primarily as a Quaker preacher. His seemingly
naive paintings are imbued with the same tenets that he preached within Quaker
meeting houses. He is best known for his *Peaceable Kingdom* series dealing with
the Old Testament prophecy of an ideal era of concord between savage and
gentle beasts. Some paintings in this series include William Penn making his
treaty with the Indians. One such version is in the Bayou Bend Collection
(B.54.1). In the ten examples of *Penn's Treaty* known today, Hicks devotes his
subject entirely to the *Treaty* theme. While that subject might not initially
appear related to Hicks's Quaker beliefs, it should be remembered that Penn's
colonization project was widely regarded among the Quakers as the establish-
ment of a New World community that would, with its religious tolerance,
achieve some measure of a peaceable kingdom on earth.

Hicks's *Treaty* composition is derived ultimately from Benjamin West's (1738–
1820) 1771 painting of the subject. The composition became known through the
John Hall/Robert Boydell print of 1775, which received wide circulation for
nearly fifty years. Hicks has made certain adaptations in the original arrangement
of the foreground figures, which, drawing on the print source, are the reverse
of West's. The plump Penn stands in the center. Hicks also eliminated the Dela-
ware River, substituting Penn's Landing on Dock Street as reconstructed from
yet another print source. The Houston example varies from the other *Treaty*
pictures in several details: in particular, to the left of the English servant is a
tray of objects identified by Hicks scholar Eleanore Price Mather as jew's-harps,
items known to have been brought by Penn to the New World. The gesturing
servant is demonstrating a jew's-harp, while the grinning figures express their
amusement.

The Museum's picture, purchased at auction in 1924 as the work of an anony-
mous artist, remained unknown in the Hogg family collection until it was
inherited by the donor and presented to the Museum. DBW

167 JOHN F. KENSETT

American; Cheshire, Connecticut 1816–New York, New York 1872

A View of Mansfield Mountain, 1849
Oil on canvas; 48 × 39⅝ (121.9 × 100.6)
Signed and dated lower right: JF K 1849
Hogg Brothers Collection; Museum purchase with funds provided by
anonymous donors and by exchange 76.200

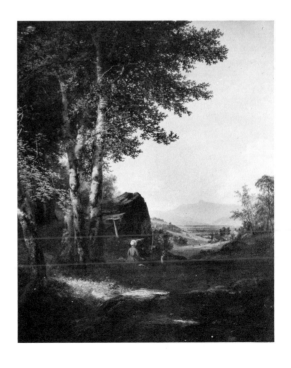

John F. Kensett, born into a family of engravers, was a member of the second
generation of Romantic landscape painters. He earned his livelihood following
his family's profession, first in New York City, later in New Haven and Albany.
His ambition, however, was to become a painter, and after receiving favorable

criticism for a landscape exhibited in 1838 at the National Academy of Design in New York, he decided to pursue the study of painting abroad. In 1840 he embarked in the company of his close friend and fellow painter Asher B. Durand (1796–1886) on what became a seven-year sojourn in Europe. There he studied and painted, supporting himself by engraving, until an inheritance gave him financial security. While in England Kensett was influenced by the atmospherics and dark woods in the paintings of John Constable (1776–1837) and by the close observation of nature in the landscapes of H. J. Boddington (1811–1865).

A View of Mansfield Mountain was painted in 1849 shortly after Kensett's artistically triumphant return to New York from Europe and the same year he became a full member of the National Academy of Design. After 1848 Kensett traveled to the country each summer, usually to the mountains of New England or occasionally to the West, where he made oil sketches from nature. These in turn served as models for large, finished, studio paintings made in New York during the winter. The seated artist in the left foreground of the Museum's painting is making such a sketch. Mount Mansfield, rising to an altitude of nearly 4,400 feet in the Green Mountains of northwestern Vermont, was a favorite stopping point for artists and tourists alike in the mid-nineteenth century. In composition, the dark, shaded foreground with patches of sunlight recalls Kensett's English works of the mid-1840's, while the large trees at the left echo work from the same period by Asher B. Durand. The distant mountain in the atmospheric, sun-filled background presages the luministic, lyrical landscapes of Kensett's mature work. DBW

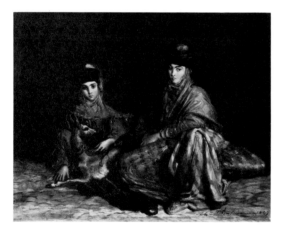

168 THÉODORE CHASSÉRIAU

French; Samaná, Hispaniola 1819–Paris, France 1856

Woman and Little Girl of Constantine Playing with a Gazelle, 1849

Oil on panel; 11⁹⁄₁₆ × 14⅝ (29.4 × 37.1)

Signed and dated lower right: Th^re Chassériau 1849

Museum purchase with funds provided by the Agnes Cullen Arnold Endowment Fund 74.265

Son of a French diplomat to the Antilles, Théodore Chassériau returned to France with his family when the artist-to-be was two, first stopping in Calais, then settling in Paris. Extraordinarily precocious, Chassériau entered the studio of the great Neoclassical painter Jean-Auguste-Dominique Ingres (1780–1867) when he was only ten years old. In spite of his Neoclassical training, he became associated with many Romantic artists, including Eugène Delacroix (1799–1863) and Théodore Rousseau (1812–1867), and writers, including Gerard de Nerval and Théophile Gautier.

In 1846 Chassériau, like Delacroix before him, visited North Africa. Houston's picture presumably depicts a subject he saw in the city of Constantine in Algeria. Although Chassériau's mature paintings generally involve a personal amalgam of the otherwise contradictory styles of Romanticism and Neoclassicism, his North African subjects tend, as here, to a more purely Romantic form. Thus he has used exceptionally free brushwork. The color of the wall of the tent is reflected on the figures. Shadowed portions of the figures' hands and drapery contain bits of color complementary to local color (see no. 159). Though Chassériau's painting is small in size, the artist liked it well enough to send it to the Salon, where it was exhibited in 1850–1851. He also made a soft-ground etching after it, published in the magazine *L'Artiste* in 1851. JMW

169 LOUIS-GABRIEL-EUGÈNE ISABEY

French; Paris 1803–1886

View along the Norman Coast, 1852

Oil on canvas; 17¼ × 25½ (43.8 × 64.8)
Initialed and dated lower left: EI 1852
Museum purchase with funds provided by Craig P. Cullinan, Jr.,
in memory of Olga Keith Wiess 78.126

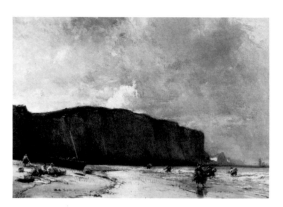

Louis-Gabriel-Eugène Isabey was born in Paris in 1803 and died there in 1886.
He was a pupil of his father, Jean-Baptiste Isabey, a successful miniaturist under
both Napoleon and Charles X, but Eugène Isabey became a member of the
group of young Romantics centered around the great painter Eugène Delacroix
(1799–1863). Isabey received a first-class medal when he made his Salon debut
in 1824, in the exhibition that included John Constable's (1776–1837) *Hay Wain*,
a picture with everyday subject matter and a freely brushed paint surface that
much impressed Isabey and other artists.

 Isabey presumably knew personally the English artist Richard Parkes Boning-
ton (1801–1828) and shared Bonington's love of coastal scenes with light reflect-
ing on water and beach. He adopted and brought into French landscape painting
Bonington's use of nearly transparent layers of paint on a white ground as
opposed to the dark ground previously employed. This technique, which pro-
duced lighter and brighter color effects, was taken over by Isabey's pupil, Johan
Barthold Jongkind (1819–1891) and by Eugène Boudin (1824–1898) and was in
turn passed on to the Impressionists, most notably to Claude Monet (1840–1926).

 JMW

170 CHARLES-FRANÇOIS DAUBIGNY

French; Paris 1817–1878

Sluice in the Optevoz Valley, 1854

Oil on canvas; 35½ × 63¼ (90.2 × 160.7)
Museum purchase with funds provided by Anaruth and
Aron S. Gordon 79.122

Charles-François Daubigny, one of the important links between the pre-Impres-
sionist generation of landscape painters and Impressionism, was the first artist to
have his pictures criticized (in 1861) as "mere impressions." Though generally
classified as a member of the Barbizon School of painters, he spent only a limited
time in the town of Barbizon and the nearby Forest of Fontainebleau, preferring
to paint riverbanks along the Oise and the Seine.

 Daubigny was a successful painter who in 1857 received the Legion of Honor
and a first-class medal at the Salon. Despite his official success, he was not immune
to the appeal of the young Impressionists; he was a personal friend of Claude
Monet (1840–1926) and resigned from the Salon jury in 1870 when works by
Monet and other Impressionists were rejected. *Sluice in the Optevoz Valley* illus-
trates Daubigny's solution to the dilemma presented to an artist who desired
official honors, but whose preferred brushwork was too free for official success.
It was commissioned by the French government in 1854. Evidently finding the
picture too spontaneous to be acceptable to the State and the Salon jury, Dau-
bigny refused to enfeeble it by overfinishing. Instead, he copied the picture on

another canvas of substantially identical size. That version, exhibited in the Salon of 1855, is now in the Musée des Beaux-Arts, Rouen. A third version, with some differences, is in the Louvre, Paris. JMW

171 SEVERIN ROESEN
German-American; d. Williamsport, Pennsylvania 1872

Victorian Bouquet, ca. 1850–1855
Oil on canvas; 36⅛ × 29 (91.8 × 73.7)
Museum purchase with funds provided by the Agnes Cullen Arnold
Endowment Fund 71.21

During the nineteenth century the still life achieved an increasingly important role in American painting. Certainly one of the most prolific practitioners was Severin Roesen, a German immigrant who worked first in New York and later in Pennsylvania. Trained as a porcelain enameler in Cologne, Roesen was strongly influenced by seventeenth-century Dutch still-life masters and like them used certain props—a heavy marble slab, a bird's nest with three eggs, a stemmed wine glass—in painting after painting with recombinations of flowers and fruit, usually arranged pyramidally against a dark background. The Houston example, primarily floral, may have had, as was often Roesen's custom, a fruit still-life pendant. Roesen's precise technique and glossy surfaces indicate his training as a porcelain painter. The vibrant colors and realistic rendering of each flower petal and dew drop were tremendously appealing to his mid-nineteenth-century, early Victorian audience. The clarity of organization and relatively sparse number of objects in contrast to the wild, disorganized profusion that marked his late work indicate *Victorian Bouquet* is early in Roesen's oeuvre. DBW

172 FREDERICK EDWIN CHURCH
American; Hartford, Connecticut 1826–New York, New York 1900

Cotopaxi, 1855
Oil on canvas; 30 × 46⁷⁄₁₆ (76.2 × 117.9)
Signed and dated lower right: F. E. Church / 1855
Hogg Brothers Collection by exchange 74.58

Frederick E. Church, also a member of the second generation of Romantic landscape painters (see no. 167), was one of the most influential artists in America during the period of 1850–1875. As a youth Church studied with Thomas Cole (1801–1848), one of the founders of the Hudson River School of Romantic landscape painting. For Church and others of his generation, the Hudson River area did not alone provide sufficient aesthetic stimulus, and they turned to more distant places for inspiration. Strongly influenced by the writings of the German naturalist and traveler Alexander von Humboldt, Church first explored the exotic wonders of the Andes of South America and later the arctic north and tropical Jamaica.

Cotopaxi is one of a group of works painted after Church's first visit to South America in 1853. The cool, classical, cone-shaped volcano, located in the Andes of Ecuador, is a subject that the artist was to paint for nearly a decade. Church's master, Thomas Cole, had been fascinated with the Sicilian volcano, Mt. Etna,

painting it no less than four times. A large version, undoubtedly known to Church, may have served as the source for the composition of *Cotopaxi*. Church dramatically juxtaposes the warm, palm-filled tropics with the cold plain and snow-capped mountain, the small scale of the foreground figures with the vast overall panorama, and the Eden-like tranquility with the powerful forces of nature suggested by the crashing waterfalls and trail of smoke from the active volcano.

American Romantic landscape paintings such as *Cotopaxi*, intended by the artist to invoke awe, had an inherent moralistic message for the viewer, reminding him of the powerful forces of nature and the small scale of man and human efforts in the face of nature. In the era before photography and easy travel these pictures also served secondarily as documents of distant, exotic sites. DBW

173 WINSLOW HOMER
American; Boston, Massachusetts 1836–Prouts Neck, Maine 1910

She Cuts Off Their Tails, from *The Eventful History of Three Little Mice*, Boston: E. O. Libby & Co., 1858
Wood engraving on paper; engraving: 4¼ × 4⅛ (10.8 × 10.5); page: 5¹³⁄₁₆ × 4⅛ (14.8 × 10.6)
Lower left: Homer del; lower right: V.L.L.Chandler Sc.
The Mavis P. and Mary Wilson Kelsey Collection of Winslow Homer
Graphics Library

Winslow Homer began his long and illustrious career as one of America's most noted nineteenth-century painters and watercolorists working as an apprentice illustrator for the Boston printing firm John Bufford and Sons. After two years of making lithographs for book illustrations and sheet-music covers, Homer left this "slavery," as he later called it, on his twenty-first birthday to become a free-lance illustrator, first in Boston and later (and more memorably) in New York.

In Homer's second year on his own, he was engaged to illustrate the *Eventful History of Three Little Mice*, an expanded narrative of the nursery-room classic, "Three Blind Mice." The booklet contained eighteen wood engravings, all probably drawn by Homer. *She Cuts Off Their Tails* is, however, the only one signed by him. Five of the engravings are also signed or initialed by Victor L. L. Chandler, a Boston wood engraver also born in 1836.

Wood engraving was the principal means of magazine and book illustration in mid-century. It both preserved and destroyed an artist's work, for artists drew their compositions directly on wood blocks and then consigned them to the wood engraver, who eradicated the artist's handwork as he incised his lines. The blocks were subsequently inked and printed, the result being an effort by the artist as interpreted by the engraver.

Homer's naive rendering of the farmer's wife as "she cut off their tails with a carving knife" is not as well organized as his later works, but the farmer's wife has one of the most expressive faces of any Homer illustration. The rendering is one of few in which Homer allows any degree of emotion. It is a youthful work by an able, but not yet great, artist.

Libby's *Eventful History* originally sold for "12½ cts. plain" and "25 cts. colored." The coloration was also block-printed. The 1858 edition was popular enough to warrant a "pirated" color edition entitled *The Three Blind Mice* (New

York: McLaughlin Brothers, 1860 [?]), which copied eight of Homer's illustrations.

The Eventful History of Three Little Mice is one of approximately 250 Homer graphics in Houston's Mavis P. and Mary Wilson Kelsey Collection of Winslow Homer Graphics. KSH

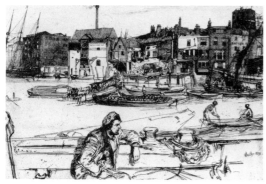

174 JAMES ABBOTT MCNEILL WHISTLER
American; Lowell, Massachusetts 1834–London, England 1903

Black Lion Wharf (second state of three), 1859
Etching, dry point; 5⅞ × 8¾ (14.9 × 22.6)
Signed and dated in the plate lower right: Whistler 1859
Gift of Marjorie G. and Evan C. Horning 74.285

After an unsuccessful experience at West Point and with the drawing division of the United States Coast Survey in Washington, James McNeill Whistler left for Europe in 1855 to become an artist. Like Claude Monet (1840–1926), he studied under Charles Gleyre (1808–1874) but admired the more avant-garde pictures of Gustave Courbet (1819–1877). In 1859 Whistler moved to London, where he spent the rest of his life except for occasional stays elsewhere, most notably in Venice from 1879–1880. Whistler was successful in both French and English art circles but always considered himself an American and, especially toward the end of his life, had many American patrons.

Though Whistler was a colorist of exceptional sensitivity as a painter, his etchings have always been regarded as among his best works. He was one of the first artists to take his copper plates out of doors and work on them directly in front of the subject. *Black Lion Wharf* was one of the *Sixteen Views of the Thames* etched by Whistler shortly after arriving in England. It depicts the portions of the Thames River near Rotherhithe, an area Whistler often portrayed in prints and paintings. JMW

175 ALBERT BIERSTADT
American; Solingen, Germany 1830–New York, New York 1902

Study of an Ancient Tree, ca. 1863–1871

Oil on canvas; 20⅛ × 14⅟₁₆ (51.1 × 35.6)
Promised gift of the Joseph S. Cullinan Family TR 355-78

Albert Bierstadt, like John F. Kensett and Frederick E. Church (see nos. 167 and 172) was a member of the second generation of Romantic landscape painters. The child of immigrant German parents, Bierstadt was sent back to Germany to train in Dusseldorf. He returned to America in 1857. Following a journey to the West in 1859 as a member of a United States Government mapping team, Bierstadt adopted the western wilderness as his primary subject matter.

Small sketches like the Museum's remarkable *Study of an Ancient Tree* were used to compose his large, finished, studio works. Houston's sketch has a vitality, tension, and looseness of brushstrokes seldom seen in the slick, grand, dramatic landscapes on which Bierstadt's reputation and tremendous popularity were based. The nineteenth-century Romantic attitudes, which regarded nature with awe and wonder, are beautifully conveyed in the careful rendering of the ancient

gnarled cedar tree whose twisted limbs and cut-off trunk recall the forces of nature—lightning, snow, ice, wind—which the tree has survived. Bierstadt visited California in 1863 and later for two years from 1871 to 1873, when he lived in San Francisco. While the species of the tree is not entirely clear, it may be a cedar; or there is a strong possibility that it is a redwood, one of that huge and ancient variety that is peculiar to the northern California coast. DBW

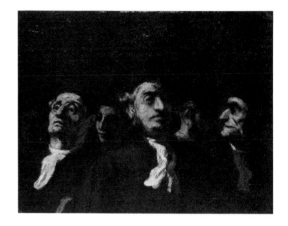

176 HONORÉ DAUMIER

French; Paris 1808–1879

Lawyers' Meeting, ca. 1860
Oil on panel; 7⅞ × 9⅜ (20.0 × 23.7)
Signed upper right: h. Daumier
John A. and Audrey Jones Beck Collection 74.137

After a first job as errand boy for the sheriffs of the law courts in Paris and a brief clerkship in a bookstore, Honoré Daumier studied art under the Neoclassical painter Alexandre-Marie Lenoir (1761–1839). He continued his training by drawing from the live model at the Académie Suisse (where artists could draw on their own) and learned lithography from a minor printmaker named Ramelet. Throughout most of his life Daumier was known as a caricature lithographer, but he did exhibit six paintings, in the Salons of 1848, 1850–1851, and 1861, which received little critical attention. Daumier was largely a self-taught artist, especially in painting, which may account at least in part for the remarkable independence of his style. Daumier's pictures are so freely painted that critics of his day would have regarded them as sketches rather than as finished works. However, when Daumier signed his paintings, as here, it can be assumed that the artist regarded them as finished. Further, the making of finished pictures in a sketchy style was characteristic of many Romantic contemporaries of Daumier, though seldom was free brushwork pushed to such an extreme.

Daumier made many lithographs, drawings, and watercolors depicting lawyers, but few paintings. His job as errand boy for the courts must have embittered him, for lawyers are generally shown in an unflattering light, as in the venal expression of the lawyer at the far right of the Houston panel. JMW

177 ETIENNE-PIERRE-THÉODORE ROUSSEAU

French; Paris 1812–Barbizon 1867

The Great Oaks of Old Bas-Bréau, 1864
Oil on canvas; 35½ × 46 (90.2 × 116.8)
Signed lower left: TH Rousseau
Museum purchase with funds provided by the Agnes Cullen Arnold
Endowment Fund 72.87

Théodore Rousseau began his career as a painter in 1826 by enrolling under Jean-Charles-Joseph Rémond (1795–1875), a successful landscapist working in a classicizing style. Dissatisfied with Rémond's teaching, Rousseau left to paint in the countryside near Paris; over the years he traveled as far as Auvergne, Normandy, Switzerland, the Berry, and the Landes. From the 1820's he painted in the Forest of Fontainebleau, and eventually he settled in the nearby town of Barbizon. Although Rousseau's submissions to the Salon were accepted between

1831 and 1835, from 1836 until after the Revolution of 1848 they were rejected. After 1849 he exhibited regularly. On the whole his later works were well received—in part because Rousseau gradually abandoned the Byronic aspect of Romanticism characteristic of his youth in favor of a more naturalizing approach (another aspect of Romanticism but one more acceptable to conservative critics), and in part because the conservative critics had other, more recent, painters to decry, most notably Gustave Courbet (1819–1877) and Edouard Manet (1832–1883).

The Great Oaks of Old Bas-Bréau was painted in 1864 according to the catalog (No. 106) of an exhibition of Rousseau's works held in Paris in 1867. Rousseau's handling of brushstroke to resemble strokes of a pen suggests an unfinished picture. The signature, however, indicates Rousseau decided that *The Great Oaks* was finished. Presumably he kept such pictures for himself or for friends; his submissions to the Salon were not left in such a sketch-like state. A pen and ink drawing of the composition is in the Mesdag Museum, The Hague. In addition, a free copy painted by Charles Jacque, but with the insertion of a shepherd and his flock of sheep, was sold at auction, Parke-Bernet, New York, October 23, 1957. JMW

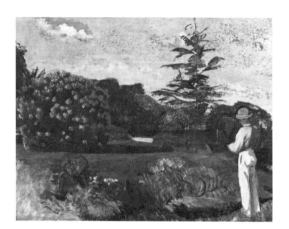

178 JEAN-FRÉDÉRIC BAZILLE
French; Montpellier 1841–Beaune-la-Rolande 1871

The Little Gardener, 1866–1867

Oil on canvas; 50⅜ × 66½ (128.0 × 169.0)
John A. and Audrey Jones Beck Collection 76.236

Born in Montpellier in a bourgeois Protestant family, Frédéric Bazille went to Paris to study medicine but rapidly abandoned these studies to devote himself entirely to painting. In the studio of Charles Gleyre (1806–1874) he befriended the young Auguste Renoir (1841–1919), Claude Monet (1840–1926), and Alfred Sisley (1839–1899). He painted in their company and even shared studios with them. Closely linked to the early history of Impressionism, Bazille's career was abruptly ended by his death during the Franco-Prussian War of 1870.

In spite of his short life, Bazille was able to produce a significant body of work. His paintings, often unfinished, witness the young artist's struggle to liberate himself from academic conventions and to adopt the free expression and painterly brushwork that became the trademarks of the Impressionist painters.

As in the Houston work, Bazille often painted familiar subjects: his relatives, views from his parents' garden near Montpellier, and friends. *The Little Gardener* was begun in 1866 at Meric, the Bazilles' family house near Montpellier, and was left unfinished, although Bazille worked on it a year later. He was then working on several large compositions in which his chief concern was to integrate properly figures into landscapes. His friend Monet had successfully solved this problem in his *Women at the Garden* (Louvre, Paris), a picture Bazille had bought from him, but Bazille still found himself more comfortable with still-life elements such as the splendid laurel tree in bloom, brilliantly painted to the left of the composition. In his *Family Reunion* (Louvre, Paris), Bazille eventually mastered the relationship between landscape and human figure. In *The Little Gardener* as in the *Rose Laurels* (*Lauriers Roses*, Cincinnati Art Museum), Bazille still tries to integrate harmoniously these figures, showing that the young Impressionist painters did not immediately adopt the easy and loose manner for which they were scorned, but that their reflection and struggles were at least equal to those of the Academic painters. JPM

179 ALBERT-ERNEST CARRIER-BELLEUSE

French; Anizy-le-Château 1824–Sèvres 1887

Bust of a Bacchante (two versions), 1860's or later

73.177: Terra cotta; h. without base 17⅛ (43.5)
 Signed across back of the truncation: A. Carrier-Belleuse
73.178: Marble; h. without base 19⅞ (50.48)
 Signed across back of the truncation: A. Carrier
Museum purchase with funds provided by the Francis A. Coates
Memorial Fund 73.177, 73.178

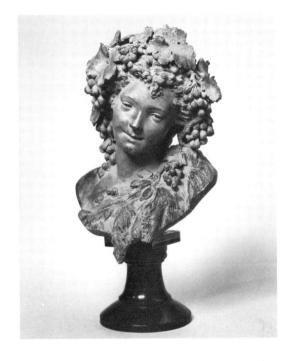

Albert-Ernest Carrier-Belleuse entered the Ecole des Beaux-Arts in 1840, began an official career with a government commission in 1848, and made his Salon debut in 1850. He left for England in 1851, where he lived until returning to France in 1855. In England he was employed by the division of the Minton porcelain works that directed design in the factory, a job that foreshadowed his most important position as director of art at the Sèvres porcelain manufactory from 1875 until his death. He was also a successful Salon sculptor, obtaining both public and private commissions, and he made architectural sculpture, most notably for the Paris Opéra.

Much of Carrier-Belleuse's work recalls the eighteenth century. *Bust of a Bacchante*, with echoes of Clodion (see no. 145), is no exception. Whereas the elements of the sculptor's personal modeling are visible in the finished, but sketch-like, terra-cotta version of the bust, the marble version is smoother and more idealized. It lacks the warm, sensuous character of the hand-modeled terra cotta. To some extent such variations emphasize the difference between building up forms in easily modeled clay (terra cotta is baked clay) and cutting them away in less tractable marble. Also involved is the nature of Carrier-Belleuse's personal sensibility, for as Rodin remarked, "Carrier-Belleuse's sketches were admirable, in finished execution everything turned cold."

Bust of a Bacchante reflects the sculptor's style in the 1860's, and there is no reason to doubt such a date for the terra-cotta version. However, another marble version, signed and dated 1872, was in the possession of the Black-Nadeau Gallery, Monte Carlo. It is unclear whether the Museum's marble was executed in the 1860's, when the model was conceived, or later, like the Monte Carlo example. JMW

180 GEORGE HUNZINGER

American; New York, New York, active ca. 1861–1910

Side Chair, ca. 1869–1870

Black walnut, ash; h. 34¹³⁄₁₆ (88.4), w. 19⅞ (50.5), d. 21⅞ (55.5)
Stamped on back of seat: HUNZINGER/N.Y./PAT. MARCH 30/1869
Bayou Bend Collection; Gift of Dr. and Mrs. Mavis P. Kelsey B.75.57

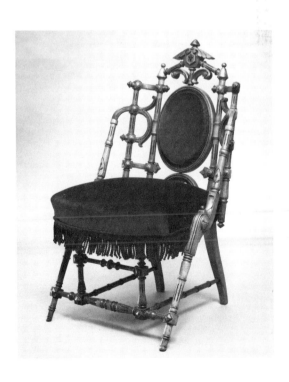

George Hunzinger was one of many immigrant cabinetmakers active in New York in the mid-nineteenth century. Like other Americans who contributed to the Industrial Revolution, Hunzinger developed innovative, mass-produced furniture, including rockers and folding and reclining chairs. This particular model bears the die stamp on the back of its seat: HUNZINGER/N.Y./PAT. MARCH 30/1869. The patent protected the seat's structural configuration. Although the chair appears to fold and its individual elements are fragile, its

bracing and vertical stays doweled into the front seat rail make it both stable and unusually strong.

Like many contemporaneous Renaissance Revival products, the Museum's example is made of walnut. It also has an ash seat frame that is concealed by upholstery. Its lathe-turned members are accented with incised, blackened flutes and stylized palmettes. A small, inlaid star caps its crest rail. When the chair was recently reupholstered, traces of its original red satin upholstery were found at the back of its oval, and tack holes from an earlier fringe marked the seat rail. According to a Hunzinger advertisement in J. Wayland Kimball's *Book of Designs, Furniture, and Drapery* (Boston, 1876), Hunzinger favored satins, terry, fringes, and braids for his dressier products like this one, which he called a "fancy chair."

KSH

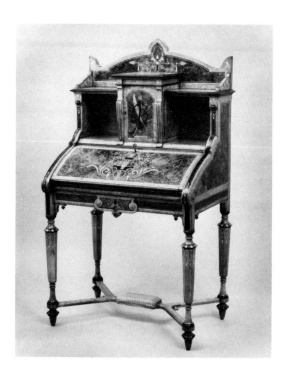

181 HERTER BROTHERS

American; New York, New York, active after 1865–ca. 1900

Lady's Writing Desk, ca. 1870–1875

Maple, walnut, walnut veneer, rosewood, other woods;
h. 54⅝ (138.7), w. 31¼ (79.4), d. 20⅛ (51.1)
Branded in wood on underside; HERTER BRO'S
Museum purchase 77.373

Gustave Herter was a cabinetmaker who emigrated from Stuttgart, Germany, to New York in 1848. By 1865 he had been joined by his younger half-brother, Christian, in one of the most successful decorating firms of the age. Herter Brothers worked in a variety of popular styles, including the Japanese, Neo-Grec, and Renaissance Revival modes. They were fortunate to practice at a time when industrial giants such as William K. Vanderbilt and Jay Gould ordered the highest quality furniture from them in an era sometimes known as the American Renaissance. For the first time in American history firms such as Herter Brothers and Louis Comfort Tiffany's Associated Artists worked with architects, craftsmen, and artists to produce a total interior space in a harmony of disciplines not seen since the Italian Renaissance.

Houston's delicate desk is stamped HERTER BRO'S under its drawer. Carefully selected maple and rosewood define the desk's simple silhouette, while a slightly convex fall front is artfully fitted with inlaid veneers. Herter Brothers is known for superb inlay work. In addition, the legs and the pediment have been decorated with incised darts or leaves highlighted with gold. Like other craftsmen of the American Renaissance, the Herter brothers have reinterpreted classicism in a highly personal way. Vase-shaped legs repeat the stylized Greek vase on the fall front, while the swagged spears and palmette of the pediment continue the Neo-Grec theme. The small pad on the desk's cross-bracing is a toe rest.

KSH

182 IGNACE-HENRI-JEAN-THÉODORE FANTIN-LATOUR

French; Grenoble 1836–Buré 1904

White Roses, 1870
Oil on canvas; 12¼ × 18½ (31.1 × 47.0)
Signed upper left: Fantin, 70
Gift of the Estate of Ann Eden Woodward 79.183

At first the pupil of his father, a provincial painter who came to Paris from
Grenoble, Henri Fantin-Latour was sent to study with Lecoq-de-Boisbaudran
(1802–1897), a gifted teacher who had his pupils draw from memory rather than
from life. He then studied for three months at the Ecole des Beaux-Arts and
became in large part self-taught by copying old masters at the Louvre. A number
of sources coalesce in the paintings of Fantin-Latour. He was influenced especially
by Titian (1477–1576) and other painters of the Venetian Renaissance, as well
as by the Romanticism of Eugène Delacroix (1798–1863) and the Realism of
Gustave Courbet (1819–1877) and more conservative Realists such as François
Bonvin (1817–1887). Further, he was friendly with such then avant-garde
painters as Edouard Manet (1832–1883) and Edgar Degas (1834–1917) but, like
Manet, believed success had to come in the official Salon, as eventually it did for
Fantin-Latour. His paintings can be divided into three categories: the still lifes,
especially of flowers, that were most popular in his own day as in ours; the
portraits, both single figures and large groups; and the allegorizing subject pic-
tures often based on the tone poems and operas of such composers as Berlioz,
Brahms, and Wagner. In addition he made many lithographs.

White Roses is unusual in that it depicts flowers growing on a bush rather than
arranged in a vase. Its dark, neutral background shows Fantin-Latour's refusal
to engage in the Impressionist's practice of painting out of doors, but, despite its
studio-derived character, it reveals his particular brand of Realism in terms of
an exceptional sensitivity to nuances of texture, color, and tone. JMW

183 GUSTAVE DORÉ

French; Strasbourg 1832–Paris 1883

Beggars at Burgos, 1871
Gouache, watercolor, India ink, chalk; 10¼ × 19³⁄₁₆ (26.0 × 48.7)
Signed and dated lower left: G. Dore Burgos 1871
Museum purchase 77.32

Gustave Doré was born in Strasbourg, but in 1840 his family moved to Bourg-
en-Bresse where he made his first lithograph at age eleven. In 1847 his family
moved to Paris, and at age sixteen he began to contribute drawings to the
satirical *Journal pour rire* published by Charles Philipon, for whom Honoré
Daumier (1808–1879) also worked. Doré made his Salon debut the same year
with landscape drawings in pen and ink. In 1854 his drawings for an edition of
the works of François Rabelais were published, and from then on his book illus-
trations were famous. Although Doré tried to be accepted both as a painter and
sculptor and as an illustrator, his paintings, and even more so his sculptures, then
as now have been overshadowed by his drawings, whether designs for wood
engravings or finished products in their own right.

Beggars at Burgos presumably depicts street beggars the artist had seen on a trip

to Spain with Baron Charles Davillier in 1862, though Doré had made an earlier trip in 1855. His interest in Spanish literature resulted in illustrations for a French edition of Miguel de Cervantes's *Don Quichotte*, published in 1863. In 1874 he drew on his Spanish voyage for illustrations to *L'Espagne* (*Spain*) by Davillier, although many of Doré's drawings for *L'Espagne* had already appeared in the journal *Le tour du monde*. Characteristic of Doré, not just in *Beggars at Burgos* but even more so in his London scenes, is the artist's revelation of his concern for the plight of the poor. Such imagery recalls the great French painter-printmakers Théodore Géricault (1791–1824) and Honoré Daumier (1808–1879) and contrasts sharply with the happy-go-lucky, well-scrubbed street urchins that dominated purportedly similar scenes in most of the Salons of Doré's era. JMW

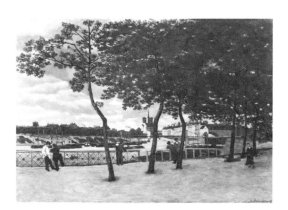

184 JEAN-BAPTISTE-ARMAND GUILLAUMIN
French; Paris 1841–1927

The Seine at Paris, 1871
Oil on canvas; 49¾ × 71⅜ (126.4 × 181.3)
Signed and dated lower right: Guillaumin 71
John A. and Audrey Jones Beck Collection 71.5

Armand Guillaumin began his career as a clerk, finding time to enroll at a small art school in Paris, and later to draw on his own at the Académie Suisse, where he met Paul Cézanne (1839–1906). Guillaumin exhibited with other artists at the show of rejected works, the Salon des Refusés, of 1863. Realizing that he had no future in the official Salon system, he participated in the Impressionist exhibition of 1874, where he attracted little attention. The 1870's and 1880's were difficult for Guillaumin, who held a routine job with the city of Paris in order to support himself and his family. In 1891 he won a lottery that made him independent for life but continued working another year to assure his pension. From then on he devoted himself entirely to painting, though it cannot be said that his later works are as significant as his earlier ones. Although Guillaumin is ultimately a "little master," much influenced by his greater contemporary Claude Monet (1830–1926), *The Seine at Paris* is an extraordinary picture, revealing the humid atmosphere and lead-gray sky of Paris in the rainy season on a scale that one does not generally associate with Guillaumin nor even with Impressionist painting. JMW

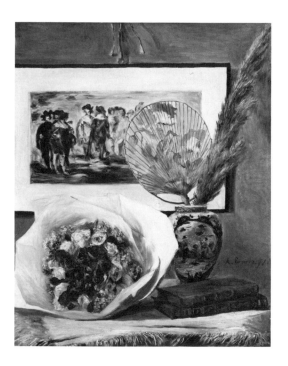

185 PIERRE-AUGUSTE RENOIR
French; Limoges 1841–Cagnes 1919

Still Life with Bouquet, 1871
Oil on canvas; 28¹³⁄₁₆ × 23³⁄₁₆ (73.3 × 58.9)
Signed and dated lower right: A. Renoir. 71
Robert Lee Blaffer Memorial Collection; Gift of Sarah Campbell Blaffer 51.7

Pierre-Auguste Renoir began his career as a painter on porcelain, but in 1862 enrolled in the studio of Charles Gleyre (1806–1874), where he met Frédéric Bazille, Alfred Sisley, and Claude Monet (see nos. 178, 189, and 210). Renoir participated in the first Impressionist Exhibition of 1874 and in some of the sub-

sequent exhibitions. However, he was unwilling to accept the rule that participants in the Impressionist exhibitions forego exhibiting in the Salon, and his works were shown in the Salon from time to time. Renoir's interest in Impressionist rendering of atmosphere and free brushwork began to wane in the early 1880's, and by 1884 he broke decisively with Impressionism in favor of a more linear, tightly brushed style. Around 1890 his brushstrokes became broader and freer again, though he was concerned more with rendering weight and mass than with his earlier interest in transient effects of light.

Still Life with Bouquet is an homage to some of the artist's predecessors: the color scheme, especially the red and green, refers to the work of Eugène Delacroix (1799–1863); the print shown on the wall is copied from Edouard Manet's (1832–1883) etching after a painting then believed to be by Diego Velásquez (1599–1660) and is, therefore, a double homage to the two men; and the Japanese fan and the oriental vase show Renoir's interest in *Japanisme*, popular among advanced artists in France in the 1860's. Despite such references to earlier art, *Still Life with Bouquet* is fully original: color attains brilliance by the artist's use of a white ground (as opposed to the dark brown ground associated with pre-Impressionist painting), which lightens and heightens the visual effect, for the ground is partly visible through the translucent paint. Further, the composition subtly plays repeated curvilinear forms—bouquet, fan, and jar—against rectangular objects—print, frame, and books. JMW

186 AUGUSTUS SAINT-GAUDENS
American; Dublin, Ireland 1848–New York, New York 1907

Portrait Bust of Belle Gibbs, 1872
Marble; h. 26¾ (67.9)
Gift of the family of Joseph S. Cullinan 50.2

As an infant Augustus Saint-Gaudens came to America with his French father and Irish mother. He studied cameo cutting in New York City before going to Paris in 1867 to study at the Ecole des Beaux-Arts. Three years later he moved to Rome to pursue a career as a sculptor. There in 1872 the young, starving artist met Montgomery Gibbs, a New York lawyer on assignment from Appleton Publishers to prepare a European guidebook. Gibbs befriended Saint-Gaudens and offered to provide the artist with funds to complete a monumental statue *Hiawatha* (now lost). Included were materials, workmen's wages, rent, and living expenses. In return the artist was to make portrait busts of Gibbs's two daughters, Florence (now in the Los Angeles County Museum) and Belle, and several copies of antique sculpture. The Gibbs girls sat for the artist while in Rome; later Saint-Gaudens required photographs to complete his work. This commission and the subsequent contacts made through Montgomery Gibbs launched Saint-Gaudens's long and successful career as a sculptor.

In his portrait of Belle Gibbs Saint-Gaudens combines the ideal of young beauty with specific realism. Belle appears as a restrained, dreamy girl, symbolizing the innocence of young womanhood. The lace and rosebud at the top of her bodice are rendered with a reality and detail that recall Saint-Gaudens's training as a cameo cutter. Houston's accomplished portrait bust draws on the traditions of Gian-Lorenzo Bernini (1598–1680) and Jean Antoine Houdon (1741–1828), yet is thoroughly in the artist's own style and is indicative of the strength he would achieve as a mature artist. DBW

187 TIMOTHY H. O'SULLIVAN
American; New York, New York 1840–1882

Ancient Ruins in the Cañon de Chelle, N.M. (Territory), 1873
Albumen photograph; 10¹³⁄₁₆ × 7¹⁵⁄₁₆ (27.5 × 20.1)
Printed in ink below photograph: T. H. O'Sullivan, Phot./No. 11/
Ancient Ruins in the Cañon de Chelle, N. M. In a niche 50 feet above present Cañon bed.
Printed in ink above photograph: War Department, Corps of Engineers, U.S. Army./Geographical Explorations and Surveys West of the 100th Meridian, Expedition of 1873. Under Command of Lieut. Geo. M. Wheeler, Corps of Engrs.
Museum purchase with funds provided by Mr. and Mrs. Robert L. Clarke
79.92

Timothy O'Sullivan first worked as a photographer in the New York studio of Mathew Brady (1823–1896) when O'Sullivan was fifteen. Later he worked in Brady's Washington, D.C., studio under the direction of Alexander Gardner (1821–1882). With the outbreak of the Civil War, Brady began a full record of the war, a record so ambitious that it required many assistant cameramen, one of whom was O'Sullivan. Gardner was also a member of Brady's Photographic Corps, but in 1863 he left Brady's employ because Brady denied individual credit to his cameramen. O'Sullivan joined Gardner's project to make a photographic record of the war, and when Gardner published his two-volume *Photographic Sketch Book of the War*, forty-four of the one hundred photographs were by O'Sullivan.

Between 1867 and 1874, O'Sullivan was employed by various government surveys of the unmapped American West. In 1867–1869, he worked with the U.S. Geological Exploration West of the 40th Parallel led by Clarence King. In 1870 he went to Panama with the U.S. Darien Surveying Expedition. In 1871, 1873, and 1874, he worked for Lieutenant George M. Wheeler, who led the U.S. Geographical and Geological Explorations and Surveys West of the 100th Meridian.

Houston's photograph was made in what is now the Canyon de Chelly National Monument, Arizona, and is among the most magnificent of O'Sullivan's career. Because it is so dramatic, it is atypical of O'Sullivan, who preferred more austere subjects. Ansel Adams considers it O'Sullivan's finest, "an image of great power and revelation" (*T. H. O'Sullivan/Photographer*, 1966). In it four men from the survey are scaling the fifty-foot cliff to the dwellings called Casa Blanca, or White House, built between the tenth and thirteenth centuries by Pueblo Indians. The men are minute against the abandoned dwellings, which are in turn dwarfed by the canyon wall, five hundred feet high and "strikingly furrowed longetudinally by the action of the driving storm and vertically by the dripping above" (descriptive legend accompanying the photograph).

Other important nineteenth-century photographs of the American West in the Museum's collection are: *Manitou, Colorado* (made after 1880) by William Henry Jackson (1843–1942) and *Yosemite Valley from the 'Best General View' No. 2* (about 1866) by Carleton E. Watkins (1829–1916). AT

188 JOHN SINGER SARGENT

American; Florence, Italy 1856–London, England 1925

The Model, 1876

Watercolor over graphite pencil; 11¹¹⁄₁₆ × 9¹⁄₁₆ (29.8 × 23.0)
Inscribed and signed lower left: à mon ami Ring [or Ringel] John Singer
Sargent
Gift of Miss Ima Hogg 39.68

Though John Singer Sargent considered himself an American, he did not visit the United States until he was twenty. He was born in Italy, where his parents settled after his father abandoned a medical practice in Massachusetts, but in 1876 his family moved to Paris. That year Sargent enrolled in the studio of the successful portrait painter Carolus-Duran (1839–1917). Inasmuch as Sargent's teacher was an admirer of Edouard Manet (1832–1883) and Sargent himself was a personal friend of Claude Monet (1840–1926), it is not surprising that Sargent's oil paintings and watercolors show something of the free brushwork and improvisation associated with Impressionism. However, they tend to be less freely painted and more obviously composed than Impressionist works, and Sargent's position midway between the modernist and conservative camps was not unrelated to his success. As early as 1877 he exhibited in the Salon. In 1884 he moved to London and soon became the most fashionable portraitist, not only in England, but also in the United States, where he spent extended periods of time.

In the opinion of David McKibbin (letter dated June 18, 1974) *The Model* was painted in 1876, the year Sargent began study in Paris. It already shows his extraordinary facility with watercolor, a medium in which he excelled quite as much as oil. An unconventional pose (in terms of the woman being seen from the back) and sketchy handling give *The Model* an immediacy more appealing than many of Sargent's finished paintings. JMW

189 ALFRED SISLEY

English; Paris, France 1839–Moret, France 1899

The Flood on the Road to Saint-Germain, 1876

Oil on canvas; 17¹⁵⁄₁₆ × 24⅛ (45.7 × 61.2)
Signed and dated lower left: Sisley .76
John A. and Audrey Jones Beck Collection 74.146

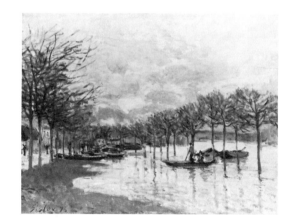

Born in Paris of English parents, Alfred Sisley entered the studio of the official painter Charles Gleyre (1806–1874) in 1862, where he encountered Frédéric Bazille, Pierre-Auguste Renoir, and Claude Monet, coming strongly under Monet's influence around 1870 (see nos. 178, 185, and 210). Sisley exhibited in the Salon in 1866, 1868, and 1870, but in 1874 he and a group of other artists, including Edgar Degas (1834–1917), Paul Cézanne (1839–1906), Camille Pissarro (1830–1903), Monet, and Renoir exhibited their pictures jointly and agreed not to submit them to the Salon jury. One of Monet's pictures was entitled *Impression-Sunrise*, the word "Impression" designed to suggest that the work fell between a traditional oil sketch and a finished picture. It attracted the disparaging comments of a critic, who called his review "Exhibition of the Impressionists." The word stuck, though with the recognition of the artist's genius it became an accolade. The essence of Impressionism was in the words of Monet (its most typical practitioner) "to have painted directly from nature, seeking to render my impressions in front of the most fugitive effects."

The Flood on the Road to Saint-Germain depicts a characteristic Impressionist subject; the flow of water attracted the group because it allowed them to concentrate on the ephemeral and to paint the dissolution of form that occurs in reflections. Despite the appeal such pictures have for today's audience, they were severely censured by conservative critics for their lack of a traditional academic finish. These critics failed to understand that Impressionist pictures had to be freely and quickly brushed; an academic finish would have taken so long to achieve that light effects would have changed before the artist had barely begun.

JMW

190 ODILON REDON

French; Bordeaux 1840–Paris 1916

The Trees, date uncertain

Charcoal on buff paper; 19¾ × 14¾ (50.2 × 37.4)
Signed lower right: Odilon Redon
Gift of Mrs. Harry C. Hanszen 72.29

Friendship with the extraordinary and eccentric printmaker Rodolphe Bresdin (1822–1885) was probably the most important artistic influence in Odilon Redon's life, though he also studied under the successful academic painter Léon Gérome (1824–1904). In the mid-1860's Redon met the Barbizon school landscape painter Camille Corot (1796–1875), whose paintings and, still more so, charcoal drawings were strong sources for *The Trees*. From the 1880's Redon became friendly with the leaders of the Symbolist movement, most notably the writers Joris Karl Huysmans and Stéphane Mallarmé, and made many lithographs depicting subjects taken from Gustave Flaubert's *Temptations of St. Anthony.*

Despite his brilliance as a colorist, Redon was especially fond of drawing in charcoal. Though Redon made a number of somewhat more straightforward renderings of trees, he is best known for his pastels of flowers and for his renderings in pastel, charcoal, and lithography of fantastic subjects—for example, a plant growing a human head instead of a flower. Even in *The Trees* there is a suggestion of the eerie. The date of the Museum's drawing is difficult to establish. Redon drew similar trees in backgrounds of figural depictions in the 1870's and 1880's, but in terms of finished, securely dated works the drawing is closest to a lithograph published in 1896 entitled *I plunged into solitude. I lived in the tree behind me.*

JMW

191 AUGUSTE RODIN

French; Paris 1840–Meudon 1917

Studies for the Titans, late 1870's

Terra cotta; 58.20a: h. 9⅜ (23.8); 58.20b: h. 11¾ (29.8)
Robert Lee Blaffer Memorial Collection; Gift of Sarah Campbell
Blaffer 58.20a, b

At the age of fourteen, Auguste Rodin began studies at the Petite Ecole, attended earlier by such sculptors as Jean Baptiste Carpeaux (1827–1875), Rodin's teacher there, and Albert-Ernest Carrier-Belleuse (see no. 179). In 1870 Rodin went to Brussels, where he worked on architectural sculpture. He made a two-month

trip to Italy in 1875, largely to see the sculptures and paintings of Michelangelo. He returned to Paris in 1878 and received his first major commission in 1880, the bronze doors for the Museum of Decorative Arts, *The Gates of Hell*. By the late 1880's Rodin was well known and successful, though his most important works tended to be controversial as, for example, when *Balzac* was rejected by the commissioning authorities.

The powerful muscles and cross-limbed postures of *The Titans* (giants of Greek mythology) show Rodin's debt to Michelangelo, not only to the latter's sculpture, but also to the figures painted on the Sistine Chapel ceiling. Thus, *The Titans* were probably modeled shortly after Rodin's trip to Italy, in any event within a few years thereafter. According to an undocumented tradition that there is no reason to doubt, the Museum's *Titans* were cast from a mold during Rodin's lifetime. They are not finished works, but rather sketches for something else. Identical figures, with the addition of two more, occur as caryatids (human figures supporting an architectural or decorative element) around a finished terra-cotta vase signed "A. Carrier-Belleuse." *The Titans* themselves are clearly the work of Rodin, but the signature on the terra cotta is not surprising because it is known that Rodin often worked for Carrier-Belleuse. One might assume that *The Titans* were produced for the factory at Sèvres, where Rodin was employed under Carrier-Belleuse from 1879 to 1882, but as H. W. Janson pointed out in a 1968 article in the *Art Bulletin*, Sèvres produced only porcelain. However, Carrier-Belleuse's personal studio produced many works in terra cotta. Presumably *The Titans* were produced for the personal studio, and it is unfortunate that Rodin's early work is not better documented. JMW

192 TIFFANY AND COMPANY
American; New York, New York 1837 to present

Tea Set, 1878
Silver, brass or gold, copper; coffee pot: 4⁹/₁₆ × 11¼ (11.6 × 28.5); tea pot: 3⅞ × 9⅛ (9.8 × 23.2); creamer: 3⁷/₁₆ × 3¹³/₁₆ (8.7 × 9.7); sugar: 4¾ × 5¹⁵/₁₆ (12.1 × 14.9)
Gift of Eleanor Freed in memory of her mother, Esther Loveman Kempner 80.75

American designers, like the American artists James McNeill Whistler (1834–1903) and William Merritt Chase (1849–1916), were strongly influenced by Japanese aesthetics in the 1870's and 1880's. Therefore, it is not surprising that one of the leading American silversmiths of the day, Tiffany and Company, should be active in this mode. The English designer Christopher Dresser offered the firm a large number of Japanese imports for exhibit and sale in 1877, and Tiffany's president, Edward C. Moore, collected in this field. So successful were the company's silver entries in the Japanese style at the Universal Exposition in Paris in 1878 that the firm was awarded the Grand Prize at Paris and Edward C. Moore received a gold medal.

Pattern numbers indicate that this tea pot, coffee pot, cream pitcher, and covered sugar bowl were fabricated in 1878. Their hand-hammered, matte-finished bodies mounted with tendrils, leaves, and whimsical insects are in the finest tradition of the style. The sugar bowl and cream pitcher are even more remarkable because they introduce gold and copper alloy mounts on silver bodies.

Tiffany and Company was twenty years ahead of its time. The hammered

surface, called "martelé" by French critics in 1878, became an accepted finish for Arts and Crafts silver at the end of the century, and the naturalistic, gourd-like shapes, tendrils, and insects are firmly fixed in American art nouveau ornamental tradition.

<div align="right">KSH</div>

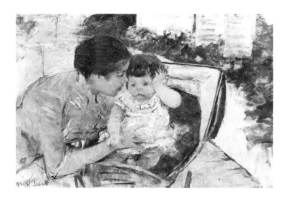

193 MARY CASSATT

American; Allegheny City, Pennsylvania 1844–Château Beaufresne, France 1926

Susan Comforting the Baby, ca. 1881
Oil on canvas; 25⅝ × 39⅜ (65.1 × 100.0)
Signed lower left: Mary Cassatt
John A. and Audrey Jones Beck Collection 74.136

Mary Cassatt left Philadelphia for Paris in 1868 to become a painter. In 1875 she enrolled in the studio of the official painter Charles Chaplin, but two years later was invited by Edgar Degas (1834–1917) to join the "Independents." Thereafter she exhibited in several of the Impressionist exhibitions. In addition, she was a friend of Edouard Manet (1832–1883), whose free brushwork was to influence her just as Degas influenced her choice of composition. Cassatt, like Degas and Manet, was interested in the depiction of modern life. However, and again like Degas and Manet, she stands apart from the more characteristic Impressionists like Claude Monet (1840–1926) and Alfred Sisley (1839–1899) because she was by no means wedded to the belief that the main focus of art was the out-of-doors, spontaneous rendering of just what the artist saw. In addition to her stature as a painter and printmaker, Mary Cassatt was important in enriching the holdings of Impressionist works in American museums, especially through her friendship with such important collectors as Mrs. H. O. Havemeyer of New York and Mrs. Potter Palmer of Chicago.

 Susan Comforting the Baby shows Cassatt's sources in Manet (the free brush-work) and Degas (the high horizon line and off-center composition). It also shows her extraordinary ability to render the emotional ambiance between mother and child or nurse and child more convincingly than any of the other Impressionists. A version of the picture limited to the heads and shoulders of the two figures, presumably a finished preliminary sketch, is in the Columbus (Ohio) Museum of Art.

<div align="right">JMW</div>

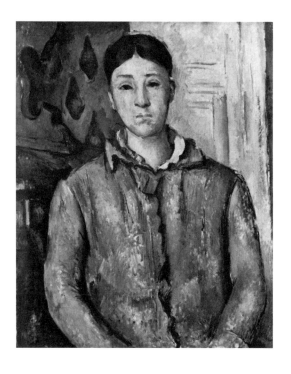

194 PAUL CÉZANNE

French; Aix-en-Provence 1839–1906

Madame Cézanne in Blue, 1885–1887

Oil on canvas; 29⅜ × 24 (74.1 × 60.9)
Robert Lee Blaffer Memorial Collection; Gift of Sarah Campbell Blaffer 47.29

Paul Cézanne studied art at the local School of Drawing in Aix-en-Provence. When he went to Paris in 1861, he attended the Académie Suisse, where artists could work on their own. There he met Camille Pissarro (1831–1903), whose influence is particularly notable on much of Cézanne's art of the 1870's, his most Impressionist phase. Cézanne, however, was by no means a pure Impressionist,

though he did seek in general to realize the sensations of light and color he saw in nature. In his maturity he came to harmonize two styles that might have been thought antagonistic: he imposed Impressionist free brushwork and high-keyed color seen in natural light on compositions in which individual elements, including the human form, were reordered, even distorted.

Madame Cézanne in Blue shows Cézanne's willingness to abandon naturalistic color and form in the interest of an abstract artistic unity. Touches of the blue of Madame Cézanne's bodice appear throughout the picture to a far greater degree than the law of color reflections would allow, as, for example, on both sides of her face and on the piece of furniture at the left. Touches of the brown furniture invade her right shoulder. Further, Cézanne has deliberately created an ambiguous space in which it is difficult to decide whether the brown band at the far right represents a view into another room or simply more wallpaper. Such alterations of the visual data of nature have the effect of forcing the viewer to see the surface of the picture as a thing of artifice, a major link with twentieth-century art. Thus, on the one hand, the paintings of Cézanne foretell the formal abstracting tendencies of twentieth-century art; on the other, Cézanne's retention of a generally naturalistic point of view represents the culmination of the naturalistic tradition that dominated nineteenth-century painting. JMW

195 PETER HENRY EMERSON
English; La Palma, Cuba 1856–Falmouth, England 1936

During the Reed-Harvest, 1886
Platinum photograph; 8½ × 11¼ (21.6 × 28.6)
Museum purchase with funds provided by Mundy General, Inc. 80.9

Peter Henry Emerson was a major force in nineteenth-century photography, not only in his adopted country, England, but throughout Europe and America as well. Emerson first studied medicine and natural science at Cambridge and was graduated with honors, but he practiced medicine for only five years before deciding to concentrate his considerable energies on photography. He was disgusted by the "high art," pictorial photography of Henry Peach Robinson (1830–1901), Oscar Gustave Rejlander (1813–1875), and others then dominant in the Photographic Society of Great Britain. Loathing the studio setups and costumes used in the narrative pictures made by the pictorialists, Emerson devised his own style, which he called Naturalistic Photography. He advocated natural settings and spontaneous poses photographed with only the central object of the scene sharply in focus. Emerson's training as a naturalist and scientist strongly influenced his views, but in his treatise *Naturalistic Photography*, published in 1889, he made a clear distinction between art and science: "To sum up then, Art is the selection, arrangement, and recording of certain facts, with the aim of giving aesthetic pleasure; and it differs from Science fundamentally, in that as few facts as are compatible with complete expression are chosen, and these are arranged so as to appeal to the emotional side of man's nature, whereas the scientific facts appeal to his intellectual side."

Houston's photograph is plate 28 from *Life and Landscape on the Norfolk Broads*, the first of nine books published with Emerson's illustrations but the only one that contained original platinum prints. The other volumes, published over the next decade, were illustrated with photogravures. His photographic books and most of his literary publications focused on the landscapes, the peasants, and the

fisherfolk of Norfolk and Suffolk on the eastern shore of England. In the daily lives of these people, Emerson found reprieve from the artificial, sentimental scenes of the pictorialists. The text and two-thirds of the photographs in *Life and Landscape* were made in collaboration with Thomas F. Goodall (1856–1944), a landscape painter and naturalist who lived in Dulwich, Suffolk, and shared Emerson's passion for working only "from nature." AT

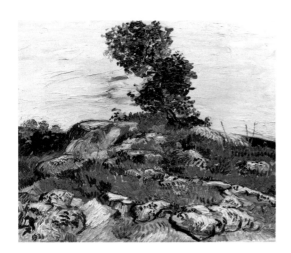

196 VINCENT VAN GOGH

Dutch; Groot Zundert, Holland 1853–Auvers, France 1890

The Rocks, 1888
Oil on canvas; $21\frac{5}{8} \times 25\frac{7}{8}$ (54.9 × 65.7)
John A. and Audrey Jones Beck Collection 74.139

In 1880 Vincent van Gogh abandoned attempts to become a pastor and decided to become a painter. The following year he moved to The Hague where he received advice from his successful painter-cousin Anton Mauve (1838–1888). In 1886 he went to Paris where he studied under Fernand Cormon (1854–1924) and became interested in the art of the Impressionists. In 1888, on the advice of Henri de Toulouse-Lautrec (1864–1901), a fellow student in Cormon's studio, van Gogh left for the South of France. He lived in Arles until 1889. There, Vincent was given financial aid by his brother Theo and was joined by Paul Gauguin (1848–1903). The artistic views of the two were anything but similar; van Gogh emotional and romantic, Gauguin interested in classicism. After a quarrel, van Gogh cut off his own left ear. Periodic hallucinations followed, and he was admitted to a hospital in nearby San Rémy. In 1890 he moved to Auvers, nearer Paris, where he was the patient of Dr. Gachet, an admirer of modernist art. On July 27, he shot himself and died two days later. Despite madness, van Gogh had long periods of lucidity that allowed him to paint even in the last tragic two years of his life.

According to A. H. Tellegen-Hoogendoorn (letter dated March 15, 1980), *The Rocks* was painted in June or July of 1888. It shows the artistic maturity van Gogh developed in Arles. Color is intense. Thick, prominent brush strokes create varied rhythms. Abandoned is the dark brown tonality that characterized his Dutch period. Also abandoned are the short, choppy, Impressionist brush strokes that characterized most of his Paris works. Although there is a preparatory drawing for *The Rocks* in a private collection in Madrid, the painting represents the artist's most direct response to nature: in a letter of September 10, 1888, to Theo van Gogh, he called it an *étude*, or study from nature (rather than an imaginative composition). Theo seems to have especially prized *The Rocks* as he is known to have had it framed, which he could not have afforded to do for most of van Gogh's large oeuvre. Van Gogh was a major source for the German Expressionists, and *The Rocks* was included in an exhibition in Cologne in 1912, the first comprehensive exhibition of his work to be shown in Germany. JMW

197 HENRI DE TOULOUSE-LAUTREC
French; Albi 1864–Malromé 1901

Portrait of Frederick Wenz, 1888
Oil on canvas; 21¹¹⁄₁₆ × 18⅛ (55.1 × 46.0)
Signed lower left: HT Lautrec (H, T, and L form monogram)
Robert Lee Blaffer Memorial Collection; Gift of Sarah Campbell Blaffer
57.41

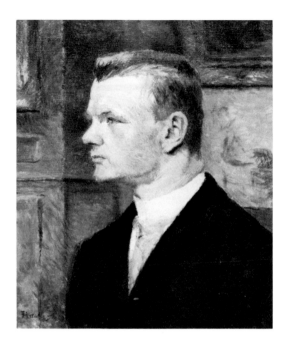

Henri de Toulouse-Lautrec, whose name incorporates that of the counts of Toulouse from whom the artist was descended, broke his left thigh in 1878 and his right in 1879. The broken bones failed to heal properly, and his legs stopped growing though his upper body matured normally. His physical disability gave him the appearance of a dwarf and set him apart from the athletic upper-class society to which his family belonged. Lautrec began to paint while recovering from his injuries. He studied first with a family friend René Princeteau (1844?–1914) and later with the academic painters Léon Bonnat (1833–1922) and Fernand ormon C(1854–1924). More important, he came to admire the work of such modernist artists as Auguste Renoir (1841–1919), Vincent van Gogh (1853–1890), and, especially, Edgar Degas (1834–1917). In the late 1880's Lautrec began to depict Paris cafés and music halls, circuses and theatres, and bordellos.

Lautrec is best known for caricatural representations in bright, theatrically exaggerated colors painted with brush strokes so long that the result can resemble draftsmanship as much as painting. However, he also painted sensitive, naturalistic portraits, particularly of his friends, generally in a more conservative technique appropriate to straightforward representation. One such work is the *Portrait of Frederick Wenz*, a fellow student in Cormon's studio, whose sister Lautrec also painted. In the Museum's picture Lautrec reveals his debt to Impressionist painters in the small, choppy brush strokes, especially on the sitter's cheeks, and his debt to Degas in the composition, which uses the horizontal and vertical elements in the background to stress similar axes in Wenz's head and torso. JMW

198 WILLIAM MERRITT CHASE
American; Indiana 1849–New York, New York 1916

The First Portrait, ca. 1888
Oil on canvas; 70⅛ × 40⅛ (178.1 × 102.0)
Gift of Ehrich Newhouse Gallery 34.81

William Merritt Chase studied in the Middle West and New York City before going to the Academy in Munich where between 1872 and 1878 he absorbed the style of the old masters, especially the Spanish and Dutch Schools. While in Munich, Chase also mastered a bravura, painterly brush technique that was to distinguish his work throughout his life. Returning to New York in 1878, Chase began a long and distinguished career at the Art Students' League. As a teacher there he exerted an important force on several successive generations of American painters.

The First Portrait is Chase's earliest study of his daughter Alice. The overall dark color scheme in sharp contrast to the child's white garment clearly shows the influences of old masters, especially of Diego Velázquez (1599–1660). Those influences are echoed in the facile brushwork of the white lace and in the Japanese-

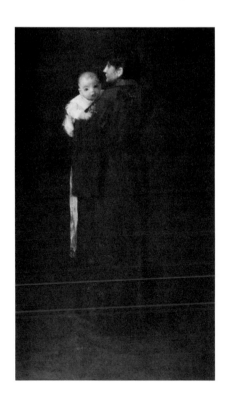

style embroidery on Mrs. Chase's robe. A slightly later painting, *The Open Air Breakfast* (Toledo Museum, Ohio), shows Alice, now several months older, and Mrs. Chase dining al fresco. It is rendered in a brilliant, light, Impressionist palette that Chase adopted in the late 1880's. DBW

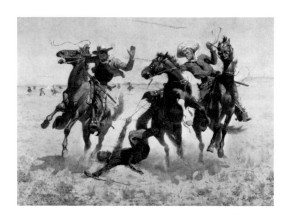

199 FREDERIC REMINGTON

American; Canton, New York 1861–Ridgefield, Connecticut 1909

Aiding a Comrade, 1890–1900
Oil on canvas; 34⅝ × 48⅛ (87.2 × 122.2)
Signed lower left: Frederic Remington
Hogg Brothers Collection 43.23

By the 1890's the American cowboy had become a national folk hero. Frederic Remington, although a born and bred Easterner, observed and recorded what were perceived as the cowboy's romantic activities on his journeys to the West. Much of Remington's work is devoted to spirited, narrative pictures like *Aiding a Comrade*, in which two mustachioed cowboys in the foreground pause to rescue their fallen compatriot from a sure death at the hands of the presumably savage Indians.

Remington's closely observed, realistic renderings of his subjects relate his work to the immensely popular painter-illustrators of the 1880's and 1890's, such as Howard Pyle (1853–1911). Many of Remington's works either were commissioned by *Harper's Weekly*, the leading illustrated periodical of the late nineteenth century, or were reproduced by the magazine. *Aiding a Comrade* is one of a large collection of Remingtons donated to the Museum as the Hogg Brothers Collection. Included are a number of black and white pictures made specifically as magazine illustrations. DBW

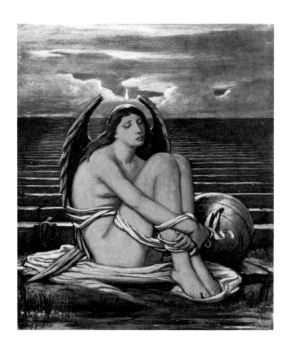

200 ELIHU VEDDER

American; New York, New York 1836–Rome, Italy 1923

Soul in Bondage, ca. 1891
Oil on paper board; 11¼ × 9⁷⁄₁₆ (28.6 × 24.0)
Gift of Mr. and Mrs. Ralph Mullin 72.33

Elihu Vedder, a native of New York, studied there and in Paris before the Civil War. In 1866 he left New York for Rome, where he lived the remainder of his life. He supplemented his income as an artist by designing stained glass, tiles, fireplace equipment, and other decorative items for the New York firm of Herter Brothers (see no. 181). His art is highly individualistic and almost always characterized by unexpected, haunting, and imaginative fantasies. In writing about his idea of the *Soul in Bondage*, Vedder said: "She is in darkness because she is turned from the light, and lightly bound because she *may* free herself . . . She will be sitting on a rocky path." Here a bound, angel-like figure sits beside water while a seemingly endless flight of steps extends to the horizon behind. The weight of the bondage is underscored by the large ball to which the cloth bonds are attached. The lengthy and difficult journey up the stone steps is further emphasized by the tortoise at the lower left who struggles up the first step toward the faint ray of light (hope?) that breaks through the clouds. Stylistically the

classical angel figure suggests Vedder's familiarity both with the Italian Renaissance and with the work of the English Pre-Raphaelites, who were his contemporaries.

Houston's small *Soul in Bondage* relates closely to a larger version in the Brooklyn Museum, although that painting omits the stone steps. Another version hangs in the Addison Gallery at Andover, Massachusetts. DBW

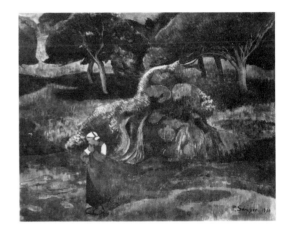

201 PAUL SÉRUSIER

French; Paris 1863–Morlaix 1927

Landscape at Le Poldu, 1890
Oil on canvas; 29¼ × 36¼ (74.3 × 92.1)
Signed and dated lower right: P. Sérusier–1890
Gift of Alice C. Simkins in memory of Alice N. Hanszen 79.255

Paul Sérusier studied at the Académie Julian intending an official career until, in 1888, the year he first exhibited in the Salon, he visited Pont-Aven in Brittany and fell under the influence of Paul Gauguin (see no. 202). The following year Sérusier rejoined Gauguin at Pont-Aven but shortly afterwards the two painters left for the nearby town of Le Poldu. There they stayed with other artists sympathetic to their avant-garde views at Marie Poupée's inn. After Gauguin left France for Tahiti, many younger artists came to know his work through Sérusier, for most of them did not know Gauguin personally. Thus Sérusier was the proselytizer among the followers of Gauguin who called themselves "Nabis," a word derived from the Hebrew word for prophet. In essence the Nabis insisted that an artist ought to impose his own personality on what the eye sees, changing the colors and contours of objects to suit an imagined mental image.

Landscape at Le Poldu shows Sérusier at the height of his powers and at his closest to Gauguin. A Breton peasant woman stands on a red ground depicting the muddy soil, but brighter than the soil's natural color. The lush trees and grass are painted in heightened hues of yellow green and emerald green. Pictorial space suggests a carving in low-relief—much flattened but not totally flat. Curvilinear rhythms unite the forms, especially the vegetation, in a decorative nonnaturalistic arabesque. In sum *Landscape at Le Poldu* is conceived in terms appropriate to a statement by Maurice Denis (1870–1943), another member of the Nabi group: "A picture—before being a horse, a nude, or an anecdotal subject—is essentially a flat surface covered with colors arranged in a certain order." JMW

202 PAUL GAUGUIN

French; Paris, France 1848–Hiva-Hoa, Marquesas Islands 1903

Arearea Joyousness II, ca. 1892–1895
Watercolor on linen; fan shaped, maximum dimensions 10¼ × 21¾
(26.0 × 55.3)
Signed lower right: P Gauguin
John A. and Audrey Jones Beck Collection 77.372

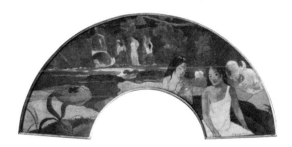

Unlike the Impressionists, with whom he was friendly and exhibited, Paul Gauguin was in large part self-taught and began as a Sunday painter while working for a Paris brokerage firm. In 1883 he quit his job to concentrate on

painting. An 1888 trip to Pont-Aven, Brittany, brought him in contact with a fellow artist, Emile Bernard (1868–1941). Out of discussions with Bernard, who is generally credited with having influenced his greater colleague, Gauguin developed his personal style of heightened color, flattened space, and forms rearranged to suit the artist's mental image. After a brief, tragic stay with Vincent van Gogh (1853–1890) in Arles, Gauguin began to think of going to the South Seas in the belief that life would be less expensive and easier there than in Paris. In 1891 he went to Tahiti, where he spent two years. In 1895 he again left Paris to go back to Tahiti, where he lived until 1901, when he settled in the Marquesas Islands. There he died two years later.

Painting on fans was popular in the nineteenth century, particularly with artists who, like Gauguin and Edgar Degas (1834–1917), were interested in the bright colors and off-center compositions of Japanese prints. As can be seen, not only from its shape but also from signs of folding, *Joyousness* was once made into a fan. It repeats, but with variations to accommodate its shape, the composition of a standard, rectangular painting, also entitled *Joyousness*, signed and dated 1892, now in the Louvre, Paris. The Museum's watercolor might, however, have been made in France between 1893 and 1895, when Gauguin occasionally used Tahitian themes.

The intensity of color, especially the crimson soil, and the curvilinear arabesque that plays across the composition to link the plants at the left with the figures on the right show Gauguin's rejection of the naturalism that dominated earlier nineteenth-century art. Both heightened color and arabesque were to be important to such twentieth-century Fauve artists as André Derain and Henri Matisse (see nos. 209 and 213). JMW

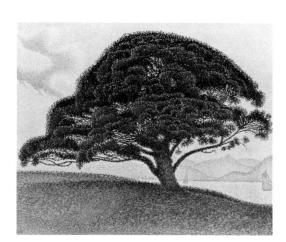

203 PAUL SIGNAC
French; Paris 1863–1935

A Pine on the Road to Saint-Tropez, 1893
Oil on canvas; 25⅞ × 31⅞ (65.7 × 81.0)
Inscribed lower left: Op 239
Signed lower right: P. Signac 93
John A. and Audrey Jones Beck Collection 74.142

Paul Signac became a full-time painter in 1882 but had no formal training except for a short period in a private studio in 1883. The following year he met and fell under the influence of Georges Seurat (1859–1891), but it was Signac who introduced his greater colleague to his circle of Symbolist writers and to the Impressionist painters. In 1886 Signac exhibited with Seurat at the last Impressionist exhibition, and his pictures were painted with Seurat's small, divided strokes. Particularly after the latter's death in 1891, Signac was the publicist of Neo-Impressionism, as the Pointillists (also known as Divisionists) preferred to call their method of painting. From 1892 Signac often painted at Saint-Tropez, and among his best pictures are his seascapes and coastal views painted from the late 1880's to the early years of the twentieth century.

A Pine on the Road to Saint-Tropez uses Neo-Impressionism's typical technique of small, dot-like strokes of color based on the purported theory that the separate, divided particles of color merge in the eye of the observer to produce an optical mixture. In fact the theory is pseudo-scientific, for an observer with good eyesight continues to see the separateness of the color dots at any normal viewing distance. Further, it is a fact that true optical mixture can only occur in color as

light (for example, in the colored filters used in theater), not in color as paint pigment. Thus opposite colors of light such as violet and yellow-green merge to produce white, but, as almost everyone knows from exposure to finger painting, a mixture of two such colors in paint produces dark gray-brown. Nonetheless, the eye does register an attempt, however imperfect, to merge the dots of color, and an optical vibration takes place, especially at the edges of the dots. This vibration produces the lively effects of color and light that make the Neo-Impressionist technique of painting exciting. JMW

204 EDOUARD VUILLARD
French; Cuiseaux 1868–La Baule 1940

The Promenade, 1894
Distemper on unprimed linen canvas; 84⅜ × 38⁹⁄₁₆ (214.3 × 97.9)
Signed and dated lower right: E Vuillard 94
Robert Lee Blaffer Memorial Collection; Gift of Mr. and Mrs. Kenneth Dale Owen 53.9

Originally intending a military career in his father's footsteps, Edouard Vuillard became involved with art through boyhood friendships with Ker-Xavier Roussel and Maurice Denis, schoolmates at the Lycée Condorcet. In 1888 Vuillard attended the Académie Julian, a freer institution than the Ecole des Beaux-Arts but with an essentially academic program. There he met Paul Sérusier (1863–1927) and became part of the Nabi group (see no. 201). The emphasis on two-dimensional design that characterized the art of the Nabis produced a flattening of masses in Vuillard's art as early as 1889; and in 1891 he began producing an extraordinary series of paintings in which forms were reduced to silhouettes. Toward the end of the decade, however, looser brushwork and concern for the rendering of three-dimensionality began to reappear in Vuillard's pictures. Such later works, though they lack the bold patterns of the pictures of the early 1890's, acquire a heightened sensitivity of touch.

The Promenade was one of a series of decorations commissioned in 1893 by Alexandre Natanson, publisher of *La Revue Blanche*, for the dining room of his Paris apartment. Of the nine large upright pictures, six are in museums (Musée de l'Art Moderne, Paris; Musées Royaux, Brussels; and Cleveland Museum of Art), and the remainder are in private hands. The paintings depict scenes in the Tuileries Gardens near where Vuillard was living at the time, scenes of the public gardens of Paris being a frequent subject in his art. Although the shapes are painted with extreme boldness, touches of color in the foliage and on the ground alleviate what might have appeared stark without them. Painted in Vuillard's flattened style of the early 1890's, *The Promenade* seems particularly appropriate for wall decoration, as the absence of illusory space leaves unbroken the flatness of the wall. JMW

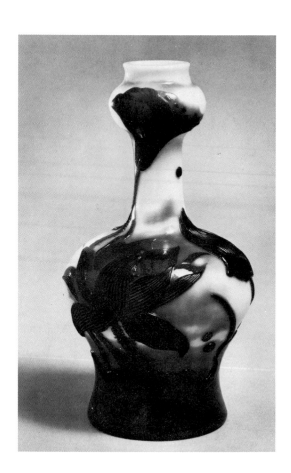

205 EMILE GALLÉ

French; Nancy 1846–1904

Water Lily Vase, ca. 1895–1900

Glass; h. 10½ (26.9), maximum diam. 5⁹⁄₁₆ (14.3), base 4⅛ (10.6)

Cameo-cut in body at base: GALLÉ

Gift of J. Brian and Varina Eby 73.141

In nineteenth-century art glass perhaps more than in any other medium, the antithetical elements of technological innovation and handcrafting allied to produce objects of extraordinary beauty and skill. The leader in the art-glass field in France was Emile Gallé, the Weimar-educated and London-traveled son of a glass-factory owner.

Gallé assumed leadership of the family concern in 1874. Although originally inspired by medieval and Persian subjects, Gallé soon directed his designers toward flower, plant, and animal ornamentation, decorative forms that comprise the bulk of his production. Unlike the art glass of Louis Comfort Tiffany (1848–1933), Gallé's glasswares and furniture line remained true to nature; he added fruits and flowers to his vessels without abstracting them.

Always Gallé and his craftsmen (some three hundred by 1889) pressed the medium to new limits: he imbedded metallic foil in the body of the vessels and used cabochon appliqués, powdered applied color, patination, and marquetry techniques in his workshops, in addition to more traditional molding, carving, and acid-etching techniques.

The Houston vase is based on an oriental form. Intended to resemble Peking glass, its opaque pale green ground was encased in red. In a cameo technique, the water-lily design was wheel-cut into the body: the more red cut away, the paler the remaining red on the body. After the pattern was cut, craftsmen fire-polished the vase, that is, they heated the vessel enough to soften the glass's crisply cut edges and smooth the surfaces abraded during cutting.

Following Gallé's death in 1904, the firm lost the creative force of its owner, who, with Antonin Daum, Louis Marjorelle, and Victor Prouvé, had made Nancy a principal contributor to France's Art Nouveau movement. With an interruption for World War I, the Gallé factory continued until 1931, producing largely repetitive, molded and etched material.

The water-lily vase is one of approximately eighty pieces of Gallé, Daum, Sèvres, Steuben, Tiffany, and Webb art glass in the Museum's collection. KSH

206 GUSTAV STICKLEY

American; Osceola, Wisconsin 1857–Syracuse, New York 1942

Sideboard, ca. 1904–1905
White oak, copper; h. 49 (124.0), w. 60¼ (153.0), d. 21 (53.0)
Red decal on back with joiner's compass and the words: Als/ik/kan/
Gustav Stickley
Museum purchase 78.65

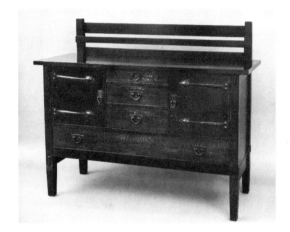

Gustav Stickley's spare and well-proportioned sideboard seems almost medieval in its board assemblage and bold mortise and tenon construction. Stickley, like his English Aesthetic Movement antecedents William Morris (1834–1896) and John Ruskin (1819–1900), turned away from more eclectic and ornate decorative designs in favor of those in a functional handcrafted tradition. After an extended trip to England and the Continent in 1898, Stickley, who was trained as a stone-mason and furniture maker, became a leading spokesman for the American Arts and Crafts movement. Stickley established the Gustave (Gustav after 1904) Stickley Company and, in 1900, began publishing the *Craftsman* magazine, which promoted his aesthetic and social philosophies.

The Houston sideboard is one of several related designs produced by the Stickley firm in what is popularly called the "Mission Style." Its exposed tenon construction, hammered copper hardware, practical, unassuming oak material, and simple plate rail are in the best craftsman tradition and clearly express the sideboard's functional intent. The sideboard bears two labels, Stickley's own decal of a joiner's compass framing "Als ik kan" (a phrase he borrowed from Jan van Eyck by way of William Morris) and that of the Cobb-Eastman Company, 111–117 Washington Street, Boston, Massachusetts. Cobb-Eastman operated at this address between 1900 and 1905. Like several other sideboards illustrated in the *Catalogue of Craftsman Furniture* (Eastwood, New York, 1909), this model also has a top drawer lined with "ooze leather" (suede).

By 1909 Stickley was pressed by more mechanized competitors, including his brothers L. and J. G. Stickley, whose factory also produced Arts and Crafts furniture. Consequently, the Craftsman Workshops, with the high operating costs required for hand work, declared bankruptcy in 1915, and the *Craftsman* magazine ceased publication in 1916. KSH

207 HILAIRE-GERMAIN-EDGAR DEGAS
French; Paris 1834–1917

Young Woman at Her Toilet, ca. 1905
Charcoal and pastel on tracing paper; 31 × 31 (78.7 × 78.7)
Stamped lower left: degas
Robert Lee Blaffer Memorial Collection; Gift of Sarah Campbell Blaffer
56.21

Despite a conservative training under the academic artist Louis Lamothe (1822–1869) and a reasonably conventional debut at the Salon of 1865, Edgar Degas became drawn to the modernist circle of the Impressionists through his friendship with Edouard Manet (1832–1883). Like the Impressionists, Degas abandoned literary and historical subjects in favor of depictions of the everyday world. However, Degas was not in the least interested in the spontaneous transcription of nature associated with Impressionism, particularly with Impressionist landscape. Further, and also unlike the Impressionists, Degas prepared his paintings by making innumerable drawings, rendering each figure with a power reflective of his debt to the tradition of Jean-Auguste-Dominique Ingres (1780–1867), who taught Lamothe. Nonetheless, Degas's technique in both painting and draftsmanship was altered toward a progressively freer stroke and rougher surface, an alteration very likely related to his exposure to Impressionism and participation in the Impressionist exhibitions. The development progressed as Degas's sight began to fail, and the artist made a virtue of necessity by working on a larger scale and in a simplified style.

From the 1880's Degas became interested in making drawings and pastels of nude women drying themselves. Their unconventional poses and powerful three-dimensionality show how far Degas departed from his academic training in a direction later to be associated with Expressionism, but in Degas's case kept in control by a concern for realism and anatomy that was perhaps his last remaining debt to Ingres. Jean Sutherland Boggs has dated the Museum's drawing (orally) "circa 1905." JMW

208 HILAIRE-GERMAIN-EDGAR DEGAS
French; Paris 1834–1917

Dancer Putting on Her Stocking, after 1900
Bronze: h. 18⅜ (46.5)
Signed upper part of base beside foot: Degas
Stamped upper part of base behind heel: cire perdue A.A.HEBRARD 29J
Gift of the Estate of Mrs. Harry C. Wiess, the Vale-Asche Foundation,
Mr. and Mrs. Lloyd Smith, and Museum purchase in memory of
Mrs. Harry C. Wiess
80.43

When Edgar Degas died about 150 sculptures were found in his studio. About 1900 Degas had commissioned the Hébrard firm to cast three of these works in plaster to preserve them from the fragility of wax. The other sculptures had remained in wax until their discovery in 1917. During the next few years seventy-three of the best-preserved models were cast in bronze by Hébrard in an edition of twenty-two examples each.

The date of execution of most of Degas's sculpture is conjectural, and *Dancer Putting on Her Stocking* is no exception. Because of its importance to the artist—

there are two other versions, both less finished than the Museum's example—it would appear likely that the sculpture was made after 1900. Had it been made earlier, it, too, would have been cast in plaster.

Considering the late date for the Houston sculpture, it is curious that the artist turned to two youthful drawings as sources. Charles Millard has pointed out that the dancer's general pose is derived from a classical figure (notebook 2, p. 78, 1854–1855), identified by Theodore Reff as a man tying his sandal copied from a figure on the Parthenon frieze. Apparently no one has heretofore remarked that the precise gesture of putting on the stocking is taken from the figure of a seated man putting on a legging at the lower right in Michelangelo's *Battle of Cascina*. Degas also drew this figure (notebook 9, p. 17, 1856–1857). Given Degas's interest in realistic observation, avant-garde for his day, it is curious that he turned to two supremely classical sources for inspiration. Given his interest in modeling in the round, it is curious that one of these sources, the Parthenon frieze, was in low relief while the other, the *Battle of Cascina*, was a two-dimensional design for a painting. Perhaps, however, it is because the artist's sources were so far removed from the end result that *Dancer Putting on Her Stocking* conveys such a powerful suggestion of modernity and originality. JMW

209 ANDRÉ DERAIN
French; Chatou 1880–Garches 1954

The Turning Road, 1906
Oil on canvas; 50½ × 76⅝ (128.2 × 194.6)
Signed lower right corner: Derain
John A. and Audrey Jones Beck Collection 74.138

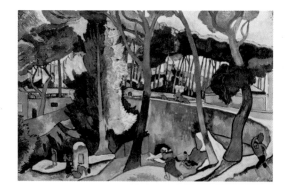

In reviewing the Paris 1905 Salon d'Automne, critic Louis Vauxcelles mockingly referred to a group of painters—Henri Matisse (see no. 213), André Derain, Maurice de Vlaminck (1876–1958), Albert Marquet (1875–1947), and Henri Manguin (1874–1949)—as "les fauves" (wild beasts) because of the vivid colors of their canvases. Thus he named a development in painting that had begun just after the turn of the century and lasted until about 1910.

Derain, Matisse, and Vlaminck formed the core of the Fauves. During his studies at the Académie Carrière the eighteen-year-old Derain began a friendship with Matisse in 1899. A decade older, Matisse was already painting in clear, complementary colors. In 1900 Derain met Vlaminck, and the two decided to share a studio in Chatou, a Parisian suburb. Derain introduced Vlaminck and Matisse to each other at the first major exhibition of works by Vincent van Gogh (1853–1890) to be held in Paris (1901). Thus the three principal Fauves shared their ideas as each pursued concepts that had evolved in the Post-Impressionist work of the Symbolists—juxtaposition of unnaturalistic color and design with an eye toward decorative rhythm and harmony.

Derain's *The Turning Road*, painted after a 1905 trip to L'Estaque, is a masterpiece of Fauve color and design. The vivid, arbitrary hues and the organization of the landscape into a decorative overall pattern are related to the works of Paul Gauguin (1848–1903) as well as to those of van Gogh, who attributed symbolic values to color and design. During the summer of 1904 Derain and Matisse are known to have visited a large private collection of Gauguin's work in Southern France. Derain's rhythmic brush strokes enhance the compositional balance of the painting, and the Neo-Impressionist brushwork in the trees adds to the overall intensity of the work. JMR

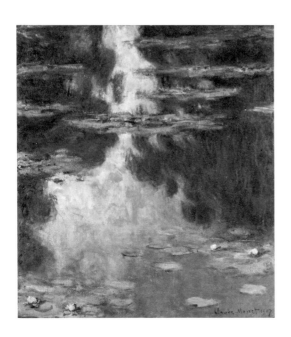

210 CLAUDE-OSCAR MONET

French; Paris 1840–Giverny 1926

Water Lilies, 1907

Oil on canvas; 36¼ × 31 ¹⁵⁄₁₆ (92.1 × 81.2)
Signed and dated lower right: Claude Monet 1907
Gift of Mrs. Harry C. Hanszen 68.31

In 1859 Claude Monet left his native Le Havre, where he had attracted the interest of Eugène Boudin (1824–1898), to go to Paris. There he studied under Charles Gleyre (1808–1874) but abandoned his teacher's academic studio practices to paint on his own. Though Monet's pictures were accepted by the Salon jury in 1865 and 1866, he then suffered a series of Salon rejections. When it became apparent that any success he achieved would have to come outside the government-sponsored Salon exhibition system, Monet joined the group of artists who, in 1874, organized the first Impressionist exhibition (see no. 189). In general Monet was and remained the most typically Impressionist of the group, but, despite Impressionism's emphasis on painting directly out of doors, it is known that he was willing to finish pictures in his studio.

In 1890 Monet bought a house and property at Giverny, where he had been living for several years. From then on his favorite subject became the water garden he created there. *Water Lilies,* or *Nympheas,* is one of a series of pictures painted in the years around 1907. In these pictures Monet concentrated on a small portion of the pool, eliminating any reference to solid land. Indeed, the reflections of sky and trees seem almost as tangible as the water lilies themselves. Such concentration on fleeting effects of nature was the heritage of Monet's Impressionism of the 1870's and 1880's. However, in the late pictures, such as *Water Lilies,* Monet began to reveal an interest in rhythmic brushwork, which had the effect of reducing the naturalism characteristic of earlier Impressionism by stressing the surface of the picture as a two-dimensional design. Such a thrust toward abstraction was to continue in yet later works like the *Japanese Footbridge at Giverny* (see no. 234). JMW

211 ALFRED STIEGLITZ

American; Hoboken, New Jersey 1864–New York, New York 1946

The Steerage, 1907

Photogravure; 12⅝ × 10³⁄₁₆ (32.1 × 25.9)
Target Collection of American Photography; Museum purchase with funds provided by Target Stores 76.254

Alfred Stieglitz was a gallery director, a magazine editor and publisher, an art collector, and a photographer. He began this diverse career as a photographer; the other roles he assumed in his efforts to have photography recognized as an art form and to have American art accepted as the equal of European. Through his galleries and his magazines he nurtured individuals who were devoted to creating uniquely American art and pushed Americans to better support their artists, both spiritually and financially. But in his search for American art forms, he did not try to isolate or codify what he considered to be "American." Nor did he exhibit and publish American arts exclusively. He introduced America to the work of most of the major European modernists, including Paul Cézanne, Henri Matisse, and Pablo Picasso (see nos. 194, 213, and 221).

In his own photographs, Stieglitz incorporated the ideas of the modern artists he advocated. Simultaneously he rejected photographs that superficially looked like paintings or that closely approximated traditional drawings and etchings. His photographs, particularly those made after 1907, shift from the impressionistic tonal harmonies favored by the Pictorialist photographers (see nos. 228 and 242) that he had initially championed, to photographs that were sharply focused, rich in detail, and distinctly modern in composition and subject.

The Steerage was a pivotal photograph for Stieglitz and a milestone in the history of photography. Stieglitz described the shapes as he saw them: "a round straw hat, the funnel leaning left, the stairway leaning right, the white drawbridge with its railings made of circular chains—white suspenders crossing on the back of a man in the steerage below, round shapes of iron machinery, a mast cutting into the sky, making a triangular shape." He also wrote about the scene in steerage class and of how he longed to join it. The power of *The Steerage* resides equally in human drama and in abstract form. It was Stieglitz's acceptance of abstraction as a means to achieve pictorial power that had a radical and profound influence on the history of photography. AT

212 GEORGES BRAQUE

French; Argenteuil-sur-Seine 1882–Paris 1963

Fishing Boats, 1909
Oil on canvas; 36¼ × 28⅞ (92.1 × 73.3)
Signed lower right: G Braque
John A. and Audrey Jones Beck Collection 74.135

Georges Braque moved to Paris from Le Havre in 1900 and by 1906 was painting with the high color of Fauvism (see no. 209). However, by the time he met Pablo Picasso (1881–1973) in Daniel Kahnweiler's Paris gallery (1907) Braque's paintings had begun to reflect his interest in the geometry and ambiguous perspective seen in the works of Paul Cézanne (1839–1906). Together, Braque and Picasso worked out a visual system that analysed the form of an object and its relationship to the flat surface of the canvas. In writing about Braque's paintings exhibited at the 1909 Salon des Indépendents the critic Louis Vauxcelles referred to the works as "bizarreries cubiques."

Fishing Boats (1909) and the related *Normandy Harbor* (Art Institute of Chicago) are two important early Cubist paintings. *Fishing Boats* is characteristic of the analytical phase of Cubism in its limited and nondescriptive color and in the geometric planes that describe the boats and surrounding harbor. No differentiation exists in the handling of the boats and the surrounding space. The verticals and diagonals of the masts and roofs give the composition order and cohesion. The absence of traditional perspective prevents the objects from receding into the background in an illusion of three-dimensional space, while the tonal gradations and faceting of the planes create constant shifts in solidity and volume.

Cubism explored the paradox between the reality of objects as they exist in space and the reality of the canvas as a two-dimensional surface. Its demonstration that form is not a stationary and immutable characteristic of an object changed the course of Western art. JMR

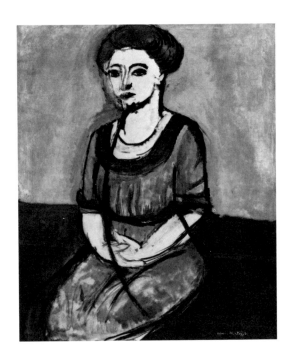

213 HENRI-EMILE-BENÔIT MATISSE
French; Le Cateau 1869–Nice 1954

Portrait of Olga Merson, 1910
Oil on canvas; 39¼ × 31¾ (99.7 × 80.7)
Signed lower right corner: Henri Matisse
Museum purchase with funds provided by the Agnes Cullen Arnold
Endowment Fund 78.125

Henri Matisse is an undisputed giant of twentieth-century art. Born in northern France, he studied law and clerked in a law office until a paint set given to him during an 1890 illness interested him in art. Matisse went to Paris, where he studied briefly with Adolphe William Bouguereau at the Académie Julian (1891–1892) and with the Symbolist painter Gustave Moreau (1892–1897). While working at the Académie Carrière in 1899, Matisse met André Derain (see no. 209), who in 1901 introduced him to Maurice de Vlaminck (1876–1958). These three artists exhibited together at the 1905 and 1906 Salon d'Automne, where the vivid, arbitrary colors of their paintings created a sensation and led the critic Louis Vauxcelles to refer to them as Fauves or wild beasts.

Portrait of Olga Merson (1910) exemplifies the broader, more monumental style that followed Matisse's Fauve period. It is one of a group of portraits executed between 1908 and 1910 in which Matisse studied and dealt with the relationship of figure to ground. The slightly diagonal line that divides the two areas of the background offsets the other diagonals in the figure. The curving black line running from chin to thigh and the parallel arc of the sitter's back represent the most radical linear innovation of Matisse's career to this point and may reflect his interest in Cubism, which continued in the years after 1910. The heavy black lines also enhance by contrast the rich blues, greens, and browns Matisse used to model the figure through the interaction of adjacent colors rather than through tonal modulation. In *Portrait of Olga Merson* Matisse was not trying to create a traditional portrait—a physical resemblance or even a psychological characterization. In his *Notes of a Painter* (1908), Matisse wrote that his goal was to "reach that state of condensation of sensations which constitutes a picture." He allowed changes, as in the face and arm of the *Portrait of Olga Merson*, to remain visible, thereby revealing the searching, probing quality of his work. Similar "corrections" are visible in many of his paintings from this period, for to Matisse overall harmony and balance were more important than conventional notions of a finished picture. JMR

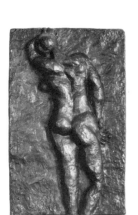

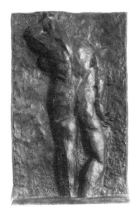

214 HENRI-EMILE-BENÔIT MATISSE
French; Le Cateau 1869–Nice 1954

The Backs I–IV, 1909, 1913, 1916, ca. 1931
Bronze
 I. h. 74⅝ (189.6), w. 45⅝ (115.9), d. 7⅜ (18.8)
 Signed lower left: Henri Matisse
 Initialed and numbered lower right: HM 9/10
 Inscribed on base lower left: Georges Rudier./Fondeur. Paris.
 Gift of Mr. and Mrs. Theodore N. Law in memory of Mr.
 and Mrs. Harry C. Wiess 80.68
 II. h. 74⅝ (189.6), w. 47¾ (121.3), d. 7⅜ (18.8)
 Signed lower left: Henri Matisse

Initialed and numbered lower right: HM 9/10
Inscribed on base lower right: Suisse Fondeur./Paris.
Gift of Mr. and Mrs. Gus Wortham 80.69
III. h. 73⅞ (187.7), w. 44¹⁵⁄₁₆ (114.2), d. 7 (17.8)
Indistinctly signed lower left: Henri M
Initialed and numbered lower right: HM 9/10
Inscribed on base lower left: Georges Rudier./Fondeur. Paris.
Gift of the Cullen Foundation 80.70
IV. h. 74½ (189.2), w. 44⁹⁄₁₆ (113.2), d. 6¹⁵⁄₁₆ (17.7)
Initialed and numbered lower right: HM 9/10
Inscribed on base lower left: Georges Rudier./Fondeur. Paris.
Gift of the Brown Foundation in honor of Mr. and Mrs.
Herman Brown 80.71

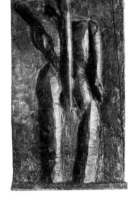

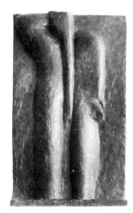

While Henri Matisse is perhaps best known as a painter, he was also one of the greatest sculptors of the twentieth century. His sculpture, which he created throughout his career, is represented in the Museum's collection by *The Backs*. These four life-sized reliefs are Matisse's largest sculptures and cover a broad span of his development, from the expressive modeling and complex volumes of *Back I* (1909) to the simplicity and clarity of *Back IV* (ca. 1931). Matisse is known to have reworked each successive *Back* from a plaster cast of the preceding one, probably adding clay to the areas of plaster that needed to be built up as Albert Elsen has suggested. *The Backs* were never shown together during Matisse's lifetime and were not conceived as a series or set. Instead, they should be seen as one work that passed through four stages—an ongoing sculptural clarification of the simplified forms Matisse simultaneously studied in both his painting and sculpture.

In *The Backs* Matisse chose to explore the challenge of endowing the human figure with expressive power without showing its face. While the pose is not common, it does have precedents in the sculpture of Auguste Rodin (1840–1917) and Aimé-Jules Dalou (1838–1902) and in the paintings of Jean-Auguste-Dominique Ingres (1780–1867), Gustave Courbet (1819–1877), and Paul Gauguin (1848–1903). The most immediate source, however, is found in Paul Cézanne's *Three Bathers*, which Matisse himself owned.

In each succeeding *Back* the figure is progressively straightened, and the axis of the spine is emphasized. The forms of the body are organized into increasingly fewer and more concise areas, and the variation between the depth of figure and ground is gradually flattened so that the volumes are enhanced rather than obscured by the play of light. JMR

215 ALBERT GLEIZES

French; Paris 1881–Avignon 1953

Woman with Phlox, 1910

Oil on canvas; 32⅛ × 39⁷⁄₁₆ (81.6 × 100.2)
Signed lower left: Albert Gleizes 10
Gift of The Esther Florence Whinery Goodrich Foundation 65.39

Albert Gleizes began painting seriously around 1902 and was a founder of l'Abbaye de Créteil (1906–1908), a community of artists and writers. By the time this commune had dissolved due to lack of finances, Gleizes's painting had become more schematic as he developed what was to become his style of Cubism.

Gleizes belongs to the group of Cubists, among them Jean Metzinger (1886–1956) and Henri Le Fauconnier (1881–1945), who worked outside the circle of Pablo Picasso (1881–1973) and Georges Braque (1882–1963) and used Cubist forms to express metaphysical ideas about modern life. *Woman with Phlox* is a major work and was first exhibited in the historic 1911 Salon des Indépendents. There, Gleizes and Metzinger, dissatisfied with the random hanging of the Salon, secured a room (Salle 41) in which many of the Cubists exhibited together.

Woman with Phlox embodies several of the characteristics that set Gleizes's Cubism apart from that of Picasso and Braque. Picasso and Braque presented their subjects without regard to conventional symbolism. In contrast, Gleizes, while working in the idiom of Cubism, interpreted his subject matter in a manner that linked his art to art of the past. In contrast to the shifting planes and multiple spatial axes of the early Cubism of Picasso and Braque, Gleizes has retained the sense of the figure as an entity existing in and apart from the surrounding space. The passages describing the physiognomic and anatomical detail of the woman's face and hands are also in opposition to the analytical purity of the early Cubist works of Picasso and Braque.

Gleizes took part in the Cubists' informal meetings at the studios of Jacques Villon (1875–1963) and Raymond Duchamp-Villon (1876–1918) in the suburb of Puteaux and exhibited with the Puteaux Cubists in the Salon de la Section d'Or at the Galerie de la Boetie in 1912 (see no. 220). With Jean Metzinger, Gleizes wrote the first treatise on Cubism, *Du Cubisme*, published in 1912. It analyzes concepts that were to have far-reaching effects on subsequent developments in modern art. His contribution to *Du Cubisme* has also helped to secure a significant place for Gleizes in early twentieth-century art history. JMR

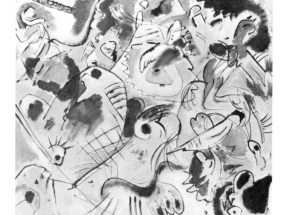

216 WASSILY KANDINSKY

Russian; Moscow, Russia 1866–Neuilly-sur-Seine, France 1944

Skizze 160 A, 1912
Oil on canvas; 37⅜ × 42½ (94.9 × 108.0)
Signed front lower left: Kandinsky 1912
John A. and Audrey Jones Beck Collection 74.140

Wassily Kandinsky, one of the first painters to develop an abstract art, was a practicing lawyer and economist in his native Russia before he left for Munich in 1896 to study painting. Although his earliest works reflected the decorative influence of the Jugendstil and portrayed subjects from legends and folk tales, he gradually moved toward abstraction and arbitrary use of color. His grasp of the potential of nonrepresentational painting was clarified in 1910 when, failing to recognize one of his paintings that had been hung upside down, he was struck by the inherent expressive qualities of shape and color.

Kandinsky believed that it was the task of the artist to reveal realities of the spiritual rather than of the material world. In his treatise *Concerning the Spiritual in Art* (written 1910, published 1912) he elaborated his belief that every shape and color had a distinct meaning and expressive value and that reciprocal correspondences existed between painting and music. In 1911 Kandinsky formed the Blue Rider Group with Alexei Jawlensky (1864–1941), Gabrielle Münter (1877–1962), and Franz Marc (1880–1916). The group existed primarily to exhibit their work and also published a journal, *The Blue Rider Almanac*, in which Kandinsky expanded upon his concept of the relation between music and painting.

Far from viewing color and form as ends in themselves, Kandinsky maintained

that each component of a composition had spiritual meaning. During the years before World War I Kandinsky often used the theme of the Apocalypse to express what he saw as a cosmic struggle between good and evil. Rose-Carol Washton Long has noted that in *Skizze 160A*, though veiled by color and stripped of details, the images of a horse and rider, a mountain, and birds and fish—all symbols of the Apocalypse—are clearly discernible. Kandinsky feared that total abstraction might become decorative and retained traces of the real world in his work until after 1920. JMR

217 EUGÈNE ATGET
French; Libourne 1857–Paris 1927

Vendors from Baskets from the *Picturesque Paris* series, 1912
Albumen photograph; 8¼ × 6½ (21.0 × 16.5)
On verso in ink: Md au Panier 369
Museum purchase 76.257

Eugène Atget became a photographer at age forty-one. He had previously been an actor playing secondary roles with provincial troupes and a sailor. A self-taught journeyman, Atget made an estimated eight thousand photographs of Paris and its environs, which he organized into series and bound into books of original photographs for display and sale.

Atget compiled a great visual catalog of the fruits of French culture. He focused his acute attention on subjects as diverse as the trees at St. Cloud, historic facades, Parisian street vendors, shop windows, and picturesque views. To some of these subjects he returned repeatedly over a period of years, for he knew that potentially each offered an infinite number of images. His photographs are "the product of an energy absolutely and continually intrigued by the problem of *how* the world and its 'ten thousand facts' can be described by a camera" (Tod Papageorge, unpublished letter to A. D. Coleman).

Vendors from Baskets has been identified by Maria Morris as part of the *Picturesque Paris* series. "When he photographed these flower vendors, Atget was engaged in making bound books of original prints that he sold to the Bibliothèque Nationale. One of these books, called *Métiers, Boutiques et Etalages*, was a collection of photographs that showed the way small commerce advertised or presented itself in Paris. This picture was probably made to be part of that book . . .[but it] is less a picture about what they are selling than a picture of a type of commerce—the kind that sold from baskets on a street corner. The title, which calls them 'vendors from baskets' instead of flower-vendors, indicates this" (letter in Museum file). AT

218 MARSDEN HARTLEY

American; Lewiston, Maine 1877–Ellsworth, Maine 1943

Abstraction, ca. 1913–1914

Oil on paper board; 24¼ × 20 (61.6 × 50.8)
Gift of Mr. and Mrs. Ralph O'Connor in honor of Mr. and Mrs.
George R. Brown 80.82

Marsden Hartley spent his youth in Ohio where he studied at the Cleveland
School of Art. He went to New York in 1899 and studied there with William
Merritt Chase (1849–1916). His work attracted the interest of photographer and
avant-garde gallery owner Alfred Stieglitz (1864–1946), who first exhibited
Hartley's paintings at the Photo Secession Gallery ('291') in 1909. In the Spring
of 1912 Hartley left for Paris, financed by Stieglitz and armed with a letter of
introduction to the French painter Robert Delaunay (1885–1941). Hartley vis-
ited Delaunay's studio and saw the Orphist works in which Delaunay synthesized
Cubist space with experimental color. The bright colors and circular shapes in
Hartley's *Abstraction* bespeak his exposure to Delaunay's work.

However, it was the art of Wassily Kandinsky (1866–1944) that led Hartley
to abstraction. On arriving in Paris Hartley discovered Kandinsky's first pub-
lished book *Concerning the Spiritual in Art*. Soon Hartley was writing to Stieglitz,
citing Kandinsky's treatise as his impetus in turning from still life to "intuitive
abstractions." In January 1913 Hartley traveled to Munich expressly to meet
Kandinsky and his fellow artists in the Blue Rider Group (1911–1914), Alexei
Jawlensky (1864–1941), Franz Marc (1880–1916), and Gabrielle Münter (1877–
1962). After Hartley's return to Paris he and Kandinsky exchanged photographs
of their work by mail. *Abstraction* is a prime example of Hartley's synthesis of
lessons learned from the experimental color and Cubist structure of Delaunay
and the abstraction and expressive intensity of Kandinsky. JMR

219 MIKHAIL LARIONOV

Russian; Teraspol, the Ukraine 1881–Fontenay-aux-Roses, France 1964

Street Lighting, 1913

Oil on board; 10 × 15 (25.5 × 38.0)
Signed and dated front lower right: ML 1910 (date is a later, incorrect
addition)
Gift of Mr. and Mrs. George R. Brown 75.358

Mikhail Larionov was a leader of the twentieth-century Russian avant-garde and,
with Wassily Kandinsky (1866–1944), one of the first painters to develop a truly
abstract style. Fusing ideas from Cubism, Futurism, and Russian folk art,
Larionov evolved his Rayonist style of painting in the spring of 1912, formally
announcing it with a Rayonist manifesto published in 1913. As seen in *Street
Lighting* (1913), Larionov's Rayonism depicted the forms created by the inter-
section of pure rays of light reflected from various objects. Larionov thus carried
the Impressionists' concern with light and color to a new conclusion, but by
limiting himself to the ray-like manifestations of light before they had been
interpreted by the eye, concentrated on the abstract qualities of color, texture,
and pure form.

Rayonism was important despite its small body of extant work. Larionov and
his colleague Natalia Goncharova (1881–1962) alone worked in this manner,
abandoning the style after they moved to Paris in 1914. After 1915 they designed

stage sets in a primitive folk style for the ballets of Sergei Diaghilev. In its synthesis of various currents of early twentieth-century avant-garde art, Rayonism provided a focus of artistic theory that led to successive developments in constructivism and nonobjective art. JMR

220 ROGER DE LA FRESNAYE
French; Le Mans 1885–Grasse 1925

The Fourteenth of July, 1914
Oil on canvas; 28¼ × 38¼ (71.8 × 97.2)
John A. and Audrey Jones Beck Collection 75.26

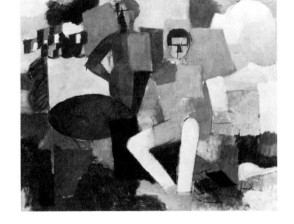

Roger de La Fresnaye, who was associated with the Puteaux Cubists, exhibited with this group in the historic Salon de la Section d'Or at the Galerie de la Boetie in Paris in 1912. These artists, who included Albert Gleizes (1881–1953), Jean Metzinger (1883–1956), and Fernand Léger (1881–1955), had been meeting in the studios of Jacques Villon and his brother, Raymond Duchamp-Villon, in the Paris suburb of Puteaux. They discussed their view of Cubism, which differed from the rigorous antisymbolic purity of the Cubism of Pablo Picasso (1881–1973) and Georges Braque (1882–1963) in its encompassment of contemporary philosophy, science, mathematics, and social concerns. Traditional themes are also characteristic of the Puteaux Cubists, who deliberately portrayed events of French life and history in order to link their modernist art with the glories of past French art.

In *The Fourteenth of July* La Fresnaye has portrayed a pair of spectators on Bastille Day, possibly watching a passing parade in celebration of the French national holiday. Whereas La Fresnaye's use of flat, rectangular planes is rooted in the Cubism of Picasso and Braque, the vivid colors of the shapes and the way in which they cling to the surface instead of receding into space are hallmarks of La Fresnaye's own style of Cubism.

The Fourteenth of July in Houston is one of a number of painted studies and drawings preparatory to a large final version that was never executed. A second larger but less fully realized study in which the figures are more naturalistic hangs in the Musée National d'Art Moderne, Centre Georges Pompidou in Paris. At the outbreak of World War I La Fresnaye joined the infantry, only to be discharged in 1918 after two lung hemorrhages. He was periodically hospitalized and by 1924 had become too ill to paint. He died in 1925 without completing the final version of *The Fourteenth of July.* JMR

221 PABLO PICASSO
Spanish; Malaga, Spain 1881–Mougins, France 1973

Pipe and Sheet Music, 1914
Collage (paper); 20½ × 26½ (51.4 × 66.6)
Signed in box bottom center: Picasso
Gift of Mr. and Mrs. S. M. McAshan, Jr. 69.11

Pablo Picasso was born in Malaga, Spain, but lived in France from 1904 until his death in 1973. The variety and prolificacy of his career, and his creation of successive master works in radically different styles, make him one of the great geniuses of the history of art.

In May 1912, Picasso created the first collage (from the French verb *coller*, to paste) when he glued a piece of oilcloth printed with a caning design onto his Cubist canvas *Still Life with Caning*. By September of the same year, Georges Braque (1882–1963), Picasso's colleague in the development of Cubism, was also creating *papiers collés*, compositions of cut and pasted papers. This technique, which added another dimension to the analytical Cubist fragmentation of objects by setting up play between the reality of painted and real surfaces, led to a second, "synthetic" phase of Cubism in which objects were created from forms that were not necessarily intrinsic to them. *Papier collé* also reintroduced to Cubism color, larger flat surfaces, and more interest in surface textures.

In *Pipe and Sheet Music* (1914) Picasso has combined drawing with pasted paper to create an interplay between levels of reality. A trompe l'oeil border of decorative paper and a painted frame cast an illusionistic shadow drawn in heavy pencil on the printed wallpaper background. The shadows cast by the rectangle of brown wrapping paper in the center of the work are also drawn. The pipe, drawn on a piece of white paper, is covered with stippled bands of yellow, red, and blue dots. The title of the sheet music "Ma Jolie" was a popular love song of the day and Picasso's tribute to his current mistress, Marcelle Humbert, whom he called Eva. The words recur throughout his works from this period. JMR

222 MORGAN RUSSELL

American; New York, New York 1886–Broomal, Pennsylvania 1953

Synchromy, ca. 1914
Oil on composition board; 13 × 13¾ (33.0 × 34.9)
Signed verso upper right corner in red paint: M.R.
Museum purchase 78.149

Morgan Russell and Stanton Macdonald-Wright (1890–1973) founded Synchromism, a movement that translated laws of optics into color-dominated abstract painting. In 1906 Morgan Russell began three years of study at the Art Students' League in New York with Robert Henri (1865–1929) and the sculptor James Earle Fraser (1876–1953). During this time he traveled in Europe every spring and summer. On such a trip in 1908 he became absorbed in the paintings of Claude Monet (1840–1926) and undertook his first study of color composition. In 1909 Russell settled in Paris to study sculpture with Henri Matisse (1869–1954). He began to paint again in 1910, and his feeling for sculptural qualities of mass and volume drew him to the work of Paul Cézanne (1839–1906), where he found the modulations and abstract relations of color that were to become the basis of his methods of color composition. By 1911 Russell was devoting all his energy to painting, and near the end of this year he met fellow American Stanton Macdonald-Wright. Drawn to each other by a mutual interest in Cézanne, both men were aware at this time of Robert Delaunay's (1885–1941) application of color theories to abstract compositions. Wright joined Russell in his studies with color theoretician Ernest Tudor-Hart, and at the same time both men were reading about color theory.

Russell and Wright held their first Synchromist exhibition at the Neue Kunst Salon in Munich in June 1913. They took the name Synchromism (literally "with color") from Russell's late 1912 painting *Synchromie en Vert* (now de-

stroyed) and prepared a joint statement for the catalog. A second Synchromist exhibition was held at the Galerie Bernheim Jeune in Paris in October 1913.

The abstract planes of Russell's *Synchromy* (1914) demonstrate his application of color theories to achieve his goal: "a piece of expression solely by means of color and the way it is put down, in showers and broad patches, distinctly separated from each other or blended . . . but with force and clearness and large geometric patterns, the effect of the whole as being constructed with volumes of color." Synchromism as a movement was disbanded with Wright's 1914 return to the United States; yet its approach to creating form through pure abstract relationships of color had a lasting impact in teaching a generation of American artists about color usage. JMR

223 STANTON MACDONALD-WRIGHT
American; Charlottesville, Virginia 1890–Pacific Palisades, California 1973

Arm Organization, 1914
Oil on canvas; 36 × 30⁹⁄₁₆ (91.4 × 76.7)
Signed recto lower left corner: S Macdonald Wright
Museum purchase 80.33

Stanton Macdonald-Wright, co-founder with Morgan Russell of Synchromism (see no. 222) studied art in California before going to Paris at the age of seventeen. After six months in Paris he abandoned his formal art studies at the academies to work on his own. During this time he bought four watercolors by Paul Cézanne (1839–1906) and became intrigued by the modulations and relations of color in Cézanne's work. His growing concern with the scientific properties of painting, interest in the color theories of the Neo-Impressionists, and awareness of the color abstractions of Robert Delaunay (1885–1941) enabled Wright to strike an immediate rapport with Morgan Russell when the two met in late 1911. Wright joined Russell in his classes with Ernest Tudor-Hart, who helped the two younger men translate into practice their readings of treatises on color theory and optics by Chevreul, Blanc, Helmholtz, and Rood.

Arm Organization, painted after Wright and Russell issued their Synchromist manifesto in Munich in June 1913, exemplifies Wright's personal use of color as the dominant formal means of organization in his painting. Unlike Russell, Wright based his abstractions on his observation of natural forms and their movement. In *Arm Organization* the placement of the disks of color is based on the pattern created by the spiral of a flexed arm, probably that of Michelangelo's *Slave* (Louvre, Paris), which Wright admired enormously. Wright's areas of color, more transparent and less sculptural than those in Russell's paintings, are modulated and arranged to create an overall harmony through correspondence and contrast. At the end of 1913 Wright made the first of several trips back to the United States, and by 1914 Russell and Wright had ended their brief collaboration.

Though Synchromism's duration as a movement was less than a year, it played an important role in disseminating modern scientific color theory in the service of abstract painting among early twentieth-century American artists.
 JMR

224 EDWARD ALEXANDER WADSWORTH
English; Cleckhealton 1889–London 1949

Enclosure, 1915
Gouache, ink, pencil, painted paper on paper; 27¹⁵⁄₁₆ × 21⁹⁄₁₆ (71.0 × 54.7)
Signed recto lower left corner in pencil: Edward Wadsworth 1915
Museum purchase with funds provided by The Brown Foundation 77.277

Edward Wadsworth studied engineering in Munich (1906) before attending the Slade School of Fine Arts in London (1908–1912). He joined Wyndham Lewis's short-lived Relief Art Center in the spring of 1914. Eventually he became a part of Lewis's Vorticist movement, signing the Vorticist Manifesto and contributing to the group's publication *Blast*.

Vorticism was the first modernist movement in England. Founded by author and painter Wyndham Lewis (1884–1957), its goal was to shock a complacent English society into an awareness of the machine age. Vorticism synthesized elements from Futurism and Cubism, balancing energy against control to create a distinctive feeling of latent power. Other Vorticists included Ezra Pound, who named the movement, Henri Gaudier-Brzeska, William Roberts, and David Bomberg (1890–1957). Bomberg is also represented in the Museum's collection.

Wadsworth exhibited *Enclosure* in the first Vorticist Exhibition held at the Doré Gallery in London in June 1915. The reds and blues of the painting are typical of Vorticism's harsh, jolting color. The densely juxtaposed, striped and solid blocks jostle one another aggressively, while the overlaying network of paper strips controls the surface, creating a feeling of energy barely held in check. The diagonal forms are at once fragmented and locked together, producing characteristic Vorticist tension.

World War I scattered the Vorticists, and although most of them returned from the War in 1918, the climate of impetuosity and experimentation had changed. In 1919 the final issue of *Blast* remained unpublished. By the 1920's Wadsworth had abandoned Vorticism for the representational style which, apart from a brief period in the 1930's, he pursued until his death. JMR

225 PATRICK HENRY BRUCE
American; Virginia 1881–New York, New York 1936

Composition VI, 1916
Oil on canvas; 64¼ × 51¼ (163.2 × 130.2)
Museum purchase with funds provided by the Agnes Cullen Arnold
Endowment Fund 79.69

Patrick Henry Bruce, great-great-great-grandson of Patrick Henry, studied in New York (1902–1903) with William Merritt Chase (1849–1916), Robert Henri (1856–1929), and Kenneth Hayes Miller (1876–1952) before moving to Paris in late 1903 or early 1904. Although at first Bruce's art was unchanged by his proximity to modern French painting, by 1908 he had become one of the original members of Henri Matisse's (1869–1954) school, and his work began to show the profound influence of Paul Cézanne (1839–1906) as interpreted by Matisse. In 1912 Bruce met and became close friends with Sonia (1885–1979) and Robert Delaunay (1885–1940). His exposure to the Delaunays' Orphist use of intense color and contrasting values led Bruce to apply heightened color to Cubist abstractions and provided him with a deep understanding of the optical theories of color. Although Bruce had become independent of the Delaunays after the

outbreak of World War I, his works continued to show his knowledge of and affinity for color.

Composition VI is one of six extant *Compositions* that are among Bruce's earliest mature works. The *Compositions* are abstract interpretations of the movement at the Bal Bullier, a fashionable dance hall in Paris frequented by many artists, poets, and writers. His break from the flat, decorative style of Orphism is evident, and his organization of color planes into volumes creates a sculptural quality. Although Bruce shared with Synchromists Morgan Russell and Stanton Macdonald-Wright (see nos. 222 and 223) the use of color theory, he was never a Synchromist and eschewed the modulation of color through tonal gradation found in Synchromist works. Instead, Bruce applied color in flat shapes, each modifying that adjacent to it according to optical laws to create geometric structures of color and movement. In late 1916 Bruce sent the six *Compositions*, *Composition VI* among them, to his friend and fellow painter Arthur B. Frost in New York. Frost was so struck by the works that he began to circulate Bruce's color principles throughout the New York art world where they influenced painters such as James Daugherty (1890–1974) and Jay Van Everen (1875–1947). *Composition VI*, with the other *Compositions* in the series, was at one time owned by Katherine Dreier, founder in 1920 of the Société Anonyme, the first museum of modern art in America. JMR

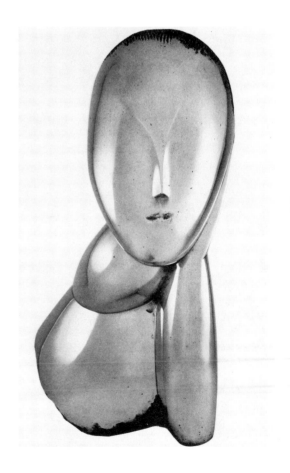

226 CONSTANTIN BRANCUSI
Rumanian; Pestisani Gorj, Rumania 1876–Paris, France 1957

A Muse, 1917
Polished brass; h. 19⅝ (49.6), w. 11¹¹⁄₁₆ (29.8), diam. 9⅝ (24.4)
Signed back bottom near bolt: C. Brancusi
Museum purchase with funds provided by Mrs. Herman Brown and
Mrs. William Stamps Farish 62.1

Born in Rumania in the foothills of Transylvania, Constantin Brancusi received a diploma from the Bucharest School of Fine Arts in 1902. He was drawn to Paris by the presence of Auguste Rodin (1840–1917), and he studied at the Ecole des Beaux-Arts from 1905 to 1907. While the roughly modeled surfaces of his student works show his esteem for Rodin, by the end of 1907 Brancusi had abandoned modeling in clay in favor of carving from stone. His use of direct carving signals the beginning of his mature style, and throughout the rest of his career Brancusi's work is distinguished by its constancy both of themes and of formal values.

A Muse exemplifies Brancusi's ongoing goal to elucidate the essence rather than the exterior form of his subject by eliminating anatomical details and condensing natural forms into streamlined, ovoid shapes. Brancusi first carved a marble version of *A Muse* (private collection, New York) in 1912. The Houston *Muse* was made in bronze for the American collector John Quinn in 1917. Two other bronze versions exist, one dated 1918 in the Portland Art Museum, and one dated after 1918 in a New York private collection.

The relatively small size of Brancusi's oeuvre, about 215 extant sculptures, belies its importance. In his reduction of natural and human form to simple biomorphic shape, in his presentation of sculpture as an object, and in his respect for the inherent qualities of the materials with which he worked, Brancusi has had far-reaching effects on twentieth-century sculpture. JMR

227 PIET MONDRIAN

Dutch; Amersfoort, Holland 1872–New York, New York 1944

Composition with Gray and Light Brown, 1918
Oil on canvas; 31⁹⁄₁₆ × 19⁵⁄₈ (80.2 × 49.9)
Signed and dated lower left: P M 18
Gift of Mr. and Mrs. Pierre Schlumberger 63.16

Although Piet Mondrian helped to found De Stijl in 1917, he had been working toward a simplified geometric style for years. In 1909, while he was a successful if conventional landscape painter, he joined the Theosophist Society, whose synthesis of Oriental beliefs stressed correspondences between the material and spiritual world and expressed dualities such as spiritual/material and male/female through combinations of verticals and horizontals. In the fall of 1911 Mondrian saw an exhibition of Cubist paintings by Pablo Picasso (1881–1973) and Georges Braque (1882–1963) for the first time. By December of that year he had moved to Paris, where he painted in a Cubist style. Mondrian visited Holland during the summer of 1914. Due to the outbreak of World War I he was forced to remain there, and in 1917 he and Theo van Doesburg (1883–1931), Bart van der Leck (1876–1958), and Vilmos Huszar (see no. 232) founded De Stijl.

De Stijl was based on the idea that, purified of references to the visual world and reduced to essential geometric patterns, art could become an abstract expression of universal harmony. *Composition with Gray and Light Brown* (1918) is one of Mondrian's earliest canvases with the grid pattern that became characteristic of his work. During the early years of De Stijl he used pastels and neutral grays and browns. It was not until 1920, a year after his return to Paris, that he switched to the red, yellow, and blue so associated with his paintings. Although Mondrian withdrew from De Stijl in 1925, he continued to paint in the simplified geometric format and primary colors associated with the movement until his death in 1944. JMR

228 EDWARD WESTON

American; Highland Park, Illinois 1886–Carmel, California 1958

Epilogue, 1919
Platinum photograph; 9⁵⁄₈ × 7³⁄₈ (24.4 × 18.7)
Recto on mount lower left in pencil: Epilogue
Recto on mount lower right in pencil: Edward Weston 1919
Target Collection of American Photography; Museum purchase with funds provided by Target Stores 78.62

Edward Weston moved to California to live with his sister in 1906. Except for a year at the Illinois College of Photography in Effingham and three years in Mexico (see no. 238), he remained in California. "Everything worth photographing," he told the *New Yorker* magazine in 1946, "is in California."

In 1911 Weston opened a portrait studio in Tropico (now Glendale), California. In 1914 Weston met Margrethe Mather (see no. 242), whom he later made a business partner and with whom he frequently exhibited and published his photographs in Pictorialist salons and publications. As a Pictorialist photographer, Weston's works were softly focused, composed in broad, tonal masses, and illuminated with the soft, atmospheric light favored by Impressionist painters. He used platinum papers to accentuate the subtle tonalities. His subjects were women, in the nude, in costume, or in long dresses.

In 1914 Weston and Mather were founding members of the Camera Pictorialists of Los Angeles, and in 1917 Weston was elected to membership of the London Salon, the British organization of Pictorialist photographers. Largely due to Mather's influence, Weston's images grew less "atmospheric" each year, and they became more decorative through use of asymmetrical compositions and dramatic shadows. Weston grew tired of the Pictorialists' aesthetic, which he felt no longer reflected the period, and in the early 1920's, he destroyed most of his Pictorialist prints and negatives.

Mather was a frequent model as well as collaborator. In *Epilogue* she posed in the Glendale studio. The staged pose and use of props, dramatic lighting, and textured backdrop were characteristic devices that Weston would shortly abandon, but *Epilogue* is one of Weston's finest Pictorialist works. AT

229 CHARLES SHEELER

American; Philadelphia, Pennsylvania 1883–New York, New York 1965

New York, 1920

Gelatin silver photograph; 9¹¹⁄₁₆ × 7¾ (24.6 × 19.7)
Verso in ink: New York / photo Charles Sheeler
Museum purchase 79.6

Searching for an occupation that would not conflict with, and might possibly assist, his work as a painter, Charles Sheeler began to photograph in 1912. He quickly realized the potential of photography as an autonomous art with unique possibilities beyond commercial illustration. For the next forty-seven years, although his primary commitment was to his painting, Sheeler continued to photograph. Works in one medium influenced those in the other: his photographs reflect his knowledge and understanding of abstract painting; his paintings reveal subjects seen initially through a camera. Sheeler was clear and outspoken on the merits of each medium and respected both. Photography, he felt, "had enlarged our acquaintance with the visual world," and Sheeler valued creative photography as an extension of vision, not as a substitute for seeing.

New York (1920) is one of a series of photographs of the city seen at a sharp, downward angle, a series in which he first identifies city buildings as a subject motif. In the same year, Sheeler made a drawing (The Art Institute of Chicago) and later a painting (The Phillips Collection, Washington, D.C.) of the same subject, from the same vantage point, but more tightly framed. In all three images, "the sharp patterns of light and dark combine with shallow depth to create strong surface patterns of considerable abstract force" (Charles Millard, *Charles Sheeler*, 1968). In the photograph, but eliminated from the painting and drawing, is a wealth of realistic detail. The photograph has an exactitude that Sheeler felt was "not to be achieved through any other medium." AT

230 GEORGE BELLOWS

American; Columbus, Ohio 1882–New York, New York 1924

Portrait of Florence Pierce, 1914

Oil on canvas; 38 × 30 (96.6 × 76.2)
Gift of Mr. and Mrs. Meredith Long in memory of
Mrs. Agnes Cullen Arnold 74.255

When George Bellows moved from Ohio to New York in 1904, he began two years of study and a lifetime of friendship with Robert Henri (1856–1929). Henri

was one of the group of American realists, later called "The Eight," who depicted scenes of the more common realities and brutalities of city life with strong color and loose, slashing brushwork. Although Bellows retained the rich surface, strong frontal lighting, and dramatic handling that he learned from Henri, his realism was not expressed in the social content of his subjects so much as in the immediacy of his canvases.

Portrait of Florence Pierce was painted in August during a 1914 summer spent at Monhegan Island off the coast of Maine, a vacation retreat introduced to Bellows by Henri in 1911. Bellows exhibited in the Spring 1913 Armory Show, and his exposure to modern European art is evident in the heightened color and concern for form and structure in the *Portrait of Florence Pierce*. However, the dramatic lighting and the loose paint handling, especially beautiful in the sitter's foreshortened arm and hand draped over the chair back, are characteristics of American realism that Bellows retained throughout his career. JMR

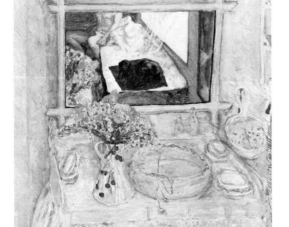

231 PIERRE BONNARD

French; Fontenay-aux-Roses 1867–Le Cannet 1947

Dressing Table and Mirror, ca. 1920

Oil on canvas; 49 × 43⅛ (124.5 × 109.3)
Signed upper right: Bonnard
John A. and Audrey Jones Beck Collection 74.134

Pierre Bonnard reached his artistic maturity in Paris in the 1890's. After having studied law unsuccessfully and at his father's insistence, he worked at the Ecole des Beaux-Arts and the Académie Julian, where he met and became part of the Nabis. This group of young artists, which included Edouard Vuillard (1886–1940), Maurice Denis (1870–1943), and Paul Sérusier (1863–1927), was influenced by the Symbolism of Paul Gauguin (see no. 202). They translated his concept of pictorial equivalents for emotion and thought into decorative canvases covered with pattern and color. After 1900 Bonnard began to assimilate to his style the short brush strokes, light tonal values, and complex color relationships of Impressionism.

Bonnard painted scenes of domestic life characterized by a sense of intimacy and suspended time. He filled his canvases with objects of everyday and personal use. Often, as in the case of the seated nude reflected in the mirror in *Dressing Table and Mirror*, he included human figures that are only gradually noticeable. Bonnard frequently used mirrors in his paintings, for they led the eye into the space of the reflected scene while at the same time the plane of the mirror preserved the intimate, limited depth of the composition. Also characteristic is the manner in which he brought the scene close to the viewer by cutting off the table in the foreground. The strong diagonals of the scene in the mirror and the manner in which the seated figure is cut off by the mirror's frame reflect Bonnard's familiarity with the composition of Japanese prints. Amidst the diversity of twentieth-century art Bonnard maintained the Symbolist notion of the expressive power of color and form. He continued to paint distillations of the ambience of domestic life until his death in 1947. JMR

232 VILMOS HUSZAR

Hungarian; Budapest, Hungary 1884–Hierden, Holland 1960

Composition, 1921
Oil on wood; 31 × 23½ (78.8 × 59.7)
Signed front lower right: V. Huszar
Museum purchase with funds provided by Mr. and Mrs.
Theodore N. Law 75.20

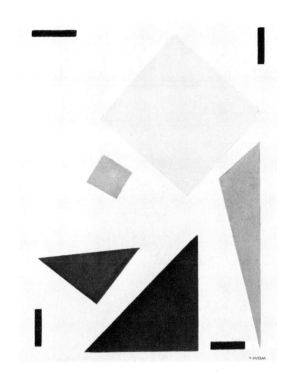

Vilmos Huszar studied art in Budapest and Munich before moving to Holland in 1905. From 1914 Huszar was concerned with the simplification of form in his work. During this time Piet Mondrian (1872–1944), Theo van Doesburg (1883–1931), and Bart van der Leck (1876–1958) were each independently developing geometric styles. The four artists met and in the summer of 1917 founded De Stijl (see no. 227). In addition to his paintings, Huszar applied the principles of De Stijl to interior design, stained glass, and theater decor, and also wrote articles for the De Stijl journal, whose cover he designed.

Huszar's earliest De Stijl paintings were geometric analyses of natural forms. However, by 1918 he was working in complete abstraction and primary colors. *Composition* (1921), an example of Huszar's fully formulated abstract style, reflects De Stijl's reductive use of color and geometry to attain an expression of harmony and purity. Huszar left De Stijl in 1923 and worked in a representational style until his death in 1960. *Composition* exemplifies Huszar's work at the time of his involvement with De Stijl, whose ideas combined with those of the contemporary Suprematist and Constructivist groups in Russia to form a basis for succeeding geometric abstraction. JMR

233 PATRICK HENRY BRUCE

American; Virginia 1881–New York, New York 1936

Peinture/Nature Morte, ca. 1920–1921
Oil on canvas; 35 × 46 (88.9 × 116.8)
Gift of The Brown Foundation 78.182

From about 1917 until his death in 1936, Patrick Henry Bruce painted only still lifes, abandoning his earlier interest in abstract scenes of contemporary Parisian life (see no. 225). Bruce, who supported himself by trading antiques and who owned a large collection of African objects, composed all of his still lifes with objects and architectural shapes abstracted from his personal surroundings. As in *Peinture/Nature Morte* (ca. 1920–1921), the paintings are marked by a strong sense of structure and the use of architectural projections instead of modulation of light and dark to create volume. Bruce, who had studied engineering draftsmanship, drew elements on the canvas with mechanical drafting tools and then applied the paint in thin and often numerous applications. He used multiple perspectives and contradictory spatial relationships to create the ambiguity that is constant in his still lifes. Bruce's use of black, white, and gray as colors stems from his early study with Henri Matisse (1869–1954), while his unusual palette of pinks, blues, greens, and purples is related to the tempera colors used by the Italian primitive painters he so admired, Andrea Mantegna (1431–1506) and Fra Angelico (1387–1455).

Plagued by health and personal problems and discouraged by lack of con-

temporary appreciation of his work, Bruce progressively withdrew from the world. He stopped exhibiting his works after 1930 and in 1933 destroyed all but twenty-one of the paintings in his possession; he gave these to a friend, Henri Pierre Roché. He continued to paint from 1933 until his suicide in 1936, but all the works from this period have been either lost or destroyed. Although Bruce's extant body of work is small—scarcely a hundred works—his paintings have a power and complexity that merits him an important place in American art.

JMR

234 CLAUDE-OSCAR MONET
French; Paris 1840–Giverny 1926

The Japanese Footbridge at Giverny, ca. 1922
Oil on canvas; 35 × 36¾ (88.9 × 93.3)
Stamped upper left: Claude Monet
John A. and Audrey Jones Beck Collection 76.198

Although Claude Monet painted views of the Japanese footbridge over his water-lily pond from 1899, the Beck picture comes from the artist's last years in which he developed a style so free that it verges on abstraction. Indeed, viewed close up the subject of the picture is not easily recognized. Only from a distance is it apparent that the dark, curving, horizontal bars represent the bridge itself, behind them flowing trees and shrubs, and below them the pool filled with water lilies and reflecting the other vegetation. Like Edgar Degas (1834–1917), Monet suffered from loss of sight in his old age, in Monet's case due to cataracts. Also like Degas, Monet made a virtue of his disability by working in a more powerfully simplified style than he had used earlier. It is no coincidence that Monet's late work tended to be denigrated until modernist critics found in its rhythmic brushwork a kinship with Abstract Expressionism, especially with the drip paintings of Jackson Pollock (see no. 260). Unlike Pollock's nonobjective compositions Monet's pictures always represent a transcription of the natural world.

JMW

235 PAUL STRAND
American; New York, New York 1890–Orgeval, France 1976

Lathe, 1923
Gelatin silver photograph; 9¹³⁄₁₆ × 7⅝ (24.9 × 19.4)
Verso of mount center in pencil: Lathe 1923 / Paul Strand AK
Target Collection of American Photography; Museum purchase
with funds provided by Target Stores 78.60

Paul Strand first studied photography at the Ethical Culture School (New York City) with Lewis W. Hine (1874–1940), who introduced him to Alfred Stieglitz (see no. 211) and Stieglitz's '291' gallery. With encouragement from Stieglitz, who periodically critiqued Strand's works, Strand began to incorporate modernist principles of abstraction into his photographs. His first experiments in abstraction, done in 1915, obscured what was being photographed, but he soon determined that the identity of the object was an inherent and necessary aspect of every photograph.

In the early 1920's Strand photographed machines because he saw them as objects of structural beauty. He wanted "to photograph the power and marvelous precision which the very functional forms, surfaces and lines of a machine reflect." The lathe is beautifully and meticulously described. The hard, metal surfaces are polished, scratched, or painted according to their function. The tonal range highlights the two most aggressive forms and silhouettes them against black space. The tension between these two forms dominates the picture.

After this series was made in 1922–1923, it was thirty-six years before Strand photographed anything more metallic than a bicycle or a stove. Instead, he applied his technique of defining essential form with clarity of edge and solidity of object almost exclusively to portraits, landscapes, and hand-made or organic objects.

The Museum also owns the following vintage works by Paul Strand: *Exposition, San Diego* (1915), *Window, San Antonio, Texas* (1918), *Mullen and Stump, Twin Lakes, Conn.* (1922), *Boats on Shore, Percé Beach, Gaspé* (1929), *Bell Rope* (1945), *Umbrian Landscape, Central Italy* (1952), *Girl, Luzzara, Italy* (1953), *The Scythes, Luzzara, Italy* (1953), and *Kwthar, Kalata al Kobra, Delta, Egypt* (1959). *The Mexican Portfolio* (1967) is also in the collection. AT

236 GEORGIA O'KEEFFE
American; Sun Prairie, Wisconsin 1887

Grey Line with Black, Blue and Yellow, ca. 1923

Oil on canvas; 48 × 30 (121.9 × 76.2)
Museum purchase with funds provided by the Agnes Cullen Arnold
Endowment Fund 77.331

In the fall of 1912 Georgia O'Keeffe took a teaching job in the Texas panhandle where she first encountered the colors and forms of the Southwest that were to provide a source of inspiration for her work. In 1914 O'Keeffe left her teaching job to go to New York, where she studied at Teachers College, Columbia University, with Arthur Wesley Dow. Dow was one of the few sophisticated art educators of his time, and he brought to his students a background of European travel, work with Paul Gauguin (see no. 202) at Pont-Aven, and an interest in Oriental art. As can be seen in *Grey Line with Black, Blue and Yellow*, O'Keeffe assimilated to her own abstractions based on natural form Dow's emphasis on clearly defined outlines and balanced lights and darks.

Alfred Stieglitz (see no. 211) gave O'Keeffe her first solo show at his avant-garde gallery '291' in New York in 1917. O'Keeffe shared with the Americans whose work Stieglitz showed regularly, an individualism and spiritual capacity that led each to seek in his own way symbolic equivalents in nature for inner emotion.

Grey Line with Black, Blue and Yellow is characteristic of O'Keeffe's vibrant color and recalls the prismatic hues of Robert Delaunay's (1885–1941) famous series of interiors of *Saint-Severin* (1909–1915). Comparable in its variety and richness to the broad spectrum of color based on optical theory used in Orphism and Synchromism, O'Keeffe's color is, however, drawn from intuition and instinct. In *Grey Line with Black, Blue and Yellow* the precisely delineated, undulating folds and the lucid, three-dimensional forms work together to create an image of potent ambiguity, suggestive of nature but without specific imagery. Although the forms appear to exist in space, they have no texture or tactile

quality. O'Keeffe began spending summers in New Mexico in 1929 and moved there permanently in 1949.

Whether abstract or representational, the two styles in which she has worked concurrently, her art is consistent in its absolute clarity and in its compelling combination of austerity and sensuousness. JMR

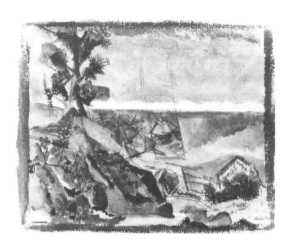

237 JOHN MARIN

American; Rutherford, New Jersey 1870–Cape Split, Maine 1953

The Little Sailboat, 1924
Watercolor, charcoal; 17 × 21 (43.2 × 53.3)
Signed front lower right: Marin 24
Bequest of Ida R. Nussbaum by exchange 75.4

John Marin studied at the Pennsylvania Academy of Fine Arts from 1899 through 1901. Like many American painters of his generation, he traveled to Europe, where he worked and studied from 1905 until the summer of 1911, with only a brief visit home in the early months of 1910. His firsthand observation of Fauve and Cubist painting enabled him to structure his poetic images within a quasi-geometrical framework.

Though Marin also painted in oil, watercolor is the medium for which he is best known. He concentrated on two main themes: views of New York City and scenes of the Maine Coast, where he spent almost every summer from 1920 until his death in 1953. In *The Little Sailboat* (1924) Marin uses a modified Cubist format, showing various facets of images without completely fragmenting them. The strong diagonals of the rocks, the surf, and the triangular sail create a pictorial energy and motion that is compressed and offset by the bold strokes of paint framing the scene. Like Paul Cézanne (1839–1906), whose late watercolors he had seen during his time in Europe, Marin developed a watercolor style that was spare and lean; the areas of white paper left bare are as important as the paint to the strength and vitality of his work. Marin regularly showed his work at Alfred Stieglitz's gallery '291' (see no. 211), which was an important showcase gallery for both European and American avant-garde work. Like his colleagues in the Stieglitz circle, Arthur Dove (1880–1946) and Georgia O'Keeffe (see no. 236), Marin imbued natural form with emotive and expressive power.
 JMR

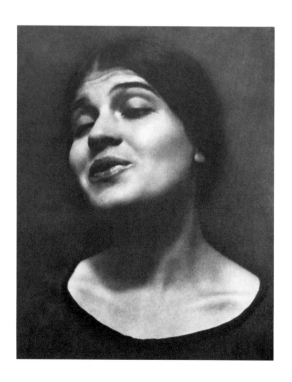

238 EDWARD WESTON

American; Highland Park, Illinois 1886–Carmel, California 1958

Tina Modotti, October 3, 1924
Platinum photograph; 9⅝ × 7½ (24.4 × 19.1)
Signed verso lower left in pencil: Tina Modotti; verso lower right in pencil: Edward Weston, Mexico, D. F. 1924
Target Collection of American Photography; Museum purchase with funds provided by Target Stores 78.61

In 1922 Edward Weston met Alfred Stieglitz (see nos. 211 and 246) in New York. Stieglitz did not particularly like Weston's work, then in a transitional phase (see no. 228), but he encouraged Weston and introduced him to Georgia O'Keeffe

(see no. 236) and Paul Strand (see no. 235). While in New York Weston also met Charles Sheeler (see no. 229).

Before his visit to New York Weston had already announced his intention to move to Mexico with Tina Modotti, whom he had met a year earlier in California. In Mexico Weston was exposed to the works and ideas of Diego Rivera (1886–1957), David Alfaro Siqueiros (1896–1974), José Clemente Orozco (1883–1949), and other leaders of the "Mexican Renaissance." This stimulation and the ideas acquired in New York, combined with "peace and an hour's time" led to the evolution of Weston's mature style: highly crafted, direct, sharp-focus pictures. Later Frederick Sommer (see no. 257) acknowledged the importance of the mature work by Weston, "whose decisive and sensuous use of the tone scale had given his photographic surfaces an impact new to art" (*Frederick Sommer*, Philadelphia College of Art, 1968, p. 5).

In Mexico Weston made a series of portraits by shooting just the face or head of the sitters, most of whom were his friends. In each case he was seeking to isolate a particular characteristic or psychological trait. Houston's portrait shows Modotti reciting poetry "to attempt the registration of her remarkable mobile face in action" (Edward Weston, *Daybooks of Edward Weston*, vol. I, George Eastman House, 1961, p. 95).

Although Weston was forty when he left Mexico, the major work of his career was still ahead of him. He settled in Carmel, California, near Point Lobos, his primary subject over the next two decades. The Museum also owns *Harold Kreutzberg* (1932), *E Town, New Mexico* (1933), both vintage prints signed by Edward Weston, and twenty-five prints by Cole Weston made from Edward Weston's negatives. AT

239 ANDRÉ KERTÉSZ
American; Budapest, Hungary 1894

Satiric Dancer, 1926
Gelatin silver photograph, modern print; 9¾ × 7¾ (24.8 × 19.7)
On mount lower right corner: A Kertész
Museum purchase with partial funding provided by The National
Endowment for the Arts 78.111.4

In a laconic introduction to one of his recent monographs, André Kertész wrote, "Photography must be realistic." A study of the thousands of photographs he has taken since 1912 shows how diverse reality has been for Kertész. There are realities of his discovery and realities of his invention. There are the journalist's dramas photographed in Budapest, Paris, and New York; there are nudes photographed in a distorting funhouse mirror, and still-life arrangements photographed in his apartment.

His style has been shaped by two preferences. He was one of the first serious photographers to work with a 35mm camera, and since 1928 he has used it almost exclusively. The small camera allowed Kertész to move quickly and unobtrusively amid the subjects that attracted him. "Perhaps more than any other photographer," John Szarkowski observed, "André Kertész discovered and demonstrated the special aesthetics of the small camera" (*Looking at Photographs*, 1973). His second preference was to find and delineate analytic structure. Kertész's work has the unity of arrangement and the inner rhythm of works by the modern painters who were his friends in Paris.

Satiric Dancer ridicules both music-hall eroticism and classical sculpture. In

her pantomime of the sculpture at her feet, the model seems to have just kicked both it and the drawing above her hips into the air to juggle. The picture has the clarity and spontaneity of Kertész's best work.

Satiric Dancer is from the portfolio of ten photographs: *André Kertész, Photographs, Volume I, 1913–1929,* edition number 32/50, published in 1973. The Museum also owns the ten photographs in *Volume II, 1930–1972; Around St. Vincent's Hospital, November 15, 1971*; and *Billboard* (1962). AT

240 PABLO PICASSO

Spanish; Malaga, Spain 1881–Mougins, France 1973

Two Women in front of a Window, 1927
Oil on canvas; 38½ × 51½ (97.8 × 130.8)
Signed lower right corner: Picasso/ Picasso
Gift of Mr. and Mrs. Theodore N. Law 64.17

Pablo Picasso's work underwent successive and radical changes during his lengthy and prolific career. His monumental neoclassical works of the early 1920's were followed during the second half of that decade by paintings that showed an awareness and assimilation of certain characteristics of Surrealism (see no. 254). Though Picasso was never actually a Surrealist he did participate in the first official exhibition of Surrealism in 1925. *Two Women in front of a Window* (1927) is a major work from this phase of Picasso's marginal Surrealism, which Robert Rosenblum has called "psychoanalytical Cubism." Picasso has retained the interlocking, geometric shapes and intersecting planes of Cubism, subverting these Cubist devices with the biomorphic shapes and layered ambiguities of Surrealism.

Two Women in front of a Window explores the theme of the artist and model recurrent throughout Picasso's work. The figure on the left, comprised of solid, geometric shapes bounded by black lines with an easel shape behind him, appears to be the artist. To the right is the model upon whose ovoid head is superimposed a plaster bust of her in profile—hence the two women of the title. The image of the bust is also present in two related paintings, *The Studio* (1927–1928) and *Painter and Model* (1928), both in The Museum of Modern Art, New York. The difficult iconography of *Two Women in front of a Window* alludes to the complex relationship between what exists and what appears in a work of art as well as to Picasso's interest in probing the irrational. JMR

241 PAUL KLEE

Swiss; Münchenbuchsee 1879–Muralto-Locarno 1940

Marjamshausen, 1928
Watercolor; 14⅛ × 8 (35.9 × 20.8)
Gift of Miss Ima Hogg 39.111

In 1898 Paul Klee left Switzerland to study art in Munich. He began his career as an etcher and draftsman working in the small scale he retained throughout his career. After numerous travels in Europe, Klee married in 1906 and established his permanent residence in Munich. In 1911 Klee met Wassily Kandinsky (1866–1944) and through him became associated with the group of artists who called themselves the Blue Rider, exhibiting with them in the second Blue Rider exhi-

bition of March 1912. His conversations with Kandinsky, whose treatise *Concerning the Spiritual in Art* was written though not yet published at this time, helped to clarify Klee's belief that an artist must be concerned with experiences beyond those of the perceptible world. Though Klee shared Kandinsky's concern with the spiritual, Klee's art, unlike Kandinsky's, never became completely abstract and usually remained closely connected to observable experience. Klee taught at the Bauhaus, first at Weimar and then at Dessau, from 1920 through 1929. His notes and lectures on the theory of form were published in 1925 under the title *Pedagogical Sketchbook*.

Imaginary architecture was a recurrent theme in Klee's work. In *Marjamshausen* (1928) the buildings rise vertically to create mosaic-like arrangements of color planes. Klee's exposure to the color and sunlight of the Mediterranean during a 1914 trip to Tunisia had a lasting impact on his palette. His use of color was also affected by his lifelong interest in music, and like Kandinsky he saw analogies between art and music in harmonies, tones, and chords. Carola Giedion Welcker's description of Klee's work as an "infinitely delicate and vibrating chamber music in colors" could certainly refer to *Marjamshausen*. JMR

242 MARGRETHE MATHER
American; Salt Lake City, Utah 1885–Los Angeles, California 1952

Untitled, 1928
Gelatin silver photograph; 7⁵⁄₁₆ × 9⁷⁄₁₆ (18.6 × 24.0)
Inscribed lower right below photograph in pencil:
Margrethe Mather—1928
Museum purchase with funds provided by Carey C. and William W. Shuart 77.56

Margrethe Mather ran away from her adoptive family to live in Los Angeles when she was about fifteen. Thereafter, she received no formal education; her tutors were the members of Los Angeles' bohemia. In 1912 Mather met Edward Weston (see no. 228) at a Los Angeles Camera Club meeting. Between 1914 and 1921, Mather was Weston's business partner in his portrait studio in Glendale, California, and the two photographers frequently exhibited their work in the same Pictorialist salons. She continued to run the studio for Weston after he left for Mexico in 1921 (see no. 238).

Until very recently, Mather's skill as a photographer has been largely unappreciated. Her life and work were overshadowed by Weston's, although it was possibly Mather who strongly influenced Weston's Pictorialist style, not the reverse, as has been assumed. After 1931 Mather's photographic output practically ceased.

The Museum's 1928 interior has the economy of detail, the minute gradations of tone, and the sophisticated understanding of space most characteristic of Mather's photographs. It was taken in Hermosa Beach, California, at the house of Harold Grieve, a Hollywood set designer and interior decorator, on a weekend visit made by Mather and William Justema. Mather and Justema collaborated between 1923 and 1928 and again in 1931 for her last exhibition, *Patterns by Photography*, at the de Young Museum, San Francisco. AT

145

243 JOHN STORRS

American; Chicago, Illinois 1885–Mer, France 1956

Abstract #1, 1932

Oil on masonite; 54½ × 42½ (137.8 × 108.0)
Signed front lower left: STORRS
Museum purchase 77.9

John Storrs is relatively unknown today, although he was one of the first American modernists to produce a major body of abstract work. After studying at the Art Institute of Chicago, in Boston with sculptor Lorado Taft (1860–1936), and at the Pennsylvania Academy of Fine Arts, Storrs moved to Paris in 1911, where he studied at the Académie Julian and the Ecole des Beaux-Arts. In 1912–1913 he moved to Rodin's atelier and established a close relationship with the older sculptor, which lasted until Rodin's death in 1917. During this time Storrs began to break away from his academic training and to concentrate on line and volume. By 1917 he was creating totally abstract sculptures, as well as figurative works based on Cubism. Storrs made intermittent trips to the United States until 1927, when the terms of his inheritance forced him to live in the United States for the better part of each year. He lived in Chicago between 1927 and 1939, returning to France for the summers. The outbreak of World War II made it impossible for him to return to the United States at the end of the summer of 1939, and he was interned as an enemy alien at the beginning of 1942, an experience from which he never fully recovered.

Although Storrs is best known for his sculpture, he also painted, especially during the 1930's. *Abstract #1* displays both the abstract imagery and the precise geometry characteristic of his sculpture. Storrs's connections with Chicago and its architectural community are reflected in the monumental, machinist shapes of *Abstract #1*. The machine iconography also recalls aspects of Futurism, the Italian movement (1909–1916) that glorified the modern machine age, and relates to the 1915–1918 machine forms of Francis Picabia (1887–1953). The red, black, and white of *Abstract #1* echoes colors Storrs often used in his polychrome sculpture. Like the American Precisionists, Storrs simplified geometric shapes into areas of color, but unlike these American artists his work was often totally abstract. JMR

244 ALBERT RENGER-PATZSCH

German; Würzburg 1897–Wamel 1966

Untitled, ca. 1932

Gelatin silver photograph; 10¹³⁄₁₆ × 14⅞ (27.5 × 37.8)
On recto and on verso in pencil: E 133
Museum purchase with funds provided by Mr. and Mrs.
Harry B. Gordon 79.93

In 1928 Albert Renger-Patzsch published *Die Welt ist schön* (The World is Beautiful). It was his fourth book in as many years but is considered the most important volume of the many he would publish over the next four decades because it was the first to align photography with the New Objectivity or New Realism (Neue Sachlichkeit) movement in German painting and film. The book's preface was by Dr. Carl Georg Heise, director of the Lübeck Museum, who defined the movement as "a revolution in aesthetic perception, an attempt

at the creation of a new concept of beauty." The new art, Heise contended, was more concerned with objectivity than with beauty, an objectivity that would redefine graphic beauty in terms of the function or "natural essence" of the subject. "The photographer," he wrote, "never seeks a new artistic form for its own sake if it does not serve to elucidate the object itself."

Die Welt ist schön was organized by subject categories: plants, animals, people, landscapes, materials, architecture. Of these, landscapes were the most maligned as "cults of ugliness." Previous generations of landscape photographers had been particularly susceptible to making "beautiful" pictures, which generally meant photographs that imitated fashionable paintings and graphic arts; these landscapes were idealized and romantic, lacking any evidence of a technological society. In Houston's untitled landscape, the subject—a snow-laden farming village—is potentially romantic, but Renger-Patzsch does not employ traditional composition, nor does he remove the untidy presence of technology. The horizon is broken by electrical wires; advertising posters decorate the building at the base of the path.

Another major figure in the New Objectivity movement, Karl Blossfeldt (1865–1932), is represented in the Museum's collection by the portfolio *12 Fotografien*. Ernst Fuhrmann (1886–1956) and Erich Salomon (1886–1944), two important German photographers from this period, are also represented in the collection. AT

245 BEN SHAHN

American; Kouno, Lithuania 1898–New York, New York 1969

New York City, ca. 1932
Gelatin silver photograph; 6¼ × 9⅜ (15.9 × 23.8)
Museum purchase with funds provided by Mundy General, Inc. 79.18

Ben Shahn was an ardent spokesman for an art devoted to the human condition, an art in which the artists took an unequivocal moral stance. In 1930's America this style was called "social realism." Its purpose was to convey the texture of social conditions in America. Shahn's earliest critical recognition came from three series of gouache paintings and watercolors inspired by political events: *The Passion of Sacco and Vanzetti* (1932), *The Dreyfus Case* (1932), and *The Mooney Case* (1933).

In the 1940's and 1950's, Shahn's paintings turned to what he called "a sort of personal realism." He wanted paintings "full of content, full of story, of perfection of likeness, of naturalness, of observation, of small things." In these paintings he began to use photographs, first as notes for details, then increasingly as the primary source for entire paintings. Perhaps the best known of Shahn's paintings drawn from photographs is *Handball* (1939, Museum of Modern Art, New York). *Handball* is based on the Houston Museum's photograph and on others in a series taken at the Houston Street playground, New York City, when Shahn first began to photograph.

Shahn loved the visual authenticity of photographs: the look of clothes and surfaces, the split-second tension of stopped action. He carried this precise detail of dress and movement from the photograph to the painting at the Modern, to a mural for the Federal Security Building in Washington, D.C. (1940), and eventually to the scenery for a Jerome Robbins ballet, *N.Y. Export: Op. Jazz* (1958). He did not transfer to the painting the satisfying symmetry of the photo-

graph; the central player in the photograph, whose motion is most vividly stopped, is centered exactly, side to side, top to base, and made the focal point of a deep perspective defined by the receding figures. It is a symmetry atypical of Shahn's photographs or paintings. AT

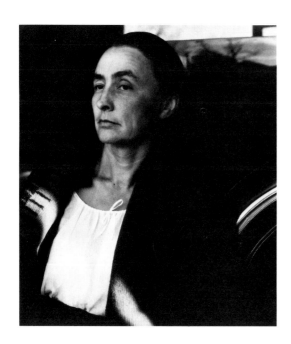

246 ALFRED STIEGLITZ
American; Hoboken, New Jersey 1864–New York, New York 1946

Portrait of Georgia O'Keeffe, 1933
Gelatin silver photograph; 8¾ × 7½ (22.2 × 19.1)
Target Collection of American Photography; Museum purchase with funds provided by Target Stores 78.63

In 1933 Alfred Stieglitz culminated a project entitled *Georgia O'Keeffe: A Portrait*. The completed portrait consisted of more than five hundred photographs, but this series was as close as Stieglitz would come to realizing a far grander project that would have extended over the subject's lifetime. "His idea of a portrait," wrote O'Keeffe (see no. 236), "was not just one picture. His dream was to start with a child at birth and photograph that child in all of its activities as it grew to be a person and on throughout its adult life. As a portrait, it would be a photographic diary" (*Georgia O'Keeffe: A Portrait by Alfred Stieglitz*, Metropolitan Museum of Art, 1978).

Falling short as a comprehensive lifetime document, *Georgia O'Keeffe: A Portrait* is nevertheless one of the most extensive serial documents existing in any medium. In 1933 Stieglitz was sixty-nine and O'Keeffe was forty-six. They had lived together for fifteen years, been married for nine, and he had exhibited her paintings in his gallery for seventeen. The photographs mark the course of their relationship from its tentative beginnings into a passionate intimacy and finally to the last phase of their marriage when O'Keeffe began to break away, spending up to six months of the year in her New Mexico studio.

In the Houston photograph, O'Keeffe leans against the Model A Ford that (one may speculate) annually transported her to New Mexico. She is wearing a woven blanket as a shawl, and in other pictures taken on the same day, a silver bracelet. Both objects appear to be from the American Southwest. The reflection in the car is the Lake George, New York, landscape where the Stieglitzes owned a weekend home and where Stieglitz made most of the photographs in his last series entitled *Equivalents*. As in Stieglitz's earlier photographs, the car is symbolic of the effects of mobility on his personal life and on American culture. The shawl, car, and landscape enrich the meaning of the photograph, but primarily it is a remarkable psychological and physical portrait. AT

247 HENRI-EMILE-BENÔIT MATISSE
French; Le Cateau 1869–Nice 1954

Study after the Rose Nude, 1935
Sanguine on tracing paper; 26⅜ × 38 (67.0 × 96.5)
Gift of the Esther Florence Whinery Goodrich Foundation 65.35

In the 1930's, Henri Matisse often concentrated on rendering forms, especially the female nude, in terms of daring simplifications. *The Rose Nude* (1935, now in The Baltimore Museum of Art, Cone Collection) was one of his most impor-

148

tant paintings of the decade. It underwent many changes, as is shown in a series of photographs taken over six months while it was being painted (see Alfred Barr, *Matisse: His Art and His Public*, 1951, pp. 247–249). These photographs indicate that Matisse began with a simplified but relatively lifelike figure on a daybed occupying a flattened but still three-dimensional space. Progressively, the figure's torso was elongated and her arms and legs enlarged. Space was flattened almost to the point of suggesting two-dimensionality.

Matisse is known to have made studies for the picture before and during its execution. These drawings were taken from the model and show a figure of normal proportions and strong three-dimensionality. The Museum's drawing, on the other hand, shows the flattened nude in outline form exactly as she appears in the finished painting. Victor Carlson and John H. Neff have suggested orally the reasonable conclusion that Houston's drawing was in fact made by Matisse himself after the painting, possibly by tracing from the finished oil onto the paper. Matisse must have particularly prized the *Rose Nude* to have wanted to keep for himself a memento of its final form. By eliminating all elements except the nude herself, the drawing reveals a monumental presence as imposing in its own way as the painting. JMW

248 WALKER EVANS
American; St. Louis, Missouri 1903–New Haven, Connecticut 1975

Roadside Sandwich Shop, Ponchatoula, Louisiana, 1936
Gelatin silver photograph; 7⅝ × 9⅝ (19.4 × 24.5)
Target Collection of American Photography; Museum purchase with
funds provided by Target Stores 76.242

Some photographers create pictures that are as artless as possible to make more convincing the illusion of direct observation. For the audience to believe it is seeing the photographic subject directly, the photographer must understate his authorship. More than most photographers, Walker Evans chose to keep his presence discrete. He perceived the camera as an "incredible instrument of symbolic actuality," and he used it to make photographs that were insistently factual. In his work, the actual is not transformed by heightened perspectives or overtly dramatic details. He evolved an unobtrusive technical mastery and preferred natural, uncontrived lighting.

From 1935 to 1938 Evans was employed by the Farm Security Administration, best known for its photographs of the dust bowl, of migrants, and of other symbols of the Depression and the human suffering, fortitude, and dignity that it engendered. Evans's photographs are dryer than most made for the F.S.A. because he sought an intellectual not an emotional appeal. He was offering respect not empathy for his subjects. His consistently frontal approach to his subjects anchored them within the picture, and in a time of chaos, imposed an enormous sense of physical stability.

George's Place is a roadside sandwich shop of no particular distinction. The awnings are up, and it is open for business but has no customers, an emptiness atypically accentuated by the long shadows of late afternoon. There is nevertheless a controlled surface tension, which, like a good quilt design, calls attention equally to every patch of information. Oysters, oranges, and poor-boy sandwiches place the stand in southern Louisiana; the prices place it in time. The stand is attached to or in the yard of a house, possibly its owner's. There is a stove, or at least a stove pipe, electricity, and a brick sidewalk. The viewer is

convinced that George's Place once existed and that this is how it would have looked had he been there. To create this conviction was Evans's intention and his pleasure.

Other works by Evans in the Museum's collection include an untitled photograph in the Anthony G. Cronin Memorial Collection, a portrait of Paul Grotz, and seven prints made by the Library of Congress from Evans's negatives. AT

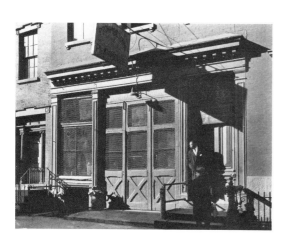

249 BERENICE ABBOTT

American; Springfield, Ohio 1898

Provincetown Playhouse, 133 McDougal St., Manhattan, December 29, 1936

Gelatin silver photograph; 7⅝ × 9⅝ (19.4 × 24.5)
Stamped on verso: Federal Art Project, "Changing New York," Photographs by Berenice Abbott; on verso in pencil: Provincetown Playhouse, 133 McDougal St. Manhattan, December 29, 1936, Negative #192, Code III.D.1
Target Collection of American Photography; Museum purchase with funds provided by Target Stores 76.237

Originally a student of painting and sculpture, Berenice Abbott moved from the Midwest to New York City and then to Paris, where she learned photography as an assistant to Man Ray (b. 1890). In 1926 she opened her own portrait studio where without sentiment or unction she photographed the intellectuals and artists of Paris. Among those invited to pose for a portrait was Eugène Atget (see no. 217). She recognized the enormous achievement of Atget's Paris document and the incomparable clarity of his photographs. When Atget died, Abbott purchased the negatives and prints in Atget's estate and continued to champion the work of the then unrecognized genius for a major part of her own career.

Provincetown Playhouse is part of Abbott's second major project, a series titled *Changing New York*, which culminated in a book of the same name. Begun as a personal assignment and completed under the auspices of the Works Progress Administration, *Changing New York* documents Abbott's fascination with the continuous evolution of the city and with the unique capacity of photography to record that evolution. "The photographer is the contemporary being par excellence," she wrote, "through his eyes the now becomes past" (*The Woman's Eye*, Alfred Knopf, p. 77).

It is irresistible to compare Atget's pictorial record of his city's most characteristic scenes and monuments to Abbott's record of New York. Both are unblinking but affectionate and intelligent testaments. Both have the characteristics of classical art: lucidity, sobriety, purity, and logic. But Abbott's pictures are more modern in their capacity for irony. They have the ironic objectivity of the camera when directed to apparently accidental but nevertheless significant contrasts.

The third major project of Abbott's career was to illustrate photographically principles of physical science. AT

250 LISETTE MODEL

American; Vienna, Austria 1906

French Gambler, Promenade des Anglais, Riviera, 1937

Gelatin silver photograph printed by John Benson or Gerd Sander
in 1976 for the portfolio *Lisette Model: Twelve Photographs*;
19⁹⁄₁₆ × 15⅝ (49.7 × 39.7)
Signed on back: Lisette Model
Museum purchase with partial funding provided by The National
Endowment for the Arts 78.113.4

Lisette Model, born in Vienna to an Austrian-Italian father and French mother,
received her early training in music as a student of Arnold Schönberg. In 1922
she moved to Paris to continue music and voice studies. In 1932 she also began
to study painting. In 1937, as the approaching war made it necessary for her to
earn a livelihood, she decided to become a photography laboratory technician.
She began to photograph and that same year made a series of pictures of wealthy
Europeans on the Promenade des Anglais on the French Riviera. After Model
came to America in 1938, publication of the *Promenade des Anglais* series in the
weekly newspaper *PM* won her almost instant acclaim as a photographer.

Model's photographs are characterized by their emotional intensity—"Never
photograph anything which does not passionately interest you," she wrote—
and by her love of massive and dynamic form. Her subjects are often ugly, even
grotesque, and she documents her perceptions with devastating clarity, filling
the frame with the sitters' bulging shapes and making her prints large so the
portrait will seem more real to the audience. Her photographs are candid, never
posed.

The Museum owns the portfolio, *Lisette Model: Twelve Photographs*. AT

251 HENRI-EMILE-BENÔIT MATISSE

French; Le Cateau 1869–Nice 1954

Woman in a Purple Coat, 1937

Oil on canvas; 31⅞ × 25¹¹⁄₁₆ (81.0 × 65.2)
Signed lower left: Henri Matisse 37
John A. and Audrey Jones Beck Collection 74.141

In December 1916 Henri Matisse spent the first of many winters in Nice on the
Riviera, and in 1922 he began to divide his time each year between Nice and
Paris. Matisse had traveled to Morocco in 1911 and 1912, and his ongoing series
of Nice interiors reflects his affinity for the sensual colors, intricate patterns, and
lush foliage of the Mediterranean.

Woman in a Purple Coat is one of a group of paintings from 1937 in which
Matisse's models were elaborately costumed in Persian coats or embroidered
Rumanian blouses. Dark-haired Princess Elena Galitzin modeled for many of
these paintings and may well be the woman in this picture. The vivid color and
profuse pattern create a sense of decorative opulence that is counterbalanced by
the arbitrary, flattened perspective and the exaggerated hands. Matisse had begun
to simplify forms in the 1930's, yet he repeatedly returned to the areas of flat,
decorative pattern that characterize his work. JMR

252 STUART DAVIS

American; Philadelphia, Pennsylvania 1894–New York, New York 1964

Gloucester Harbor, 1938

Oil on canvas, mounted on panel; 23⅟₁₆ × 30⅛ (58.6 × 76.5)
Signed lower right: STUART DAVIS
Museum purchase with funds provided by the Agnes Cullen Arnold
Endowment Fund 77.330

Stuart Davis, whose career spanned more than half a century, uniquely combined Cubist syntax with the pulse and ambience of distinctly American scenes. A leader in the development of abstract art in America, his paintings provided a bridge between the pioneer American modernists such as Max Weber (1881–1961) and Marsden Hartley (1877–1943), who had abandoned abstraction by 1920, and the generation of American artists of the 1940's, who were influenced by the European abstract artists forced by World War II to regroup in the United States.

Davis, whose parents were both artists, left high school in 1910 to study with Robert Henri (1856–1929), noted for his realistic American scene paintings. In 1913, the year he left Henri's classes, Davis exhibited five watercolors at the now famous Armory Show, where he saw European abstract painting for the first time. Davis's resolve upon seeing the Armory Show to become a "modern" artist was probably reinforced by his acquaintance in the summer of 1913 with Charles Demuth (1883–1935), who had studied in France and was acquainted with European abstract art. Like the Precisionists, Davis began searching for abstract pattern in real objects and in 1927 did his first truly abstract paintings, the "eggbeater" series. Figurative elements, which re-emerged in his paintings of the 1930's, were flattened out and stylized into jigsaw-like patterns.

From 1915 through 1934 Davis summered in Gloucester, Massachusetts, a town that provided the visual stimuli for much of his work through the 1930's. In *Gloucester Harbor* (1938) the ships and docks have been fragmented to create a rhythmic arrangement of stylized shapes. The painting surface is in the shape of a ship's flag, a motif found throughout the scene he paints. The unmodulated planes of clear arbitrary color, related to Leger, provide a succinct distillation of a uniquely American scene. One of the first artists to perceive jazz music as an intrinsically American idiom, Davis translated the syncopation and energy of jazz to his canvases. JMR

253 ILYA BOLOTOWSKY

American; St. Petersburg, Russia 1907

Construction in a Square, 1940

Oil on canvas; 30⅛ × 30⅛ (76.5 × 76.5)
Signed lower right corner: Ilya Bolotowsky
Museum purchase with funds provided by The National Endowment
for the Arts and Joan Fleming 77.272

Ilya Bolotowsky first saw the Neo-Plasticist paintings of Piet Mondrian (see no. 227) in the Albert E. Gallatin Collection exhibited at New York University in 1933. From that time, Bolotowsky, a founding member of the American Abstract Artists in 1936, has committed his work to the Neo-Plastic goal of harmony and equilibrium achieved through purely plastic means. In *Construction in a Square* (1940), Bolotowsky has used pure color and pure form, free of

any subconscious or narrative imagery, to formulate an expression of balance and poise. Subsequent modifications in Bolotowsky's work, his move away from the use of black lines, his use of stronger color, and his 1961 move into the creation of three-dimensional, columnar structures, have left unchanged his basic aim, "to create visual poems of a lyrical structural nature—each with that particular aliveness which distinguishes art from decoration." JMR

254 MAX ERNST
German; Bruhl 1891–Seillens 1976

Moonmad, plaster 1944, cast 1956
Bronze; h. 37½ (95.3), w. 15¼ (38.75), d. 11⅝ (29.55)
Gift of D. and J. de Menil 57.5

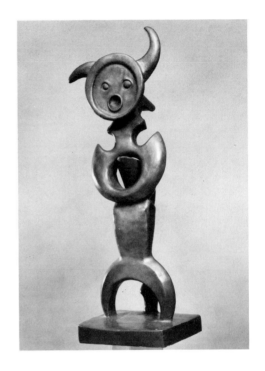

Max Ernst, a founder in 1919 of the Dada group in Cologne, was a chief protagonist of this anarchic intellectual movement (1915–1922) and later of Surrealism, the literary and artistic offspring of Dada. From Dada came the use of automatism, juxtaposition of banal objects, and images of the fantastic and irrational that Surrealism (1924–1938) explored and developed in depth.

Ernst lived and worked in France from 1922 until 1941 when World War II forced him to flee to the United States. Primarily a painter, Ernst did his first sculptures from rocks he carved and painted during a summer spent with Alberto Giacometti (1901–1966) in Maloja, Switzerland, in 1934. In Paris the following winter (1934–1935) Ernst created fantastic sculpture by casting found objects in plaster and then arranging the resultant shapes into various combinations. His next period of sculptural activity occurred during the summer of 1944 in Great River, Long Island, where he shared a summer house with the art dealer, Julien Levy.

In the catalog for an exhibition of his collection at the Yale University Art Gallery (1964) Levy recounts Ernst's creation of *Moonmad* during this time: " . . . I found Max in the garage casting a ghostly array of white shapes in any and every mold available from the kitchen and the backyard, from utensils, milk cartons and eggshells, and even from a few spare automobile parts. Within two days he had put his random castings together into a construction, a two-faced haunting figure which he later carved in wood. *Moonmad*." The plaster version of *Moonmad* was not cast in bronze until 1956. In addition to the ten unsigned and unnumbered bronzes, there is a mahogany version still in Julien Levy's private collection. The Museum also owns the original plaster version of *Tortoise*, which Ernst made during the same summer and later cast in bronze in an edition of nine. JMR

255 DAVID SMITH
American; Decatur, Illinois 1906–Bolton Landing, New York 1965

War Spectre, 1944
Painted steel; h. 14½ (36.8), w. 22⅝ (57.5), d. 6¾ (17.1)
Stamped in the steel outside "calf" of raised back leg: David Smith 1944
Museum purchase 78.58

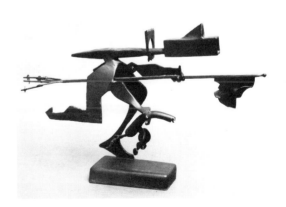

In 1926 David Smith moved to New York City where he studied painting at the Art Students' League until 1932. Although he made constructions with pieces of

coral and fishbone during a 1932 trip to the Virgin Islands, he did not concentrate his efforts on sculpture until 1933 when reproductions of Picasso's welded sculpture in the journal *Cahiers d'Art* prompted him to experiment with welded metal. Knowledge of steel cutting and welding techniques gained through a 1925 summer job in an automobile factory provided him with technical background for his use of this medium.

One of a series of five "spectres" welded by Smith during the 1940's, *War Spectre* (1944) is related to Surrealism in its combination of fantastic and mechanistic imagery. In portraying a mindless monster with a dagger-shape in place of a head, a cannon clutched in one hand, and a flag held spear-like in the other, Smith has expressed his own political and moral convictions. Strong horizontals create a feeling of onrushing movement, while small, punctuating, vertical details arrest the viewer's attention. Smith was one of the most important American sculptors of this century, and his exploration of the expressive potential of welded metal, culminating in the geometric stainless steel "Cubi" series, continued until his death in 1965. JMR

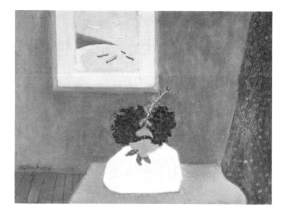

256 MILTON AVERY

American; Altmar, New York 1893–New York, New York 1965

Flowers on the Table, 1944

Oil on canvas; 32 × 44 (81.3 × 111.8)
Signed and dated lower left: Milton Avery 1944
Gift of Mary Jane Walne Marshall and Whitfield H. Marshall in
memory of Margaret Butler Walne 77.59

Milton Avery spent his youth in Hartford, Connecticut, where in 1913 he worked at nights in a factory in order to paint during the day. Largely self-taught, Avery pursued only one term of formal study at the Connecticut League of Art Students in 1923. In 1925 Avery moved to New York City, where for the first time he saw modern French painting as well as work by American Impressionists. He first exhibited his work at the Opportunity Gallery in 1928, where he met Mark Rothko (1903–1970) and Adolph Gottlieb (1903–1973), who became his close friends. A generation younger than Avery, both these artists learned from him the use of color masses, which was to affect their mature painting.

Avery's work is distinguished by his distillation of recognizable form into flat areas of pattern and pure color. Taking the arbitrary color of the Fauves (1905–1908) and Henri Matisse's (see no. 213) organization of pattern and shape as his points of departure, Avery depicted the essence of his subject matter, often verging on abstraction but always maintaining references to the world as he knew it. In *Flowers on the Table* the flattened forms of the vase, curtain, table, and wall smoothly interlock like pieces in a painterly puzzle. The abstract character of the shapes is heightened by his elimination of detail and decorative use of pattern. The small seascape within the picture in *Flowers on the Table* also alludes to a subject Avery often painted. JMR

257 FREDERICK SOMMER
American; Angri, Italy 1905

Arizona Landscape, 1945
Gelatin silver photograph; 7⅝ × 9½ (19.4 × 24.1)
Verso upper left: Arizona Landscape 1945; verso center:
Frederick Sommer
Target Collection of American Photography; Museum purchase with
funds provided by Target Stores 76.253

Frederick Sommer was born in Italy to a German father and a Swiss mother. In
1913 his family moved to Brazil where Sommer became fluent in Spanish,
French, and Portuguese in addition to his native Italian and German. In his
twenties, Sommer learned English. This fluency seeded an international, and
ultimately interdisciplinary, ground from which his art evolved. Although he
has lived in Prescott, Arizona, since 1935, European culture has continued to be,
in his words, "the mother lode," and its influence is evident in Sommer's photo-
graphs, paintings, and music.

Frederick Sommer's photographs are not public reports of his perceptions,
and they are not concerned with social needs but are most powerfully situated
in the realm of symbols, transformations, and poetry. They are not decipherable
without "extra-photographic" knowledge of myths, science, literature, and the
history of other arts. He is most closely associated with the Surrealist movement.
(Max Ernst [see no. 254] and Dorothea Tanning [b. 1910] lived near Sommer
in Sedona, Arizona.)

Arizona Landscape is part of the first series Sommer initiated after acquiring
an 8 × 10 camera in 1938. For the next ten years, he continued to make paintings
and photographs that were independent of one another; the photographs were
primarily of the incidents, events, and landscapes of Prescott's surroundings.
Although Sommer had been strongly influenced by the work of Edward Weston
(see nos. 228 and 238), his landscapes were radically different from those of
Weston and the other major American landscape photographers at that time.
They were closer to the ideas of contemporary painting. As Gerald Norland
observed in a 1968 essay: "Without a horizon, these vast details of desert have
no beginning and are without an end. The clumps of ground cover, mesquite
and cactus, without any suggestion of man's having trod this way, are moving
documents of what might be thought of as a surreal imagination . . . scores of
greys melting into each other in a radical compositionless image. . . . The com-
positionlessness of the works may remind us that men in Seattle and in New
York were venturing into similar edge-to-edge paintings at this time, unknowing
of the experiments of their counterparts elsewhere." AT

258 ANNE RYAN
American; Hoboken, New Jersey 1889–New York, New York 1954

#462, ca. 1948–1954
Collage on paper mounted on handmade paper; 6⅞ × 5¼ (17.5 × 13.3)
Signed lower right quadrant in pencil: A Ryan
Gift of Miss Elizabeth McFadden 79.23

Anne Ryan only began to work in collage, the medium in which she reached her full power, during the last six years of her life. However, in this brief time she created a body of work whose quality and depth assure her an important place in twentieth-century American art. Anne Ryan was already a painter and printmaker when she first saw the collages of Kurt Schwitters (1887–1948) at a retrospective exhibition at the Rose Fried Gallery in 1948. She immediately set to work to create her own collages. Though her use of paper wrappers and other bits of debris related her earliest collages to those of Schwitters, she soon developed her own style, distinctive in its paradoxical delicacy and power. Using scraps of handmade rag paper by Douglass Howell and other bits of paper and fabric, which she systematically sorted and stored, she created meticulous and subtle arrangements of color and texture.

Anne Ryan's collages are for the most part untitled and undated, and their numbers do not indicate any kind of chronological order. They fall roughly into three groups in which she worked simultaneously. The collages in the first group are distinguished by a figure/ground relationship, with the pieces of fabric and paper carefully arranged as elements on a background. A second group of collages has in common an overall distribution of shapes and seems related to contemporary Abstract Expressionist painting. Collage #462 belongs to a third group of works distinguished by the architectonic character of the vertical and horizontal shapes and the oval format, a device often used by Pablo Picasso (1881–1973) and Georges Braque (1882–1963) in their early Cubist collages. The orderly layers of color contain a wide range of hues and textures and give the collage a monumentality that belies its small size.

It is estimated that Anne Ryan made some four hundred collages between 1948 and her death in 1954. The Museum was given a group of thirty-three of these works by the artist's daughter and subsequently purchased two woodcut prints. JMR

259 ALBERTO GIACOMETTI
Swiss; Stampa 1890–1966

Figura Allongata, 1949
Bronze; h. 65 (165.1)
Gift of Robert Sarnoff 76.369

After attending the Ecole des Arts et Métiers in Geneva (1919), Alberto Giacometti settled in Paris, where he studied with the sculptor Emile Antoine Bourdelle (1922–1925). Although Giacometti's style evolved from his Cubist-based works of the mid-1920's and Surrealist sculptures of 1929–1934, to the thin, elongated figures of his post-1947 work, his preoccupation with the difference between exterior and interior reality remained constant.

In *Figura Allongata* Giacometti imbues tangible form with his perception of

the human figure, a perception in which weight and size are conceptual rather than visual data and the envelope of space surrounding the figure is as important as its mass. Elongated and majestic, the volumes compressed as if by the pressure of the surrounding space, the figure has the presence and monumentality as well as the pose of Egyptian burial figures or Greek korai. The base of the sculpture, actually a perspectival representation of the floor on which the model stood, has become an integral part of the sculpture.

Giacometti was a close friend of the philosopher Jean-Paul Sartre, whom he met in 1941. Sartre's Existentialist interpretation of Giacometti's elongated figural style, written for a 1948 exhibition of his work, did much to identify his mature sculpture with the milieu of Existential thought. JMR

260 JACKSON POLLOCK
American; Jackson, Wyoming 1912–Southampton, New York 1956

Number 6, 1949
Duco and aluminum paint on canvas; 44³⁄₁₆ × 54 (112.0 × 137.3)
Gift of D. and J. de Menil 64.36

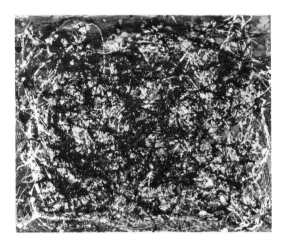

At age seventeen Jackson Pollock went to New York where he studied painting with Thomas Hart Benton (1889–1975) at the Art Students' League (1930–1932). The effect of the swirling contours of Benton's Regionalist paintings can be seen in Pollock's subsequent work, as can the influence of the powerful totemic images of José Orozco (1883–1949), Diego Rivera (1886–1957), and David Alfaro Siqueiros (1896–1974), whose murals interested Pollock in the late 1930's. The directness and vehemence of Pollock's work during this period anticipated the immediacy of his later "drip" paintings. During the 1940's he became familiar with the work of the emigré Surrealists associated with Peggy Guggenheim's Art of This Century Gallery, where he also exhibited. Knowledge of Surrealist concepts of biomorphic form, mythic imagery, and automatism is evident in his 1942–1947 works, as well as in his increasing concentration on the act of painting itself. During 1947 Pollock did his first "drip" paintings, so-called because he placed the canvas on the floor, pouring the pigment directly from the can.

The fluid tracery of *Number 6*, as in other classic "drip" paintings, does not define images or planes; rather, it creates a rich density of rhythmical, lyrical interlacings. The absence of a single focal point causes the image to be perceived as a whole. Pollock was an accomplished draftsman who used chance without relinquishing control. His "drip" technique involved constant decisions and choices and a high degree of manual skill.

Between 1951 and 1952 Pollock limited his palette to black and white and by 1953 had abandoned the "drip" technique, using a brush to paint figural abstractions during the last years of his life. Called "the ice-breaker" by Willem de Kooning (b. 1904), Pollock developed a kind of painting that was more direct, spontaneous, and abstract than anything that had yet appeared in American art. His enormous influence can be seen in the stain paintings of Helen Frankenthaler (see no. 287) and Morris Louis (see no. 270); the single image format that relates the work of Kenneth Noland (see no. 272), Claes Oldenburg (see no. 283), and Don Judd (see no. 294); environmental art; and works by Carl Andre (b. 1935), which rely on chance distribution. Pollock's "drip" painting pointed out new and diverse directions that have influenced virtually every major artist to follow. JMR

261 CLYFFORD STILL
American; Grandin, North Dakota 1904–Baltimore, Maryland 1980

Untitled, 1949
Oil on canvas; 68 × 58¼ (173.0 × 148.0)
Museum purchase with funds provided by The Brown Foundation
76.320

Clyfford Still belongs, with Mark Rothko (1903–1970) and Barnett Newman (1905–1970), to the "color field" group of Abstract Expressionists who eliminated figure and symbol in their work in order to focus on the expressive qualities of color and shape. Still's work stands apart, however, in its characteristic, thickly encrusted layers of paint.

During the 1930's Still painted landscapes of the American West and figures. His work became increasingly abstract in the 1940's and evolved from two symbolic images in his early work: the upright individual in an open field and the dualities of sun and earth, male and female, good and evil. By 1947 he had synthesized this imagery into a transcendent abstract statement in which all figurative references were eliminated. Still gave his earlier paintings titles that referred to mythical allusions but decided that specific titles were inappropriate to his intent to create a universal visual metaphor for the sublime. From 1948 on, he abandoned conventional titles.

In Untitled (1949) the jagged vertical areas appear as zones in a continuous field of color, rather than as shape against ground. The blue and orange seem to fight their way through the tight structure of the painting to its surface with an almost tangible presence and energy. Still has stated, "I never wanted texture to be texture, or images to become shapes. I wanted them all to fuse into a living spirit." The emotional power of his abstractions places him within the American tradition of romantic, visionary artists such as Thomas Cole (1801–1848) and Albert Pinkham Ryder (1847–1917). JMR

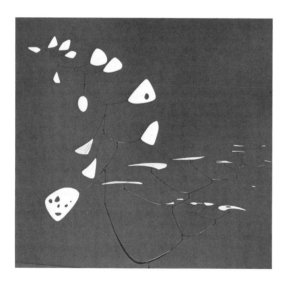

262 ALEXANDER CALDER
American; Philadelphia, Pennsylvania 1898–New York, New York 1976

International Mobile, 1949
Sheet aluminum, rods, wire; ca. 240 × 240 (610.0 × 610.0)
Gift of D. and J. de Menil in memory of Marcel Schlumberger 62.46

Alexander Calder was born into a family of well-known sculptors. He was graduated from Stevens Institute of Technology before attending the Art Students' League in New York. Calder was always interested in mechanics and motion; during a 1930 visit to the Paris studio of Piet Mondrian (1872–1944), he commented that it would be wonderful if the rectangular shapes of Mondrian's abstract canvases could be made to oscillate. Immediately after this visit, Calder began to experiment with abstraction, and by 1932 he had incorporated movement into abstract constructions, which Marcel Duchamp named "mobiles."

In International Mobile (1949) the biomorphic metal shapes and their chance movement by air current are closely related to the Surrealism of Joan Miró (b. 1893) and Jean Arp (1888?–1966). At the same time Calder's use of industrial materials and emphasis on motion in space rather than on volume is rooted in Constructivism. With these sources, Calder created a new type of sculpture made

of free-floating shapes suspended from rods and wires whose movement made them the first kinetic sculptures. The Museum also owns a stabile by Calder, *The Crab* (1962), in which cut, biomorphic shapes are joined in a large free-standing sculpture. JMR

263 HERBERT FERBER
American; New York, New York 1906

Horned Sculpture, 1949
Bronze; h. 74 (188.0), w. 15 (38.0), d. 12 (30.0)
Museum purchase with funds provided by The National Endowment for the Arts, Mr. and Mrs. George R. Brown, and Mr. George S. Heyer
79.1

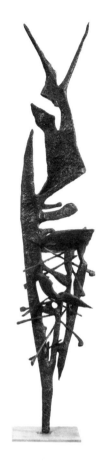

Between 1927 and 1930 Herbert Ferber divided his time between the study of dentistry at Columbia University and evening sculpture classes at the Beaux-Arts Institute of Design. By 1932 Ferber was a serious sculptor, working initially in wood and stone. His first works had literal subjects—usually exaggerations of the human figure. However, by late 1945 he had turned to abstraction and experimented with soldered, and later welded, metal.

During the late 1940's, Ferber became friends with many of the painters of the incipient Abstract Expressionist movement and through this involvement assimilated many concepts of Surrealism. Ferber's contact with this milieu is evident in the reference to primordial themes, the use of primitive organic shapes, and the intensified expressive content of his works from the late 1940's.

The vertical character of *Horned Sculpture* is characteristic of a number of works Ferber did in the late 1940's. Its spiky, angular shapes metamorphose from organic to geometric as it rises into space. The sculpture does not displace space, but instead pierces and contains it so that its open quality is as integral a part of the sculpture as is its mass. Ferber took the movement that results as the eye follows the transition between space and form even further by bringing *Horned Sculpture* to a single point that can be swiveled on its base. This involvement with spatial concepts led Ferber to abandon the traditional base in 1952 and eventually to create his environmental sculpture, first shown at the Whitney Museum of American Art, New York, in 1961. JMR

264 AARON SISKIND
American; New York, New York 1903

Jerome Arizona, 1949
Gelatin silver photograph; 19½ × 14⅝ (49.5 × 36.4)
Museum purchase
72.7

Aaron Siskind was forty-three years old when he first exhibited his work at the Egan Gallery in New York City. The 1947 exhibition was Siskind's first public recognition as a participant in the mid-century movement now known as the New York School. Siskind was the only photographer associated with the group. His bond was both aesthetic and social; Barnett Newman (1905–1970) had been a friend since college; Siskind "belonged" to the Eighth Street Club.

By 1947 Siskind had been a photographer for fifteen years. Like the work of

many artists in the 1930's, his early documentary photographs showed a strong social motivation, but Siskind also concentrated on architecture, particularly on facades and architectural detail. By 1947 he had extended this attraction to include any flat plane on which organic objects or pattern played across the picture surface. He had, he said, accepted "the flat plane of the picture surface as the primary reference of the picture" and had become interested in what Thomas Hardy identified as the "deeper reality underlying the scenic." His emphasis, he acknowledged, had shifted from what the world looks like to what he felt about the world and what he wanted the world to mean.

Jerome Arizona (1949) was made on a trip West that included a visit with Frederick Sommer (see no. 257). The subject of the photograph is not stucco walls in disrepair; it is Siskind's feeling expressed by the relationship of the curling, brittle paint to the hard, cracked stucco and by the animated, almost frantic configuration of the paint. The evocative energy of the shapes, not ecology, interests him.

Other works by Siskind in the Museum's collection include a photograph from the series *Homage to Franz Kline* and the portfolio *Terrors and Pleasures of Levitation* in the Anthony G. Cronin Memorial Collection. AT

265 HARRY CALLAHAN
American; Detroit, Michigan 1912

Eleanor, Chicago, 1949
Gelatin silver photograph; 10 × 9⅜ (25.4 × 23.8)
Recto lower right below image: Harry Callahan
Museum purchase 75.579

When Harry Callahan married Eleanor Knapp in 1936, he was working for the Chrysler Corporation and had no interest in photography. By 1948 Callahan was a photography instructor at the Institute of Design in Chicago and had begun to photograph Eleanor. Over the next ten years she became one of three sustaining motifs; the others were Landscape and the City.

Eleanor exists as a separate motif, and also as a bench mark in the other two. Callahan's landscapes without Eleanor are brittle and sharp. When Eleanor is included, the land appears fecund; the image evokes more poetic meaning. In *Eleanor, Chicago* (1949) she becomes Venus emerging from the Sea. Callahan's city views lack spirit except when Eleanor appears; she is a smiling stranger in an icy world. The other women that he photographed, absorbed in their thoughts as they passed on the sidewalk before his camera, lack spiritual presence; they are as cold and as hard as the darkness behind them.

"What I am concerned with," Callahan wrote, "is an expression of life, my life, which relates to others' lives." He has been committed to revealing the complexity and freshness of his feelings in an intense, highly personal, new way. He has felt no obligation to be faithful to an exterior reality; nor has he felt bound by traditional concepts of how a photograph should look. Callahan has worked with sequential images, with double exposure, with collage, and with photographs so void of detail that they might appear, at a glance, not to be photographs. In his restless search, Callahan has extended the possibilities of expression in photography.

Other works in the collection are: *Chicago* (1953), *Bob Fine* (ca. 1952), and *Telephone Wires,* a series begun in 1945. AT

266 LEE KRASNER

American; Brooklyn, New York 1908

Blue and Black, 1951–1953
Oil on canvas; 57¾ × 82½ (146.7 × 211.6)
Sarah Campbell Blaffer Foundation Funds and Museum purchase 80.42

Lee Krasner studied at the Women's Art School of Cooper Union (1926–1929), at the National Academy of Design (1929–1932), and with Hans Hofmann (1937–1940). She began exhibiting her work with the American Abstract Artists Group in 1940 and from that time was associated with most of the artists who came to be known as Abstract Expressionists. She was married to Jackson Pollock (see no. 260) from 1945 until his death in 1956.

The shallow, frontal space of *Blue and Black*, in which positive and negative areas balance one another, has been characteristic of Krasner's work since her study with Hofmann. As in *Blue and Black*, she frequently uses a limited palette, yet her use of color is powerful and expansive and attests to a careful observation of Matisse's work, which Krasner first saw at The Museum of Modern Art, New York, in 1929. The curved organic shapes of *Blue and Black* are related both to Matisse and to a longstanding interest in hieroglyphics and calligraphy. Krasner's work has always resisted categorization. However, in *Blue and Black* her use of spontaneous gesture as a point of departure and her rhythmic organization of pattern and shape reflect her involvement with the Abstract Expressionist milieu.

JMR

267 MINOR WHITE

American; Minneapolis, Minnesota 1908–Cambridge, Massachusetts 1976

Road & Poplar Trees, 1955
Gelatin silver photograph; 9⅜ × 11⅜ (23.8 × 28.9)
Signed front: Minor White
Target Collection of American Photography; Museum purchase with
funds provided by Target Stores 76.313

In 1945 Minor White, thirty-seven years old, was discharged from the army. He obtained a job as a photographer at The Museum of Modern Art, New York, where he studied museum methods with Beaumont and Nancy Newhall. He also enrolled in the Columbia University Extension Division, where he studied art history and aesthetics under Meyer Schapiro. Within a year, White had met Harry Callahan (see no. 265), Paul Strand (see no. 235), Edward Steichen (1879–1973), Todd Webb (b. 1905), Edward (see nos. 228 and 238) and Brett Weston (b. 1911), and Alfred Stieglitz (see nos. 211 and 246). These contacts deeply influenced White's photographic career as well as his service to the medium as teacher, critic, publisher, and mentor for a large portion of the next generation of serious photographers.

White's meetings with Stieglitz were profound and liberating because his subsequent photographs and theoretical writing adopted and considerably extended Stieglitz's concept of "equivalence." A photograph functions as an equivalent, White wrote, when one can say "that at that moment and for that person the photograph acts as a symbol or plays the role of metaphor for something that is beyond the subject photographed."

In part White extended the concept of equivalence through a sequence or series of photographs without a literary or story content related by formal similarities rather than by subject matter. His first successful sequence was made in 1947. *Road & Poplar Trees* is part of *Sequence 10/ Rural Cathedrals*, which was made in the vicinity of Naples and Danville, New York, during six weekends in October and November 1955. White considered *Sequence 10* to be the fruit of his previous experiments with infrared film, which he used to give contrast and an eerie other-worldliness to the landscape.

The Museum also owns a five-panel version of *Intimation of Disaster*, a sequence originally done in 1949 that exists in several subsequent variations, and twelve photographs in the *Jupiter Portfolio*. AT

268 ROBERT FRANK
American; Zurich, Switzerland 1924

Hoboken, 1955
Gelatin silver photograph; 8¹⁄₁₆ × 12³⁄₁₆ (20.5 × 31.0)
Recto lower right in ink: Hoboken, 1955 R. Frank
Target Collection of American Photography; Museum purchase with funds provided by Target Stores 76.243

In the 1960's there emerged a tradition that was termed "social landscape" photography. Its chief proponents were Bruce Davidson (b. 1933), Lee Friedlander (see no. 293), and Garry Winogrand (see no. 279), who were, in fact, among the third generation of photographers to base their pictures on the banality of America's urban scene. Their work had been influenced by the photographs of Robert Frank, who in turn had been responding to the work of Walker Evans (see no. 248). When Frank published his seminal monograph, *The Americans* (1959), he was very open about his debt to Evans, but most critics did not perceive that empathy and instead attacked the subjective, burning nature of Frank's vision as contrasted to Evans's coolness.

Robert Frank was the first European to receive a Guggenheim Fellowship. He spent two years traveling by car throughout America, photographing mundane scenes that anyone would recognize but "no one had accepted . . . as the basis for a coherent iconography for our time" (Szarkowski, *Looking at Photographs*, 1973). As Jack Kerouac explained in his introduction for *The Americans*, "he sucked a sad poem right out of America onto film."

The subject of *Hoboken* is a political ceremony that has the unenthusiastic attention of middle-aged men on a viewing stand. Two men in the front row stand out. One is a tall, heavy, hard-eyed man in a cloth coat and felt hat who embodies the stereotype of a political "Boss." The other is a politician in a silk hat described by Walker Evans as "exuding the utmost fatuity that even a small office-seeker can exhibit."

Other works by Frank in the Museum's collection include: *Reno* (1956), *Reno* (1956), and *Los Angeles* (1956), all in the Anthony G. Cronin Memorial Collection. AT

269 MARK TOBEY

American; Canterville, Wisconsin 1890–Basel, Switzerland 1976

Prophetic Light-Dawn, 1958
Tempera on paper; 59⅞ × 34¾ (152.0 × 88.2)
Signed and dated lower left corner: Tobey 58
Museum purchase 64.3

Mark Tobey worked outside the mainstream of twentieth-century American art by synthesizing aspects of Western painting and Oriental calligraphy. He studied at the Art Institute of Chicago and went to New York in 1911, where he worked as a portraitist and fashion illustrator. In 1918 Tobey joined the Baha'i World Faith, whose principles of unity, balance, and universality became the basis of his own thinking. A year after his 1922 move to Seattle, Washington, Tobey met a Chinese student at the university there who taught him Chinese brush work. In 1934 Tobey spent a month studying Japanese calligraphy in a Zen Buddhist monastery in Kyoto. It was this study of calligraphy that formed the basis of his mature style.

Prophetic Light-Dawn is characteristic of Tobey's work in its "white writing," an interwoven network of white lines that coalesces into form and is juxtaposed by skeins of darker underlying color. In calligraphy white line has traditionally been used to define highlights or the part of a form that reflects light. Thus, in its dual potential to create form and to symbolize light, a life giving force, Tobey found in white line the means to express his personal vision. Tobey's works have sometimes been related to those of Jackson Pollock (1912–1956) because both artists used an all-over patterning. However, there is a dramatic contrast in the scale of the work of these two artists, with the intimate scale of Tobey's work requiring close and thoughtful contemplation. Like Wassily Kandinsky (1866–1944), Paul Klee (1879–1940), and Piet Mondrian (1872–1944), Tobey sought to portray a reality that was spiritual rather than material, a reality echoed in the title, *Prophetic Light-Dawn*. JMR

270 MORRIS LOUIS

American; Baltimore, Maryland 1912–Washington, D.C. 1962

Loam, 1958
Acrylic on canvas; 90¾ × 148 (230.0 × 355.0)
Museum purchase with funds provided by The Brown Foundation
 76.319

Morris Louis was born Morris Bernstein in Baltimore, where he lived until 1936 and attended the Maryland Institute of Arts. Between 1936 and 1940 he worked in New York City and during this time adopted the name Morris Louis, which he used throughout his career. In 1952 he moved to Washington, D.C., where he taught at the Workshop Center from 1952 to 1956 and where he remained until his death from lung cancer in 1962.

In the spring of 1953 Louis and Kenneth Noland, who was then also living in Washington (see no. 272), went to New York City, where they saw Helen Frankenthaler's painting *Mountains and Sea* (1952). This painting, in which pigment was stained directly into the canvas, was of seminal importance to Louis. Speaking of Frankenthaler (see no. 287), Louis has said, "She was the bridge

between [Jackson] Pollock and what was possible." In Pollock's drip paintings executed between 1947 and 1950 (see no. 260), Louis had seen that paint could be freed of its traditional roles—line could exist without describing figure, and pigment could be applied without creating tactile illusionism. In Frankenthaler's stain technique, Louis recognized a method through which he could explore and develop in his own syntax the implications of Pollock's methods. Louis diluted his paint even more than Frankenthaler had done, uniformly soaking it into the canvas so that texture was almost totally eliminated. Unlike Pollock and Frankenthaler, Louis took pains to avoid the gestural in his canvases and instead used a chromatic organization that relates his works to those of Barnett Newman (1905–1970) and Clyfford Still (see no. 261). Louis was the first major artist to use acrylic (plastic) paints. This new medium, which dissolved in water and flowed more thinly and evenly than oil, made it possible for Louis to apply layer after layer of color without building up a tactile surface or muddying his subtle tones.

In *Loam*, one of a group of paintings known as "veils," Louis poured the acrylic paint onto a length of raw canvas, manipulating the material to control the paint flow. Though Louis always painted in absolute privacy, the areas of separate pigment at the top of the veil imply that it was here that he began to pour the pigment. Louis's workspace was smaller than many of the 1957–1959 veils, hinting that he sometimes pleated the canvas so he could work on it in sections, creating a wishbone shape like the one visible in the center of *Loam*. Through successive veils of paint, unstructured and without tactile or illusory qualities, Louis was able to present color with a new directness, immediacy, and beauty. JMR

271 JOSEF ALBERS
American; Bottrop, Germany 1888–New Haven, Connecticut 1976

Homage to the Square: Transmuted, 1959
Oil on masonite; 40 × 40 (101.6 × 101.6)
Signed lower right corner: A 59
Gift of Mrs. Anni Albers and the Josef Albers Foundation, Inc. 79.59

Josef Albers's preoccupation with the square can be traced to his years at the Bauhaus, where he began as a student in 1920 and taught between 1923 and 1933. With the closing of the Bauhaus in 1933, Albers came to America, where he taught at the avant-garde Black Mountain College in North Carolina (1933–1948) and served as chairman of the Art School at Yale University (1950–1958). Albers stressed to his students the principles of abstract design, which had been the core of the curriculum at the Bauhaus and which played an important role in the development of abstract art in America.

Albers began his famous ongoing *Homage to the Square* series in 1949. Not a new motif in twentieth-century art, the square had been used by Kasimir Malevich (1887–1935) as an important element in his Suprematist compositions as early as 1913. From 1917 on, the square was a characteristic element of the work of the De Stijl group. To these artists the square was an essential primary form, an end in itself.

To Albers, however, the neutral shape of the square was a tool through which he could explore the infinite variety of color. The proportions of the super-imposed squares in the *Homage to the Square* series are invariable—the margins of the overlapping squares exist in a ratio of one to two between the bottom and sides, and two to three between the sides and top. However, deceptive spatial illusions exist within this format due to the constant interaction between color and square. The *Homage to the Square* series provided Albers with a controlled structure for the explication of his ideas and feelings about color.

His 1963 treatise, *Interaction of Color*, and his example of nonallusive, single-image painting, where color is given precedence over design, served as important background for painters such as Kenneth Noland (b. 1924) and Frank Stella (b. 1936), who began to develop a new kind of nonhierarchical abstract painting in the mid-1960's. *Homage to the Square: Transmuted* is one of thirteen paintings dating from 1937 to 1970 given to the Museum by Mrs. Anni Albers and the Josef Albers Foundation. JMR

272 KENNETH NOLAND
American; Asheville, North Carolina 1924

Half, 1959
Acrylic on canvas; 68⅝ × 68⅝ (174.3 × 174.3)
Museum purchase 74.260

Half (1959) is one of a series of concentric-circle paintings (1957–1959) that comprise the first mature work of Kenneth Noland. Noland studied with Josef Albers at Black Mountain College (1946–1948) and became familiar with Albers's investigation of color relationships within a predetermined format. Noland was intrigued, as was his friend Morris Louis (see no. 270), by the staining technique used by Helen Frankenthaler (see no. 287) in the early 1950's and began to apply paint soaked directly into unprimed canvas. He found that quick-drying acrylic paint worked best on his raw cotton canvases, and this medium, which could not be easily touched up or reworked, lent itself to the simple and immediate configurations he has called "one shot" images. In *Half* Noland has used the concentric circle as a structure for pure color, with the ragged edges of the outermost circle creating an area of transition between the rings of color and the bare canvas. The soft edges intrinsic to the staining process also serve to counter-act the hard geometry of the shape and prevent the image from appearing brittle or decorative.

Noland belongs to the generation of American artists who reacted against Abstract Expressionism during the late 1950's. In their skepticism about the ability of abstract art to convey subjective content, these artists, who included Ellsworth Kelly (b. 1923), Frank Stella (b. 1935), and Jack Youngerman (b. 1926) as well as Noland, eschewed qualities that were not strictly pictorial and there-fore intrinsic to painting. While they retained the immediacy and all-over image Jackson Pollock (1912–1956) had brought to Abstract Expressionism, they re-jected tactile quality, symbolism, and metaphor. Called "post-painterly abstrac-tion" by Clement Greenberg, their art is characterized by its cool detachment and concentration on the optical sensation of pure color. JMR

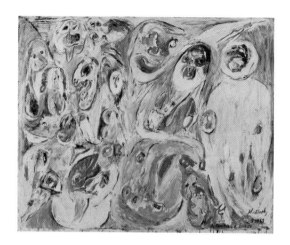

273 PIERRE ALECHINSKY
Belgian; Brussels 1927

The Tomb of Ensor, 1961
Oil on canvas; 67⅜ × 80 (171.2 × 203.2)
Signed, dated, and titled lower right: Alechinsky/ IV 1961/ le tombeau
d'Ensor
Museum purchase 61.47

From 1949 to 1951 Pierre Alechinsky was allied with COBRA, an informal
group of artists that included Asger Jorn (1914–1973), Karel Appel (b. 1921),
and Corneille (b. 1922) and took its name from the acronym formed by the first
letters of the artists' capitol cities, Copenhagen, Brussels, and Amsterdam. These
artists reacted against the strict geometry of Piet Mondrian (1872–1944) and
Theo van Doesburg (1883–1931) and sought a freer, more spontaneous art
through myth, humor, fantasy, and experimentation with various media. The
COBRA group retained images of the human figure, which set their art apart
from the Abstract Expressionists who were working simultaneously in the
United States.

Although *The Tomb of Ensor* (1961) was painted a decade after the dispersal of
the COBRA group, its fantastic imagery and humor give substance to Ale-
chinsky's statement, "COBRA was my school." The title of the painting and
its mask-like forms refer to the Belgian artist James Ensor (1860–1949), who
frequently used masks and skeletons in his macabre imagery. Because of the
fantastic and figurative character of much of Ensor's work, the COBRA artists
considered the earlier artist a predecessor, and reference to Ensor and his works
recurs throughout Alechinsky's oeuvre. JMR

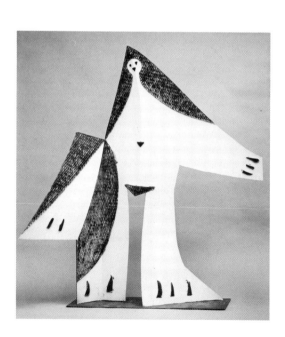

274 PABLO PICASSO
Spanish; Malaga, Spain 1881–Mougins, France 1973

Woman with Outstretched Arms, 1961
Painted iron; h. 70⁹⁄₁₆ (178.6), w. 61⁹⁄₁₆ (156.4), d. 28⁹⁄₁₆ (72.5)
Gift of The Esther Florence Whinery Goodrich Foundation 66.15

As a child Pablo Picasso had amused his sister by making paper cutouts. Decades
later the photographer Brassai (b. 1899) documented some twenty folded paper
cutouts the artist had made in 1943. In 1953 Picasso enlarged his paper maquettes
in cut and folded sheet metal.

Woman with Outstretched Arms, one of a series of sheet-metal sculptures from
1961, combines drawing, collage, and sculpture and gives substance to his hal-
lucinatory figures from his paintings of the 1930's. The pieces of screening and
painted metal, which define the details and shadows of the form, are painted and
attached to the free-standing figure, much as Picasso had pasted pieces of painted
paper to the canvas in his collages decades earlier.

Two other versions of *Woman with Outstretched Arms*, one almost identical to
the Houston piece and one a 14½-inch study in metal, were in the artist's col-
lection at the time of his death in 1973. Picasso's dealer D. H. Kahnweiler was
so fond of this work that he commissioned a twenty-foot version in sandblasted
concrete for his garden in southern France. JMR

275 MARK ROTHKO

American; Dvinsk, Russia 1903–New York, New York 1970

Painting, 1961
Oil on canvas; 92⅞ × 80 (235.9 × 203.2)
Museum purchase 67.19

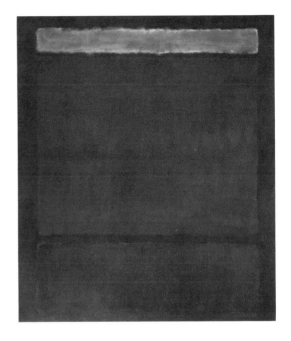

Mark Rothko, born Marcus Rothkowitz, emigrated with his family from Russia to the United States in 1913. He was raised in Portland, Oregon, and attended Yale University before moving to New York City, where he studied with Max Weber at the Art Students' League (1926–1927). His works from the early 1940's were distinctly Surrealist in their morphology and mythic themes, but by 1947 Rothko had begun to heighten the rectangular elements already present in his paintings while purging them of their Surrealist imagery. By 1950 he had arrived at the ethereal, floating rectangles of color that formed his hallmark style.

Like his contemporaries Clyfford Still (1904–1980) and Barnett Newman (1905–1970), Rothko viewed color as a vehicle for emotional expression, as a medium through which the material—paint and canvas—could be transformed into the sublime. Brushing on the paint in delicate washes, soaking it into the weave of the canvas, Rothko built up layer after layer of subtle, glowing color, which he distilled into two or three luminous rectangles.

The paintings of the early and mid-1950's are generally bright in color. Rothko was commissioned in 1958 to create a set of murals for the Four Seasons Restaurant in the Seagrams Building in New York City; he made three sets of panels, each group progressively darker and more somber. Rothko finally decided he could not allow the paintings to be placed in a restaurant and donated them to the Tate Gallery in London. Done soon after the completion of these works, *Painting* (1961) continues this departure from the vivid color of his earlier canvases. The rich, dark rectangles of color, which seem to have an inherent luminosity despite their deep tones, have a majestic iconic power. The fourteen canvases commissioned for the Rothko Chapel in Houston (1964–1967) continue the somber tone of Rothko's work.

In the tradition of Wassily Kandinsky (1866–1944) and Paul Klee (1879–1940), Rothko saw color as the window to the soul. In 1968 he suffered an aneurysm, which was aggravated by further health and personal problems. He took his own life in February 1970. JMR

276 ROBERT MOTHERWELL

American; Aberdeen, Washington 1915

Black on White, 1961
Oil on canvas; 78 × 163³⁄₁₆ (198.1 × 414.5)
Museum purchase 62.7

Robert Motherwell studied philosophy at Stanford and Harvard Universities. His graduate thesis on Delacroix's journals took him to France where he became immersed in the French Symbolist poets and modern French aesthetic theories. In 1939 he returned to the United States to study at Columbia University with the eminent art historian Meyer Schapiro, who introduced him to many of the European painters whom the war had exiled to New York. Motherwell's knowledge of French language and aesthetics gave him a unique tie with the Surrealist artists and enabled him to participate in their activities. Although by

1941 he was committed to a career as a painter, Motherwell has written about art continuously and has been an articulate spokesman for abstract painting.

Motherwell was one of the youngest members of the Abstract Expressionists. This group of New York painters used Surrealist biomorphism and automatism as its point of departure, substituting painterly qualities for Surrealist illusionism and mythic symbols for imagery of personal fantasy to create a heroic art expressive of universal emotions and truths.

Around 1950 Motherwell, in his ongoing *Spanish Elegy* series, began to paint large mural-sized canvases and to restrict his palette to mainly black and white with touches of ocher and cerulean blue. In *Black and White* (1961) Motherwell has reconciled the painterly improvisation of the drips of paint and irregularly brushed edges with the clarity of the large, simple shapes. Balance between contradictory elements—intellect and the unconscious, shape and line—is central to Motherwell's art as it is to Abstract Expressionism as a whole. JMR

277 HENRI CARTIER-BRESSON
French; Chanteloup 1908

Sawyer-Flood House, Galveston, Texas, 1962
Gelatin silver photograph; 12¹⁄₁₆ × 8¹⁄₁₆ (30.6 × 24.0)
Stamped on verso: Photograph by Henri Cartier-Bresson/©1962
Magnum Photos, 15 W. 47th Street, N.Y.C. 36
Museum purchase 65.237

Henri Cartier-Bresson, by trade a photojournalist who makes picture-essays for magazines, is by reputation a master of the "one unique picture whose composition possesses such vigor and richness, and whose content so radiates outward from it, that this single picture is a whole story in itself" (Cartier-Bresson, *The Decisive Moment*, 1952). His ability to recognize intuitively moments of significance in human events, what James Soby called "the poetic accidents," and to give graceful form to those accidents influenced a generation of photographers on both sides of the Atlantic.

In 1962 Cartier-Bresson and the American architectural photographer, Ezra Stoller (b. 1915), were commissioned by The Museum of Fine Arts, Houston, to photograph historic buildings in Galveston, Texas. The project was initiated by Howard Barnstone, a Houston architect, and sponsored by the Museum under the direction of James Johnson Sweeney. In 1965 the text by Barnstone and photographs by Bresson and Stoller were published in a book entitled *The Galveston That Was*. In the book's foreword, Sweeney acknowledges that the Museum chose in Bresson and Stoller "two pairs of eyes of such broadly different curiosity." Stoller's photographs (there are thirty-eight in the Museum's collection) are intelligent, informative, clear, direct, and technically majestic. Bresson's work (there are forty-six Galveston photographs in the Museum's collection) is ultimately less concerned with the architectural significance of the buildings he was commissioned to photograph than with the way the buildings were used, and misused, by their current inhabitants. Unlike Stoller, who excluded all but the random passer-by, Bresson found people irresistible and includes them in almost every picture. In this photograph Bresson was supposed to record, in detail, the bay window at the front entry of the Sawyer-Flood House, but the window, partially obscured by a low branch, and the still elegant but decaying staircase become foils to the youthful presence of a girl playing on the steps. AT

278 ROBERT RAUSCHENBERG
American; Port Arthur, Texas 1925

Urban, 1962
Lithograph; 41⅛ × 29¾ (105.1 × 75.6)
Gift of Barbara Rose 79.136

Occasionally classified, and to some extent misclassified, among the Pop artists, Robert Rauschenberg turns popular images toward an art goal, especially in his lithographs. *Urban* was his first lithograph to make multiple use of photoengraved newspaper plates, the hallmark of Rauschenberg as a printmaker. In early 1962 he selected about fifty plates used and discarded by *The New York Times*. In using these images Rauschenberg discovered a graphic equivalent for the found objects, for example a real stuffed goat, he had long incorporated into his paintings. At the same time, he blended his photographic imagery with the nonrepresentational, gestural shapes associated with Abstract Expressionism. Thus Rauschenberg amalgamates the intense, spontaneous creativity of Abstract Expressionism with the subject connotations associated with representational art. The resulting juxtaposition of abstract shapes and images from photoengraved plates—a Boston-New York baseball game, President Kennedy, the Treasury Building, and the tiros satellite—suggests a kinship with the Surrealist tradition.
JMW

279 GARRY WINOGRAND
American; New York, New York 1928

Untitled, 1964
Gelatin silver photograph; 8⅞ × 13⅜ (22.5 × 34.0)
Signed on verso upper right: Garry Winogrand 100
Anonymous gift 79.20

Garry Winogrand studied painting at City College of New York and Columbia University. He studied photography with Alexey Brodovitch for one semester at the New School for Social Research. From 1952 to 1969 he worked as a photojournalist and advertising photographer in New York City; since 1969 he has taught photography at various universities and art schools. His work was first exhibited in 1955 at The Museum of Modern Art, New York, in Edward Steichen's exhibition *The Family of Man*. In 1966 Winogrand's work was included in *Toward a Social Landscape* at the George Eastman House Museum, Rochester, New York, and a year later in *New Documents* at The Museum of Modern Art. Both shows were group exhibitions that also included the work of Lee Friedlander (see no. 293).

The literature written around these two exhibitions identified Winogrand and Friedlander as "street photographers" and their subject as the "social landscape" (see no. 268). Their styles were determined by their choices of subject, of camera, and of cropping. Working with 35mm cameras and wide-angle lenses, they produced pictures that are complex, lyric, and descriptive.

Winogrand has chosen subjects that are a challenge to photograph freshly because they are popular subjects: animals, beautiful women, political gatherings. They are subjects in which photojournalists easily find cheap puns or sentimentality. Winogrand avoids clichés by keeping the subject in the original context (not isolating it as a journalist would) and by composing the picture so

that its central axis is off-balance. For instance, he may tilt the horizon line. In Houston's picture, the sun streaks on the windshield of the photographer's car add a static energy that competes with the falling cow for the viewer's attention and keeps the picture from being morbidly sentimental.

Other works by Winogrand in the Museum's collection include: *Copenhagen* (1969), *Forest Lawn Cemetery* (1964), and an untitled photograph from the portfolio *New California Views* (1979). AT

280 FRANK STELLA
American; Malden, Massachusetts 1936

Moultonville I, 1966
Fluorescent alkyd and epoxy paint on canvas; maximum dimensions
124¾ × 87¹³⁄₁₆ (213.7 × 223.0)
Anonymous gift 73.85

From his earliest works done soon after his graduation from Princeton University in 1958, Frank Stella was until recently concerned with geometric form and pictorial structure. Stella belongs to the generation of artists who followed the Abstract Expressionists, and his cool, clean geometry exemplifies the post-painterly abstractionists' reaction to the painterly, emotional, and mythical qualities of Abstract Expressionism.

In the late 1950's and early 1960's Stella worked with loosely parallel lines and bands that often reiterated the form of his shaped and notched canvases, identifying the image with the canvas surface. In 1966 he began the *Irregular Polygon* series to which *Moultonville I* belongs. In *Moultonville I* Stella creates an intricate balance between the geometry of the interpenetrating, painted shapes and the literal shape of the canvas support. The broad areas of color, unbroken by the stripes and lines of his earlier works, are the first instances in which Stella juxtaposed different pigments—fluorescent alkyd and epoxy enamel—using the contrasting finishes to heighten surface tension. The areas of color are separated by unpainted quarter-inch lines that allow the shapes breathing space and whose ragged finish prevents the work from becoming hard-edged. *Moultonville I* is one of eleven works in each of three separate series of *Irregular Polygons*. The canvases were titled after mountains in New Hampshire, where Stella had been artist-in-residence at Dartmouth College during the summer of 1963. JMR

281 LARRY BELL
American; Chicago, Illinois 1939

Untitled, 1966
Coated glass, metal; h. 12¼ (31.0), w. 12¼ (31.0), d. 12¼ (31.0)
Gift of Janie C. Lee 77.371

Larry Bell spent his youth in California and studied at the Chouinard Art Institute in Los Angeles (1957–1959). Bell began as a painter, seeking to achieve concreteness and presence by shaping his canvases (1961–1962) and adding glass and mirrors, in whose visual properties he was interested. In 1963 he built his first three-dimensional works, mirrored cubes, which would break down the space between viewer and object through reflection. In 1964 Bell developed a

commercial process through which panes of transparent glass could be coated with vacuum-evaporated minerals, leaving a semitransparent film of evanescent metallic color. The untitled cube (1968) in the Museum's collection is an example of Bell's application of this technique.

Along with Don Judd (see no. 294), Sol LeWitt (see no. 284), and other so-called minimal sculptors of the 1960's and 1970's, Bell rejected traditional sculpture's ordered relationship of various elements in favor of simple, single geometric shapes that could be perceived immediately and as a whole. Bell's cubes have a precision and directness rooted in the reaction of a generation of younger artists against the gestural and emotional qualities of Abstract Expressionism. The immediacy of Bell's cube is emphasized by the textural sameness of the glass and the precise fabrication of the piece in which all possible flaws and distractions have been eliminated from the surface. Bell acquired his own vacuum equipment in 1966 and from that time has been able to adapt industrial techniques to his own uses in his studio. The cube sits at eye level on a transparent stand especially designed by Bell to allow the light to travel up through the cube and contribute to the vaporousness of the color. Bell thereby gives the work a heightened clarity and directness by identifying color and light as part of and intrinsic to the surface. The fusion of color, light, and surface gives Bell's work a common bond with the fluorescent light structures of Dan Flavin (b. 1933) and the work of Don Judd, who emphasizes the colors inherent to his materials. JMR

282 PAUL MOGENSEN

American; Los Angeles, California 1941

Untitled, 1966–1978

Oil and stand oil on canvas; diam. 90 (229.0)
Gift of Fredericka Hunter 78.230

A native of Los Angeles, Paul Mogensen attended the University of Southern California there. Following his graduation he traveled in Europe, India, and Asia and alternated between living in New York City and Los Angeles. Since 1973 he has worked and lived in New York.

Mogensen's untitled spiral painting belongs to a series he began around 1970. These paintings all share a structure predetermined by a logical external system —two parallel, spiraling bands, one monochromatic and the other a systematic progression of the color spectrum. However, Mogensen set up an opposition to this logical system by varying the tone and saturation of each color progression.

The sources of Mogensen's single-image format lie in Jackson Pollock's (see no. 260) all-over patternings and Josef Albers's (see no. 271) series of squares. The circular canvas distantly echoes Jasper Johns's (b. 1936) *Targets* of the mid-1950's, in which the image and field were identical. In its immediacy and emphasis on the literal characteristics of painting, Mogensen's art has helped shape a contemporary response of "post-painterly abstraction" to Abstract Expressionism. JMR

283 CLAES OLDENBURG
American; Stockholm, Sweden 1929

Giant Soft Fan, Ghost Version, 1967
Canvas, wood, foam rubber; h. 120 (305.0), w. 59 (150.0), d. 64 (163.0)
Gift of D. and J. de Menil 67.18

Claes Oldenburg was graduated from Yale University and sporadically attended classes at the Art Institute of Chicago before moving to New York City in 1956. An interest in the theater led to his involvement in 1958 with a group of artists who were staging Happenings—environmental productions combining theater and art. Here he developed a love for and fascination with the common object, the objects of the street and everyday life. Oldenburg's first soft sculptures grew out of a 1962 installation in the Green Gallery of his environmental work *Store*. The scale of the gallery required larger works and led Oldenburg to his first soft sculptures of oversize objects.

Metamorphosis is a constant theme in Oldenburg's work. He often works in series, investigating the same objects in different forms, colors, and sizes. In addition to the white *Giant Soft Fan, Ghost Version* (Houston), there is a black vinyl *Giant Soft Fan* (Museum of Modern Art, New York), and a related sketch *Proposed Monument: Fan in Place of the Statue of Liberty*, *Bedloe's Island* (Private Collection). In writing about his work, Oldenburg has stated: "There is a black fan and a white one—the theme of opposites in the context of superstition. I have a shiny black fan and a dry white fan—like the two angels, those winged victories that walk beside you, the white angel and the black angel."

His fascination with the mutability of banal objects allies him, in sensibility at least, to Surrealism. However, where the Surrealists were interested in altering psychological states, Oldenburg concerns himself with the permutation of physical properties such as scale, surface, and texture as well as with altering the content and use of the object. The drape of the soft material and the scale of the *Giant Soft Fan* create the quality of anthropomorphism and parody present in all of Oldenburg's soft sculptures. His giant objects share with the abstract objects of sculptors Don Judd (see no. 294) and Larry Bell (see no. 281) the immediacy of the single image, a legacy from the impact of the overall patternings of paintings by Jackson Pollock (see no. 260). In his soft sculptures Oldenburg stresses his subject's character as an object, but at the same time the often voluptuous creases and folds of the stuffed vinyl and canvas forms show a retention of tactile values rooted in Abstract Expressionism. JMR

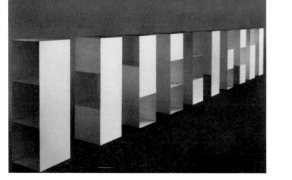

284 SOL LEWITT
American; Hartford, Connecticut 1928

333, 1967 (refabricated 1975)
Baked white enamel on steel; 10 units, each measuring
h. 54 (137.0), w. 18 (46.0), d. 18 (46.0)
Gift of Donald Judd 77.332

Like many "object" sculptors whose work reached maturity during the 1960's, Sol LeWitt began his career as a painter. He was graduated from Syracuse University with a Bachelor of Fine Arts degree in 1949, taught at the school of The Museum of Modern Art, New York, from 1964 to 1967, and had his first one-man show in New York at the Daniels Gallery in 1965. By the mid-1960's he

had begun to create structures that used the cube as a modular unit and to refer to his work as "conceptual."

LeWitt believes that the underlying concept of a work of art is as important as the visual result. His use of industrial materials and simple, primary structures caused his early conceptual works to be categorized, along with those by Don Judd (b. 1928) and Larry Bell (b. 1939), as minimal. However, LeWitt's premise that a work of art is simply a manifestation of a more important underlying system is in direct opposition to the minimalists' emphasis on form and physical presence and belies the extraordinary power of his work.

In *333*, from the series *49 3-Part Variations Using 3 Different Kinds of Cubes*, LeWitt uses the openness of the cubes to de-emphasize their physicality so that the viewer will concentrate on the predetermined logical arrangement of forms instead of the forms themselves. LeWitt likes to use cubes as his units because, in his own words, "released from the necessity of being significant in themselves, they can be better used as grammatical devices from which the work may proceed." LeWitt chooses to have his steel modules covered with white baked enamel because he finds the white less obtrusive against white gallery walls, and less "expressive" than black or a color. The industrial fabrication also draws attention to the arrangement and structure of the cubes rather than to a handwork finish. All of LeWitt's structures are preceded by working drawings, and he has also produced books, prints, and wall drawings created by assistants according to his instructions. JMR

285 ROBERT GOODNOUGH
 American; Cortland, New York 1917

Anghiari II, 1968
Acrylic on canvas; 60¼ × 114⁵⁄₁₆ (153.0 × 290.3)
Signed and dated lower right corner: Goodnough '68
Gift of the artist 69.24

Robert Goodnough first studied in New York (1946) with Amédée Ozenfant (1886–1966), a founder of Purism, who tried to instill discipline and exactitude in the work of his students. This emphasis was modified by Goodnough's studies with Hans Hofmann (1880–1966) in the summer of 1947. During 1948–1949 Goodnough was a member of the "Club," which became an informal center of Abstract Expressionism where artists and critics met to exchange ideas.

However, during the late 1950's Goodnough looked to the tradition of Cubism in his efforts to arrange clean-edged shapes to create a feeling of solidity and volume on the two-dimensional plane of the canvas without creating the illusion of three-dimensional space. "I try to uncube the 'cube' to create a space which is neither recessive nor advancing, but just special relationships being on a single plane." In 1952 Goodnough began to work in collage, and there is a direct relationship between his arrangements of cut and pasted paper shapes and the interlocking planes of *Anghiari II*. Goodnough purposely allowed the runs and drips of paint in *Anghiari II* to remain. This painterly handling reflects the relation of his work to Abstract Expressionism. Goodnough's strong sense of continuity with the past is expressed in the title of the work, which refers to Peter Paul Rubens's (1577–1640) copy after the lost cartoon by Leonardo (1452–1519) of *The Battle of Anghiari* (1505). JMR

286 WALTER DARBY BANNARD
American; New Haven, Connecticut 1934

Western Air #1, 1968
Alkyd resin on canvas; 66 × 99 (167.6 × 251.5)
Museum purchase with funds provided by Joan H. Fleming 72.23

Walter Darby Bannard attended Princeton University (1952–1956), where he shared a studio class with Frank Stella (see no. 280), who was to become a good friend. After a year spent living in New York City and traveling through Europe, Bannard returned (1958) to Princeton, New Jersey, where he lives and works today.

In *Western Air #1* Bannard has combined a geometric format with fluid variations of hue. One of a generation of younger painters who reacted to what they perceived as the excesses of Abstract Expressionism, Bannard set out to present color in a simple format on a flat surface. At the same time, he was influenced by the work of Clyfford Still (see no. 261), which he first saw in 1959. Both Bannard's subsequent juxtaposition of matte and gloss finishes and his modulation of the surface exclusively through variations of color and texture are rooted, at least in part, in his response to Still's work. Since the late 1950's Bannard has used commercial house paint because it exists in both matte and gloss textures and enables him to create areas of contrast within the same color. Moreover, it is available premixed in the voluptuous yet delicate colors that are characteristic of his work. JMR

287 HELEN FRANKENTHALER
American; New York, New York 1928

Blue Rail, 1969
Acrylic on canvas; 106¹⁵⁄₁₆ × 93¾ (271.6 × 238.1)
Museum purchase with funds provided by The National Endowment for the Arts and The Friends of Modern Art 73.82

Helen Frankenthaler is a pioneer of the staining technique that was the technical point of departure for Kenneth Noland (b. 1924), Morris Louis (1912–1962), and Friedel Dzubas (b. 1915). Jackson Pollock's (1912–1956) 1951 paintings of black enamel dripped on unprimed canvas were her source. Frankenthaler poured paint onto unsized canvas spread on the floor, controlling the flow of the pigment with the gesture of her entire body. Her painting technique differed from Pollock's drip method in the smooth flow of pigment that formed broad areas of color rather than dripped linear patterns, and in the thin washes of paint that were stained directly into the canvas, creating a smooth rather than a densely built up surface. It is this characteristic of staining, the physical integration of image with support, that prevents the color shapes from taking on any three-dimensional quality they might otherwise possess and enables Frankenthaler to develop the spatial ambiguity that creates such complexity and tension within her work.

In 1962 Frankenthaler switched from oil paint, which tends to fade when stained into unprimed canvas, to water-base acrylic paint. *Blue Rail* (1969) belongs to a group of works painted after this medium change, in which color shapes are placed one against the other. In *Blue Rail* the straight blue line connecting the shapes at the top of the canvas was not stained, but painted with a ruler, and marks the reintroduction of drawing into Frankenthaler's work.

JMR

288 GEOFF WINNINGHAM

American; Jackson, Tennessee 1943

Tag Team Action, Wrestling—Houston, 1971

Gelatin silver photograph; 11¹³⁄₁₆ × 17⁹⁄₁₆ (30.0 × 44.6)

Signed front below image: V/1 Tag Team Action, Wrestling Houston 1971 Geoff Winningham

Anthony G. Cronin Memorial Collection; Gift of The Cronin Gallery in memory of Anthony G. Cronin 78.258.1

With the exception of his years at graduate school in Chicago, Geoff Winningham has lived in Houston, Texas, since 1961. Since 1970 he has focused his camera on the rites of the city and state: rodeos, wrestling, parades, dances, and football. He is committed to the camera's ability to describe and preserve an experience. A picture, he says, is "just me, the sponge, out there trying to soak everything I wanted in a single frame" (*Geoff Winningham: Photographs*, The Museum of Fine Arts, Houston, 1974, p. 17). Characteristically, he frames the incongruities inherent in any gathering, the random gestures and unexplained relationships. Because he works quickly and because his subjects are frequently in motion, Winningham does not always find all the incongruities he has captured until he looks at the contact sheets of his negatives, an element of surprise that pleases him.

Tag Team Action was made during a seven-month project of photographing wrestling matches in Houston. His photographs and interviews with the wrestlers and their faithful audience were published in 1971 in *Friday Night in the Coliseum*. In 1972 Winningham published *Going Texan*, an intense and loving investigation of the Houston Livestock Show and Rodeo. His most recent book, *Rites of Fall* (1979), studies high-school football in Texas.

The Museum's collection comprises thirty-four photographs by Winningham, including works from each of the projects named above and one photograph from a series on Texas county courthouses. AT

289 FRIEDEL DZUBAS

American; Berlin, Germany 1915

Late Fire, 1972

Oil on canvas; 52 × 120 (132.0 × 304.8)

Museum purchase with funds provided by The National Endowment for the Arts and The Friends of Modern Art 73.26

Friedel Dzubas, along with Kenneth Noland (b. 1924) and Morris Louis (1912–1962), took Helen Frankenthaler's innovation of stain painting (see no. 287) as the point of departure for his own explorations of fluid color shapes. Born in Berlin in 1915, Dzubas studied at the Prussian Academy of Fine Arts and at the Kunstgewerbeschule (1931–1933) and with Paul Klee (1879–1940) in Düsseldorf. Dzubas emigrated to the United States in 1939, settling in New York City in 1949. During 1952 he shared a studio with Helen Frankenthaler, from whom he learned the staining technique of soaking paint into unprimed canvas.

Late Fire (1972) is an important work in Dzubas's oeuvre because it synthesizes the fluidity of his earliest stain paintings and the form of his hard-edged works of the late 1960's. In *Late Fire* Dzubas has established a tension between the crisp profiles of the color shapes and the variations—from dense to diaphanous—of

color saturation. The horizontality of the canvas is reinforced by the four horizontal rectangles and the two long, thin shapes that run along the lower edge of the canvas. Through shifts of texture and tone within the rectangles, the fading of edge into atmosphere, Dzubas has created a painterly articulation of color and form. JMR

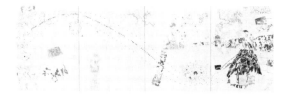

290 NANCY GRAVES
American; Pittsfield, Massachusetts 1940

Nearside of the Moon 20° North–South by 70° East–West, 1972
Acrylic on canvas; 96 × 288 (234.0 × 732.0)
Anonymous gift 74.250

Nancy Graves was graduated from Vassar College and then studied fine arts at Yale University. Since the late 1960's her subject matter has been material forms, and works from this time include her Camel sculptures and abstract compositions of feather, bone, and shell. In 1971 she began the *Camouflage* series in which she depicted sea animals within their ocean environment. It was in this series that she first used a pointillist technique to define shape through small dots of color. However, her pointillism differs from that of the Neo-Impressionists such as Georges Seurat (1859–1891) and Paul Signac (1863–1935), who saw in it a scientific method to break down and recreate color. In her own words, "The connection between local pinpoints and cosmic points is one of the majestic relations recognized by science." Additionally, the fragmentation of shape into dots allows the forms to retain their descriptive quality and at the same time creates an almost abstract flow across the canvas.

Graves became intrigued by maps in 1969 and in 1972 did a series of ten drawings and eight paintings based on lunar maps. *Nearside of the Moon 20° North–South by 70° East–West* followed the *Lunar Series* and was her first extremely large painting. Based on a large body of research, the four-part canvas is a composite summary of different kinds of twentieth-century moon mapping and includes references to sequential photographs taken by satellite, to computer and video interpretations of the moon, and to linear lunar maps. The variety of depictions of the same area and the large size of the work make it necessary for the viewer to study it from many vantage points. A wavy line, which represents the orbit of the Apollo, connects the four sections of the work. Graves has always felt that a recognizable image in a new medium and context can lead to a fresh view of information that is already part of our existence. In *Nearside of the Moon 20° North–South by 70° East–West* she has used the map as an a priori structure to order a response to the natural world through form, line, and color.
 JMR

291 JOHN BALDESSARI

American; National City, California 1931

A Different Kind of Order (The Thelonius Monk Story),
1972–1973
Five gelatin silver photographs and one typewritten sheet,
individually framed; each image: 6⁹⁄₁₆ × 9¹³⁄₁₆ (16.7 × 24.9);
each frame: 11⅝ × 14¹¹⁄₁₆ (29.52 × 37.3)
Museum purchase with funds provided by The National
Endowment for the Arts and matching funds 78.4

John Baldessari was a painter, but in the mid-1960's he decided that the inter-
action between photographs and language better suited his art interests. Baldessari
does not make finely crafted photographs. His presentations are casual, almost
"throwaway." This casualness typifies the humor that is often part of his work.
Accused of making banal or "dumb" art, Baldessari refers to parables as models
for his multilevel, narrative works.

A Different Kind of Order contains five news photographs and a sheet of type-
written text. The photographs are of natural disasters: flood, earthquake, tornado.
The text is narrative: "There's a story about Thelonius Monk going around his
apartment tilting all the pictures hanging on the wall. It was his idea of teaching
his wife a different kind of order. When she saw the pictures askew on the wall
she would straighten them. And when Monk saw them straight on the wall,
he would tilt them. Until one day his wife left them hanging on the wall tilted."
The photographs and the text are mounted in dime-store, black, wooden frames.
When exhibited, the frames are hung in a line, but each is slightly askew.

The tilted frames illustrate the text, but the pictures are a more poetic evoca-
tion of "a different kind of order." Tilted telephone poles and muddy streets
would normally be called "disorder," but when accompanied by this text, the
receding perspective of the flattened poles becomes a different kind of order.
This interaction between visual and verbal, connotative and denotative possi-
bilities, is central to Baldessari's art. The reference to another artist (Thelonius
Monk) and to artistic theories is also characteristic. AT

292 DAVID NOVROS

American; Los Angeles, California 1941

Untitled, 1974
Oil on canvas; 80 × 120 (203.0 × 305.0)
Museum purchase with funds provided by The National Endowment
for the Arts and matched by anonymous donors 74.263

After attending the University of California David Novros moved to New
York City in 1964 and has remained there to live and work. The Museum's
untitled painting is a complex and precise arrangement of color shapes. Novros
has eschewed any modulation of tone or texture in his color areas and has fitted
them together so that each section holds its place on the plane of the wall without
receding or coming forward. Novros's literalism, his presentation of painting
as actual surface and shape rather than as illusion, is taken a step further by his
use of three separate canvases whose edges are fitted together. Line becomes a
physical entity formed by the canvas edges that separate the color areas. The
inverted "L" shapes of the painting have appeared in Novros's work since the

late 1960's, and the asymmetrical composition is also characteristic. During 1974 and 1975 Novros worked in New Mexico, and the earthy colors of the Museum's painting evidence the influence of that landscape.

Novros has studied Quattrocento fresco painting and has worked in fresco since 1972. In his frescoes, related in format to his paintings on canvas, Novros took the unity of color and surface a step further by actually uniting painting with the plane of the wall. JMR

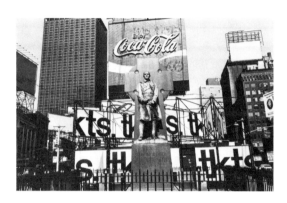

293 LEE FRIEDLANDER
American; Aberdeen, Washington, 1934

Father Duffy. Times Square, New York, New York, 1974
Gelatin silver photograph; 6⅝ × 10 (16.8 × 25.4)
Signed on verso: Lee Friedlander
Museum purchase with funds provided by The National
Endowment for the Arts and matching funds 78.11

In 1960 the John Simon Guggenheim Memorial Foundation awarded Lee Friedlander a fellowship to photograph "the changing American scene." One might suppose from the proposal that Friedlander wanted to make sociological documents, but he was less interested in social problems than in pictorial ones. He wanted to investigate how America looked in photographs.

"The most interesting thing is the shooting," he answered when asked what motivated him. He does not mean the mechanical act, which involves skill, but the artistic decision of what and how to photograph. The possibilities are tempered both by the subject and by the inherent character of the medium as Friedlander has come to understand it. Regarding the subject, Friedlander explained that it "demands certain things . . . For instance, there is a difference in photographing a flower and a bush. The bush requires that you walk back 4' or 6' or 8'. It demands it."

Rather than consciously choose a subject he will recognize that he has been increasingly attracted to a particular theme—monuments, parties, flowers. Frequently, there are specific pictorial problems built into photographing a particular subject (using a flash attachment when photographing parties). As he becomes more curious about a given theme and the concurrent picture problems, a series evolves. He is challenged by the number of good pictures that it is possible to make of a single subject, and he will work on a series for several years. *Father Duffy* is part of Friedlander's series on American monuments, which culminated in an exhibition and book.

The Museum owns two other photographs by Lee Friedlander: *Phoenix, Arizona* (1975) and *Santa Fe, New Mexico* (1969). AT

294 DONALD JUDD
American; Excelsior Springs, Missouri 1928

Untitled Commissioned Piece, 1975
Brass, painted aluminum; h. 36⅛ (92.0), w. 60 (152.0), d. 60 (152.0)
Museum purchase with funds provided by The National Endowment
for the Arts and matched by The Brown Foundation 75.370

Don Judd studied philosophy and art history at Columbia University and painting at the Art Students' League concurrently between 1949 and 1953.

Between 1957 and 1962 he completed the requirements for a Master's Degree in Art History at Columbia, where he studied with Meyer Schapiro. Articulate and informed, he wrote art criticism from 1959 through 1965, first as a reviewer for *Art News* and then as a contributing editor to *Arts Magazine*.

Like many sculptors of the 1960's, Judd began his career as a painter, and he was deeply impressed by the uninflected ordering and the large scale of works by Jackson Pollock (see no. 260). His goal of unity between canvas and image and his unsuccessful attempts to rid his paintings of all traces of illusionism led Judd to create his first freestanding objects in 1962.

Judd's untitled box (1975–1976) commissioned by the Museum is a compendium of the major themes of his work. Rejecting traditional composition of ordered and balanced individual parts, Judd chooses instead a single image in which structure, color, surface, and material are united. The single image produces the clarity and directness of Pollock and Barnett Newman (1905–1970) but without the painterly excesses of earlier art. In 1964 Judd began to use industrial materials and fabrication, coupling the physical properties such as reflectiveness, density, and transparency with vivid color to rivet the viewer's response to the work as a physical entity. In the Museum's sculpture the aluminum bottom of the box is painted Cadmium red light. This brilliant color is reflected on the inside of the brass panels of the box, creating a fusion of light with surface. JMR

295 HORACIO TORRES

Uruguayan; Leghorn, Italy 1924–New York, New York 1976

Composition with Figures, 1975
Oil on canvas; 70 × 95 (178.0 × 241.0)
Signed and dated lower left front: Horacio Torres 1975
Museum purchase with funds donated by Mrs. Colletta Lake Ray 75.40

Horacio Torres spent his early childhood in Paris where his father, the Cubist painter Joaquin Torres-Garcia, founded the Cercle et Carré group in 1929. The family moved to Montevideo, Uruguay, in 1934. In 1938 Torres began to receive regular instruction in painting and drawing from his father, who despite the modernism of his own work, felt that a thorough study of the Old Masters was essential. Torres divided his time between South America and Europe until 1971, when he settled in New York City.

Torres's painting is unusual in its juxtaposition of traditional subject matter with modern formalist concerns usually associated with abstraction. While at first glance *Composition with Figures* may seem evocative of Venetian and Baroque painting, upon closer examination one is struck by the way in which its existence as a painted picture overwhelms any potential autonomy of subject matter. By omitting the head of the standing figure at the left and by leaving the head of the reclining figure at the right unfinished Torres emphatically reminds the viewer that these figures are not flesh and blood, but paint and canvas. Similarly, the figures are placed so that they do not portray any special event. Torres has deliberately left the painting unfinished, and in the background the underpainting appears continuous with the draperies at certain points. The absence of finish has made possible the broad range of color and paint handling and the complexities of space and volume, which contribute to the immediacy and beauty of the picture. *Composition with Figures* epitomizes Torres's paradoxical goal, to deal with the human figure as an abstraction while painting it in three dimensions. JMR

179

296 ROBERT HEINECKEN
American; Denver, Colorado 1931

Space/Time Metamorphosis #1, 1975–1976
Photo emulsion and charcoal pencil; 42 × 62 (106.7 × 157.5)
Target Collection of American Photography; Museum purchase with
funds provided by Target Stores and The National Endowment for
the Arts 76.274

Robert Heinecken is a photographer who infrequently uses a camera and who
freely employs materials not traditionally associated with photography, includ-
ing plastic, canvas, charcoal, acrylic, and found objects. Until recently he rarely
exhibited straight, unmanipulated photographs. He has instead made lithographs,
etchings, offset prints, collages, and sculpture. But always, his works rely on
that illusion of reality that is unique to photography. "I want it to be photo-
graphic," he said, "because of that residual actuality."

For twenty years, human sexuality has been his primary theme. *Space/Time
Metamorphosis #1* is the second in a trilogy of large photographic collages on
canvas about sexual metamorphosis. The first work in the trilogy was *Invitation
to Metamorphosis* (1974). *Space/Time Metamorphosis #1* and *#2* were made in
1975–1976. The same woman appears in *#1* at least five times. The figures touch
and intertwine with each other and with the landscape. A rock becomes a foot;
a leg becomes a hand; a body has four legs. Drawing on the photographs,
Heinecken adds a mask, the straps of lingerie, and repeatedly a strange reptile
form.

As is characteristic of all Heinecken's work, the primary source of the Houston
picture is photographic. The viewer is convinced that this woman existed and
that she was photographed but that the reference to reality is suggestive, not
explicit, that the picture articulates not what the artist saw, but what he synthe-
sized. Perhaps more than any other post-war photographer, Heinecken has
explored the possibility that photographers have an obligation to an internal
as well as to an external landscape. AT

297 ROBERT MANGOLD
American; North Tonawanda, New York 1937

A Quarter Circle Not Totally within a Rectangle and a Square,
1976
Acrylic and crayon on canvas; two sections, irregular 96 × 120
(244.0 × 305.0)
Museum purchase by exchange with funds provided by The
National Endowment for the Arts and matching funds 79.12

Robert Mangold had his first one-man show in New York City in 1964, soon
after receiving his Master of Fine Arts degree from Yale University. From the
outset his art has been marked by the pragmatism shared by many artists of his
generation in response to Abstract Expressionism. At the same time, the influ-
ence of a movement of the scope and depth of Abstract Expressionism is inevit-
able. Thus, Mangold cites the color-field abstractions of Barnett Newman (1905–
1970) as a chief source of his art and refers to himself as an "intuitive" artist who
has followed his feelings or hunches.

Mangold's use of geometric forms and his choice of a singular image rather

than one composed of related parts, connects his work to that of so-called mini-mal artists such as Don Judd (see no. 294), Sol LeWitt (see no. 284), and Larry Bell (see no. 281). However, unlike the "minimalists" Mangold does not empha-size the physical qualities of his materials. With the exception of a group of works done between 1968 and 1970, he plays down any serial quality in pieces that have individual and independent meaning though they may be related.

Literalism, the definition of painting as actual surface and shape rather than as illusion, is the subject of Mangold's work. In *A Quarter Circle Not Totally within a Rectangle and a Square* the gap in the quarter circle, which occurs at the point where the rectangular and square canvases abut, underlines the paint-ing's identity as an object hung on the wall. The line created by the butted edges of the canvases interrupts the surface defined by the quarter circle and prevents the development of a figure-ground relationship. Tension is created by the relationship of the shape of the canvas to the shape drawn in crayon on the canvas, with neither dominating. Mangold uses controlled, subdued color that enhances the unity of color, line, and shape he is seeking and applies the acrylic paint with a roller to avoid expressionistic brushwork. Mangold's work is para-doxical. Rational and intuitive, austere and delectable, it possesses both intel-lectual and visual power. JMR

298 NEIL WELLIVER
American; Millville, Pennsylvania 1929

Beaver Pond, 1976
Oil on canvas; 71¾ × 96¾ (182.0 × 246.0)
Signed lower right corner in paint: Welliver
Museum purchase with funds provided by The National Endowment
for the Arts and Mr. George S. Heyer, Jr. 78.160

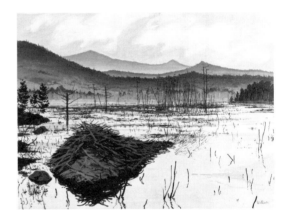

Neil Welliver followed his studies at the Philadelphia Museum School, where he was trained in a strict academic watercolor tradition, with graduate work at Yale University with Josef Albers (1888–1976), Burgoyne Diller (1906–1965), Conrad Marca-Relli (b. 1913), and James Brooks (b. 1906). This exposure to the activities and ideas of contemporary art stimulated Welliver's interest in the Abstract Expressionist painting of Jackson Pollock (see no. 260) and Willem de Kooning (b. 1904).

Welliver's stated goal is "to make a 'natural' painting as fluid as a de Kooning." In his canvases, he combines the careful scrutiny of nature associated with tradi-tional landscape painting, with a painterly articulation whose breadth and energy are values of Abstract Expressionist painting. On close examination the *Beaver Pond* is actually composed of a network of fluid "abstract marks," each with its specific role within the larger context of the picture.

Except for the broad area of the sky and hills in *Beaver Pond*, Welliver has avoided tonal modulation and instead uses linear strokes of flat paint to define three-dimensional form. In articulating the delicate reeds and the mass of the beaver dam, Welliver's brush strokes take on a calligraphic character. Welliver uses a limited, cool palette, evocative of the distilled light of the Maine country-side where he paints. In most cases his large canvases are repainted from smaller works done outside. JMR

299 DOROTHEA ROCKBURNE

Canadian; Verdun, Quebec

Arena V, 1978

Vellum paper, colored pencil, varnish, glue on ragboard; 61 × 47
(154.9 × 119.4)
Signed recto lower right corner in pencil: Arena V/ Rockburne, 78
Museum purchase with funds provided by The National
Endowment for the Arts, Mr. and Mrs. Fox Benton,
and The Charles Ulrick and Josephine Bay Foundation 79.119

Dorothea Rockburne's work evolves out of creative cycles. Since 1969–1970 she has used the concept of set theory, the branch of mathematics dealing with the nature and relationship of sets, to organize her thoughts and work. *Arena V* in the Museum's collection is one of seven works in the *Arena Series*, whose title refers to the Arena Chapel, site of Giotto's (1266/1267–1337) famous fresco cycle in Padua, Italy.

Rockburne has read widely in the field of mathematical theory. The concept of the Golden Section, which she first used in her *Golden Section Paintings* (1974), has been a consistent theme in subsequent works, including *Arena V*. The Golden Section is that proportion which, since antiquity, has been thought to have a hidden, harmonic relationship with the rest of the universe. This proportion, a line divided so that the small part is to the large part as the large part is to the whole, was used by artists and craftsmen throughout ancient, medieval, and Renaissance times. Rockburne finds strong appeal in the proportion itself and in its link with the past.

The drawn arc first appeared in *Arc* from Rockburne's 1972–1973 series *Drawing that Makes Itself*. This involvement with the arc was carried a step further and united with her predilection for historical reference in her 1974 series of drawings *In Consideration of the Curve*, based on photographs made by Rockburne of curved architectural details found in the Romanesque, Gothic, and Renaissance buildings in and around Florence. Rockburne's use of vellum paper also grew out of the series *Drawing that Makes Itself*. Always concerned with structure, Rockburne found she could make the physical layering of her work visible through folding the semitransparent vellum. The vellum also appeals to her as an ancient material. The colors of *Arena V*, their choice influenced by Giotto's frescoes in the Arena Chapel, also refer to art of the past.

Rockburne's work is austere, cerebral, and concerned with underlying structure, systems of mathematics, and historical reference. At the same time, it possesses great beauty and elegance. Though conveyed through systems and theories, the basis of her work is intuitive: "I always seem to have a vision in my eyes and in my head. Realizing this vision is the joy of working and living." Her complex art is the realization and communication of a private concept into a tangible abstraction of complexity and power. JMR

300 SUSAN ROTHENBERG

American; Buffalo, New York 1945

Red Banner, 1979
Acrylic on canvas; 90 × 123⅞ (228.6 × 314.6)
Museum purchase with funds provided by The National Endowment
for the Arts and Mrs. Theodore N. Law 79.263

Susan Rothenberg studied at Cornell University, George Washington University, and the Corcoran Museum School in Washington, D.C., and currently lives and works in New York City. Since the mid-1970's, Rothenberg has used the image of the horse in her paintings. Before she painted horses Rothenberg made collages and painted abstractions that investigated the relationships between parts and wholes. As she relates it, her choice of the horse as an image was entirely arbitrary: "I drew a line down the middle and before I knew it, there was half a horse on either side." Her first horses were bisected by lines, carrying on the involvement with parts and wholes of her abstract works. The function of these lines was gradually moved from division to containment. In *Red Banner* the lines evolved into the diagonals defining the emblematic shape that surrounds the horse and its skeletal counterpart. Both image and field are united by Rothenberg's sensuous paint handling, which recalls the Abstract Expressionist's predilection for the brushed, painterly surface.

The real subject of Rothenberg's painting is not the horse, but the nature of painting itself. The image of the animal, dislocated from any associative background or environment, is a vehicle for the exploration of formal qualities of painting. In *Red Banner* Rothenberg deals with the relationships of shape to edge, figure to ground, and surface to depth, focusing attention on the painting as a physical object. At the same time her use of the horse image with its implied connotations of primitivism establishes a powerful tension in the painting between emotional content and formal qualities. JMR

Pre-Columbian and Tribal Arts

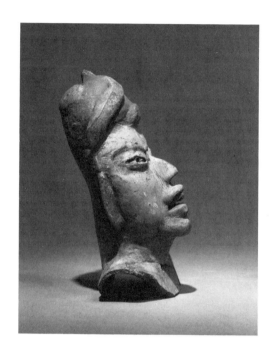

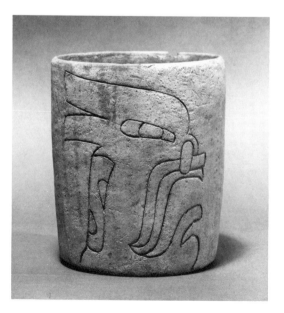

Pre-Columbian

301 OLMEC
Mexico

Head (from a figure), ca. 1000 B.C.
Ceramic; h. 7⅜ (18.7)
Gift of Mrs. Harry C. Hanszen 65.65

The works of art produced by the Olmecs of ancient Mexico during the centuries around the turn of the first millennium B.C. are much admired and investigated today. The esteem in which they are held is based on several factors, not the least of which is the unusual use of a "baby-faced" imagery. The Olmec "baby-face" has recognizably human features with an added elaboration of the mouth. Olmec mouths are often open, toothless, and wide-lipped, and they have, for all their seeming anguish, an inexpressive and remote aspect. Baby-faces appear everywhere in Olmec art: on small jade carvings, on large basalt sculpture, on ceramic figures.

The Houston head belonged to a ceramic figure of substantial size, quite large for its time, and its now missing body would probably have resembled that of a rather fleshy child. The surface color of the head is white, the traditional color of such figures. There is red pigment on the turban-like "hat" and a black, painted design running down the left cheek from forehead to neck. Only remnants of the delicate, linear design remain.

Olmec ceramic figures of this kind reportedly come from a number of different places in Mexico. It is possible that the Houston example, because of the quality of its surface color, may have come from the ancient settlement now called Tlapacoya. Tlapacoya is in central Mexico not far from modern Mexico City, and the Olmec ceramics identified with it are noted for a particularly dense gray-white surface color. JJ

302 OLMEC
Mexico

Straight-sided Bowl with Incised Designs, ca. 1000 B.C.
Ceramic; h. 5⁹⁄₁₆ (14.1), diam. 4¾ (12.1)
Gift of Mrs. Harry C. Hanszen 65.68

The large, stark, deeply incised, profile faces on each side of the white-surfaced Houston bowl are those of an ancient Mexican creature identified today as a were-jaguar. Were-jaguars are thought to result from a mythological union of

184

a human mother and a jaguar father. Large, spotted, jungle-dwelling cats, jaguars were among the most important animals in the ancient New World. Olmec were-jaguars combine human and cat features and add specific characteristics of their own. Most notable is the extraordinary head, whose shape resembles the claw end of a hammer, as in the Houston bowl. The mouth is another feature that receives unusual elaboration.

The Houston bowl is identified with Tlapacoya in central Mexico, where there seems to have been a vogue for white bowls with were-jaguar designs. Central Mexico was but one of the areas in which Olmec influence was felt at the turn of the first millennium B.C. Apparently as politically powerful as they were artistically accomplished, the Olmecs were at home along the Gulf of Mexico in the lowland swamps of coastal Tabasco and Veracruz. Olmec remains, chiefly in the form of stone sculpture, have been found as far from the Gulf Coast as Guerrero in the west and El Salvador in the south. The Olmecs were among the most accomplished sculptors ever to work in the ancient world.　　JJ

303 MONTE ALBAN
Mexico

Funerary Urn, 1st–3rd centuries A.D.
Ceramic; h. 10%₁₆ (26.8)
Gift of Mrs. Harry C. Hanszen　　　　　　　　　　　　65.146

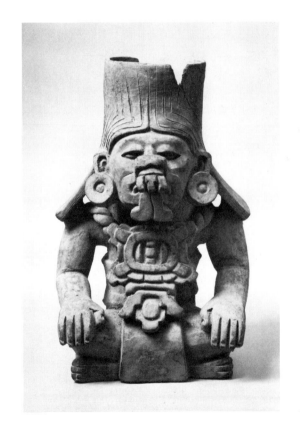

In southern Mexico, in the area that is now the state of Oaxaca, there developed in ancient times a civilization and an art of marked individuality. For many centuries the focus of this individuality was in and around Monte Alban, the beautiful city placed on mountain ridges several hundred feet above the surrounding valley of Oaxaca. One of the peculiarly well-developed ceramic forms at Monte Alban was the so-called funerary urn. These urns come principally from burials. The urns are usually fired to a metallic gray color and were much embellished through the centuries they were in use, particularly by detailing of costume and headdress. The urns are often found in groups of some size in tomb chambers, and they represent gods and/or attendant figures.

The god depicted on the Houston urn is known as the god with the serpent mouth-mask. The mouth-mask consists primarily of the nonhuman nose, fangs, and tongue. The god with the serpent mouth-mask appeared very early in Oaxaca and continued in use throughout the history of Monte Alban. He was a particular favorite in the early centuries of the first millennium A.D., when the Houston example was made. At this time the god was quite simply decorated without the elaborate headdress he later acquires. He is a god who is seldom dressed up, for he only occasionally wears a small, simple cape. Most often, as in the Houston example, he wears none. Sculpturally the urns of this time are among the most successful produced at Monte Alban. Their pleasing volumes and clean sharpness of detail are later lost in the proliferation of elements and formal inattentiveness.　　JJ

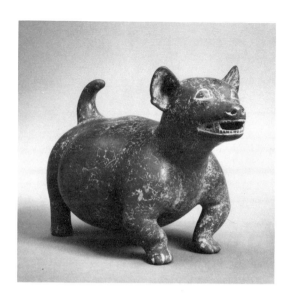

304 COLIMA
Mexico

Dog, 4th–5th centuries A.D.
Ceramic; h. 12 (30.5), w. 17⅜ (44.1), d. 9¹⁵⁄₁₆ (25.2)
Gift of Mrs. Harry C. Hanszen 65.115

Few ancient Mexican objects have charmed as many modern viewers as have the so-called Colima dogs. The dogs are among the quantities of ceramic offerings found in important tombs in the small western Mexican state of Colima. Some of the graves are quite large and will have had dozens of ceramic, stone, and shell offerings deposited in them. The ceramic objects range from simple bowls to complex representational sculpture that includes human and animal images. The animals and birds used were common to the Colima area at the time of their manufacture.

The Colima dogs were given the greatest variety of personalities. These ceramic animals can be ferocious and menacing, good natured and willing-to-please, or sleeping, vulnerable creatures. One group of them appears to be particularly well fed, and conjecture has long held that they represent animals so fattened in order to be eaten. The popular appeal of the dogs seems in part to be based on carefully observed canine detail. Formally the dogs exhibit considerable artistic sophistication. The generalized, rounded bulk of the canine body in the Houston example is emphasized by the outlines formed by the legs—they are not angular, bony legs. The tail curves in a stubby but well-realized curl above the broad back. The surface of the dog, too, is tight and well smoothed, contributing to the overall aspect of pleasing, round compactness. JJ

305 TEOTIHUACAN
Mexico

Cylindrical Tripod Vessel, ca. 500 A.D.
Ceramic, painted stucco; h. 6⅛ (15.5), diam. 6⁷⁄₁₆ (16.4)
Gift of Mrs. Harry C. Hanszen 65.70

During the early centuries of the Christian era, one of the largest, most lavish cities ever to exist in ancient America flourished in the small Valley of Teotihuacan in central Mexico. The city, named for the valley in which it stood, was powerful, rich, and cosmopolitan, and at its height it had an estimated population of 100,000. Within that population were numerous artisans; some two hundred craft workshops were located in the city, most of them ceramic workshops.

One vessel form particularly noted among the ceramics of Teotihuacan is the cylindrical tripod vessel, which apparently came into widespread use in Mesoamerica during the fifth century and was of artistic and presumably ceremonial and/or religious significance. Care and attention went into making cylindrical tripods. Painted stucco was perhaps the most elaborate of the different surface treatments to be found on these vessels. Thin layers of lime plaster cover the outside body of the vessel, and the plaster is painted. The matte absorbency of the stucco mutes and subdues the painted colors, giving the whole a delicate softness not found on other kinds of ceramic surfaces. The Houston vessel shows a pair of elegantly dressed hunters apparently hunting birds with blowguns. The hunters are wearing feathered headdresses and tassel-ended loincloths. Neck ornaments and large, circular earplugs are also worn. The plaster surfaces of these vessels are very fragile and do not often survive burial. Fortunately some few have managed to endure intact. JJ

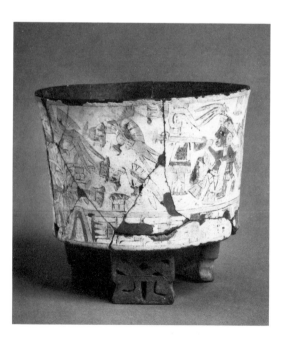

306 MAYA

Guatemala

Covered Bowl, 4th–5th centuries A.D.
Ceramic; h. 10½ (26.7), diam. 12⅞ (32.7)
Museum purchase with funds provided by The Brown Foundation
and The Hobby Foundation 76.426

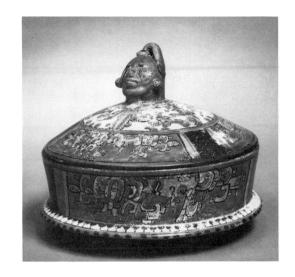

Mayan ceramic vessels of the fourth and fifth centuries A.D. are not as well known
as their later counterparts. There are marked differences between the earlier and
later examples, and the attenuated refinement for which Mayan art is so famous
is not characteristic of these earlier works, which tend to be grander in scale and
formally more inventive.

One of the most favored vessel shapes of the earlier time, particularly for the
lowland Maya who had their artistic focus in the Peten district of Guatemala,
was the basal flange bowl. The bowl takes its name from the extended ridge
around the bottom of the body of the vessel. The vessels are often large, often
lidded, and are known from burials of important people. The decoration on the
basal flange bowls can consist of rectangular, painted design units with smaller,
plain areas in between. Two such design units appear on the body of the Houston
bowl, and the images therein are of profile faces wearing big, multi-element
headdresses. These images are horizontal, and the profile face is looking down
toward the foot of the bowl. Two similar images appear on the lid, where the
faces look toward the rim.

A striking feature of the covered bowls is the sculptural form frequently given
to the knob. The modeled Houston head is of particular interest, although its
meaning in relation to the profile face designs is presently unclear. Important
basal flange bowls were made essentially in two colors: the polychrome orange
of the Houston example and monochrome blacks. The significance of these
colors for the ceramic vessels of this period is also presently unclear. JJ

307 MAYA

Guatemala

Covered Bowl, 4th–5th centuries A.D.
Ceramic; h. 11⅞ (30.2), diam. 13⅞ (35.2)
Gift of Mr. and Mrs. George R. Brown 77.47

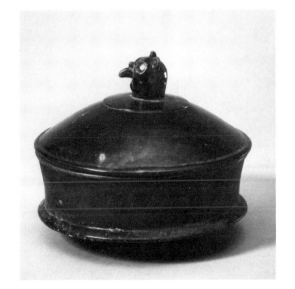

The Museum's bowl was made at roughly the same time and in the same place
as the preceding example (76.426) during the fourth to fifth centuries A.D. in
the Peten district of Guatemala. It, too, would have been a burial offering in an
important Mayan tomb. These tombs are known from excavations at major
Mayan sites such as Tikal, where they are found deep in the structural core of
temple platforms or dug into bedrock beneath them. The glossware bowls, as
the polychrome orange and monochrome black pieces were called because of
the high shine of their surfaces, were among the "fancy" ceramics included
in the tomb. Plain ceramic bowls would also have been placed there to hold food.

Houston's blackware bowl is one of a group of tetrapods (four-footed vessels)
in which animal aspects and the bowl form are integrated in a most extraordinary
manner. In most Mesoamerican ceramic vessels of animal shape the vessel is so
well integrated that no suggestion of "bowl" remains. Here the bowl is much in

evidence. An imposing bird head tops the bowl, which thus becomes its body. The whole sits on four fat, apparently animal, legs. While bird imagery is very much part of the decorative idiom of glossware vessels, nothing avian save the head appears here. Wing patterns often adorn glossware lids, yet on this bowl, where they would be expected as further definition of the bird "body," they are not present. Instead a most fantastic part-bird creature is formed, a work of formal originality and strength. JJ

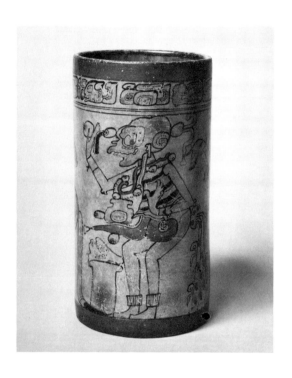

308 M A Y A
Guatemala

Cylindrical Vessel, 8th century A.D.
Ceramic; h. 8½ (21.6), diam. 4⅜ (11.1)
Museum purchase 79.13

Painted, more or less straight-sided vessels such as the Houston example are among the most famous Mayan ceramics. They were made principally during the eighth century throughout much of the Maya area, which includes southern Mexico, all of Guatemala, and regions in adjacent Honduras and El Salvador. The vessels are noted not for their ceramic forms, but for their elegantly painted surfaces. The vessels made in the Guatemalan lowlands enjoy the highest reputation, and the paintings on them do indeed exhibit the greatest technical virtuosity and conceptual subtlety. The Houston vessel is allegedly from El Peru, a small site not far from Tikal in the Guatemalan lowlands.

The painted images of these vessels are usually of figures, apparently both real and mythological, that are given a shallow, linear space in which to exist. Particularly for mythological subjects, the space is often undefined as to locale, much like a stage with no scenery, and it runs continuously around the body of the vessel. The space is delimited top and bottom by clearly painted lines, the one at the bottom functioning as a ground line. A great many extraordinary activities take place in these spaces, some quite astonishing to the modern viewer. Death is a frequent participant, a fact that has contributed to the interpretation of the painted scenes as dealing uniquely with death and the underworld. While this interpretation is not wholly accepted, there is no question that death, both actually and figuratively, plays an important role in the subject matter of these paintings. In the Houston example the death god himself stands over a severed head. He is quite cheerful, as he often is, and he is depicted as usual in somewhat skeletalized form and lacking his lower jaw. Stylized smoke is coming from beneath his rib cage, and he is wearing in his necklace and on the front and back of his head a number of death eyes. The death-eye motif had its origin in a totally disembodied eyeball. JJ

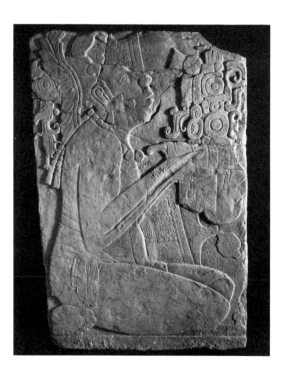

309 M A Y A
Mexico

Relief of a Figure Holding an Offering, 8th century A.D.
Limestone; 39⅛ × 26½ (99.4×67.3)
Museum purchase 62.42

The Museum's relief is believed to be part of a larger sculpture of which at least one other piece is known (National Museum, Mexico City); the Mexico City

piece was found in the 1880's and is comparable in size and content to the Houston example. It depicts a similarly seated, profile personage holding an offering in front of him. The entire sculpture would have included the upper portion, or area above the heads of the seated figures, and the lower midsection depicting whomever or whatever was receiving the offerings.

The Houston figure is holding a container draped with a short cloth. In the bowl are one, or possibly two, masks of a type associated with the rain god of Teotihuacan. Pushed to the back of the figure's head, allowing his hair to show, is a headdress made of feathers topped by a mythic, owl-like bird known as a Moan bird. This headdress is normally worn by a Mayan god designated today simply as God L. Other attributes of God L, which can include various combinations of an aged and sunken-jawed face, a jaguar ear atop a human ear, and a burning cigar, are not present. The Houston figure is clearly not aged—he is also clearly well-fed. He wears heavy, multipartite ear ornaments, a bead necklace that ends in tassels on his back, and a finely detailed loincloth. A short fringe finishes the bottom of the loincloth, and its tie ends are decorated with a restrained pattern.

On the right side of the relief, somewhat above the figure's knees, is a stylized cacao pod attached to a stylized tree. In ancient times, cacao was an important crop in the lowland area of the present-day state of Tabasco where the Jonuta site, from which the Houston relief is said to come, is located. The carving of the relief resembles work found at Palenque, the nearby Mayan site renowned for the elegance of its relief sculpture. JJ

310 MAYA
Mexico

Cylindrical Vessel, 9th–10th centuries A.D.
Ceramic; h. 8¾ (22.2), diam. 5¹⁄₁₆ (12.9)
Museum purchase 67.11

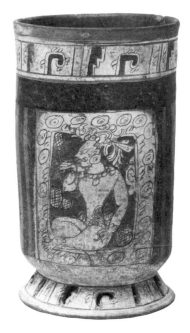

One important kind of Mayan pottery, made for many centuries, is called Fine Orange by archaeologists. Fine Orange ware, so named for its fineness and its color, was made of very finely textured clay that produced thin, smooth-surfaced vessels. A particularly interesting group of Fine Orange vessels was made during the ninth and tenth centuries in the area that seems to have its focus in the eastern part of the present-day state of Tabasco.

The Houston example belongs to this group; while it clearly shows the strength of its heritage, it is equally distinctive in a number of aspects. The straight-sided shape, the two discreetly contained images on opposite sides of the vessel, and the decoration of the rim area are common Mayan devices. The human figures with their elaborate poses, headdresses, necklaces, and ear ornaments are also familiar. Different are the short pedestal base of the cylinder, the splendid spontaneity of execution in incising, and the great sophistication of color effects. The basic orange of the vessel is slipped white in the areas to be incised. In the areas that were not to be incised, a translucent black has been applied, some of it in stripes. Into the excised spaces, like those behind the figures and in the pattern below the rim, a deep red has been rubbed. The final color is an edge of pale blue-green stucco at the rim. Only an artist of great experience would attempt such a combination, and only a master would achieve it with such understated refinement. JJ

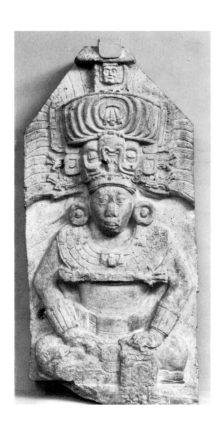

311 MAYA

Guatemala

Niche Figure, early 8th century A.D.
Limestone; 53⁹/₁₆ × 26¾ (135.1 × 67.9)
Museum purchase 68.51

Among the most noted works of art produced by the lowland Maya in the long centuries they flourished in the rain forests of southern Mexico and Guatemala are the carved stone slabs or stelae that were placed in front of important temple buildings. The slabs were carved on two, three, or four sides and reached to many feet in height. Hieroglyphic inscriptions and human images commonly appeared on them. Recent deciphering of Mayan hieroglyphs has led to a greater understanding of these stone slabs. Much of the import of the stelae is historical, and they tell of the lives of particular rulers.

At Piedras Negras, a Mayan site on the Usumacinta River in Guatemala, a number of richly decorated stelae were carved during the seventh and eighth centuries when a particular form of stela was used for the proclamation of the ascent to power of a new ruler. The unusual feature of these stelae is the frontal, high-relief figure seated in a deep niche that occupies roughly the upper half of the front surface.

The Houston niche figure was part of Stela eleven at Piedras Negras. Depicted is Seven Eagle who was born at the beginning of the eighth century and began ruling at Piedras Negras when he was twenty-eight years old. Stela eleven was erected in the West Group Plaza of Piedras Negras to announce Seven Eagle's accession some two years after he came to power. JJ

312 VERACRUZ

Mexico

Frog Yoke, 7th century A.D.
Stone; h. 5⅛ (13.0), w. 17¼ (43.8), d. 14⅜ (36.5)
Gift of Mrs. Harry C. Hanszen 65.164

Ancient Mexican yokes, which are stone sculptures in the form of large U's so named because of their similarity to the shape of harness frames, are among the most endlessly discussed of pre-Columbian objects. The ancient stone yokes are said to have been worn during the playing of the Mexican ballgame. The game called for a heavy, padded "belt." While such "belts" are known from depictions of Mesoamerican ballplayers, dating particularly to the middle centuries of the first millennium A.D., there is some present-day disbelief that the extant stone yokes were actually worn during the playing of the game itself. The Houston yoke weighs almost fifty-four pounds, a weight that would be a burden to any ballplayer, however slow the pace of the game he played. It is improbable that there will ever be an irrefutable answer to the dilemma of whether or not the stone yokes were actually worn while playing.

Yokes are known in plain and worked form; the Houston example depicts a frog, one of the most common and most ancient themes. The frog is a well-realized sculpture in yoke form, undoubtedly because of its use over such a period of time. The salient features of the frog are singled out and carefully worked into the yoke shape. The long amphidian mouth curves around the

entire front of the yoke; the enlarged eyes square off and frame the face, and the wide, protruding tongue laps smoothly onto the underside of the sculpture. Secondary decoration can often be added to the frogs although there is none on this example. The Houston yoke is believed to come from the Mixtecquilla area of the south central part of the state of Veracruz. JJ

313 VERACRUZ
Mexico

Female Figure, 7th–8th centuries A.D.
Ceramic; 9⁷⁄₁₆ × 8 (24.0 × 20.3)
Gift of Mrs. Harry C. Hanszen 65.154

The ceramic figures made in Veracruz during roughly the middle centuries of the first millennium of the Christian era, varied widely in size, surface, and subject matter; they were also made in considerable quantities, so proficient were the potters of that time and place. Not only are the ceramic figures found in burials, but also large caches of figures and fragments of figures have been found. Among this wealth of material one group separates itself so distinctly that when examples were first unearthed they were thought to have been ancient imports from the Mayan area. Now known rather generally as Nopiloa figures, named after one location at which they were found, it is clear that they were made in Veracruz. The figures are identified with the region between the lower reaches of the Blanco and Papaloapan rivers in Veracruz.

Nopiloa figures are made in a technique known as slip-casting, which results in a thin, fine ceramic ware. Much attention was paid to surface detail of the figures, at least on the front. Hair, ornaments, and clothing were given specific and different surface qualities. In ancient times these elements were painted different colors as well, although few have survived with much color intact. The Houston figure has more color remaining than most. Nopiloa figures are formally quite interesting, for in spite of their three-dimensional shape, sculpturally they are relief images with simple slab backs. There was apparently no concern with seeing them in the round. In common with other figures of the period, the Nopiloa figures could be made as either rattles or whistles. JJ

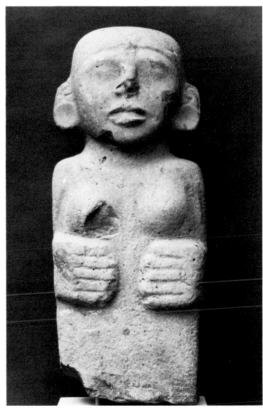

314 HUASTEC
Mexico

Female Figure, 11th–13th centuries A.D.
Stone; h. 23½ (59.7)
Gift of Mrs. Harry C. Hanszen 65.153

The ancient history of the Huastec region of Mexico is less well known today than is that of many other areas. The region was located in the north of the state of Veracruz in what was in ancient times border country between civilized Mexico and the less cultivated peoples to the north. The stone sculpture that was produced in the Huasteca, apparently during the early centuries of the second millennium A.D., is among some of the most stylized sculpture produced in pre-Columbian Mesoamerica. The sculpture is done largely in the form of male and female figures. The stylization can include the form of the figure and

an unusual integration of figure and headdress. It has been suggested that some of the formal characteristics of Huastec sculpture result from the kind of layered sandstone from which it was made. The Houston figure is one of the simpler female sculptures. She does not have an integral headdress, and she has lost, through time, the bottom of her skirt and her feet. Her hands, however, are traditionally placed, their great size and simplicity giving emphasis to them. Her arms are locked close to her sides, thus forming an uninterrupted body line. Even her ears with the large circular ornaments continue that outline. The facial features, although not rendered in detail, are gracefully executed and suggest they may have been completed by painting. Evidence of original paint has been found on some Huastec sculpture.

JJ

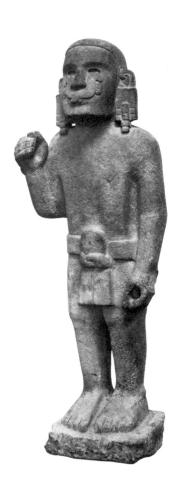

315 AZTEC
Mexico

Standard-bearer, 15th–early 16th century A.D.
Stone; h. 47⁷⁄₁₆ (120.5)
Gift of D. and J. de Menil 66.8

Although the stone sculpture of the Aztecs, the people who dominated Mexico at the time of the Spanish conquest in the sixteenth century, is famous, it has been relatively little studied. Excavations of the 1970's in the ruined Aztec capital of Tenochtitlan have done much to turn interest once again to the accomplishments of this extraordinary group of ancient Mexicans. Latecomers to the rich cultural heritage of central Mexico, the Aztecs were ambitious assimilators of everything they encountered, artistic traditions included. Certain kinds of stone sculpture were inherited from the Toltecs—their most powerful Central Mexican predecessors. Among the Toltec figures were the standard-bearers, so named because they are presumed to have originally carried standards or banners through the openings in their hands. Aztec sculpture goes far beyond its initiating influences. It is formally more accomplished and has an infinitely larger range of subject matter.

The Houston standard-bearer well illustrates the basic formal simplicity characteristic of Aztec works in stone. Wearing only beech cloth and nose and ear ornaments, the figure is straightforward and cleanlined; yet he is particularized by the bulk of his chest and shoulders, by the thickness of his neck, and by the squareness of his chin. The nose ornament, which covers his mouth and reaches up to just under his eyes, is associated with the gods of pulque or drunkenness. The pulque gods are believed to have originated in the Huasteca. It is possible that the present figure comes from Veracruz, where Aztec enclaves did exist in the years prior to the conquest.

JJ

North American Indian

316 EASTERN WOODLANDS

Birdstone, ca. 2500–1500 B.C.
Gray-green hard stone; h. 2¹¹⁄₁₆ (6.8), w. 5⅝ (14.2), d. 2 (5.0)
McDannald Collection 63.139

Birdstone, ca. 2500–1500 B.C.
Gray hard stone; h. 1½ (3.7), w. 5½ (14.0), d. 1¼ (3.2)
McDannald Collection 63.144

The Late Archaic period of the Eastern Woodlands area is generally dated from 2500–1500 B.C. The peoples of this epoch in North American prehistory are known primarily through their burial sites, which included status objects such as ornaments of shell and worked copper tools. Small-scale stone carvings representing birds have also been found in these burials. These "birdstones" exemplify a diversified and widespread sculptural tradition of great variety and elegance.

The exact purpose of these stone birds is not known. However, the sets of holes, which are usually divided in the bottom of the objects, have led to the supposition that they were used as weights or handles on the *atlatl*, or spear thrower. Birdstones were made in a great variety of shapes using an equally diverse number of stone types. The simple, elegant form of the bird in dark gray stone (63.144) is a type found principally in Indiana. Its extended head and neck give an impression of forward motion like that of a water bird paddling across the surface of a lake.

A light gray-green, hard stone was used to make the much more elaborate image of the "pop-eye" variety (63.139), a type most often found in Ohio sites and characterized by the broad body with upturned head and tail. The prominent, extended features on the head may be versions of head plumes common in Woodland and Southeast iconography. EM

317 MISSISSIPPIAN/SPIRO

Cup Fragment, 1200–1700 A.D.
Shell; l. 4¼ (10.8)
McDannald Collection 63.222a

Cup Fragment, 1200–1700 A.D.
Shell; l. 4¼ (10.8)
McDannald Collection 63.223c

Gorget, 1200–1700 A.D.
Shell; maximum l. 7 (17.8)
McDannald Collection 63.213

Left to right: "Pop-eye" Birdstone, 63.139; Birdstone 63.144

Above left to right: Gorget, 63.213; Cup Fragment, 63.223c; Miniature Mask, 63.180; Earspool, 63.103
Below left to right: Cup Fragment, 63.222a; Earspool, 63.105

Earspools, 1200–1700 A.D.

Copper, stone; 63.103: diam. 3⁵⁄₁₆ (8.4); 63.105: diam. 2⁵⁄₁₆ (6.6)
McDannald Collection 63.103, 63.105

Miniature Mask, 1200–1700 A.D.

Wood, shell; h. 2⁵⁄₁₆ (5.8)
McDannald Collection 63.180

The ancient peoples of the Southeast developed a series of highly sophisticated cultural complexes based on agriculture and trade. From about 1000 to 1600 A.D., the Mississippian period of Southeastern prehistory, the people evolved a large number of complex urban sites centered around monumental earthen platforms on which were erected the houses, temples, and mortuaries of the chiefs' families. One of these "mound" cities is Spiro in Eastern Oklahoma, where an unprecedented number of ceremonial objects of high aesthetic quality have been found.

The McDannald Collection, donated to the Museum in 1965, contains a large group of objects and fragments that are representative of the typical object types and artistic styles found at Spiro. Most numerous are pieces of large marine conch shells traded from the Gulf area and used to make ceremonial cups and objects of personal adornment. The first European visitors to the Mississippian tribes observed rituals in which the participants used these engraved shell cups to drink a strong, black liquid. Like many others from Spiro, the Houston cup shows a dancing warrior portrayed in the simple, direct lines of the Craig style, which takes its name from the principal mound in which the majority of the Spiro objects were discovered (63.223c). The more realistic and refined Braden style was used to depict the animal head seen in one of the collection's many engraved fragments (63.222a). Not only is the descriptive line more flowing, but a greater sense of surface character and texture is achieved through linear patterns. Non-representational designs, such as the equilateral cross inscribed within a circle that decorates the shell gorget or neck pendant (63.213), were also common and may have symbolic reference to the ritual fires kept in mortuary temples, as well as to the sun.

Individuals of high position and status in Spiro wore personal decorations indicating rank, which were produced in many materials. The beautifully worked earspools (63.103, 63.105) of repoussé copper over stone disks seem to have been worn by males only. The decoration of these ornaments incorporates the cross symbol used on the gorget, as well as the symmetrical, curvilinear design used on the pottery of the period. Miniature masks of wood and shell (63.180) were also worn as ear ornaments by warriors as seen in the famous "Big Boy" pipe in the collection of the University of Arkansas. The Houston mask is one of forty-two miniatures known to have been found in Spiro excavations.

The McDannald Collection also contains twelve repoussé copper plaques representing falcon warriors. Like most of the surviving specimens these objects are in fragmentary condition. EM

318 MISSISSIPPIAN / CADDOAN

Bottle, ca. 1200–1700 A.D.

Ceramic; h. 7 (17.7), diam. 6½ (16.5)
McDannald Collection 63.81

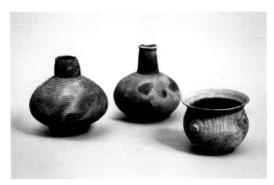

Left to right: Vessel, 63.82; Bottle, 63.81; Bowl, 63.31

Vessel, ca. 1200–1700 A.D.
Ceramic; h. 6¾ (17.1), diam. 7¹⁄₁₆ (13.4)
McDannald Collection 63.82

Bowl, ca. 1200–1700 A.D.
Ceramic; h. 4½ (11.4), diam. 5¹¹⁄₁₆ (14.2)
McDannald Collection 63.31

The Mississippian period of the southeastern section of the United States pro-
duced a highly developed pottery tradition that featured finely shaped vessels
decorated either with painted or engraved designs. Like all native American
pottery these ceramics were built by hand from coils of clay fired in open-brush
ovens. The three Houston vessels are representative of the Caddoan types found
in the late Mississippi Horizon circa 1200–1700 A.D.

The basic Caddoan bottle shape is beautifully illustrated in the Houston exam-
ple (63.81); its full, round body is elegantly topped by a tall, shaped neck. The
spiral lines engraved into the wall of the unfired pot produce a pattern that is a
variant of the Keno Trailed type from Arkansas.

The Caddoan form and decoration were elaborated in the vessel with the
slightly flattened, globular body (63.82); the jar is raised on a foot smaller in
diameter than the vessel itself to create the effect of the pot floating over the
surface on which it rests. The engraved patterns of lines are arranged in two
sections. The upper area of horizontal lines articulates the sloping shoulder of the
vessel, while below it quadrants of upward-curving lines provide a visual lift
to the body.

The lipped bowl (63.31) is another variant of the technique of engraved linear
decoration used by ceramic artists of the Caddoan style in areas now known as
Arkansas and Mississippi. In the Museum's example concentric circles are placed
slightly off-center around a raised boss. These vessels share common elements of
materials and finish as well as a similar attitude toward the relationship of applied
decoration to three-dimensional form. However, the particular formal and
decorative character of each piece shows the subtle range of creative individuality
that was common among the ceramic artists of the ancient Southeast. EM

319 ANASAZI

Tularosa Vessel, ca. 1100–1250 A.D.
Ceramic; h. 4⅝ (11.8), diam. 5¾ (14.6)
Gift of Miss Ima Hogg 44.114

Jar, ca. 1100–1250 A.D.
Ceramic; h. 6⁷⁄₁₆ (16.3), diam. 8¼ (20.9)
Gift of Miss Ima Hogg 44.109

Sikyatki Bowl, ca. 1400–1625 A.D.
Ceramic; h. 3⅞ (9.8), diam. 9⅞ (25.1)
Gift of Miss Ima Hogg 44.65

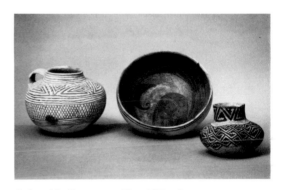

Left to right: Jar, 44.109; Sikyatki Bowl, 44.65;
Tularosa Vessel, 44.114

Of the four major archaeological regions of the prehistoric Southwest, the
Anasazi and the Mogollon stand out as the largest and most thoroughly studied.
Their area includes the southern sections of Utah and Colorado and reaches down
into Arizona and New Mexico. From circa 100 B.C. through the historical period
in the seventeenth century these early Pueblo farmers produced many objects

and decorative styles of great formal beauty, best reflected in the wide variety of ceramic vessel shapes and decorative motifs.

Certain motifs are so commonly found that they must be thought of as a generally understood pattern within the culture as a whole. Houston's delicate four-lobed vessel (44.114) is decorated with one of the most typical of these motifs, a three-step pattern painted in black over a white clay slip. This basic design was even used by historic Pueblo potters at Zuni and Acoma among others. Physical indications show that the vertical wall of the neck of the Museum's vessel originally supported the small sculptural representation of an animal head, which has since broken off.

The larger jar with handle (44.109) is a fine example of the architectonic function of Southwestern pottery decoration. The neck, shoulder, and body of Houston's pleasingly round vessel are articulated by separate design areas that emphasize the structural elements of the total form. The pattern of sharply angled meanders and crisp zigzag lines on the shoulder is reminiscent of styles found in the Mogollon area and illustrates the often close cultural contact between these two major areas of the prehistoric Southwest.

The late prehistoric phases of the Hopi villages in Arizona produced some of the area's most inventive and beautiful painted pottery. The interior of the Sikyatki bowl (44.65) was first painted with a textured background of a reddish-brown color. Using a brown-black vegetable pigment, the artist painted a highly stylized bird that takes full advantage of the curving sides of the bowl. The interior was then completed by scratching through the paint of the central form to create the conventionalized curving feather pattern, one of the hallmarks of the Sikyatki style that provided one of the bases of historic Hopi pottery. The exterior wall of the Houston bowl is painted with a representational image of a long, feathered arrow shaft piercing a horned toad. While most Sikyatki bowls have some type of linear design on the exterior rim, the use of a recognizable image is very unusual. EM

320 MIMBRES

Dish, ca. 1100 A.D.
Ceramic; h. 3 5/16 (8.4), diam. 8 5/8 (21.9)
McDannald Collection 63.20

Bowl, ca. 1100 A.D.
Ceramic; h. 3 11/16 (9.4), diam. 8 7/16 (21.4)
McDannald Collection 63.21

The prehistoric Mogollon region includes the southern half of New Mexico and part of the western section of Arizona. Archaeologists believe that the agricultural communities of the Mogollon had an earlier prehistory than the Anasazi and were producing pottery by circa 400 B.C. The height of Mogollon artistry was achieved by the Mimbres culture, which in its classic phase (circa 1100 A.D.) produced the most sophisticated, imaginative painting ever achieved by natives of North America.

The rectilinear dish (63.20) displays a fish whose body is decorated with the bold, black and white, geometric patterns typical of the Mimbres style. The borders of the white-slipped interior are marked by two straight lines and a scalloped line, which collectively indicate the pictorial field. Fish were often used

Left to right: Dish, 63.20; Bowl, 63.21

as subjects by the Mimbreno artists, who depicted a great range of animal life including insects, birds, mammals, humans, and strange, anthropomorphic creatures.

The larger, round bowl (63.21) is typical of the Mimbres style of abstractly decorated pottery. In the Museum's example, as in many others, the circular field of the interior has been narrowed by symmetrically opposed areas of geometric design painted on two sides of the bowl from the rim to the bottom of the curving wall. The remaining central field of white is articulated by a variant of the three-stepped motif also used by the Anasazi. The Houston bowl is painted with a warmly toned, reddish-brown mineral pigment, rather than with the more typical black. The jagged holes in the bottom of the bowl and the rectilinear dish are known as "kill holes" and were intentionally made as part of a mortuary ritual before these ceramics were interred in the burial sites. EM

321 CASAS GRANDES

Macaw Bowl, ca. 1300 A.D.
Ceramic; h. 5⅛ (13.0), diam. 14½ (36.8)
Gift of Miss Ima Hogg 44.107

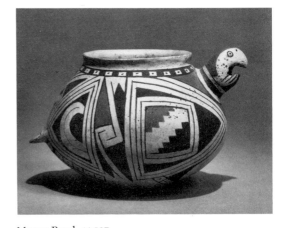

Macaw Bowl, 44.107

Mesoamerican cultures had a definite influence on the prehistoric peoples of the American Southwest. Although the exact nature of this interrelationship is not yet known, vital links arose from the domestication of corn and the accompanying development of agricultural communities that spread northward from Mexico. The complexity of this cultural interchange can best be seen in the Casas Grandes site in Northern Chihuahua, about one hundred miles from the New Mexico border. Casas Grandes experienced three principal phases of development from circa 1000–1350 A.D. The first phase was marked by the use of Mogollon pit-house and pottery types, which gave way in the second phase to an adobe pueblo building tradition that also came down from the north. The third and most evolved stage occurred in the Tardio Period, which introduced such formalized architectural features from Mesoamerica as the ball court and the temple mound.

During the Tardio phase a large quantity of high-quality pottery was produced, of which the Houston effigy representing a Macaw is a fine example (44.107). The basic form of the vessel is the standard Casas Grandes bowl shape, but the addition of the bird's head and tail transforms the bowl into an animal effigy in much the same process used by the Anasazi (see no. 319, 44.114). Direct influence of the Mimbres tradition can be seen in the crisp painting and general design principles of the polychrome, geometric decoration.

The Macaw is a prominent Casas Grandes symbol whose importance was underlined by the discovery at the Casas Grandes site of specially designed areas where the birds were bred and raised. These brilliantly colored birds were also staple items in the trade with the ancient Pueblo communities of the Anasazi and Mogollon areas to the north. The direct influence of Macaw imagery can be seen in the stylized feather designs of the Sikyatki in Arizona as well as in the bird images found on the historic pottery of the Acoma, Zia, and Zuni Pueblo (see nos. 324, 44.5; 330, 44.21; 323, 44.98). EM

197

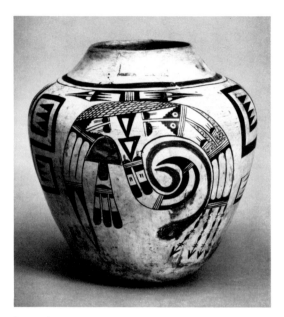

Jar, 44.67

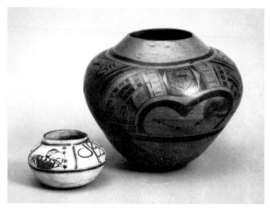

Left to right: Jar, 44.56; Olla, 44.68

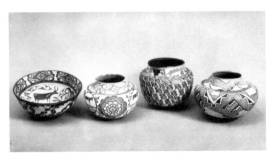

Left to right: Bowl, 44.148; Jar, 44.96; Jar, 44.98; Jar, 44.94

322 HOPI/POLACCA

Jar, ca. 1880
Ceramic; h. 6⅛ (15.6), diam. 9⅜ (23.7)
Gift of Miss Ima Hogg 44.56

HOPI

Olla, ca. 1920
Ceramic; h. 17¼ (43.7), diam. 20⅝ (52.3)
Gift of Miss Ima Hogg 44.68

Jar, ca. 1925
Ceramic; h. 13½ (34.3), diam. 13⁷⁄₁₆ (34.1)
Gift of Miss Ima Hogg 44.67

The Hopi people live in pueblos situated on three mesas in an arid section of northern Arizona. They have been there for over eight hundred years, practicing subsistence desert agriculture that is spiritually supported by their traditional ritual system. Many arts are pursued at Hopi, but the production of ceramic vessels is concentrated in the villages on and surrounding First Mesa. The various forms of historic Hopi pottery produced there are directly linked to the ancient forms of their ancestors, especially to those of Jeddito and Sikyatki.

The Polacca Polychrome jar (44.56), named after the farming village below First Mesa, is covered with a light cream slip that is painted with design motifs in red and black. The star-like flowers and birds are typical features of Polacca pottery as is the abstract motif with curved lines that is based on Sikyatki Polychrome designs of the fifteenth and sixteenth centuries.

Hopi artists have also maintained a style of painting directly on the burnished surface of the vessel without the use of a slip. In the twentieth century the technique became a hallmark of Hopi pottery. For the large Houston olla (44.68) the potter has used the earthy orange clay that was popular at Hopi in the 1920's. The decoration is a highly structured combination of stylized forms based on Sikyatki prototypes. Certain areas of the pattern are shaded with a lightly textured surface stippling that is only used by the Hopi painters.

The tall, high-shouldered jar (44.67) is a typical Hopi shape of the 1920's that was popularized by a woman named Nampeyo. This ceramic artist, most famous potter of her generation, revitalized the art at Hopi in the late 1880's. The pale yellow color of the burnished clay surface is found in ancient Hopi ware, and the stylized birds and feathers can be traced directly to the elegant style of Sikyatki pottery. Today the descendants of Nampeyo are still producing ceramics of great beauty in the artistic tradition of their ancestors. EM

323 ZUNI PUEBLO

Jar, ca. 1885
Ceramic; h. 11½ (29.2), diam. 13⅝ (34.6)
Gift of Miss Ima Hogg 44.98

Jar, ca. 1850–1880
Ceramic; h. 10¾ (27.2), diam. 14¾ (37.5)
Gift of Miss Ima Hogg 44.94

Jar, ca. 1880
Ceramic; h. 9⁵⁄₁₆ (23.6), diam. 13 (33.0)
Gift of Miss Ima Hogg 44.96

Bowl, ca. 1885
Ceramic; h. 7³⁄₈ (18.7), diam. 16 (40.6)
Gift of Miss Ima Hogg 44.148

The Pueblo of Zuni is located near the western border of New Mexico. Springing from ancient roots its people and houses were first described by Spanish explorers who visited the area in the late sixteenth century. Early ceramic vessels of this period through the eighteenth century form the traditional types on which the great production of Zuni pottery in the nineteenth century was based.

The Museum has a splendid collection of Zuni ceramic ware that covers a broad range of styles for which the pueblo is justly famous. The beautifully painted jar (44.98) decorated with the archetypical three-step design used so extensively by the Anasazi and Mogollon potters of the prehistoric period dates from the late nineteenth century. This usage exemplifies the historical continuity of designs in the periodic restatement of a motif, in this case one often found on the eighteenth-century Zuni pots of the Ashiwi and Kiapkwa types. The inverted three-step cloud forms and double-feather motifs used on the neck of the vessel are also derived from these early styles and further demonstrate the historical integrity of the Zuni artistic tradition.

The jar with the sloping neck (44.94) is an extraordinary example of Zuni artistry circa 1850–1880. In typical Zuni fashion the neck is separated from the full, rounded body by a strongly indicated line. The decoration is based on the traditional vocabulary of forms such as the hook-curved line in the neck area and the repeated three-step design. The Houston vessel excels both in the broad, flowing character of its decorative scheme and in the bold use of heavy black lines on a chalk-white ground. The fine-line texturing produces a shaded area that reads like a medium gray, a contrast giving greater emphasis to the stark intensity of the black and white design. The heavier black lines take on an unusually languid sensuosity as they flow around the full form of the vessel.

In the 1880's the Zuni developed a style of jar decoration that matched units of the familiar conventionalized motifs with profile images of deer alternating with rows of other animals or birds with long, curving tails. On many examples these elements are arranged around large, round flowers, which rarely achieve the grace and beauty of the Houston jar (44.96).

The large bowl with slightly flaring rim is the second most typical Zuni shape after the olla or jar form. While the decorative vocabulary of the Houston bowl (44.148) is also standard, the crisply indicated forms of stylized birds and feathers create a marvelous sense of quick, rhythmic energy. The deer, which are so gracefully represented, walk through this decorative field with an alert and sure step. The red line that passes from their chests to their mouths is known as the "heart line" and carries a symbolic reference to the spiritual nature of the animal.

EM

324 ACOMA/MCCARTYS

Jar, ca. 1880
Ceramic; h. 9⁹⁄₁₆ (23.3), diam. 11⁵⁄₁₆ (28.7)
Gift of Miss Ima Hogg 44.19

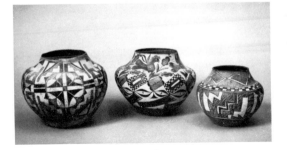

Left to right: Jar, 44.17; Jar, 44.5; Jar, 44.19

ACOMA

Jar, ca. 1890
Ceramic; h. 11¹⁵⁄₁₆ (30.4), diam. 14⁷⁄₁₆ (36.6)
Gift of Miss Ima Hogg 44.17

Jar, ca. 1900
Ceramic; h. 11¼ (28.6), diam. 14½ (36.8)
Gift of Miss Ima Hogg 44.5

Acoma is the southernmost of the Rio Grande pueblos and is magnificently sited on a tall outcropping of rock in the midst of the rugged mesas. The long tradition of Acoma pottery has always included the farming villages of Acomita and McCartys, for which two early Acoma styles are named. The McCartys Polychrome jar (44.19; ca. 1880) is distinguished by the tall neck emphasized by a separate decorative motif that is divided from the body by a line of black and white checks. The zigzag shapes painted on the body in red, black, and white are an unusually bold use of the motif.

Two characteristics that mark the transition from McCartys to Acoma Polychrome are the higher shoulder and the overall decoration seen in the Houston jar, circa 1890 (44.17). The patterns of such Acoma pots have grown more complicated in styles that represent a collective tour de force of graphic design on a three-dimensional field. The red of McCartys Polychrome has been replaced by fine-line shading that reads as gray. In the best Acoma tradition, the finely rendered geometric patterns are precisely delineated, and the correct proportions of their designs are maintained uniformly over the whole surface of the vessel.

One of the most popular Acoma types of the nineteenth and twentieth centuries is the polychrome jar decorated with plants and large parrots. The Houston example (44.5) shows an attractive blending of the bird and the flowers with a contrasting three-part base of geometric designs. These parrots were actually found near the pueblo until the late nineteenth century and were specially regarded by the people. The red diamond on the bird's breast is similar to the heart line found on Acoma and Zuni renderings of deer and symbolizes the spiritual power of the animal. EM

Left to right: Jar, 44.40; Jar, 44.41; Jar, 44.42

325 SANTA ANA

Jar, ca. 1780
Ceramic; h. 12⅛ (31.1), diam. 13¼ (33.7)
Gift of Miss Ima Hogg 44.40

Jar, ca. 1860
Ceramic; h. 10⁷⁄₁₆ (26.5), diam. 11¹³⁄₁₆ (30.0)
Gift of Miss Ima Hogg 44.41

Jar, ca. 1885
Ceramic; h. 11⅞ (30.2), diam. 12 (30.9)
Gift of Miss Ima Hogg 44.42

Santa Ana is a small pueblo of the Keresan group, which has been located on a site near the Jemez River since the late seventeenth century. The people of Santa

Ana are closely related to those of Zia Pueblo, and their pottery was stylistically very similar until the mid-eighteenth century. During this period they began to develop independent though still closely related styles of manufacture and decoration.

Late eighteenth-century Santa Ana vessels are decorated in a style known as Ranchitos Polychrome (44.40). The elaborately painted vessel with large volutes and finely crosshatched triangles also bears strong similarities to the early Zia form called Trios Polychrome. The two styles are so close that the final test often lies in an examination of the material of the vessel. Santa Ana ceramics, even the older type like the Houston example, use fine, light-colored sand as the tempering material mixed with the clay. Pottery made at Zia usually contains bits of crushed, black, volcanic rock.

The simpler, more geometric style of the Santa Ana Polychrome jar (44.41) appeared around 1800 and continued to be used into the present century. Its principal motif is a boldly painted, three-step design in red, edged with a thin black line. The red step designs alternate in vertical orientation and are so broad that the areas of white background on which they are painted themselves create an independent visual presence in a positive-negative design relationship.

The large Houston vessel (44.42) is taller than the usual Santa Ana jar, but the decoration is typical. Other hallmarks of Santa Ana polychromes are the soft red and cream colors, the black edging of the main design, and the wide red band that runs underneath the decorated area. The art of the potter began to decline in the pueblo in the 1920's and has since almost disappeared. EM

326 SANTA CLARA

Water Jar, ca. 1920
Ceramic; h. 11¾ (29.8), diam. 12⁵⁄₁₆ (31.2)
Gift of Miss Ima Hogg 44.100

Jar, ca. 1900
Ceramic; h. 21¾ (55.3), diam. 22⅝ (57.5)
Gift of Mrs. W. B. Sharp 50.24B

Santa Clara is one of the six Tewa pueblos grouped together just east of the Rio Grande. Since the early historic period the potters of Santa Clara have been famous for their highly burnished black pottery. One of the principal forms of Santa Clara ceramics is the Houston water jar (44.100). Like most ceramic forms at this pueblo the jar has remained close to its eighteenth-century prototype and features a tall neck on a body that is widest at its middle and has a concave base. Santa Clara is also one of the few Rio Grande pueblos that uses sculptural details on its water and storage jars. Often rims and shoulder areas are decorated with softly indented lines or scallop patterns. The Houston jar also is embellished by the most common sculptural decoration used at Santa Clara, the bear paw. The paw usually has four or five toes and is impressed three or four times around the upper section of the vessel.

Houston's huge storage jar (50.24B) is typical of the ovoid jars with narrow necks that have brought recognition to the ceramic artists of Santa Clara and are the largest ceramic vessels produced in the Southwest. The technical difficulties in creating a vessel this size are many. The process of forming the piece takes months, as the potter must allow the clay of the ever-growing wall to dry prop-

Left to right: Water Jar, 44.100; Jar, 50.24B

erly before more material is added. Finally, weeks must be spent in the laborious process of burnishing the surface to a uniformly rich luster.

In response to a developing commercial interest that began in the 1920's, the potters of Santa Clara started to produce a wide variety of new ceramic forms. These included items of household use such as candlesticks and sugar and creamer sets as well as delightful small images of animals, which are often painted with matte black decorations on the polished black background. EM

327 SAN ILDEFONSO

Jar, ca. 1880
Ceramic; h. 15⅜₆ (38.6), diam. 19⅛ (48.5)
Gift of Miss Ima Hogg 44.73

MARIA AND JULIAN MARTINEZ
San Ildefonso

Jar, ca. 1910
Ceramic; h. 10⅝ (27.0), diam. 13 ⁵⁄₁₆ (34.2)
Gift of Miss Ima Hogg 44.79

Jar, ca. 1920
Ceramic; h. 14¼ (36.2), diam. 18⅝ (47.2)
Gift of Miss Ima Hogg 44.171

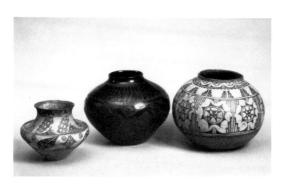

Left to right: Jar, 44.79; Jar, 44.171; Jar, 44.73

From the late eighteenth century through the 1880's the Southern Tewa Pueblo of San Ildefonso developed a strong ceramic style that was called Powhoge Polychrome after the Indian term for the village. Like the Houston example (44.73), these vessels usually have short necks and round, almost spherical bodies whose surfaces are largely covered by a burnished white slip. The geometric decoration is always painted a rich black, and the only red used is on the underbody and the rim. The decoration is typically separated into three bands articulating the neck, shoulder, and body of the vessel, and the motifs used in series are abstract symbols of clouds, feathers, and stars.

The coming of the railroad in 1880 engendered a resurgence of ceramic art at San Ildefonso, where potters are still actively engaged in selling to tourists and collectors. The most famous of the historic potters was Maria Martinez, who, with her husband Julian and other members of her family, produced an extraordinary group of objects since they began working in the early 1900's. The jar dating from circa 1910 (44.79) is characteristic of their polychrome ceramics of this period, all of which were formed by Maria and painted by Julian. The flaring rim and tall neck curve into a wide, flat shoulder, which quickly tapers to a small base. The black and white motifs combine flowers with clouds and stars.

Around 1920 Maria and Julian developed a new style using matte black paint on a brilliantly polished black surface to produce some of the most beautiful and elegant ceramics made in the Southwest. The Houston example (44.171) exhibits all the balance and grace associated with pottery made by Maria. Its decoration was painted by Julian and consists of an ancient feather motif on the shoulder and the mythical Avanyu serpent around the body of the vessel. EM

Jar, ca. 1850
Ceramic; h. 9⁹⁄₁₆ (23.3), diam. 11½ (29.2)
Gift of Miss Ima Hogg 44.39

Olla, ca. 1885
Ceramic; h. 10 (25.3), diam. 12¼ (31.1)
Gift of Miss Ima Hogg 44.36

Olla, ca. 1885
Ceramic; h. 21½ (54.6), diam. 20¹⁄₁₆ (51.1)
Gift of Miss Ima Hogg 44.38

Bowl, ca. 1890
Ceramic; h. 9½ (24.1), diam. 16⅛ (40.9)
Gift of Miss Ima Hogg 46.14

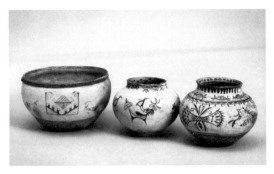

Left to right: Bowl, 46.14; Olla, 44.36; Jar, 44.39

Of all the Rio Grande potters, those from the Keresan village of Cochiti follow the most lively tradition of painting representational imagery on their ceramics. Unlike their more conservative neighbors at Santo Domingo, the artists of Cochiti use the animal and plant motifs usually reserved for ritual vessels on secular objects as well. The large olla (44.36) provides a broad field on which the artist has painted a series of stylized plant, feather, and bird motifs that have a sprightly energy despite their highly conventionalized forms. The plump, long-legged birds and composite feather-flowers are displayed under a bower-like wreath of delicate patterns painted around both the inside and the outside of the neck.

The neck and shoulder of the jar (44.39) are extensively painted with three distinct patterns that have the graceful, decorative quality of fringe or garlands. This extended painting of the upper portion of the jar compresses the main band of decoration around its middle. In the somewhat narrowed space, the large feather motif seen in the previous vessel has become symmetrical, based on vertical and horizontal axes. The birds, which are commonly used at Cochiti, have been rendered in an abstract fashion that is as much botanical as avian.

The decoration of the very large, tall olla (44.38) frames the Cochiti bird in a series of rough circles that are set around the waist of the vessel like drawings in an animated film. The three geometric borders are different from each other, yet their juxtaposition gives a pleasing sense of movement to the ensemble.

The bowl (46.14) seems to have been made for ritual use by these desert farmers whose world depends on the water that gives life to the fields. The painted line is lighter and more delicate than that of the secular jars. The typical Cochiti motifs of the bird and feather are here joined by clouds and lightning, ancient symbols related to water, and a delicately painted star decorates the bowl's interior. The Cochiti potters also produced jars and bowls with boldly painted, geometric decoration that is very close to the abstract style produced at Santo Domingo. However, the Cochiti abstract forms tend toward lighter shapes drawn with a curving line. EM

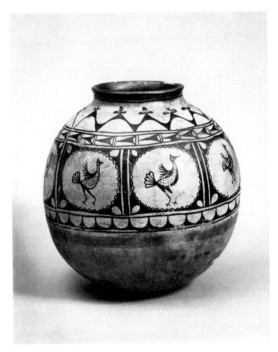

Olla, 44.38

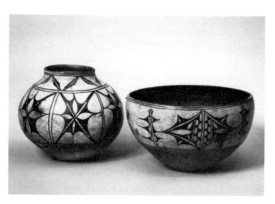

Left to right: Storage Olla, 44.46; Dough Bowl, 46.22

329 SANTO DOMINGO/KIUA

Storage Olla, ca. 1870
Ceramic; h. 15 (38.1), diam. 17⁷⁄₁₆ (44.3)
Gift of Miss Ima Hogg 44.46

SANTO DOMINGO

Dough Bowl, ca. 1880
Ceramic; h. 11¼ (28.5), diam. 20⅝ (52.4)
Gift of Miss Ima Hogg 46.22

Santo Domingo is a large and very traditional pueblo of the Northeast Keresan group and is closely related to Cochiti. The pottery styles of the two pueblos are similar in that both juxtapose large geometric forms in strong black and white patterns, but Santo Domingo pots are distinguished by the use of a heavy black line, while a thinner, busier line is preferred by the Cochiti artists. In keeping with its conservative tradition, the potters of Santo Domingo never use sacred symbols or the representation of most animals on their secular pottery.

The two basic vessel shapes found at Santo Domingo are illustrated by the Houston examples. The large Kiua Polychrome storage olla (44.46) dates from the end of the nineteenth century. Its full, round body diminishes clearly but smoothly into a narrow neck of medium height. The neck and shoulder are decorated with a simple feather design set in a forty-five-degree zigzag pattern. A burnished white slip extends well below the center of the jar and presents the artist with a large area to be painted. The design combines a four-petaled white flower within an eight-pointed black star.

The large dough bowl of Santo Domingo is one of the great forms of historic Pueblo pottery (46.22), and one of the strongest painting styles typically used to decorate it features a band of large black and white forms on a complementary background. The decoration on the Houston bowl is predominantly formed from abstract feather designs that relate to such eighteenth-century styles as Ako, Ashiwi, and Puname Polychrome. EM

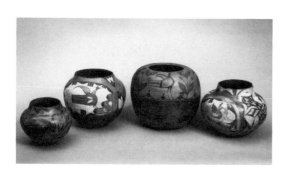

Left to right: Jar, 44.23; Jar, 46.21; Jar, 46.19; Jar, 44.21

330 ZIA/TRIOS POLYCHROME

Jar, ca. 1850
Ceramic; h. 13⁹⁄₁₆ (34.4), diam. 15½ (39.3)
Gift of Miss Ima Hogg 44.21

ZIA

Jar, ca. 1880
Ceramic; h. 10 (25.4), diam. 12¼ (31.1)
Gift of Miss Ima Hogg 44.23

Jar, ca. 1930's
Ceramic; h. 15ⁱ⁄₁₆ (38.2), diam. 18¼ (46.3)
Gift of Miss Ima Hogg 46.19

Jar, ca. 1920
Ceramic; h. 12⁹⁄₁₆ (31.9), diam. 16¹⁄₁₆ (40.8)
Gift of Miss Ima Hogg 46.21

Zia is a Keres-speaking pueblo west of the Rio Grande, whose long tradition of fine pottery continues today. Zia vessels are well shaped in the ancient, hand-built tradition of all Southwestern ceramics; their beautiful symmetry is all the more meaningful because their balance reflects the spiritual world view of the artist who achieved these attractive, round forms without the aid of the wheel.

The older nineteenth-century style, called Trios Polychrome, is beautifully illustrated by the Houston example (44.21). Trios jars of about 1850 are marked by a tall neck on a low-shouldered body whose greatest width is slightly less than half its height. Large birds in profile are framed by a graceful orange and red arch, typical Zia features that are the most commonly used today. The Zia bird spreads a wing over its back and extends its plumed head over the proudly puffed chest. The spaces between the two birds are roughly oval in form and are filled with a crisply painted geometric design in black on a white ground.

The circa 1880 jar (44.23) represents an early example of the Zia Polychrome style that followed Trios Polychrome in the 1870's and 1880's. The artist has begun to shorten the neck of the vessel and make its waist exceed half its height. The bird and flowers on the pot are painted with a strong, directional emphasis that slowly but insistently brings the eye around the vessel. In the jar dating from the 1930's (46.19), the neck has become a low, raised lip around the opening of the vessel and blends directly into the high shoulder. The delicate birds and flowers are contrasted to the undecorated lower half of the vessel. The artist has emphasized the pot's height and grace by concentrating the decoration, with its illusion of figures in space, on the top of the form. This form is reminiscent of the seed-jar vessels made by the Anasazi and Mogollon peoples in prehistoric times.

The jar decorated with the traditional bird framed in an arch (46.21) is painted a warm red-orange on a stark white ground. While the form of the vessel follows the modern trend, the decorative painting is directly within the early traditions established in the nineteenth century (44.21). EM

331 NAVAJO

Chief's Blanket, ca. 1875
Wool; 78½ × 63 (199.4 × 160.0)
McDannald Collection 63.197

The native peoples of the Southwest have been weaving cotton and animal fibers for over one thousand years. By circa 800 A.D. development of a true loom led to the production of large carrying and storage bags and wearing blankets whose principal decorative pattern was based on the horizontal stripe.

The Navajos are an Athabascan-speaking people who came to the Southwest as hunters and raiders. During the seventeenth century influence from the neighboring Pueblo farmers spread the art of weaving to the Navajo women, who produced the so-called Chief's Blanket in a progression of styles from the late eighteenth century through the 1880's. These blankets comprise three major styles, which developed in chronological sequence. The first phase, which began around 1800, was marked by alternating horizontal stripes of natural dark brown and cream-white wool. By the 1850's, narrow rectangles of red and thin lines of blue had been added to the basic striped pattern in what is known as the second phase. By the mid-1860's, the mature third phase emerged with the appearance of red triangles and diamonds with terraced edges (63.197). The juxtaposition of the progressive arrangement of triangular units and horizontal stripes is harmonious and pleasing when displayed on a flat plane. However, to

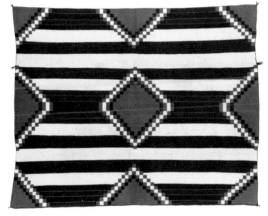

Chief's Blanket, 63.197

appreciate fully the potential of the design, the object's function as a garment must be considered. When it is worn, the central diamond falls in the middle of the wearer's back, and as the edges of the blanket are wrapped around the front of the body, the two triangles at the middle edge join to make a second diamond of the same shape and position. The harmony of the design is thus completed by wearing the garment, an example of how often in Indian culture the function and use of an object add to the spirit that breathes art and life into its form. EM

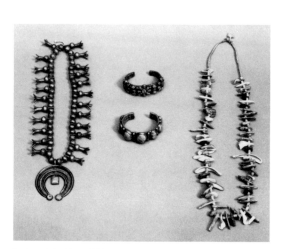

Left to right: Squashblossom necklace, 70.67; *top*, Zuni Bracelet, 44.214; *bottom*, Navajo Bracelet, 44.209; Necklace, 44.179

332 SANTO DOMINGO

Necklace
Turquoise, shell; maximum l. 17¾ (45.0)
Gift of Miss Ima Hogg 44.179

NAVAJO

Squashblossom Necklace
Silver; maximum l. 13⅞ (35.2)
Gift of Mrs. O. S. Simpson, Jr. 70.67

Bracelet
Silver, turquoise; w. 3⅜ (8.6)
Gift of Miss Ima Hogg 44.209

ZUNI

Bracelet
Turquoise, silver; w. 3⅛ (7.9)
Gift of Miss Ima Hogg 44.214

Objects of personal adornment have been used by the peoples of the Southwest since 6000 B.C. This ancient jewelry tradition included necklaces, bracelets, earrings, and pendants made from various types of shell and stone. In the historic period jewelry has been and is still produced by the Pueblo communities and the Navajo.

Closest to the ancient tradition is the Southwestern jeweler's use of roughly shaped turquoise stones that have been drilled and arranged in alternating patterns with smaller disks and beads of shell and stone. The strength and power of this style is exemplified by a necklace made by the Santo Domingo in New Mexico (44.179), in which the subtle blues and greens of the precious stones harmonize beautifully with the whites and reds of the shell. As with most jewelry produced in the Southwest, these necklaces are worn by both men and women.

The art of silversmithing was introduced to the Pueblo and Navajo through contact with the Spanish traditions of Mexico around 1850. The craftsmen of the Southwest soon mastered the techniques and developed an ongoing production of silver jewelry often combined with turquoise. Perhaps the best-known necklace type of the Southwest is the "squashblossom" made by the Navajo (70.67). First developed in the 1880's, the type owes its name to the characteristic flower-like beads that are derived from Mexican silver buttons shaped like the pomegranate. A pendant is usually hung from the bottom of the necklace. Called Najahe, it takes various crescent forms, with or without turquoise additions.

The Navajo smiths are also well known for their massive, sand-cast bracelets (44.209), which often incorporate large nuggets of shaped or rough turquoise.

In contrast to the large proportions of this style, the jewelers of the Pueblo of Zuni often use small, beautifully shaped and polished pieces of turquoise set in delicate patterns. Houston's Zuni bracelet (44.214) features three flower forms that are very similar to the rosette designs found on Zuni pottery. EM

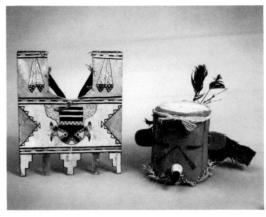

Left to right: Tablita, 44.483; Kachina Mask, 44.481

333 HOPI

Kachina Mask, ca. 1930
Wood, feathers, plant fiber; h. 9¾ (24.7)
Gift of Miss Ima Hogg 44.481

Tablita, ca. 1930
Wood, leather, string; 16¾ × 14 (42.5 × 35.5)
Gift of Miss Ima Hogg 44.483

The Pueblo cultures of the Southwest continue their traditional belief in an animated universe all of whose elements share a common life source. Among the Zuni and Hopi peoples, some of the many spirit entities are represented by anthropomorphic creatures called Kachinas. These spiritual beings figure importantly in the ritual lives of the people and are personified by costumed, masked dancers in the sacred ceremonies that mark the passing seasons. Individual Kachina types are recognizable by the details of their masks and costumes, and they appear both singly and in groups. Although their roles are assumed by male members of the Kiua societies, for the native performers and audience the masked dancers transcend their individual identities while engaged in the transcultural phenomenon of "God-impersonator."

The shape and color of the Houston mask (44.481), its wooden beak and ears, and the treatment of the plant fiber and feathers are features that form an iconographic whole used to denote an Eagle or Kwa Kachina. It is an example of a type known as the Hunter Kachinas, who appear either singly or in small groups.

The headdress, called a Tablita (44.483), represents another decorated object worn by male and female dancers of the Rio Grande pueblos and by Kachina dancers of the Hopi villages. The central image on this tablita is a Kachina that is close to the Broadhead or Whipper varieties. The flanking, stepped triangles and the cutout forms decorating the top of the tablita are cloud symbols that refer directly to the rain-seeking aspect of the Kachina drama, an essential part of the agricultural life of these desert tribes. EM

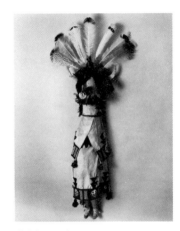

Shalako Kachina, 44.485

334 ZUNI

Shalako Kachina, ca. 1915
Wood, cloth, feathers; h. 43⅜ (115.3)
Gift of Miss Ima Hogg 44.485

Buffalo Kachina, ca. 1915
Wood, cloth, fur; h. 15⅞ (40.3)
Gift of Miss Ima Hogg 44.438

HOPI

Antelope Kachina, ca. 1920–1940
Wood, feathers; h. 12¼ (31.1)
Gift of Miss Ima Hogg 44.383

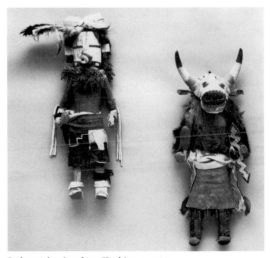

Left to right: Antelope Kachina, 44.383;
Buffalo Kachina, 44.438

Kachina spirits and the dancers who represent them are the subjects of an ancient tradition of small-scale sculpture. The carving of these so-called Kachina dolls flourished at Zuni through the early 1900's and is still a popular art form among the Hopi men. Within the traditional tribal context, they are presented to young girls as part of their religious education. The children are taught to recognize and remember the ritual dancers through the descriptive carving and decoration of these familiar but mysterious images. The appealing quality of Kachina dolls has made them popular with collectors since the late nineteenth century, and by the 1900's pieces were being produced for the commercial trade. However, Kachina figures continue to be made for traditional use by the pueblo tribes.

The Museum has a fine collection of Zuni Kachina figures that date from the first two decades of this century. The extremely large Kachina (44.485) is a Zuni Shalako, one of the six messengers of the gods who appear once a year for a long and dramatic midwinter ceremony. These great horned birds are about eleven feet tall when they are borne aloft by carriers who are completely hidden by the beautifully embroidered Mantas done to the figures' scale. The animal-headed dancer (44.438) is a Buffalo Kachina which holds a rattle and a lightning bolt in its hands. In typical Zuni style the figure is adorned with a variety of materials to simulate, in miniature, the significant aspects of the Kachina's iconography.

In contrast to the three-dimensional representation of costume detail favored by the Zuni, the sculptors of Hopi produced Kachinas of less elaborate decoration. The Antelope Kachina (44.383) is a typical example of 1920–1940. The figure is very solid and frontal, emphasizing a stillness of pose that contrasts with the Kachina's actual appearance as a dancer. The forms and colors are differentiated by the Hopi with paint rather than with materials.

335 ESKIMO
Kuskokwim River, Alaska

Mask, ca. 1875
Wood; h. 13¾ (34.9), w. 10 (25.4), d. 2¼ (5.7)
Museum purchase 79.9

The Eskimo peoples live in two large geographic regions, Greenland and the extreme Northwestern sections of Canada and Alaska. While Eskimo peoples of all areas produce highly imaginative and artistic objects, the production of masks is most commonly found among the Yupik-speaking Eskimos of the lower section of their Alaskan and Canadian range, bordering on the Bering Sea. Like many other fine examples, the Houston mask representing a wolf spirit was said to have been collected on the Kuskokwim River, Alaska (79.9)

Animal masks of this type were most often carved for shamanistic ceremonies or for elaborate winter rituals. Shamanism is a complicated phenomenon involving the ritual transformation of an individual into a spiritual and psychic healer. All shamans develop special relationships with animal and other natural spirits who aid them in their ritual performances. Masks were most often carved to interpret and express the particular spiritual power of a dream or vision. The central portion of the Houston mask is carved from a single piece of light wood and then painted with strong, contrasting tones. The fish and disks that are suspended from the mask may have some relationship to the artist's vision. The two thin branches arching gracefully around the wolf head probably supported feathers and down that would have added to the movement and drama of the dance. EM

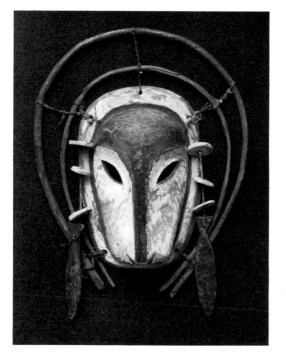

Mask, 79.9

African

336 BENIN CITY
Nigeria, West Africa

Plaque, possibly late 16th or early 17th century
Brass; 18¹¹⁄₁₆ × 12⅜ (47.5 × 31.4)
Museum purchase with funds provided by the
Agnes Cullen Arnold Endowment Fund 73.78

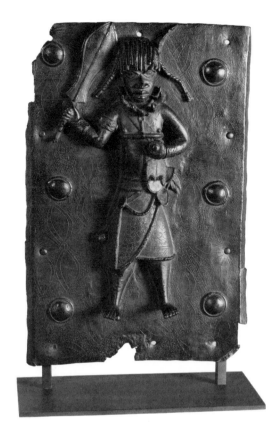

The bronze casters of the king of Benin had mastered the lost-wax technique
before the Portuguese arrived at Benin's port town in the late fifteenth century.
The brass that the king obtained through trade with the Portuguese was melted
down and fashioned into many diverse objects that glorified his palace and his
reign. From the middle of the sixteenth to the end of the seventeenth century,
brass plaques were nailed to the wooden pillars that supported the many galleries
of the red earth palace. The plaques depicted a wide range of scenes and objects
from Benin history and court life.

The Houston plaque shows a high-ranking member of an association of royal
retainers. His importance is indicated by the fish-shaped dancing sword in his
right hand, the hilt of a war sword in his left hand, and his collar of upright
leopard fangs. The ornamental mask—almost certainly cast in metal—below the
pommel of the war sword is an abstract rendering of the head of a maned ram.
The six convex forms at the sides of the plaque probably represent European
basins, one of the main forms in which brass came to Benin. They might identify
the central figure as a member of the palace association that both guarded the
king's treasure and supervised trade with European merchants. LS

337 DOGON
Mali, West Africa (Western Sudan)

Vessel, 19th century
Wood; l. 76¾ (195.0)
Gift of D. and J. de Menil 64.11

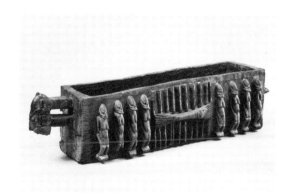

As cultivators of pearl millet in a poorly watered region, the Dogon are greatly
concerned with securing supernatural protection for their crops. This concern
centers in a cult of vegetation under the direction of regional priests, the Hogons.
The ritual activity and personal life of the Hogons required diverse images, most
of which are highly decorated. According to one Dogon myth, the kind of
container exemplified by the Houston vessel is interpreted as the replica of an
ark that ferried a celestial blacksmith and the first Dogons to earth. A more
pragmatic explanation would note that a donkey or a horse was an important
attribute of a Hogon's office. In view of the scarcity of horses, water, and fodder
in Dogon country, it seems likely that a trough would be an essential means of
keeping the Hogon's mount in one safe place. These vessels consistently show

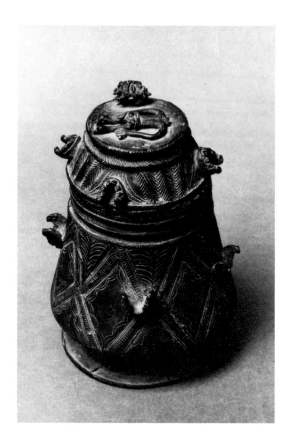

groups of figures carved in high relief on their sides. In other examples the figures show more clearly the high, tiered cap that was a distinctive part of a Hogon's traditional attire. The "female" quality of the figures may derive more from design imperatives and an exaggeration of the physical features of some elderly men than from an attempt to depict hermaphroditic beings. The forms on the middle zones of the Houston trough walls are problematic; the space is usually filled with the figures of one or two crocodiles in relief. LS

338 AN AKAN PEOPLE
Ghana, West Africa

Vessel, possibly late 19th century
Brass; h. with lid 7¹¹⁄₁₆ (19.5)
Gift of Mr. and Mrs. Alvin S. Romansky 77.241

The cast-brass container (*kuduo*) played an important role in the lives of Akan notables, almost one of ritual alter ego. The vessel contained parts of sacrifices or ablutions intended for use in the later stages of certain important ceremonies, some of them vital to a king's person and soul. The *kuduo*, containing gold dust and rare glass beads, was often buried with its owner. His descendants would sometimes retrieve it to pay family debts, and it would thereby return to use, taking on the added importance of an heirloom. Some *kuduo* that belonged to famous men, such as priests, were installed in public as shrines to their memory.

The vessels were cast in two pieces by the lost-wax technique. The Houston example is unusual because the lid is not hinged to the container. It also departs from most *kuduo* because it apparently was shaped considerably by chasing after it was cast. The motifs on its sides are depicted in high relief—another unusual feature—and represent human mandibles, an important element in the Akan imagery of war and political power. The lid is embellished with a related theme that could refer to a proverb or be a statement of martial or judiciary power. Representational themes on *kuduo* lids are believed to have been introduced around the middle of the eighteenth century. LS

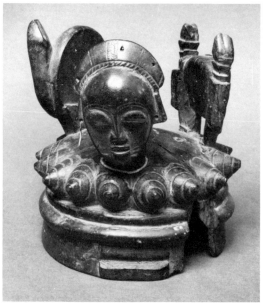

339 KULANGO
Ivory Coast, West Africa

Problematic Object, probably either a headdress or a lid, probably late 19th or early 20th century
Wood, beads; h. 9 (22.9), diam. at base 7⁷⁄₁₆ (18.9)
Museum purchase 75.353

The masklike face surmounting the Houston object is a noteworthy example of the Kulango style. The Kulango are one of the least-studied peoples in the region of Bondoukou. Their situation at the edge of the West African rain forest has exposed them to strong influences from the Manding and Akan peoples. Some Kulango groups are organized into small states on the eastern Akan model. They employ political insignia, which could include crown-like headgear of cloth onto which are sewn golden and gold-covered objects. The Houston object seems to have no published counterpart. Its material, form, and imagery appear to preclude its being a rustic variation on the theme of the Akan crown. If it

were a headdress, it could have been used in other contexts than regal display, perhaps by a cult priest or by the master of ceremonies of a certain dance. The animal motifs—crab, snake, and snail—surmounting and surrounding the top suggest another use for the object. Many Akan ritual vessels are made of a lustrous blackware embellished with figures of aquatic creatures modeled in relief. The Houston sculpture could have served as the lid of a large container—wooden or ceramic—that held either the magical materials of a certain cult or funerary sacrifices, as did similar Akan vessels. LS

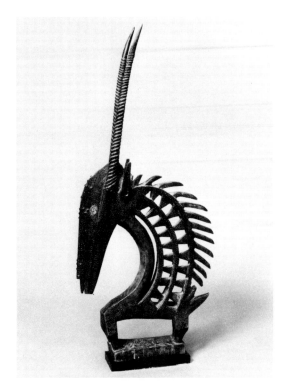

340 BAMANA (BAMBARA)
Mali, West Africa (Western Sudan)

Figure of an Antelope, first third of 20th century
Wood, brass; h. 47¼ (120.0)
Gift of D. and J. de Menil 64.23

Bamana dedication to the cultivation of indigenous Sudanic grains—pearl millet and sorghum—led to the growth of populous and highly organized towns. Members of the families that made up the towns were grouped together across family lines, according to their age. Each age-group performed special functions in maintaining the community. Towns depended for their subsistence upon great tracts of farmland, often too extensive for one family to clear and hoe by itself. A group of young men was charged with the communal hoeing of the great fields of the town families. The association had strong religious overtones. Among the eastern Bamana, between the cities of Segou and Koutiala, the protective spirit of the association was embodied in the images of a roan antelope buck and his mate. The noble-looking and highly pugnacious roan is the largest common antelope in Bamana country. Its image was worn tied to a basketry cap on the head of a dancer who, disguised by capes and skirts of blackened fiber from the base of the image to his feet, would follow the beat of drums in miming the characteristic movements of the antelope. From the end of the nineteenth century the dance was performed in public while communal hoeing was in progress, as a means of exhorting the laborers to greater effort. Images of the roan antelope exploit its mane and deep neck as a field for openwork design and chip-carved or punched decorative detail. LS

341 UNDETERMINED PEOPLE OF THE MIDDLE SASSANDRA
RIVER BASIN
Ivory Coast, West Africa

Mask, first third of the 20th century
Wood; h. 61⅝ (156.5)
Gift of D. and J. de Menil 64.10

The inhabitants of the west-central Ivory Coast, a predominantly forested region, cultivate rice and live in villages characterized by simple, informal political organization. These peoples include the western Guro, the Tura, the Wobe, the Niabwa, and the Bete. They often resort to the use of masks in political activity. Masks formerly judged difficult cases, especially those arising from the imputed abuse of supernatural power, and enforced their judgments. Their authority derives from their association with village cults made up by men initiated into the

knowledge and use of supernatural forces. Masks usually represent spirits of the forest, fantastic beings that combine human and animal attributes.

The large Houston mask of unrecorded provenance was worn horizontally; its wearer looked out through its mouth. Its chimerical form incorporates features of a lyrate-horned antelope and a raptorial bird; both themes are common in the imagery of the Manding peoples in the savannah to the north. A mask quite similar to this example was collected among the Wobe. It was said to have had the power to detect and execute "sorcerers," that is, villagers believed guilty of antisocial acts. (Its costume was neither collected nor described.) LS

342 SENUFO

Ivory Coast, West Africa (Western Sudan)

Figure of a Bird, first half of 20th century
Wood; h. 44⅝ (113.3)
Gift of D. and J. de Menil 63.12

The Senufo live in sizeable towns and villages composed of family quarters. Their success in farming gave them security and leisure in which to elaborate their religious belief in a universe in which unpredictable, threatening forces could be balanced by the power of magic under human control. As the efficacy of such magic lies in its secrecy, the young men of a village have to acquire the knowledge of essential practices through a long course of initiation. Senufo families keep their magical materials and perform their initiations in a secluded grove outside the village. Certain groups in south-central Senufoland kept large wooden figures of long-beaked birds in the house of the overseer of the family enclosure in the sacred grove. These supposedly protective images often represented the fishing eagle, a bird greatly admired by many West African peoples. Senufo woodcarvers expanded the bird theme into a fantastic montage of diverse avian (especially hornbill) and animal features. As the Houston example shows, the image is often given human proportions, posture, and physical details. Note the ears and the trapezoidal projections on the head. The latter recall a hairdress style of pompoms along the median line of the head, which in turn could recall the crest of a bird. LS

343 BAKOTA

Gabon, Western Equatorial Africa

Mask, first half of 20th century
Wood, raffia, pigments; h. 23¾ (60.3)
Gift of D. and J. de Menil 64.9

The BaKota people lived as shifting cultivators of plantains (starchy bananas) in the rain forest of the Middle Ivindo Basin. In their informally organized villages a number of cults and festivities served to draw members of unrelated families together. The main festivities were the circumcision of youths—their partial initiation into manhood—and funeral ceremonies. These occasions were greatly heightened by the emergence of a spectacular helmet mask (*empoli*) whose wearer danced through the village during the day, entertaining the celebrants and amassing gifts for himself and his entourage. The gifts compensated the dancer

for his expenses and rewarded him for his dancing ability. His mask was difficult and therefore costly to make. It had to be carved and hollowed out of a sizeable tree-trunk. The mask was enhanced by bouquets of feathers and raffia streamers attached along the edges of its crests. The dancer was disguised in much the same way that his mask was colored: a full ruff of raffia fiber covered his shoulders, and spots of pigment were dabbed onto zones of contrasting ground colors that covered his otherwise minimally clad body. The dance of *empoli* demanded skill in its portrayal of a forest spirit who was stately yet belligerent, massive yet agile. LS

344 BOBO
Upper Volta, West Africa (Western Sudan)

Mask, first half of 20th century
Wood, pigments; h. 65½ (166.3)
Gift of D. and J. de Menil in memory of Dr. Jermayne MacAgy 64.13

In their need to control the supernatural forces believed to affect their grain crops, Bobo men practice a cult that mediates between them, the spirits of their ancestors, and the spirits of nature. Nature-spirits of this cult are personified by masks of leaves, fibers, and wood. The masks represent plant-like beings, birds, animals, and humans. They emerge to dance on such special occasions as the funeral of a notable villager, the festival for all those who died during a certain interval, and the ritual purification of the village. They also undertake police functions in forcing villagers to join in communal tasks and in keeping order during festivities. Their nonpublic roles are even more important: they are essential to the system that initiates young men into their cult. Ironworkers—specialized craftsmen who are socially distinct from farmers—carve all wooden masks. They enjoy the prerogative of wearing the more important masks, which would include the kind represented by the Houston example. Bobo masks often combine human and animal attributes: the face tends to be human or human-like, while the top of the head bears identifying animal features, such as stylized wings, crests, or horns. The crescentic horns of this type of mask would refer to the buffalo. The production of such large masks is laborious and ritualistic, and it requires felling a small tree and carving out one longitudinal half of its trunk. LS

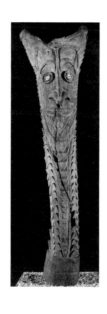

345 KAPRIMAN PEOPLE

Papua New Guinea, East Sepik Province, Blackwater River, Tunggambit village

House Post, first half of 20th century
Wood with conus-shell eyes and traces of polychrome; h. 102¾ (261.0)
Museum purchase with funds provided by the
Director's Fund 61.56

Among the most impressive architectural achievements of the Oceanic peoples are famous ceremonial houses of the Sepik River area of Papua New Guinea. These houses were the congregating places of men for performance of ritual, storage of sacred objects, and planning of such essential male activities as head-hunting raids. The Kapriman people live on the Krosmeri and Blackwater rivers, southern tributaries of the Sepik River, on which lives the large Iatmul tribe. Although they speak a different language, the Kapriman seem to have been profoundly influenced at some point in their history by the Iatmul and to have adopted much of their culture, including their style of ceremonial house construction.

These houses are two-story buildings with pitched roofs rising at either end into towering spires. The roof beams, the rafters, and the platform that formed the ground floor of the attic were supported by large carved posts. The Houston carving is clearly the upper part of such a post. The point at which the carved section meets the uncarved lower section probably marks the point at which the attic floor was placed, while the forked top provided a cruck for a beam.

The subject is probably an ancestor of one of the clans that congregated in the house and used a sitting-platform built near or around the shaft of the post. The overlapping "scales" below the faces may well be the ripples on the primal water from which ceremonial houses are often said to have arisen. Whether or not the explanation applies in this case, the doubling of the face is described by the Manambu (another Iatmul-related group) as showing the way in which the ancestor rapidly turned his head to and fro in order to protect his rear from his enemies. DN

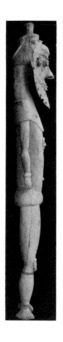

346 YAUL PEOPLE

Papua New Guinea, East Sepik Province, Yuat River, Dimiri village

Figure, probably second half of 19th century
Wood; h. 87¼ (222.0)
Museum purchase 62.44

On either side of the Yuat River, a southern tributary of the Sepik River, large figures were carved as images of spirits who were patrons of hunting and war. Although some of these figures were kept in private houses, in the Sepik area

such sacred objects were usually installed in the men's ceremonial houses. The Yuat practice is somewhat aberrant, perhaps due to cultural break-up. The Yaul people, living in the swampy lands east of the Yuat, were used by the Biwat people who lived along the river itself both as raiding victims and as suppliers of pots in exchange for tobacco and sago. The Biwat were much more prolific artists than the Yaul and clearly exercised a considerable influence on their carving style.

The Houston figure probably refers to a local myth concerning a spirit named Urungenam who wandered with three brothers from Dimiri to the Yuat River. He and one of his brothers played bamboo flutes during the night and retired during the day into a tree trunk, which thereby became the first slitgong. (Slitgongs are large hollowed-out logs, beaten on the sides to produce rhythms which, like the music of flutes, were thought of as ancestral voices.) Each brother sat on his knees and chest: hence the positions of the small masks seen on the Museum's figure. Through the agency of a man from a nearby village, human beings gained the secret of the sacred musical instruments. The protrusion at the top of the head probably served as the support for a headdress, while the holes bored around the jaws were used for the attachment of a beard, perhaps of human hair. DN

347 KARAWARI PEOPLE
Papua New Guinea, East Sepik Province, Karawari River,
Manjamai village

Crocodile, early 20th century
Wood, paint; l. 275 (699.0)
Gift of Houston Endowment, Inc. 61.46

A group of about ten wooden crocodiles collected from the villages of the Karawari people are perhaps the largest known carvings, apart from canoes and architectural elements, to have been found in New Guinea. They are the most striking representations of a creature that plays a leading role in Sepik mythology as creator and ancestor.

The Karawari crocodile figures were kept in men's ceremonial houses in pairs, representing brothers who were the founders of the village's clans. Details of mythology and function varied from village to village, but generally speaking they were involved both in initiation ceremonies for men and in preparations for headhunting. Initiates were kept in seclusion in the ceremonial houses for long periods during which they received scarification marks on their backs and arms; these were explained to women as bestowed by the crocodiles, which had eaten the boys during the ceremonies. A symbolic death, followed by rebirth into adult society, was intended. As a prelude to headhunting raids, the men danced with the figures, supporting them on poles inserted through the holes in the sides of the carvings. The crocodiles then responded with knocking sounds that indicated whether success could be expected. After the raid, the captured heads were placed in the crocodiles' jaws, yet another symbolic assimilation, this time of the victims to the tribe.

The curvilinear designs, which form collars at the creatures' necks, represent ripples in water. The complex subsidiary carvings of bird and human heads along the back and sides seem to indicate an amalgam of seminaturalistic, middle Sepik River styles with the highly stylized "opposed hooks" style common in the area south of the river. DN

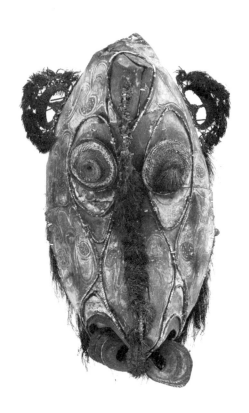

348 SAWOS PEOPLE
Papua New Guinea, East Sepik Province, Torembi village

Gable Mask, first half of 20th century
Sago spathes, basketry, fiber, cord, paint; h. 49¾ (126.4)
Museum purchase 62.43

The Sawos people live in a belt of savannah and swamp that runs parallel to the north side of the Sepik River. Their language, culture, and art are very similar to those of the Iatmul, who live along the river itself; the latter claim, in fact, that their ancestors migrated from Sawos territory to some of their present locations.

Sawos ceremonial houses differ only in detail from those of the Iatmul. For instance, large masks placed on the gables at either end of Iatmul houses were usually built as part of the fabric itself. The Sawos, on the other hand, construct such masks from flattened sheets of sago spathe (possibly reflecting an important local cult involved with sago) and use cane and basketry details. Some of the masks collected from Torembi, a large village that had at least four ceremonial houses, are basically trapezoidal panels. The Houston mask is less usual in being a three-dimensional form, but even so the delineation of all the visible features is made with strips of cane that enclose areas indicating eyes, nose, and nostrils. Basketry openwork attachments indicate the ears, basketry discs the eyes, and three sago spathe cutouts, thrust through the septum, simulate pearl-shell nose ornaments. The painted designs, which repeat the design of the mask's eye areas within a system of loops, may refer to water plants.

Among the Iatmul, the gable masks represent a female creative and totemic ancestor, who is personified by the whole structure of the house itself. In the complex symbolism of this tribe, the house also represents the first floating island of vegetation, created by male ancestral crocodiles, on which human beings found a foothold. It is possible that Sawos symbolism reflects the same myth of creation. DN

349 MATANKOR PEOPLE
Admiralty Islands, Lou Island

Bowl, probably late 19th century
Wood; h. 25¾ (65.4), diam. 41¼ (104.8), w. across handles 52⅞ (134.3)
Gift of D. and J. de Menil 62.4

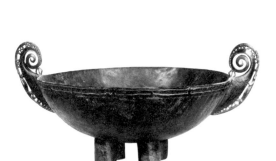

The three main groups of people who inhabit the Admiralty Islands formerly had a complex trading system based on localized sources for materials and manufacturing skills. The Matankor were the major craftsmen, and those living on Lou Island specialized in making the elaborate feast bowls, large and small, of which the Houston bowl is an example. Not only were they used as serving vessels and containers of contributions towards bridal payments, but also they were sufficiently capacious and substantial to be used for cooking food under layers of hot stones and leaves.

The body and legs of the bowl were sculptured from a single block of wood; the "handles" (the carvings are not really suited to this purpose and are largely ornamental) were carved separately and attached by a paste made from parinarium nuts. Much the same design is used for canoe prows, handles of ladles, and other objects. The abstraction of the spirals has gone beyond detectable

natural referents, but at least one example shows them as the tails of animals, probably lizards. Stylized lizards or crocodiles appear on the outer edges of the handles of the Museum's bowl.

Smaller bowls of this type were also used as containers for ancestral skulls and finger bones and were hung from the roof. These relics embodied spirits of male forebears acting as guardians of the males of the household, as punishers for infringements of social conventions, and as consultants on important ventures. The apparent association of canoe prows, bowl handles, and skulls has engendered speculation that the complex is related to an ideology involving canoes and the dead, which is widespread in Southeast Asia and Oceania. DN

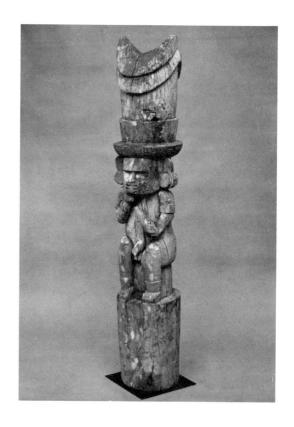

350 SAN CRISTOBAL, SURVILLE PENINSULA
Solomon Islands

House Post, first half of 20th century
Wood; h. 82⅜ (209.0)
Gift of D. and J. de Menil 66.12

The Surville Peninsula of southeast San Cristobal and two small offshore islands, Santa Ana and Santa Catalina, form a quite distinct cultural and stylistic area of the eastern Solomon Islands. Here the role of the men's ceremonial houses of New Guinea and other parts of Melanesia was taken by the *aofa* ("custom house," in current usage), which was decorated by carved posts. The Houston post and a number of others were collected in 1965 from the ruins of *aofa* in deserted villages called Nansi and Funukunwa, by people of the present Mwa Korukoru village. According to the collector, the *aofa* was named Unu, and the post's own name was Uuh. The date at which it was carved is uncertain.

The *aofa* performed a number of functions: apart from serving as a clubhouse for men and a center for ritual activities, it housed the great canoes used in bonito fishing and shrines for the bones of important men. The shrines (*airi*) were carved in the form of sharks with closed niches in their sides to hold a man's skull. They represent Karemanua, a deity who was half-shark and half-man who killed his human brother. The collector said an ancestor holding an image of Karemanua is represented on the housepost. The carving is more likely to show the god himself, carrying a lime gourd for betel chewing and wearing a shell nose ornament (a stylized school of fish) and large tubular ear ornaments. In this area sharks are sea creatures of importance both in their own terrifying right and as companion of the bonito, fish that are not only sacred but also a prime source of food. DN

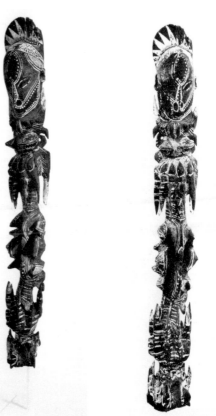

351 ABELAM PEOPLE
Papua New Guinea, East Sepik Province, Prince Alexander Mountains

Figure, probably second half of 19th century
Wood, paint; h. 70⅜ (179.0)
Gift of D. and J. de Menil 65.37

The Abelam people of the mountains near the northeast coast of New Guinea had a complex religious life, consisting of cults for the growth of yams (a food staple) and cults for important ancestors. For both, and the many stages of initi-

217

ation they entailed, a quantity of paintings and carvings were made: the Abelam were perhaps the most prolific artists of the Sepik area.

Among the most sacred carvings were the figures, revealed at a late stage of initiation to the ancestral cult, known as *nggwal ndu* ("grandfather man"). These were owned by clans, rather than by individuals, and represented clan ancestors. The Houston figure is carved in the older, eastern Abelam form. The anthropologist Anthony Forge states that recently the style was superseded by a more naturalistic type of figure sculpture influenced by the northern Abelam. When this substitution took place cannot be determined, as is so often the case with statements made by indigenous informants. Only the head of the Houston figure, wearing a crest based on a small basketry ornament used in real life, is in human form. It is placed above several assemblages of birds' beaks at top and bottom of the carving, with a group of whole bird figures at the center. A recent repainting of the carving obscures some of the details. In general, the style is related to the "opposed hooks" style of the area south of the Sepik River, especially along the Karawari River. DN

Index of Entries

A

Abbott, Berenice
 Provincetown Playhouse, 133 Mc-
 Dougal St., Manhattan (76.237), 249
Abelam People (Papua New Guinea)
 figure (65.37), 351
Acoma
 jar (44.17, 44.5), 324
Acoma/McCartys
 jar (44.19), 324
Akan People (Ghana, West Africa)
 vessel (77.241), 338
Alari-Bonacolsi, Pier Jacopo. *See*
 Antico, L'
Albers, Josef
 Homage to the Square: Transmuted
 (79.59), 271
Alechinsky, Pierre
 The Tomb of Ensor (61.47), 273
American (Baltimore, Md.)
 album quilt (45.4), 165
American (Boston, Mass.)
 card table (B.69.406), 123
 high chest of drawers (B.69.43), 114
American (East Haven/Branford,
 Conn.)
 great chair (B.69.354), 111
American (Massachusetts)
 easy chair (B.60.89), 133
 toilet table (B.70.24), 113
 two-drawer chest (B.69.356), 112
American (New Hampshire)
 high chest (B.69.231), 135
American (New York)
 side chair (B.69.33), 128
American (New York, New York)
 sofa (B.78.79), 162
 sofa table (B.71.106), 161
American (Philadelphia, Pa.)
 pier table (B.59.82), 136

American (Salem, Mass.)
 gaming table (B.69.377), 157
 side chair (B.61.92), 155
Amman, Jost
 Ensign Carrying a Flag (70.37), 83
Anasazi
 jar (44.109), 319
 Sikyatki bowl (44.65), 319
 Tularosa vessel (44.114), 319
Antico, L'
 Hercules Resting after Slaying the
 Nemean Lion (44.582), 57
Apulian
 epichysis with Eros and two women
 (76.199), 16
Assyrian
 eagle-headed winged deity (80.53),
 12
Atget, Eugène
 Vendors from Baskets (76.257), 217
Auwera, Johann Wolfgang van der
 Kneeling Angels in Adoration
 (74.59.1,2), 127
Avery, Milton
 Flowers on the Table (77.59), 256
Aztec (Mexico)
 standard-bearer (66.8), 315

B

BaKota (Gabon, Western Equatorial
 Africa)
 mask (64.9), 343
Baldessari, John
 A Different Kind of Order (78.4), 291
Bamana (Bambara; Mali, West Africa)
 antelope figure (64.23), 340
Bannard, Walter Darby
 Western Air #1 (72.23), 286
Barna da Siena, Circle of the so-called
 Madonna and Child (44.564), 38
 Madonna and Child with Saints and
 Angels (44.566), 39

Bassett, Frederick
 tankard (B.60.55), 137
Batoni, Pompeo
 Portrait of a Man (61.76), 132
Bazille, Jean-Frédéric
 The Little Gardener (76.236), 178
Bell, Larry
 untitled box, 1966 (77.371), 281
Belliniano, Vittore
 Two Young Venetian Men (44.553), 59
Bellotto, Bernardo
 The Marketplace at Pirna (61.71), 131
Bellows, George
 Portrait of Florence Pierce (74.255), 230
Benin City (Nigeria, West Africa)
 plaque (73.78), 336
Bening, Simon, Workshop of
 Triptych with the Virgin and Child
 and Saints Catherine and Barbara
 (44.529), 66
Bernini, Circle of
 Portrait of Clemente IX (75.27), 104
Bernini, Workshop of
 Portrait of a Man (73.80), 105
Berthélemy, Jean-Simon
 The Pest of Milan (70.20), 144
Bertin, Nicolas
 Prophets and Kings of the Old Testa-
 ment Adoring the Name of Jehovah and
 Awaiting the Messiah (69.5), 117
Bertucci, Giovanni Battista
 St. Thomas Aquinas (64.34), 75
Bierstadt, Albert
 Study of an Ancient Tree
 (TR 355-78), 175
Bloemaert, Abraham
 The Gateway to a Town (74.254), 91
Bobo (Upper Volta, West Africa)
 mask (64.13), 344
Bol, Ferdinand
 Portrait of Saskia (Vanitas) (69.4), 97
Bolotowsky, Ilya
 Construction in a Square (77.272), 253

Bonnard, Pierre
 Dressing Table and Mirror (74.134), 231
Bourdon, Sébastien
 Laban Searching the Belongings of Jacob (80.16), 94
Brancusi, Constantin
 A Muse (62.1), 226
Braque, Georges
 Fishing Boats (74.135), 212
Briosco, Andrea. *See* Riccio
Bruce, Patrick Henry
 Composition VI (79.69), 225
 Peinture/Nature Morte (78.182), 233
Byzantine (Constantinople)
 plaque with the Koimesis (71.6), 27

C

Calder, Alexander
 International Mobile (62.46), 262
Caliari, Paolo. *See* Veronese
Callahan, Harry
 Eleanor, Chicago (75.579), 265
Canal, Antonio. *See* Canaletto
Canaletto
 Grand Canal, Entrance Looking West (56.2), 120
 Grand Canal, Looking Southeast from near Rialto Bridge (55.103), 120
Carrier-Belleuse, Albert-Ernest
 Bust of a Bacchante (73.177, 73.178), 179
Cartier-Bresson, Henri
 Sawyer-Flood House, Galveston, Texas (65.237), 277
Casas Grandes
 macaw bowl (44.107), 321
Cassatt, Mary
 Susan Comforting the Baby (74.136), 193
Catena, Vicenzo
 Sacra Conversazione (61.61), 72
Cavallino, Bernardo
 The Sacrifice of Noah (61.63), 98
Cézanne, Paul
 Madame Cézanne in Blue (47.29), 194
Champaigne, Philippe de
 The Penitent Magdalen (70.26), 100
Chapron, Nicolas
 The Presentation of the Virgin in the Temple (70.19), 95

Chase, William Merritt
 The First Portrait (34.81), 198
Chassériau, Théodore
 Woman and Little Girl of Constantine Playing with a Gazelle (74.265), 168
Chelsea Porcelain Works
 dish (74.170), 134
Chinese (Early T'ang Dynasty)
 equestrian figure (73.68), 3
 pair of grooms (73.67.1,2), 2
Chinese (Early Western Han Dynasty)
 stamped tomb brick (69.25), 1
Chinese (Sung Dynasty)
 pillow (75.351), 4
Church, Frederick Edwin
 Cotopaxi (74.58), 172
Clodion
 The Bird Nest Thieves (44.576, 44.577), 145
Cochiti
 bowl (46.14), 328
 jar (44.39), 328
 olla (44.36, 44.38), 328
Colima (Mexico)
 dog (65.115), 304
Coney, John
 tankard (B.74.19), 115
Copley, John Singleton
 Mrs. Paul Richard (B.54.18), 142
Coptic
 male head (72.14), 25
Corneille de Lyon
 portraits (44.538, 44.539, 44.540), 86
Cranach, Lucas the Younger
 The Fall of Man (44.546), 81
Cycladic
 female idol (37.26), 10

D

Daubigny, Charles-François
 Sluice in the Optevoz Valley (79.122), 170
Daumier, Honoré
 Lawyers' Meeting (74.137), 176
Davis, Stuart
 Gloucester Harbor (77.330), 252
de'Carli, Raffaelino. *See* del Garbo, Raffaelino
Degas, Hilaire-Germain-Edgar
 Dancer Putting on Her Stocking (80.43), 208

Young Woman at her Toilet (56.21), 207
del Garbo, Raffaelino
 Portrait of a Young Woman (44.554), 77
Derain, André
 The Turning Road (74.138), 209
di Paolo, Giovanni. *See* Paolo, Giovanni di
Dogon (Mali, West Africa)
 vessel (64.11), 337
Doré, Gustave
 Beggars at Burgos (77.32), 183
Dürer, Albrecht
 St. Eustace (44.548), 61
 Virgin and Child Seated by the Wall (77.364), 62
Dzubas, Friedel
 Late Fire (73.26), 289

E

Early Christian or Medieval
 shallow footed bowl (70.95), 26
Eastern Woodlands
 birdstone (63.139, 63.144), 316
Egyptian (Hermopolis)
 fragment of a relief (62.13), 11
Emerson, Peter Henry
 During the Reed-Harvest (80.9), 195
English (Lambeth)
 charger (B.57.60), 110
English (London)
 tea pot (TR 134-79), 109
English (Nottingham)
 Virgin and Child Enthroned (62.3), 37
English (Staffordshire)
 agateware coffee or chocolate pot (B.56.107), 129
Ernst, Max
 Moonmad (57.5), 254
Eskimo
 mask (79.9), 335
Evans, Walker
 Roadside Sandwich Shop, Ponchatoula, Louisiana (76.242), 248

F

Fantin-Latour, Ignace-Henri-Jean-Théodore
 White Roses (79.183), 182

Feke, Robert
Anne McCall (B.71.81), 130
Ferber, Herbert
Horned Sculpture (79.1), 263
Ferrarese School
Meeting of Solomon and the Queen of Sheba (44.574), 51
Fletcher, Thomas
pitcher (B.77.16), 160
Fontebasso, Francesco
The Adoration of the Shepherds (73.1), 122
Fra Angelico
The Temptation of St. Anthony the Abbot (44.550), 43
Fragonard, Jean-Honoré
Rodomonte and Mandricado State Their Case before Agramante (78.64), 149
Franco-Netherlandish
God the Father (44.581), 34
Frank, Robert
Hoboken (76.243), 268
Frankenthaler, Helen
Blue Rail (73.82), 287
French
Venus Marina (69.3), 107
French (Limoges)
Crozier Head with St. Michael Trampling the Serpent (70.38), 29
French (Mosan)
funerary processional figure (44.580), 33
French (Normandy)
Virgin and Child (71.15), 32
Friedlander, Lee
Father Duffy. Times Square, New York, New York (78.11), 293
Fungai, Bernardino
The Rescue of Hippo (44.560), 55

G

Gainsborough, Thomas
Landscape with a Woodcutter (61.9), 139
Gallé, Emile
water lily vase (73.141), 205
Gardiner, Sidney
pitcher (B.77.16), 160
Gauguin, Paul
Arearea Joyousness II (77.372), 202

Gellée, Claude. *See* Lorrain, Claude Le
Gentileschi, Orazio
A Sibyl (61.74), 88
German (Lower Saxony)
canon page from a Sacramentary, with the Crucifixion (71.8), 28
reliquary monstrance from the Guelph Treasure (70.16), 35
Giacometti, Alberto
Figura Allongata (76.369), 259
Giordano, Luca
Allegory of Prudence (75.33), 106
Gleizes, Albert
Woman with Phlox (65.39), 215
Gogh, Vincent van
The Rocks (74.139), 196
Goodnough, Robert
Anghiari II (69.24), 285
Gossaert, Jan. *See* Mabuse
Graeco-Egyptian (Alexandrian)
A Youth Clasping a Bird and a Bunch of Grapes (57.50), 21
Graeco-Roman
Eros, statuette of (44.603), 20
Graves, Nancy
Nearside of the Moon 20° North-South by 70° East-West (74.250), 290
Greek
horse, statuette of (37.22), 13
Greek (Attic)
grave stela of a woman (37.25), 15
Greek (Hellenistic)
necklace with Ethiopian head clasps (37.41), 17
Guardi, Francesco
View of Venice: Santa Maria della Salute and the Dogana (44.562), 147
Guillaumin, Jean-Baptiste-Armand
The Seine at Paris (71.5), 184

H

Hals, Frans
Portrait of a Woman (51.3), 102
Hartley, Marsden
Abstraction (80.82), 218
Heda, Willem Claesz.
Still Life (57.56), 101
Heinecken, Robert
Space/Time Metamorphosis #1 (76.274), 296
Herter Brothers
lady's writing desk (77.373), 181

Hicks, Edward
Penn's Treaty with the Indians (B.77.46), 166
Holbein, Hans the Younger
Portrait of Sir Henry Guildford (44.549), 78
Homer, Winslow
She Cuts Off Their Tails (Library), 173
Honthorst, Gerrit van
Venus Chastising Cupid (75.41), 90
Hopi
antelope kachina (44.383), 334
kachina mask (44.481), 333
jar (44.67), 322
olla (44.68), 322
tablita (44.483), 333
Hopi/Polacca
jar (44.56), 322
Houdon, Jean-Antoine
Portrait of Anne-Ange Houdon (44.578), 150
Huastec (Mexico)
figure (65.153), 314
Hunzinger, George
side chair (B.75.57), 180
Huszar, Vilmos
Composition (75.20), 232

I

Indian (Medieval Period)
Shiva Nataraja (73.77), 8
Vishnu and his Avatars (71.1), 7
Isabey, Louis-Gabriel-Eugène
View along the Norman Coast (78.126), 169

J

Japanese (Heian Period)
Bosatsu (68.50), 6
Judd, Donald
untitled, 1975 (75.370), 294

K

Kandinsky, Wassily
Skizze 160A (74.140), 216
Kapriman People (Papua New Guinea)
house post (61.56), 345
Karawari People (Papua New Guinea)
crocodile (61.46), 347

Kauffman, Angelica
 *Ariadne Abandoned by Theseus on
 Naxos* (69.23), 146
Kensett, John F.
 A View of Mansfield Mountain
 (76.200), 167
Kertész, André
 Satiric Dancer (78.111.4), 239
Kierstede, Cornelius
 silver bowl (B.63.3), 116
Klee, Paul
 Marjamshausen (39.111), 241
Krasner, Lee
 Blue and Black (80.42), 266
Kulango (Ivory Coast, West Africa)
 object (75.353), 339

L

La Fresnaye, Roger de
 The Fourteenth of July (75.26), 220
La Hyre, Laurent de
 The Rape of Europa (70.12), 99
Lamerie, Paul de
 ewer (TR 682-74), 124
Langa Master
 Virgin and Child with Angels (58.6),
 42
Larionov, Mikhail
 Street Lighting (75.358), 219
Laudin, Nicolas I
 cup and saucer (74.261.1,2), 108
Lefèvre, Robert-Jacques-François
 *Portrait of a Woman Leaning on a
 Green Velvet Cushion* (79.120), 159
Leonardo, Benedetto di. *See* Maiano,
 Benedetto da
LeWitt, Sol
 333 (77.332), 284
Lombardo, Antonio, Circle of
 St. John the Baptist (44.588), 58
Lorrain, Claude Le
 *Pastoral Landscape with a Rock Arch
 and a River* (73.172), 93
Lotto, Lorenzo
 Holy Family with St. Catherine (30.5),
 73
Louis, Morris
 Loam (76.319), 270
Luini, Bernardino
 Pietà (61.68), 76

M

Mabuse
 The Holy Family (59.27), 67
Macdonald-Wright, Stanton
 Arm Organization (80.33), 223
Magna Graecian
 relief with a symposium scene
 (72.25), 14
Magnasco, Alessandro
 Landscape with Figures (61.73), 119
 Landscape with Washerwoman (61.72),
 119
Maiano, Benedetto da
 Madonna and Child (44.589), 53
Mangold, Robert
 *A Quarter Circle Not Totally
 within a Rectangle and a Square*
 (79.12), 297
Marin, John
 The Little Sailboat (75.4), 237
Martinez, Julian
 jar (44.79, 44.171), 327
Martinez, Maria
 jar (44.79, 44.171), 327
Master of Georg Muehlich's Meisterlin
 Chronicle
 The Crucifixion (72.32), 50
Master of the Berlin Triptych,
 Workshop of
 Virgin and Child in Glory (71.7), 30
Master of the Drapery Studies
 Ecce Homo (72.44), 60
Master of the Holy Blood
 Virgin and Child (44.531), 64
Master of the Straus Madonna
 Madonna and Child of the Goldfinch
 (44.565), 41
Matankor People (Admiralty Islands)
 bowl (62.4), 349
Mather, Margrethe
 untitled, 1928 (77.56), 242
Matisse, Henri-Emile-Benôit
 The Backs (80.68, 80.69, 80.70,
 80.71), 214
 Portrait of Olga Merson (78.125), 213
 Study after the Rose Nude (65.35), 247
 Woman in a Purple Coat (74.141), 251
Maya (Guatemala)
 bowl (76.426), 306
 bowl (77.47), 307
 figure (68.51), 311
 vessel (79.13), 308

Maya (Mexico)
 relief (62.42), 309
 vessel (67.11), 310
Meeks, Joseph and Son
 sideboard (B.67.6), 163
Memling, Hans
 Portrait of an Old Woman (44.530), 49
Michel, Claude. *See* Clodion
Middle Sassandra River Basin People
 (Ivory Coast, West Africa)
 mask (64.10), 341
Mimbres
 bowl (63.21), 320
 dish (63.20), 320
Mississippian/Caddoan
 bottle (63.81), 318
 bowl (63.31), 318
 vessel (63.82), 318
Mississippian/Spiro
 cup fragment (63.222a, 63.223c), 317
 gorget (63.213), 317
 earspools (63.103, 63.105), 317
 miniature mask (63.180), 317
Model, Lisette
 *French Gambler, Promenade des
 Anglais, Riviera* (78.113.4), 250
Mogensen, Paul
 untitled, 1966–1978 (78.230), 282
Mondrian, Piet
 *Composition with Gray and Light
 Brown* (63.16), 227
Monet, Claude-Oscar
 The Japanese Footbridge at Giverny
 (76.198), 234
 Water Lilies (68.31), 210
Monte Alban (Mexico)
 funerary urn (65.146), 303
Monti, Francesco
 Jael and Sisera (72.20), 121
Motherwell, Robert
 Black on White (62.7), 276

N

Navajo
 bracelet (44.209), 332
 chief's blanket (63.197), 331
 squashblossom necklace (70.67), 332
Noland, Kenneth
 Half (74.260), 272
North German
 double mazer cup (71.11), 36

North Italian
 Enthroned Virgin and Child (44.602), 31
 Hercules and the Nemean Lion (44.591), 70
Novros, David
 untitled, 1974 (74.263), 292
Nuzi, Allegretto, Circle of
 Saints and Angels (44.568, 44.569), 40

O

O'Keeffe, Georgia
 Grey Line with Black, Blue and Yellow (77.331), 236
Oldenburg, Claes
 Giant Soft Fan, Ghost Version (67.18), 283
Olmec (Mexico)
 bowl (65.68), 302
 head (65.65), 301
O'Sullivan, Timothy H.
 Ancient Ruins in the Cañon de Chelle, N. M. (Territory) (79.92), 187

P

Panini, Giovanni Paolo
 Imaginary Landscape with Monuments of Ancient Rome (61.62), 125
Paolo, Giovanni di
 St. Clare Saving a Child Mauled by a Wolf (44.571), 47
 St. John the Baptist and Catherine (53.2, 53.3), 45
Pater, Jean-Baptiste
 Pastoral Concert (44.544), 118
Patinir, Joachim, Follower of
 St. Jerome Praying in a Landscape (56.18), 63
Peale, Charles Willson
 Self-Portrait with Rachel and Angelica Peale (B.60.49), 152
Peale, James
 Pleasure Party by a Mill (B.62.16), 153
Picasso, Pablo
 Pipe and Sheet Music (69.11), 221
 Two Women in front of a Window (64.17), 240
 Woman with Outstretched Arms (66.15), 274
Pietro, Sano di
 Madonna and Child with St. Jerome,

St. Bernardino, and Six Angels (44.572), 46
Piombo, Sebastiano del
 Portrait of Anton Francesco degli Albizzi (61.79), 74
Piranesi, Giovanni Battista
 Imaginary Prisons (78.146), 126
Pollock, Jackson
 Number 6 (64.36), 260
Preti, Mattia
 The Decollation of St. Paul (69.17), 103

R

Rauschenberg, Robert
 Urban (79.136), 278
Redon, Odilon
 The Trees (72.29), 190
Remington, Frederic
 Aiding a Comrade (43.23), 199
Renger-Patzsch, Albert
 untitled, ca. 1932 (79.93), 244
Renoir, Pierre-Auguste
 Still Life with Bouquet (51.7), 185
Riccio
 Chained Satyr (44.594), 68
 Vulcan Forging the Arrows of Cupid (44.596), 69
Robert, Hubert
 The Large Staircase (44.545), 138
Robert-Lefèvre. *See* Lefèvre, Robert-Jacques-François
Rockburne, Dorothea
 Arena V (79.119), 299
Rodin, Auguste
 Studies for the Titans (58.20a, b), 191
Roesen, Severin
 Victorian Bouquet (71.21), 171
Roman
 Torso of Aphrodite Anadyomene (61.8), 19
Roman (Republican)
 Standing Figure of a Goddess (74.253), 18
Roman (Late Severan Period)
 sarcophagus front (76.228), 24
Roman (Severan Period)
 portrait head of a young woman (70.39), 23
 Portrait of a Ruler (62.19), 22

Romano, Antoniazzo
 Madonna and Child with Donor (44.551), 54
Romney, George
 sketchbook (78.187), 148
Rosselli, Cosimo
 Portrait of a Young Man with a Pink (55.88), 52
Rothenberg, Susan
 Red Banner (79.263), 300
Rothko, Mark
 Painting (67.19), 275
Rousseau Etienne-Pierre-Théodore
 The Great Oaks of Old Bas-Bréau (72.87), 177
Russell, Morgan
 Synchromy (78.149), 222
Ryan, Anne
 #462 (79.23), 258

S

Saint-Gaudens, Augustus
 Portrait Bust of Belle Gibbs (50.2), 186
Saint-Memin, Charles-Balthazar-Julien-Févret de
 Unknown Man (B.59.52), 158
San Cristobal, Surville Peninsula (Solomon Islands)
 house post (66.12), 350
San Ildefonso
 jar (44.73), 327
Santa Ana
 jar (44.40, 44.41, 44.42), 325
Santa Clara
 jar (50.24B), 326
 water jar (44.100), 326
Santo Domingo
 dough bowl (46.22), 329
 necklace (44.179), 332
Santo Domingo/Kiua
 storage olla (44.46), 329
Sargent, John Singer
 The Model (39.68), 188
Sawos People (Papua New Guinea)
 gable mask (62.43), 348
Senufo (Ivory Coast, West Africa)
 bird figure (63.12), 342
Sérusier, Paul
 Landscape at Le Poldu (79.255), 201
Seymour, John and Thomas
 lady's desk (B.65.12), 156

Shahn, Ben
 New York City (79.18), 245
Sheeler, Charles
 New York (79.6), 229
Signac, Paul
 A Pine on the Road to Saint-Tropez
 (74.142), 203
Silber, Jonas
 Coriolanus Meeting the Roman Women
 (71.56), 82
Siskind, Aaron
 Jerome Arizona (72.7), 264
Sisley, Alfred
 The Flood on the Road to Saint-
 Germain (74.146), 189
Smith, David
 War Spectre (78.58), 255
Sommer, Frederick
 Arizona Landscape (76.253), 257
Stella, Frank
 Moultonville I (73.85), 280
Stickley, Gustav
 sideboard (78.65), 206
Stieglitz, Alfred
 Portrait of Georgia O'Keeffe (78.63),
 246
 The Steerage (76.254), 211
Still, Clyfford
 untitled, 1949 (76.320), 261
Stomer, Mathias
 The Judgment of Solomon (70.15), 96
Storrs, John
 Abstract #1 (77.9), 243
Strand, Paul
 Lathe (78.60), 235
Strozzi, Bernardo
 The Guardian Angel (76.256), 92
Stuart, Gilbert
 John Vaughan (B.61.55), 154
Susini, Antonio
 Madonna and Child (44.586), 87

T

Teotihuacan (Mexico)
 vessel (65.70), 305
Tibetan
 Mahakala Heruka (71.68), 9
Tiepolo, Giovanni Domenico
 Study for an Altar with St. Francis of
 Paola, St. Anthony of Padua, and an
 Angel (79.121), 143

Tiffany and Company
 tea set (80.75), 192
Tintoretto, Domenico
 Tancred Baptizing Clorinda (61.77), 84
Tobey, Mark
 Prophetic Light-Dawn (64.3), 269
Torres, Horacio
 Composition with Figures (75.40), 295
Tosini, Michele
 St. Mary Magdalene (61.67), 80
Toulouse-Lautrec, Henri de
 Portrait of Frederick Wenz (57.41),
 197
Townsend-Goddard School
 dressing table (B.69.91), 140
Tribolo, Niccolò
 Day (44.584), 79
Tucker Porcelain Factory
 pitchers (B.71.53, B.80.1), 164

V

van der Hamen y Leon, Juan
 Still Life (61.78), 89
van der Weyden, Rogier
 Virgin and Child (44.535), 48
van Gogh, Vincent. *See* Gogh, Vincent
 van
van Orley, Barend, Follower of,
 Saint Matthew and *Saint Hugo*
 (58.19 a,b), 65
Vedder, Elihu
 Soul in Bondage (72.33), 200
Veneto, Bartolommeo
 Portrait of a Man (44.573), 71
Veracruz (Mexico)
 figure (65.154), 313
 frog yoke (65.164), 312
Veronese
 The Dead Christ with Angel and a
 Monk (79.254), 85
Vivarini, Antonio
 Madonna and Child (44.575), 44
Vuillard, Edouard
 The Promenade (53.9), 204

W

Wadsworth, Edward Alexander
 Enclosure (77.277), 224
Wang Li
 Two Mynahs (75.343), 5

Wedgwood
 vases (B.69.523.1,2), 151
Welliver, Neil
 Beaver Pond (78.160), 298
Weston, Edward
 Epilogue (78.62), 228
 Tina Modotti (78.61), 238
Whistler, James Abbott McNeill
 Black Lion Wharf (74.285), 174
White, Minor
 Road & Poplar Trees (76.313), 267
Winningham, Geoff
 Tag Team, Wrestling-Houston
 (78.258.1), 288
Winogrand, Garry
 untitled, 1964 (79.20), 279
Worcester Porcelain Factory
 serving bowls, pair (78.263.1,2), 141

Y

Yaul People (Papua New Guinea)
 figure (62.44), 346

Z

Zaganelli, Bernardino
 The Virgin and Child Enthroned with
 Sts. Michael, Catherine, Cecilia, and
 Jerome (78.1), 56
Zia
 jar (44.23, 46.19, 46.21), 330
Zia/Trios Polychrome
 jar (44.21), 330
Zuni
 bowl (44.148), 323
 bracelet (44.214), 332
 buffalo kachina (44.438), 334
 jar (44.98, 44.94, 44.96), 323
 shalako kachina (44.485), 334

Blessing
or Curse

You Can Choose

Books by Derek Prince

Biography
 Appointment in Jerusalem
 Pages from My Life's Book

Guides to the Life of Faith
 Baptism in the Holy Spirit
 Blessing or Curse: You Can Choose!
 Chords from David's Harp
 Does Your Tongue Need Healing?
 Extravagant Love
 Faith to Live By
 Fatherhood
 Fasting
 God Is a Matchmaker
 God's Medicine Bottle
 God's Plan for Your Money

 The Grace of Yielding
 The Holy Spirit in You
 How to Fast Successfully
 If You Want God's Best
 Life's Bitter Pool
 The Marriage Covenant
 *Objective for Living: To Do
 God's Will*
 Rejection: Cause and Cure
 *Shaping History through Prayer
 and Fasting*
 Spiritual Warfare

Systematic Bible Exposition
 Foundation Series (also available in one-volume hardback)
 VOLUME I *Book 1: Foundation for Faith*
 Book 2: Repent and Believe
 VOLUME II *Book 3: From Jordan to Pentecost*
 Book 4: Purposes of Pentecost
 VOLUME III *Book 5: Laying On of Hands*
 Book 6: Resurrection of the Dead
 Book 7: Eternal Judgment

 In Search of Truth
 The Last Word on the Middle East
 Self-Study Bible Course
 Christian Foundations Correspondence Course

Derek Prince

Blessing or Curse

You Can Choose

Chosen Books

A Division of Baker Book House Co
Grand Rapids, Michigan 49516

To protect the privacy of some of the individuals referred to, names of persons and places, and some other details, have in a few cases been changed.

Unless otherwise noted, Scripture quotations in this publication are from The New King James Version. Copyright © 1979, 1980, 1982 Thomas Nelson, Inc., Publishers. Other versions quoted are: the King James Version (KJV); the New American Standard Bible (NASB); the New International Version (NIV); The Living Bible (TLB).

Library of Congress Cataloging-in-Publication Data

Prince, Derek.
 Blessing or curse: you can choose / Derek Prince.
 p. cm.
 ISBN 0-8007-9166-5
 1. Success—Religious aspects—Christianity. 2. Blessing and cursing. 3. Blessing and cursing in the Bible. I. Title.
 BV4598.3.P73 1990
 248.4—dc20 90-38671
 CIP

A Chosen Book
Copyright © 1990 by Derek Prince
Chosen Books are published by Fleming H. Revell
a division of Baker Book House Company
P.O. Box 6287, Grand Rapids, MI 49516-6287

ISBN: 0-8007-9166-5

Fourteenth printing, April 1995

Printed in the United States of America

This day I call heaven and earth
as witnesses against you that I have
set before you life and death,
blessings and curses.
Now choose life, so that you and
your children may live. . . .

Deuteronomy 30:19, <small>NIV</small>

Contents

Foreword by Ruth Prince 9

Section 1: Blessings and Curses

 Introduction to Section 13
1 Wrestling with Shadows 15
2 Invisible Barriers 22
3 How Blessings and Curses Operate 31
4 Moses' List of Blessings and Curses 38
5 Seven Indications of a Curse 45

Section 2: No Curse without a Cause

 Introduction to Section 59
6 False Gods 61
7 Various Moral and Ethical Sins 75
8 Anti-Semitism 81
9 Legalism, Carnality, Apostasy 88
10 Theft, Perjury, Robbing God 99
11 Authority Figures 104
12 Self-Imposed Curses 121
13 Servants of Satan 135
14 Soulish Talk 146
15 Soulish Prayers 155
16 Summary of Section 2 166

Section 3: From Curse to Blessing

Introduction to Section 169
17 The Divine Exchange 171
18 Seven Steps to Release 185
19 From Shadows to Sunlight 198
20 Forceful Men Lay Hold of It 210
21 Beyond Confession: Proclamation,
 Thanksgiving, Praise 219
22 Proclamations for Continuing Victory 228

Important Afterwords

Introduction to Section 241
23 Curses Not Yet Revoked 243
24 To Bless or to Curse? 251

Background of the Author 262

Foreword

In 1978, shortly before our marriage, Derek and I were lying on the beach in Fort Lauderdale, Florida. I said to Derek, "Would you pray for my legs? They hurt *so* much." Immediately he knelt, placed his hands on the calves of my legs—and began to speak to them:

> "Thank you, legs. I want you to know I appreciate you. You have carried Ruth safely everywhere she needed to go—and now you have brought her to me. Thank you, legs!"

I thought that was an extraordinary way for a serious Bible teacher to pray for his fiancée! But the pain subsided.

Later Derek told me that he thought he had been "unsaying" something I might have said about my legs. I recalled a scene in the girls' room at my high school when I was fifteen

or sixteen. Another girl had come in and stood combing her hair. I looked at her shapely legs, and at my own heavy calves and ankles, and said, "I *hate* my legs!" In effect, I had placed a curse on my own legs!

Together Derek and I broke the curse I had pronounced on my own legs more than thirty years before. I thought that was the end of the story.

Nine years later I found myself being rushed by ambulance to the hospital in Jerusalem with thrombosis (blood clots) in both legs. A pulmonary embolism (blood clot that moved to the lungs) came near to taking my life. It seemed there was still a curse or curses on my legs—and perhaps on my very person.

Since then, now nearly three years, I have battled for my health—and my life. It was painfully obvious to both of us that supernatural forces were at work in my physical body. As we worked together on this book, we realized that every mark of a curse referred to in chapter 5 applied to me and/or my family. Releasing myself from the self-imposed curse had been only the *beginning* of the process. The Holy Spirit revealed ancestral curses, curses resulting from involvement in the occult, curses resulting from specific sins and much more.

Renouncing any and all curses has been a lengthy process, but the Holy Spirit has been wonderfully patient and thorough. Often He has given supernatural direction through words of knowledge and words of wisdom. We have enlisted the prayer support of thousands of Christians around the world. Our way of thinking about the power of Scripture—and about ourselves—has changed remarkably.

Many times I have asked God this question: "Why did You give Derek Prince a wife with so many physical problems, and so many curses over her life?" (Those who have read *God Is a Matchmaker* will recall that God specifically chose me to be

Derek's wife.) I have not received a direct answer to that question, but I am so grateful that God took me, *just as I was*, so He could receive the glory as He releases me and heals me.

Furthermore, Derek and I can affirm: We have proven the truths contained in this book in our own experience! My health is not yet perfect, but I know in reality that the blessing promised to Abraham is *mine*. As with Abraham, it has been a pilgrimage.

Our prayer is that *Blessing or Curse: You Can Choose!* will release you—and others whom you seek to help—into the full liberty that is your inheritance in Jesus Christ!

Ruth Prince

Section 1
Blessings and Curses

Introduction

It could be you and your family. Or the family next door. Or the person who works with you. Whoever it may be, his or her life is a history of disappointments, frustrations and even tragedies. Somehow the story never ends.

Conversely, we all know families who are similar in background and social position—and yet trouble never seems to touch them. They are almost "too good to be true."

In both cases, invisible forces are at work that determine each person's destiny, whether for better or for worse. The Bible identifies these respectively as *blessings* and *curses*. Furthermore, it shows us how to relate to these forces in such a way that we can enjoy the beneficial effects of the one and protect ourselves from the harmful effects of the other.

A scriptural understanding of both blessings and curses, and how they work, will give you a totally new perspective on your own life, and an answer to problems that have hitherto perplexed and frustrated you.

1
Wrestling with Shadows

To the superficial observer, human life presents a confused mingling of light and shadow, arranged according to no recognizable pattern, governed by no discernible laws. Across this scene two men may start out walking side by side. Similar in background and ability, they are headed in the same direction. Yet one walks almost always in the light of success and fulfillment. The other, close by him, scarcely sees the light. He is continually overshadowed by failure and frustration, and his life is snuffed out at an untimely age.

Neither of these men understands the forces at work in his life. The sources of light and shadow are hidden to them both. Probably they have never even considered the possibility that both light and shadow may have their source in previous generations.

The Bible speaks plainly about these forces. In fact, it has a great deal to say about them. It calls them respectively *blessings* and *curses*.

Let us look closer, for a moment, at the man under the shadows. He does all the right things: changes his job or place of residence; acquires further vocational skills; studies all the latest literature on positive thinking. Perhaps he even takes a course on how to release some mysterious "potential" within himself.

Yet success eludes him. His children are rebellious, his marriage under strain, accidents and illnesses routine. His cherished goals slip through his fingers like water through the fingers of a drowning man. He is "haunted" by a sense of inevitable failure, which he can perhaps postpone, but never overcome.

All his life he has the sense of struggling against something he cannot identify—something amorphous and elusive. He feels at times as if he is wrestling with a shadow. No matter how hard he struggles, he cannot pinpoint the cause of his problem or get a grip on it. Often he feels like giving up.

"What's the use?" he exclaims. "Nothing ever goes right for me! My father had the same problems. He was a failure, too!"

The person under the shadows could just as well be a woman, of course. She has married young and started out with all sorts of plans for a successful marriage and a happy home. She finds herself, however, on an invisible teeter-totter— "up" one day and "down" the next. Physically, she goes from one problem to another, always on the verge of health, but never quite achieving it. Her son begins to abuse drugs and then her husband leaves her. One day she wakes up to the shocking realization that she herself has become an alcoholic.

Like the man under the shadows, this woman, too, did all the right things. She studied books on nutrition and child psychology. In her pursuit of success, she goaded herself on from one effort to the next—each one demanding all the

strength that she could muster. Yet she watched other women, with less motivation or qualifications, achieve the goals she herself could never attain.

As you look closer at the person under the shadows, perhaps you see something that reminds you of yourself. You feel as if you are looking at your own life—but somehow from a point outside yourself. With a shock you begin to wonder if the cause of your problems could be the same: *a curse going back to preceding generations.*

Or again, it may not be yourself that you see, but someone close to you—a spouse or a family member or a dear friend. You have often agonized over this person and longed for some ray of hope, but always in vain. Now you are confronted with a possible explanation of the shadows, which is a new idea to you. Could the root of the problem really be a curse?

Your mind goes back to events and situations in your life or that of your family that never seemed to make sense. You tried many times to dismiss them from your thoughts, but never completely succeeded. You realize that you need to know more. *Suppose I am the one under a curse,* you may say to yourself. *What can I do? What could be its source?*

A curse could also be likened to a long, evil arm stretched out from the past. It rests upon you with a dark, oppressive force that inhibits the full expression of your personality. You never feel completely free to be yourself. You sense that you have potential within you that is never fully developed. You always expect more of yourself than you are able to achieve.

Or again, that long, evil arm may have the effect of tripping you up as you walk. Your way seems clear before you, but from time to time you stumble—yet you cannot see what it was you stumbled over. For some uncanny reason, the moments at which you stumble are those when you are within

reach of attaining some long-sought goal. Yet your goal eludes you.

Actually, the word *uncanny* could be likened to a red warning light. You experience events or situations for which you can find no natural or logical reason. It seems that there is some force at work that is not completely subject to the usual laws of nature or of averages.

There is one word that sums up the effects of a curse: *frustration*. You reach a certain level of achievement in your life and everything looks set for a bright future. You have all the obvious qualifications—and yet something goes wrong! So you start all over again, and reach the same level as before, but once again things go wrong. After this happens several times, you realize it is the pattern of your life. Yet you cannot see any obvious reason for it.

Many people have shared with me the story of a life that has a similar pattern. The individual details may differ, but the pattern is there. Often such people say something like, "The same thing always happened to my father. I feel as if I'm reliving his frustrations," or, "I can hear my grandfather saying again and again, 'Things never go right for me.'"

This pattern may occur in various areas of people's lives: business, career, health or finance. Nearly always it has some kind of negative effect on personal relationships—especially marriage and family. Frequently, too, it affects not just one isolated individual, but a larger social group. Most often this would be a family, but it can extend to a wider circle, such as a community or a nation.

It would be misleading, however, to suggest that a curse always causes a person to fail. A person may achieve what appears to be real success and yet be plagued by frustration, never enjoying the fruits of success.

On a ministry journey in Southeast Asia I met an intelli-

gent, well-educated female judge, who was descended from royalty. She knew Jesus personally as Savior and was not conscious of any unconfessed sin in her life. Yet she told me that she was not truly satisfied. Her successful career and her high social position had not brought her personal fulfillment.

As I talked with her, I discovered that she was descended from many generations of idol worshipers. I explained to her that, according to Exodus 20:3–5, God had pronounced a curse on idol worshipers down to the third and fourth generations. Then I showed her how to receive release from this curse through Jesus her Savior.

Sometimes curses may not have their origin in previous generations. They may be the result of deeds or events in your own lifetime. Or it may be that a curse from previous generations has been compounded by things you yourself have done. Whatever the source of your problem, however, one thing is certain: You are struggling with something that you can neither identify nor understand.

Like that judge, you, too, may have tasted success. You do indeed know the sweetness of it—but it never lasts! Suddenly, for no reason you can explain, you are dissatisfied. Depression settles over you like a cloud. All your achievements seem so insubstantial.

You look at others who appear content in similar circumstances, and you ask yourself, *What's wrong with me? Why don't I ever experience real fulfillment?*

Perhaps at this point your reaction is something like this: *Some of these descriptions really fit me. Does that mean there is no hope for me? Do I have to go on like this for the rest of my life?*

No, there is hope for you! Do not be discouraged. As you read on, you will discover that God has provided a remedy,

and you will be given simple, practical instructions on how to apply the remedy in your own life.

Meanwhile, you will find encouragement in the following letters I received from two people who listened to my radio Bible teaching program on the theme "From Curse to Blessing." The first letter is from a man and the second from a woman.

> I listened to your messages on the curse and I found out that I had been under one for years and never knew it. I was never able to be successful in life, and constantly suffered from feelings of homosexuality, though I never fueled the feelings into action. I have been a Christian for 10 years now but because of the curse was never able to get as close to God as I wanted to. I became very depressed.
>
> Since I have been freed from this curse I have felt so free in Jesus and alive in Him. I have never felt so close to God!

<center>* * *</center>

> Thank you for your recent broadcasts on curses and your booklet "From Curse to Blessing." My life has been greatly changed by them.
>
> For most of my life I have been troubled by recurring depression, and altogether for five years I have been under the care of a psychiatrist.
>
> This spring a lady prayed with me and for me and I renounced all involvement with the occult, such as tarot cards and tea leaves. Praise the Lord, the beginning of real freedom!
>
> Then I heard your broadcasts on being under a curse without really knowing it and prayed with you as you

prayed the prayer of release from curses. Now I am free!

It is as if a dam has broken and God can move in my spirit. The blockage is gone and I have grown so much spiritually in a few weeks that I can only praise Him for His blessing. Sometimes I weep when I think about all He has done and is doing for me, and it is such a relief to be able to relax.

Truly, we worship a wonderful God!

2
Invisible Barriers

In previous years I spent much time counseling people like those described in the previous chapters. But it was often a frustrating task. Certain people would progress spiritually up to a point, and then they seemed to encounter an invisible barrier. It was not that they lacked sincerity or dedication. In fact, they often seemed more sincere and dedicated than others who made better progress. They would accept the counsel I gave them and try to put it into practice, but the results were—to say the least—disappointing, both for them and for me.

After dealing with such a case, I would find myself praying, "Lord, why is it that I cannot better help this person? Is there something I don't understand—something more that I need to know?" After a while, I realized that God was answering my prayer. He began to draw aside a veil and to reveal a world of powerful forces that do not operate according to natural laws.

The revelation did not come all at once, but step by step as I discerned a single thread running through a series of apparently unconnected incidents.

One key incident occurred when I was a guest speaker in a Presbyterian church. I had come to the end of my prepared message, and was uncertain how to proceed. As I remained standing behind the pulpit, I noticed a family—father, mother and teenage daughter—on the front row to my left. The thought came to me, *There is a curse over that family*. This was not related to the theme of my message, or to anything I had in mind at that time. Yet the impression would not leave me: *There is a curse over that family.*

Finally, after some moments of hesitation, I stepped out from behind the pulpit and went over to the father. I explained to him what I was feeling and asked if he would like me to revoke the curse and release the family from it in the name of Jesus. He replied immediately that he would. It was the first time I had ever done anything like this, and I was quite surprised that the man so readily accepted my statement. Only later did I come to understand why.

I stepped back behind the pulpit and said a brief prayer out loud, breaking the curse over the family. I was not touching any member of the family as I prayed, but when I concluded with the words *In the name of Jesus*, there was a distinct, visible, physical reaction in the whole family. A momentary shudder seemed to pass through each of them in turn.

At this point I noticed that the girl, who was about eighteen years old, had her left leg in a cast from above the thigh to the bottom of her foot. I went over to the father again and asked if he would like me to pray for his daughter's leg to be healed. Again he responded very positively, then added, "But you need to know that she has broken the same leg three times in eighteen months, and the doctors say it will not heal."

Today, such a statement—that a person had broken the same leg three times in eighteen months—would set off an alarm bell inside me warning that a curse was at work. At the time, however, I did not see any connection between a curse and such an unnatural series of accidents. I merely picked up the leg in its cast, held it in my hands and prayed a simple prayer for healing.

Some weeks later I received a letter from the father, thanking me for what had happened. He said that when they took their daughter back to the clinic, a new X-ray showed that her leg had healed. Shortly afterward the cast was removed.

He also mentioned briefly a series of strange, unhappy incidents that had affected the life of his family, and this explained his readiness to acknowledge the need for the whole family to be released from a curse.

In the months that followed, my mind kept returning to this incident. I felt that there was something significant about the order in which the Holy Spirit had led me. First, He had revealed the curse over the family and had prompted me to revoke it. Only then had He released me to pray for the healing of the daughter's leg. If I had prayed for healing without first revoking the curse, would the leg have been healed?

The more I pondered this, the more I was convinced that the revoking of the curse was an essential prelude to the healing of the girl's leg. It was an invisible barrier that would have prevented the healing God wanted her to receive.

All this seemed to tie in somehow with an incident in my own life. In 1904 my maternal grandfather had commanded a British expeditionary force sent to suppress the Boxer Rebellion in China. He had returned with various specimens of Chinese art, which became family heirlooms. In 1970, at the

death of my mother, some of them passed by inheritance
to me.

One of the most interesting items was a set of four exquis-
itely embroidered dragons, which found a place of honor on
the walls of our living room. Their blend of colors—mainly
purple and scarlet—was typically Oriental. They had five
claws on each foot, which—an expert informed me—indicated
they were "imperial" dragons. And, because my grandfather
had been very close to me, they brought back memories of my
early years in their home.

About this time, I began to sense some kind of opposition
to the success of my ministry that I could not define or iden-
tify. It manifested itself in various kinds of frustrations, ap-
parently unrelated, but which produced a cumulative pressure
against me. I encountered barriers of communication that had
never been there before with people close to me. Others on
whom I had been relying failed to keep their commitments. A
substantial legacy from my mother's estate was delayed inter-
minably by a lawyer's inefficiency.

Eventually I set aside a period for intensive prayer and
fasting. Quite soon, I began to notice a change in my attitude
toward the dragons. From time to time, as I looked at them,
a question would form in my mind: Who in the Bible is rep-
resented as a dragon? I had no doubt about the answer: Satan.[1]

This question would be followed by another: Is it appro-
priate for you, as a servant of Christ, to display in your home
objects that typify Christ's great adversary, Satan? Again, the
answer was clear: No! My inner struggle continued for a while,
but finally I got rid of the dragons. I did this as a simple act of
obedience, without any ulterior motive.

At that period I was serving as a Bible teacher to the Church
at large, speaking to groups of various kinds throughout the

[1] See Revelation 12:1–12.

United States. My income, which came from the honoraria I received, was just sufficient to cover the basic needs of my family. Shortly after I got rid of the dragons, however, my financial position underwent a dramatic improvement. Without any special planning on my part, or any significant change in the nature or scope of my ministry, my income more than doubled. Also my long-delayed legacy finally came through.

I began to wonder if there was some undiscovered principle that linked this unexpected improvement in my personal finances with the healing of the girl with the broken leg. In the case of the girl, a curse over her family had been an invisible barrier to healing. When the barrier had been removed, healing had followed. In my case, too, perhaps there had been an invisible barrier—not to physical healing, but to the financial prosperity that proved to be an important element in God's plan for my life.

The more I pondered this, the more certain I became that those embroidered dragons had brought a curse into my house. By disposing of them, I had released myself from the curse and opened myself up to the blessing God had planned for me.

These changes enabled me to buy a home, which was to play a decisive part in the subsequent extension of my ministry. Nine years later, I sold that house for more than three times as much as I had paid for it! This money came exactly at a time when God was challenging me to major new financial commitments.

That experience with the dragons gave me new insight into the passage in Deuteronomy 7:25–26 where Moses warned Israel against any association with the idolatrous nations of Canaan:

> "You shall burn the carved images of their gods with
> fire; you shall not covet the silver or gold that is on them,

nor take it for yourselves, lest you be snared by it; for it is an abomination to the Lord your God.

"Nor shall you bring an abomination into your house, lest you be doomed to destruction like it; but you shall utterly detest it and utterly abhor it, for it is an accursed thing."

My embroidered dragons were not carved images, but they certainly were images of a false god who had been worshiped for millennia in China. By bringing them into my home, I had unknowingly exposed myself—and my family with me—to a curse. How grateful I was to the Holy Spirit for opening my eyes to what was at stake!

This led me to make a systematic study of the Bible's teaching on both blessings and curses. I was surprised by how much the Bible has to say about them. Words for *bless* or *blessing* occur about 410 times—excluding instances where the word in the original text merely has the meaning of "happy" or "fortunate" (as, for instance, in the Beatitudes). The word *curse*, in various forms, occurs about 230 times. This caused me to reflect how little teaching I had ever heard on this theme in all the years of my Christian experience. In fact, I could not recall hearing even one message that dealt systematically with this whole subject.

As a result of my study, I began to teach about curses in my public ministry. Each time I did this, I was surprised both by the powerful impact this teaching produced and by the number of people who obviously needed to hear it. Tapes from some of these meetings were circulated to other groups, and astonishing reports came back to me. Often it seemed that the message had transformed not merely the lives of individuals, but even whole congregations. Eventually I released three cassettes entitled "Curses: Cause and Cure."

Subsequently, on a trip to South Africa, I met a Jewish lady who had come to acknowledge Jesus as her Messiah. This lady—whom I will call Miriam—personally described to my wife, Ruth, and me the miracle she had experienced through listening to those three tapes.

Miriam had been working as executive secretary for a businessman who was president of his own company. She had discovered that her employer and all the executives in the company were in some strange cult that was led by a female "guru."

One day Miriam's employer handed her a cassette and said, "Here are some blessings that our guru has pronounced over us. Please type them." As she began to type, Miriam realized that the "blessings" were actually fortune-telling, with strong occult overtones. She explained to her employer that such things were contrary to her faith in the Lord Jesus and the Bible, and asked to be excused. Her employer was gracious and apologized for having asked her to do something against her conscience.

Almost immediately after this, Miriam began to develop acute pain in both hands. Her fingers curled up and became absolutely rigid. She was no longer able to carry out her tasks as a secretary. The pain was so intense that she could not sleep in the same bed as her husband, because every time he turned over, the movement of the bed caused unbearable agony in her fingers. X-ray diagnosis revealed that her problem was rheumatoid arthritis.

A Christian friend of Miriam's heard of her distress and brought her my tapes on "Curses" to listen to. Miriam was a rather sophisticated lady, skeptical about such things as curses, which she associated with the Middle Ages. She had wondered, however, if there was any connection between her refusal to type the "blessings" and the subsequent problem

with her hands. Could it be that the guru had pronounced a curse on her? So she consented to listen, feeling like the proverbial drowning man "clutching at a straw."

When they reached the point in the third tape where I led people in a prayer of release from any curse over their lives, the cassette jammed. It would not go forward or backward, neither would it eject!

"Obviously, then, I can't pray the prayer!" Miriam responded.

Miriam's friend had previously typed out the concluding prayer of release, however, and had a copy with her. She insisted that Miriam read the prayer out loud. Once again Miriam's skepticism asserted itself. She could not see how reading words from a typed sheet could have any effect on the condition of her hands.

Eventually, however, Miriam yielded to her friend's insistence, and began to read the prayer out loud. As she did so, her fingers uncurled and became free. The pain ceased, and by the time she had finished reading the prayer, she was completely healed. The whole experience had lasted only a few minutes.

Later Miriam returned to her doctor, who had taken the first X-rays. A second set of X-rays revealed no trace of arthritis.

One feature of this incident is particularly significant. The prayer of release that Miriam read *made no reference to physical healing.* Her hands were healed solely as a result of praying for release from a curse.

Here was further, dramatic evidence that a curse can be a barrier to keep people from receiving healing. The same had been true of the girl with the broken leg. In my own case, on the other hand, an unsuspected curse had been keeping me from the level of prosperity that God had intended for me.

If a curse could be a barrier to blessings such as healing or prosperity, was it not possible—or even probable—that many other kinds of blessing were likewise being withheld for the same reason? It was on this basis that I set myself to seek the answers to three related questions:

> First, how can we recognize that a curse is operating in our lives?

> Second, what must we do to revoke a curse and release ourselves from its consequences?

> Third, how can we enter into the blessing of God?

The results of my search are presented in the following pages.

3
How Blessings and Curses Operate

The forces that determine history fall into two categories: visible and invisible. It is the interplay of these two realms that determines the course of history. As long as we confine our attention to things that are visible and material, we will find ourselves confronted from time to time by events and situations that we cannot fully explain or control.

To the visible realm belong all the normal objects and events of the material universe. We are all familiar with this realm and feel at home in it, even though events often do not follow the course we would wish. For many people, the limits of their awareness do not extend further. Yet the Bible opens a door to another, invisible realm, which is not material, but spiritual. The forces at work in this realm exercise a continuous and decisive influence on events in the visible realm.

In 2 Corinthians 4:17–18 Paul delineates these two realms:

For our light affliction, which is but for a moment, is
working for us a far more exceeding and eternal weight
of glory,
 while we do not look at the things which are seen, but
at the things which are not seen. For the things which
are seen are temporary, but the things which are not seen
are eternal.

The things that belong to the visible realm are transitory
and impermanent. It is only in the invisible realm that we can
find true and abiding reality. It is in this realm, too, that we
discover the forces that will ultimately shape our destiny,
even in the visible realm. Paul makes it clear that success in
life depends upon being able to apprehend and relate to that
which is invisible and spiritual.

Both blessings and curses belong to the invisible, spiritual
realm. They are vehicles of supernatural, spiritual power.
Blessings produce good and beneficial results; curses produce
bad and harmful results. Both are major themes of Scripture.
As already pointed out, the two words are mentioned in the
Bible more than 640 times.

Two important features are common to both. First, their
effect is seldom limited to the individual. It may extend to
families, tribes, communities or whole nations. Second, once
they are released, they tend to continue from generation to
generation until something happens to cancel their effects. A
number of both blessings and curses mentioned in the Bible
in connection with the patriarchs have continued to work for
nearly four thousand years and are still at work today.

This second feature of blessings and curses has important
practical implications. There may be forces at work in our
lives that have their origin in previous generations. Conse-
quently, we may be confronted with recurrent situations or
patterns of behavior that cannot be explained solely in terms

of what has happened in our lifetimes or personal experiences. The root cause may go back a long way in time, even thousands of years.

The main vehicle of both blessings and curses is *words*. Such words may be spoken or written or merely uttered inwardly. Scripture has much to say about the power of words. The book of Proverbs, in particular, contains many warnings as to how words may be used either for good or for evil. Here are just a few examples:

> The hypocrite with his mouth destroys his neighbor,
> But through knowledge the righteous will be delivered.
> > Proverbs 11:9

> There is one who speaks like the piercings of a sword,
> But the tongue of the wise promotes health.
> > Proverbs 12:18

> A wholesome tongue is a tree of life,
> But perverseness in it breaks the spirit.
> > Proverbs 15:4

> Death and life are in the power of the tongue,
> And those who love it will eat its fruit.
> > Proverbs 18:21

The apostle James also has much to say about the use of words. He points out that the tongue is a small member of the body, but the hardest of all to control:

> Even so the tongue is a little member and boasts great things. See how great a forest a little fire kindles!
> And the tongue is a fire, a world of iniquity. The tongue is so set among our members that it defiles the whole body, and sets on fire the course of nature; and it is set on fire by hell.
> With it we bless our God and Father, and with it we

curse men, who have been made in the similitude
[likeness] of God.

Out of the same mouth proceed blessing and cursing.
My brethren, these things ought not to be so.

James 3:5–6, 9–10

James uses vivid imagery to emphasize the tremendous
power that words have to affect people and situations, either
for good or for evil. It is significant that he singles out both
blessings and curses as words that can be charged with this
kind of almost measureless power.

Words are not, however, the only channels through which
the spiritual power of blessings and curses may be transmit-
ted. There are various ways in which, at times, physical ob-
jects may become vehicles for this kind of power.

In Exodus 30:22–33 the Lord gave instructions to Moses for
making a special anointing oil, which was to be used solely
and exclusively for anointing the Tabernacle and its furniture,
and also the priests who were to minister in the Tabernacle.
In Leviticus 8:1–12 we read how this oil was applied. In
verses 10–12 the account concludes:

> Then Moses took the anointing oil, and anointed the
> tabernacle and all that was in it, and sanctified them.
>
> He sprinkled some of it on the altar seven times,
> anointed the altar and all its utensils, and the laver and
> its base, to sanctify them.
>
> And he poured some of the anointing oil on Aaron's
> head and anointed him, to sanctify him.

The word *sanctify* in this passage means "to set apart to
God, make holy." Thus the anointing oil became a vehicle to
impart the blessing of holiness both to the Tabernacle and its
furniture and to the priests who ministered in it.

Later in Israel's history, olive oil was used to impart appro-

priate blessing to the kings who were to rule the people on God's behalf. First Samuel 16:13 records how the prophet Samuel set David apart as God's chosen king:

> Then Samuel took the horn of oil and anointed him in the midst of his brothers; and the Spirit of the Lord came upon David from that day forward.

The oil poured on David's head by Samuel became a vehicle through which the blessing of the Holy Spirit was released in his life to equip him for his task as king.

In the New Testament, the emblems used in the Lord's Supper likewise become vehicles of God's blessing to those who partake of them. In 1 Corinthians 10:16 Paul says:

> The cup of blessing which we bless, is it not the communion of the blood of Christ? The bread which we break, is it not the communion of the body of Christ?

For those who partake with scriptural faith, these emblems transmit the blessing of God. Paul speaks specifically of "the cup of blessing"—that is, the cup that transmits the blessings of the new covenant to those who drink from it.

It must be emphasized, however, that in all the ordinances described above there is no room for "magic." The blessings are not inherent in the physical objects as such. They are imparted only to those who apprehend the will of God as revealed in Scripture, and who then by personal faith and obedience receive what is offered to them through the physical objects. Without faith and obedience, no blessing results.

On the contrary, in 1 Corinthians 11:29, Paul says concerning the emblems of the Lord's Supper: "He who eats and drinks in an unworthy manner eats and drinks judgment to himself." Such, then, are the alternatives. Faith and obedi-

ence receive God's blessing through the emblems; unbelief
and disobedience provoke God's judgment. In both cases
alike, it is the physical objects used in the Lord's Supper
through which the spiritual power is transmitted, whether it
be for blessing or for judgment.

Numbers 5:11–31 describes an ordinance used to deter-
mine whether a man's wife has been unfaithful to him or not.
The appropriate prayers and sacrifices are required, but the
focus of the ordinance is on a cup of water, into which the
priest mixes dust from the floor of the Tabernacle and ink,
which he scrapes from a written curse. The woman is then
required to drink the water.

If she is guilty, the outworking of the written curse will be
manifested in her physical body: "Her belly will swell, her
thigh will rot, and the woman will become a curse among her
people." That will be the punishment for her sin. In this case,
the cup of water is the vehicle through which the curse is
transmitted.

If the woman is innocent, on the other hand, she will not
experience any harmful effects. In this way, God will have
vindicated her righteousness, and her husband will not be free
to bring any further accusation against her. Her innocence will
have protected her from the curse.

The various instances given above establish one important
scriptural truth: In certain circumstances, both blessings and
curses can be transmitted through physical objects. On the
other side, if we turn our attention from biblical practices to
all the various forms of false religion and the occult, there is
virtually no limit to the ways in which physical objects can
become vehicles of curses.

In Exodus 20:4–5, in the second of the Ten Command-
ments, God explicitly forbids the making of any kind of idol
or image for religious purposes, and He warns that those who

break this commandment will bring judgment not only on themselves, but also on at least three following generations:

> "You shall not make for yourself any carved image, or any likeness of anything that is in heaven above, or that is in the earth beneath, or that is in the water under the earth;
>
> you shall not bow down to them nor serve them. For I, the Lord your God, am a jealous God, visiting the iniquity of the fathers on the children to the third and fourth generations of those who hate Me."

A wide range of objects comes under this ban. In my own case, which I have already described, the embroidered Chinese dragons exposed me to the invisible influence of a curse. It was true that I had no intention of worshiping them. Nevertheless, they represented something that had been an object of idolatrous worship for many centuries. They opened a channel into my home for the evil power of pagan worship that had been practiced for millennia.

Looking back later, I noticed one particular effect that those dragons had on me. Not merely were they a barrier that kept me from moving forward into the blessing of prosperity. They even kept me from seeing that the blessing was actually there. Only after I was free from their influence could I discern by faith what God had prepared for me.

Since that time, I have observed the same effect in the lives of many people under a curse. The curse not only keeps them from receiving the blessing God is offering to them. It also keeps them from realizing that the blessing is there to receive. Only when the Holy Spirit shines the light of Scripture into our lives do we begin to understand how the devil has been deceiving and cheating us.

4
Moses' List
of Blessings
and Curses

Some people are happy to accept the fact that blessings are valid, but are skeptical about curses, which they associate with superstitious practices from the Dark Ages. Such thinking is unrealistic. We cannot focus exclusively on one aspect of opposites because it is acceptable to us, and simply ignore the other because it is unacceptable. The opposite of hot is cold; both are real. The opposite of good is evil; both are real. In just the same way, blessings are real and so are curses.

My ministry brings me in touch with Christians from many different backgrounds in many different lands. I find that most of God's people do not know how to discern between blessings and curses. Many Christians who should be enjoying blessings are actually enduring curses. There are two main reasons for this: First, they simply do not know how to recognize what a blessing or a curse is, or how to discern them; second, if they are under a curse, they do not understand the basis upon which they can be released.

God is the sole and supreme source of all blessings, although they may come to us through many channels. Curses, too, often proceed from God, but He is not the sole source. Later on, we shall deal with other sources of curses.

The curses that proceed from God are one of His main ways of bringing judgment on the rebellious, the unbelieving and the ungodly. The history of the human race provides a long, sad record of the outworking of God's curses pronounced upon such people.

Over the years it has become fashionable to suggest that there is a dichotomy between the Old Testament and the New. According to this interpretation, the Old Testament depicts God as a God of wrath and judgment; the New depicts Him as a God of love and mercy. In fact, however, the two Testaments are consistent with each other. Each depicts God as being, at one and the same time, a God of mercy and of judgment.

The story of Jericho, related in Joshua 6, combines these two sides of God's dealings as vividly and dramatically as any passage in the New Testament. While the city of Jericho perished under one single, comprehensive judgment of God, the harlot Rahab, with her entire family, emerged unscathed. The record indicates, furthermore, that later Rahab became the wife of Salmon, one of the princes of Judah, and took her place in the genealogical line from which Israel's Messiah, Jesus, was to come! (See Matthew 1:5.)

In Romans 1:17–18 Paul explains that the Gospel contains the supreme revelation of these two aspects of God, His mercy and His judgment:

> For in it [the Gospel] the righteousness of God is revealed from faith to faith. . . .
> For the wrath of God is revealed from heaven against all ungodliness and unrighteousness of men.

On the one hand, God's mercy offers His righteousness, which He imparts to those who receive by faith the substitutionary sacrifice of Jesus on their behalf. Yet, at the same time, this sacrifice is also the ultimate revelation of God's wrath, poured out upon Jesus when He became identified with man's sin. Christians who question the reality of God's judgment on sin should ponder afresh the significance of the crucifixion. Even Jesus could not make sin acceptable to God, but had to endure the full outpouring of His wrath.

Further on, in Romans 11:22, Paul again presents these two aspects of God's dealings side by side: "Therefore consider the goodness [or kindness] and severity of God." To obtain an accurate picture of God, we must always keep both aspects of His character before us. His blessings proceed out of His kindness, but His judgments proceed out of His severity. Both are equally real.

In Proverbs 26:2 Solomon makes it clear that there is always a reason for every curse:

> Like a flitting sparrow, like a flying swallow,
> So a curse without cause shall not alight.

This principle has a double application. On the one hand, a curse cannot take effect unless there is a cause for it. On the other hand, the converse is also true. Wherever there is a curse at work, there is a cause for it. In seeking to help people obtain release from a curse, I have learned by experience that it is often helpful first to discover the cause.

The 68 verses of Deuteronomy 28, which are devoted solely to the theme of blessings and curses, reveal the primary cause of each. In verses 1 and 2 Moses deals first with the cause of blessings: "If you diligently obey the voice of the Lord your God, to observe carefully all His commandments . . . all these

blessings shall come upon you and overtake you, because you obey the voice of the Lord your God."

More literally, the first part could be translated: "If you will listen listening to the voice of the Lord your God. . . ." The repetition of the verb *to listen* gives added emphasis. Simply stated, the conditions for enjoying the blessings are: first, listening to God's voice; second, doing what He says.

Throughout all dispensations, these have been the unchanging requirements for living in a covenant relationship with God. In Exodus 19:5, when God prepared to enter into His first covenant with Israel at Sinai, He said: "Now therefore, if you will indeed obey My voice and keep My covenant, then you shall be a special treasure to Me above all people." The basic requirements were to listen to God's voice and obey the terms of His covenant.

Under the new covenant, in John 10:27, Jesus similarly described those whom He acknowledged as "His sheep"— that is, His true disciples: "My sheep hear My voice . . . and they follow Me." The basic requirements are still the same: hearing the Lord's voice and following Him in obedience.

Hearing the Lord's voice takes us beyond mere religious profession or formal observances. Nothing is more unique and distinctive than a person's voice. Hearing the Lord's voice implies an intimate relationship with Him in which He can speak to each one of us *personally*.

The Lord does not speak in this way to our physical ears or to our natural minds. His communication is Spirit-to-spirit— that is, by His Spirit to our spirit. Projected in this way, His voice penetrates to the innermost depths of our being. From there its vibrations are felt in every area of personality.

The Lord may speak in this way through the Bible, or He may impart a word of direct revelation. Merely reading the Bible, however, is not sufficient by itself, unless the words on

its pages are transformed by the Holy Spirit into a living voice. It is only a relationship of this kind with God that truly qualifies us for the blessings He has promised to those *who hear and obey His voice.*

Further on, in Deuteronomy 28:15, Moses states the primary cause of all curses:

> "But it shall come to pass, if you do not obey the voice of the Lord your God, to observe carefully all His commandments and His statutes which I command you today, that all these curses will come upon you and overtake you."

The cause of curses is exactly opposite to that of blessings. Blessings result from hearing God's voice and doing what He says. Curses result from *not* hearing God's voice and *not* doing what He says. This refusal to hear and obey God's voice can be summed up in one word: *rebellion*—not against man, but against God.

In Deuteronomy 28 Moses also gives comprehensive lists of the various forms that both blessings and curses take. The blessings are listed in verses 3 through 13, the curses in verses 16 through 68. Anyone who seeks to understand this whole subject should study this chapter carefully in its entirety.

Out of my own studies, I have attempted to make two lists that sum up the blessings and the curses in the order in which they are mentioned. My suggested list of blessings is as follows:

Exaltation	Prosperity
Health	Victory
Reproductiveness	God's favor

Reproductiveness is not a common English word, but it is intended to describe a condition in which every area of a person's life is fruitful and reproductive. This would include family, livestock, crops, business and the exercise of creative talents. All these should reflect God's blessing in appropriate ways.

In his list of curses in verses 16 through 68, Moses goes into much greater detail than with the blessings. Essentially, however, the curses are the opposite of the blessings. Here is my suggested summary:

Humiliation
Barrenness, unfruitfulness
Mental and physical sickness
Family breakdown
Poverty
Defeat
Oppression
Failure
God's disfavor

Earlier, in verse 13, Moses concludes his list of blessings with two vivid verbal pictures. Each of us would do well to consider how these pictures might apply in our own lives.

First, Moses says: "The Lord will make you the head and not the tail. . . ." I once asked the Lord to show me how this would apply in my life. I felt He gave me this answer: The head makes the decisions and the tail just gets dragged around.

It was left to me to decide which role I was playing. Was I acting like a head, in control of each situation, making the appropriate decisions and seeing them successfully carried out? Or was I merely playing the part of a tail, being dragged

around by forces and circumstances I did not understand and could not control?

To drive his meaning home, Moses uses a second phrase: "You shall be above only, and not be beneath." This might be illustrated by a meeting between two Christian acquaintances.

"How are you doing?" the first asks.

"Under the circumstances," the second replies, "I'm not doing badly."

"I'm glad for that," the first one responds. "But whatever are you doing under the circumstances?"

These illustrations of Moses confront us with an opportunity for self-evaluation. Am I living like a head or a tail? Am I living under my circumstances, or above them? The answers we give will help us to see how much of God's blessing we are actually enjoying.

5
Seven Indications of a Curse

Through personal observation and experience, I compiled the following list of seven problems indicating that a curse is at work. When I compared my list with that of Moses in Deuteronomy 28, I was impressed by the close correspondence between them.

1. Mental and/or emotional breakdown
2. Repeated or chronic sicknesses (especially if hereditary)
3. Barrenness, a tendency to miscarry or related female problems
4. Breakdown of marriage and family alienation
5. Continuing financial insufficiency
6. Being "accident-prone"
7. A history of suicides and unnatural or untimely deaths

The presence of only one or two of these problems would not necessarily be sufficient, by itself, to establish conclu-

sively the working of a curse. But when several of the problems are present, or when any one of them tends to recur repeatedly, the probability of a curse increases proportionately. In the last resort, however, it is only the Holy Spirit who can provide an absolutely accurate "diagnosis."

1. *Mental and/or emotional breakdown*

The corresponding phrases from Deuteronomy 28 are: *madness, driven mad* (28, 34);[1] *confusion of heart* or *confusion of mind* (20, 28); *a trembling heart* or *an anxious mind* (65); *anguish of soul* or *a despairing heart* (65).

The areas affected are described as the heart, the soul or the mind. In other words, the inner citadel of human personality has been breached by invading, hostile forces. Such people no longer have full control over their own thoughts and emotions and reactions. They may be "haunted" by an inner specter continually taunting them: "You're losing control. . . . There's no hope for you. . . . Your mother ended up in a mental institution, and you'll be next!"

I have been amazed to discover how many Christians are going through these inner struggles. Often they are reluctant to acknowledge their problem to others—or even to themselves—for fear that this would be a denial of their faith.

Two key words are *confusion* and *depression*. These almost invariably have their roots in some form of occult involvement. Often there is demonic activity. In most cases, however, it is necessary to deal with the occult involvement and to revoke the resulting curse, before the demons can be driven out.

[1] The numbers in parentheses indicate verses in Deuteronomy 28 that speak of similar conditions. In some cases, the words used in the NIV are included beside those of the NKJ Version.

2. *Repeated or chronic sicknesses (especially if hereditary)*

The corresponding phrases from Deuteronomy 28 are numerous: *plague* or *plagued with diseases* (21); *consumption* or *wasting disease* (22); *severe burning fever* (22); *inflammation* (22); *incurable boils* (27, 35); *tumors* (27); *scabs* or *festering sores* (27); *incurable itch* (27); *blindness* (28); *extraordinary, fearful, prolonged plagues* (59); *serious and prolonged sicknesses* or *severe and lingering diseases* (59); *every other kind of sickness and plague* (61).

This list does not necessarily indicate that every form of sickness or disease is the direct result of a curse. There are, however, certain key words that occur: *plague, incurable, extraordinary, fearful, prolonged, lingering*. These serve as warning signals. They create what might be called "the atmosphere of a curse." They suggest evil, malevolent forces at work.

There is another common medical term that is not explicitly used in Deuteronomy 28, but has a similar connotation. It is *malignant* or *malignancy*. The primary definition of *malignant* in *Collins English Dictionary* is "having or showing desire to harm others." Obviously this describes a person, rather than a mere physical condition. Even more than the words in the previous paragraph, it suggests an evil, malevolent intelligence at work. Our use of such a term indicates an unconscious recognition that we are dealing with factors that are not purely physical.

Another very significant term used in reference to certain types of sickness is *hereditary*. It describes a condition that passes down from generation to generation. This is one of the commonest and most typical marks of a curse at work. For this reason, whenever I am asked to pray for someone who has a hereditary physical problem, I am always open to the possibility that I am confronting the effects of a curse.

At about the age of sixty, a friend of mine, who is a pastor,

developed a condition diagnosed as hemochromatosis, a disease that causes the patient to produce too much iron in the blood, especially storing it in the vital organs, namely the liver and heart. His father had died of the same disease at age 67. The doctor pronounced it hereditary, incurable and life-threatening. Every week he had to have phlebotomy (old-fashioned blood-letting).

After much prayer, especially by one of the prayer groups, my friend stood before his congregation in a Sunday morning service and made a simple, unemotional affirmation: "In the name of Jesus, I release myself from every evil inheritance from my father."

He was immediately and completely cured. Five years have passed since then. He has received no further treatment and there has been no recurrence of his problem.

In the foregoing comments, I have deliberately refrained from suggesting that any specific sickness is always, or necessarily, attributable to a curse. In many of the sicknesses mentioned, it would be highly probable that a curse is at work, but, without further evidence, it would be wrong to assert that this is necessarily so. There is only one "expert" whose diagnosis is final, and that is the Holy Spirit. We always need to be conscious of our dependence on Him.

3. *Barrenness, a tendency to miscarry or related female problems*

The key phrase here from Deuteronomy 28 is: "Cursed shall be the fruit of your body" or your womb (18). This curse may affect any of the various organs or functions involved in procreation. Ruth and I have ministered to hundreds of women whose infirmities came under the heading of "female problems." These included: inability to conceive; a tendency to

miscarry; failure to menstruate; irregular menstruation; debilitating menstrual cramps; frigidity; cysts, tumors or other growths or structural defects affecting any of the various organs connected with the reproductive process. Quite often this kind of curse affects whole families, with the result that all, or almost all, the females in a family may be afflicted with problems of this kind.

Ruth and I make it a principle not to minister to such people without first instructing them on the nature and causes of curses, and then praying with them for release. In many cases this has produced healing and wholeness in the affected areas or functions. Sometimes it proves sufficient merely to revoke the curse, without any specific prayer for healing.

The following letter illustrates the results that can follow when the curse of barrenness is revoked.

My husband and I had been married for twelve years and had not been able to have children. Medical tests revealed that there was nothing physically wrong with us.

On July 7, 1985, we attended a meeting in Amsterdam at which you were speaking. You taught on healing, and also reasons why people are not healed. As you began speaking on curses over families, the Lord spoke to my heart that this was a problem in my family. As you led everyone in a prayer for deliverance from any curse over their lives, I felt a definite sense of release from bondage.

When I came to the platform, you asked me to fetch my husband for prayer also. Then as you prayed for us, you pronounced that the curse over my life had been broken, and as Ruth laid hands on my womb, she spoke that I would be "neither barren nor unfruitful." The whole congregation was asked to stand and join in prayer for us. Following that meeting, my husband and I both felt strongly that the Lord had heard our prayers.

About two and a half years later, in another public meeting
in England, this couple came up to show us the beautiful baby
boy who was the manifestation of the blessing that had re-
placed the curse of barrenness over their lives.

The connection between menstrual problems and a curse is
brought out in another letter, dated December 22, 1987, from
a Christian lady in her thirties serving the Lord in Southeast
Asia:

> In 1985 I borrowed a set of tapes that had been re-
> corded in Singapore, among which was the message by
> Derek Prince on "Blessings and Cursings." After listen-
> ing to this message one night in my room I stood in the
> darkness to say the prayer on the end of the tape even
> though I was not aware of anything in particular. I just
> thought, If there is something, I want to be free from it.
>
> I didn't immediately become aware of any change,
> although something did happen, the significance of
> which didn't strike me until later. The Lord prompted
> me shortly after this to make a note in my diary when I
> had my period. This was something I had never done
> before as I'd not had regular periods since the time they
> first began at age thirteen. Therefore there had been
> little point in keeping a record. My periods in fact had
> been so irregular that I'd even gone six or eight or ten
> months at a time without having one at all.
>
> I'd been to doctors about this in my twenties and had
> been given medication (without result) and much un-
> wise and ungodly advice.
>
> I had prayed about my condition but not too
> seriously—possibly because I was single—but I had been
> told that I would experience a certain amount of discom-
> fort and irregularity in my metabolism due to hormonal
> imbalance until this condition was corrected.
>
> On listening to the tape again a few months later, I

was struck by Derek Prince's statement that "almost all, if not all, menstrual disorders are a result of a curse." I realized as I reached for my diary and checked the dates that I'd been perfectly regular (28-day cycles) since praying the prayer in August 1985. I was amazed to realize I was healed and that it had been the Lord who had prompted me to write down the dates of my periods.

As I reflected on my life, questioning where "the curse" could have come in, since no curse can alight without a cause, I remembered how throughout my high school years (ages 13–17) menstruation was generally referred to as "the curse" by me and my peers. Surely that confirms that "death and life are in the power of the tongue" (Proverbs 18:21).

Since that time in August '85 I have regularly kept a record and found my cycle to be consistently 27–29 days. Also, my weight which previously fluctuated has remained stable.

It is important to notice that—like Miriam in chapter 2—this lady did not pray for physical healing. She simply released herself from a curse, and healing followed as a consequence.

In this area of the procreative functions there is another common indication of a curse at work: an infant born with the umbilical cord wrapped around its neck—sometimes more than once. Quite often, of course, this can result in a stillbirth—thus causing death where there should be a new life.

4. Breakdown of marriage and family alienation

One effect of the curse in this area is described in Deuteronomy 28:41: "You shall beget sons and daughters, but they shall not be yours; for they shall go into captivity." Countless parents in the present generation have experienced this curse.

They have seen their sons and daughters taken captive by a rebellious subculture devoted to drugs, sex, satanic music and every form of the occult.

In Malachi 4:5–6 the prophet paints a grim picture of conditions in the world just before this age closes:

"Behold, I will send you Elijah the prophet
Before the coming of the great and dreadful day of the
 Lord.
And he will turn
The hearts of the fathers to the children,
And the hearts of the children to their fathers,
Lest I come and strike the earth with a curse."

Malachi depicts an evil force at work, alienating parents from children and producing a breakdown of family relationships. Unless God intervenes, he warns, this curse that is destroying family life will be extended to the whole earth, bringing disaster in its train.

Malachi has put his finger on the most urgent social problem of our contemporary culture. We need to see it as the outworking of a curse, which is responsible for the agonies of strife-torn homes, broken marriages and disintegrated families. Perhaps the most accurate word to describe the force responsible for these results is *alienation*. It comes between husbands and wives, parents and children, brothers and sisters, and all others who should be united by the bonds of family. Its goal is the destruction of the family.

Nevertheless for those who will accept God's counsel, the situation is not hopeless. There is a remedy. First we must face the fact that a curse is at work. Then we must take the steps indicated by Scripture to revoke the curse and release its captives. I have seen families transformed and restored by these means.

5. *Continuing financial insufficiency*

Two related phrases from Deuteronomy 28 are: "Cursed shall be your basket and your kneading bowl" or trough (17); "You shall not prosper in your ways" or you will be unsuccessful in everything you do (29).

The full outworking of this curse, however, is most graphically presented in verses 47–48:

> "Because you did not serve the Lord your God with joy and gladness of heart, for the abundance of all things,
>
> "therefore you shall serve your enemies, whom the Lord will send against you, in hunger, in thirst, in nakedness, and in need of all things."

Moses here presents two opposite alternatives. Verse 47 describes God's will for His obedient people: to "serve the Lord your God with joy and gladness of heart, for the abundance of all things." The NIV renders this: to "serve the Lord your God joyfully and gladly in the time of prosperity."

Verse 48 describes the curse that will come on God's people if they are disobedient: to "serve your enemies, whom the Lord will send against you, in hunger, in thirst, in nakedness, and in need of all things." Consider what is depicted in this verse: hunger, thirst, nakedness and need of all things. Combine all four elements into one situation, and the result can be defined in a single phrase: *absolute poverty*.

Taken together, verses 47 and 48 point to a simple conclusion: prosperity is a blessing and poverty is a curse.

Over the centuries, however, a tradition has developed within the Christian Church that poverty is a blessing. Certainly God has great compassion on the poor, and Christians should have the same attitude and be willing to make great personal sacrifices on their behalf. But Scripture never sug-

gests that God *inflicts* poverty as a blessing upon His believing people.

In this respect, the revelation of the New Testament harmonizes with that of the Old. In 2 Corinthians 9:8 Paul sums up the abundance of God's provision for Christians:

> And God is able to make all grace abound toward you,
> that you, always having all sufficiency in all things, have
> an abundance for every good work.

In this one terse sentence Paul doubles and redoubles his words to emphasize the generosity of God's provision for His people. The word *abound* or *abundance* occurs twice. The word *all*—or its equivalent—occurs five times: *all* grace . . . *always* . . . *all* sufficiency in *all* things . . . *every* good work. Such is the measure of God's provision. It transcends mere sufficiency and lifts us to a level of abundance, where we have something over and above our own needs and can minister to the needs of others.

It would be unscriptural, however, to interpret poverty and abundance by the materialistic standards of contemporary Western civilization. In John 6:38 Jesus revealed the motivation of His life on earth: "For I have come down from heaven, not to do My own will, but the will of Him who sent Me." The motivation of the disciple must be the same as that of the Master: *to do God's will.*

It is from this perspective that "poverty" and "abundance" must be defined. Poverty is having less than all you need to do God's will in your life. The greater the gap between what you need and what you have, the greater the degree of poverty. Abundance, on the other hand, is having all you need to do God's will—and something over to give to others. God's abundance is not provided for us to squander on carnal self-

indulgence, but *for every good work*, that is, sharing with others the blessings of grace that have enriched our own lives.

When poverty and abundance are interpreted in this way, it follows that there is no absolute standard that can be applied to all Christians. The standard for each believer must be determined in relation to *the will of God for his or her life.*

These conclusions about poverty and abundance need to be further qualified in two ways. First, we must recognize that faith to appropriate God's abundance is certain to be tested. There may be periods when we have to content ourselves with the barest sufficiency. Such periods, however, should be temporary. Once our motives have been purified and our faith has stood the test, God will release His abundance in the measure that He can trust us to use for His glory.

Second, we must recognize also that there is a higher level of wealth than just the material. When Moses turned his back on the wealth and luxury of Egypt and settled in a remote corner of a desert, the writer of Hebrews says that he esteemed "the reproach of Christ *greater riches* than the treasures in Egypt" (Hebrews 11:26). Moses did not settle for poverty. He exchanged material riches for riches of a higher order.

In the same way today, there is the kind of Christian who renounces material wealth deliberately in order to serve God in a situation where wealth would be an encumbrance. Often this is a prerequisite for identifying with the poor and oppressed of the earth. In Proverbs 13:7 Solomon contrasts such a person with one whose only wealth is material:

> There is one who makes himself rich,
> yet has nothing;
> And one who makes himself poor,
> yet has great riches.

There are also many Christians in our day who are enduring affliction and persecution for Christ's sake. They may be de-

prived of everything that could be described as material wealth, but in its place they are heirs to wealth of a higher order.

Nevertheless, this does not alter the basic nature of persistent material poverty. Where this is not the direct outcome of commitment to Christ, it is normally a mark of a curse, whether it affects an individual, a family or a larger social group.

6. Being "accident-prone"

This phrase describes a person who is unnaturally prone to personal accidents. Deuteronomy 28 contains no specific mention of this, although it is hinted at in the phrase "you shall grope . . . as a blind man gropes in darkness" (29).

One characteristic effect of this curse might be seen in what are called "freak" accidents. The girl described in chapter 2, who had broken the same leg three times in eighteen months, would be an obvious example.

To take another example, some people are good drivers, yet they have an abnormally high number of automobile accidents. In most cases, perhaps, it may be the fault of "the other driver." Nevertheless, the accidents still happen. A typical comment that identifies this kind of person would be: "Why does it always happen to me?"

Here are further examples, chosen more or less at random, of types of accidents that might indicate a curse at work: breaking an ankle through stepping off a curb; breaking a tooth on a soft piece of fruit; shutting a car door on a finger (here again, it may be "the other person"); slipping on a stair and falling headlong down a whole flight, with multiple injuries; swallowing a fish bone and choking on it; an insect in the eye causing some rare infection; being struck in the face by a

stone thrown up by a passing car; a surgeon's error on the operating table resulting in permanent disability . . . the list could be endless.

It almost seems that there is an invisible, malicious force working against such people. At critical moments, it trips them, or causes them to stumble, or impels them to make a rash, unpremeditated move. Typically, such a person will exclaim, "I don't know what made me do that!" A remark of this kind is very revealing. It indicates that the person is aware that his actions are not entirely under his own control, but are affected by a nameless influence he cannot identify and against which he has no way of protecting himself.

The recognition of this type of problem is not purely subjective. It can be determined by statistical analysis. Some insurance companies use this kind of analysis to identify people who would be unusually high risks for insurance. They set their premiums accordingly.

7. *A history of suicides and unnatural or untimely deaths*

The references to unnatural or untimely death in Deuteronomy 28 are too numerous to itemize. A curse that takes this form affects not just a single individual but a larger social unit, such as a family or tribe. Normally, too, it continues from one generation to another. Many different cultures have recognized a force at work in human history that pursues the members of a family or a clan relentlessly until it finally destroys them. The ancient Greeks gave it the status of a "goddess," whom they named Nemesis. Other cultures have used different terminologies. Beneath the pagan overtones is an objective reality.

Quite often people who are affected by this type of curse experience a strong foreboding. They sense something dark

and evil in the road ahead, but they do not know how to avoid it. A typical comment might be: "Well, it happened to my father, and I suppose I'm next on the list."

One common symptom of a curse of this kind is that people set dates for their own deaths. "I know I'll never live to see forty-five," they may say. Or, "All the men in my family die young." They imply, if they do not actually say, that this will be their fate, too. They have a kind of negative faith that embraces death, but refuses life.

The above list of seven indications of a curse is by no means exhaustive. Others could be added. You have probably read far enough by now, however, to take stock of your situation.

Various reactions are possible. You may, for example, no longer have any doubt about the nature of your problem. You have clearly identified one or more indications of a curse that apply to your life or to that of your family.

Alternatively, you may have an uneasy sense that a curse is at work, but you cannot pinpoint the precise form that it takes. You feel like the kind of person described in chapter 1. You have sensed the dark shadow from the past, but you do not know its source. Or you have seen that long, evil arm at work in various situations, but it operates behind a veil that you have not been able to tear aside.

In either case, you will be asking yourself: How could such a thing happen to me? What is the source of my problem?

This means that it is time for you to move on to Section 2: "No Curse without a Cause." This section explains many of the most common sources of a curse. If you can once discover the cause of your particular problem, you will be in a much better position to deal with it effectively.

Section 2
No Curse
without a Cause

Introduction

The operation of blessings and curses in our lives is not haphazard or unpredictable. On the contrary, both of them operate according to eternal, unchanging laws. It is to the Bible, once again, that we must look for a correct understanding of these laws.

In Proverbs 26:2 Solomon establishes this principle with respect to curses: "A curse without cause shall not alight." Behind every curse that comes upon us, there is a cause. If it seems that we are under a curse, we should seek to determine its cause. Then we shall be in a position to take appropriate action against it. This will also silence that nagging question: "Why do things like this always happen to me?"

This section lays bare the causes of the main curses that commonly afflict our lives. After reading it, you will be better able to understand and apply God's remedy, which is unfolded in the following section.

6
False Gods

In the preceding chapters we have established two important facts concerning curses that proceed from God. First, they are one of the main ways in which He brings judgment on the rebellious and the ungodly. Second, the basic cause of such curses is the failure to hear God's voice and do what He says—or, in one simple word, *disobedience*.

Disobedience can take many forms. It is natural, therefore, to ask: What are some of the main forms of disobedience that particularly provoke God's curse?

The Bible leaves no doubt about the answer. The form of disobedience that most surely and inevitably provokes God's curse is the breaking of the first two of the Ten Commandments, which are stated in Exodus 20:1–5:

And God spoke all these words, saying:

"I am the Lord your God, who brought you out of the land of Egypt, out of the house of bondage.

"You shall have no other gods before Me.

"You shall not make for yourself any carved image, or any likeness of anything that is in heaven above, or that is in the earth beneath, or that is in the water under the earth;

you shall not bow down to them nor serve them. For I, the Lord your God, am a jealous God, visiting the iniquity of the fathers on the children to the third and fourth generations of those who hate Me."

What are the two sins God specifies here? The first is acknowledging any other god before—or besides—the Lord. It is not enough to acknowledge the Lord as the first or greatest of all gods. We must acknowledge that He is *the only true God.* There is no other besides Him.

In Isaiah 45:21 the Lord declares with great emphasis:

"There is no other God besides Me,
A just God and a Savior;
There is none besides Me."

The second sin, described in the next commandment, is the making of any artificial representation of God and offering worship to it. In Romans 1:20–23 Paul analyzes what is involved in the breaking of these two commandments:

For since the creation of the world God's invisible qualities—his eternal power and divine nature—have been clearly seen, being understood from what has been made, so that men are without excuse.

For although they knew God, they neither glorified him as God nor gave thanks to him, but their thinking became futile and their foolish hearts were darkened. Although they claimed to be wise, they became fools and

exchanged the glory of the immortal God for images made
to look like mortal man and birds and animals and reptiles.

<div align="right">NIV</div>

Those who acknowledge false gods and practice idol wor-
ship have deliberately rejected the clear revelation of God
available to them through creation. Instead, they have chosen
to worship idols that become progressively debased. First,
they take human form, but from there they descend to birds,
then to animals and finally to reptiles. This exactly describes
the practice of ancient Egypt. Three of their main gods were
the vulture, the jackal and the cobra.

Our human minds are slow to understand the awful wick-
edness of idol worship. The true God, revealed first in cre-
ation and then more fully in Scripture, is holy, awesome,
glorious, omnipotent. To represent Him in the likeness of
any created being—whether human or animal—is to offer
Him a deliberate insult. It is a calculated provocation of His
wrath.

Let me illustrate this by a crude example. Suppose some-
one were to find a cockroach crawling on the floor, photograph
it and then display the photograph over the title *Derek Prince*.
I would surely interpret this as an insult aimed deliberately at
me. How immeasurably worse is the insult offered to God by
those who give His name not merely to the noblest of His
creatures, but even to the most debased!

God's judgment on the breaking of these first two com-
mandments bears the characteristic mark of a curse: It con-
tinues from generation to generation, at least as far as the
fourth generation. In some nations and some cultures, the
practice of worshiping false gods goes back over hundreds and
even thousands of years, compounding the effect many times
over.

A person who comes from such a background is heir to a curse that may be compared to a weed planted in his life, linking him to satanic forces outside himself. This weed has two kinds of roots: one long tap root going straight downward, and other less powerful lateral roots stretching out in various directions. The tap root represents the influence of ancestors who worshiped false gods. The lateral roots represent other influences to which the person has been exposed in his own lifetime, either through various sins he has committed or through his own attachment to false gods or in various other ways.

Before he can enjoy true liberty and the fullness of the new creation in Christ, this weed must be completely pulled out, with all its roots. The most important root, and the one hardest to deal with, is the tap root that links him to many generations who have worshiped false gods. Nothing but the supernatural grace and power of God can effectively remove all these roots. But thank God, there is hope in the promise of Jesus in Matthew 15:13: "Every plant which My heavenly Father has not planted will be uprooted."

The sins that bring this generational curse, however, do not stop short at the more obvious forms of idolatry. They include a second, wider range of practices that are not necessarily openly idolatrous, or even religious. Because their true nature is concealed by deceptive terminology, they are appropriately described as *occult* (derived from a Latin word meaning "hidden" or "covered over"). These occult practices have always held a powerful fascination[1] for fallen man, never more so than in the present generation.

Two of the strongest cravings of human nature are the desire for knowledge and the desire for power. Up to a certain

[1] It is significant that the word *fascination* is derived from a Latin verb that means "to bewitch."

point, man is able to satisfy these cravings from natural sources and by natural means. If he is not fully satisfied by what he obtains in this way, he will turn inevitably to supernatural sources. It is at this point that he easily becomes entrapped in the occult.

The reason for this is that there are actually only two available sources of supernatural knowledge and power in the universe: either God or Satan. Every form of supernatural knowledge or power that does not proceed from God, therefore, necessarily proceeds from Satan. If derived from God, it is legitimate; if derived from Satan, it is illegitimate.

Since God's Kingdom is the Kingdom of light, His servants know whom they are serving and what they are doing. On the other hand, since Satan's kingdom is a kingdom of darkness, most of those in his kingdom do not know the true identity of the one whom they are serving, or the true nature of what they are doing.

It was this craving for illegitimate knowledge that prompted man's first transgression in the Garden of Eden. God had set an invisible boundary between him and the tree of knowledge of good and evil. When man crossed this boundary, he found himself in Satan's territory and became a captive of Satan. Ever since then, the same kind of craving for illegitimate knowledge or power has continually lured men into an area where Satan is able to take them captive at his will (see 2 Timothy 2:26). As already stated, the generic name for this area is the occult.

Those who trespass in this area are seeking from Satan the supernatural knowledge or power that God does not permit man to seek from any other source but Himself. In so doing, they are, in fact, acknowledging Satan as a god besides the one true God, and are thus breaking the first of the Ten Commandments. In this way they are exposing themselves to the curse

God has pronounced on all who break this commandment—a curse that extends as far as the fourth generation.

This conclusion is so important that it needs to be reemphasized: *All who become involved in the occult are exposing themselves to the curse pronounced on those who break the first commandment.*

In various passages the Bible describes the act of turning to false gods as "spiritual adultery," and condemns it as an even greater sin than physical adultery. Understood in this way, the warnings given in the book of Proverbs against involvement with an "immoral woman"—or an adulteress—apply to involvement in the occult. In Proverbs 5:3–6 this immoral woman is depicted as alluring and fascinating in her initial approaches, yet causing final ruin to those whom she seduces:

> For the lips of an immoral woman drip honey,
> And her mouth is smoother than oil;
> But in the end she is bitter as wormwood,
> Sharp as a two-edged sword.
> Her feet go down to death,
> Her steps lay hold of hell.
> Lest you ponder her path of life—
> Her ways are unstable;
> You do not know them.

The final statement is particularly illuminating: "Her ways are unstable; you do not know them." No limit can be set to the forms of deception practiced in the occult. As soon as one is exposed, another emerges in its place. It is, therefore, impossible to give a complete or definitive list of the various types of occult practices. It is, however, possible to identify and briefly describe the following three main branches: witchcraft, divination and sorcery.

Witchcraft is the *power* branch of the occult. Its root is exposed by a brief statement in 1 Samuel 15:23: "For *rebellion* is

as the sin of witchcraft." Witchcraft is an expression of man's rebellion against God. It is man's attempt to gain his own ends without submitting to God's Law. Its driving force is a desire to control people and circumstances. To gain this end it may use either psychological pressures or psychic techniques, or a combination of both.

There are three key words that expose the activity of witchcraft: manipulate, intimidate, dominate. Domination is its ultimate purpose. Manipulation and intimidation are alternative ways of achieving this purpose. Wherever people use verbal or nonverbal tactics to manipulate, intimidate and dominate those around them, witchcraft is at work.

In its simplest form, witchcraft is merely an expression of the corrupt, rebellious nature of fallen humanity. In Galatians 5:20, in the King James Version, it is listed—with idolatry—among "the works of the flesh." There are probably few people who have not resorted at some time or other to witchcraft in this form.

This is only "the tip of the iceberg," however. It is characteristic of Satan that he exploits this "work of the flesh" as an opening for supernatural, demonic power that emanates from the kingdom of darkness. Through this opening, he moves in and takes control of men and women, making them tools of his evil purposes and slaves of his kingdom. The result is witchcraft practiced as an occult art, operating primarily through spells and curses.

The other two forms of the occult—divination and sorcery—are motivated by the same basic desire: to control people and circumstances.

Divination is the *knowledge* branch of the occult, offering many different forms of knowledge that cannot be obtained by purely natural means. In its commonest form, as *fortunetelling,* it offers supernatural knowledge of the future. It also

includes all false forms of religious revelation that claim a supernatural source.

Sorcery operates through *material objects* or through other ways of impacting the physical senses, such as *drugs* or *music*. In Revelation 9:21 the word for *sorceries* is directly derived from the Greek word for *drugs*. In 2 Timothy 3:13 Paul warns that at the close of this age "evil men and impostors will grow worse and worse, deceiving and being deceived." The word translated *impostors* means literally "enchanters." Chanting— or incantation—has always been a technique of sorcery. The contemporary drug culture, with its accompaniment of "heavy metal" rock music, is a vivid example of two forms of sorcery working together.

The following is a brief list of various categories under which the "tools" of sorcery may be classified:

> Any objects associated with idolatrous worship, whether pagan or professing to be Christian.
> Any objects representing any kind of false religion or cult or satanic practice.
> Any objects upon which a practitioner of the occult has invoked supernatural power. (Even if this power is ostensibly directed toward a "good" purpose, such as healing, its source makes it the channel of a curse.)
> Any objects that are the expression of superstition, such as horseshoes, "lucky" coins, figures of "saints" and so on.

The following are some specific forms of the occult prevalent in our contemporary culture:

1. *The power branch of the occult*

Acupressure, acupuncture, astral projection, hypnosis, levitation, martial arts (those that invoke supernatural spiritual power), mind control, mind dynamics, parakinesis, table-tipping, telekinesis, "touch" healing, witchcraft.

2. *The knowledge branch of the occult*

Astrology, automatic writing, "channeling," clairaudience (hearing "voices"), clairvoyance, crystal balls, diagnosing by color therapy or a pendulum, divining, ESP, handwriting analysis, horoscopes, iridology, kabbala, mediums, mindreading, numerology, omens, palmreading, phrenology, seances, tarot cards, tea leaf reading, telepathy, "witching." Also, all books that teach occult practices.

Also included under this heading are all false religions or cults that claim supernatural revelation but contradict the Bible. Distinguishing between true and false in this realm is like distinguishing between straight and crooked in the natural realm. Once we have established a standard of what is straight, we know that anything departing from that standard is crooked. It makes no difference whether it varies by one degree or by ninety degrees. It is crooked.

In the spiritual realm, the Bible is the standard of that which is *straight*—that is, *true*. Anything that departs from the Bible is *false*. Whether it departs by little or much is relatively unimportant. Some of the subtlest deceptions are those that appear to differ only a little from the Bible.

Particularly dangerous are religions that misrepresent the Person, the nature or the redemptive work of Jesus Christ. The New Testament, for example, presents Jesus as "God manifest in the flesh," but Jehovah's Witnesses teach that He

was a created being. Again, Islam rejects the claim of Jesus to be the Son of God, and denies that He ever actually died on the cross. Yet the atoning death of Jesus is the only basis on which man can claim forgiveness of sins.

The following are some of the many false religions or cults that are active today: Anthroposophy, Black Mass, Children of God, Christadelphians, Christian Science, Freemasonry, Inner Peace Movement, Jehovah's Witnesses (Dawn Bible Students), Mormons (Church of Jesus Christ of Latter-day Saints), New Age movement, Religious Science, Rosicrucianism, Scientology, Spiritual Frontiers Fellowship, Spiritualism, Theosophy, Unification Church (Moonies, One World Crusade), Unitarian Church, Worldwide Church of God (founded by Herbert W. Armstrong).

Also, Eastern religions or cults, such as Bahai, Buddhism, Confucianism, Divine Light Mission, gurus, Hare Krishna, Hinduism, Islam, Shintoism, Transcendental Meditation, yoga.

3. *The branch of the occult operating through physical objects, etc.*

Amulets, ankhs (an ankh is a cross with a ring at the top), birthstones, charms (e.g., for wart removal), crystals used for healing, hallucinogenic drugs, "heavy metal" rock records or cassettes, hex signs, "lucky" symbols (e.g., inverted horseshoes), ouija boards, pagan fetishes or religious artifacts, planchettes, talismans, zodiac charms.

God's estimate of those who are involved in the kinds of practices listed above is stated plainly in Deuteronomy 18:10–13:

> Let no one be found among you who sacrifices his son
> or daughter in the fire, who practices divination or sor-

cery, interprets omens, engages in witchcraft, or casts spells, or who is a medium or spiritist or who consults the dead. Anyone who does these things is detestable to the Lord, and because of these detestable practices the Lord your God will drive out those nations before you. You must be blameless before the Lord your God.

NIV

Notice that those who engage in these occult practices are classed in the same category with those who sacrifice their children in fire to pagan gods. Under the law of Moses, the mandatory penalty for all such practices was death.

It is important to recognize that *books* can be channels of occult power. When the professing Christians in Ephesus were confronted through the ministry of Paul with the reality of Satan's power, their reaction was dramatic:

Many of those who believed now came and openly confessed their evil deeds. A number who had practiced sorcery brought their scrolls together and burned them publicly. When they calculated the value of the scrolls, the total came to fifty thousand drachmas.[2]

Acts 19:18–19, NIV

The only appropriate way to deal with such occult material is to destroy it completely—by fire or by whatever means may be most suitable—even though the value of the material destroyed may be very great.

It has already been pointed out that the occult, like the "immoral woman," is constantly changing its ways. No final or exhaustive list of occult practices can ever be offered.

Over many years I have sought to help people with problems that had not been resolved by the type of counseling or

[2] A drachma was about a day's wage. At today's rates in the United States, the total amount could be as much as $200,000.

ministry normally offered by the majority of churches today. So far as I could tell, these people's problems were not due to lack of sincerity or earnestness. In fact, they often seemed to be more earnest and sincere than many regular churchgoers who manifested no obvious problems.

In the cases in which I did succeed in helping such people, I almost invariably discovered some root of involvement with the occult in their backgrounds. Often they themselves did not see this as a potential cause of their problems. Yet once the occult root was exposed and dealt with, it was usually comparatively easy to resolve the other, more obvious problems.

A simple but vivid example comes to my mind. In a home prayer meeting, I found myself next to a young man in his early twenties. We had not met before, but I felt led to ask him, "Have you received the Holy Spirit?"

"Yes," he replied, but then added rather wistfully, "but I don't speak in tongues." Clearly he felt there was something lacking in his experience.

Without discussing any further the issue of tongues, I asked him, "Did you ever visit a fortune-teller?"

He reflected for a moment, and then said, "Yes, once, when I was about fifteen. But I only did it as a joke. I didn't really believe in it."

"But still," I pressed him, "you did actually have your fortune told?"

"Yes," he acknowledged rather reluctantly, and then added defensively, "but I didn't mean anything by it."

"Would you be willing to confess that as a sin," I said, "and ask God to forgive you and release you from its consequences?"

When he agreed to this, I led him in a simple prayer, in which he confessed his visit to the fortune-teller as a sin, and

asked God to forgive him and release him from its consequences. Then, without a further word of explanation, I put my hand on his shoulder and asked God to release the Holy Spirit within him. Instantly, without hesitation or stammering, he began to speak clearly and fluently in an unknown tongue. In a few moments he was lost in the presence of God, oblivious to all that was going on around him. The invisible barrier in his life had been removed!

Since then, I have reflected many times on my brief encounter with that young man. His problem was not lack of earnestness or sincerity. It was a failure to recognize the nature of his act in visiting the fortune-teller. He did not understand that in God's sight he had been guilty of spiritual adultery.

Suppose I had asked him, "Did you ever commit adultery with a married woman?" He would never have replied, "Yes, but I only did it as a joke. . . . I didn't mean anything by it."

Countless multitudes of people today are in a similar situation. Many of them are churchgoers. Yet, through ignorance, they have trespassed in the area of the occult and have become involved in a sin that is worse than physical adultery. Until they recognize the true nature of what they have done, they must continue under the shadow of the curse God has pronounced on all who turn away from Him to false gods. Furthermore, the same shadow may continue to rest over the lives of the next four generations of their descendants.

When confronted with these issues, Christians sometimes respond, "But I didn't know that I was doing anything wrong." My reply is to point out that in 1 Timothy 1:13–15 Paul describes himself as "the chief of sinners" for sins he committed "ignorantly in unbelief." Ignorance does not absolve us from the guilt of our sins, but it may dispose God to show us mercy if we repent and turn to Him.

All of us, without exception, need to consider carefully how these principles may apply in our lives. In the first two of the Ten Commandments God has pronounced His judgment on two specific sins: turning to any false god besides the one true God; and making and worshiping any artificial representation of God. These two sins include the whole area of the occult. God's judgment on those who commit them, as we have seen, extends to the four generations following.

Conversely, any one of the four generations preceding us, by having committed these sins, could be the cause of a curse over us in our generation. Each of us has two parents, four grandparents, eight great-grandparents and sixteen great-great-grandparents. This makes a total of thirty persons, any one of whom might be the cause of a curse over our lives. How many of us would be in a position to guarantee that none of our thirty immediate ancestors was ever involved in any form of idolatry or the occult?

Thank God He has provided a way of release from any curse that might have come from this source! Thank God we can avail ourselves of His provision! In the final day of reckoning, God will not hold against us the fact that our ancestors brought a curse upon us, but He will hold us guilty if we refuse to avail ourselves of the provision He has made for us to be released from such a curse.

7
Various Moral and Ethical Sins

The primary form of disobedience that provokes God's curse is stated in Exodus 20:3–5: acknowledging and worshiping false gods. In addition, the Old Testament also reveals a large number of secondary forms of disobedience upon which God has pronounced a curse. In this category, in Deuteronomy 27:15–26, Moses lists twelve moral and ethical sins, all of which provoke God's curse.

Earlier in this chapter Moses had instructed Israel to carry out a solemn ceremony after they had entered the land of Canaan. On the two adjoining mountains of Ebal and Gerizim they were to offer sacrifices and set up large stones with all the words of the Law written on them. With these words in plain view, half of the tribes would first invoke a blessing on all Israelites who were obedient. Then the other six tribes would invoke a curse on all who were disobedient. To both the bless-

ing and the curse, all the people were required to respond, "Amen!"[1]

In this way, God ordained that Israel's occupation of Canaan would confront them with two diametrically opposite alternatives: a blessing for obedience or a curse for disobedience. Between these two was no middle ground. No other option was open to them. From then onward, every Israelite who entered Canaan would either enjoy God's blessing or endure His curse.

These two alternatives are presented with stark clarity in the history of Israel, and subsequent records confirm their outworking. Nevertheless, these alternatives are not confined to Israel. They apply equally to all who would enter into a covenant relationship with God. Under the New Covenant, just as under the Old, God offers the same two alternatives: either blessing for obedience or curse for disobedience. One great delusion among Christians, which Satan carefully fosters, is that there is some third possibility, which is neither obedience, with its blessings, nor disobedience, with its curses. Neither the Old Testament nor the New offers any such option.

The twelve curses pronounced on the Israelites from Mount Gerizim were detailed and specific. The following is a suggested summary of the main kinds of conduct covered by them:

> Acknowledging and worshiping false gods.
> Disrespect for parents.
> All forms of oppressions and injustice, especially when directed against the weak and the helpless.
> All forms of illicit or unnatural sex.

[1] Joshua 8:32–35 records how this ceremony was actually carried out after Israel had entered the land of Canaan.

The final curse covered all forms of disobedience to the Law.

As always, the primary cause of God's curse is any form of involvement with false gods. This is followed by disrespect for parents. The requirement to respect our parents is restated and reemphasized in the New Testament. In Ephesians 6:1–3 Paul reaffirms the fifth of the Ten Commandments:

> Children, obey your parents in the Lord, for this is right.
> "Honor your father and mother," which is the first commandment with promise:
> "that it may be well with you and you may live long on the earth."

Countless people today—including many Christians—are unaware that disrespect for parents brings God's curse. I could not estimate the number of people I have dealt with personally on this issue. Thank God that I have seen a wonderful change for the better in the lives of those who have recognized this sin, repented of it and changed their attitude toward their parents!

On this theme, it is appropriate to quote a passage from my book on marriage, *God Is a Matchmaker.*

> Paul points out that the preceding four commandments had no promise attached to the keeping of them. But to this fifth commandment, relating to parents, God added a special promise: "That it may go well with you." At the same time, the promise implies a condition: If you want it to go well with you, you must be careful to honor your parents. Conversely, if you do not honor your parents, you cannot expect it to go well with you.
>
> Bear in mind that it is possible to honor your parents without agreeing with them on all points or endorsing everything they do. You may disagree strongly with them in

some matters, yet maintain a respectful attitude toward them. To honor your parents in this way is also to honor God Himself, who gave this commandment.

I am convinced that a proper attitude toward parents is an essential requirement for God's blessing on any person's life. In all the years I have dealt with Christians in teaching, pastoring, counseling, and other relationships, I have never met one who had a wrong attitude toward his parents and enjoyed the blessing of God. Such a person may be zealous in many areas of the Christian life, active in the church, energetic in ministry. He may have a place in heaven waiting for him. Yet there is always something lacking in his life: the blessing and favor of God.

I have seen many Christians, on the other hand, whose lives were revolutionized when they acknowledged a wrong attitude toward parents, repented of it and made the necessary changes. I remember one man who was convicted of a lifetime of bitterness and hatred toward his father. Although his father was already dead, this man journeyed hundreds of miles to the cemetery where his father was buried. Kneeling beside the grave, he poured out his heart to God in deep contrition and repentance. He did not rise from his knees until he knew his sin was forgiven and he was released from its evil effects. From that point on, the whole course of his life changed from frustration and defeat to victory and fulfillment.

The next form of conduct in the list of Deuteronomy 27 is oppression and injustice, especially against the weak and the helpless. There are certainly many examples of such behavior in our contemporary culture, but none is more likely to provoke God's curse than the deliberate aborting of an unborn infant. Who is more helpless and incapable of self-defense

than a baby in its mother's womb, if its own parents do not protect it?

How strange that people who are active in the fight against racial prejudice and injustice—and rightly so—actually condone and promote the practice of abortion! Strange, too, that people who would never think of raising a hand in violence against a small child feel no compassion toward an even smaller child in its mother's womb. Somehow the substitution of the word *fetus* for *infant* dulls people's consciences. Yet the change in terminology in no way affects the real nature of such an act.

Someone has asked, "What hope is left for a society in which mothers kill their own babies?" God's attitude toward abortion is not affected by a change in terminology. He classifies it quite simply as "murder"—and deals with it accordingly. In nation after nation around the world today, millions of lives are being blighted by the curse that follows this act.

The final form of curse-provoking conduct in the list taken from Deuteronomy 27 is the abuse and perversion of the sexual relationship. Some Christians, unfortunately, have formed the impression that sex is somehow unclean, something that cannot be avoided but nevertheless needs an apology. Yet the biblical picture is just the opposite. Sex is part of the Creator's original plan for man, something sacred and beautiful. For this reason God has set stringent boundaries around the sexual act, to protect it from abuse and perversion. These boundaries are marked out by the curses pronounced in verses 20 through 23 of Deuteronomy 27.

The forbidden acts here listed cover sex with various persons related either by blood or marriage, and any form of sex with animals. The acts forbidden in the Bible also include all expressions of homosexuality. In Leviticus 18:22 God declares: "You shall not lie with a male as with a woman. It is an

abomination"—also translated "detestable." This is the same word used in Deuteronomy 18:12 to describe various forms of occult practice.

Today many of these boundaries designed to protect the sanctity of sex are being deliberately set aside—sometimes even in the name of Christianity. Yet no arguments based on "situation ethics" or "the new morality" (which is by no means new) can affect or change the laws of God that govern human behavior. All who indulge in sexual perversion expose themselves to the curse of God.

It is significant that this list of acts that provoke God's curse in Deuteronomy 27 is followed immediately in Deuteronomy 28 by the complete list of blessings for obedience and curses for disobedience. It is as if God says: "Before you decide whether to obey or not, you had better give careful consideration to the consequences. So here they are!"

8
Anti-Semitism

About 4,000 years ago God made a choice that has affected all subsequent history. He was looking for a man who would meet His conditions so that he might ultimately become a channel of God's blessing to all nations. The man He chose was called Abram (later renamed Abraham).

God's purpose in choosing Abraham is unfolded in Genesis 12:2–3. Characteristically, blessing and curse are closely connected. God pronounces four promises of blessing upon Abraham:

> "I will bless you."
> "You shall be a blessing."
> "I will bless those who bless you."
> "In you all the families of the earth shall be blessed."

Interposed in the midst of these blessings, however, is a curse:

> "I will curse him who curses[1] you."

The addition of this curse serves an important practical purpose. Any person on whom God pronounces His blessing is thereby automatically exposed to the hatred and opposition of the great enemy of God and His people: Satan. Paradoxical as it may seem, the blessing of God provokes the curse of Satan, channeled through the lips of those whom Satan controls. For this reason, when God blessed Abraham, He added His curse on all who would curse Abraham. This meant that no one could curse Abraham without incurring the curse of God in return.

In Genesis 27:29, when Isaac blessed his son Jacob, he also extended to him the same protection that God originally provided for Abraham: "Cursed be everyone who curses you." Later, under divine compulsion, Balaam uttered a prophetic revelation of Israel's destiny, which was exactly opposite to his original intention to curse Israel. Part of this revelation, recorded in Numbers 24:9, echoed the words already spoken concerning Abraham and Jacob:

> "Blessed is he who blesses you,
> And cursed is he who curses you."

Taken together, these Scriptures make it clear that both the blessing and the curse originally pronounced on Abraham were extended to his descendants, Isaac and Jacob, and then on to their succeeding generations, who are today known collectively as the Jewish people.

[1] This second verb here translated "to curse" also means "to revile," "to speak evil of."

God did not make it impossible for His enemies to curse Abraham, Isaac, Jacob and their descendants, but He did ensure that no one could do it with impunity. From that time onward, no one has ever cursed the Jewish people without bringing upon himself a far more fearful curse: that of almighty God. In contemporary speech, the attitude that provokes this curse of God is summed up in a single word: *anti-Semitism*.

It would take a full-length book to trace the outworking of this curse in the history of individuals and nations from the time of the patriarchs until our day. Suffice it to say that in nearly 4,000 years, no individual and no nation has ever cursed the Jewish people without bringing upon themselves in return the blighting curse of God.

The story of Nabil Haddad provides a vivid contemporary illustration of both aspects of God's promise to Abraham: on the one hand, the curse on those who revile the Jewish people; and on the other hand, the blessing that results from blessing them. Nabil is a Palestinian Arab, born in Haifa into a well-known Arab family. Subsequently, he emigrated to the United States, where he became a successful businessman. He also had a powerful personal encounter with the Lord Jesus Christ. Here is his story in his own words:

> My name is Nabil Haddad. I am a Palestinian Arab born in Haifa in 1938 to Christian Arab parents.
>
> I remember that from my earliest childhood, I would always go to bed depressed. I became determined to find a way to be happy. I knew my parents loved me, but that didn't change my unhappiness. I became convinced that if I could become rich and successful, then I would be happy. That became my goal.

In 1948, the fighting between the Arabs and the Jews began. Our whole family moved to Lebanon. In the late 1950s I came to the United States for college.

So, in America, I set out to achieve my goal of becoming rich and successful through education and business. Over the next few years, I married, became an American citizen, started a family and became a franchisee of McDonald's restaurants. By the age of thirty I was a millionaire. However, the depression had not left me. I started seeking material things—cars, trips, recreation, anything that money can buy—to make me happy. Nothing worked.

Finally, I began to ask questions: Who is this Man Jesus? Who is this One that people still talk about 2,000 years after His death? Who is this One that some people even worship?

I opened the Bible, wanting to see what this Jesus had said about Himself, and a Presence filled the room. Somehow I knew that Jesus is the Son of God. I spent most of the next year reading the Bible and talking to my friends about Jesus. But still I was depressed. During this time, I sold my nine McDonald's restaurants for a few million and started a new business. Things started to go sour. I became more depressed. I began to question God again.

"Why, Lord? Before I knew that Jesus is Your Son, I was doing fine. Now everything is going wrong!"

God replied, *What have you done with the revelation that Jesus is My Son? Nothing in your life has changed. Even Satan knows that Jesus is My Son.*

"What do You want me to do, Lord?"

Repent, and receive Him into your life.

I found someone who could show me how to pray. I repented and asked Jesus into my heart. A few months later, I was baptized in the Holy Spirit. Now I had the

answer. *I no longer went to bed depressed.* But my life was still not right. My business continued to go downhill. Again I confronted the Lord.

"Lord!" I said. "You tricked me. Before I knew anything about Your Son Jesus, I was doing all right. Then you showed me He is Your Son, and things started going wrong. Then I received Him into my life, and now I'm losing everything!"

I'm a jealous God, He replied. *Your business is your god, your Rolls Royce is your god, your position is your god. I'm going to take all these false gods away from you to show you who the true living God is. But—I will restore you.*

Within ten months, I was bankrupt.

A little later I went to Fort Lauderdale for a seminar called "Curses: Cause and Cure" taught by Derek Prince. I learned that many areas of my life were under a curse—financial, physical, not enjoying my children, etc. I remembered the same kinds of problems in my father's life and in the lives of other family members.

On the third day, when Derek led the few hundred people in a prayer to be set free from curses, I stood up. People in front of me, next to me, and behind me had physical manifestations of release. But my release did not occur at the meeting. The next day, for eight straight hours, I was being released from curses with painful vomiting of things that were attached deep inside my body. When I asked the Lord what I was being delivered from, He showed me witchcraft and many other specific problems.

For months the Lord continued to show me additional areas of curses. Each time I repented and claimed my release on the basis of Jesus becoming a curse for me.

One day as I was worshiping, I said, "How great You are! You created the universe *and everything in it!*" The Lord asked me if I really believed that. I said, "Yes, Lord."

He said, *What about the Jewish people? You still hold resentment in your heart against them.*

I remembered how my whole family had always cursed the Jews. I was trained to *hate* them from my earliest years. Now, in the presence of the Lord, I said, "I renounce any resentment in my heart toward the Jewish people. I forgive them!" Immediately something changed inside of me.

Shortly after this I saw that God in His Word had told Abraham, the father of the Jews, "I'll bless those who bless you and curse those who curse you" (Genesis 12:3). Then I realized that my finances had not been under a blessing, but under a curse—a curse of insufficiency. I had never been able to make enough money to meet my needs. Even if I made $250,000, I would need $300,000. Later, when I made $500,000, I would need $700,000 to cover my expenses.

Since 1982, when I was released from the curse of anti-Semitism and the curse of insufficiency that went with it, my income has always exceeded my expenses and my needs. And I am able to *give liberally* to the work of the Kingdom of God.

God has also healed my body and my emotions. I am totally free from depression. I can truly say I am walking in victory. My testimony has helped many others to be delivered from the curse and to live under God's blessing.

The lesson of Nabil's life is clear: *No one can afford to hate or curse the Jewish people.* This lesson was never more needed than it is today. Both socially and politically, anti-Semitism is one of the most powerful forces at work in our contemporary world. Yet ultimately it spells disaster for all who allow themselves to be controlled by it.

Unfortunately, throughout many centuries, the professing

Christian Church has often been guilty of propagating flagrant anti-Semitism. Yet the Church owes every spiritual blessing she claims to those who have been her victims: the Jewish people. Without the Jews, the Church would have had no apostles, no Bible and no Savior.

Here is one main reason for the present lukewarm, powerless condition of so much of Christendom—especially in Europe and the Middle East, where anti-Semitism is most deeply entrenched. The story of Nabil Haddad points to the solution: open acknowledgment of anti-Semitism as a sin, followed by repentance and renunciation. This will result in a deep, inner change of heart toward the Jewish people, and a recognition of the measureless spiritual blessings the Christian Church has received through them.

On this basis, we can then entreat God to remove the dark shadow of the curse, which at present rests upon major sections of the Church, and to replace it by His blessing.

9
Legalism, Carnality, Apostasy

In Jeremiah 17:5 God pronounces His curse on another kind of sin, which, like anti-Semitism, is at work in many sections of the Church:

> Thus says the Lord:
> "Cursed is the man who trusts in man
> And makes flesh his strength,
> Whose heart departs from the Lord."

In this context—as in many other passages of Scripture—the word *flesh* does not denote the physical body. Rather, it denotes the nature each of us has received by inheritance from our common ancestor, Adam. Adam did not beget any children until he himself had transgressed God's commandment. The essential motivation of his transgression was not so much the desire to do evil as the desire to be independent of God.

This desire is at work in every one of Adam's descendants. It is the distinctive mark of the "flesh." In the field of religion, it seeks to perform righteous acts without depending on the supernatural grace of God. No matter how good its intentions, the final product will always be an "Ishmael," not an "Isaac."

The adjective that Scripture applies regularly to the flesh is *corrupt*. Although it can produce much that is designed to impress the mind and the senses, it is all tainted by corruption. The outcome of all its efforts is described in Hebrews 6:1 as "dead works," from which God requires us to repent.

The kind of person described in Jeremiah 17:5 is not a stranger to God's grace. This is indicated by the closing phrase: "whose heart departs from the Lord." If he had never known the Lord, he could not be said to "depart" from Him. A person of this kind has experienced God's supernatural grace and power, but then turns back to relying on his own natural ability. His conduct reveals that he has more confidence in what he can do for himself than in what God can do for him. He has, in fact, "snubbed" God. It is this attitude that calls forth God's curse.

The next verse describes the outworking of the curse that such a person brings upon himself:

> "For he shall be like a shrub in the desert,
> And shall not see when good comes,
> But shall inhabit the parched places in the wilderness,
> In a salt land which is not inhabited."

What a vivid picture of a person under God's curse! He finds himself living in "parched places" and "a salt land." All that surrounds him is barren and dreary. Refreshing may come to others all around him, but in some mysterious way it always passes him by. He is doomed to barrenness and frustration.

The curse of Jeremiah 17:5–6 is at work in the lives of many individuals, but it also applies to a much wider area. It is one real but invisible cause of the barrenness and ineffectiveness of many sections of the contemporary Christian Church. Almost every movement of any significance in Christendom can trace its origin to a powerful, supernatural work of God's grace and God's Spirit. It is to this, above all else, that they owe the impact they have made on history.

Yet, today, many—perhaps most—of these movements no longer place much emphasis on the grace of God and the power of the Holy Spirit. They have turned back to relying on the best that they can accomplish by their own efforts. They are "trusting in man"—that is, in themselves—and "making flesh their strength." Surely, but imperceptibly, "their heart has departed from the Lord." They have, perhaps, achieved religious and intellectual "respectability," but in so doing they have forfeited God's favor. In its place, they have brought upon themselves the dark shadow of the curse pronounced in Jeremiah 17:5.

To put human ability in the place of divine grace is to exalt the carnal above the spiritual. The effect will be manifested in many different areas. For example:

> *Theology* will be exalted above *revelation;*
> *intellectual education* above *character build-ing;*
> *psychology* above *discernment;*
> *program* above *the leading of the Holy Spirit;*
> *eloquence* above *supernatural power;*
> *reasoning* above *the walk of faith;*
> *laws* above *love.*

All these errors are different manifestations of one great, basic error: putting man in a place God has reserved solely for the Lord Jesus Christ.

This was the kind of situation Paul sought to deal with in the churches of Galatia. In Galatians 3:1–10 he traces the problem from its source to its culmination. The following is a brief outline.

In verse 1 Paul identifies the source as a deceiving satanic influence that he calls *witchcraft:*

> O foolish Galatians! Who has *bewitched* you . . . before whose eyes Jesus Christ was clearly portrayed . . . as crucified?

An alternative version renders Paul's question, "Who has put you under *a spell?*"

This satanic influence had obscured the only source of God's all-sufficient grace: *Jesus Christ crucified.* Cut off in this way from God's grace, His people inevitably turn back to the only alternative: a system of religious laws. This leads to Paul's next question in verse 2: "Did you receive the Spirit *by the works of the law,* or by the hearing of faith?" The word normally used to describe this is *legalism.* Since this word is often used in an imprecise way, however, it is important to define it more exactly.

Legalism may be defined in two related ways. First, it is the attempt to achieve righteousness with God by observing a set of rules.

In Romans 3:20 Paul has ruled this out with absolute finality: "Therefore by the deeds of the law no flesh will be justified in His sight, for by the law is the knowledge of sin." The word *the* in front of *law* is put in by the translator. What Paul actually says is, *"By the deeds of law* no flesh will be justified." The primary reference is to the Law of Moses, but the state-

ment applies no less to any other set of religious rules. Law can show us that we are sinners, but it does not have the power to change us.

Alternatively, *legalism* could be defined as the attempt to impose any extra condition for achieving righteousness beyond what God Himself has laid down. God's requirement is stated in Romans 4:24–25:

> It [righteousness] shall be imputed to us who believe in Him who raised up Jesus our Lord from the dead, who was delivered up because of our offenses, and was raised because of our justification [in order that we may be reckoned righteous by God].

This is God's simple but all-sufficient requirement to attain righteousness: that we trust ourselves to Him, believing that He did two things on our behalf. First, He delivered Jesus to death for our sins. Second, He raised Jesus from the dead that we might be reckoned righteous. God asks no more than this, and no one has ever been authorized to add anything to God's requirements.

After that, once we have received righteousness in this way by faith, the righteous acts that are appropriate will flow out of our faith. But if we add any extra requirement for attaining righteousness, God will not meet us on this basis, and the righteous acts will not follow. We will never be able to go beyond the best that we can achieve by our own fleshly efforts.

This explains Paul's next question in Galatians 3:3: "Having begun in the Spirit, are you now being made perfect *by the flesh?*" The normal term for this is *carnality*—that is, relying on our own fleshly nature. Further on, in Galatians 5:19–21, Paul lists at least fifteen "works of the flesh." Not one of them is good or acceptable to God, because the flesh is not capable of

producing anything that God will accept. In Romans 8:8 Paul sums this up: "So then, those who are in the flesh *cannot* please God."

Finally, in Galatians 3:10, Paul states the culmination of this descending process: *a curse*. "For as many as are of the works of the law are under the curse."

Thus, by the logic of the Holy Spirit, Paul analyzes the problem of the Galatian churches, which is also the problem of many contemporary churches. It stems from a deceiving, satanic influence that infiltrates the church and diverts the attention of God's people from the only source of His grace: *Jesus Christ crucified*. Paul categorizes this influence as *witchcraft* or *a spell*.

Cut off in this way from the source of grace, Christians inevitably degenerate into carnality and legalism. The final outcome of this downward drift is a *curse*. It has already been pointed out—in chapter 6—that spells and curses are the main tools of witchcraft.

In this way, the truth of Jeremiah 17:5-6 is carried over into the New Testament, and finds its expression in Galatians 3:1-10. "Trusting in the works of the law [legalism]" and "making flesh our strength [carnality]" culminate in a curse. As a result, God's people find themselves living in "parched places" and "a salt land."

Carnality can take many forms. Often these are obvious and unappealing to people with a religious outlook. Some typical examples would be: sexual uncleanness or immorality; vulgar language; overindulgence in food or drink; driving personal ambition; uncontrolled anger or other evil passions. What makes legalism especially dangerous is that it appeals to earnest, dedicated men and women who would not easily be entrapped by these more obvious sins of the flesh. Yet in its final consequences, legalism is just as deadly as other, less

"respectable" sins. It is Satan's favorite tool to divert Christians who could otherwise become a serious threat to his kingdom.

For me personally, the analysis of the Galatian problem is no mere exercise in abstract theology. On the contrary, it is very real, and also painful. In 1970, in Fort Lauderdale, I found myself sovereignly and supernaturally "joined" to a small group of ministers from various backgrounds. None of us had anticipated what happened to us, and none of us understood what God had in mind for us. Doubtless, if we had continued to rely on the Holy Spirit who had initiated our relationship, He would have gradually unfolded His purpose to us, but that was not the path we followed.

All too soon, and without our discerning what was happening, the various features of the Galatians 3 "syndrome" began to manifest themselves. Our decisions and actions were no longer initiated by the Holy Spirit, but were based on an elaborate system of rules and concepts that had been devised. We continued to acknowledge the Holy Spirit, but in the way that guests in a restaurant might acknowledge a waiter. If we felt we needed something, we would summon Him briefly. But for the most part we relied on methods and plans of our own devising.

Looking back, I realize now that the work the Holy Spirit had initiated among us posed a serious threat to Satan. He resorted, consequently, to the tactics that had been so successful in Galatia, and in countless other situations throughout subsequent Church history. There were two decisive steps. First, he displaced the cross from the center of our lives and ministries. Second, he displaced Jesus as "Head over all things" in our practices and relationships.[1] By an inevitable

[1] See Ephesians 1:22–23.

process, we degenerated into the normal type of religious organization, operating on the plane of our natural reason and ability.

Paradoxically, one main cause of our problems was the very fact that we had had a supernatural beginning. Like the Galatians, we had "begun in the Spirit." From that beginning, there was no easy or painless route by which we could simply become just another religious organization, functioning on the natural plane and taking our place alongside countless similar groups throughout Christendom. As Paul pointed out to the Galatians, that which has been initiated by the Holy Spirit can never be brought to completion by human flesh.

It was not long before we were confronted by the outworking of the curse we had thus brought on ourselves. Its manifestations were characteristic of other similar developments throughout Church history. Personal relationships were ruptured; congregations were split and scattered; promising ministries were cut short or else diverted from God's purpose; once-enthusiastic Christians were blighted by frustration and disillusionment. Many abandoned their faith. If we had been obliged to give a name to it all, we would have had to call it "Ichabod, saying, 'The glory has departed' " (1 Samuel 4:21).

The product of all religious activity that is not initiated and directed by the Holy Spirit is summed up, in Hebrews 6:1, by the phrase *dead works*. For this, the remedy is stated in the same verse: *repentance*. This was made real to me personally. I could not blame others. I had to accept responsibility for what I had been involved in. More than anything else, I realized that I had grieved and slighted the Holy Spirit.

I saw that I had to confess my sins to God and trust Him for forgiveness and restoration. This was a personal decision that only I could make. I could not make it on behalf of others, but if I could find a path that led to restoration, then those who

saw their need could follow the same path. In 1983 I repented and made the break.

In His mercy, God showed me, step by step, the path I was seeking. I discovered that there is a way to pass out from under the curse and enter once more into the blessing. If I had not made this discovery, this book would never have been written. For those who may find themselves in a similar situation, I offer a full explanation of the steps they need to take in Section 3: "From Curse to Blessing."

In Galatians 1:6–9 Paul exposes another way a curse may come upon the people of God: *apostasy.*

> I marvel that you are turning away so soon from Him who called you in the grace of Christ, to a different gospel,
>
> which is not another; but there are some who trouble you and want to pervert the gospel of Christ.
>
> But even if we, or an angel from heaven, preach any other gospel to you than what we have preached to you, let him be accursed.
>
> As we have said before, so now I say again, if anyone preaches any other gospel to you than what you have received, let him be accursed.

The kind of person here described is one who represents himself as a minister of Christ, but perverts the central truth of the Gospel. Paul declares that such a person brings a curse upon himself. The Greek word translated "accursed" is *anathema.* It denotes something that provokes God's wrath and is subject to His irrevocable condemnation and rejection.

The Gospel contains a central core of revealed truth that has been accepted and upheld by the general Church throughout all generations. It may be summed up as follows:

Jesus Christ is the divine, eternal Son of God, who became a member of the human race by virgin birth. He led a sinless life, died on the cross as a propitiatory sacrifice for the sins of humanity, was buried and rose again in bodily form from the grave on the third day. He ascended into heaven, whence He will return to earth in person, to judge the living and the dead.

Everyone who repents of sin and trusts in the sacrifice of Jesus receives forgiveness of sins and the gift of eternal life.

It is important to emphasize that the Gospel centers in the death and resurrection of Jesus. In 1 Corinthians 15:3–4 Paul sums up its message in three historical facts: "Christ died for our sins according to the Scriptures. . . . He was buried. . . . He rose again the third day according to the Scriptures."

The first authority that Paul cites in support of these facts is "the Scriptures"—at that time meaning the Scriptures of the Old Testament. As further confirmation of the resurrection, Paul goes on to list various eyewitnesses who saw Jesus after He rose from the dead. Their testimony is secondary, however, to that of the Old Testament Scriptures.

In two successive statements, Paul then stresses that faith in the bodily resurrection of Jesus is essential to salvation:

And if Christ is not risen, then our preaching is vain and your faith is also vain. . . . And if Christ is not risen, your faith is futile; you are still in your sins!

1 Corinthians 15:14, 17

In 2 Thessalonians 2:3 Paul warns that at the close of this age there will be widespread apostasy from the Christian faith. There are strong reasons for believing that we are now in the predicted period of apostasy. In some major Christian denominations, many recognized leaders have publicly renounced

faith in the Scriptures and—in particular—in the bodily res-
urrection of Christ. Probably they do not realize that their
declaration of unbelief is in itself a fulfillment of the Scrip-
tures they are rejecting!

One fact, however, they cannot change: Unless they re-
pent, those who in this way pervert the Gospel bring upon
themselves the wrath and the curse of God.

10
Theft, Perjury, Robbing God

The last three prophets of the Old Testament—Haggai, Zechariah and Malachi—all deal with various areas in which Israel experienced the outworking of God's curse. It is as though these prophets were given the task of summarizing the history of the Israelites since they had come under the Law of Moses, and of confronting them with the reasons why specific curses of the Law had come upon them.

In Zechariah 5:1–4 the prophet describes a vision he had of God's curse coming upon the homes of His people:

> I looked again—and there before me was a flying scroll!
>
> He asked me, "What do you see?"
>
> I answered, "I see a flying scroll, thirty feet long and fifteen feet wide."
>
> And he said to me, "This is the curse that is going out over the whole land; for according to what it says on one

side, every thief will be banished, and according to what it says on the other, everyone who swears falsely will be banished. The Lord Almighty declares, 'I will send it out, and it will enter the house of the thief and the house of him who swears falsely by my name. It will remain in his house and destroy it, both its timbers and its stones.' "

NIV

The curse that Zechariah depicts enters the house of all who have committed two specific sins: theft and swearing falsely. (The contemporary term for the latter is *perjury*.) Having once entered, the curse remains until it has destroyed the entire house—timbers and stones and all.

This is a vivid picture of the way a curse works, if we once admit it into our lives. We cannot set limits of our own choosing to the areas that will be affected by it. Unless we repent and seek God's mercy to deliver us, it will ultimately destroy the whole house.

The prevalence of these two sins of theft and perjury in our contemporary culture may be measured by some simple statistics. Theft is so pervasive today in the United States that nearly ten percent of the price of goods displayed in retail stores is due to the cost of insurance against theft. Here is a little-publicized cause of inflation! On the other side, perjury defrauds the U.S. Internal Revenue Service of billions of dollars each year through dishonest tax returns. Complete honesty in this area could perhaps wipe out the entire budget deficit!

According to Zechariah's vision, the curse that follows these two sins of theft and perjury affects not merely the individual, but also his entire house. In biblical Hebrew, the word *house* applies not simply to a material structure, but also to the people who live in it—that is, a family. Much more than would at first appear, these two sins, and the curse that follows them, have contributed to the breakdown of family life, which is a unique

feature of our present age. Their ultimate effect will be similar to that of the scroll Zechariah saw in his vision: the erosion of whole nations and even an entire civilization.

Earlier, Haggai had given an equally vivid picture of the blight that was affecting the lives of his people:

> "Is it time for you yourselves to dwell in your paneled houses, and this temple to lie in ruins?"
> Now therefore, thus says the Lord of hosts: "Consider your ways!
> "You have sown much, and bring in little;
> You eat, but do not have enough;
> You drink, but you are not filled with drink;
> You clothe yourselves, but no one is warm;
> And he who earns wages,
> Earns wages to put into a bag with holes."
>
> Haggai 1:4–6

The curse Haggai describes can be summed up in one word: *insufficiency*. To all outward appearances, the Israelites had everything they required to satisfy their main material needs. Yet for some reason they could not understand, there was always a deficiency. God had to send them a prophet to show them that the invisible force eroding their provisions was a curse they had brought upon themselves by putting their own selfish concerns before the needs of God's house.

Many of the affluent nations of the world today face a similar situation. Most people are earning far more than their parents or grandparents ever earned. Yet while the previous generations enjoyed a sense of contentment and security, the present generation is plagued with a restless craving that is never satisfied. In some of these nations, the level of personal indebtedness is higher than it has ever been.

Malachi, the last of the three prophets, combines the charges already brought against Israel by his two predecessors.

He accuses his people not only of a wrong attitude toward
God, but also of theft in its most serious form: robbing not
merely men, but even God Himself.

> "Will a man rob God?
> Yet you have robbed Me!
> But you say,
> 'In what way have we robbed You?'
> In tithes and offerings.
> You are cursed with a curse,
> For you have robbed Me,
> Even this whole nation."
>
> Malachi 3:8–9

This passage reveals a principle that governs God's dealings
in every age and dispensation: He keeps a record of what His
people offer to Him. More than a thousand years earlier, God
had ordained that Israel should set aside for Him the first
tenth of their total income, in cash or in kind. This was one
important mark of their covenant relationship with God. Dis-
obedience in this was a breach of their covenant.

Now, through Malachi, God presents His account. In re-
spect of all that His people have unlawfully withheld, He
charges them with "robbery." He points out that this has
brought a blighting curse on the whole nation and on every area
of their lives.

But God does not end on this negative note. In the next
verse He instructs His people how to pass out from under the
curse and enter into His blessing:

> "Bring all the tithes into the storehouse,
> That there may be food in My house,
> And prove Me now in this,"
> Says the Lord of hosts,
> "If I will not open for you the windows of heaven
> And pour out for you such blessing

That there will not be room enough to receive it."

Malachi 3:10

To pass from the curse to the blessing, God requires from His people two things: repentance and restitution. In every case of robbery, these requirements never vary, whether it is God or man who has been robbed.

In the New Testament, God never establishes a specific law, like that of the Old Testament, requiring Christians to set aside for Him a tenth of their total income. The covenant of grace does not operate through laws enforced from without, but through laws written by the Holy Spirit in the hearts of believers. In 2 Corinthians 9:7 Paul instructs Christians, "So let each one give *as he purposes in his heart*, not grudgingly or of necessity."

One thing, however, is certain: The Holy Spirit will never cause a believer to be stingy. In Psalm 51:12 David prays to the Lord, "Uphold me with Your *generous* Spirit." One distinctive characteristic of the Holy Spirit is generosity. God Himself is the greatest of all givers. When His Spirit moves on the hearts of His people, He will make them like Himself: generous givers.

In Hebrews 8:6 the writer contrasts the Old and the New Covenants, and reminds Christians that they have entered into "a better covenant, which was established on better promises." It is inconceivable that people who enjoy this better covenant should be less generous in giving to God than those who were under an inferior covenant. If God's people under the Law gave Him their tithes—and much more—how could Christians under grace possibly justify doing less? The standards of grace are higher, not lower, than those of law.

Throughout all dispensations, one basic principle continues unchanged: stinginess toward God provokes His curse, but liberality releases His blessing.

11
Authority Figures

Both blessings and curses are part of a vast, invisible spiritual realm, which affects the lives of every one of us. One central and decisive factor in this realm is *authority*. Without a grasp of the principles of authority, it is impossible to understand the realm of the spirit or to function effectively in it.

The twentieth century has witnessed an almost worldwide revolt against forms of authority that have been generally recognized by the human race for millennia. Major areas of social structure that have been affected include the family, the church and the various branches of secular government.

People often assume that this revolt has changed or abolished these forms of authority, but *this is not so*. The principles that govern the exercise of authority are as objective and universal as the law of gravity.

A person in an attitude of revolt may decide to reject the law of gravity and to jump out of a window on the tenth floor.

But his rejection of that law in no way changes or invalidates it. He will still fall to his death on the sidewalk below. The same applies to the laws that govern the exercise of authority. People may ignore them or reject them, but the course of their lives will still be determined by them, whether they recognize it or not.

Throughout the universe there is one, and only one, supreme source of authority: God the Creator. God does not normally exercise His authority directly, however, but delegates it to others of His choice. After Jesus rose from the dead, He told His disciples, "All authority has been given to Me in heaven and on earth" (Matthew 28:18). Since that time, God has placed all authority in the hand of Jesus. But Jesus, in His turn, delegates to others the authority He has received from the Father.

Thus authority throughout the universe may be pictured as an extremely strong cable, descending from God the Father to Jesus. In the hand of Jesus, the cable is separated into countless smaller cables that reach to persons whom He has appointed—both angelic and human—in various parts of the universe.

One term used in the Bible to denote a person who exercises authority is *head*. In 1 Corinthians 11:3, for instance, Paul writes:

> But I want you to know that the head of every man is Christ, the head of woman is man, and the head of Christ is God.

By this analogy of headship, Paul depicts a "cable" of authority that originates with God the Father, descends to Christ and from Christ to the man who fills the role of husband and father in a family. By virtue of this relationship, the man is the appointed authority in his home.

In human social relationships, the husband/father is the primary example of a person appointed to exercise authority. There are, however, many other commonly recognized authority figures: a ruler over his people; a military commander over his soldiers; a teacher over his pupils; a pastor over the members of his congregation.

God alone has *absolute* authority. All other forms of authority are subject to limitations of various kinds. Delegated authority is valid only *within a given sphere.* A ruler's authority, for instance, is normally limited by the laws of his nation and does not extend to "private" areas in the lives of his subjects. A father's authority over his family does not permit him to infringe the laws of the secular government. A teacher has authority over his pupils only within the limits of school life. A pastor has authority over his congregation only in matters that are governed by the form of religion the congregation has accepted.

All the above examples are generalities. For complete accuracy, it would be necessary to add many other qualifications and restrictions. Also, there could be cases where two forms of authority overlap, giving rise to conflicts. The examples given are sufficient, however, to establish the basic principles that govern the exercise of authority.

It is commonly assumed that whenever authority is abused, it is automatically canceled. This may happen in extreme cases, but normally it is not so. Authority in some form is a basic necessity for any kind of social life. Authority that is abused may inflict many hardships, but even so it is better than the alternative, which is anarchy.[1]

In many population centers today, the air that people

[1] Webster's Dictionary defines anarchy as: 1. The complete absence of government 2. political disorder and violence; lawlessness 3. disorder in any sphere of activity.

breathe has become so polluted that it is dangerous to health. God does not for this reason, however, remove all air from that area of the earth's surface. Even polluted air is preferable to no air at all. Similarly, even abused authority is better than anarchy.

One important way a person may exercise authority is by blessing those under his authority. Genesis 27 records the tremendous importance that both Jacob and Esau attached to the blessing of their father, Isaac. And with good reason, since the history of their descendants has been determined ever since by the words Isaac spoke over each of them at that time. Nor is Isaac an isolated exception. On the contrary, all through the Bible, the blessing of a father is considered second in importance only to that of God Himself.

Implicit in the authority to bless, however, is the authority also to curse. Blessing and cursing can never be separated from one another, any more than heat from cold or day from night. This means that persons with authority may exercise it in one of two ways: to bless or to curse. The same authority that makes a blessing effective makes a curse equally effective.

One dramatic example is provided by the family life of Jacob. Genesis 31 records how Jacob, with his two wives, two concubines and eleven children, departed by stealth from his Uncle Laban in Mesopotamia and set out to return to the land of Canaan. Laban, however, with a company of his relatives, set out in pursuit of Jacob and overtook him in the mountains of Gilead. There followed a confrontation between them, in which Laban accused Jacob of stealing his *teraphim* (household images or "gods" used for divination and supposed to "protect" a home from evil forces).

What Jacob did not know was that Rachel, the wife he loved most dearly, had secretly taken the images. Conse-

quently, Jacob reacted indignantly to Laban's accusation. He challenged Laban to search all his family's belongings, and then—to protest his innocence—he added what was in effect a curse: "If you find anyone who has your gods, he shall not live" (Genesis 31:32, NIV).

Laban did proceed to search all the belongings of Jacob's household, but Rachel succeeded in keeping the *teraphim* hidden. Nevertheless, the words of Jacob's curse were charged with a husband's authority. They were equivalent to a sentence of death on the person who had stolen the images. The fact that Jacob did not realize that his words were directed against Rachel did not prevent the curse from taking effect. Shortly afterward, in giving birth to her second son, Rachel died in labor. (See Genesis 35:16–19.) Such is the authority of a husband, either to bless or to curse!

It should be added that, by taking possession of false "gods," Rachel had trespassed in the area of idolatry and of the occult. Thus, by her own action she had already forfeited God's protection and exposed herself to the curse that inevitably follows occult involvement. Here is a clear example that the laws governing blessings and curses are—in their own sphere—as real and as objective as the law of gravity. They work, whether people recognize them or not.

In God's plan for marriage, husband and wife become "one flesh," thus merging their separate identities in a new unity. On this basis, a husband naturally includes his wife in the authority they share jointly over their children. Failing to do this, the husband may become arbitrary or despotic.

Today, however, it is more common for a husband to go to the opposite extreme by reneging on his responsibilities to his wife and children, and even abandoning them completely. In such circumstances, the wife is left to carry on her own a burden that should have been shared by the two of them

together. The result is frequently a complete breakdown of the whole family structure. All credit should be given to Christian wives who find themselves in this situation, but by faith, prayer and the grace of God successfully carry the extra burden that has been thrust upon them.

In the case of Jacob, he did not realize that the words he had uttered were directed against Rachel. In our contemporary culture, however, it often happens that a husband knowingly and deliberately directs bitter and crushing words against his wife. Here is a typical example:

Mary, who never received any domestic training from her mother at home, marries Jack, a business executive with a quick temper. Mary never succeeds in serving meals that are tasty or attractive. For a while, Jack exercises self-control and contains his impatience. Finally, he blurts out his frustration: "I'm sick of the way you serve our meals. You'll never learn to cook!" He repeats this—with variations—on many subsequent occasions.

From then on, Mary's hands tremble whenever she brings food to the table. Meals become an ordeal from which she longs to escape. After some years, the marriage breaks up. But the curse pronounced by Jack follows Mary through the rest of her life. Although talented and successful in other areas, she never does learn to cook. Whenever she finds herself in a kitchen, something dark comes over her that inhibits her natural ability. There is only one solution for her: to recognize the fact that her husband put a curse on her and to seek the release God has provided.

It also transpires, however, that Jack has pronounced a curse on himself, without knowing it. From the time he says, "I'm *sick* of the way you serve our meals," he begins to develop chronic indigestion, for which physicians can find no natural

cause or cure. Just like Mary's inability to cook, Jack's indigestion follows him to the end of his days.

(Chapter 12 will cover this important area of *self-imposed* curses.)

Obviously there could be many variations to the story of Jack and Mary. Mary's problem might be overweight. Jack's comment would take this form: "You just don't have the willpower that it takes to lose weight. You'll be fat for the rest of your life."

Or again, Mary might be one of those women who do not know how to handle money. Her budgeted amount runs out before the week is up. She never succeeds in balancing her checkbook. Jack might give vent to his frustration by saying: "A fourth-grader could handle money better than you do. You don't deserve to prosper. You'll be struggling for the rest of your life."

Picture another couple: Jim and Jane. Jim's language is more brutal than Jack's. He frequently closes bitter arguments by saying, "I hate your guts!" In the years that follow the inevitable divorce, Jane requires surgery in the area of the abdomen for three successive conditions, none of them directly related to the others.

The correct diagnosis for all three of Jane's problems is stated in Proverbs 12:18: "There is one who speaks like the piercings of a sword." It required the surgeon's scalpel to deal with the invisible wounds that Jim had inflicted by his bitter words.

Words such as Jack uses against Mary—or Jim against Jane—proceed out of moods that may range from impatience to anger to rage. Usually there is demonic pressure behind them. They are like barbed arrows, tipped with poison. Once they penetrate the flesh, the barbs make it difficult to pull

them out. Yet if they are left in, the poison spreads on the inside.

Greater even than the authority of a man over his wife is that of a father over his children. This is the most basic of all authority relationships. It is actually an extension of the eternal relationship of Father to Son within the Godhead.

Just as a father's blessing has measureless potential for good, so a father's curse has a corresponding potential for evil. Sometimes such a curse may be uttered deliberately. More often, perhaps—as in the relationship of a husband to his wife—a father may speak words to a child that are not deliberately intended as a curse, but nevertheless have exactly the same effect. Each of the following examples is a composite of elements I have encountered in real-life situations.

A father has three sons. The firstborn is welcome just because he is that—the firstborn. The youngest has unusual talent and an outgoing personality. But the middle son has neither of these factors in his favor. He broods over misunderstandings, but tends to keep his feelings to himself. Furthermore, the father sees in this middle son aspects of his own character that he does not like, but has never been willing to deal with in his own life. He finds it less painful to condemn them in his son than in himself.

As a result, the middle son never has a sense of his father's approval. In the end, he no longer tries to win it. His father interprets this as stubbornness. More and more frequently, he vents his disapproval in words such as: "You don't even try! You're lazy! You'll never make good!" Little does he realize that he is pronouncing an evil destiny that may easily follow his son through the rest of his life.

I could not count the men I have encountered personally whose lives have been blighted by negative, critical, destructive words spoken by a father. Out of these encounters I have

learned that such words are, in reality, a *curse*. The passage of time does not diminish their effect. Men past middle age may still find their lives blighted by words a father spoke to them in childhood. The only effective solution is to deal with them specifically as a curse, and to apply the remedy God has provided.

As with the cases of Jack and Mary, or Jim and Jane, there are many different variations to such a situation. A father who is skillful with his hands, for example, may have a son who is unusually late in developing manual dexterity. After the son has bungled various practical tasks assigned to him, the father exclaims, "Your fingers are all thumbs!" or, "You have two left hands!"

The father may speak these words jokingly, not in anger. Nevertheless, they make a permanent impact on the son. Thirty years later he is still embarrassed or diffident every time he is confronted with even a simple practical task. This continues to be an area of his life in which he never succeeds. Yet his root problem may not be so much lack of skill as lack of confidence. He has never rebuilt the confidence his father unintentionally destroyed in childhood.

Daughters, too, like sons, may suffer from the effects of a father's negative words. A teenage daughter, for instance, acutely conscious of her acne, spends hours each morning in front of her mirror, struggling to cover the blotches with various types of skin cream. Her father, waiting to drive her to school, is increasingly irritated by her failure to be ready on time. One day, when the daughter is later than usual, his irritation explodes. "You're wasting your time in front of that mirror," he barks. "You'll never get rid of your pimples!" Twenty years later the daughter—now a married woman with children of her own—is still struggling vainly to cover up her acne.

Bitter, angry words—whether spoken by a husband to his wife or a father to his child—are usually the outcome of a period of growing inner tension. It is like a whistling kettle placed on a stove to boil. At first, the tension builds up inwardly, without any outward indication. But when the water inside reaches the boiling point, the steam is expelled and the whistle is blown. After that, there is no way to recall that whistle. The only remedy is to take the kettle off and cool the water down.

For a Christian, this means turning to God with an urgent, inward prayer: "Lord, I'm beginning to lose control, but I yield my spirit to You. Will *You* please take control?"

Otherwise, when irritation and anger continually build up inside a person, they will ultimately be expelled, like steam, in hurtful, wounding words. The curse that accompanies them is like the whistle. Once it has been uttered, there is no way to recall it. Then the only solution is to recognize that a curse has been uttered, and seek God's help to revoke it.

A mother, too, has authority over her children, which is either shared with her husband or delegated by him. Sometimes, however, a mother is not content with the exercise of her legitimate authority. Instead, she exploits her children's affection and loyalty to gain illegitimate control over them and to direct the course of their lives. Another example of "witchcraft"! This becomes particularly evident when her children come to choose their mates. If the mother approves of their choice, she is all sweetness. But if she disapproves, a totally different side of her character appears.

In the section that follows, a husband and wife each relate their experiences resulting from a curse pronounced by the wife's mother at the time of their marriage. They describe, first of all, the effects that the curse had on each of them; then

how they became aware of the curse and took the scriptural steps to be released from it.

Husband

Living under a curse is like living in a vapor: The effects can be seen, yet it is without clear form and substance. Even though you may experience success, you feel only *frustration* and *hopelessness*.

For me, the blessings of God always seemed somewhat remote and unattainable. I often knew the Lord's presence and moved in the spiritual gifts, yet satisfaction in ministry and life always seemed just out of reach. My wife and children had nagging health problems, and finances were continually short (even though we tithed, gave regularly and lived frugally).

Though I knew clearly the ministry to which God had called me, I could not move into it. Most of my work seemed to end with just a measure of fruitfulness. I could start things, but couldn't complete them. I seemed to be facing some kind of invisible resistance.

This struggle went on for years. Then one day I found myself explaining the situation to a group of fellow ministers, including Derek Prince. They discerned a curse coming on my family from my mother-in-law. I will let my wife explain:

Wife

Early in my marriage I spent two days in prayer and fasting. I felt the Lord showed me that there was a curse in my family. My husband and I were newly baptized in the Holy Spirit and had never even heard of such a thing as a curse. Our experience, as we have sought to become free, could be compared to peeling layers off an onion.

This curse revolves around a spirit of witchcraft that has operated through the women in my family, especially my mother. My family was churchgoing, moral and quite "normal," but the witchcraft worked subtly to undermine the authority of the men in our family, while manipulating the other family members.

I was not aware of the extent of my mother's control until I became engaged. As my loyalty began to switch to my future husband, I could sense her growing resentment. That was when my mother said, "He'll never make any money and you'll have to work the rest of your life." All through the years of our marriage I have labored against that "curse." I was determined to "show her" by not working in an outside job, but I was, in fact, controlled by it because I wasn't free to have a job! Also, my husband and I could never visualize ourselves as prosperous, and we have had continual financial problems.

Then, shortly after I married, my mother said, "You know you're not a strong person physically." I felt as if someone had hit me on the head! What she said was such a shock to me because I had never perceived myself as a weak or sickly person. On the contrary, I had always been healthy and athletic. So I began to think that perhaps I had been wrong, and really wasn't strong physically. . . . Subsequently I have battled a lot of physical ailments, some of long duration.

I also struggled because I was responding to my own husband and children in some of the same ways my mother did. This left me with a sense of hopelessness. How could I get completely free from this curse? Witchcraft had exercised control in several generations of my family. It seemed the spirit associated with it truly believed it had the right to dominate me and, in fact, it believed it *owned* me!

Whenever I would be ministered to for deliverance this spirit would whisper to me that I couldn't really be completely free. I blamed my mother. . . . Through a slow, "layer-by-layer" process of revelation and deliverance I came to see that my enemy is *not* my mother. I have forgiven her, and acknowledged the curse of witchcraft that had been influencing both of us.

Since having ministry specifically to break these curses, I have had to learn to battle old thought and habit patterns. Now I daily confess with confidence: "Through the sacrificial offering of Christ on the cross I have been purchased out from under the curse and have entered into the blessings of Abraham, whom God blessed in all things" (Galatians 3:13–14). *Christ has redeemed me from the curse!*

Husband

After prayer for breaking of curses, there was a distinct "clearing of the air." The changes have been neither dramatic nor immediate, but they have been real. There is a sense of *direction* in my life.

There is *progress*. I feel that I have a scriptural degree of control over my life and that I can take my rightful place in my family. I can also see productivity and fruitfulness as a result of my labors.

Most important to me, there is *hope*. The nebulous darkness of the future has been replaced by excitement and joy at what God is doing. The "fog" is clearing!

It is important to see that the wife's mother was not aware of all the effects her words had on her daughter and son-in-law. She herself was the prisoner of a spiritual force that came from her own family background. Quite possibly it had af-

fected that family for many generations. The mercy of God provided a way of release from its control.

School life is another area in which authority relationships are important, although the authority of a teacher over pupils is not so clear-cut as that of a parent. Negative words spoken by a teacher to a pupil may have the same blighting effect as if they had been spoken by a parent. For instance, a teacher may become exasperated by a pupil who is inattentive and slow to learn, and blurt out words such as: "You'll never be able to read properly!" or "You always get things the wrong way 'round; you'll never succeed!"

In all probability, the teacher is unaware of the danger of such words and will never see the result they produce on the pupils in later life. Yet I have met grown men and women who have been struggling for the rest of their lives against the effect of words spoken by a teacher in grade school. I recall one dedicated Christian lady who had been haunted for forty years by a sense of inferiority going back to a remark by a teacher who had told her, "You're shallow!" In fact, it would have been difficult to find anyone to whom these words were less applicable.

Examples have been given above of the potentially blighting effect of words spoken by people who have authority proceeding out of a relationship. The specific relationships— chosen merely as examples—were those of a husband, a father, a mother and a schoolteacher. There is one characteristic thread that runs through the various ways in which these authority figures expressed themselves. It can be summed up in one brief phrase: "You'll never prosper—or succeed!"

Surely it is significant that Moses, in describing to Israel the outworking of "the curse of the law," used precisely the same words: "You shall not prosper in your ways" (Deuteronomy 28:29). For my part, whenever I hear a person using such

words, I am always on my guard against the possibility that a curse is being uttered.

Religion is another main area in which authority is vested in people who hold certain offices. Consequently, their words have a potential for good or evil that corresponds to the authority of their office. For many centuries in Europe, one main weapon used by the popes of the Roman Catholic Church was their papal "ban" (that is, *curse*), which they would proclaim on all whom they deemed to be heretics. It would be impossible to write an accurate history of Europe without taking into account the effects of this papal ban. Even rulers of nations feared it more than an actual declaration of war.

In the Protestant section of the Church, no person has ever achieved an authority equal to that of the pope. Nevertheless, wherever there is ecclesiastical authority, there is always the possibility of its misuse. Even the pastor of a small "independent" church, with a mere handful of members, can speak words that are, in effect, a curse.

I am reminded of a man with excellent business qualifications—let's call him Frank—who came for counseling. He had spent ten frustrating years in which nothing went right for him and he was barely able to support his wife and family. I asked Frank if anything had happened in his life at the point when things began to go wrong for him. His mind went back to a period when he and his family had been attending a small independent church. After various disagreements with the pastor, they had withdrawn their membership.

Since the family was one main source of the church's income, the pastor reacted out of fear and insecurity. The final exchange between Frank and the pastor was acrimonious—on both sides. Finally the pastor closed by saying: "God put you

in this church. If you leave, you'll be out of His will. Nothing will ever go right for you!"

Sure enough, from that time on, nothing did go right for Frank. Fortunately, when he understood the cause of his frustrations, he was able to release himself from that pastoral curse. But first he had to forgive the pastor and put things right between them. After that, the course of Frank's life changed for the better.

Frank's case is not exceptional. I have met an astonishing number of people who have been through similar experiences. Almost invariably, the pastor has taken the same line: "God put you in this congregation. If you leave, you'll never prosper!" (Note those familiar words!) But thank God, He has provided a solution—for both parties to the dispute.

In 1985, while ministering in Australia, I was confronted by the effects of an ecclesiastical curse that had persisted for more than three centuries. A lady—whom we will call Margaret—heard me teach on the theme of blessings and curses. At the end of my message, recognizing clear evidence of a curse at work in her family, Margaret stood—with many others—and repeated the prayer of release. Later, she sent me a letter giving the background of her case.

Her ancestors were from Scotland, from a clan called Nyxon. In the 1600s this clan had been involved in border wars between the Scots and the English. As a result, the Bishop of Scotland (who was appointed by the English) had pronounced a curse on the entire Nyxon clan. Margaret enclosed a copy of the curse, which decreed—among other things—that the members of the clan should be hanged, drawn and quartered,[2] and their entrails fed to the dogs and the swine. After the clan had been defeated in battle, this

[2] They were first hanged, then their corpses were dragged through the street by a horse or some other animal, and finally cut up into four pieces.

sentence was duly carried out on those members who were captured alive.

Two years later, on my return to Australia, I met Margaret briefly. Later she wrote this letter:

> Thank you so very much for praying for me and my family, and for delivering God's prophetic word to us while here in Melbourne. You asked if our family had changed since the release from the curse. I did not have time to tell you when we spoke, but, yes, my whole family—my husband, my two daughters, ages 24 and 23, and my son, age 21—have all come to know the Lord over the last two years and now we have joined a Full Gospel church here in Melbourne.

What astonishing testimony to the power of a curse! It had followed Margaret's clan through three centuries, and Margaret's branch of the clan right across the world, from Britain to Australia. Once the curse had been identified and revoked, the invisible barrier that kept God's blessing from Margaret's family was removed, and her entire household entered into salvation.

This naturally raises the question, *How many other families are being kept from salvation because of an unrecognized curse?*

12
Self-Imposed Curses

In one of the examples from the previous chapter, Jack said to his wife, "*I'm sick* of the way you serve our meals." By these words he unwittingly brought upon himself a curse of indigestion that continued to afflict him for the rest of his life.

With this example in mind, it is time now to examine more thoroughly this whole area of *self-imposed curses*. It is of vital importance for all who are concerned about their own personal welfare. It uniquely exposes the frightening power of the words we speak about ourselves. They are frequently like boomerangs, which come flying back to strike the one who spoke them.

In Matthew 12:36–37 Jesus gives a solemn warning about the danger of words carelessly spoken:

> "But I say to you that for every idle word men may speak, they will give account of it in the day of judgment.

"For by your words you will be justified, and by your
words you will be condemned."

Jesus here focuses on "idle words"—that is, words spoken
carelessly, without premeditation. Often when a person says
something foolish or negative about himself, he then excuses
himself by saying, "But I didn't really mean it." Yet it is
precisely against words of this kind, which people "don't
really mean," that Jesus warns us. The fact that the speaker
"doesn't really mean them" does not in any way minimize or
cancel the effect of his words. Nor does it release him from his
accountability.

In Proverbs 6:2 Solomon warns a person who has unwisely
put up security for a neighbor: "You have been trapped by
what you said, ensnared by the words of your mouth" (NIV).
This is only one of countless ways in which people are "en-
snared by the words of their mouths." We may easily be
caught in a snare of this kind without realizing it, but to get
free demands the conscious application of biblical principles.
We need to remember that God takes our words seriously,
even when we ourselves do not.

Mark 14:66–72 records how, in the court of the high priest,
Peter three times denied that he was a disciple of Jesus. To
enforce his third denial, he actually "began to curse and
swear." In other words, he invoked a curse on himself.

Peter was quickly stricken with remorse, but it is doubtful
even so that he understood the full implication of his own
words. Three days later, at the empty tomb, the angels told
the women, "Go and tell His disciples—*and Peter*—that He is
going before you into Galilee" (Mark 16:7). Peter was no
longer reckoned as being one of the disciples. By his own
words he had forfeited his standing as a disciple of Jesus.

Later, John 21:15–17 records how, by the Sea of Galilee,

Jesus graciously opened the way for Peter to regain his standing as a disciple. He asked Peter three times, "Do you love Me?" Peter answered each time in the affirmative, but he was grieved that Jesus put the question three times. He did not realize that Jesus was leading him in this way to revoke his previous denials. For each time that he had made a wrong confession, he now made the right confession. On this basis, he was reinstated as a disciple.

The way Jesus dealt with Peter establishes a pattern for all who need to be released from the snare of a bad confession. There are three successive steps: Repent—Revoke—Replace. First, we must acknowledge that we have made a wrong confession and *repent* of it. Second, we must *revoke* it—that is, we must unsay, or cancel, whatever we said that was wrong. Third, we must *replace* our previous wrong confession with the right one. These three steps, taken in faith, can release us from the snare.

Genesis 27:12–13 provides another example of a self-imposed curse. Rebecca was persuading her son Jacob to deceive Isaac, his father, now blind, in order to obtain his blessing (which Isaac intended to pronounce on his other son, Esau). Jacob was eager for the blessing, but fearful of the consequences if Isaac should discover his deception.

"Perhaps my father will feel me," he said, "and I shall seem to be a deceiver to him; and I shall bring a curse on myself and not a blessing."

Rebecca responded immediately, "Let your curse be on me, my son."

Rebecca's plan to obtain the blessing for Jacob succeeded, but her own words exposed her to a curse that kept her from enjoying the fruits of her success. Her mood quickly became one of pessimism and cynicism. Soon afterward we find her saying to Isaac, "I am weary of my life because of the daugh-

ters of Heth; if Jacob takes a wife of the daughters of Heth
. . . what good will my life be to me?" (Genesis 27:46).

Almost immediately, too, Jacob had to leave home to es-
cape the vengeance of his brother, Esau, and he was gone for
about twenty years. The Bible tells us nothing about the rest
of Rebecca's life or about the time and manner of her death.
It would seem, however, that she never had the satisfaction of
seeing Jacob enjoying the blessing that her deceptive scheme
had obtained for him.

Over the years I have heard many people speak about them-
selves in the same way as Rebecca: "I'm tired of living. . . .
Nothing ever goes right. . . . What's the use? . . . I give
up! . . . I might as well be dead. . . ." I have learned by
experience that expressions such as these almost always indi-
cate a self-imposed curse at work in the life of the one who
utters them.

A much more tragic and far-reaching example of a self-
imposed curse is depicted in Matthew 27:20–26. Against his
own judgment, the Roman governor, Pilate, consents to re-
lease to the crowd a murderer named Barabbas and to impose
the death sentence on Jesus instead. In order to disassociate
himself from this act, however, he washes his hands in front
of the crowd and says, "I am innocent of the blood of this just
person."

To this the crowd responds, "His blood be on us and on our
children."

These words combined two forms of curse: a *self-imposed*
curse on themselves; a *relational* curse on their descendants.
The objective record of history confirms the outworking of
both. Within one generation the Roman armies had destroyed
Jerusalem, and either killed or sold into slavery the entire
population.

Since that time, for nineteen centuries, a dark strand of

bloodshed and tragedy has been interwoven in the destiny of the Jewish people. Time after time, in pogrom after pogrom, Gentile rulers have turned loose against defenseless Jews violent, depraved men of the caliber of Barabbas—the one whom they had chosen.

But thank God, that is not the end! God has provided a way of reconciliation and restoration. Through His unsearchable wisdom and His marvelous mercy, the death of the One who was executed as a criminal has provided a way of escape from the consequences of the curse. Chapter 17 will explain this in detail.

Earlier, in chapter 8, we saw that when God originally called Abraham and blessed him, He also pronounced a curse on all who would curse him. Later, this curse was reaffirmed when Isaac blessed Jacob, and once more when Balaam pronounced a prophetic blessing on Israel as a nation. In this way God provided protection for Jacob and his descendants—the Jewish people—from all who would seek to put a curse on them. Subsequent history revealed, however, that there was one kind of curse from which even God could not protect His people: *the curse they pronounced on themselves.*

The same applies to Gentile Christians who have become heirs to Abraham's blessing through the New Covenant initiated by Jesus. Included in the provisions of the Covenant is the right to invoke God's protection against curses that proceed from any external source. But there is one kind of curse against which even God cannot provide protection: *the curses that Christians pronounce upon themselves.*

This is one way in which Christians frequently bring upon themselves various kinds of trouble of which they do not understand the source. By speaking negative words about themselves, they shut themselves off from blessings and expose themselves to curses.

In this, too, the history of Israel provides a vivid example. Chapters 13 and 14 of Numbers record how Moses sent twelve tribal leaders to spy out the land of Canaan, which God had promised to Israel as an inheritance. Two of them—Joshua and Caleb—returned with a positive report: "Let us go up at once and take possession, for we are well able to overcome it." The other ten gave a negative report that focused on giants and walled cities. Their conclusion was: "We are not able to go up against the people, for they are stronger than we."

In due course, the Lord pronounced His judgment. To all those Israelites who gave credence to the negative report He said: "Just as you have spoken in My hearing, so I will do to you: The carcasses of you who have murmured against Me shall fall in this wilderness." The carcasses of the unbelieving spies were the first to fall. To Joshua and Caleb, on the other hand, the Lord promised that they would take possession of the land concerning which they had given a positive report.

All those spies—both the believing and the unbelieving—determined their own destiny by the words they spoke concerning themselves. Those who said, "We are able to enter the land," did enter it. Those who said, "We are not able," did not enter. God took them at their own word. He has not changed! To Christians, just as much as to Israelites, God still says, "Just as you have spoken in My hearing, so I will do to you."

Earlier, in chapter 4, we listed seven characteristic conditions that may be marks of a curse. Often it is the way in which people speak about themselves that exposes them to these conditions. Without recognizing it, such people are actually pronouncing curses upon themselves. To guard against this, they need to recognize the wrong forms of speech that they have been using and to cultivate new, positive speech patterns in their place.

The list below repeats the seven conditions that may indi-

cate a curse, but adds under each heading typical forms of speech that commonly open people up to the condition described. These few examples should be sufficient to indicate the kinds of expressions that are dangerous and the areas in which it may be necessary to change. For our part, Ruth and I have learned to exercise continual vigilance and self-control in the way we speak about ourselves.

1. *Mental and/or emotional breakdown*

"It's driving me crazy!"
"I just can't take any more."
"It makes me mad to think. . . ."

2. *Repeated or chronic sicknesses (especially if hereditary)*

"Whenever there's a bug, I catch it."
"I'm sick and tired. . . ."
"It runs in the family, so I guess I'm the next."

3. *Barrenness, a tendency to miscarry or related female problems*

"I don't think I'll ever get pregnant!"
"I've got the 'curse' again."
"I just know I'm going to lose this one—I always do!"

4. *Breakdown of marriage and family alienation*

"The palmreader said my husband would leave me."
"Somehow I always knew my husband would find another woman."
"In our family we have always fought like cats and dogs."

5. *Continuing financial insufficiency*

"I never can make ends meet—my father was the same."

"I can't afford to tithe."

"I hate those 'fat cats' who get all they ever want—it never happens to me!"

6. *Being "accident-prone"*

"It always happens to me!"

"I knew there was trouble ahead. . . ."

"I'm just a clumsy kind of person."

7. *A history of suicides and unnatural or untimely deaths*

"What's the use of living?"

"Over my dead body!"

"I'd rather die than go on the way I am."

People who use this negative kind of language are unconsciously inviting evil spirits to take them over. The type of evil spirit that responds is determined by the language used. There are classes of spirits that correspond to each of the seven categories listed above.

One kind of spirit that is particularly common is the spirit of "death." This responds to the kind of language listed under the category of "Suicides and unnatural or untimely deaths." It produces a sense that life is meaningless and hopeless, and a morbid tendency to focus on thoughts of death. It is often manifested also in a never-ending series of physical infirmities, for many of which there is no obvious medical cause.

Ultimately, this spirit of death will either drive a person to suicide or cause untimely death in some other way. In John 8:44 Jesus warned us that Satan is a murderer. One of the

agents that he uses to murder people is the spirit of death, which causes people to die before their time. When I shared this with a physician friend, he confirmed that he often saw people die when there was not sufficient medical cause to explain it.

It may be that in one or another of the categories listed above you have recognized things that you yourself have said. If so, don't be discouraged! There is a way out! Earlier in this chapter the apostle Peter provided an example of the three steps that are necessary to escape from a self-imposed curse: Repent—Revoke—Replace.

First, we must recognize that we have made a negative confession about ourselves and we must *repent* of it. Second, we must *revoke* it—that is, unsay or cancel it. Third, we must *replace* our previous wrong confession with the right one. All this will be explained more fully in chapter 21.

Another way in which people can bring a curse upon themselves is by pledges or oaths that are required for admission to a closed fraternity or sorority, or to a secret society. I recall a situation in which my first wife, Lydia, and I were seeking to help a Christian young woman be set free from demonic bondage. In spite of many prayers and struggles, there was no deliverance. Suddenly Lydia was prompted to tell the young woman to take off a ring she was wearing. As soon as she did so, she was set free without further struggles.

Lydia acted solely on the prompting of the Holy Spirit. She knew nothing about the ring, which was actually a college sorority ring. To join the sorority the young woman had been required to make certain pledges that were inconsistent with her Christian faith. By discarding the ring, she effectively canceled those pledges and regained her liberty as a child of God.

On another occasion, Lydia and I were part of a group

ministering to a young woman who confessed that she had been a priestess of Satan. She was wearing a ring that symbolized her "marriage" to Satan. When we told her she would have to take the ring off, she did so—but then, under the compulsion of Satan, she swallowed it. A young man present received a special anointing of faith, and commanded the woman to regurgitate the ring, which she promptly did! We then threw the ring into a nearby lake. The final stage in the woman's deliverance followed when she publicly burned all the clothes she had worn while worshiping Satan.

Incidents such as these have made very real for me the directions given in Jude 23: "Save others, snatching them out of the fire; and on some have mercy with fear, hating even the garment polluted by the flesh" (NASB).

In both the above instances, satanic bondage was associated with a ring. The significance of a ring is that it often symbolizes a covenant relationship. In our Western culture, for example, it is normal for a man and his wife each to wear a ring, symbolizing the covenant relationship of marriage. By biblical standards, a covenant is the most solemn and powerful form of relationship into which a person can enter, whether the covenant is between God and man, or between man and his fellow men. Satan is well aware of this, and he therefore exploits covenant relationships of his own making in order to gain the strongest possible control over people.

For this reason, in Exodus 23:32, God instructed the Israelites concerning the idolatrous nations of Canaan: "You shall make no covenant with them, nor with their gods." God was warning His people that if they entered into a covenant with the Canaanites who worshiped false gods, that covenant would bind them not merely to the Canaanites, but also to their gods. They would thus be bringing themselves into bondage to those gods.

One section of contemporary society to which this warning particularly applies is Freemasonry. Masons claim that the nature of their association is a secret, but this is not correct. All the major rites and formulas of Freemasonry have been publicized at various times, both by people who were formerly Masons (including some who had advanced to the highest degree), and by others who have carefully examined the material that is available to any competent researcher.

For present purposes, it is sufficient to point out two facts about Freemasonry. First, in order to be initiated, a person has to bind himself by the most cruel and barbarous oaths never to reveal any of Masonry's secrets. It would be impossible to find anywhere a more frightening example of self-imposed curses than these oaths.

Second, Masonry is a false religion. Some Masons would deny that it is a religion, but here are some of the main features that clearly mark it as such: Masonry has its own *revelation;* its own *temples;* its own *altars;* its own religious *symbols* and *emblems* (which include a *ring*); its own *confession of faith;* its own *priests;* its own *rituals.* Finally, it has its own *deity,* a false god, whom it calls a "Creative Principle" or "the Great Architect of the Universe."

Masonry is a *false religion* because it acknowledges a *false god.* Many of the objects and symbols associated with Christianity—including the Bible—are used in Masonry, but this is a deliberate deception. The god whom Masonry acknowledges is *not* the God of the Bible. Although the sacred, biblical name of four letters—JHVH (commonly spelled out as "Jehovah")—is used in Masonic literature, it is interpreted as referring to a divine entity that combines in itself both male and female principles. Again, the Royal Arch degree uses an abbreviated form of the name Jehovah in combination with abbreviated forms of two heathen deities, Baal and Osiris, and

acknowledges this "combined" being as god. This is nothing short of a deliberate insult to the one true God revealed in the Bible as Jehovah.[1]

For my part, I had no interest at all in Freemasonry until I began to discover the harmful effects it had produced in the lives of people who came for prayer. Some of the most frightening examples that I have encountered of curses at work in people's lives were associated with Freemasonry. The effects were manifested in the second and third generations of those who had a Mason in their family background.

One case made a special impression on me. At the close of a Sunday morning worship service in Australia, Ruth and I were praying for people who needed healing. One of those who came forward was a young woman whose dull eyes, unkempt hair and slurred voice suggested a background in the subculture. In her arms she carried a tiny baby.

"She just won't take anything to eat," the mother mumbled with her eyes averted. "Just an ounce or two at a time."

"How old is she?" we asked.

"Six weeks," the mother replied, but the baby looked more like six days than six weeks old.

When Ruth and I placed our hands on the mother to pray for her, she fell backward under the power of the Holy Spirit. As she fell, Ruth caught the baby from her and held it in her own arms. Two church workers began to pray for the mother on the floor.

Ruth then received a word of knowledge by the Holy Spirit. "Her father is a Freemason," she said to the two workers. "Tell her to renounce that spirit."

The mother on the floor struggled to get out the words, "I

[1] Anyone interested in a comprehensive study of this subject is referred to the book *Freemasonry: An Interpretation* by Martin L. Wagner (obtainable from HRT Ministries, Box 12, Newtonville, N.Y. 12128–0012).

renounce . . . that spirit . . . of Freemasonry." As soon as she uttered those words, the evil spirit came out of her with a prolonged scream. At the same moment, the baby in Ruth's arms emitted a precisely similar scream, and then became limp. The workers helped the mother onto her feet, and Ruth placed the baby back in her arms.

About six hours later we were back again in the same church for an evening service. At the close, the same young woman came up once more with her baby.

"How's she doing?" we asked.

"She's completely different," the mother replied. "She's taken three full bottles since the morning!" I could not help thinking that the mother, too, had undergone a dramatic change, which shone out of her eyes and sounded in the clarity of her voice.

I reflected later that in one brief encounter we had seen visible evidence of a curse due to Freemasonry that had carried over to at least two generations: from the father himself who was a Mason, to his daughter and then to his granddaughter, a baby just six weeks old. I determined from then on that I would be diligent to warn people of the harm that Masons bring not only on themselves, but on the members of their families, even those who have no direct involvement in Freemasonry.

To all who have made a pledge or a vow binding them to an evil association, such as those mentioned above, Solomon offers an urgent word of counsel in Proverbs 6:4–5:

> Give no sleep to your eyes,
> Nor slumber to your eyelids.
> Deliver yourself like a gazelle from the hand of the
> hunter,
> And like a bird from the hand of the fowler.

There are two minimum requirements for deliverance. First, you must make a verbal renunciation of your association. *What you have said with your lips, only you can unsay.* It is best to do this in the presence of sympathetic witnesses who will support you with their faith.

Second, you must get rid of, and destroy, all the emblems, books and other materials that were marks of your association. In all the three types of situations mentioned above a ring was of special significance. In the case of a Freemason, there would also be various other objects—particularly the apron. Remember the words of Jude 23: "Hating even the garment defiled by the flesh."

13
Servants
of Satan

In this chapter we will uncover a completely different source of curses: servants of Satan.

Attitudes toward Satan among Christians vary between two extremes. Some ignore Satan totally, and try to act as if he is not real. Others are afraid of him and give him far more attention than he deserves. Between those two extremes there is a scriptural balance.

Satan is a created being, a rebellious angel, who was cast out of God's heaven. He rules over a spiritual kingdom of evil, rebellious angels, together with lesser evil spirits, who are called "demons."

The name *Satan* means "Adversary" or "Opposer." He is the unchanging, implacable enemy of God Himself and of the people and the purposes of God. His aim is to bring the whole human race under his control. His primary tactic is deception, of which he is a master. In Revelation 12:9 he is described as

"the great dragon . . . that serpent of old, called the Devil and Satan, *who deceives the whole world.*"

Satan already exercises dominion over the great majority of mankind—all those who are in an attitude of rebellion against God. In Ephesians 2:2 he is described as "the spirit who now works in the sons of disobedience." Most of these have no clear picture of their real condition. They are simply driven to and fro by forces they do not understand and cannot control.

There are those among them, however, who have deliberately opened themselves up to Satan, even though they may not be aware of his true identity. In pursuit of power and material gain, they systematically cultivate the exercise of the supernatural forces Satan has released to them. Such servants of Satan are recognized in almost all cultures and have been given a variety of different titles: witch doctor, medicine man, mchawi, shaman, tohanga, wizard, witch, priest or priestess of Satan, and so on. In almost all tribal cultures throughout the world there is a special name for this kind of person.

Jesus Himself is our main source of information concerning Satan. When He sent out seventy disciples to prepare the way before Him, they returned with joy, saying, "Lord, even the demons are subject to us in Your name." To this Jesus responded, "Behold, I give you the authority to trample on serpents and scorpions, and over all the power of the enemy, and nothing shall by any means hurt you" (Luke 10:17–19).

Jesus did not deny that Satan was real or that he had power. But He promised His disciples that the authority He conferred upon them would make them victorious over Satan's power and would protect them against all his attempts to harm them. It is important for all of the Lord's servants to recognize the authority He has given them and to learn to exercise it effectively.

Curses are one of the main weapons that servants of Satan

use against the people of God. This is vividly illustrated by the story of Balak and Balaam in Numbers 22–24.

Balak was king of the territory of Moab, on the east of the Jordan. On their journey from Egypt to Canaan, Israel had encamped on the border of Moab. Balak felt his kingdom was threatened, but he lacked the strength or the courage to launch an open attack on Israel. Instead, he hired Balaam to pronounce curses on them, in the hope that Israel would thus be weakened to the point where Moab could defeat them. Balaam was a "witch doctor," famous throughout the whole region, who commanded a high fee for his services.

Many Christians today would dismiss all this as superstitious "nonsense," devoid of any real power. God's reaction, however, was entirely different. He viewed the curses that Balaam might pronounce as a serious threat to Israel. Consequently, He intervened supernaturally and warned Balaam not to accept the assignment. But Balaam was eager for the wealth Balak had promised him, and so went ahead with the intention of doing what Balak had asked. In due course, however, each time Balaam tried to pronounce curses on Israel, God again intervened and changed the proposed curses into blessings!

Subsequently, in Deuteronomy 23:5, Moses reminded Israel of this incident as evidence of God's love for them: "Nevertheless the Lord your God would not listen to Balaam, but the Lord your God turned the curse into a blessing for you, because the Lord your God loves you."

One important fact needs to be emphasized: God did not view Balaam's proposed curses against Israel as empty words that had no power. He regarded them as a serious threat to Israel, and for this reason He intervened personally to frustrate Balaam's intention.

Time has not changed God's viewpoint. He does not ignore

or belittle curses directed against His people by servants of
Satan. On the contrary, as Jesus said, God recognizes the
power of Satan, but equips His own servants with superior
power.

The Bible presents various pictures of the activities of Sa-
tan's servants. These serve to warn God's servants, against
whom these satanic activities are often directed. In Ezekiel
13:17–20, for example, God condemns certain false prophet-
esses, or sorceresses:

> "Likewise, son of man, set your face against the
> daughters of your people, who prophesy out of their own
> heart; prophesy against them,
> "and say, 'Thus says the Lord God: "Woe to the
> women who sew magic charms on their sleeves and make
> veils for the heads of people of every height to hunt
> souls! Will you hunt the souls of My people, and keep
> yourselves alive?
> "And will you profane Me among My people for
> handfuls of barley and for pieces of bread, killing people
> who should not die, and keeping people alive who should
> not live, by your lying to My people who listen to lies?"
> 'Therefore thus says the Lord God: "Behold, I am
> against your magic charms by which you hunt souls there
> like birds." ' "

Some of the details are not clear, but it seems that these
women played the typical role of a witch doctor. Anyone who
had a quarrel with some other person would hire them to use
their magic arts against that person. One of their methods was
to attach magic charms to people's clothing. In this way, they
"hunted souls" and actually killed innocent persons. In re-
turn, they were paid in handfuls of barley or pieces of bread.

This is not some farfetched accusation reminiscent of the
Middle Ages. It is a charge brought against these women by

God Himself. Furthermore, servants of Satan have used similar methods for the same purposes all through the centuries and still continue to use them today.

In 1979–80, in the city of Bath in the West of England, archaeologists uncovered the remains of a temple of the goddess Minerva dating back to the Roman period. The priests in this temple had a similar ministry to that of the sorceresses in Ezekiel's day. People seeking revenge on someone would employ the priests to write out an appropriate curse against that person. The writing of the curse required special skills possessed only by the priests. Once the curse had been written, some kind of magic ceremony was used to direct it against the person who was its target. For all this, of course, the priests received appropriate payment. Also, the worshipers would cast their votive offerings for the goddess into the spring associated with the temple.

This way of using curses and magical arts is still a familiar part of daily life among the majority of the world's peoples, particularly in Asia, Africa, Oceania and Central and South America. The following account comes from a missionary friend of mine who has lived his whole life in Zambia, in central Africa, and is intimately acquainted with the languages and the customs of the people there.

At a General Conference of Christians in our rural district of Zambia, the Holy Spirit had spoken a strong prophetic word calling for holiness in the Church. Many Christians were convicted of sin in their lives and had truly repented, confessing their sin and pleading for God's forgiveness.

After the service, an elder from one of our remote village churches came to the preacher in tears, trembling

all over, confessing to the terrible sin of *murder through witchcraft.*

The elder told him that for some years he had been fighting with his fellow elder in the church who was senior to him. The situation had gotten so bad that he had decided to punish him by going to a local witch doctor and paying him to curse this other elder. The witch doctor had been happy to do so, especially as he knew that these men were supposed to be Christians. He asked for a large down payment, and then told the man to come back the following day.

When he returned, the elder found the witch doctor sitting under a tree with a mirror in his hand and a bowl of witchcraft medicine on the ground before him. The witch doctor then proceeded to sponge the medicine all over the mirror, and asked the elder to look carefully at the mirror and tell him what he could see.

Startled, the elder saw the face of his fellow elder quite clearly. Whereupon the witch doctor took a razor blade and cut across the throat of the face reflected in the mirror. Immediately the mirror was covered in blood.

The elder cried out, "You have killed him! I only asked you to curse him." The witch doctor replied with a chuckle, "I thought I would do the job properly whilst I was at it!"

The elder hurried home. To his horror he learned that his fellow elder was indeed dead, having died mysteriously of a sudden hemorrhage. The elder was terrified of the consequences of his action, so he had kept quiet about it. Now the Holy Spirit had powerfully convicted him of his sin.

Fortunately for him, "where sin abounded, grace did much more abound." Through confession, repentance and faith in Jesus Christ, the man was not only brought to forgiveness and peace with God, but to the reality of the new birth.

Some Western readers might be disposed to dismiss all of this as primitive, superstitious practices from "darkest Africa." But the truth is that even in the more highly civilized nations (so-called), occult practices, which had been on the decline, are once again making tremendous inroads. In West Germany, for example, many businessmen, who would never seek counsel from a Christian minister, make a regular practice of consulting a fortune-teller concerning their business deals.

In the mid-1980s a leader of the Satanic Church in America was interviewed on television. He was asked if it is true that Satanists practice human sacrifice. He replied: "We perform human sacrifices by proxy, you might say—the destruction of human beings who would, let's say, create an antagonistic situation toward us—in the form of curses and hexes."[1] This was not a charge brought against him by some hostile critic; it was an admission he made freely of his own accord.

In Israel, under the Law of Moses, this would have been punishable by death. In our contemporary culture, however, occult practices are not a crime, and there is no penalty attached to them, even if they are used to kill people.

The statement of the Satanist quoted above reveals their use of curses and hexes to kill people, but it by no means absolves them from the charge of performing human sacrifices. Gruesome evidence to the contrary is contained in the following report from the New York *Times*, which ran April 12, 1989, dateline Matamoros, Mexico:

On Tuesday, . . . officials [Mexican and U.S.] found the bodies of 12 people, including a 21-year-old University of Texas student who had vanished here a month ago,

[1] Quoted from *America: The Sorcerer's New Apprentice* by Dave Hunt and T. A. McMahon (Harvest House Publishers, 1988).

in eight crude graves on [a remote ranch near the U.S. border]. Today, at news conferences here and in Brownsville, Tex., the officials said that a drug gang, seeing human sacrifice as "a magical shield" that would protect it from the police, was responsible for the murders. . . .

Among the suspects still at large is an accused drug smuggler identified as Adolfo de Jesus Constanzo, a native of Cuba, whom the others call El Padrino—the godfather. The police said he ordered the ritual murders, pointing out young men at random on city streets for his followers to abduct, then murder and mutilate on the ranch.

The officials described the murders as a twisted blend of sacrificial and black magic practices from Haiti, Cuba and Jamaica. . . .

There have also been reports from various places in the United States of the sacrifice of infants and small children, carried out by Satanists as part of their rituals.

The primary targets of satanic curses and other occult weapons are the servants of God and Jesus Christ. Satanists rightly recognize who their main enemies are, and direct their attacks against them accordingly. This is illustrated vividly by an incident related to me by a minister friend.

A Christian lady known to my friend was eating with her family in a restaurant in New Orleans—which is reported to be the spiritual center for witchcraft in the U.S.A. While at the table, they were approached by Satanists who had entered the restaurant to "witness" in the same way some Christians might do, going from table to table. They were actively recruiting people for Satanism and showed the lady a printed prospectus for the year 1988, outlining the following six-point, worldwide program, which was to be accompanied by fasting and prayer (!):

1. That the Antichrist would manifest himself soon.
2. That ministers, leaders and missionaries would fall.
3. That ministries and works of God would be destroyed.
4. That Christians would become complacent; want peace over and above all; and seek churches that do not preach a full gospel with pastors that keep peace no matter what the sin.
5. That Christians cease their fasting and prayer.
6. That the gifts of the Holy Spirit be ignored.

This is but one of many evidences that the Church of Jesus Christ is currently under intense, systematic attack by the forces of Satan. What can the Church do? Christ defeated Satan on the cross. How can we, first of all, defend ourselves; and secondly, make Christ's victory a daily reality in our personal lives and in our churches?

Some illuminating answers are provided by the story of Balaam's attempt to bring a curse on Israel. God intervened on behalf of Israel and turned the proposed curse into a blessing. What did God see in the conduct of Israel at that time that moved Him to take His stand against Satan on their behalf?

Here are some important factors that combined to draw God's favor down upon His people:

1. The people of Israel were moving in fulfillment of God's plan for them.
2. They were supernaturally guided, day and night, by a cloud and a pillar of fire. This corresponds to the guidance of the Holy Spirit for New Testament believers. (See Romans 8:14.)
3. They were a nation under discipline, with God-appointed leaders and God-given laws.

4. Their relationships were carefully ordered according to a divine pattern. This harmonious pattern of relationships was beautifully depicted by Balaam's own visionary description of them in Numbers 24:5–6:

> "How lovely are your tents, O Jacob!
> Your dwellings, O Israel!
> Like valleys that stretch out,
> Like gardens by the riverside,
> Like aloes planted by the Lord,
> Like cedars beside the waters."

Obviously, this was not a literal picture of Israel, since they were encamped at that time in a desert area.

5. Much of the above was due to the fact that a whole generation of unbelieving and disobedient Israelites had been purged out from among them. (See Numbers 26:63–65.)

What are the lessons to be learned from this picture of Israel? Its main features could be summed up thus: Israel was a community divinely ordered, disciplined and guided, living in harmony with one another. To state it another way, Israel was not just an assembly of individuals each "doing his own thing."

God has not changed in what He looks for in His people; nor has Satan changed in his tactics against God's people. If the Church at this time does not fulfill the requirements for God's favor and protection, there is only one remedy: *the Church must change.*

Unfortunately, however, the record of Balaam's strategy against Israel does not end with total victory for Israel. Having failed in his attempt to bring a curse upon Israel, Balaam resorted to a second tactic. He advised Balak to use the Mo-

abite women as a snare, to entice the men of Israel, first, into sexual immorality and, second, into idolatry. Where Balaam's first tactic had failed, his second succeeded.

After that, he had no need to pronounce a curse upon the Israelites. By breaking God's first commandment, they had brought God's own curse upon themselves, and 24,000 of them perished. (See Numbers 25.) In Numbers 31:16, Moses states specifically that this came about through the counsel of Balaam.

In 1 Corinthians 10:8 Paul holds up this incident as a warning to believers in the New Testament. The deceitful tactics of Balaam are also mentioned in three other passages of the New Testament: 2 Peter 2:15–16, Jude 11 and Revelation 2:14. Obviously the strategy of Balaam against Israel contains important warnings also for believers in the New Covenant. The central lesson is simple: Christians who are living in disciplined obedience to God and in harmony with each other can look to God for His protection against Satan. But Christians who are undisciplined, disobedient and out of harmony forfeit their claim on God's protection.

14
Soulish Talk

It is not difficult for Christians to understand that spiritual forces directed against them from servants of Satan would be dangerous and harmful. Many Christians would be surprised, however, to learn that there are situations in which spiritual forces emanating from their fellow believers could also be harmful. Yet in James 3:14–15 the apostle is writing both to and about Christians when he warns:

> But if you have bitter envy and self-seeking in your hearts, do not boast and lie against the truth.
> This wisdom does not descend from above, but is earthly, sensual, demonic.

To describe a certain kind of "wisdom," James uses adjectives on three descending levels: first, "earthly"; below that, "sensual"; and below that, "demonic." The key to understanding the downward process lies in the second adjective,

here translated "sensual." The Greek word is *psuchikos*, formed directly from *psuche*, meaning "soul." The corresponding English word would be "soulish." Translated in this way, it fits in naturally with the Bible's picture of human personality.

In 1 Thessalonians 5:23 Paul prays: "Now may the God of peace Himself sanctify you completely; and may your whole spirit, soul, and body be preserved blameless." Paul here puts together the three elements that make up a complete human personality, listing them in descending order from the highest to the lowest: first, spirit; then, soul; then, body.

The spirit is that part of human personality that was directly inbreathed by God at creation. It is therefore capable of direct union and communion with the Creator. In 1 Corinthians 6:17 Paul says: "He who is joined to the Lord is *one spirit* with Him." It would not be correct to say "one soul with Him." Only man's spirit is capable of direct union with God.

In the original pattern of creation, man's spirit related upward to God and downward to his soul. God communicated directly with man's spirit, and through man's spirit with his soul. Together, man's spirit and soul expressed themselves through his body.

At the fall, as a result of man's disobedience, his spirit was cut off from God, and at the same time his soul began to express itself independently of his spirit. This new, "disjointed" relationship was both the consequence and the expression of man's rebellion against God.

Elsewhere in the New Testament, the word *soulish* denotes the activity of man's soul when it is out of its proper relationship to his spirit. It describes, therefore, a condition that is contrary to God's highest will. This can be established by considering briefly two other passages in the New Testament where the word *psuchikos*—that is, "soulish"—occurs.

In 1 Corinthians 2:14–15 Paul says that "the natural [soul-ish] man does not receive the things of the Spirit of God . . . nor can he know them, because they are spiritually discerned." On the other hand, "he who is spiritual judges all things." It is obvious that "soulish" and "spiritual" are in opposition to each other. The "spiritual" person is functioning according to God's will; the "soulish" person is out of harmony with God. The "soulish" person seeks to apprehend spiritual truth in the realm of his soul, but is unable to do so. The "spiritual" person is united with God through his spirit and is thus able to receive spiritual revelation directly from God.

In Jude 16–19, the apostle describes a class of persons who are associated with the church, but are nevertheless "murmurers, complainers, walking according to their own lusts." He concludes by saying of them: "These are sensual [soulish] persons, who cause divisions, not having the Spirit [that is, the Holy Spirit]."

Taken together, these passages in 1 Corinthians and in Jude present a consistent picture of a person described as "soulish." He is apparently one who associates with the church and wears a veneer of spirituality. At the same time, his soul is not rightly related to God through his spirit. In spite of the faith he professes, he is in reality a rebel, out of harmony with God and with the people of God. He is incapable of apprehending spiritual truth. His rebellious attitude and conduct grieve the Spirit of God and cause offense in the Body of Christ.

This analysis explains the descending levels of the corrupt wisdom described in James 3:15: from earthly, to soulish, to demonic. The root problem is rebellion—some form of disobedience to God—some form of rejection of God's authority. This rebellion cuts a person's spirit off from God and from the

things of heaven. He is now confined to the plane of earthly values and motives.

At the same time, his soul—out of harmony with God—is exposed by its rebellion to the influence of demons, which his blunted spiritual senses cannot identify. The outcome is a form of wisdom that appears to be "spiritual" but is, in fact, "demonic."

The whole of this third chapter of James focuses on one specific problem: the misuse of the tongue. Furthermore, the entire epistle is addressed mainly—if not exclusively—to those who profess faith in Christ. It is clear, therefore, that this corrupt, counterfeit, demonic wisdom, of which James speaks, finds its expression in words used by Christians. How does such a situation arise?

There are two main areas in which Christians are often guilty in this way on account of the words they utter. The first area is words Christians speak among themselves; the second is words they speak to God—primarily in prayer.

The New Testament gives very clear warnings to Christians as to how they should speak about other people—and especially their fellow believers. In Titus 3:2 Paul says that we are "to speak evil of no one." The phrase *no one* applies to all other people, whether believers or unbelievers.

The Greek verb translated "to speak evil" is *blasphemo*—from which is derived the word *blaspheme*. It is important to understand that the sin of "blasphemy" includes not only evil words spoken against God, but also evil words spoken against our fellow human beings. Whether spoken in reference to God or to other people, such language is forbidden to Christians.

In James 4:11 James deals more specifically with words that Christians speak *about one another:* "Do not speak evil of one another, brethren." The word here translated "to speak evil"

is *katalalo*, which means simply "to speak against." Many Christians interpret James to mean that we are not to say anything *false* against other believers. What he actually says, however, is that we are not to speak against fellow believers at all—even if what we say about them is *true*. The sin that James is dealing with is not speaking *falsely* but speaking *against*.

One of the sins that Christians fall into most easily is *gossip*. In some Christian congregations, if gossip were excluded, scarcely any kind of conversation would be left!

Collins English Dictionary offers the two following definitions of "gossip":

1. Casual and idle chat
2. Conversation involving malicious chatter or rumors about other people

Two of the adjectives here applied to gossip are *idle* and *malicious*. It is not enough for Christians to avoid malice in their talk. In Matthew 12:36 Jesus Himself explicitly warns us against mere idle speech: "But I say to you that for every *idle* word men may speak, they will give account of it in the day of judgment."

Although the New Testament explicitly forbids gossip, many Christians regard it as a relatively "harmless" sin. Most definitely, however, this is not how God views it. In Romans 1:29–30 Paul lists some of the consequences of man's turning away from God. Here is part of his list: "They are full of envy, murder, strife, deceit and malice. They are gossips, slanderers, God-haters, insolent, arrogant and boastful"(NIV).

The position of *gossips* in this list is significant. Some of the heart attitudes directly associated with gossip are strife, deceit and malice. Gossips themselves are classified with people who are slanderers, God-haters, insolent, arrogant and boastful.

Christians who indulge in gossip may think of themselves as "exceptions," but that is not how God sees them.

The danger of this kind of talk is brought out by the descending order of adjectives in James 3:15: "earthly, soulish, demonic." Christians who permit themselves to gossip about other people—especially their fellow believers—are directly disobedient to God's Word. As a result, they find themselves on a slippery downward slope. Before they realize what is happening, they have slipped from the "earthly" to the "soulish," and then from the "soulish" to the "demonic."

The words these people speak about others would not normally be described as "curses," but their effect is the same. They are in fact channels through which demonic forces are directed against other members of Christ's Body. Furthermore, it is not only the individuals spoken about who are affected. In James 3:6 the apostle says, "The tongue is so set among our members that it defiles the whole body." The believer who is guilty of this kind of speech actually defiles both himself and that part of the Body of Christ to which he is related.

Some years ago, while in Europe on a ministry trip, I found myself in a situation that gave me vivid new insight into the dangers of soulish talk. I was preparing to speak at a very significant meeting, when I was seized with a crippling pain in my lower abdomen. Fearing that I might have to cancel my commitment to speak that evening, I called out to God for help.

Immediately I had a mental picture of two Christian friends of mine, about 6,000 miles away in the United States, talking about me. There was a very warm personal relationship among the three of us, but my two friends had disagreed strongly with a recent course of action I had taken. I sensed that in their conversation they were criticizing me for my action and that their negative words about me were producing the phys-

ical symptoms I was struggling against. Furthermore, this was
a strategy of Satan to keep me from ministering that evening.

I saw that I needed to do two things. First, by a decision of
my will, I forgave my friends for the words they were speak-
ing against me. Then I acted on the promise of Jesus in
Matthew 18:18: "Whatever you bind on earth will be bound
in heaven, and whatever you loose on earth will be loosed in
heaven." With the authority vested in the name of Jesus, I
bound the satanic forces at work against me, and then I loosed
myself from the effect of my friends' words about me. Within
five minutes, the pain in my abdomen had ceased entirely
(and never returned!). A few hours later I was able to minister
effectively in the meeting, and I had the sense that God's
purpose had been fulfilled.

Later, on returning to the United States, I had a meeting
with my two friends and the tension between us was resolved.
Today the relationship among us is closer than before.

In Matthew 7:1–2 Jesus says:

> "Judge not, that you be not judged.
> "For with what judgment you judge, you will be
> judged; and with the same measure you use, it will be
> measured back to you."

It is from the verb translated "to judge" that the English
words *critic* and *criticize* are directly derived. When we permit
ourselves to criticize other people—especially our fellow
believers—in such a way that we are pronouncing judgment
on them, we are disobeying Scripture and are thus guilty of a
rebellious attitude toward God. This exposes us to the "syn-
drome" of James 3:15: "earthly, soulish, demonic."

If we find ourselves in disagreement with the conduct of a
fellow Christian, it is permitted—and sometimes necessary—
to follow the pattern of Paul in his disagreement with Peter

concerning Judaic practices. In Galatians 2:11 Paul says, "I withstood him [Peter] *to his face.*"

Paul did not criticize Peter's conduct to his own co-workers, Barnabas and Titus. Instead, he went straight to Peter himself and settled his differences with him in person. Had Paul been guilty of criticizing Peter behind his back, the relationship between the two of them might have been permanently fractured. As it was, however, in 2 Peter 3:15—written near the end of Peter's life—he spoke with warm approval of "the wisdom given to our beloved brother Paul."

In Proverbs 27:5 Solomon states this as a principle of conduct:

> Better is open rebuke
> than hidden love.
>
> NIV

A different kind of situation, in which we may have to speak about another person's wrongdoing, arises when we are legally obligated to serve as a witness. In this case, it is our duty to speak "the truth, the whole truth and nothing but the truth." No one can, however, be at the same time both a witness and a judge. In such a situation, we are not filling the role of a judge, but of a witness. We leave the responsibility of pronouncing judgment to someone else.

The specific sin that Jesus warns us against is taking the position of a judge when God has not assigned that to us. He also warns us that if we do give way to criticizing other people, in due course—from one source or another—the same kinds of criticism we have spoken against others will be leveled against us in our turn.

The Bible's penetrating analysis of the harm caused by misuse of the tongue probably leaves very few among us who would dare to plead "not guilty." If we recognize that we

have indeed been guilty of wounding other people with our tongues and thus defiling ourselves and the Body of Christ, we need to repent and to seek God's forgiveness and cleansing. We may also need to ask forgiveness from those we have offended.

Beyond that, we need to learn how to protect ourselves from wounding and hurtful words that others may speak against us. This issue of protection is dealt with in Section 3.

15
Soulish Prayers

Many Christians are shocked when confronted with the
harm they cause by speaking wrongly among themselves
about other people. They are still more shocked, however,
when confronted with the even greater harm they can cause
when they speak wrongly about others *in their prayers to God.*
They assume that prayer is always acceptable and its effects
are always good. Yet this view is not supported by the Bible.
In Proverbs 28:9, for example, we are warned:

> One who turns away his ear from hearing the law,
> Even his prayer shall be an abomination.

God has laid down in the Bible the principles of prayer that
are acceptable to Him. Anyone who ignores these principles
and offers prayer that is contrary to them incurs God's dis-
pleasure and the rejection of his prayer. In describing God's
estimate of this kind of prayer, Solomon uses one of the Bi-
ble's strongest terms of disapproval: *abomination.*

Because it is so important for us to pray the right kind of prayers, we dare not depend on our own wisdom. Mercifully, God has not left us to our own devices. He has made available to us a divine Helper: the Holy Spirit. By His enabling we can pray prayers that are acceptable to God. Apart from the Holy Spirit, however, we are incapable of praying in a way that will please God or accomplish His purposes.

In Romans 8:26–27 Paul puts these issues very clearly:

> Likewise the Spirit also helps in our weaknesses. For we do not know what we should pray for as we ought, but the Spirit Himself makes intercession for us with groanings which cannot be uttered.
>
> Now He who searches the hearts knows what the mind of the Spirit is, because He makes intercession for the saints according to the will of God.

In our fleshly nature, all of us have certain weaknesses. They are weaknesses not of the body, but of the understanding. They manifest themselves in two related ways. First, we often do not know *what* we should pray for. Second, even when we know *what* to pray for, we do not know *how* to pray for it. We are therefore shut up to total dependence on the Holy Spirit. Only He can show us both the *what* and the *how* of prayer.

In two passages in Ephesians Paul further emphasizes our dependence upon the Holy Spirit to give us prayers that are acceptable to God. In Ephesians 2:18 he stresses that it is only the Holy Spirit who can give us access to God: "For through Him [Jesus] we both [Jews and Gentiles] have *access by one Spirit* [the Holy Spirit] to the Father." Two conditions for acceptable praying are here combined: *through* Jesus and *by* the Holy Spirit. Each is essential.

There is no natural force that can carry our puny human voices from earth to the very ears of God on His throne in

heaven. Only the supernatural power of the Holy Spirit can do that. Without Him, we have no access to God.

Further on, in Ephesians 6:18, Paul again stresses our need for the Holy Spirit's help, particularly in praying for our fellow believers. He says that we should be "praying always with all prayer and supplication *in the Spirit* [the Holy Spirit] . . . for all the saints." Only prayers prayed *in the Holy Spirit* can call down upon those for whom we pray the help and encouragement they need.

How, then, can we avail ourselves of the Holy Spirit's help? Two primary requirements are *humility* and *purity of motive*. First, we must humble ourselves before the Holy Spirit and acknowledge our need of Him. Then we must allow Him to purge from us all wrong motives and selfish attitudes, and to inspire us with sincere love and concern for those for whom we desire to pray.

The prayers that the Holy Spirit inspires are not necessarily lengthy or eloquent. God is not particularly impressed by fine phrases or a solemn tone of voice. Some of the most effective prayers in the Bible were amazingly simple. When Moses prayed for his sister, Miriam, who had been smitten with leprosy, he simply said, "Please heal her, O God, I pray!" (Numbers 12:13). When the tax collector prayed in the Temple, he uttered only one brief sentence: "God be merciful to me a sinner!" (Luke 18:13). Yet we know that God heard and answered both these prayers.

If you feel the need to pray, but do not know how to begin, simply ask God for help. Here are some simple words you might use:

> Lord, I need to pray, but I don't know how.
> Please help me by Your Holy Spirit to pray the kind
> of prayer You will hear and answer.

After that, accept God's response by faith and pray what-ever comes from your heart. Jesus has assured us that if we ask God for bread, He will never give us a stone (Matthew 7:9).

Suppose, however, we do not submit ourselves to the Holy Spirit and seek His direction. Instead, our prayers are moti-vated by envy and self-seeking (mentioned in James 3:14) or by other fleshly attitudes, such as resentment, anger, criticism or self-righteousness. The Holy Spirit will not endorse prayers that proceed from such attitudes, nor will He present them before God the Father.

Inevitably, therefore, our praying degenerates into the James 3:15 "syndrome": earthly—soulish—demonic. The ef-fect of such soulish prayers is like that of soulish talk: nega-tive, not positive. It releases against those for whom we are praying invisible, indefinable pressures, which do not relieve their burdens, but rather add to them.

In particular, when we pray for our fellow believers, there are two soulish attitudes we must guard against: We must not *accuse*, and we must not seek to *control*.

It is all too easy to see the faults of other Christians. In fact, this is often what motivates us to pray for them. It is right to pray, but we must be careful how we pray. We are not free to come before God with a catalog of their faults.

When we begin to play the role of accusers, we are follow-ing the pattern of Satan, not of Christ. Satan's main title—*devil*—means "slanderer" or "accuser." In Revelation 12:10 he is described as the one who accuses Christians day and night before God. He has been engaged in this task from time immemorial and he is an expert at it. He needs no help from Christians!

I have observed that in almost all the prayers of Paul for his fellow Christians—whether individuals or congregations—he begins by thanking God for them. A remarkable example is

provided by the opening to 1 Corinthians. According to what Paul writes later in the letter, there were many kinds of sin in that congregation: strife between the members; carnality; incest; drunkenness at the Lord's Table. Yet Paul opens his letter with eloquent thanksgiving:

> I thank my God always concerning you for the grace of God which was given to you by Christ Jesus,
> that you were enriched in everything by Him in all utterance and all knowledge,
> even as the testimony of Christ was confirmed in you,
> . . . who will also confirm you to the end, that you may be blameless in the day of our Lord Jesus Christ.
>
> <div align="right">1 Corinthians 1:4–6, 8</div>

Giving thanks at the beginning of a prayer has an important psychological effect. It creates a *positive* attitude in the one who is praying. From such a beginning, it is much easier to go on praying with positive faith, even though we are not unaware of serious faults or problems in those for whom we are praying. For my part, I make it a principle never to pray for fellow believers without first thanking God for them. If I cannot do that, then I feel it is better not to pray at all!

A missionary to India in a previous generation developed such an effective ministry of prayer that he became known as "Praying Hyde." On one occasion he was praying for an Indian evangelist whose ministry lacked both fire and fruit. He was about to say, "Lord, You know how cold that brother is." He got as far as the words, "Lord, You know how . . ." but the Holy Spirit would not allow him to complete his sentence.

Suddenly Hyde realized that it was not his business to accuse his fellow servant. Instead of focusing on the man's faults, he began to thank God for everything good he could find in him. Within months, the Indian brother was dramat-

ically transformed. He became known throughout the whole area as a dedicated, effective winner of souls.

That is the power of prayer based on positive appreciation and thankfulness for all that is good in a person. But suppose Hyde had not been sensitive to the Holy Spirit and had continued to pray in a negative, condemnatory spirit. Could not his prayer still have been effective, but in the opposite direction? Could he not have brought upon his fellow servant such a heavy burden of condemnation that he might never have been able to rise above it?

From time to time, like most other Christians, I experience periods of spiritual "heaviness." In some undefined way, I begin to feel guilty or inadequate or unworthy. Yet I may not be aware of anything specific in my life or conduct to explain these feelings.

In such a situation, I have learned by experience that the cause may not be in me at all. My "heaviness" may be due to some other Christian—well-intentioned but misguided—who is accusing me before God. In particular, the sense of *guilt* is often a warning sign. After all, guilt is the logical outcome of accusation. Once I have correctly diagnosed my problem, I can turn to my High Priest, who sees all my faults and yet continually pleads my case before the Father.

There is hardly such a thing as prayer that is not effective. The question is not whether our prayers are effective. The question is whether their effect is positive or negative. That is determined by the power that works through them. Are they truly from the Holy Spirit? Or are they a soulish counterfeit?

True intercession is based on the pattern of Jesus, as described in Romans 8:33–34:

> Who will bring any charge against those whom God has chosen? It is God who justifies.

Who is he that condemns? Christ Jesus, who died—
more than that, who was raised to life—is at the right
hand of God and is also interceding for us.

NIV

Christ certainly sees our faults as believers more clearly
than we see each other's. Yet His intercession on our behalf
does not result in our condemnation, but in our justification.
He does not establish our guilt, but our righteousness.

Our intercession for our fellow believers should follow the
same pattern. Shall we dare to bring a charge against those
whom God has chosen? Or to condemn those whom God has
justified? Surely that would be presumption in the highest
degree!

The message of Scripture is unequivocal. It leaves no room
in our prayers for us to accuse our fellow believers. There is,
however, a second temptation to misuse the power of prayer,
which is more subtle and harder to detect. It takes the form of
using prayer to *control* those for whom we pray.

There is something in our fallen, Adamic nature that makes
us desire to control other people and to impose our will upon
them. In chapter 6 it was pointed out that this desire to con-
trol others is the root that produces witchcraft—first as a work
of the flesh, and then as an occult practice.

One of the key words that indicate the operation of this
force is *manipulation*. There are countless areas in which peo-
ple may resort to manipulation to get what they want from
others. Husbands manipulate their wives, and wives their hus-
bands; children their parents; preachers their congregations;
and media advertisers the general public! It is such a common
practice that people do not usually recognize it—in them-
selves or in others.

Nevertheless, manipulation is not the will of God. God

Himself never manipulates us, and He never authorizes us to manipulate other people. Whenever we resort to manipulation, we have passed from the realm of the spiritual to that of the soulish. We are operating in a form of wisdom that is not from above.

Because we normally think of prayer as something good and spiritual, we assume that any results we achieve by prayer are necessarily legitimate and must represent the will of God. This is true if the power at work through our prayers is the Holy Spirit. But if our prayers are motivated by our own soulish determination, their effect will be harmful, not beneficial.

Behind this soulish kind of prayer there often lies an arrogant assumption that we have the right to "play God" in the lives of others. In reality, however, any influence that would seek to set aside God's sovereignty over an individual's life is *not* from the Holy Spirit.

There are many different situations in which Christians might be tempted to pray in a way that seems spiritual, but actually is soulish. Here are two typical examples:

1. *Accusatory and condemnatory prayers*

A church "split" is certain to bring out the soulish element in all parties involved. In this case, Pastor Jones, of the First Full Gospel Church, discovers that his wife is having an affair with Brother Williams, the music minister. He divorces his wife and dismisses Brother Williams.

Brother Williams, however, refuses to admit the charge of adultery. He complains of "injustice," wins over half the congregation to his side, and starts to build a new church. There follows a lengthy dispute between the two groups concerning the division of the building fund.

A year later Pastor Jones marries again. Brother Williams

and his group charge that it is unscriptural for a divorced minister to remarry. They start a special prayer meeting to call down "judgment" upon him.

In the next two years Pastor Jones' new wife twice becomes pregnant, but each time her pregnancy ends in a miscarriage. The gynecologist can find no medical reason for these miscarriages. Brother Williams and his group hail this as the answer to their prayers and God's vindication of their righteous cause.

With their first conclusion I would agree. Their prayers were responsible for the two miscarriages. But what was the power that worked through those prayers? Since the Holy Spirit in Scripture clearly warns us not to judge our fellow believers, He could never lend His authority to prayers with such a motive. The only credible diagnosis that remains is that of James 3:15. The power working through such prayers is "earthly, soulish, demonic."

2. *Dominating, manipulating prayers*

Pastor Strong is accustomed to dominating those around him. He is a widower with two sons and a daughter. He expected both sons to become ministers, but in the end they chose secular careers. Mary, the daughter, remains at home. She is devoted to her father and an active helper in the congregation.

At an evangelistic rally, Mary meets Bob, a Christian worker from another denomination, and they begin a courtship. Pastor Strong is at odds with the church Bob belongs to, however, and opposes the relationship from the beginning. Also, he is fearful of losing Mary's help, at home and in the church. Eventually Mary moves out of her father's home to share an apartment with a girlfriend. Pastor Strong calls this "rebel-

lion." When Mary tells him she is engaged, he sets himself to pray against the planned marriage.

Bob and Mary go ahead with their plans, but the longer they know one another, the more strained their relationship becomes. Neither seems able to relax in the presence of the other. Minor misunderstandings somehow develop into painful clashes. Every activity they plan together ends in inexplicable frustration. Eventually Mary says, "Bob, this can't be God's will for us!" and hands him back his ring.

Mary concludes that the way out of her frustration is to break all contact with professing Christians. Alienated from her father and the church, she follows her brothers into a secular career. Eventually she meets and marries a man who is an agnostic.

How shall we evaluate Pastor Strong's prayers? They were certainly effective, but their effect was harmful. They were the expression of his lifelong desire to dominate those who were close to him. They were powerful enough to break up a relationship that could have brought his daughter happiness and fulfillment. Beyond that, however, they could not bring her back to her faith, or keep her from a subsequent, unscriptural marriage. The power of prayer that brings such negative results does not proceed from the Holy Spirit.

The principles illustrated by these two examples apply to many different kinds of situations in contemporary church life. The lesson they enforce is highly relevant: The power of soulish prayer is both real and dangerous. The result it produces is not a blessing, but a curse.

The sin of soulish praying must be dealt with in the same way as the sin of soulish talking, described in the previous chapter. If we have been guilty, we need to repent and seek God's forgiveness. We may also need to ask forgiveness from

people who have been affected by the negative influence of our prayers.

Finally, for the future, we must firmly renounce any attempt either to accuse other people or to control them by the words we speak in prayer.

16
Summary
of Section 2

The preceding ten chapters have dealt with many of the most important causes of curses as they are revealed in the Bible. It will be helpful to conclude the section with a summary of these causes.

Acknowledging and/or worshiping false gods
All involvement with the occult
Disrespect for parents
All forms of oppression or injustice, especially when directed against the weak and the helpless
All forms of illicit or unnatural sex
Anti-Semitism
Legalism, carnality, apostasy
Theft or perjury
Withholding from God money or other material resources to which He has a claim

Words spoken by people with relational authority, such
 as father, mother, husband, wife, teacher, priest or
 pastor
Self-imposed curses
Pledges or oaths that bind people to ungodly associations
Curses that proceed from servants of Satan
Soulish talk directed against other people
Soulish prayers that accuse or seek to control other people.

In addition, there are curses for other causes or from other
sources, mentioned in Scripture, that are not included in the
above list. The most significant of these are listed below in
the order in which they occur in the Bible. Various passages
that merely reaffirm curses pronounced in Deuteronomy 27
and 28 are not included.

It is noteworthy that the largest category of people who
incur God's curse consists of deceptive and unfaithful proph-
ets, priests and teachers. These have been indicated by an
asterisk.

A curse on the people of Meroz because they did not
join Barak as leader of the Lord's army against Sisera
(Judges 5:23).

A curse from Jotham on those who had murdered the
sons of Gideon (Judges 9:57).

A curse on Jezebel for witchcraft and immorality (2
Kings 9:34—compare 2 Kings 9:22).

A curse on those who reject God's commandments
through pride (Psalm 119:21).

A curse on the house of the wicked (Proverbs 3:33).

A curse on the earth because its inhabitants have de-
filed it, changing and transgressing God's laws and cov-
enant (Isaiah 24:6).

A curse on the people of Edom for persistent enmity and treachery toward Israel (Isaiah 34:5).

*A curse on false prophets who promised peace to people who were disobeying God (Jeremiah 29:18).

*A curse on false prophets who commit immorality (Jeremiah 29:22).

A curse on Israelites who went down to Egypt in defiance of God's warning (Jeremiah 42:18—compare Jeremiah 44:8, 12).

A curse on any man who fails to carry out the Lord's judgment on His enemies (Jeremiah 48:10).

*A curse on the blessings of priests who reject God's discipline (Malachi 2:2).

A curse on "goat" nations who show no mercy to the brothers of Jesus (Matthew 25:41).

A curse on people who are regularly taught the truth of God, but do not produce appropriate fruit (Hebrews 6:8).

*A curse on false teachers who are guilty of covetousness, deception and immorality (2 Peter 2:14).

Section 3
From Curse
to Blessing

Introduction

Have you come to see by now that your life has somehow been blighted by a curse? Are you wondering if there is a way out from under the dark shadow that has been shutting off the sunlight of God's blessing?

Yes, there is a way out! *But there is only one:* through the sacrificial death of Jesus on the cross.

This section will explain in simple, practical terms how you may find and follow God's way—from shadow to sunlight, from curse to blessing.

For your further encouragement you will read—in chapter 20—the story of a man who found the way from frustration and despair to fulfillment and fruitfulness. You can do the same!

17
The Divine Exchange

The entire message of the Gospel revolves around one unique historical event: the sacrificial death of Jesus on the cross. Concerning this the writer of Hebrews says: "For by one offering [sacrifice] He [Jesus] has perfected forever those who are being sanctified" (Hebrews 10:14). Two powerful expressions are combined: "perfected" and "forever." Together, they depict a sacrifice that comprehends every need of the entire human race. Furthermore, its effects extend throughout time and on into eternity.

It is on the basis of this sacrifice that Paul writes in Philippians 4:19: "And my God shall supply *all your need* according to His riches in glory *by Christ Jesus*." "All your need" includes, specifically, the release you are seeking from the curse. But first you need to see this as part of a much larger whole—a single, sovereign act of God that brought together all the guilt and the suffering of humanity in one climactic moment of time.

God has not provided many different solutions for the multitudinous problems of mankind. Instead, He offers us one all-sufficient solution, which is His answer to every problem. We may come from many different backgrounds, each of us burdened with our own special need, but to receive God's solution we must all make our way to the same place: the cross of Jesus.

The most complete account of what was accomplished at the cross was given through the prophet Isaiah seven hundred years before it actually took place. In Isaiah 53:10 the prophet depicts a "servant of the Lord" whose soul was to be offered to God as a sin offering. The writers of the New Testament are unanimous in identifying this unnamed servant as Jesus. The divine purpose accomplished by His sacrifice is summed up in Isaiah 53:6:

> All we like sheep have gone astray;
> We have turned, every one, to his own way;
> And the Lord has laid on Him the iniquity of us all.

Here is the basic, universal problem of all humanity: We have turned, each of us, to our own way. There are various specific sins that many of us have never committed, such as murder, adultery, theft and so on. But this one thing we all have in common: We have turned to our own way. In so doing, *we have turned our backs on God.* The Hebrew word that sums this up is *avon,* here translated "iniquity." Perhaps the closest equivalent in contemporary English would be "rebellion"— not against man, but against God. In chapter 4 we saw this as the primary cause for the curses listed in Deuteronomy 28.

No one English word, however, whether it is *iniquity* or *rebellion,* conveys the full meaning of *avon.* In its biblical use, *avon* describes not merely iniquity but also the *punishment* or the *evil consequences* that iniquity brings in its train.

In Genesis 4:13, for instance, after God had pronounced judgment on Cain for the murder of his brother, Cain said: "My punishment is greater than I can bear!" The word here translated "punishment" is *avon*. It covered not merely Cain's "iniquity," but also the "punishment" it brought upon him.

In Leviticus 16:22, concerning the scapegoat released on the Day of Atonement, the Lord said: "The goat shall bear on itself all their iniquities to an uninhabited land." In this symbolism, the goat bore not merely the iniquities of the Israelites, but also all the consequences of their iniquities.

In Lamentations 4 *avon* occurs twice with the same meaning. In verse 6 it is translated: "The *punishment of the iniquity* of the daughter of my people." Again, in verse 22: "The *punishment of your iniquity* . . . O daughter of Zion." In each case, the single word *avon* is translated by a complete phrase "the punishment of iniquity." In other words, in its fullest sense *avon* means not simply "iniquity," but also includes *all the evil consequences* God's judgment brings upon iniquity.

This applies to the sacrifice of Jesus on the cross. Jesus Himself was not guilty of any sin. In Isaiah 53:9 the prophet says, "He had done no violence, nor was any deceit in His mouth." But in verse 6 he says, "The Lord has laid on Him the iniquity of us all." Not merely was Jesus identified with our iniquity. He also endured all the evil consequences of that iniquity. Like the scapegoat that had prefigured Him, He carried them away so that they might never return again upon us.

Here is the true meaning and purpose of the cross. On it a divinely ordained exchange took place. First, Jesus endured in our place all the evil consequences that were due by divine justice to our iniquity. Now, in exchange, God offers us all the good that was due to the sinless obedience of Jesus.

Stated more briefly, the evil due to us came upon Jesus

that, in return, the good due to Jesus might be offered to us. God is able to offer this to us without compromising His own eternal justice, because Jesus has already endured on our behalf all the just punishment due to our iniquities.

All of this proceeds solely out of the unfathomable grace of God, and it is received solely by faith. There is no logical explanation in terms of cause and effect. None of us has ever done anything to deserve such an offer, and none of us can ever do anything to earn it.

Scripture reveals many different aspects of the exchange, and many different areas in which it applies. In each case, however, the same principle holds good: *The evil came upon Jesus that the corresponding good might be offered to us.*

The first two aspects of the exchange are revealed in Isaiah 53:4–5:

> Surely He has borne our griefs [literally, sicknesses]
> And carried our sorrows [literally, pains];
> Yet we esteemed Him stricken,
> Smitten by God, and afflicted.
> But He was wounded for our transgressions,
> He was bruised for our iniquities;
> The chastisement [punishment] for our peace was upon
> Him,
> And by His stripes [wounds] we are healed.

Two truths are here interwoven. The application of one is spiritual and the other physical. On the spiritual plane, Jesus received the punishment due to our transgressions and iniquities that we, in turn, might be forgiven and so have peace with God. (See Romans 5:1.) On the physical plane, Jesus bore our sicknesses and pains that we through His wounds might be healed.

The physical application of the exchange is confirmed in

two passages of the New Testament. Matthew 8:16–17 refers
to Isaiah 53:4 and records that Jesus "healed all who were
sick, that it might be fulfilled which was spoken by Isaiah the
prophet, saying:

> "He Himself took our infirmities
> And bore our sicknesses."

Again, in 1 Peter 2:24, the apostle refers to Isaiah 53:5–6
and says of Jesus:

> [He] Himself bore our sins in His own body on the
> tree, that we, having died to sins, might live for
> righteousness—by whose stripes [wounds] you were
> healed.

The twofold exchange described in the above verses may
be summed up as follows:

Jesus was punished that we might be forgiven.
Jesus was wounded that we might be healed.

A third aspect of the exchange is revealed in Isaiah 53:10,
which states that the Lord made the soul of Jesus "an offering
for sin." This must be understood in the light of the Mosaic
ordinances for various forms of sin offering. The person who
had sinned was required to bring his sacrificial offering—a
sheep, a goat, a bull or some other animal—to the priest. He
would confess his sin over the offering, and the priest would
symbolically transfer the sin he had confessed from the person
to the animal. Then the animal would be killed, thus paying
the penalty for the sin that had been transferred to it.

In the foreknowledge of God, all this was designed to fore-
shadow what was to be accomplished by the single, all-
sufficient sacrifice of Jesus. On the cross, the sin of the whole

world was transferred to the soul of Jesus. The outcome is described in Isaiah 53:12: "He poured out His soul unto death." By His sacrificial, substitutionary death, Jesus made atonement for the sin of the whole human race.

In 2 Corinthians 5:21 Paul refers to Isaiah 53:10 and at the same time he also presents the positive aspect of the exchange:

> For He [God] made Him [Jesus] who knew no sin to
> be sin for us, that we might become the righteousness of
> God in Him.

Paul does not speak here about any kind of righteousness that we can achieve by our own efforts, but about God's own righteousness—a righteousness that has never known sin. None of us can ever earn this. It is as high above our own righteousness as heaven is above earth. It can be received solely by faith.

This third aspect of the exchange may be summed up as follows:

> *Jesus was made sin with our sinfulness that we might
> become righteous with His righteousness.*

The next aspect of the exchange is a logical outworking of the previous one. The entire Bible, in both the Old Testament and the New, emphasizes that the final outcome of sin is death. In Ezekiel 18:4 the Lord states, "The soul who sins shall die." In James 1:15 the apostle says, "Sin, when it is full-grown, brings forth death." When Jesus became identified with our sin, it was inevitable that He should also experience the death that is the outcome of sin.

In confirmation of this, in Hebrews 2:9, the writer says that "Jesus . . . was made a little lower than the angels, for the suffering of death . . . that He, by the grace of God, might

taste death for everyone." The death that He died was the inevitable outcome of human sin that He had taken upon Himself. He bore the sin of all men, and so died the death due to all men.

In return, to all who accept His substitutionary sacrifice, Jesus now offers the gift of eternal life. In Romans 6:23 Paul sets the two alternatives side by side: "For the wages [just reward] of sin is death, but the [unearned] gift of God is eternal life in Christ Jesus our Lord."

Thus the fourth aspect of the exchange may be summed up as follows:

Jesus died our death that we might share His life.

A further aspect of the exchange is stated by Paul in 2 Corinthians 8:9: "For you know the grace of our Lord Jesus Christ, that though He was rich, yet for your sakes He became poor, that you through His poverty might become rich." The exchange is clear: from poverty to riches. Jesus became poor that we in return might become rich.

When did Jesus become poor? Some people picture Him as poor throughout His earthly ministry, but this is not accurate. He Himself did not carry a lot of cash, but at no time did He lack anything He needed. When He sent His disciples out on their own, they likewise lacked nothing. (See Luke 22:35.) So far from being poor, He and His disciples made a regular practice of giving to the poor. (See John 12:4–8; 13:29.)

True, Jesus' methods of obtaining money were sometimes unconventional, but money has the same value, whether withdrawn from a bank or the mouth of a fish! (See Matthew 17:27.) His methods of providing food were also at times unconventional, but a man who can provide a substantial meal for five thousand men plus women and children certainly

would not be considered poor by normal standards! (See Matthew 14:15–21.)

Actually, throughout His earthly ministry, Jesus exactly exemplified "abundance," as defined in chapter 5. He always had all that He needed to do the will of God in His own life. Over and above this, He was continually giving out to others, and His supply was never exhausted.

So when did Jesus become poor for our sakes? The answer is: *on the cross*. In Deuteronomy 28:48 Moses summed up absolute poverty in four expressions: hunger, thirst, nakedness and need of all things. Jesus experienced all this in its fullness on the cross.

He was *hungry*. He had not eaten for nearly 24 hours.

He was *thirsty*. One of His last utterances was: "I thirst!" (John 19:28).

He was *naked*. The soldiers had taken all His clothes from Him (John 19:23).

He was *in need of all things*. He no longer owned anything whatever. After His death He was buried in a borrowed robe and in a borrowed tomb (Luke 23:50–53). Thus, Jesus, exactly and completely, endured *absolute poverty* for our sakes.

In 2 Corinthians 9:8 Paul presents more fully the positive side of the exchange: "And God is able to make all grace abound toward you, that you, always having all sufficiency in all things, have an abundance for every good work."[1] Paul is careful to emphasize throughout that the only basis for this exchange is God's *grace*. It can never be earned. It can only be received by faith.

Very often our "abundance" will be like that of Jesus while He was on earth. We shall not carry large amounts of cash, or have large deposits in a bank. But from day to day we shall

[1] Other implications of this verse were discussed in chapter 5 on page 54.

have enough for our own needs and something over for the needs of others.

One important reason for this level of provision is indicated by the words of Jesus quoted in Acts 20:35: "It is more blessed to give than to receive." God's purpose is that all His children should be able to enjoy the greater blessing. He provides us, therefore, with enough to cover our own needs and also to give to others.

This fifth aspect of the exchange may be summed up:

> *Jesus became poor with our poverty that we might become rich with His riches.*

The exchange at the cross covers also the emotional forms of suffering that follow from man's iniquity. Here again, Jesus endured the evil that we in turn might enjoy the good. Two of the cruelest wounds brought upon us by our iniquity are *shame* and *rejection*. Both of these came upon Jesus on the cross.

Shame can vary in intensity from acute embarrassment to a cringing sense of unworthiness that cuts a person off from meaningful fellowship either with God or with man. One of the commonest causes—becoming more and more prevalent in our contemporary society—is some form of sexual abuse or molestation in childhood. Often this leaves scars that can be healed only by the grace of God.

Speaking of Jesus on the cross, the writer of Hebrews says that He "endured the cross, *despising the shame*" (Hebrews 12:2). Execution on a cross was the most shameful of all forms of death, reserved for the lowest class of criminal. The person to be executed was stripped of all his clothing and exposed naked to the gaze of passersby, who jeered and mocked. This was the degree of shame Jesus endured as He hung on the cross (Matthew 27:35–44).

In place of the shame Jesus bore, God's purpose is to bring those who trust in Him to share His eternal glory. In Hebrews 2:10 the writer says: "For it was fitting for Him [God] . . . *in bringing many sons to glory*, to make the author of their salvation [that is, Jesus] perfect through sufferings." The shame Jesus endured on the cross has opened the way for all who trust in Him to be released from their own shame. Not only that, but He then shares with us the glory that belongs to Him by eternal right!

There is another wound that is often even more agonizing than shame. It is *rejection*. Usually this stems from some form of broken relationship. In its earliest form, it is caused by parents who reject their own children. The rejection may be active, expressed in harsh, negative ways, or it may be merely a failure to show love and acceptance. If a pregnant woman entertains negative feelings toward the infant in her womb, the child will probably be born with a sense of rejection—which may follow it into adulthood and even to the grave.

The breakup of a marriage is another frequent cause of rejection. This is pictured vividly in the words of the Lord in Isaiah 54:6:

> "The Lord will call you back
> as if you were a wife deserted and distressed in spirit—
> a wife who married young,
> only to be rejected," says your God.
>
> NIV

God's provision for healing the wound of rejection is recorded in Matthew 27:46, 50, which describes the culmination of the agony of Jesus:

> And about the ninth hour Jesus cried out with a loud voice, saying, *"Eli, Eli, lama sabachthani?"* that is, "My God, My God, why have You forsaken Me?"

> Jesus, when He had cried out again with a loud voice,
> yielded up His spirit.

For the first time in the history of the universe, the Son of God called out to His Father and received no response. So fully was Jesus identified with man's iniquity that the uncompromising holiness of God caused Him to reject even His own Son. In this way Jesus endured rejection in its most agonizing form: rejection by a father. Almost immediately after that, He died, not of the wounds of crucifixion, but of a broken heart. Thus He fulfilled the prophetic picture of the Messiah given in Psalm 69:20: "Reproach has broken my heart."

The record of Matthew continues immediately: "And behold, the veil of the temple was torn in two from top to bottom." This demonstrated symbolically that the way had been opened for sinful man to enter into direct fellowship with a holy God. The rejection of Jesus had opened the way for us to be accepted by God as His children. This is summed up by Paul in Ephesians 1:5–6: "Having predestined us to adoption as sons by Jesus Christ to Himself . . . He [God] has made us *accepted in the Beloved.*" The rejection of Jesus resulted in our acceptance.

God's remedy for shame and rejection has never been needed more desperately than it is today. My estimate is that at least one-quarter of the adults in America today suffer from wounds of shame or rejection. It has given me measureless joy to point such people to the healing that flows from the cross of Jesus.

The two emotional aspects of the exchange at the cross that have been analyzed above may be summarized as follows:

> *Jesus bore our shame that we might share His glory.*
> *Jesus endured our rejection that we might have His*
> *acceptance as children of God.*

The aspects of the exchange analyzed above cover some of humanity's most basic and urgent needs, but they are by no means exhaustive. Actually, there is no need resulting from man's rebellion that is not covered by the same principle of exchange: *The evil came upon Jesus that the good might be offered to us.* Once we have learned to apply this principle in our lives, it releases God's provision for every need.

Now you must lay hold of this principle to meet that special need in your life: *release from the curse.* Paul describes the relevant aspect of the exchange in Galatians 3:13–14:

> Christ has redeemed us from the curse of the law, having become a curse for us (for it is written, "Cursed is everyone who hangs on a tree"),
>
> that the blessing of Abraham might come upon the Gentiles in Christ Jesus, that we might receive the promise of the Spirit through faith.

Paul applies to Jesus on the cross an enactment of the Law of Moses, stated in Deuteronomy 21:23, according to which a person executed by hanging on a "tree" (a wooden gibbet) thereby came under the curse of God. Then he points to the resulting opposite: the blessing.

It does not require a theologian to analyze this aspect of the exchange: Jesus became a *curse* that we might receive the *blessing.*

The curse that came upon Jesus is defined as "the curse of the Law." It includes every one of the curses, listed by Moses in Deuteronomy 28, which were examined in chapter 4. Every one of these curses, in its fullness, came upon Jesus. He has thus opened the way for us to obtain *an equally full release* and to enter into the corresponding blessings.

Try for a moment to picture Jesus as He hung there on the

cross. Then you will begin to appreciate the full horror of the curse.

Jesus had been rejected by His own countrymen, betrayed by one of His disciples and abandoned by the rest (though some later returned to follow His final agony). He was suspended naked between earth and heaven. His body was wracked by the pain of innumerable wounds, His soul weighed down by the guilt of all humanity. Earth had rejected Him, and heaven would not respond to His cry. As the sun withdrew its light and darkness covered Him, His lifeblood ebbed out onto the dusty, stony soil. Yet out of the darkness, just before He expired, there came one final, triumphant cry: "It is finished!"

In the Greek text that phrase, "It is finished," consists of only one word. It is the perfect tense of a verb that means "to make something complete or perfect." In English, it could be rendered "It is completely complete" or "It is perfectly perfect."

Jesus had taken upon Himself every evil consequence that rebellion had brought upon humanity. He had exhausted every curse of God's broken Law. All this, that we in turn might receive every blessing due to His obedience. Such a sacrifice is stupendous in its scope, yet marvelous in its simplicity.

Have you been able to accept with faith this account of the sacrifice of Jesus and of all that He has obtained for you? In particular, if you are living under the shadow of a curse, have you begun to see that Jesus, at infinite cost to Himself, has made full provision for your release?

If so, there is one immediate response that you need to make—a response that is the simplest and purest expression of true faith. It is to say, "Thank You!"

Do that right now! Say, "Thank You! Thank You, Lord

Jesus, for all that You have done for me! I do not fully understand, but I do believe, and I am grateful."

Now keep on thanking Him in your own words. The more you thank Him, the more you will believe what He has done for you. And the more you believe, the more you will want to thank Him.

Giving thanks is the first step to release.

18
Seven Steps
to Release

There is one—and only one—all-sufficient basis for every provision of God's mercy: the exchange that took place on the cross. In the previous chapter, eight main aspects were summarized:

Jesus was punished that we might be forgiven.

Jesus was wounded that we might be healed.

Jesus was made sin with our sinfulness that we might become righteous with His righteousness.

Jesus died our death that we might share His life.

Jesus became poor with our poverty that we might become rich with His riches.

Jesus bore our shame that we might share His glory.

Jesus endured our rejection that we might have His acceptance as children of God.

Jesus became a curse that we might receive a blessing.

This list is not complete. There are other aspects of the exchange that could be added. But all of them are different facets of the provision God has made through the sacrifice of Jesus. The Bible sums them up in one grand, all-inclusive word: *salvation.* Christians often limit salvation to the experience of having one's sins forgiven and being born again. Wonderful though this is, however, it is only the first part of the total salvation revealed in the New Testament.

The full scope of salvation is obscured—at least, in part—by problems of translation. In the original Greek text of the New Testament, the verb *sozo,* normally translated "to save," is also used in a variety of ways that go beyond the forgiveness of sins. It is used, for instance, in many cases of people being physically healed.[1] It is also used of a person being delivered from demons,[2] and of a dead person being brought back to life.[3] In the case of Lazarus, it is used of recovering from a fatal illness.[4] In 2 Timothy 4:18 Paul uses the same verb to describe God's ongoing preservation and protection from evil, which will extend throughout his life.

The total outworking of salvation includes every part of man's being. It is beautifully summed up in Paul's prayer in 1 Thessalonians 5:23: "Now may the God of peace Himself sanctify you completely; and may your whole spirit, soul, and body be preserved blameless at the coming of our Lord Jesus Christ." Salvation includes the total human personality— spirit, soul and body—and it is consummated only by the resurrection of the body at the return of Christ.

No one enters into all the varied provisions of salvation simultaneously, however, or by one single transaction. It is

[1] Matthew 9:21–22; 14:36; Mark 5:23, 28, 34; 6:56; 10:52; Luke 8:48; Acts 4:9; 14:9; James 5:15
[2] Luke 8:36
[3] Luke 8:50
[4] John 11:12

normal to progress by stages from one provision to the next. Many Christians never go beyond receiving forgiveness of their sins. They are not aware of the many other provisions that are freely available to them.

The order in which a person receives the various provisions is determined by the sovereignty of God, who deals with all of us as individuals. The starting point, generally, is forgiveness of sins, but not always. In the earthly ministry of Jesus, people often received physical healing first, and then forgiveness of their sins.

This can still happen today. In 1968 my own wife, Ruth, while still single and living as a practicing Jewess, had lain sick in bed for many weeks. Then she received a miraculous visitation from Jesus in her bedroom and was instantly and totally healed. But it was two years later before she recognized her need to have her sins forgiven. Only then was she born again.

When we come to God on the basis of Christ's sacrifice for us, we need to be sensitive to the leading of the Holy Spirit. We cannot impose our priorities upon God, but we must let Him work with us in the order He chooses. A person may, for instance, be determined to seek financial prosperity, whereas God's first priority for him is righteousness. If he stubbornly insists on claiming prosperity before righteousness, he may not receive either!

Again, a person may seek physical healing, not knowing that the root of his physical sickness is an inner emotional problem—such as rejection or grief or insecurity. In response, God will move to bring the emotional healing that is needed. If the person does not open himself up to this, however, but continues to beg merely for physical healing, he may in the end receive no healing at all, either physical or emotional.

Sometimes God seeks to reveal to us a provision of salvation that is our most urgent need, and yet we are not aware of it. This applies particularly to the provision for release from a

curse. Very often a curse over a person's life is the unsuspected barrier that holds him back from the other provisions of salvation. Normally, this barrier must be dealt with first, before other needs can be met.

This is the provision we will now focus upon: *the exchange from curse to blessing.* At this point we are confronted by precisely the same issues Moses put before the Israelites as they were preparing to enter the land of Canaan: "This day I call heaven and earth as witnesses against you that I have set before you life and death, blessings and curses. Now choose life, so that you and your children may live" (Deuteronomy 30:19, NIV). The issues were so solemn, and so far-reaching in their consequences, that Moses called heaven and earth to witness Israel's response.

The alternatives were clear: life and blessings, on the one hand; death and curses, on the other. God required the Israelites to make their own choice. He urged them to make the right choice: life and blessings. But He would not make the choice for them. He also reminded them that the choice they made would affect not merely their own lives, but also the lives of their descendants. This emerges once again as a characteristic feature of both blessings and curses: They continue from generation to generation.

The choice that Israel made at that time determined their destiny. The same is true for us today. God sets before us precisely the same alternatives: life and blessings or death and curses. He leaves it to us to choose. Like Israel, we determine our destiny by the choice we make. Our choice may also affect the destiny of our descendants.

I remember when I was first confronted by those words of Moses. As I realized that God required a response from me, I was overawed. God was waiting for me to choose! I could not evade the issue. Not to choose was, in effect, to make the wrong choice.

I thank God that He gave me the grace to make the right choice. Never, in all the years since then, have I regretted it. God soon began to show me, however, the implications of my choice. I had passed through a door leading to a lifetime walk of faith and obedience, from which there was no turning back.

All who desire to pass from curse to blessing must go through the same door. First, there must be a clear recognition of the issues God sets before us. Then there must be a simple, positive response: "Lord, on the basis of Your Word, I make my response. I refuse death and curses, and I choose life and blessings."

Once we have made this choice, we can go on to claim release from any curses over our lives. What are the steps that we must take for this? There is no one set pattern that everyone must follow. In bringing people to the point of release, however, I have found it helpful to lead them through the seven stages outlined below.

You may be approaching this issue from the perspective of one who is concerned to help or counsel others. To receive the full benefit of this instruction, however, I recommend that you put yourself mentally in the place of the person who needs release. In so doing, you may discover that is where *you* actually are!

1. *Confess your faith in Christ and in His sacrifice on your behalf.*

In Romans 10:9–10 Paul explains that there are two essential conditions for receiving the benefits of Christ's sacrifice: to *believe* in the heart that God raised Jesus from the dead and to *confess* with the mouth that He is Lord. Faith in the heart is not fully effective until it has been completed by confession with the mouth.

Literally, the word *confess* means "to say the same as." In the context of biblical faith, confession means saying with our mouth what God has already said in His Word. In Hebrews 3:1 Jesus is called "the High Priest of our confession." When we make the right scriptural confession concerning Him, it releases His priestly ministry on our behalf.

To receive the benefits of Christ's sacrifice, we need to make our confession specific and personal. For example:

Lord Jesus Christ, I believe that You are the Son of God and the only way to God; and that You died on the cross for my sins and rose again from the dead.

2. *Repent of all your rebellion and your sins.*

There may have been many external factors—even going back to previous generations—that have contributed to the curse over your life. Nevertheless, the root of all your problems lies within yourself. It is summed up in that one word *avon* (iniquity): your rebellious attitude toward God and the sins that have resulted from it. For this, you must accept personal responsibility.

Before you can receive God's mercy, therefore, He requires that you *repent*. This must be a deliberate decision on your part: You lay down your rebellion and submit yourself without reservation to all that God requires of you. A person who has truly repented no longer argues with God!

The New Testament leaves no room for faith that bypasses repentance. When John the Baptist came to prepare the way before Jesus, the first word in his message was "*Repent . . .* !" (Matthew 3:2). Later, when Jesus commenced His public ministry, He took up where John had left off: "*Repent,* and believe in the gospel" (Mark 1:15). *Without repentance, no effective faith is possible.* Many professing Christians are contin-

ually struggling for faith because they have never fulfilled the prior condition of repentance. Consequently, they never receive the full benefits of Christ's sacrifice.

Here is a suggested confession that expresses the repentance that God demands:

> I give up all my rebellion and all my sin, and I submit myself to You as my Lord.

3. *Claim forgiveness of all sins.*

The great barrier that keeps God's blessing out of our lives is *unforgiven sin.* God has already made provision for our sins to be forgiven, but He will not do this until we confess them. *"If we confess our sins,* He is faithful and just to forgive us our sins and to cleanse us from all unrighteousness" (1 John 1:9). God is *faithful* to do this because He has given us His promise, and He always keeps His promises. He is also *just* because the full penalty for our sins has already been paid by Jesus.

It may be that God has shown you certain sins that opened you up to a curse. If so, make a specific confession of those sins.

It is also possible that a curse has come upon you because of sins committed by your ancestors (especially idolatry or the occult). You do not bear the guilt of sins your ancestors committed, but you may be affected in various ways by the consequences of their sins. If you know this to be the case, ask God also for release from those consequences.

Here is a suitable prayer that covers this:

> I confess all my sins before You and ask for Your forgiveness—especially for any sins that exposed me to a curse. Release me also from the consequences of my ancestors' sins.

4. *Forgive all other people who have ever harmed you or wronged you.*

Another great barrier that can keep God's blessing out of our lives is *unforgiveness* in our hearts toward other people. In Mark 11:25 Jesus put His finger on this as something that we must deal with, if we expect God to answer our prayers:

> "And whenever you stand praying, if you have anything against anyone, forgive him, that your Father in heaven may also forgive you your trespasses."

The same principle runs all through the New Testament: If we want God to forgive us, we must be prepared to forgive others.

Forgiving another person is not primarily an emotion; it is a *decision*. I sometimes illustrate this with a little "parable." You have in your hand IOUs from another person in a total of $10,000. In heaven, however, God has in His hand IOUs from you to Him in the amount of $10,000,000. God makes you an offer: "You tear up the IOUs in your hand, and I'll tear up the IOUs in Mine. On the other hand, if you hold onto your IOUs, I'll hold onto Mine!"

Understood in this way, forgiving another person is not a tremendous sacrifice. It is merely enlightened self-interest. Anyone who is not willing to cancel a debt of $10,000 in order to have his own debt of $10,000,000 canceled is lacking in business sense!

God may now be bringing to your mind some person or persons whom you need to forgive. If so, you can look to the Holy Spirit for help. He will prompt you to make the right decision, but He will not make it for you. While you feel His prompting, respond. Make a clear-cut decision to forgive. Then verbalize your decision. Say out loud, "Lord, I forgive . . ." and name the person or persons involved. The ones you find it hardest to name are the ones you most need to forgive! Here are some simple words you can use:

By a decision of my will, I forgive all who have harmed me or wronged me—just as I want God to forgive me. In particular, I forgive . . . [name the person or persons].

5. *Renounce all contact with anything occult or satanic.*

Before you come to the actual prayer for release, there is one further, important area that must be dealt with: all contact with anything occult or satanic. This includes a very wide range of activities and practices. You may need to turn back for a moment to pages 68–71 in chapter 6, where there is a list that covers some, but not all, of the forms that these may take. If you are unclear about an area that is not mentioned in the list, ask God to make it clear to you.

If you have been involved at any time in such activities or practices, you have crossed an invisible border into the kingdom of Satan. Since that time, whether you know it or not, Satan has regarded you as one of his subjects. He considers that he has a legal claim to you. Since the Kingdom of God and the kingdom of Satan are in total opposition to one another, you cannot enjoy the full rights and benefits of a citizen in God's Kingdom until you have finally and forever severed all connection with Satan and totally canceled any claim he may have against you.

In 2 Corinthians 6:14–15 Paul stresses the necessity of a complete break with Satan's kingdom: "What fellowship can light have with darkness? What harmony is there between Christ and Belial [that is, Satan]?" (NIV). In verse 17 he concludes with a direct charge from the Lord Himself:

Therefore

"Come out from among them
And be separate, says the Lord,

Do not touch what is unclean,
And I will receive you."

Making this break requires also that you deal with any "contact objects"—that is, objects that would still link you with Satan. This could include many different items. In my case, as I related in chapter 2, it was the Chinese dragons I had inherited. If you have any doubts about how this might apply in your situation, ask God to put His finger on anything that is offensive to Him. Then get rid of it in the most effective way: burn it, smash it, throw it into deep water—or whatever!

If you are ready to make this total break with Satan and his kingdom, here is an appropriate way to affirm it:

> I renounce all contact with anything occult or satanic—if I have any "contact objects," I commit myself to destroy them. I cancel all Satan's claims against me.

6. *You are now ready to pray the prayer for release from any curse.*

If you have been willing to commit yourself to each of the preceding five steps, you are now at the place where you can pray the actual prayer for release from any curse over your life. But remember, there is only one basis upon which God offers His mercy: the exchange that took place when Jesus died on the cross. Included in that exchange was provision for release from every curse. By being hanged on a cross, Jesus became a curse with every curse that could ever come upon you, that you in turn might be released from every curse and receive God's blessing in its place.

It is important that you base your faith *solely* upon what Jesus obtained for you through His sacrifice on the cross. You

do not have to "earn" your release. You do not have to be "worthy." If you come to God with thoughts like that, you will have no solid basis for your faith. God responds to us only on the basis of what Jesus has done on our behalf, not of any merits we may fancy we have in ourselves.

If you pray with this basis for your faith, your prayer should end not merely with asking, but with actually receiving. In Mark 11:24 Jesus established this as a principle: "Therefore I tell you, whatever you ask for in prayer, *believe that you have received it,* and it will be yours" (NIV).

In this kind of prayer there are two distinct stages, related as cause and effect: *receiving* and *having. Receiving* is the cause, from which *having* follows as the effect. *Receiving* is in the past tense; *having* is in the future. *Receiving* takes place when we pray. Then *having* follows at a time and in a way determined by God's sovereignty. But the principle Jesus emphasizes is this: If we do not *receive* at the time we pray, we have no assurance that we will ever *have.*

Here is a prayer that would be appropriate. You might first read through this prayer and then read on for further instructions.

> Lord Jesus, I believe that on the cross You took on Yourself every curse that could ever come upon me. So I ask You now to release me from every curse over my life—in Your name, Lord Jesus Christ!
>
> By faith I now receive my release and I thank You for it.

Now, pause for a moment! Before you pray this prayer for release, you would be wise to reaffirm each of the five preceding confessions you have already made. To make this easier for you, they are repeated below, but without any added comments or explanation.

Read them out loud, slowly and deliberately, with undi-

vided attention. If you feel uncertainty about any section, go
back and read it again. Identify yourself with the words you
utter. By the time you have read them through, *you should
have the sense that you have brought yourself to God* with the words
you have spoken. Then go straight on into the prayer of re-
lease, which is repeated at the end.

Here, then, is the complete prayer:

> Lord Jesus Christ, I believe that You are the Son
> of God and the only way to God; and that You died
> on the cross for my sins and rose again from the dead.
>
> I give up all my rebellion and all my sin, and I
> submit myself to You as my Lord.
>
> I confess all my sins before You and ask for Your
> forgiveness—especially for any sins that exposed
> me to a curse. Release me also from the conse-
> quences of my ancestors' sins.
>
> By a decision of my will, I forgive all who have
> harmed me or wronged me—just as I want God to
> forgive me. In particular, I forgive. . . .
>
> I renounce all contact with anything occult or
> satanic—if I have any "contact objects," I commit
> myself to destroy them. I cancel all Satan's claims
> against me.
>
> Lord Jesus, I believe that on the cross You took
> on Yourself every curse that could ever come upon
> me. So I ask You now to release me from every
> curse over my life—in Your name, Lord Jesus
> Christ!
>
> By faith I now receive my release and I thank
> You for it.

Now don't stop at saying "Thank You" just once or twice.
Your *mind* cannot grasp a fraction of what you have asked God
to do for you, but respond to God with your *heart!* This could

be the time to release hurts or pressures or inhibitions that have built up inside you over the years. If a dam breaks inside you, don't try to hold back the tears that are the outflow of your heart.

Don't be held back by self-consciousness or embarrassment! God has known all along the things that you kept shut up inside you—and He is not the least embarrassed by them. So why should you be? Tell God how much you really love Him. The more you express your love, the more real it will become to you.

On the other hand, there is no set pattern for responding to God that everyone has to follow. The key to release is not some particular type of response. Faith can be expressed in many different ways. Just be your real self with God. Open your whole being to God's love as a flower opens its petals to the sun.

7. *Now believe that you have received, and go on in God's blessing!*

Do not try at this stage to analyze what form the blessing will take or how God will impart it to you. Leave that in God's hands. Let Him do it just how and when He will. You do not have to concern yourself with that. Your part is simply to open yourself, without reservation, to all that God wants to do in you and for you through His blessing.

Remember that God "is able to do exceedingly abundantly above all that we ask or think" (Ephesians 3:20). So do not limit God to doing only what you think.

Here is a simple form of words that you can use:

> Lord, I now open myself to receive Your blessing
> in every way You want to impart it to me.

It will be exciting for you to see just how God will respond!

19
From Shadows
to Sunlight

If you followed the instructions in the previous chapter, you have crossed an invisible boundary. Behind you now is a territory overshadowed by curses of many different kinds and from many different sources. Before you lies a territory made bright by the sunshine of God's blessings. Before you go any further, cast your mind back to the summary of the list Moses gave in Deuteronomy 28:2–13:

Exaltation	Prosperity
Health	Victory
Reproductiveness	God's favor

These are all parts of your inheritance in Christ, waiting for you to explore and to claim.

It could help you to repeat these key words over to yourself several times—preferably out loud. Living under a curse of-

ten makes it difficult for a person to envisage what it would be like to enjoy the corresponding blessing. Ask God to make your new inheritance real and vivid to you. You may need to go on repeating these words frequently—even many times a day—until you really know they are yours!

As you repeat them, pause and thank God that each one is now part of your inheritance. Remember that giving thanks is the purest and simplest expression of faith. If you have had a long struggle with a curse over your life, there may be areas of your mind from which the darkness is not immediately dispelled. Repeating these positive words that describe the blessings will be like seeing the first rays of the sun shining into a dark valley, then spreading until the whole valley is illuminated.

The transition from the dark to the sunlit territory may take many different forms. There is no single pattern that is standard for everyone. Some people experience an almost instantaneous release and seem to enter immediately into the blessings that Scripture promises. For others, who are equally sincere, there may be a long, hard struggle. The more deeply people have been involved in the occult, the harder may be their struggle to escape. Satan regards them as his legitimate prey, and he is determined to hold onto them. On their part, they must be even more determined to assert their claim to the freedom that has been purchased for them by the sacrifice of Jesus.

Also, Satan has at least some foreknowledge of what God has prepared for those who escape from his oppression. The greater the blessings in store for a person, the more determined will be Satan's attempt to hold him back. Viewed in this light, as foreshadowings of blessings ahead, our struggles can actually become a source of encouragement.

Over and above these factors, we are confronted with the
sovereignty of God. God's perspective is different from ours.
He takes into account factors in a situation about which we
know nothing. He always keeps His promises, but in most
cases there are two things He does not reveal in advance: the
precise way that He will work in each life, and the precise
time that He will take. No one can dictate to God exactly how
to fulfill His promises. What we must do is maintain an atti-
tude of firm, unwavering trust that God will move when and
how He sees fit.

We need to look once more at the positive side of the
exchange described by Paul in Galatians 3:13–14:

> Christ has redeemed us from the curse of the law,
> having become a curse for us (for it is written, "Cursed
> is everyone who hangs on a tree"),
>
> that the blessing of Abraham might come upon the
> Gentiles in Christ Jesus, that we might receive the prom-
> ise of the Spirit through faith.

Paul points out three important facts concerning the prom-
ised blessing:

First, it is not something vague or undefined. It is quite
specific: *the blessing of Abraham*. In Genesis 24:1 its extent is
defined: "The Lord had blessed Abraham in *all things*." God's
blessing covered every area of Abraham's life. He has a cor-
responding blessing prepared for each person who fulfills His
conditions.

Second, the blessing comes only *in Christ Jesus*. It cannot be
earned by our own merits. It is offered solely upon the basis
of our relationship to God through Jesus Christ. There is no
other channel through which the blessing can flow into our
lives. If the relationship with Christ is ruptured by unbelief or

disobedience, the blessing will cease to flow. But thank God, it can be restored immediately by sincere repentance!

Third, the blessing is further defined as *"the promise of the [Holy] Spirit."* Concerning this, Jesus tells us in John 16:13–15:

> "But when he, the Spirit of truth, comes, he will guide you into all truth. . . . He will bring glory to me by taking from what is mine and making it known to you. All that belongs to the Father is mine. That is why I said the Spirit will take from what is mine and make it known to you."
>
> NIV

What wonderful words of encouragement! All three Persons of the Godhead—Father, Son and Holy Spirit—are united in their purpose to share with us all that has been purchased for us by the sacrifice of Jesus. Because this is far greater than the natural mind can comprehend, we must depend upon the Holy Spirit to guide us into our full inheritance and to show us how to appropriate what God has provided for us.

In Romans 8:14 Paul again emphasizes the unique role of the Holy Spirit: "For as many as are led by the Spirit of God, these are sons of God." Paul is careful to use here the continuing present tense: "as many as *are continually led* by the Spirit of God." To be "led by the Holy Spirit" is not a single, once-for-all experience. It is something on which we must depend moment by moment. It is the only pathway to spiritual maturity. Through it we grow up from being little children to become *mature sons* of God.

Unfortunately, many Christians never fully enjoy the guidance and companionship of the Holy Spirit for one basic reason: They do not realize that He is a *Person.* "The Lord is the Spirit" (2 Corinthians 3:17). Just as God the Father is Lord,

and God the Son is Lord, so also God the Spirit is Lord. He
is not just a theological abstraction, nor a set of rules, nor half
a sentence at the end of the Apostles' Creed. He is a Person,
and He wants us to cultivate an intimate, *personal* relationship
with Him.

The Holy Spirit has His own distinctive characteristics. He
is not aggressive or "pushy," nor does He shout at us. He
usually speaks in soft tones and directs us by gentle impulses.
To receive His direction, we must be attentive to His voice
and sensitive to His impulses.

Furthermore, the Holy Spirit deals with each of us as indi-
viduals. To enter into God's blessings, there is no single set of
rules that everybody must follow. Each of us has a special,
distinctive personality with unique needs and aspirations,
unique strengths and weaknesses. The Holy Spirit respects
our uniqueness. Someone has said that God never makes one
believer a carbon copy of another. Nor does He produce Chris-
tians on a factory assembly line.

Only the Holy Spirit knows the special dangers that
threaten us in any situation or the particular blessings that will
meet our individual needs. He guides us faithfully through
the dangers and opens up to us the blessings. If we begin to
follow some religious system or to model ourselves on some
other Christian, we shall miss some of the choicest blessings
God has marked out for us.

You would be wise, therefore, to pause for a moment and
offer up a brief prayer:

Holy Spirit, I open my heart and mind to You.
Reveal to me the blessings that Jesus has obtained
for me and how I may receive them.

In Hebrews 10:14—already quoted in chapter 17—the
writer uses two contrasted tenses to depict two opposite sides

of the exchange that took place on the cross. To describe what Jesus accomplished, he uses the *perfect* tense: "By one offering He *has perfected* forever." What Jesus has done is absolutely and eternally complete. Nothing need ever be added, and nothing can ever be taken away.

On the other hand, to describe the outworking of the sacrifice in those who accept it for themselves, the writer uses the *continuing present:* "those who *are being sanctified.*" Our appropriation of the sacrifice is not immediately complete; it is *progressive.* The process by which we appropriate it is described as "being sanctified"—that is, being set apart to God in holiness. As we bring our lives progressively into line with God's requirements of holiness, we are able to enter into His blessings more fully.

When confronted with this challenge, Christians sometimes respond, "But I thought I got everything when I was born again!" The answer to that is yes—and no. There are two sides to this issue: the legal and the experiential. The answer will differ according to which side we view it from.

Legally, you did indeed "get everything" when you were born again. According to Romans 8:17, when you became a child of God, you were made "an heir of God and a joint heir with Christ." Legally, from that point on, you were entitled to share Christ's whole inheritance with Him.

Experientially, however, you were only at the beginning of a process that takes a lifetime to complete. The Christian life could be described as a progression from the legal to the experiential. Step by step, in faith, we must appropriate in experience all that is already ours by legal right through our faith in Christ. This is what the writer of Hebrews calls "being sanctified."

In John 1:12–13 the apostle says, concerning those who have been born again through receiving Jesus, that God has

given them *"the right to become children of God."* The Greek word translated "right" is *exousia*, usually translated "authority." That is what a person actually receives at the new birth: *authority to become a child of God.*

Authority is effective, however, only insofar as it is exercised. The potential of the new birth is unlimited, but the actual results depend on the exercise of the authority that goes with it. What a person will become through the new birth is determined by the extent to which he exercises his God-given authority.

There is a close parallel between the experience of believers entering into the blessings of God in the New Covenant and that of the Israelites entering into Canaan under the Old Covenant. In the first covenant, under a leader named Joshua, God brought His people into *a promised land.* In the second covenant, under a leader named Jesus (which is another form of Joshua), God brings His people into *a land of promises.* Just as the land of Canaan was the physical inheritance appointed for Israel, so the promises of God, offered through Jesus, are the spiritual inheritance appointed for Christians in this dispensation. The same principles that applied to Israelites then apply to Christians now.

In Joshua 1:2–3 God gave Joshua instructions on how the Israelites were to take possession of their inheritance:

> "Moses My servant is dead. Now therefore, arise, go over this Jordan, you and all this people, to the land which I am giving to them—the children of Israel.
> "Every place that the sole of your foot will tread upon I have given you, as I said to Moses."

There is precisely the same contrast of tenses here as in Hebrews 10:14. In verse 2, the Lord uses the continuing present: "I *am giving* [the land]." But in verse 3 He uses the

perfect tense: "I *have given* [the land]." From verse 3 onward, the legal ownership of Canaan was settled: It belonged to Israel. Experientially, however, nothing had changed. The Canaanites were still in occupation of the land.

The challenge to Joshua and his people was to move from the legal to the experiential. This they were to do one step at a time. As they placed their feet on each place, it became theirs not just legally, but in actual experience.

Had the Israelites responded to God's promise in the same way that some Christians would like to, history would have been very different. They would have lined up on the east bank of the Jordan, folded their arms, looked westward and said, "It's all ours!" But the Canaanites would have laughed at them. They knew who still had possession of the land.

As it was, Joshua and his people acted very differently. First, they crossed the Jordan by a miracle that God performed in response to their obedience. Then they besieged and captured Jericho—again by a miracle. But after that their further progress was mainly by battles, not by miracles. They moved out in every direction across Canaan and fought a long series of battles against the various inhabitants of the land. Even after much arduous warfare, their task had not been completed. A long time later, God said to Joshua, "There remains very much land yet to be possessed" (Joshua 13:1).

Precisely the same challenge confronts us as believers in the New Testament: to move from the legal to the experiential. Like Israel, we must progress one step at a time. Like Israel, too, we will face opposition. Our progress will continually be contested by satanic forces, and we must learn to overcome them with the spiritual weapons God has provided for us. Ultimately, Christ's promises in the New Covenant are given to only one kind of person: "to him who overcomes." (See Revelation 2 and 3.) The right to the inheritance is

summed up in Revelation 21:7: "He who *overcomes* shall inherit all things."

To further strengthen and encourage us, God has also set before us the example of Abraham, who is called "the father of us all." Through Abraham, God did not merely establish the measure of the blessing He has prepared for each of us, which is "in all things." He also marked out ahead the path that leads to that blessing. The life of Abraham is both an example and a challenge in three main areas: his prompt obedience, his complete confidence in God's word and his steadfast endurance.

In Hebrews 11:8 the writer emphasizes Abraham's prompt, unquestioning obedience: "By faith Abraham obeyed when he was called to go out to the place which he would afterward receive as an inheritance. And he went out, not knowing where he was going."

Abraham did not ask for any explanation of why he should go, or any description of the place he was going to. He simply did what God told him to do, promptly, without questioning. The same kind of obedience characterized his entire life: for instance, when God required him and all his household to be circumcised (Genesis 17:9–14, 23–27); and even when God asked him to offer up his son, Isaac, as a sacrifice (Genesis 22:1–14). At no time did Abraham ever hesitate in his obedience or question God concerning what he was asked to do.

In Romans 4:16–21 Paul points out that when God called Abraham "a father of many nations," he had only one son by Hagar, a slave woman, while Sarah, his wife, had been barren for many years. Yet he reckoned God's description of him as true from the moment it was spoken. Because he thus accepted God's word without questioning, even against the evidence of his own senses, ultimately there came a physical fulfillment that was confirmed by his senses.

Actually, about 25 years passed from the time God first promised Abraham that his descendants would be as numerous as the stars, until the birth of the son who was the promised heir. Through all those years he had nothing to hold onto but God's promise. He must have faced endless temptations to discouragement. Yet he never gave up or abandoned his faith. Finally, the reward of his steadfastness is summed up in Hebrews 6:15: "And so, after he had patiently endured, he obtained the promise."

In Romans 4:11–12 Paul tells us that we are children of Abraham "if we walk in the steps of Abraham's faith." This is the scriptural requirement for entering into "the blessing of Abraham," promised in Galatians 3:14. Like Abraham, we must accept God's Word as the one sure, unchanging element in our experience. All the variable opinions of men, and all the fluctuating impressions of our senses, are just "grass that withers." "But the word of our God stands forever" (Isaiah 40:8).

Our acceptance of God's Word, however, must not be purely intellectual or theoretical. We must demonstrate it in our actions just as Abraham did: by prompt, unquestioning obedience and by steadfast endurance in the face of all discouragement. In this way, we shall find that God's Word will ultimately be proved true in our experience. We shall come to know God's blessing—just as Abraham did—"in all things."

Satan will continually oppose us with mental and emotional pressures: doubts, fear, guilt, confusion and so on. He may also assail our bodies with various forms of physical infirmity. Against all this God has provided us with one supremely effective weapon: His Word. In Ephesians 6:17 Paul directs us: "Take . . . the sword of the Spirit, which is the word of God."

This requires the interplay of the human and the divine. The sword is the sword of the Holy Spirit, but it is our responsibility to "take" it. If we take it, the Holy Spirit will wield it. But if we do not take it, the Holy Spirit has nothing to wield.

The Greek word Paul uses here to describe God's Word is *rhema.* This is primarily *a word that is spoken.* It becomes effective only when it is spoken through believing lips. It is not the Bible in our bookshelves, or even on our nightstands, that Paul is speaking about. It is the Bible when we take it on our lips *and speak it out with bold faith.*

Our great pattern in the use of this sword is the Lord Jesus Himself, as He demonstrated in His temptation by Satan in the wilderness. (See Matthew 4:1–11.) Each of Satan's three temptations contained the word *if.* In other words, it was aimed to produce *doubt.*

The first two temptations each began with the phrase "*If* You are the Son of God. . . ." Shortly before, when Jesus was baptized by John in the Jordan, God the Father had publicly declared, "This is My beloved Son, in whom I am well pleased" (Matthew 3:17). Now Satan was tempting Jesus to doubt what the Father had said about Him.

The third temptation also began with *if,* but it was no longer a temptation merely to doubt, but also to direct disobedience: "*If* You will fall down and worship me. . . ." Satan now challenged Jesus to commit the greatest of all sins: the breaking of the first commandment.

The temptations Satan brings against us, as disciples of Jesus, will follow a similar pattern. First, he will tempt us to doubt what God has said about us; to doubt that our sins have been forgiven, that God really loves us, that we have been accepted into God's family as His children, that we have been released from the curse and have entered into the blessing.

But always the final thrust of his temptation will be to direct disobedience.

Jesus used only one weapon to defeat Satan: the *rhema*— the spoken Word of God. He countered each temptation with the same phrase: "It is written." Each was a direct quotation from the Scriptures of the Old Testament. Satan has no defense against the Word of God thus quoted directly at him. He has to withdraw, defeated.

In all of this, Jesus is our perfect example. He did not rely on any wisdom or arguments of His own. He used precisely the same weapon God has given to us: the Word of God. Our security depends on following the example of Jesus. We would certainly be foolish to rely on our own wisdom or strength or righteousness. Satan is a thousand times wiser and stronger than we are. He can point to a thousand flaws in our own righteousness. But there is one weapon against which he has no defense: the Word of God spoken in faith.

Such, then, is the path that leads us out of the territory overshadowed by curses into the territory that enjoys the sunlight of God's blessings. Its first requirement is determined, unswerving faith, based on the exchange that took place on the cross. Faith of this kind reckons God's promises as effective from the moment they are apprehended. We do not wait for confirmation from the senses. By prompt, unquestioning obedience and patient endurance, we move from our legal rights in Christ into the full, experiential enjoyment of them. We meet all satanic opposition with "the sword of the Spirit": the spoken Word of God.

20
Forceful Men
Lay Hold of It

When Joshua was commissioned as the leader who would bring Israel into their inheritance in Canaan, he received the same admonition three times: "Be strong and of good courage" (Joshua 1:6, 9, 18). The first two admonitions came from the Lord Himself; the third came from his fellow Israelites. After the third admonition Joshua must surely have understood one thing: entering into the Promised Land would not be easy!

The same applies to Christians today who set out to appropriate the promised blessings of the New Covenant. God assures us that He will be with us and fulfill all His promises to us. At the same time, He warns us that we will face various forms of opposition, which will test our faith and our commitment.

In Matthew 11:12 Jesus spoke of the Gospel dispensation He had come to initiate: "From the days of John the Baptist

until now, the kingdom of heaven has been forcefully advancing, and forceful men lay hold of it" (NIV). In Luke 16:16 He emphasized the same point: "The Law and the Prophets were proclaimed until John. Since that time, the good news of the kingdom of God is being preached, and everyone is forcing his way into it" (NIV).

Clearly the promise of the Kingdom is not for those who merely indulge in wishful thinking or religious talk. It demands "forcefulness"—an attitude of fixed determination that presses ahead regardless of every kind of difficulty or discouragement.

In Acts 14:22 Paul and Barnabas gave a similar warning to a group of new converts: "We must through many tribulations enter the kingdom of God." Any road that bypasses the tribulations will not take us into the Kingdom. Once we have settled this issue in our own minds, then the tribulations will not deter us.

Otto Aguiar is one man who set out to lay hold of God's promises with forceful determination. Otto is a Brazilian who was born with curses over his life that went back many generations. He had also brought further curses upon himself by his own foolishness. Nevertheless, he has finally crossed over from the dark territory of curses to the sunlit land of God's blessings, which is where he now lives.

Otto Aguiar tells his story:

I was born fifty years ago in Rio de Janeiro, Brazil. My father was a well-known general from mixed European and Indian stock; my mother came from a family of governors and statesmen. Both sides of my family had been in spiritism for generations.

I was the seventh of ten children—a fourteen-pound

breech birth. For several years I was accused of almost killing my mother. I was guilt-ridden and withdrawn. I would sit, hiding my head in my arms, reliving the gruesome experience of being dragged out with forceps, and not ready to cope. I repeated first grade *four* times. By the time I was promoted to second grade, I was almost the size of my teacher.

Ancestral curses began to affect the older members of my family while I was still a child. My eldest sister, while in a strict Catholic school, was taken to a spiritist center, and began to "receive spirits of saints," as they say in Brazil. She has spent most of her life in mental institutions.

The second child, my eldest brother, a brilliant student, took a fall on his head at age ten, and became an epileptic. In Brazil at that time it was commonly believed that epilepsy was contagious, so he was moved, with all his belongings, from the main house to the servants' quarters. When he would have an attack, my mother would become totally distraught and scream, "There is no God!" He has been institutionalized for the past fifteen years.

When I was sixteen I began to have all the symptoms of epilepsy—foaming at the mouth, fainting, vomiting, in complete confusion. Yet brain scans showed nothing.

My father, an excellent leader of men, was extremely passive with his seven sons, and exercised no real authority. I cannot remember his even speaking to me until I became a man—yet I adored him. He frequented a spiritist center. I never felt good about spiritism, but would on occasion go myself.

I don't really understand how it happened, but I was accepted for study at a fine arts school—where I obtained a master's degree, with honors in graphic arts! But I never pursued that career. I chose to become a

fashion model, and traveled from Brazil to Paris, modeling.

I was heavily involved in drugs and a fast-paced lifestyle. Sometimes I would spend time alone at my family's beach house. I would look at the sky and think of the One who put the stars in the sky and caused the sun to rise. I hungered to know who He was, but I didn't know where to look.

Then I met Ellen, a Jewess from the U.S.A., also a fashion model. When I met her, I decided to change my lifestyle, but I couldn't do it. She went away for five days on an assignment, and I went to the beach with my friends. We were high on drugs and when I entered the rough water, I was immediately dragged in by a powerful wave. Wave after wave slammed on me. I couldn't get my breath. I thought, "*O God,* now that I've met Ellen and I want to change, am I going to *die?*" This was the first time in my 37 years that I had called on God, but He heard me—and suddenly I was on the sand, trembling and bruised all over, in total panic, yet amazed to be alive.

Within eleven months I not only had a wife, but also a baby—and I could not cope. Instead of hiding my head in my arms as I did as a small boy, I would "phase out" and stare at the ceiling in a trance. . . . I was still a model, and everything else I tried failed . . . so I decided to take my wife and son to Fort Lauderdale, Florida.

My first job was working part-time in a men's clothing shop on fashionable Las Olas Boulevard. I was terrified— I couldn't speak proper English—so I also dug ditches, cracked holes in cement, cleaned bathrooms and washed cars. I had a serious problem with pornography and was in total depression. I could not adjust to American culture, and most of the people I worked for cheated me or didn't pay me at all.

Then we were invited to Good News Church; Ellen was brought to her knees and received the Lord with no intellectual understanding—just fear and trembling! I went forward for salvation the next week, but nothing seemed to happen. The trances got worse; I couldn't keep a job for even one week; my depression was worse; Ellen and I fought constantly because we had no money.

Since Ellen had been involved in the occult, she knew she needed deliverance—and she got it when she renounced everything occult. I could not believe that I needed deliverance from evil spirits—and I also could not believe that God wanted to bless me the way I saw Him blessing others.

By this time, I had done almost every menial task a general's son would never do! People would say, "Why don't you use your creative abilities?" But I was afraid—anything good seemed unattainable.

I went to Derek Prince's seminar on "Curses: Cause and Cure," but nothing happened. I got the tapes and played them over and over. I could see my need, and I desperately wanted to be set free—but it seemed that it didn't work for me.

I got delivered gradually. After two and a half years as a Christian, with no progress, I decided to fast and ask God to help me and deliver me. I was able to fast ten days, and when some Christian friends prayed for me, I received partial deliverance.

For the first time in my life I had some JOY . . . but it didn't last. We had numerous car accidents; I was never able to support my family; I worried about my father in Brazil, who was dying, but we could not possibly afford to go to visit him.

People who tried to help me thought my situation was impossible—I was so passive. I was very uncomfortable with Christian men. . . .

Ellen and two friends began to meet and pray for their husbands at 6:00 A.M. at the prayer house. She would say, "I'm going to pray that you will be a success in all that you put your hand to, and that the Lord will give you a job that you'll love and use the gifts He's set within you." I could not believe that God would answer such a prayer; how could she? (Since then all three women have seen their prayers answered: One husband is now in full-time ministry, one was delivered from alcoholism and I got exactly what my wife prayed for.)

Finally, after six years as a Christian, I went to the pastor for deliverance from evil spirits (after years of being too proud to admit I needed it). Then I went to "Evangelism Explosion" training. When I discovered what Jesus Christ had done for me, I was totally amazed. I had so much JOY—I was in love with God—my co-workers and clients in the store began to come to church to find out what had happened to me!

Again, after a while, my joy dwindled—my job, my finances, my concern for my dying father . . . I was still passive, still frustrated. I began to get an urge to paint—but I was so scared, so afraid of failing. Finally I tried—and I did such primary work that people thought my son, age eight, had done it! But God was stirring up ideas—I began to create in my mind. . . .

I decided to go on a forty-day fast. I felt God wanted me to leave my job in the clothing store, but I wanted to be *sure*. I said I wouldn't eat until He spoke to me. After forty days I still had heard nothing. So I ate for two weeks and fasted for two weeks all summer. That was the hardest summer of my life. It was so hard that I learned to *cry out* to God for His mercy. I *begged* Him to speak to me. *I needed to know His will.* My wife and my children would lay hands on me and pray that God would do a miracle in my life. . . .

Then an artist friend gave me some canvas stretched on boards. . . . One Sunday I sent my family to church, and did my first painting.

Two days later, seated in the clothing shop, the Lord spoke to me: *Otto, do you believe that I really want to bless you?*

I said, "Yes, Lord. . . ."

Then why are you sitting here? You are here because you do not want to be blessed. It is your choice. You have never really trusted Me to completely control your life.

I said, "Take it! My life is Yours."

He said, *Take your bag and go home.* (For me, it was as if He had said, "Take up your pallet and walk.")

I got up, walked out and never looked back.

That first painting sold within one week for $80. Within two weeks I was paid $900 for six paintings. After two months my paintings brought $600 each; within one year $1,800; before two years up to $6,500.

I have sold everything I have ever painted and I cannot keep up with the demand—and *I love my work!*

After nine months of painting, not only was I able to support my family, but we had enough money to go to Brazil. My father had *never* heard the Gospel, but when he heard, he believed! I had the joy of seeing my 89-year-old father gather up every ounce of strength to pray the sinner's prayer, and I also led several of my brothers and sisters, plus nurses and strangers, to the Lord. Two weeks after we returned to the U.S., my father died with joy on his face! What a privilege God gave me.

The main changes in my life seem obviously financial—but, far more important, God completed the revelation of what Jesus did for me on the cross. Now I fully believe He set us free from the curse and that His desire is to bless us, and that He wants us to give Him *complete* control over all that concerns us. That without

His power, His grace, I cannot do anything—much less create. I am totally dependent upon His anointing. I *know that He loves me!*

God now speaks to me in dreams and very clearly. . . . I am confident if He wants me to stop painting, it will be to do something better. I'll continue praising Him and trusting.

I now have three precious healthy children, a happy marriage, wonderful friends and consider myself blessed among men. *I have seen the enemy completely defeated in my own life,* and God has given me a testimony that has encouraged multitudes of Christians and baffled the unsaved.

Otto's story contains a number of features that are typical of people whose lives are overshadowed by curses. It can also encourage those who are seeking to help loved ones in a similar condition. Here are some of the main lessons to be learned.

The root cause of the curses over Otto's life was his ancestors' deep involvement in spiritism over many generations. It has been my observation that curses follow this type of involvement as surely as night follows day.

The ensuing curses did not just affect Otto as an individual. They affected almost all his brothers and sisters, but in various ways. He states that two of them have spent long periods in psychiatric institutions.

One of the first steps in Otto's release was a *correct diagnosis* of his condition. Once he understood clearly that his life was under a curse, he was motivated to seek the release that Jesus had purchased for him through the exchange on the cross.

But, like many others, Otto had lived so long under a curse that he could not envisage God's blessing as a reality in his own life. Left to himself, he probably would never have been

able to enter into the blessing. He was too timid and with-drawn. He lacked the "forcefulness" needed to press into God's Kingdom. But persistent intercession by Otto's wife and children, and by others, gradually released him from his timidity and built up in him the determined faith that enabled him to pass from the curse to the blessing.

This should encourage other Christians who are concerned about family members or other loved ones under a curse. Patient, persistent intercession—motivated by love—can re-lease those who are not able to exercise faith for themselves.

Perhaps parents are reading this who realize with deep an-guish that their trespassing into the occult has brought curses upon their children, causing them to become captives of Sa-tan. For such parents who repent and seek God with their whole hearts, He has a special promise in Isaiah 49:24–25:

> Can plunder be taken from warriors,
> or captives rescued from the fierce?
> But this is what the Lord says:
> "Yes, captives will be taken from warriors,
> and plunder retrieved from the fierce;
> I will contend with those who contend with you,
> and your children I will save."
>
> NIV

Finally, it is encouraging to look at the extent of the bless-ings Otto now enjoys. God has blessed him—just as He blessed Abraham—"in all things."

21
Beyond Confession: Proclamation, Thanksgiving, Praise

In the prayer of release in chapter 18, the initial focus was on the truth revealed in Hebrews 3:1: Jesus is "the High Priest of our confession." This principle should also govern our ongoing relationship with the Lord. In every situation we encounter, we must respond with an appropriate scriptural confession in order to invoke on our behalf the continuing ministry of Jesus as our High Priest.

In most situations we have three possibilities: to make a positive, scriptural confession; to make no confession; to make a negative, unscriptural confession. If we make a positive confession, we release the ministry of Jesus to help us and to meet our need. If we make no confession, we are left at the mercy of our circumstances. If we make a negative confession, we expose ourselves to evil, demonic forces. In chapter 12, on the theme of "self-imposed curses," various examples

were given, showing how negative words release evil and negative forces into people's lives.

It is important to distinguish between the scriptural confession of genuine faith and such things as wishful thinking or irreverent presumption or some kind of "mind-over-matter" philosophy. There are three main differences. First of all, "confession" in the biblical sense is limited to the statements and promises of the Bible. It consists in saying with our mouth what God has already said in His Word. Beyond this confession cannot go.

Second, confession is also limited by the conditions attached to any particular promise. The great majority of the promises in the Bible are *conditional*. God says, in effect, "If you will do this, then I will do that." If we have not done the appropriate "this," then we have no right to expect that God will do the corresponding "that." Confession is valid only if the appropriate conditions have been fulfilled. It is never a substitute for obedience.

Third, confession cannot be reduced to a convenient "system," operated by human will. According to Romans 10:10, confession is effective only if it proceeds from faith in the *heart*. There is a radical difference between faith in the heart and faith in the mind. Faith in the mind is produced by our own mental processes; all it can produce is words, devoid of power. On the other hand, faith in the heart is produced only by the Holy Spirit, and it produces *words charged with power* to accomplish what is confessed. What God has promised to faith in the heart is out of the reach of mere mental faith.

In imparting faith to the heart, the Holy Spirit jealously guards His own sovereignty. He is not amenable to "witchcraft." No one can manipulate Him or intimidate Him or make Him do anything contrary to His own will. Concerning this kind of faith, Paul tells us in Ephesians 2:8–9 that it is

"not of yourselves; it is the gift of God, not of works, *lest anyone should boast.*" Mental faith often tends to be boastful and self-assertive. Genuine faith in the heart, on the other hand, humbly acknowledges its total dependence upon God.

With these qualifications, however, confession—rightly understood and practiced—can be a decisive factor in the Christian life. In James 3:4–5 the apostle compares the tongue to the rudder of a ship. Although tiny in comparison to the whole structure of the ship, the rudder determines the course that the ship will follow. Used rightly, it will guide the ship safely to its appointed harbor. Used wrongly, it will cause shipwreck.

This applies to the way we express our faith. Right confession can bring us into all the blessings God has promised. Wrong confession can take us further and further away—into perilous, uncharted seas where some kind of shipwreck awaits us.

People are often unwilling to accept responsibility for the words they speak. According to Jesus, however, there is no way to escape the issue: "For by your words you will be justified, and by your words you will be condemned" (Matthew 12:37). Our words will either confirm our righteousness in God's sight, or they will bring us under condemnation. There is no middle ground.

According to Romans 10:10, faith in the heart becomes fully effective only when it is confessed with the mouth. This is also true of unbelief. When we express our unbelief in words, we release its negative power to work against us, and to withhold from us the blessings God has promised to faith.

The writer of Hebrews offers two further warnings concerning the importance of right confession. In Hebrews 4:14:

> Seeing then that we have a great High Priest who has passed through the heavens, Jesus the Son of God, let us hold fast our confession.

Again, in Hebrews 10:21, 23:

> . . . And having a High Priest over the house of
> God . . .
> Let us hold fast the confession of our hope without
> wavering, for He who promised is faithful.

In each of these passages, there is a direct link between our
confession and the ministry of Jesus as our High Priest. The
same principle holds true throughout the New Testament: It
is our confession that unites us to Jesus as our High Priest and
releases His priestly ministry on our behalf.

The other main emphasis in these passages is on the words
hold fast. It is important to make the right initial confession,
but that is not sufficient by itself. In every subsequent situ-
ation where the same issues apply, we must consistently re-
affirm our original confession.

In Hebrews 10:23 the writer challenges us not merely to
hold fast our confession, but to hold it fast *without wavering*.
Clearly he envisages various possible situations that might
cause us to waver. "Wavering" might express itself in failing
to maintain the initial right confession, or even in changing a
positive confession to a negative one. In any case, the warning
against wavering indicates that the pressures directed against
us all have one objective: to make us retract, or even deny,
our original right confession.

The concept of right confession seems so simple, perhaps
even simplistic: just to say concerning each problem or each
test exactly, and only, what the Bible says about it, and to
keep on saying it. Yes, it is simple, but it is not easy! In fact,
I have concluded—both from experience in my own life and
from observation in the lives of others—that it is perhaps the
most searching test of Christian character and commitment.

It is the test that has confronted every martyr. Faced by

accusation, threats, torture, he has one supreme commitment: to maintain his confession of the truth *to the end.* When the accusations come from visible, human enemies, the issues at least are clear. But there is another kind of test, less easy to discern, in which the accusations are inward, directed against the mind by invisible demonic powers. Yet the issue is the same: to maintain the confession of the truth with unwavering determination until those invisible forces are silenced and routed.

Any Christian who successfully passes this test can be assured that he will be an overcomer and that, as such, he will inherit the blessings that God has promised to those who overcome.

To give full, victorious expression to faith, however, there is one further biblical concept that takes us beyond confession. It is "proclamation." Derived from a Latin verb meaning to "shout forth" or to "shout aloud," *proclamation* suggests strong, confident assertion of faith, which cannot be silenced by any form of opposition or discouragement. It implies a transition from a defensive posture to one of *attack.*

In Psalm 118:11–17 the psalmist describes such an experience. His enemies had surrounded him on every side and were about to destroy him, but the Lord intervened and gave him victory. His transition from defense to attack is described in verses 15 and 17:

> Shouts of joy and victory
>> resound in the tents of the righteous:
>> "The Lord's right hand has done mighty things! . . ."
> I will not die but live,
>> and will *proclaim* what the Lord has done.
>
> NIV

It was the psalmist's joyful, confident proclamation of what the Lord had done for him that set the seal on his victory. Rightly practiced, it will do the same for us.

As we practice the confident proclamation of all that God has provided for us through the sacrifice of Jesus, it will naturally lead us on to two further forms of expression: thanksgiving and praise. If we truly believe what we proclaim, this is the only appropriate response! Wherever there is genuine faith, proclamation will always be followed by thanksgiving and praise.

Although thanksgiving and praise are closely related, there is a distinction between them. Simply stated, we thank God for what He *does;* we praise Him for who He *is*. Joined together, thanksgiving and praise give us direct access to God's presence.

This is depicted vividly in the imagery of Psalm 100:4:

> Enter into His gates with thanksgiving,
> And into His courts with praise.
> Be thankful to Him,
> and bless His name.

The psalmist pictures two stages in approaching God. First, we enter His *gates* with *thanksgiving;* then, we pass through His *courts* with *praise*. This brings us into the immediate presence of God. If we do not fulfill these requirements for access, we can still cry out to God—but only from a distance. In His mercy He will respond to our cry, but we have no direct access into His presence.

Thanksgiving and praise are the two most immediate ways in which our faith can respond to God. Whenever God gives us a promise of blessing or reveals a provision He has made for us, we need to respond like Abraham and accept God's word to us as true from the moment it is spoken. Logically, therefore, we begin to thank and praise Him immediately. We do not wait until we have actually experienced the fulfillment of the promise or the provision.

In 2 Chronicles 20, this principle is illustrated by an event in the reign of Jehoshaphat, king of Judah. Word had come to the king that a vast invading army was advancing against him from the south. Jehoshaphat knew that he did not have the military resources to oppose this army. Consequently, he summoned all his people together to seek God's help by united prayer and fasting.

God responded to their prayer by a prophetic utterance, given through a Levite, which directed Jehoshaphat to lead his people against the enemy by a certain route. It also contained words of assurance and encouragement: "Do not be afraid or dismayed because of this great multitude, for the battle is not yours, but God's. . . . You will not need to fight in this battle. Position yourselves, stand still and see the salvation of the Lord, who is with you."

Nothing had changed at this point in the military situation, but Jehoshaphat received God's promise *by faith*, without demanding further evidence. The next day "he appointed those who should sing to the Lord, and who should praise the beauty of holiness, as they went out before the army and were saying,

> 'Praise the Lord,
> For His mercy endures forever.' "

This was certainly not the conventional way for an army to go into battle—but it worked! As soon as the Lord heard the praises of His people, He intervened sovereignly and supernaturally by sending a spirit of division among the various national groups within the invading army. Suddenly, and for no apparent reason, they began to fight each other, until all were totally destroyed. The people of Judah did not need to fight, but only to gather the booty from their slain enemies! God intervened in this way because His people responded to His promise by faith, without waiting for further confirmation.

Two important principles are illustrated by this account. First, God expects us to praise Him for the promises He gives us, without waiting to see them fulfilled. Second, praise offered in faith releases the supernatural intervention of God on our behalf. Briefly stated: Faith begins to praise God *before* the promised victory, not merely after it.

In the New Testament, in Acts 16, the experience of Paul and Silas in Philippi dramatically illustrates the same principles. As a result of casting a demon out of a slave girl, they had been unjustly arrested, savagely abused and beaten, and then thrown into the maximum security section of the jail, with their feet in stocks. There was no ray of light in their darkness, no source of comfort or encouragement in their physical situation, no assurance as to what the future held.

Yet in their spirits they knew that nothing could change the eternal faithfulness of God, and nothing could rob them of the victory Christ had won for them. The logic of their faith triumphed over the logic of their circumstances. At midnight— the darkest hour—they were singing hymns of praise to God!

Their praises did the same for them as for Jehoshaphat's army: They released the supernatural intervention of God on their behalf. "Suddenly there was a great earthquake, so that the foundations of the prison were shaken; and immediately all the doors were opened and everyone's chains were loosed" (Acts 16:26).

The lesson of Jehoshaphat's army and of Paul and Silas in the jail is summed up by the Lord Himself in Psalm 50:23:

> "He who sacrifices thank offerings honors me,
> and he prepares the way
> so that I may show him the salvation of God."
>
> NIV

God's salvation is already complete through the sacrifice of Jesus on the cross. Nothing we say or do can ever change that.

But when we respond with sacrifices of thanksgiving and praise, we open the way for salvation's benefits to be manifested in our lives. Like Jehoshaphat, and like Paul and Silas, we must learn to offer these sacrifices in faith, before we have actually experienced the benefits.

In Psalm 20:5 David said, "In the name of our God we will set up our banners." Again, in Song of Solomon 6:10, the Bride of Christ is portrayed as "awesome as an army with banners." Three of the most effective "banners" God has given us are *proclamation, thanksgiving* and *praise.*

First, we raise the banner of *proclamation.* We speak out boldly, in faith, the promise or the provision of God's Word that applies to our particular situation or meets our particular need. Then we go on to thank God—still in faith—for the truth we have proclaimed. Finally, we move from *thanksgiving* to jubilant *praise.* All this we do *in pure faith,* without waiting for any visible change in our situation.

In His own way and time, God responds to our faith, just as He did to that of Abraham. The truth, which we have proclaimed and for which we have thanked and praised Him, becomes a reality in our experience.

By raising these three banners of proclamation, thanksgiving and praise, we achieve two purposes at one and the same time. First, we secure for ourselves the promised blessings of God that we have proclaimed. Second, we shut out the satanic forces that would resist us and seek to withhold the blessings from us. In this way, marching together into our inheritance, we fulfill Solomon's prophetic picture of an army awesome with banners.

22
Proclamations for Continuing Victory

The truths I have been sharing in this book are much more than the outcome of an intellectual pursuit of knowledge in the abstract. On the contrary, I have "mined" them out of intense, persistent prayer and spiritual conflict, in which Ruth and I have shared together for at least three years. Every main truth unfolded in this book has been subjected first to the test of our own experience. I have not felt free to pass on to others theories that have not worked for us.

In the previous chapter I explained how proclamation, thanksgiving and praise, working together, can release into our lives the promised blessings of God. In this chapter I am going to share briefly how Ruth and I have been learning to apply this principle in our own lives. The regular practice of proclaiming God's Word, and then thanking and praising Him for it, has become an integral part of our personal spiritual discipline. We regard this as one of the most

valuable truths that God has opened to us from the Scriptures.

God has led us to establish a central "bank" of Scriptures, which we have memorized and which we draw upon in our times of prayer, or whenever we become involved in spiritual conflict. Proclaiming these in faith invariably releases corresponding expressions of thanksgiving and praise.

Normally, we speak these out loud, alone or together. We are not talking to one another, however, nor to the walls or the ceiling of our room. We are speaking to a vast, invisible world of spirit beings: first of all, to God the Father, the Son and the Spirit; then to all the heavenly beings who worship and serve God, and who have been appointed "ministering spirits, sent out to render service for the sake of those who will inherit salvation" (Hebrews 1:14, NASB). We are also conscious that we are surrounded by a "great cloud of witnesses," made up of the saints of all ages who have victoriously completed their earthly pilgrimage (Hebrews 12:1).

We believe that this is a legitimate application of Hebrews 12:22–24:

> But you have come to Mount Zion, to the heavenly Jerusalem, the city of the living God. You have come to thousands upon thousands of angels in joyful assembly, to the church of the firstborn, whose names are written in heaven. You have come to God, the judge of all men, to the spirits of righteous men made perfect, to Jesus the mediator of a new covenant, and to the sprinkled blood that speaks a better word than the blood of Abel.
>
> NIV

Also included in our audience, however, are Satan and all the evil angels and other demonic beings under his control.

These operate in a way exactly opposite to God's ministering angels. Their purpose is to inflict every form of harm and evil on the entire human race, but first and foremost on those who are serving the true God.

In this context, our proclamation has two effects. On the one hand, it invokes on our behalf the help of God and His angels. On the other hand, it protects us from the schemes and assaults of Satan and his demonic forces.

This form of proclamation is continually building up our faith. According to Romans 10:17, "Faith comes by hearing . . . the word [the *rhema*, the spoken word] of God." Hearing others speak God's Word is helpful, but hearing ourselves speak it is even more effective. As we both speak and hear, both edges of the sword of God's Word are at work in us simultaneously. (See Hebrews 4:12.)

Finally, when we make the same proclamation together, in harmony, supernatural power is released. Jesus says, "If two of you agree [harmonize] . . . concerning anything . . . it will be done for them by My Father in heaven" (Matthew 18:19). The power of one believer making a proclamation on his own is tremendous, but the power of two or more making the same proclamation together in harmony increases by geometric progression.

There are many times and situations, of course, when it would be out of place to make a proclamation out loud. The alternative is to make the same proclamation inaudibly in one's mind. Inaudible words can also make a powerful impact in the spiritual realm.

This is probably the most effective way to deal with lies and accusations with which the enemy bombards our minds. The mind is the main field of battle in all conflicts of this kind. When our minds are actively responding to the Word we are

proclaiming inwardly, no room is left for the enemy's negative thoughts and insinuations.

In all of this, however, we must be careful to recognize our continuing dependency on the Holy Spirit. Otherwise, the carnal mind can reduce these principles to a "system" in which God plays the role of a "heavenly vending machine." We simply insert the right proclamation, and out comes any brand of carnal gratification that we select! Obviously, this is a caricature of a believer's relationship with God.

There may be a wide gap between the way we view ourselves and the way the Holy Spirit views us. We may be conscious of what we *want*, whereas the Holy Spirit sees what we *need*. He alone can be trusted to direct each of us to the type of proclamation that applies to our individual situation and level of faith. In this way, God can accomplish His purpose in our lives.

With this caution, I feel it would be helpful for me to list below, simply as patterns, some of the proclamations that Ruth and I make regularly, together with the situations in which they would be appropriate. So far as possible, we "personalize" the Scriptures we quote. For instance, if a statement is addressed to believers and introduced with the pronoun "you," we normally change it to "I" or "we," and also make any other grammatical changes that are indicated.

My list opens with Scriptures that are directly connected with the theme of this book, but continues with others that have a more general application. Some comments and words of explanation are interspersed. In each case, the relevant Scripture reference is given.

1. *As a result of praying the prayer for release from curses (see chapter 18)*

> Through the sacrifice of Jesus on the cross, I have passed out from under the curse and entered into the blessing of Abraham, whom God blessed in all things.
>
> based on Galatians 3:13–14

Ruth has received release from many curses over her life, but she has had a continuing battle walking it out in experience. This proclamation has therefore become particularly significant for us. We often make it several times in a day. Over the past two or three years we have repeated these words many hundreds of times. Each time we do so, we move further away from effects of curses and into the blessing that is our inheritance.

2. *When becoming aware of negative forces directed against us, either from servants of Satan or from soulish utterances of Christians (see chapters 13, 14 and 15)*

> No weapon formed against me shall prosper, and every tongue that rises against me in judgment I do now condemn. This is my heritage [my inheritance right] as a servant of the Lord, and my righteousness is from You, O Lord.
>
> based on Isaiah 54:17

There are two important points to note in connection with this proclamation. First, we are not directed to ask God to condemn any tongue that speaks against us. God has given us the authority to do this for ourselves, and He expects us to exercise it.

Second, our right to exercise this authority depends on the fact that we are not acting out of our own righteousness, but because God's righteousness is imputed to us on the basis of our faith. Clearly this proceeds out of the exchange by which

Jesus, on the cross, was made sin with our sinfulness that we might become righteous with His righteousness. The various benefits of that exchange are all interrelated, and should not be separated from each other.

But God requires more of us than just turning back the evil words spoken against us. After that, He instructs us to forgive those who seek to harm us. Finally, He expects us to move from the negative to the positive: to respond to a curse with a blessing.[1]

Blessing those who curse us, just like forgiving those who harm us, does not depend on our emotions. It proceeds from a firm decision of our will, made in obedience to God's Word. Here is a suitable form of words that covers both forgiving and blessing:

> Lord, I forgive all who have spoken evil against me, and having forgiven them, I bless them in Your name.

Altogether, we need to follow three successive steps in responding to those who curse us. First, we condemn the tongue that has uttered the curse. Second, we forgive the person from whom the curse proceeded. Third, we ask God to bless the person. By carrying out these three steps, we can dissipate any spiritual darkness or heaviness that a curse has brought on us.

3. When pressures of sin or guilt or unworthiness pursue us from our past

> I am in Christ, and therefore I am a new creation. All those old things have passed away. Everything in my life has become new, and everything is from God.
>
> based on 2 Corinthians 5:17–18

[1] This is dealt with more fully in chapter 24.

God accepts total responsibility for the new creation. It is all His doing. Nothing is carried over from the old creation, which has been marred and corrupted by sin.

When the past reasserts its claims over us, we need to meditate on the picture John gives us in Revelation 21:5:

> Then He who sat on the throne said, "Behold, I make all things new." And He said to me, "Write, for these words are true and faithful."

These words come from the One who sits on the throne, the One who has under His control the entire universe and everything in it. That includes every detail of our lives. He reaffirms that He makes *everything* new.

It seems that John might have wondered inwardly whether this was too stupendous a claim, even for God. But the Lord assures him: "Write, for these words are true and faithful." It is as if He says: "Yes, John, you really can assure My people: I do exactly what I say."

4. *When oppressed by hopelessness and gloomy forebodings of death*

> I will not die but live, and will proclaim what the Lord has done.
>
> Psalm 118:17, NIV

Of course, this does not mean "I will never die"—but only "I will not die before God's appointed time—I will not allow myself to be murdered by Satan." Proclaimed with faith and understanding, this verse can deliver and protect those who are assailed by the spirit of death. It can be used to revoke the negative utterances by which people expose themselves to that spirit. (For examples, see chapter 12.)

For some people it may be necessary to repeat this proclamation many times over, until it becomes more real than all their previous negative thought patterns. Remember that Jesus required Peter to reaffirm his love for Him just as many times as he had previously denied Him.

5. *When assailed by physical sickness or infirmity*

> Jesus Himself bore my sins in His own body on the tree, that I, having died to sins, might live for righteousness—by whose wounds I was healed.
>
> based on 1 Peter 2:24

I have also prepared the following special proclamation, which combines truths from many different Scriptures and which has helped Christians in many areas of the world:

> My body is a temple for the Holy Spirit, redeemed, cleansed and sanctified by the blood of Jesus. My members—the parts of my body—are instruments of righteousness, presented to God for His service and for His glory. The devil has no place in me, no power over me, no unsettled claims against me. All has been settled by the blood of Jesus.
>
> I overcome Satan by the blood of the Lamb and by the word of my testimony, and I do not love my life to the death. My body is for the Lord, and the Lord is for my body.
>
> based on 1 Corinthians 6:19; Ephesians 1:7;
> 1 John 1:7; Hebrews 13:12;
> Romans 6:13; 8:33–34;
> Revelation 12:11; 1 Corinthians 6:13

Someone might ask, Is it honest for me to make proclamations such as these, when I see in my body the physical evidences of sickness, or when I feel in my soul the oppositions

of sin? The answer depends on your point of view. If you are looking at yourself in your own natural condition, then it is not honest. But if you are looking at yourself as God sees you in Christ, then you have the right to make such a proclamation.

Once we have repented of our sins and committed ourselves to Christ, God no longer looks at us as we are in our natural state. Instead, He looks at us from the perspective of the exchange that took place on the cross. Spiritually, He sees us as made righteous; physically, He sees us as made whole.

It is significant that, in the Scriptures, the healing provided through the sacrifice of Jesus is never spoken of in the future tense. In Isaiah 53:5, written more than seven hundred years before the death of Jesus, healing is already presented as an accomplished fact: "By his wounds *we are healed*" (NIV). In the New Testament, in 1 Peter 2:24 (quoted above), the apostle refers to Isaiah 53:5, but uses the past tense: "By whose stripes *you were healed.*"

When the words we speak about ourselves agree with what God says about us in Christ, then we open the way for Him to make us in actual experience all that He says we are. But if we fail to make the appropriate confession—or proclamation—about ourselves, we are confined to the prison of our own natural state. We have shut ourselves off from the supernatural, transforming grace of God, which works only through faith.

Again, someone might ask, What about someone who says and does all the right things, and yet the promised results do not follow? An answer is to be found in the words of Moses in Deuteronomy 29:29: "The secret things belong to the Lord our God, but those things which are revealed belong to us and to our children forever, that we may do all the words of this law."

The reason some people do not receive some part of the promised blessings often belongs in the category of "secret

things." It is vain for us to seek to pry God's secrets from Him. It is also irreverent. If God withholds an answer, it is more important to trust than to understand.

On the other hand, the words of Moses remind us of our responsibility, as God's people, to believe, to proclaim and to act upon those things He has clearly revealed in His Word. Central to these is the provision God has made for us through the sacrifice of Jesus on the cross. We must not let our concern about the secret things keep us from believing and obeying the things that are revealed.

6. *When Satan attacks an area for which God holds us responsible—our home, our family, our business, our ministry, etc.*

> The bolts of our gates will be iron and bronze, and our strength will equal our days.
> There is no one like the God of Jeshurun, who rides on the heavens to help us and on the clouds in his majesty.
> The eternal God is our refuge, and underneath are the everlasting arms. He will drive out our enemy before us, saying, "Destroy him!"
>
> based on Deuteronomy 33:25–27, NIV

By this proclamation we are enabled to move from defense to attack. First of all, "our gates" represent our defense system. God promises that this will be strong enough to keep out our enemy's attack. Then there is a wonderful picture of God intervening supernaturally on our behalf: "He rides on the heavens to help us." Our proclamation is one way that we invoke His intervention.

Finally, there is assurance of our enemy's defeat: "He [God] will drive out our enemy before us." God requires us to play our part in this final stage; therefore, He says, "Destroy him!" He has equipped us with the spiritual weapons we need to do this.

7. When we awaken to the realization that the mind is a battlefield in which the lies of Satan are at war with the truths of God's Word

> The weapons of my warfare are mighty in God. With them I pull down the strongholds that Satan has built in my mind. I bring all my thoughts into obedience to Christ. Three of my mightiest weapons are proclamation, thanksgiving and praise.
>
> based on 2 Corinthians 10:3–5

It is important to remember, however, that our "enemies" in the Christian life are not our fellow human beings. Our enemies are the evil spiritual forces directed against us from the kingdom of Satan. Paul makes this clear in Ephesians 6:12: "For we are not fighting against people made of flesh and blood, but against persons without bodies—the evil rulers of the unseen world . . . and against huge numbers of wicked spirits in the spirit world" (TLB).

In this strange kind of warfare to which God has called us, the standards of measurement are different from those we use in the world of the senses. Measured by the spiritual scale, *forgiving* is stronger than *resenting*; *blessing* is stronger than *cursing*; *giving thanks* is stronger than *complaining*; *praise* is stronger than *accusation*; and *loving* is stronger than *hating*.

Based on this paradox, here are two proclamations that unlock God's strength and God's enabling when our own resources fail.

8. When confronted by a task too big for me

> I can do all things through the One who empowers me within.
>
> based on Philippians 4:13

9. *When my own strength fails or is insufficient*

> God's strength is made perfect in my weakness, and so
> when I am weak, then I am strong.
>
> based on 2 Corinthians 12:9–10

Finally, here are two proclamations that cover needs that arise at some time or other in the lives of almost all of us.

10. *When exercising faith for financial needs*

> God is able to make all grace abound toward us, that
> we, always having all sufficiency in all things, may have
> an abundance for every good work.
>
> based on 2 Corinthians 9:8

The level of God's provision for His people is revealed as *abundance*, not mere sufficiency. Ruth and I make this proclamation regularly, as the financial base for Derek Prince Ministries.

11. *When assailed by fear*

> God has not given me a spirit of fear, but of power and
> of love and of a sound mind.
>
> based on 2 Timothy 1:7

> In the name of Jesus I submit to God and I resist the
> spirit of fear. Therefore it has to flee from me.
>
> based on James 4:7

The above Scriptures are only a few examples. There is no limit to the number of scriptural proclamations we can make. Each of us must rely on the Holy Spirit to guide us to those that suit our particular situations.

Choosing and making appropriate proclamations based on Scripture has one very important result. We receive and

apply God's Word in the *active*, not the passive mode. We no longer just read a Scripture and then pass on. Instead, we go through three successive stages. First, we ask the Holy Spirit to direct us to Scriptures that are especially appropriate for us. Second, we fix them firmly in our minds. Third, by proclaiming them, we release their power into the areas of our lives where we need them.

Perhaps you are one of the many Christians today who feel the need to "take the sword of the Spirit"—referred to in chapter 19—but do not know of a simple and practical way to do this. If so, Ruth and I would like to recommend to you this method of selective proclamation of Scriptures. We have practiced it in our own lives, and we can say, *It works!*

But let me add one final word of warning! Do not put your faith in your proclamation, or in any other method or procedure. *Our faith must be in God alone*—not in anyone or anything else. Our proclamation is merely an effective way to express the faith we have in God.

So now, as you set your face toward the land of God's blessings, receive the admonition given three times to Joshua:

"Be strong and of good courage!"

Important Afterwords

Introduction

The theme of *blessings* and *curses* is central to the whole of God's dealings with the human race. It can be compared to the trunk of a tree whose branches reach out in many different directions. A systematic study raises important, practical questions about various other main areas of biblical truth.

This section deals with two of these questions:

1. Is it possible at this present time, through faith, to experience release from all the curses that sin has brought upon the human race? If not, when—and how—will this finally be accomplished?

2. The Old Testament contains many examples of God's servants who pronounced curses on His enemies. What should the Christian response be when we are opposed and mistreated?

23
Curses Not
Yet Revoked

On the cross Jesus took upon Himself all the evil consequences that disobedience to God had brought upon the human race. These fall into two main categories: those brought upon man by his original disobedience in the Garden; and those pronounced later in connection with the Law given through Moses.

In Galatians 3:13 Paul refers to this latter category. He states specifically that "Christ has redeemed us from *the curse of the law*." He relates this to the fact that the Law had declared that anyone executed by hanging on a tree had—by that very fact—become a curse. The same Law that pronounced the curse thus opened the way for deliverance from the curse through the substitutionary sacrifice of Christ.

In chapter 4 we summarized "the curse of the Law" as follows: humiliation; barrenness, unfruitfulness; mental and physical sickness; family breakdown; poverty; defeat; oppression; failure; God's disfavor.

According to the clear statement of Paul in Galatians 3:13, the death of Christ on the cross offers deliverance from all these consequences of the broken Law. Paul does not here include, however, the various forms of the original curse that God pronounced upon Adam and Eve after their disobedience in the Garden. This curse—recorded in Genesis 3:16–19— falls into two main sections, the first spoken to Eve, and the second spoken to Adam.

The curse spoken to Eve relates to her unique function as a woman and it again falls into two sections:
1. Childbearing would be arduous and painful.
2. She would be subject to her husband's authority and dependent upon him for the fulfillment of her basic feminine desire for children.

The curse spoken to Adam relates primarily to the original task assigned to him by God in Genesis 2:15 to "tend and keep the garden"—that is, to cultivate the soil. This curse can be divided into three main sections:
1. The nature of the soil would undergo a change. Henceforth, it would yield its produce only by hard, sweat-producing labor.
2. The evidence of the change in the soil would be seen in a change in the vegetation it would produce—specifically in the growth of two unproductive forms of vegetation: thorns and thistles.
3. Man himself would be subject to decay and death, doomed ultimately to return to the dust from which he was taken. Though directed to Adam, this third section actually affected Eve as well, together with their descendants.

It is clear that the curses pronounced at this time also affected the earth itself. This followed from the close connection between Adam and his environment, which is indicated

by the Hebrew word for earth: *adamah*. Adam himself was made from the earth. He was also held responsible by God for the care of the earth.

In addition, a special curse was placed upon the serpent, which thereafter distinguished it from all other members of the animal kingdom.

In Ecclesiastes 1:2 and in Romans 8:20, the condition of the earth and its inhabitants produced by these curses is described by two words that have the same meaning: *vanity* and *futility*.

The redemption from "the curse of the law," to which Paul refers in Galatians 3:13, does not include the curses described above. These resulted from the original disobedience of Adam and Eve in the Garden. At this time there was no God-given system of law, and consequently no curse pronounced for breaking it.

In Romans 5:13–14 Paul says: "For until the law sin was in the world, but sin is not imputed when there is no law. Nevertheless death reigned from Adam to Moses, even over those who had not sinned according to the likeness of the transgression of Adam."

During this period "from Adam to Moses" humanity was without any God-given system of law. All men suffered, however, from the effects of the curse pronounced originally upon Adam and Eve, and each person paid the penalty for his own individual sin, which was death.

The beginning of the period of the Law is indicated in John 1:17: "The law was given through Moses." In connection with the giving of the Law, a long series of curses was pronounced on those who came under the Law, but then failed to keep it. These are the curses that are listed primarily in Deuteronomy 28:15–68. Collectively, they are called "the curse of the law." When Paul says in Galatians 3:13 that "Christ has redeemed us from the curse of the law," it is to these curses that he refers.

What about the curses pronounced originally on Adam and Eve? Has God provided redemption also from these? And if so, upon what basis?

To answer these questions, we need to recognize two different ways in which Jesus, when He came to earth, was identified with those whom He came to redeem. The New Testament depicts two different aspects of His identification with humanity, which are indicated by the two different genealogies given for Him.

In Matthew His genealogy is traced back to Abraham. As the promised "seed of Abraham," He identified with Abraham's descendants, the nation of Israel, who were under the Law. In Galatians 4:4–5 Paul says that Jesus was "born under the law, to redeem those who were under the law."

In Luke, however, the genealogy of Jesus is traced back to Adam, and He is thus identified with the whole race descended from Adam. During His earthly life the title He applied to Himself more than any other was "Son of man." In Hebrew the name *Adam* is also the word for *man*. Thus, "Son of man" is also "Son of Adam." By using this title, therefore, Jesus continually emphasized His identification with all of Adam's descendants—the whole human race.

Because of this identification, the substitutionary sacrifice of Jesus on the cross did not merely provide redemption from the curse of the broken Law. It also provided deliverance from all the evil consequences that the original sin of Adam had brought upon all his descendants—whether under the Law or not.

This is brought out by two different titles that Paul gives to Jesus in 1 Corinthians 15. In verse 45 he calls Him "the last Adam," and in verse 47 "the second Man." These two titles refer respectively to the death and the resurrection of Jesus.

On the cross Jesus died as "the last Adam." He took upon

Himself all the evil consequences that Adam's disobedience had brought upon the entire human race. When He died, they were terminated. When He was buried, they were forever put away.

Then on the third day Jesus rose again from the dead as "the second Man." He thus became the Head of an entirely new race—the Immanuel race, the God-man race—a race in which the nature of God and man are blended together in a new creation.

All those who by faith and commitment are identified with Jesus in His death, His burial and His resurrection become members of this new race. In 1 Peter 1:3–4 the apostle says of these: "God . . . has begotten us again to a living hope through the resurrection of Jesus Christ from the dead, to an inheritance incorruptible and undefiled and that does not fade away."

There were, therefore, two complementary aspects to the redemption from the curse provided through the death of Jesus. As "the seed of Abraham," born under the Law, He took upon Himself all the curses of the broken Law summed up in Deuteronomy 28:15–68. As "the last Adam," He also took upon Himself the curses pronounced upon Adam and Eve for their original act of disobedience. As we have seen, these extended also to earth's soil and its vegetation, being specifically manifested in two unproductive forms of vegetation: thorns and thistles.

The New Testament uses very beautiful imagery to reveal how Jesus took upon Himself not merely the curses upon Adam and Eve, but also the curse upon the earth. In John 19:5 the apostle records the scene when Pilate brought Jesus out before His accusers:

> Then Jesus came out, wearing the crown of thorns and the purple robe. And Pilate said to them, "Behold the Man!"

The phrase *the Man* pointed out Jesus as a descendant of Adam—unique in His perfection, yet representative of the whole race. At the same time, Jesus' attire represented the double curse that Adam had brought upon the earth. The crown on His head represented the curse of *thorns*; the purple color of His robe represented the curse of *thistles*.

This brief but vivid scene revealed Jesus as "the last Adam," who took upon Himself both the curse that had come upon Adam and Eve, and also the curse that their sin had brought upon the earth.

From every point of view, therefore, the redemption from the curse provided by the death of Jesus was complete. It covered every curse that had ever come upon humanity. It covered the curse pronounced upon Adam and Eve for their disobedience; it covered the curse their disobedience had brought upon the earth; and it covered all the curses subsequently pronounced in connection with the Law of Moses.

Further study of Scripture indicates, however, that full redemption from the curse will be worked out in successive phases. Redemption from "the curse of the law" is already offered in this present age to those who can appropriate it by faith. It will be manifested in its completeness only upon the return of Christ. At that time, too, those who are caught up to meet Him will finally and forever be released from the Adamic curse.

In Philippians 3:20–21 Paul describes the change that will take place at this time in the body of each redeemed believer:

> For our citizenship is in heaven, from which we also eagerly wait for the Savior, the Lord Jesus Christ,
> who will transform our lowly body that it may be conformed to His glorious body, according to the working by which He is able even to subdue all things to Himself.

Paul here contrasts two kinds of bodies: "our lowly body" and "His [Christ's] glorious body." More literally, these phrases could be rendered "the body of our humiliation" and "the body of His glory." The curse pronounced upon Adam confined him—and his descendants—in "a body of humiliation." As such, it reminds each of us continually of our fallen condition.

From the moment of birth, this body is continually subject to decay, depending on many external factors for life and well-being. By luxury and self-indulgence we may briefly seek to forget our inherent weaknesses, yet within a matter of moments we are inevitably confronted once more with our body's humiliating limitations.

We may put on the most elegant and expensive clothes, but as soon as we become physically active, the smell of our sweat reminds us that we are confined in "a body of humiliation." Or we may fill our stomachs with the finest of food and drink. Within a few hours, however, we will be compelled to empty our bladders and our bowels—actions that leave no room for pomp or arrogance.

For those who have accepted the redemption provided by Christ, all these humiliating features of our present body will be changed not gradually or progressively, but in one single, glorious moment. In 1 Corinthians 15:51–53 Paul describes this supernatural transformation:

> We shall not all sleep [in death], but we shall all be changed—
> in a moment, in the twinkling of an eye, at the last trumpet. For the trumpet will sound, and the dead will be raised incorruptible, and we shall be changed.
> For this corruptible must put on incorruption, and this mortal must put on immortality.

Altogether, in 1 Corinthians 15, Paul sums up the following five changes that will take place in the body of each believer at the return of Christ:

1. From corruptible to incorruptible
2. From mortal to immortal
3. From dishonor to glory
4. From weakness to power
5. From natural—literally, "soulish"—to spiritual

All the five negative features in the above list are the effects of the original curse on Adam. Full deliverance from all of them will come first to the believers who are caught up to meet Christ at His return. In James 1:18 these are described as "a kind of firstfruits of [God's] creatures." The transformation they undergo will serve as a guarantee of the redemption that will ultimately come to the whole creation.

In the period that will follow for earth's remaining inhabitants, the righteousness and justice of Christ's Millennial reign will minimize, but not abolish, the curse of the Law. Human life will be greatly extended, but the Adamic curse also will still prevail. Earth, too, as well as the animal creation will experience a period of fruitfulness and abundance without parallel since the Fall—but "futility" will not yet be done away with. The full and final abolition of every curse must wait until the period of "new heavens and a new earth" (2 Peter 3:13).

All this will be the outworking of the exchange by which Jesus on the cross was made a curse in order to cancel every curse that man's disobedience had brought on himself and on creation. In Revelation 22:3 its consummation is summed up in one brief, but comprehensive, statement: "And there shall be no more curse."

24
To Bless
or to Curse?

Suppose that people revile us, curse us, oppose us and persecute us for our faith in Christ. Suppose that they spread malicious lies about us and use all sorts of dishonest and illegal means to do us harm. Are we free to retaliate by pronouncing some kind of curse against them? To this the answer of the New Testament is a clear, emphatic NO!

In Romans 12:9–21 Paul lists various principles that should govern Christian behavior. In verse 9 he begins with the one supremely important motivation: "Let *love* be without hypocrisy." All the other directions that follow are simply different ways in which Christian love expresses itself.

In verse 14 he instructs Christians how to respond to those who seek to do them harm: "Bless those who persecute you; bless and do not curse."

In verse 21 he closes with a more general application of the same principle: "Do not be overcome by evil, but overcome

evil with good." There is only one power strong enough to overcome evil, and that is *good*. Whatever form of evil confronts us, we must always respond with the corresponding form of good. Otherwise we shall find evil too strong for us.

In 1 Peter 3:8–9, Peter gives a similar warning against the wrong kind of reaction to evil:

> Finally, all of you be of one mind, having compassion for one another; love as brothers, be tenderhearted, be courteous;
> not returning evil for evil or reviling for reviling, but on the contrary blessing, knowing that you were called to this, that you may inherit a blessing.

By thus overcoming evil with good, we share in Christ's own triumph over evil, as depicted in 2 Corinthians 2:14–15:

> Now thanks be to God who always leads us in triumph in Christ, and through us diffuses the fragrance of His knowledge in every place.
> For we are to God the fragrance of Christ among those who are being saved and among those who are perishing.

Like Mary of Bethany, who poured costly ointment on the head of Jesus, we fill the whole area around us with a sweet fragrance. Even those who oppose us and criticize us are nevertheless blessed by the fragrance. (See Mark 14:3–9.)

This brings out a basic difference between the Old and the New Covenants. In the Old Testament God frequently used His people as instruments of judgment against other people. In bringing Israel into the land of Canaan, for instance, God used Joshua and his army as the instruments of His judgment on the Canaanites who had previously occupied the land. There are also many other instances in the Old Testament in which God's servants pronounced curses on people who op-

posed or disobeyed Him, and the effect was the same as if
God Himself had uttered them.

In Joshua 6:26, for example, after the Israelites had cap-
tured and destroyed Jericho, Joshua pronounced the following
curse on anyone who would ever afterward rebuild a city on
the same site:

> "Cursed be the man before the Lord who rises up and
> builds this city Jericho; he shall lay its foundation with
> his firstborn, and with his youngest he shall set up its
> gates."

About five hundred years later, during the reign of Ahab
king of Israel, this curse was fulfilled, as recorded in 1 Kings
16:34:

> In his [Ahab's] days Hiel of Bethel built Jericho. He
> laid its foundation with Abiram his firstborn, and with his
> youngest son Segub he set up its gates, according to the
> word of the Lord, which He had spoken through Joshua
> the son of Nun.

In the margin of the New King James the phrase "with his
son" is rendered "at the cost of the life of. . . ." The NASB
renders it "with the loss of. . . ." The NIV renders it: "at the
cost of. . . ."

This is a vivid example of the invisible forces that are con-
tinually at work in human history, and yet are so often ignored.
How many secular historians today, when describing this in-
cident, would trace the death of these two young men to words
spoken by a servant of God five hundred years earlier?

It is important to notice, in 1 Kings 16:34, that the writer
emphasizes that the curse was fulfilled "*according to the word of
the Lord*, which He had spoken through Joshua the son of
Nun." Joshua was the channel through which the curse came,

but the Lord was its source. This—and this alone—accounts for its effect.

David was another servant of God who pronounced curses that took effect many generations later. In Psalm 69:22–25, and again in Psalm 109:6–13, he pronounced a lengthy series of curses on some unnamed person, or persons, on account of treachery and disloyalty to a righteous man who had been unjustly accused and condemned. About one thousand years later, after the death and resurrection of Jesus, the apostles recognized that these curses of David had found their fulfillment in Judas Iscariot, who had been the betrayer of Jesus. (See Acts 1:15–20.)

Some of the prophets who followed David also pronounced curses that released God's judgments in various ways. In 2 Kings 1:9–12, for instance, Elijah called down fire from heaven that destroyed two successive bands of soldiers sent to arrest him. In 2 Kings 2:23–24, his successor, Elisha, cursed a group of youths who had mocked him, with the result that 42 of them were mauled by bears.

Subsequently, God used Elisha to bring miraculous healing of leprosy to the Syrian general, Naaman, who in turn offered Elisha a variety of lavish presents. Elisha, however, refused to accept any of them, thus showing Naaman that there was no way he could "pay" for his healing from God. Later, Elisha's servant, Gehazi, motivated by covetousness, ran after Naaman and, on false pretenses, persuaded Naaman to give him a substantial gift of silver and clothing (2 Kings 5:1–27).

When Gehazi returned, Elisha—by supernatural revelation—confronted him with his covetousness and dishonesty. Then he pronounced God's judgment on him:

> "Therefore the leprosy of Naaman shall cling to you and your descendants forever." And he went out from his presence leprous, as white as snow.

The effect of Elisha's curse was visible and instantaneous. Gehazi found himself afflicted by leprosy in the same advanced stage from which Naaman had just been healed. Furthermore, the same disease would continue to afflict Gehazi's descendants so long as there was one of them remaining on earth.

There is one important feature common to all the curses referred to above—whether uttered by Joshua, David, Elijah or Elisha. Each of them expressed a sovereign judgment of almighty God. *They did not proceed from the mind or will of the man who uttered them.* They were not the expression of mere human anger or vindictiveness. God sovereignly chose human channels through whom to administer His justice. There is no suggestion in Scripture that God has ever renounced His right to do this.

In the New Testament, however, God has chosen to use His servants primarily as instruments of mercy and not of judgment. The contrast between the two covenants is brought out in an incident in Luke 9:51–56. Jesus had sent messengers ahead of Him to prepare for His reception in a Samaritan village through which He intended to pass, but the Samaritans refused to receive Him. In response, James and John had asked, "Lord, do You want us to command fire to come down from heaven and consume them, just as Elijah did?"

In reply, Jesus rebuked them for their attitude, saying: "You do not know what manner of spirit you are of. For the Son of Man did not come to destroy men's lives but to save them."

Jesus did not deny that Elijah had called down fire to destroy his enemies. Nor did He question that James and John might have been able to do the same. Instead, He reminded them that they were in a period when God was using His servants in a different way. They were called to be instruments of God's mercy, rather than His judgment.

Nevertheless, there are a few instances in the New Testament of curses pronounced by God's servants. Jesus Himself provided one of the most dramatic examples. On His way into Jerusalem, becoming hungry, He went up to a fig tree to get some of the early fruit that would have been appropriate at that season. Discovering that the tree was full of leaves, but had produced no fruit, He said to it, "Let no fruit grow on you ever again" (Matthew 21:19).

Next day, when He and His disciples passed by, the fig tree had withered from the roots. Peter commented: "Rabbi, look! The fig tree which You *cursed* has withered away" (Mark 11:21). In reply, Jesus delegated to His disciples the same authority that He Himself had demonstrated in cursing the fig tree: "Assuredly, I say to you, if you have faith and do not doubt, you will not only do what was done to the fig tree . . ." (Matthew 21:21). In other words, He gave them authority to pronounce curses similar to that which He had pronounced on the fig tree.

Many commentators see in this fig tree a type of the form of religion into which the practice of the Law of Moses had degenerated. It was full of "leaves"— that is, the outward forms of religion—but it did not yield the true fruit of the Law, which Jesus summed up as "justice and mercy and faith" (Matthew 23:23). As a result, sincere seekers who looked to that form of religion to satisfy their spiritual hunger were turned away, empty and disappointed. Within a generation, under the judgment of God, the whole system was destined to "wither from the roots."

The disciples apparently saw no significance in the fruitless fig tree, and would have passed it by. It was Jesus who took action against it, and then commissioned His disciples to take similar action. In succeeding generations, this lesson seems to have been lost on most Christians. Certainly there are times

when we encounter such "fruitless fig trees"—that is, deceptive religious systems that disappoint hungry seekers after the reality of the Gospel. Do we merely pass these "fig trees" by, unconcerned? Or do we take the same kind of aggressive action that Jesus demonstrated?

In Matthew 10:14–15, when Jesus sent out the first apostles to preach the Gospel, He gave them authority of a similar kind to deal with those who rejected them and their message:

> "And whoever will not receive you nor hear your words, when you depart from that house or city, shake off the dust from your feet.
> "Assuredly, I say to you, it will be more tolerable for the land of Sodom and Gomorrah in the day of judgment than for that city!"

By this act of shaking off the dust from their feet, the apostles would, in effect, hand over those who rejected them to the judgment of God, which would ultimately be more severe than that on the inhabitants of Sodom and Gomorrah.

The apostles of the New Testament took this command of Jesus literally. In Pisidian Antioch, after Paul and Barnabas had ministered for some time with great effect, their adversaries finally drove them out of the city. Acts 13:51 records the apostles' response:

> But they shook off the dust from their feet against them, and came to Iconium.

Incidents such as these confirm a principle already established in the Old Testament: Blessings and curses are never far separated from one another. When blessings are offered, but rejected, curses almost inevitably follow in their place. When Israel entered Canaan under the Law of Moses, God required them to invoke upon themselves either the blessings

promised for obedience, or the curses that followed disobedience. There was no third option. The same applies to those who have the Gospel with its blessings proclaimed to them, but deliberately and consciously reject it. Almost inevitably they expose themselves to corresponding curses.

Earlier, on the island of Cyprus, God had opened the way for Paul and Barnabas to bring the Gospel to the Roman proconsul,[1] Sergius Paulus. However, a sorcerer—that is, a practitioner of the occult—named Elymas sought to keep them from speaking to the proconsul. Paul's response to this challenge from Satan is described in Acts 13:9–12:

> Then Saul, who also is called Paul, filled with the Holy Spirit, looked intently at him
> and said, "O full of all deceit and all fraud, you son of the devil, you enemy of all righteousness, will you not cease perverting the straight ways of the Lord?
> "And now, indeed, the hand of the Lord is upon you, and you shall be blind, not seeing the sun for a time." And immediately a dark mist fell on him, and he went around seeking someone to lead him by the hand.
> Then the proconsul believed, when he saw what had been done, being astonished at the teaching of the Lord.

The effect of Paul's words on Elymas was as immediate and dramatic as the curse of leprosy that Elisha had pronounced upon Gehazi. The writer of Acts emphasizes that at this moment Paul was "filled with the Holy Spirit." Therefore, his words were not the product of his own fleshly reaction to opposition, but represented God's sovereign judgment on the sorcerer, uttered by the Holy Spirit. The proconsul was so impressed by this demonstration of the supremacy of Jesus over Satan that he became a believer.

[1] A senior Roman official.

This incident brings out the decisive issue in determining whether or not there are situations in which it is right for Christians to pronounce a curse. If the motive is some reaction of our fleshly nature, such as resentment or anger, or the desire for revenge or self-justification or self-glorification, then to utter a curse in such a situation would be a sin. Furthermore, it would do much greater harm to the one who utters the curse than to the one who is cursed.

In Romans 6:16 Paul emphasizes the danger of yielding to this kind of satanic motivation:

> Don't you know that when you offer yourselves to someone to obey him as slaves, you are slaves to the one whom you obey—whether you are slaves to sin, which leads to death, or to obedience, which leads to righteousness?
>
> NIV

It can be tempting to seek momentary gratification of some evil impulse by allowing a curse to pass through our lips, but in so doing we offer ourselves as slaves to the author of the temptation: Satan. He is not content with merely temporary influence over us. He uses the temptation as an opening through which he can move in and take permanent control of our lives. Our temporary yielding to him thus becomes permanent enslavement. In this way, *the one who uses a curse to bring evil upon others brings a far greater and more enduring evil upon himself.*

On the other hand, the New Testament gives clear examples of situations in which the Holy Spirit sovereignly chose to pronounce a curse through a servant of God. If we refuse to acknowledge this possibility, we shut ourselves off from one of the ways in which God might wish to use us. Our only safeguard is to cultivate a relationship with the Holy Spirit in

which we are sensitive both to His prompting and to His restraining. If we have any doubts as to the purity of our motives or the leading of the Holy Spirit, we should most certainly keep silent.

The possibility that the Holy Spirit may in certain circumstances prompt us to utter a curse was made very real to me by an incident that occurred in my ministry in the mid-1960s. At that time I was part of the ministerial staff of a church located in the inner city of Chicago. The building immediately adjoining the church was a pub. This had become a center for various forms of vice, which included drug-peddling, knife fights and prostitution—both male and female.

One evening I was on the platform of the church, leading a meeting of people gathered to pray for the city of Chicago. In the midst of the prayer, without any premeditation on my part, I heard myself make a loud declaration: "I put the curse of the Lord on that pub!" After that, the meeting continued along its normal course. Personally, I gave little further thought to what I had said.

About two months later, I was awakened at 3 A.M. by an urgent phone call to say that the church was on fire. I dressed and hurried to the scene, to discover that it was not the church, but the pub next door, that was on fire. The wind off Lake Michigan, however, was blowing the flames onto the church. Just when it seemed inevitable that the church would be destroyed along with the pub, the direction of the wind suddenly changed 180 degrees and blew the flames away from the church.

In the end, the pub was completely destroyed and the church suffered only smoke damage, which was fully covered by insurance. No lives were lost, and no one was injured. After surveying the scene and what had taken place, the fire chief commented to the senior elder of the church: "You people must have a special relationship with the Man upstairs!"

My personal reaction was one of awe, mingled with fear. I had no doubt that what I had witnessed was the outworking of the curse on the pub that I had pronounced two months earlier. I did not regret what I had done. I felt that God had intervened in righteous judgment, tempered with mercy. At the same time, I realized in a new way the awesome power that could be released through words spoken by a servant of God. I resolved that, for my part, I would seek God for His grace never to misuse that power.

On a small scale, the destruction of that pub by fire reinforces a truth of Scripture that is central to this whole theme of blessings and curses: *The power of the tongue is measureless— whether for good or for evil.* With our tongue we can bless and we can curse; we can build up and we can break down; we can wound and we can heal; we can do great good, and just as great harm.

The power of the tongue is also frightening, because we ourselves cannot control it. Again and again, our experience compels us to acknowledge the truth of James 3:8: "But no man can tame the tongue." There is therefore only one safe course: to yield the tongue to God through the Holy Spirit and ask Him to control it for us. To help us do this, here are two prayers of David that are patterns for us to follow:

> Set a guard, O Lord, over my mouth;
> Keep watch over the door of my lips.
>
> Psalm 141:3

> Let the words of my mouth
> and the meditation of my heart
> Be acceptable in Your sight,
> O Lord, my strength and my redeemer.
>
> Psalm 19:14

Background of the Author

Derek Prince was born in India, of British parents. He was educated as a scholar of Greek and Latin at two of Britain's most famous educational institutions—Eton College and Cambridge University. From 1940 to 1949, he held a Fellowship (equivalent to a resident professorship) in Ancient and Modern Philosophy at King's College, Cambridge. He also studied Hebrew and Aramaic, both at Cambridge University and at the Hebrew University in Jerusalem. In addition, he speaks a number of other modern languages.

In the early years of World War II, while serving as a hospital attendant with the British Army, Derek Prince experienced a life-changing encounter with Jesus Christ, concerning which he writes:

> Out of this encounter, I formed two conclusions which I have never since had reason to change: first, that Jesus

Christ is alive; second, that the Bible is a true, relevant, up-to-date book. These two conclusions radically and permanently altered the whole course of my life.

At the end of World War II, he remained where the British Army had placed him—in Jerusalem. Through his marriage to his first wife, Lydia, he became father to the eight adopted girls in Lydia's children's home there. Together the family saw the rebirth of the State of Israel in 1948. While serving as educators in Kenya, Derek and Lydia adopted their ninth, an African baby girl. Lydia died in 1975, and Derek Prince married his present wife, Ruth, in 1978. Derek Prince's nondenominational, nonsectarian approach has opened doors for his teaching to people from many different racial and religious backgrounds, and he is internationally recognized as one of the leading Bible expositors of our time. His daily radio broadcast, "Today with Derek Prince," reaches more than half the globe, including translations into five Chinese languages (Mandarin, Amoy, Cantonese, Shanghaiese, Swatow), Spanish and Russian. He has published more than thirty books, which have been translated into more than fifty foreign languages.

Through the Global Outreach program of Derek Prince Ministries, his books and audiocassettes are sent free of charge to hundreds of national Christian leaders in the Third World and behind the Iron Curtain. Now past the age of 75, he still travels the world—imparting God's revealed truth, praying for the sick and afflicted, and sharing his prophetic insight into world events in the light of Scripture.

The international base of Derek Prince Ministries is located in Fort Lauderdale, Florida, with branch offices in Australia, Canada, Hong Kong, New Zealand, Singapore, South Africa, the United Kingdom and West Germany.

Three-Cassette Series
Curses: Cause and Cure

Many people experience continual frustration in areas such as marriage, health or finance, yet never discern the underlying cause: *a curse.* This series reveals both *cause* and *cure.*

Curses: Cause I–6011
Curses: Cure, Part 1 . . . I–6012
Curses: Cure, Part 2 . . . I–6013
3-cassette album I–CC1

Order books, audio and videocassettes
from your local bookstore or:

Derek Prince Ministries—International
P.O. Box 300
Fort Lauderdale, FL 33302
U.S.A.
(305) 763–5202

Write for free catalog of books, teaching tapes
and videos by Derek Prince